Introduction to **Photography**

Introduction to Photography

Fourth Edition

Marvin J. Rosen
California State University, Fullerton

David L. DeVries
California State University, Fullerton

Wadsworth Publishing Company
Belmont, California
A Division of Wadsworth, Inc.

Mass Communications Editor: **Kris Clerkin**
Editorial Assistant: **SoEun Park**
Production Editor: **Angela Mann**
Designer: **Ann Butler**
Art Editor: **Nancy Spellman**
Print Buyer: **Barbara Britton**
Permissions Editor: **Jeanne Bosschart**
Copy Editor: **Jane Townsend**
Photo Researcher: **Stuart Kenter**
Technical Illustrator: **Precision Graphics**
Cover Designer: **William Reuter Design**
Compositor: **Fog Press**
Printer: **Courier**

Cover photo by Jay Maisel

Frontispiece photo by Kenneth Josephson

Printed in the United States of America

1 2 3 4 5 6 7 8 9 10—97 96 95 94 93

Library of Congress Cataloging in Publication Data
Rosen, Marvin J.
 Introduction to photography: a self-directing approach / Marvin J. Rosen,
 David L. DeVries.—4th ed.
 p. cm.
 Includes bibliographical references (p.) and index.
 ISBN 0-534-17850-2
 1. Photography. 2. Photography—Programmed instruction.
 I. DeVries, David. II. Title.
 TR146.R85 1993
 770'.7'7—dc20 92-20746

Brief Contents

Contents

Preface

Introduction to Photography, Fourth Edition, is a general introduction to photography designed for those with little or no previous experience with photography as well as intermediate photographers who wish to extend their knowledge and skill. The text covers the basic skills needed to make effective black-and-white photographs and to process, print, and finish them. It also provides a basic introduction to the principles of color photography. It teaches how to use an adjustable camera; common attachments and accessories; and basic darkroom supplies and equipment. Because successful photography also depends on the photographer's perception and style, the book encourages students to seek out subjects that interest them and guides them in communicating their thoughts and feelings to others through visual means.

New and Continuing Features

The technical content of this edition reflects the rapid development of photographic technology and incorporates the suggestions of many colleagues and students. The emphasis on using electronic flash and automated cameras reflects current practices in introductory photography classes. The fourth edition also includes new sections on push processing, assessing negatives, handling photochemicals, creative printing techniques, available light photography, careers in photography, processing for permanence, large-format photography, electronic photography, and law and ethics for photographers. It also includes field and laboratory assignments of larger scale than those included in earlier editions.

The fourth edition retains the characteristics that have made the text useful in a variety of instructional modes: a modular approach to photographic skills that includes learning objectives, key concepts, illustrated instructional material, questions to consider, field and laboratory assignments, and an extended glossary of terms and concepts. In addition, this edition incorporates some changes that conserve space, improve organization, and enhance the text's motivational features. Blank spaces formerly provided for students' written responses have been removed. A single reference section replaces the references that formerly appeared with each unit. Famous photographs, famous photographers, and interesting careers are highlighted in special feature boxes that appear in each unit.

This edition continues the practice of using student photographs extensively to illustrate various principles, because we believe that students are motivated by peer examples. Students recognize that these images are within their grasp, that they were produced by students like themselves rather than by professional photographers. Works of professional photographers also appear throughout the book wherever they serve to illustrate a point made by the text.

Self-Directed Approach

Used as a conventional text, the book continues to provide basic information, allowing instructors to supplement its content with their own demonstrations, lectures, and discussions. However, the self-directing features of the text also allow students to instruct themselves in many basic skills and procedures, thus freeing instructors from repetitive lecturing and demonstrating, and allowing them to concentrate more of their own efforts on topics of special interest.

The text has proven successful in programs of individualized teaching and learning. Incorporating a modular design, the text serves as a guide for individual study and practice for students who can work with a minimum of supervision. Used in this way, the book allows students to learn at their own pace: Those who are able and so inclined may proceed rapidly toward mastery of photographic skills; others may proceed more slowly to suit their levels of skill or interest. The instructor's role can thus be more tutorial, the student-teacher interaction more adjusted to the needs of individual students.

Independent learners will find the book especially well suited to studying photography on their own. The book is designed to serve as a tutor: It systematically introduces each new topic; provides instruction and practice in an orderly and cumulative fashion; and builds complex skills on simpler ones.

Organization

The book contains thirteen units. Unit 1 provides a history of photographic technology and style, designed to be studied in a contemplative mode. Its rich portfolio of historical and contemporary photographs is intended to be experienced holistically rather than studied in detail. The unit's intent is to inform students of the milestones and heroes in the history of photography and to provide a pleasurable visual sense of its development.

Practice in the craft follows. In Units 2 through 7, students concentrate on the technical skills of operating a camera, selecting materials, developing film, and making and finishing prints. Unit 8 introduces students to composition as a craft. Controllable elements and techniques of composition that aid in communicating ideas and feelings are identified without imposing inflexible rules that may cloud vision and stunt growth. In Units 9 through 11, students explore more deeply the interaction of light and film through the use of filters and supplementary lighting. In Unit 12, students practice applying their knowledge to some of the great themes in photography—scenery, architecture, still life, people, action, and human interest. A new section on photojournalism concludes the unit. In Unit 13, students study and practice additional special topics—the fine print, the zone system, processing for permanence, large-format photography, closeup and copy photography, electronic photography, and law and ethics for photographers.

Acknowledgments

We gratefully acknowledge the contributions of many persons to this work—Dr. J. William Maxwell and Mrs. Barbara Machado for their early encouragement and material support; the students and photographers whose works appear herein and in earlier editions; and our many colleagues who provided invaluable suggestions for strengthening this fourth edition. Especially helpful were the comments of David R. Anderson, St. Cloud State University: Michael Barnes, Sheridan College; Wayne Braith, St. Cloud State University; James B. Colson, University of Texas at Austin; Richard W. Conrad, University of Washington; Robert Curran, College of Boca Raton; Roger Graham, Los Angeles Valley College; Robert Heller, University of Tennessee; Neville Hylton, Center for the Media Arts; Offie Lites, University of Central Arkansas; Andrew Venclauskas, Virginia Marti College; and Gregory J. Wurtzler, Ohio Institute of Photography.

Introduction to Photography

Unit One

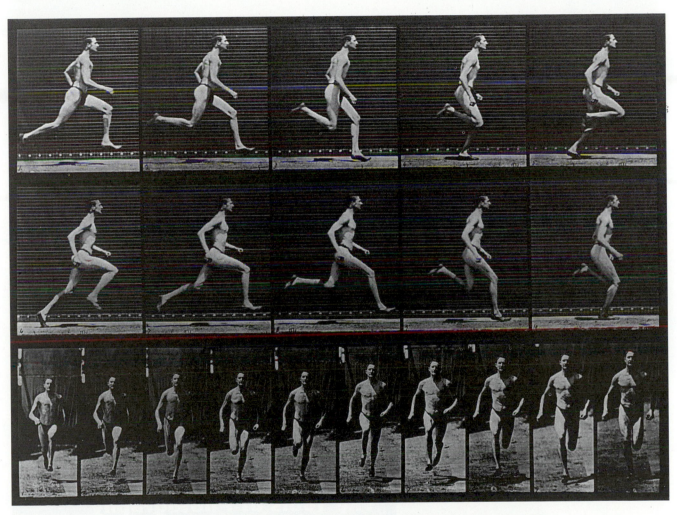

Eadweard Muybridge, "Man Running," (0.042 second), first published in 1887.

The history of photography provides a background for learning about the craft of photography. Not only does history help us to understand how the technology has evolved, but it also helps us to understand the evolution of our visual thinking.

This unit describes how cameras and chemistry developed into a technology called photography. It also discusses how artists, journalists, and others have used photography to document the world around them and to communicate their ideas. Examples of the various styles and content that characterize photography's diverse history are presented throughout the unit.

Imaging: Expression and Representation in Pictures

Human beings expressed themselves and told their stories in pictures long before they could write. Pictures on the walls of early cave dwellings are evidence of the human compulsion to describe the world in both representational and symbolic images. Until the invention of printing in Western Europe in the fifteenth century, pictures were unique creations, each handmade, highly prized, and often thought to possess spiritual qualities.

From the beginning, these handmade images seemed to reveal dual purposes: to describe objects and events in precise objective detail, and to express feelings about them. Primitive peoples probably used these images as we use pictures today—to inform, to teach, to persuade, to inspire, and to express feelings and insights.

In Renaissance Europe, artists became preoccupied with representing the three-dimensional physical world in two dimensions. In fifteenth-century Florence, Filippo Brunelleschi and Leon Battista Alberti introduced the mathematical concept of linear perspective. This concept established a standard of realism that continues to dominate Western visual thinking and that, at the time of its invention, created a demand for mechanical aids to achieve it. From the array of mechanical aids that were developed during the sixteenth century, the modern camera found its beginnings.

The Tools of Photography

Interestingly, the device that gained the greatest popularity among perspective artists, the **camera obscura** (Latin for *a dark room*), was based on principles that had been known for centuries. As early as the fourth century B.C., Aristotle had manipulated the passage of light through a small hole in a dark room to produce images of solar eclipses and had observed that the image was sharper when the hole was smaller.

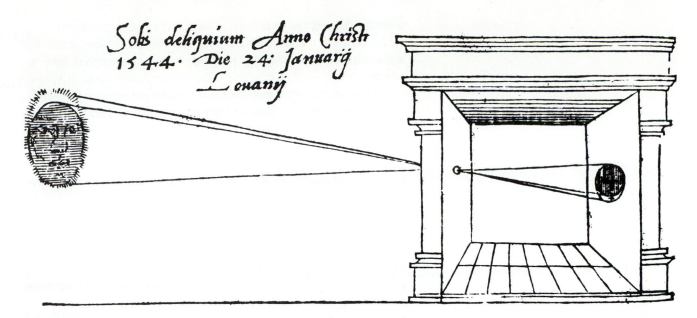

Soks defiquium Anno Christi
1544. Die 24: Januarij
Louanij

FIGURE 1-1

Rainer Gemma-Frisius. This first published illustration of a camera obscura showed its use to observe a solar eclipse in 1544 A.D.

During the Dark Ages, Aristotelean knowledge was preserved by Arab scholars. Early in the eleventh century, Alhazan, an Arab mathematician, described how to make a *camera obscura* in a dark tent.

In the sixteenth century, lenses and mirrors were added and various forms of the *camera obscura* became common artist's tools.

Until the seventeenth century, the device used to produce an image was an actual room, sometimes of permanent construction, sometimes portable, but large enough for persons to work within. The size of this device gradually became smaller, and smaller, until finally it emerged as a small box, large enough for only the artist's hands to work in. It was often painted black inside, sometimes equipped with an opal-glass focusing screen, and sometimes designed with a telescoping body to modify the image size.

One important step remained. Although images could be produced in mirrors and projected onto plane surfaces by the *camera obscura*, the images were fleeting. To make the images permanent, artists had to trace them with pencil and brush. If artists could make the projected images permanent without manual tracing, they could increase the speed and the accuracy of their work.

The Chemistry of Photography

Pioneers

Early in the eighteenth century, 100 years before the first permanent photographic image was recorded, Johann Heinrich Schulze, working in Germany, discovered that light darkened the silver salts he kept stored in bottles. Although he recognized no practical use for this phenomenon, his discovery would later become the foundation for photography.

In the mid-eighteenth century, a Swedish chemist, Carl Wilhelm Scheel, observed that although the silver salts themselves were soluble in ammonia, the metallic silver that had been freed by the action of light was not.

At the turn of the nineteenth century, several adventurous craftworkers, scientists, and artists were working to capture *camera obscura* images. In Britain, Humphrey Davy and Thomas Wedgwood found that objects placed directly on materials that had been sensitized with silver chloride and exposed to sunlight would leave momentary impressions that would later fade. Wedgwood and Davy's work, however, did not progress to the point of recording an image produced by a *camera obscura.*

The French inventor Joseph Nicéphore Niépce was also experimenting with *camera obscura* images. By 1816 he had succeeded in making a paper negative in a *camera obscura*, but he could not prevent it from fading. Failing with paper, he turned to plates of pewter coated with bitumen of Judea, a type of varnish that hardened when exposed to sunlight. After placing a drawing in contact with this plate, he exposed it to sunlight for many hours. After exposure he removed the unexposed areas with a mixture of turpentine and lavendar oil to reveal a barely visible image of the original drawing. He called this process **heliography**—sun drawing.

Still attempting to "fix the image of objects by the action of light," he experimented with heliography and a *camera obscura*. He apparently enjoyed some success, though only one of these plates is known to survive. Made in about 1826, it shows a view from Niépce's attic workroom and is generally regarded as the world's earliest surviving photograph.

In about 1827, Niépce met Louis Jacques Mandé Daguerre, who became interested in Niépce's work because of his uses of the *camera obscura* for painting and theatrical designing (see "Famous Photograph: The Daguerreotype"). After working with Niépce and his son Isidore for ten years, Daguerre developed a method of producing extremely fine, luminous, and permanent images on sheets of copper plated with silver.

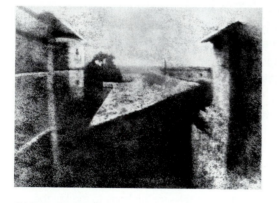

FIGURE 1-2

Joseph Nicéphore Niépce. View from his studio window. 1826. Earliest known photograph, on pewter.

The Daguerreotype

Daguerre was a flamboyant theatrical entrepreneur and showman whose Diorama productions had thrilled audiences in London and Paris for many years. Now, sensing a hit, he moved to promote his photographic invention. In 1839, he arranged for the French Academy of Sciences to announce the process that he named the **daguerreotype**. He cajoled the French government into buying the rights and making them public in France, and awarding him and Isidore Niépce lifetime pensions.

Fascination with the daguerreotype swept Paris. Upon seeing the process for the first time, painter Paul Delaroche pronounced, "From today, painting is dead!" Daguerreotypomania, as it was dubbed in the press, seemed to take over every phase of life. Nothing like it had ever been seen before. The perfect perspective, the exquisitely etched details of cobblestone streets, carved facades, brocaded dresses, and the subtle shadings of facial features and elaborate coiffures evoked comparisons with the great artists.

Famous Photograph: The Daguerreotype

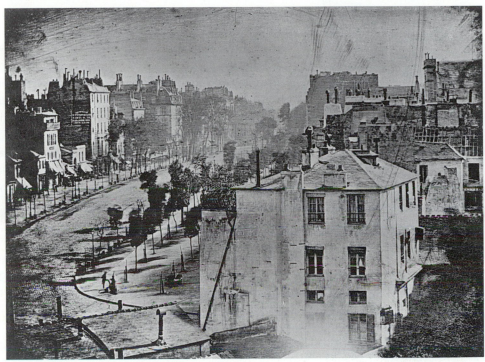

FIGURE 1-3

Louis J. M. Daguerre. "Paris Boulevard." 1839. Daguerreotype.

This daguerreotype, made in 1839 by Louis Jacques Mandé Daguerre, is generally regarded as the first photograph showing the image of a human being. Early daguerreotypes required lengthy exposures; Daguerre was fortunate that for this shot, his human subject remained in a relatively stationary position while having his boots shined, allowing his image to be captured. Meanwhile, pedestrian and carriage traffic that may have passed along the street while the image was being slowly recorded were never stationary long enough to become fixed in this memorable scene.

A showman by profession, Daguerre specialized in creating spectacular Dioramas that mixed projected images, painted backdrops, and three-dimensional objects to create realistic displays of exotic subjects. He had long used the *camera obscura* to sketch the exacting perspectives of his elaborate illusions, and he saw quickly the connection between Joseph Nicéphore Niépce's work with heliography and his own work. The two men entered into a partnership to perfect Niépce's process, a collaboration that continued without practical result until Niépce's death in 1831. Daguerre and Niépce's son, Isidore, continued with the experiments until, in 1837, they discovered how to make a strong, permanent image using sheets of silver-plated copper fumed with iodine vapor and processed in mercury vapor.

Early in 1839, the year of this photograph, astronomer and physicist Dominique-Françoise-Jean Arago demonstrated Daguerre and Niépce's process—the daguerreotype—before the French Academy of Sciences. Later that year, Arago made public the technical details and Daguerre published a detailed booklet on the process. Daguerre may not have been the "inventor" of photography, but he probably did more than any other person to make photography a matter of public interest. People from London to St. Petersburg and even in America reacted with wild enthusiasm, and before long "Daguerreotypomania" had captured the public's imagination. Studios sprung up everywhere and excited amateurs clamored to buy daguerreotype apparatus.

Popular photography had been born.

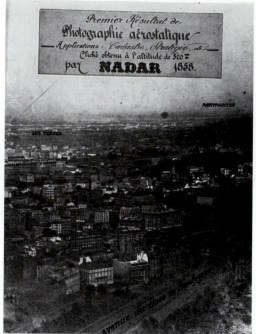

A

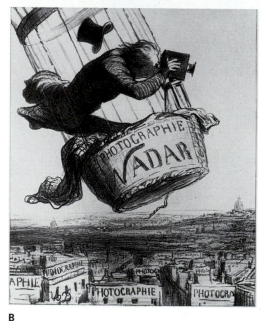

B

FIGURE 1-4

A. Gaspard-Felix Tournachon—or Nadar. "A View of Paris," 1858. First aerial photograph, made from a balloon hovering at an altitude of 1600 feet.
B. Honoré Daumier. "Nadar Elevating Photography to a High Art," 1862. Nadar's photographic feats, including aerial shots from a balloon, inspired this popular lithograph.

The daguerreotype spread rapidly throughout Europe. Daguerreotypists appeared everywhere, offering convenient portrait services to celebrities and common folk alike. Enterprising publishers dispatched daguerreotypists to foreign lands and began illustrating their travel books with illustrations and drawings that were hand-copied from daguerreotype views. Daguerreotypes also appeared as miniature works of art and as documentations of events. It seems certain that by 1843, only four years after Daguerre's announcement, every European town of consequence had at least one daguerreotype studio, and others were served by itinerant photographers.

Daguerre's patent restrictions made daguerreotypy costly in England, but the process spread unfettered to America. The American inventor Samuel F. B. Morse, who had also tried unsuccessfully to fix *camera obscura* images, learned of Daguerre's work during a visit to Paris and, by mid 1840, he and John William Draper had become partners in a portrait studio atop New York University. The craft spread rapidly in America. By 1853 New York City alone boasted an estimated 100 or more studios.

The Calotype

In the early 1830s, while Niépce and Daguerre were struggling to capture images on metal plates, others were also at work. One of these was England's Sir John Herschel, who by 1839 had succeeded in capturing images on paper that had been sensitized with carbonate of silver, and who was the first to make them permanent by fixing in hyposulfite of soda.

The noted English scientist William Henry Fox Talbot had also taken a different direction. Talbot first captured images on paper coated with silver chloride. By 1835 he had learned to make these images permanent by washing them in a strong salt solution. To speed up exposure, he worked with very small images, some only an inch or so square. These little negative images—curiosities at best—were of little compelling interest, even to Talbot. Between 1835 and the time of Daguerre's dramatic announcements in 1839, Talbot had all but abandoned this line of work. However, when he heard the news from France, Talbot rushed to claim prior discovery by sending letters to members of the French Academy of Science and a report of his own work with "photogenic drawings" to the Royal Society in England. Although his report was widely circulated in the press, his coarse little images could not compete for public favor with the larger, brighter, positive daguerreotype images.

Embedded in Talbot's report to the Royal Society was the following observation, offered almost casually:

If the picture so obtained is first preserved so as to bear sunshine, it may be afterwards itself employed as an object to be copied, and by means of this second process the lights and shadows are brought back to their original disposition.

With this statement, Talbot advanced the negative-positive principle that was to become the basis for nearly all photography after that time.

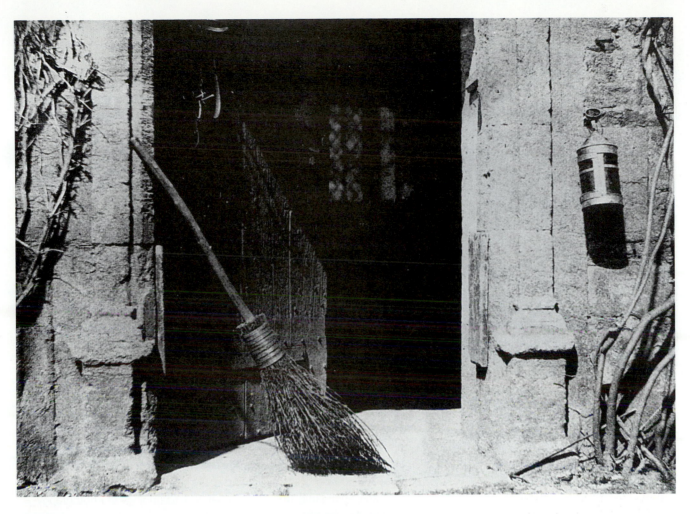

FIGURE 1-5

Henry Fox Talbot. "The Broom," 1844. Calotype from Pencil of Nature, *the first book illustrated with photographs.*

Eclipsed by the popularity of the daguerreotype and frustrated by the lukewarm interest of the Royal Society, Talbot worked on alone, continuing his experiments with larger cameras and improved lenses. He began using hyposulfite of soda as a fixing agent, as Sir John Herschel had suggested. The following year, he discovered that latent, unseen images resided in the sensitized paper after only a brief exposure, and that they could be made visible by resensitizing the paper. Talbot was thus able to reduce exposure time from many hours to less than a minute. To produce a positive image, Talbot resurrected his negative-positive idea and invented contact printing. He waxed his paper negatives so that they would better transmit light and exposed them to sunlight in contact with photosensitive paper to produce positive prints. In 1841 he secured a patent for his process, which at first he called the **calotype**—beautiful image—but which he was later persuaded to call the **talbotype**.

Talbot set up a studio in Reading, outside of London, where he and his employees operated what was probably the world's first photofinishing company. From 1844 to 1846 he produced, probably from this studio, his landmark, six-volume work, *The Pencil of Nature*, the first photo-illustrated book, each volume containing twenty-four pasted-in calotypes.

Talbot's vigorous enforcement of his patent rights discouraged widespread adoption of his process in England. However, calotype studios opened elsewhere in Europe without his licensure. In 1843 David Octavius Hill, a noted landscape painter, and Robert Adamson, a calotypist, opened

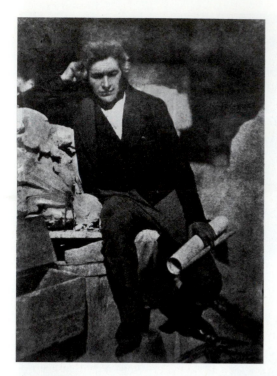

FIGURE 1-6

David Octavius Hill and Robert Adamson. "Architect George Meikle Kemp," circa 1844. This Scottish pair, a painter and a chemist collaborated to explore calotype photography and created over 2000 portraits and genre scenes.

a studio in Edinburgh, Scotland; in their four-year association they produced more than two thousand calotype portraits, genre and architectural views, and landscapes that remain classics of the Victorian era.

The calotype became more popular in France than elsewhere in Europe. Hippolyte Bayard, an experimenter and noted daguerreotypist, invented the method of printing in cloud formations and produced memorable calotype landscapes. Gustave Le Gray, whose seascapes were ahead of their time, developed a process for waxing the calotype paper first to reduce dramatically the paper grain and to give the sensitized paper longer storing properties. In 1851 Louis Desiré Blanquart-Evrard opened a studio in Lille primarily to produce calotype prints for book illustrations. The 125 pasted-in calotypes he produced for Maxime Du Camp's *Egypte, Nubie, Palestine et Syrie* in 1851 were a remarkable achievement for the time. He also developed a faster, sharper, glossy-surfaced printing paper using photo salts suspended in the whites of eggs, which enabled him to increase print production more than 300 percent. This **albumen paper** dominated photographic printing for more than forty years.

Although the calotype never achieved the popularity of the daguerreotype, some photographers recognized the aesthetic qualities of the process. Because of its method of printing through a paper negative, the calotype was soft and lacked the fine, etched detail of the daguerreotype. Yet these same qualities produced a soft, charcoal-like impression that was better suited to the representation of shapes and masses of tone with soft edges—characteristics that appealed to the more interpretive of the early photographers. Further, unlike daguerreotypy, which produced single, unique, unreproducible images, the calotype process could be used to produce any number of identical prints.

Thus, by the mid 1840s, more than one technology of photography existed. This period of early photography, including both the popular daguerreotype and the calotype, was relatively short; it lasted only until the early 1850s. It served, however, to establish photography as an art and craft accessible to the common people.

Wet Plate Photography

Recognizing the advantages of the negative-positive process, but dissatisfied with the coarse quality of images printed through paper, numerous experimenters searched for a transparent medium. Many tried the obvious, glass, but experienced difficulty in bonding the emulsion to the surface. In 1848, however, Abel Niépce de Saint Victor succeeded by using albumen as a coating on glass. Although his process produced a storable, dry plate, a great convenience, the required exposures were excessively long and the process never became popular.

Nevertheless, experimentation continued and, in 1851, Frederick Scott Archer succeeded in bonding a photographic emulsion to glass. The process employed **collodion**, a viscous solution of guncotton dissolved in alcohol and ether, as the transparent bonding agent. The sensitized plate had to be exposed and processed before the highly volatile collodion could dry, for when dry it formed a shield impervious to the developing and fixing solutions. Because it was used in this fashion, the process became known as **collodion wet plate** photography.

FIGURE 1-7

Artist unknown. Portable wet-plate darkroom tent and equipment, circa 1877. The gear necessary for wet plate photography in the field weighed over 120 pounds.

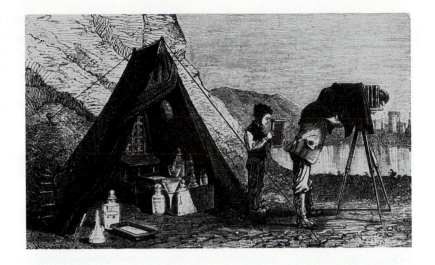

The collodion wet plate process was unbelievably awkward. Imagine toting with you on even the most casual photographic outing a portable darkroom such as a light-tight tent, a supply of 8-in. by 10-in. (or larger) glass plates, photosensitive and processing chemicals in their various containers, and a bulky wooden camera and tripod. Then imagine setting up a tent, coating each glass plate with a photographic emulsion, loading the plate while still wet into a plate holder and then into the camera, immediately making an exposure, and rushing back into the tent to process the plate before it could dry; then repeating the process for each exposure!

Despite these inconveniences, the collodion wet plate rapidly superseded the daguerreotype in popularity. The materials were less costly. Exposure times were usually less than a minute, and often were as short as ten seconds. Unlike the daguerreotype, which was a single, unreproducible image, the glass collodion wet plate produced a negative from which unlimited prints could be made. The final prints, on paper, were lightweight and flexible. And, happily, the rendering of exquisitely fine detail, uncompromised by printing through paper, was comparable to that of the daguerreotype. Collodion wet plate photography began a wave of popular photography, enticed thousands of new amateurs to the craft, dominated photographic practice worldwide for nearly thirty years, and established the negative-positive process as the standard for photography thereafter.

Two variations of the collodion wet plate, which simulated the appearance of the daguerreotype, also became popular. One, the **ambrotype**, patented by James Ambrose Cutting, used underexposure or bleaching to produce a faint negative image on glass. When viewed against a deep black background, the positive image would be seen. A **union case** was used to bind the glass plate permanently with, usually, a piece of deep black velvet. Another variation was the **tintype**, introduced in 1856 by Hamilton L. Smith. In this case, the wet collodion emulsion was applied to a metal plate, usually tin, that was lacquered deep black. A faint image was produced on the surface, and when the plate was viewed against the black background, the positive image would be seen. Because ambrotypes and tintypes were inexpensive and easy to make, they became very popular in America and supported a virtual army of studio and itinerant

FIGURE 1-8

Photographer unknown. Untitled ambrotype, circa 1858. The black backing has been partially removed on the right to show how the backing made the negative image appear as a positive one.

photographers. However, these one-of-a-kind techniques would eventually go the way of the daguerreotype, superseded by the more flexible negative-positive processes.

Dry Plate Photography

In 1871 Richard Leach Maddox discovered a means of bonding a dry emulsion to a glass plate using gelatin, and by 1878 a practical dry plate process was available that rapidly superseded the collodion wet plate process. Because dry plates could be mass produced, stored, distributed through retail shops, and processed at leisure, commercial channels quickly developed.

However, even in the late 1880s, photography remained the domain of the very determined. Photographic plates were still heavy and fragile. Camera equipment was bulky and unwieldy. Photographers in the field were obligated to carry about the stuff of their trade by covered wagon or mule train. This was no easy craft.

One American dry plate manufacturer, George Eastman, recognized that would-be photographers represented a huge market for anyone who could simplify this process; in 1888 he did just that. He introduced a small, lightweight box camera that was easy to operate and that boasted a shutter fast enough to eliminate the need for a tripod. More important, however, was the fact that the camera came loaded with a roll of paper film. For thirty-five dollars a purchaser could shoot one hundred pictures and then return the entire camera to the Eastman Company, where the film would be removed and processed. One hundred individually mounted pictures would be returned to the purchaser together with the camera, reloaded with a fresh roll of film.

FIGURE 1-9

Fred Church. "George Eastman on Board Ship," 1890. Eastman is shown here with a No. 1 Kodak identical to the one that took this picture.

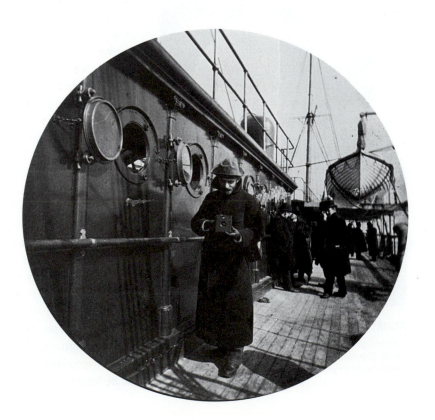

Eastman dubbed his little camera *Kodak*, a meaningless word that was easy to remember and easy to say. He popularized the slogan: "You push the button and we do the rest." A year later, he replaced the paper base of his roll film with transparent nitrocellulose. By the turn of the century, Eastman was marketing his simple cameras and popular film products to ordinary people everywhere, who carried their cameras about with them on their travels, at home, at play, and in the workplace. By simply combining the hand-held camera that was easy to operate and dry roll film that was painless to process, George Eastman had made photography simple and practical for everyone.

Color Photography

The images produced by the *camera obscura* appeared, of course, in full color, and the artists who used the device normally produced their final works in color. When people dreamed of capturing the image of the *camera obscura*, they naturally dreamed in color.

The earliest photographic experimenters sought to capture not only line, shape, mass, and relative brightness, but color as well. Both Niépce and Daguerre experimented with color. The latter even expressed disappointment that his process failed to show his subjects "in the full splendor of their colors."

In 1861 the British physicist James Clerk Maxwell demonstrated the principle of color separation and linked the principle to color photography. He photographed a tartan ribbon three times, each time using a different color filter—red, green, or blue. Then, after making positive black-and-white transparencies of the three images, he projected them simultaneously on three projectors through these same filters, demonstrating the principle of **additive color mixing**. When the three images were superimposed, a kind of "photograph" of the ribbon in its original colors was produced.

In 1869 Louis Duco du Hauron and Charles Cros, working independently, simultaneously announced their discoveries of **subtractive color mixing.** They knew that passing white light through a filter caused the filter's colors to be transmitted while its complements were absorbed. Therefore, passing white light through two or more successive filters of pure secondary colors would cause the light from the filter's complementary primary to be blocked as the light passed through each filter (see Color Plate 1C). By applying this principle they were able to reproduce full color images by passing white light through superimposed transparent cyan, magenta, and yellow images, each of varying density. A full color image was produced as varying amounts of primary color were subtracted from the transmitted image at each filter stage.

The first commercial color film process, **Autochrome**, was an additive process introduced in 1907 in France by Auguste and Louis Lumière. They thinly coated a sensitized glass plate with grains of starch colored orange, green, and violet, and then processed it to produce a full color transparency.

The subtractive process, however, provided the foundation for modern color photography. As early as 1912, a method for chemically forming dyes in the emulsion during development had been demonstrated. However, this process remained unreliable because the dyes tended to

migrate between color layers. In 1930, Leopold Mannes and Leopold Godowsky, both musicians and amateur photo scientists who were working with the Eastman Kodak Company to develop the Kodachrome process for the movie industry, overcame this problem. They removed the color couplers from the emulsion and introduced them during processing instead. By this process a single sheet of film is coated with three layers of emulsion, each sensitive to one of the primary colors of light. A single exposure, properly processed, produces a positive transparent image. Both **Kodachrome** and **Agfacolor**, a similar material introduced almost simultaneously in Germany, were made available for still photography in 1935.

Many approaches to color photography have emerged subsequently. In 1950 Kodak introduced another Mannes and Godowsky invention, the color reversal film, **Ektachrome**, which provided for home processing. **Kodacolor**, **Ektacolor**, and other films that used nonreversal processes, by which positive color prints were produced from transparent color negatives, soon followed. Another noteworthy approach, **Cibachrome**, was based on a method of selectively removing dyes from the emulsion, a method that was described as early as 1918 by Christiansen. The modern variation produces highly stable prints of incredible sharpness. Another is the Polaroid line of instant color films that are based on Edwin Land's demonstration that full color may be perceived with only two superimposed images if they are illuminated by light of different colors. These films are remarkably complex layered materials that contain all photosensitive and processing chemistry in a single, integrated configuration.

Later Camera Developments

The first photographic cameras available to the public followed the announcement of the daguerreotype in 1839. These were relatively simple devices, derived directly from the *camera obscura* —wooden boxes with a lens mounted at one end and a ground-glass focusing screen on the other end, with some provision for altering the distance between the lens and the film plane. Later elaborations included aperture controls. A complete daguerreotype outfit including the camera, tripod, plate box, iodine/mercury vaporizing boxes, spirit lamp, bottles of chemicals, and the rest, weighed over 100 pounds.

Because the plates used for these early processes were very large, lenses were generally slow, requiring long exposures, often many minutes. Those long exposures generally ruled out photographs of people or other moving subjects. Several attempts were made to solve this problem. Alexander S. Wolcott patented a concave mirror camera in 1840 that was fast enough to produce 2-in. by 2-in. daguerreotype portraits. In 1841 Peter Friedrich Voigtländer marketed a barrel-shaped brass camera fitted with a relatively fast portrait lens designed by Josef Max Petzval. The lens, thirty times faster than any other lens of this period, remained the standard for portrait photography for more than fifty years.

Cameras designed for the calotype also appeared in 1839; they were similar to those designed for the daguerreotype. In 1850, Roger Fenton carried with him to Crimea a calotype camera specially designed by his

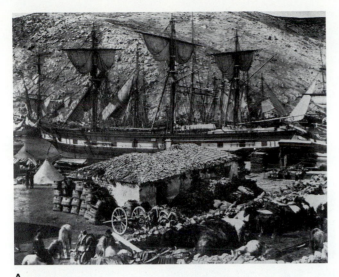

A

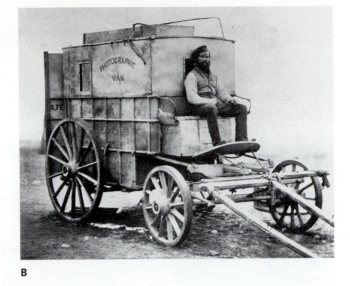

B

FIGURE 1-10

A. Roger Fenton. "Balaclava Harbor during the Crimean War," 1855. Fenton was the first photographer to cover a war under fire. However, his photographs show none of the bloodshed and brutality of battle; such photographs would have offended Victorian tastes. B. Roger Fenton. "Fenton's Photographic Van," 1855. Fenton carried his equipment in this horse-drawn wagon. Even though "Photographic Van" was painted boldly on its side, it was a frequent target for enemy artillery. This portable darkroom was fully equipped for making and processing wet plate emulsions.

assistant, Marcus Sparling, to hold ten sheets of calotype paper in special holders within the camera. In 1854, a pair of ingenious inventors designed a camera that would accept a roll of calotype paper that could be advanced to a take-up roller after exposure within the camera.

During the wet plate period, a complete wet plate outfit outweighed the comparable daguerreotype outfit by twenty pounds. It included a portable tent and water containers, in addition to everything else. Itinerant photographers often hired a porter as well as a van to carry this paraphernalia about. Roger Fenton outfitted a van to serve also as sleeping quarters during his sojourn in the Crimea, an idea quickly adopted by Civil War and expeditionary photographers later in the nineteenth century.

Unique cameras were designed for special purposes when needed. Tiny cameras seem always to have been a fascination. One pocket daguer-reotype camera was designed to produce 8-mm by 11-mm daguerreotypes. One of the largest cameras made in the nineteenth century was a horse-drawn wet-plate camera designed in 1860 for John Kibble of Glasgow to accept a 44-in. by 36-in. glass plate weighing about 44 pounds. Another was the Mammoth, built in Chicago, which used a 4 1/2-ft. by 8-ft. glass plate that weighed 500 pounds and took 10 gallons of chemical solution to process.

Stereoscopic views became enormously popular after they were commercially introduced in 1851 by Louis Jules Dubosc. The stereoscopic view was a single card on which were mounted two images of the same subject taken from slightly different views, corresponding to the human binocular separation. When viewed through Sir David Brewster's lenticular stereoscope, the two images merged to present a three-dimensional view of astonishing reality. Special cameras were designed and marketed to photograph these stereoscopic views. Some were single-lens devices providing for defined movement between successive shots. Others were twin-lens devices designed to shoot both distinct views simultaneously.

Another popular nineteenth-century application was the ***carte de visite*** —the visiting card. So ubiquitous did photography become during the century that it became a social custom to exchange photographic

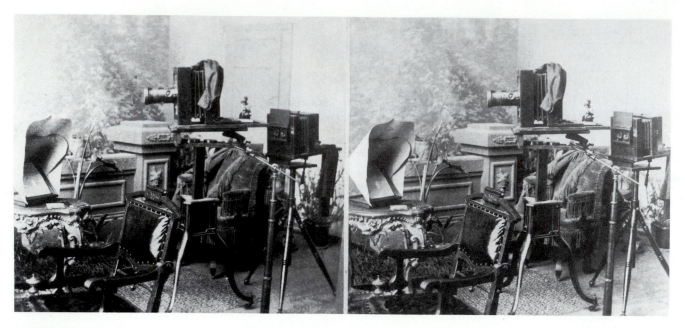

FIGURE 1-11

Photographer unknown. Stereograph of photographer's studio. Viewing stereographic photographs was an extremely popular pastime from its introduction in the 1850s until well into the twentieth century. A stereopticon viewer was needed to view the twin pictures as a single, three-dimensional image.

visiting cards depicting the parties. For this purpose, in 1854 André Adolphe Eugène Disdéri patented a camera fitted with four identical short-focus lenses corresponding to four interior compartments. Using an internal device, one could first expose one half of a plate and then the other half one lens at a time, to obtain eight separate poses on a single plate that could be made into *cartes de visite*.

By the end of the century, an enormous variety of cameras for use with dry plates, cut film, and roll film were produced for an enormous variety of purposes. By 1900 it was estimated that 10 percent of Britain's population—about four million people—owned cameras.

FIGURE 1-12

Adolphe-Eugène Disdéri. Uncut print from a carte-de-visite negative, circa 1860. So popular was the exchange of these little images that the carte-de-visite album became a fashionable feature in Victorian parlors.

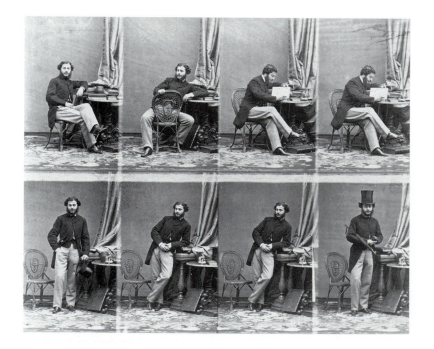

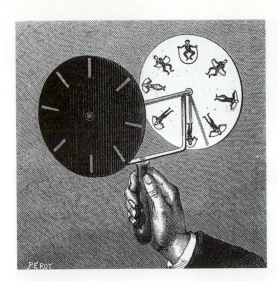

FIGURE 1-13

Phénakisticope de Plateau.

The Emergence of Motion Pictures

The phenomenon of the persistence of vision was known by the ancients; the brain retains images slightly longer than the eye physically records them. During the nineteenth century, experiments with this phenomenon using still photography combined with optical projection produced a practical motion picture technology by the early 1880s.

In 1832 Joseph Plateau patented a novelty he called the phenakistiscope. Individual paintings on a flat, circular board were viewed in a mirror through slits in the board while it was rotated at high speed. The slits provided a kind of shutter so that the successive images would be seen one at a time rather than as a spinning blur. The result was the illusion of a single moving picture. Plateau found that 16 frames per second was an optimal number for producing the illusion of continuous movement.

Simultaneously, Simon Ritter von Stampfer developed a similar device in Germany and dubbed it the stroboscope. Two years later, William George Horner created a similar device, which he named the zoetrope, that used a circular drum with interchangeable picture strips. That same year, Baron Franz von Uchatius experimented with similar toys combined with the **magic lantern**, a kind of candle-powered slide projector that was popular at the time. He continued these experiments for many years and by 1853 had developed the projecting phenakistiscope. All these devices relied upon hand-drawn images, similar to animated cartoons.

The first attempts at motion photography were posed still photographs that simulated movement. The stills were mounted on picture strips and displayed with the projecting phenakistiscope. The result was far from realistic, because the process was a synthesis of discrete, posed, nonmoving images. A method of breaking a single, continuous movement into discrete, sequential, photographic units was needed.

The first person to succeed in this attempt was Eadweard Muybridge, a ne'er-do-well English inventor living in California, who was hired by then governor Leland Stanford to prove that all four of a racing horse's hooves left the ground at some point in its stride. After five years without success, Muybridge devised a scheme whereby he arranged twelve cameras in a row along a race track, each triggered separately by a string stretched across the track. When the galloping horse tripped the wires, Muybridge had his motion picture sequence. (See Famous Photograph, Unit 4, p. 119.) Over the next twenty years he perfected this technique, increasing the number of cameras and the variety of subjects, and combining these photographs with his version of the projecting phenakistiscope, which he called the zoopraxiscope.

After seeing Muybridge's work, Etienne-Jules Marey attempted to record successive phases of movement on a single plate. He succeeded in 1882, using one camera that used a circular photographic plate that was rotated twelve times in a single second to produce twelve sequential exposures. The device looked so much like a shotgun that he referred to his activity as "shooting," and this term has been in popular use ever since. Marey's work inspired the American painter Thomas Eakins, who produced his own multiple-exposure photographs and influenced the Futurist painters and their pursuit of "simultaneity."

All that now remained to complete the technology was a continuous photographic material capable of holding thousands of sequential images.

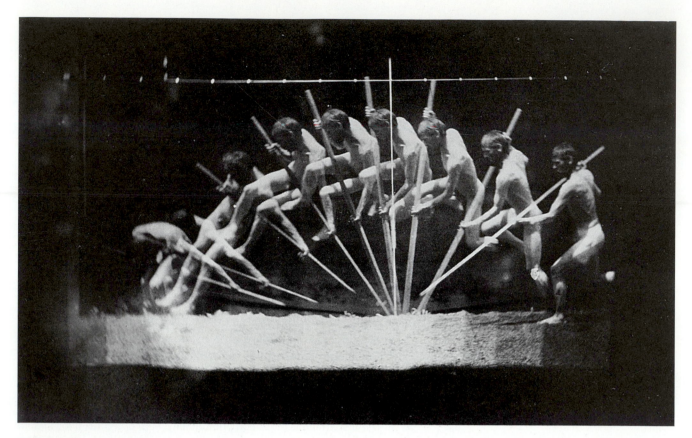

FIGURE 1-14

Thomas Eakins. "George Reynolds Pole-Vaulting," 1884. Eakins, a great American painter, made photographic studies of models in motion using multiple exposures on a single plate.

George Eastman's celluloid roll film, developed originally for still photography in 1889, provided an answer. For nearly a decade, major experiments with motion picture photography were carried on by Thomas Edison in America and by Auguste and Louis Lumière in France, among others, using roll film. But it was the Lumières who most influenced motion picture photography, establishing sixteen frames-per-second and a film width of 35 mm as standards that survive to this day.

Still photographers naturally conceived of the idea that cine-film might be used in a still camera. As early as 1912 George P. Smith of Missouri designed a camera that would use 35-mm motion picture film, and by 1914 Oskar Barnak had developed a prototype of his Leica camera, which would later transform the industry. The Leica went into full-scale production following World War I, equipped with a fast Elmar Lens and a lens-coupled rangefinder for accurate focusing. An era of true miniature cameras had begun.

Twentieth-Century Developments

Developments since that time include twin-lens and single-lens reflex designs, variable focal length and zoom lenses, automatic exposure systems, and a host of special-purpose cameras and attachments far too numerous to describe. In little more than a century and a half, photography has advanced from Niépce's first crude heliograph of his pigeon loft, to NASA's computer-enhanced images of Jupiter's moons, transmitted through millions of miles of space. And the dance goes on—electronically

FIGURE 1-15

Magellan satellite radar image of the surface of Venus.

generated images stored on magnetic media, laser-generated images, holograms, digital images, computer enhancements—there seems to be no limit to the possibilities.

A Visual History of Photography

One cannot view the visual history of photography as a simple chronology. Its technical history is bound intimately to its visual history, as technology interacted with personal visions and purposes. From its earliest beginnings, photography was used to record the commonplace, to document the unusual, to comment upon social life, to express aesthetic ideas, to inform, to teach, to influence. These many uses help to explain how photography developed simultaneously in many directions under the influence of visionary individuals, social and aesthetic movements, and technical possibilities. They help explain, too, why this brief visual history may appear episodic and discontinuous—reflecting the very nature of photography's evolutionary development.

Prior to photography, hand-painted family portraits, decorative landscapes, and pictures of exotic places were much in demand by the affluent classes for the walls and libraries of their homes. From its introduction, photography represented a less expensive alternative to painting and was rapidly adopted by the middle classes for these same purposes. However, it was also apparent that this new craft offered a means to represent the physical world with greater detail and fidelity than previously had been possible. So as demand for family and celebrity portraits, landscapes, cityscapes, and architectural views increased, a new aesthetic began also to emerge—one based primarily upon the play of light and shadow on physical objects.

This new aesthetic vision did not appear at once. To achieve critical recognition, early photographers attempted to mimic the aesthetics of contemporary artists. Early portrait photographers, for example, posed their subjects in the fashion of contemporary portrait painters, and many photographers staged elaborate setups intended to resemble the style of fashionable paintings.

For the most part, however, the daguerreotypes that survive are portraits and depictions of simple, realistic subjects. They suggest a kind of static world, mostly unpeopled, except for those people who appear in stiff, formal, stern-looking portraits or family groups. Because exposures were long, subjects had to pose motionless. Because daguerreotypes had to be processed immediately following exposure, most were taken within studios or from studio windows. Although the constraints were extreme, a few masters emerged to point the way toward a new photographic aesthetic that eventually broke away from the traditions of painting.

As faster processes emerged and exposure times decreased, the need for posing was gradually eliminated, making it possible to photograph moving subjects. People, animals, and other subjects in natural motion appeared increasingly in calotypes. With the introduction of collodion wet plates, photographic images virtually sprang to life as photographers discovered and exploited the medium's capacity to freeze life's fleeting moments. When dry plates, and later roll film, were introduced, photographers gained greater freedom to carry their cameras to places formerly denied them, to use their cameras as unobtrusive extensions of their own eyes, to record not only moments but motions. Further advances enabled them to extend their vision into microworlds and even into outer space.

Throughout the entire development of photographic technology, photographers explored their increasing ability to freeze on film their impressions of the natural world as they found it, to transform their impressions by selecting and controlling photographic elements, to extend their vision of the physical world beyond the limits of sight, and to expand their personal visions of physical reality. However, these personal visions varied widely.

A Brief History of Styles

High art and pictorialism The earliest attempts to advance photography as a fine art tended to mimic the aesthetics of painting. One early effort was that of J. E. Mayall, who in 1845 produced a series of daguerreotypes illustrating the Lord's Prayer and who later exhibited other works to "illustrate poetry and sentiment." Apart from Mayall's efforts, only simple photographs of the physical world seemed to characterize the first fifteen years of photography.

Though Mayall's pictures were criticized as "a mistake . . . imagination supplanted by the presence of fact," others were to follow his lead. The Photographic Society of London encouraged photographers to produce pictures for exhibition and critical review. But the critics did not know how to deal with this new medium. They drew invidious comparisons between photography's "mere reproduction of reality" and fine art's loftier, ennobling themes. They encouraged photographers to produce the historical, allegorical, and literary images of fine art.

FIGURE 1-16

Oscar G. Rejlander. "The Two Ways of Life," 1856. A composite photograph made from thirty separate negatives. Although initially considered risqué, this image so impressed Queen Victoria that she purchased a copy, which gave credibility to photography as an art. The creation of images bearing a strong relationship to allegorical painting became a cornerstone of art photography during the Victorian era.

This attitude encouraged many painters to approach photography as they would brush and canvas, an approach exemplified by the works of William Lake Price, Oscar G. Rejlander, and Henry Peach Robinson, which were praised as **high art photography** by critics of the time. Their method involved first sketching a detailed composition, then making numerous individual negatives of its various parts, and finally combining these negatives, with generous retouching, into a composite image. Rejlander's allegorical master work, *The Two Ways of Life,* a 16-in. by 31-in. composite of thirty negatives, was an instant success when exhibited in 1857. Queen Victoria's purchase of this work legitimized the high art approach and encouraged others.

Robinson followed Rejlander's lead into high art photography, producing a five-negative composite called *Fading Away* in 1858 that also was purchased by the Queen. For more than thirty years Robinson exhibited his composite pictures at every exhibition of the Photographic Society of London, wrote prolifically on his style of **pictorial photography**, and influenced generations of photographers until well after World War I, particularly with his classic book, *Picture Making by Photography.*

Naturalism Daguerre recognized that photography's uniqueness was its superior ability to reproduce nature in fine detail. He wrote, "Nature has the artlessness which must not be destroyed." Others intuitively followed his lead, expressing discomfort with contrived picture making. Using the medium to create fictitious allegories produces "at best, only the impression of a scene on the stage," they said. Nevertheless, throughout the late nineteenth century, photographic exhibitions were dominated by the artificiality and pompous sentiment of the high art pictorialists.

One of those to take up the challenge in the mid 1880s was Dr. Peter Henry Emerson, an American living in England, who boldly urged photographers to look instead to nature for inspiration and subject matter. He

FIGURE 1-17

Peter Henry Emerson. "Gathering Water Lilies," 1886. In a reaction against the artificial devices of pictorial photography, Emerson urged a return to nature for inspiration, setting forth his views in Naturalistic Photography *(1889), and influencing generations of landscape photographers who followed.*

spent more than a decade photographing ordinary life and landscapes around the Norfolk Broads, effectively demonstrating that the photographer can reveal a personal aesthetic vision of natural subjects. He strongly advocated soft focus to simulate human vision, and he suggested that a photograph's principal elements be in sharp focus against soft-focus backgrounds and foregrounds. He published his theories in *Naturalistic Photography* in 1889, asserting that naturalistic photographs should be truthful in appearance, naturally sentimental, and decorative.

His example led to a revived interest in landscape photography, exemplified in the works of Benjamin Gay Wilkinson, Joseph Gale, Lyddell Sawyer, Frederick Evans, Frank Sutcliffe, and George Davison. These naturalistic photographers formed a movement in 1892 called the Linked Ring Brotherhood, which advocated more impressionistic images of natural subjects—soft focus and coarse textures. Within a short time, the Linked Ring included leading art photographers from all over Europe and America. Its annual international exhibitions became the premier events in aesthetic photography through 1914.

Straight photography Many photographers in Europe applied photography to the realistic documentation of objects and events. As early as 1851, Richard Beard produced daguerreotypes of the London poor, and these appeared as woodcuts in Henry Mayhew's *London Labour and the London Poor*. In 1855, Roger Fenton was commissioned by Queen Victoria to photograph the Crimean War, becoming the first to carry a camera into battle. John Thomson, a Scottish explorer and photographer, published studies of the Far East in the 1860s and his classic *Street Life in London* in 1877.

In America, realistic photography that aimed at producing accurate factual records of families, celebrities, war, and topography had become a preoccupation. Mathew Brady, a staid portrait photographer to the rich and famous, was compelled by a "spirit in my feet" to carry his camera into the battles of the Civil War. Later recruiting a dozen others, such as Alexander Gardner and Timothy O'Sullivan, he amassed more than seven

FIGURE 1-18 ▲

George Davison. "The Onion Field," 1890. By combining soft focus and rough-textured paper, Davison introduced impressionism to photography.

FIGURE 1-19 ▶

Timothy H. O'Sullivan. "A Harvest of Death, Gettysburg," 1863. One of Mathew Brady's staff of nineteen photographers who covered the battlefields of the American Civil War. Their Civil War photographs make up one of the most remarkable and treasured collections of documentary photographs in American history although they were little appreciated in their own time.

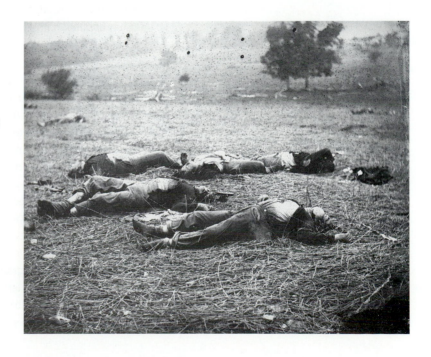

thousand negatives that documented that tragic American conflict. Following the war, many of these same photographers joined teams commissioned to survey the western lands of the United States. These works were never seen as photographs in the popular press of their times because no technology existed for reproducing photographs in printer's ink. However, they did appear as handmade block prints and engravings copied from the original photographs. These scenes generated in America an appreciation for truthfulness and objectivity in photographic images. This almost tangible preference for factual, unadorned representations of reality helps to explain why America showed little interest in the aesthetic movements of Europe, which were dominated by the standards of contemporary painting.

Toward the beginning of the new century, however, the spiritual center of aesthetic photography began to tilt toward America, largely due to the influence of one American, Alfred Stieglitz. Stieglitz had gone to Europe as an engineering student in 1882 and became captivated by photography, winning a medal at the Linked Ring exhibition in 1888. Returning to New York in 1890, influenced by the aesthetic movements of Europe, he encountered the American documentarians, including Jacob Riis, a police photographer who documented the tenement life of poor immigrants. Stieglitz became a principal advocate for photography as an independent art form, rooted in objective reality but adhering to its own aesthetic principles. In 1902 he started the Photo-Secession, a group dedicated to photography as an art form, and the following year he brought out the first edition of *Camera Work*, a prestigious quarterly that he edited for the next fifteen years. In 1905 the Photo-Secession opened the Little Gallery at 291 Fifth Avenue in New York City. Usually referred to simply as 291, the gallery featured the most innovative works in the visual arts and which introduced in America such avant-garde masters as Picasso, Cèzanne, Matisse, Braque, and Rodin.

Though his own art grew from the pictorialist tradition, Stieglitz gradually shifted his focus to straight photography—an approach that eschewed darkroom manipulations, retouching, or other artificialities in favor of straightforward, truthful photographs of natural subjects taken so as to integrate their natural elements into cohesive, romantic, idealized compositions of light, shade, tone, and texture. He considered his photograph *The Steerage* to be his finest work.

Others who emerged from Stieglitz's Photo-Secession and took the straight photography approach were Gertrude Käsebier, Paul Strand, Imogen Cunningham, Alvin Langdon Coburn, Edward Weston, Ansel Adams, and Edward Steichen. Steichen, as director of photography for the Museum of Modern Art, organized over fifty photography exhibitions, including "The Family of Man," which is probably the most famous.

Despite its enormous influence on the direction taken by aesthetic photography, the Photo-Secession still represented a self-conscious approach that would eventually yield to more direct interactions with subjects.

Abstractionism In the last two issues of *Camera Work* in 1917, there appeared some photographs by Paul Strand that manifested a break with traditional subject matter and style. Strand observed abstract forms and patterns in ordinary subjects that did not rely upon fine detail or even subject recognition to achieve their powerful aesthetic appeal. In other works,

FIGURE 1-21

Paul Strand. "The White Fence," 1916. Strand explored the abstract forms found in everyday subjects. In this image, Strand intentionally avoids any effect of perspective to emphasize the abstract qualities of his subject.

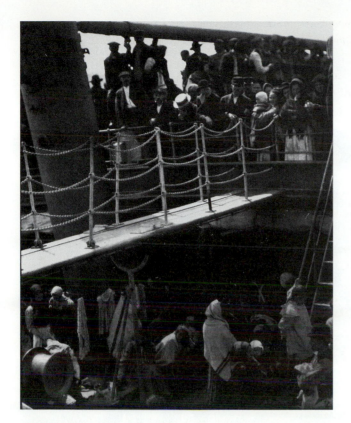

FIGURE 1-20

Alfred Stieglitz. "The Steerage," 1907. Seeking to regenerate photography as art in America toward the end of the nineteenth century, Stieglitz was a purist who advocated straight, unmanipulated images of everyday subjects to reveal a romantic vision.

Strand deliberately avoided traditional representations of perspective to emphasize these abstract qualities in ordinary subjects. He used this same technique effectively to startle his viewers into a confrontation with his subjects, unadorned by romantic idealism.

Although Strand's subjects did not rely upon recognition for impact, they were, in fact, recognizable objects. Other photographers, however, experimented with the purely abstract. In 1917, Coburn produced *Vortographs*, a series of photographs of bits of wood and crystal, photographed with three mirrors, that derived their power from their patterns and arrangements of light and shadow rather than from their depiction of recognizable detail. In the aftermath of World War I, artists worldwide tended to cast aside traditional principles of composition in search of new forms. This was true of many photographers as well. Some, such as Christian Schad, Tristan Tzara, and Man Ray, experimented with camera-less images, producing their abstract designs by placing objects directly on photosensitive paper in a manner reminiscent of Talbot's early work.

In the 1920s and 1930s, the Bauhaus School in Germany encouraged a group of avant-garde artists and crafts workers, including photographers, to experiment with new techniques and materials. The Bauhaus had much influence on photography as well as on furniture design, typography, and architecture. From the Bauhaus emerged László Moholy-Nagy, who experimented with photomontage, photograms, X rays, microphotography, solarization, and other manipulations to produce a fascinating array of creative works that employed photographic processes, if not photography, to achieve his purposes. These techniques were aimed at abstracting light patterns and shapes from objective detail and tonal gradations. The

FIGURE 1-22

László Moholy-Nagy. "Jealousy," 1927. A member of the German Bauhaus group of artists who were dedicated to rethinking art in all its forms, Moholy-Nagy experimented with photographic technique and darkroom manipulations to achieve novel designs and images. This image is a photomontage combining pieces of several photographs.

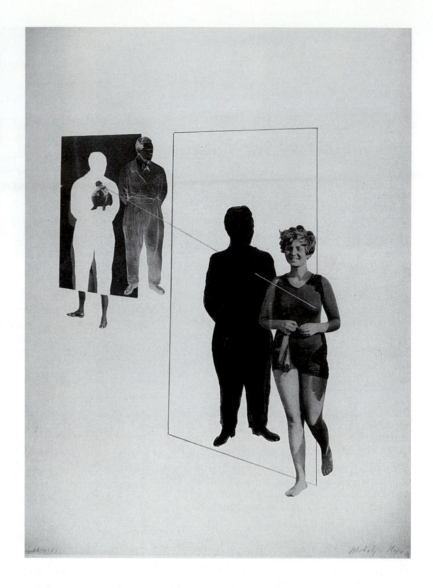

contribution of abstractionism to photographic style was its extension of photographic vision to include the abstract qualities of subjects, a vision that forcefully influenced both aesthetic and realistic photographers thereafter. Its influence can be seen in later works of photoillustration, fashion, and portraits, as well as documentaries, as in the works of Bert Stern, Richard Avedon, Joel Meyerowitz, and Aaron Siskind.

New Realism In contrast to these experiments with abstractionism, some photographers began expressing a renewed fascination with natural subjects. Albert Renger-Patzch, for example, trained his camera closely on everyday objects, revealing their beauty of form and texture with the utmost possible fidelity. His 1928 book, *Die Welt ist Schön* (the world is beautiful) supports his view that photographs "can stand alone on account of their photographic quality—without borrowing from art." The *Neue Sachlichkeit*, the New Realism, as it was dubbed by Gustav Hartlaub of the Mannheim Museum of Art, was a reaction against sentimentality, falsification, and self-conscious abstraction in art, which found expression as well in cinema and photography.

Although it was arrived at independently, Renger-Patzch's approach echoed those of Paul Strand and Edward Steichen in America a decade earlier. By 1925, Edward Weston had adopted this approach as well, exhibiting landscapes, portraits, and closeups of ordinary objects remarkable for their form and texture. In the International Film and Photo Exhibition in Stuttgart in 1929, Edward Weston, his son Brett Weston, Imogen Cunningham, Berenice Abbot, and Charles Sheeler, greatly influenced the direction of photographic style. In 1930, Ansel Adams, encouraged by Edward Weston, also moved in this direction, before turning to the great landscapes for which he became known. In 1932, Willard van Dyke formed the f/64 group, which included Weston, Cunningham, Adams, and Peter Stackpole, and which was dedicated to achieving honesty, directness, and naturalism by making brilliant, sharp images with the greatest possible depth of field using only unmanipulated contact prints with large, usually 8-in. by 10-in., plates. Today, the objective, straightforward style pioneered by the New Realists remains a contemporary standard for realistic photography. The work of Stieglitz, Steichen, Weston, Strand, and Adams inspired many who followed such as Harry Callahan, Minor White, Nicholas Nixon, Arnold Newman, Wynn Bullock, Larry Fink, and Chauncey Hare.

FIGURE 1-23

Edward Weston. "Dunes, Oceano," 1936. Weston's penetrating vision enabled him to present a precise description of a subject while simultaneously revealing its abstract, rhythmic, emotional, and almost musical qualities.

Since World War II, other approaches have emerged, influenced largely by the small, hand-held camera. The documentary, journalistic styles of such photographers as Henri Cartier-Bresson and W. Eugene Smith, made possible by the small camera, reasserted the importance of content in photographic art. The drama of everyday life was made intimate and compelling by the proximate camera, sophisticated composition, and widespread publication in the press. For some, penetrating the surface of physical reality became their preoccupation. Psychological themes are evident in the works of Minor White, Ralph Hattersley, Robert Frank, Diane Arbus, Gary Winogrand, and Les Krims.

Photography itself remains neutral, open to experimenters and practitioners to use for their purposes as they will.

A Brief History of Content

Portraits From the start of photography, portraits were probably the most popular form. Although daguerreotype portraits were awkward, requiring subjects to be held motionless by mechanical devices during long exposures, it is clear that many were willing to put up with the inconvenience to obtain the product. Daguerreotype portraits of high quality were exhibited in America by Mathew Brady, John Plumbe, and the firm of Southworth and Hawes in the 1840s. In Europe, the calotype portraits produced by Hill and Adamson in Edinburgh stand today as remarkable achievements of early photography, combining the soft qualities of calotype with painterly compositions.

André Adolphe Eugène Disdéri, a Parisian photographer, realized early that there was a demand for cheap portraits to give away. He invented a way to produce eight inexpensive images on a single plate and introduced the *carte-de-visite*—a visiting card with a picture. It was not popular at first, but a *carte-de-visite* craze swept Europe after Napoleon III halted his army to visit Disdéri's studio in 1859. The popularity of the *carte-de-visite* was surpassed after 1866 by the larger cabinet portrait, which dominated portrait photography until World War I.

Gaspard Félix Tournachon, called Nadar, a flamboyant French balloonist and photographer, dominated French portraiture with both his skill and his personality. His red-painted studio was a meeting place for celebrities. In 1858, Nadar ascended in his balloon with a camera to become the first aerial photographer, and he later was the first to shoot underground by electric arc light. In later years, he pioneered the photo interview in a classic series of images featuring the hundredth birthday of chemist M. E. Chevreul.

Julia Margaret Cameron, a latecomer to photography in the 1860s, advocated soft-focus portraits in her work with celebrities, and pioneered the closeup portrait to reveal something of the inner personality of her subjects.

Modern portraiture was advanced in the early part of the twentieth century by Edward Steichen and, more recently, by Arnold Newman, Philippe Halsman, and Yousuf Karsh, whose work spans forty years.

Landscape One of the earliest landscape photographers was Henry White of London, whose close-ups of natural subjects in the 1850s were highly regarded by his contemporaries and foreshadowed the New Realist movement of the 1920s. Other noteworthy early landscapists were

FIGURE 1-24

Julia Margaret Cameron. "Sir John Herschel," 1867. Taking up photography for pleasure at age forty-eight, Cameron deplored the shallowness of carte-de-visite portraits and sought to record "the greatness of the inner as well as the features of the outer man."

FIGURE 1-25

Robert Demachy. "Au Bord Du Lac," circa 1905. Oil print. Influenced by Degas and the impressionists, Demachy used every sort of darkroom manipulation of his negatives and prints in order to "endow" his images with maximum interpretive effect.

Gustave Le Gray, who captured clouds and moving waves in his seascapes, and Hippolyte Bayard, who invented the technique for printing-in from separate negatives.

From the 1870s until the turn of the century, landscape photography was dominated by the English tradition espoused by Henry Peach Robinson, Peter H. Emerson, George Davison, the French photographer Robert Demachy, and others of the pictorial and naturalist schools. The central aesthetic principle of this approach was to produce sentimental, pretty pictures that looked like paintings.

After 1900, the influence of the Photo-Secession appeared in landscape and other photography. Influenced by Stieglitz, Steichen, and others, landscape photographers broke away from imitating painting to search for purely photographic idioms. The forms, shapes, and textures of landscape subjects as revealed by the play of light and shadow became the basis for a new aesthetic of landscape. This aesthetic of landscape continued to evolve in later years under the influence of Edward and Brett Weston, Ansel Adams, Wynn Bullock, Imogen Cunningham, Paul Caponigro, George Tice, and others, who advocated scrupulous honesty, ultra-sharp detail, nearly tangible textures, and unlimited depth of field, without manipulation or artifice.

FIGURE 1-26

Ansel Adams. "Mt. Williamson, The Sierra Nevada, From Manzanar, California," 1945. A founding member of the f/64 group, Adams was a master at revealing with impeccable clarity and precision the formal beauty of natural objects, from trees, roots, and driftwood to landscapes of the grandest scale.

Natural documentary A distinction should be made between landscape and natural documentary photography. Landscape photography was motivated initially by the goals of fine art and initially adopted the traditions of English landscape painting. Natural documentary photography, on the other hand, was motivated primarily by a need to document the exploration of geographical and topographical subjects with great fidelity.

Thus, driven by objectives quite different from those of the landscapists, early photographers took up their cameras to record their observations of distant lands. As early as 1841, John Lloyd Stephens and Frederick Catherwood carried a daguerreotype camera with them during their archeological exploration of the Yucatan. In the 1850s, the British Army was photographing its activities in India and Roger Fenton was recording his observations of Moscow. Similarly, in 1851 Maxime du Camp published *Egypte, Nubie, Palestine et Syrie* with 125 pasted-in calotypes of these regions.

Photographs of lands and sights that previously had been known only from drawings and writings enabled viewers to gain new insights about the world. Between 1856 and 1860, Francis Frith took three journeys to Egypt, Palestine, and Syria, traveling 1,500 miles beyond the Nile Delta by

FIGURE 1-27

Francis Frith. "Pyramids of Dahshoor, Egypt," 1858. Frith journeyed three times to Egypt, Palestine, and Syria between 1856 and 1860, enduring sand, flies, and intense heat in his portable wet-plate darktent to obtain some of the finest travel and topographical views of those regions ever seen.

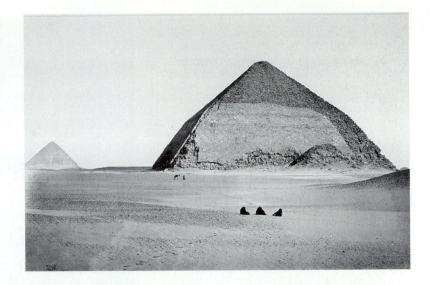

horse and carriage, and producing wet plate photographs as large as 16-in. by 20-in., copies of which appeared in many publications. Frith became Europe's largest publisher of topographical photographs.

The Stereopticon viewer and its accompanying stereoscopic pictures became one of the major entertainments of the Victorian age. When viewed through the Stereopticon, twin images mounted on cards produced three-dimensional images that captivated viewers for three generations, providing a form of home entertainment akin to television today. William England, chief photographer of the London Stereoscopic Company in the 1850s, took thousands of pictures of distant lands, finally specializing in Alpine views, as did Adolphe Braun and the Bisson brothers.

Photographers became standard fixtures on a wide range of expeditions and explorations during the latter half of the nineteenth century. Philip Egerton photographed the Shigri Glacier and the natives of Spiti near Tibet; Samuel Bourne photographed the Himalayas and in thousands of photographs revealed the beauties of India to the people of Europe; John Thomson of Scotland spent ten years in the Orient photographing the wonders of China, Siam, and Cambodia.

In America, San Francisco photographer Carlton E. Watkins was the first to discover the photographic potential of the Yosemite Valley, exhibiting some astonishing views in 1867 in Paris. Eadweard Muybridge, who learned photography from Watkins, worked as a photographer on an official survey of Alaska in 1868, and later made hundreds of topographical photographs for railroad and steamship companies before embarking on the animal locomotion studies for which he is primarily remembered.

Many photographers accompanied the government's numerous geologic surveys of the American West. Between 1870 and 1877, William Henry Jackson accompanied eight such surveys, and his photographs of the Yellowstone region, distributed in Congress, were said to be instrumental in the passage of legislation establishing the first national park. Timothy H. O'Sullivan accompanied surveys of the fortieth parallel, the Isthmus of Panama, and the canyons of the Colorado River and Arizona.

Outstanding expedition shots and topographical views of the Antarctic were produced by Herbert Ponting, who was official photographer to Robert Scott's second South Pole exploration during 1910–1912;

FIGURE 1-28

Timothy H. O'Sullivan. "Ruins of White House, Canyon de Chelly," 1873. After the Civil War, O'Sullivan served in several surveys of the American West conducted by the United States government. This photograph is one taken during the Wheeler Survey of what was to become the State of Arizona.

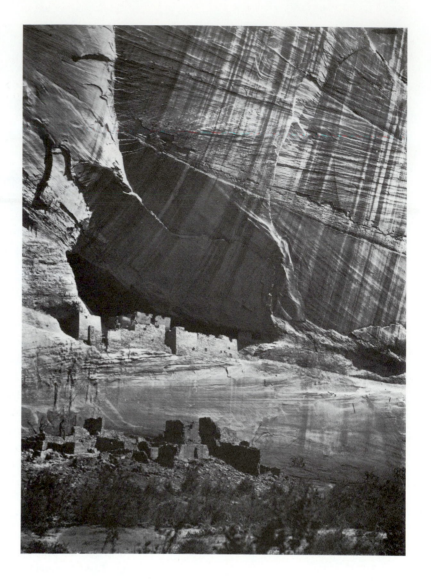

Captain Frank Hurley held the same position on five subsequent Antarctic expeditions.

Similarly motivated were the architectural and cityscape photographers, who faithfully recorded the details of manmade structures and city scenes. During 1853–1854, Philip Henry Delamonte documented the rebuilding of the Crystal Palace at Sydenham in hundreds of photographs, starting with the leveling of the site and continuing through the opening ceremonies a year later. Other noteworthy architectural photographers were Robert MacPherson, who depicted Roman antiquities in a striking way; the Alinari brothers, who specialized in Italian cathedrals and works of art; and Roger Fenton, who turned out a fine series of English cathedrals after returning from the Crimea in 1856.

Another approach was that exemplified by Eugène Atget in Paris and Sir Benjamin Stone in England. Both undertook in similar ways the documenting of city life, in a nonjudgmental manner, to capture for all time the physical characteristics of their respective locales. Stone left a collection of some 22,000 photographs of English townscapes, festivals, pageants, and ceremonies, whereas Atget left nearly ten thousand prints of buildings, staircases, shop fronts, and common street life.

FIGURE 1-29

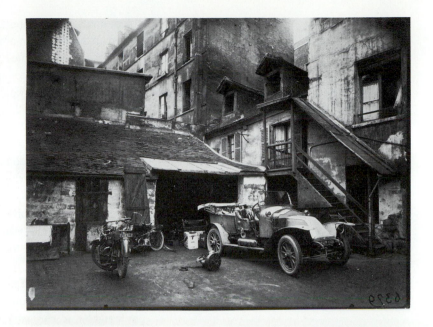

Eugène Atget. "Cour, 7 rue de Valence," 1922. For thirty years Atget photographed street scenes of Paris. Unappreciated, he died in poverty, leaving a remarkable legacy of over 10,000 photographs documenting Paris street life.

Social documentary The ability of photography to record the most complete array of details with dazzling accuracy did not escape the attention of journalists and social commentators, even from the beginnings of the craft. Hermann Biow and Carl Ferdinand Stelzner had produced what was perhaps the first news photograph—a daguerreotype of the devastation following the Great Fire of Hamburg in 1842. Scenes of the Mexican War, 1846–1848, were also recorded by individual photographers.

The first extensive war reportage was carried out in 1855 by Roger Fenton and James Robertson during the Siege of Sebastopol in the Crimea. Though somewhat romanticized, in keeping with the public tastes of the day, the 360 photographs produced by this team provided a convincing and intimate view of life at the front in a way that the public had never seen before.

Mathew Brady's organized coverage of the American Civil War is legendary. Driven by motives that he himself was unable to explain entirely in later years, Brady left his successful portrait studios in New York and Washington to direct a staff of nineteen photographers in documenting almost every scene of the war. His photographic wagons, dubbed "what's-it wagons" by the troops, were familiar features at encampments and battle sites. His staff included such luminaries as Alexander Gardner, Timothy O'Sullivan, George Barnard, James Gibson, and others known only from their credit lines in albums published after the war. The government took little interest in the project before, during, or after the war, and Brady received little compensation for producing one of the most treasured documents of American history.

A major problem facing these new photojournalists and social documentarians was the fact that no means existed to reproduce photographic images in printers ink until very late in the century. Until then, the works of these photographers could be viewed only in the form of photographic prints, which were expensive to distribute in great numbers, or as hand-drawn woodcuts or metal plates copied from the original photographs. Nevertheless, the images produced by these early war photographers found their way to the view of most citizens, mostly through hand-cut

block prints in newspapers and magazines. Even in this form, they conveyed an authenticity more intimate, more brutal, than the artists' interpretations of earlier times.

As a tool of mass communication, photography's greatest impact has been felt since the introduction of the half-tone process late in the nineteenth century, and with it the technology to reproduce photographs rapidly, mechanically, and faithfully in the press. Though it seems surprising, nearly forty years elapsed between Stephen Horgan's demonstration that half-tone images could be printed together with type and the appearance in 1919 of the exclusively photographic *Illustrated Daily News*.

Since that time, social documentarians and photojournalists have been able to share their visions with far wider audiences, and their influence has increased accordingly. War photography has been increasingly truthful, conveying more vividly than ever before possible the senselessness, brutality, and horror of war. The war photographs of Robert Capa, David Douglas Duncan, and Eliot Elisofon, for example, were seen firsthand by a much greater proportion of the population than ever saw those of Fenton or Brady.

Other social phenomena attracted photographers. The ordinary life of ordinary people, for example, interested many early photographers. In the late 1840s, Hill and Adamson did a series of genre photographs sentimentally depicting ordinary life around the port town of Newhaven. Ordinary life was also the subject for Frank Sutcliffe, who in the 1880s applied his naturalistic style to depict a quaint, idealized life around Whitby in England.

But extraordinary life—life among the poor, the exploited, the ill—attracted the attention of an emerging breed of social documentarians and photojournalists. We have already noted the social concerns of Richard Beard in 1851 for London's poor and of John Thomson in the 1870s for the street folk of London. In the same spirit, Jacob Riis, a New York police reporter-photographer, consciously used his camera to arouse the public conscience over the intolerable living conditions in the city's tenements. His books, *How the Other Half Lives* (1890) and *Children of the Poor* (1892), so

FIGURE 1-30

Jacob A. Riis. "Sabbath Eve in a Coal Cellar, Ludlow Street," circa 1890. One of the many photographs Riis made that documented life among the poor immigrants in the tenements of New York City in the 1890s. Photographs like this led eventually to his book, How the Other Half Lives, *which inspired Theodore Roosevelt, as governor and later president, to implement social reforms.*

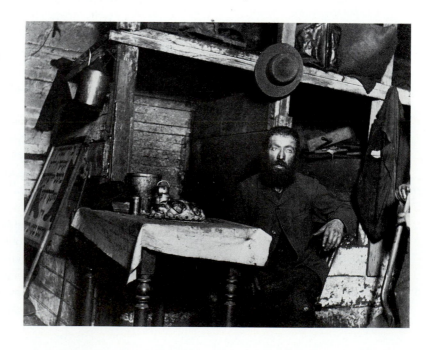

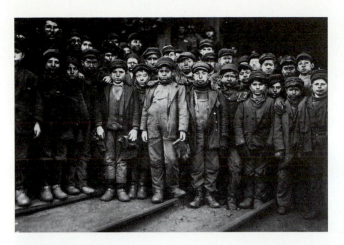

FIGURE 1-31

Lewis Wickes Hine. "Breaker Boys," 1911. As staff photographer to the National Child Labor Committee, Hine exposed the deplorable conditions of working children in factories and mines. His work influenced passage of child labor laws.

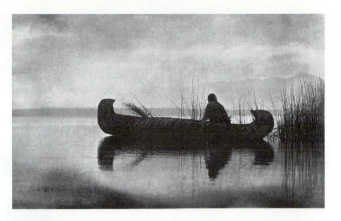

FIGURE 1-32

Edward S. Curtis. "Kutenai, Duck Hunter," 1910. From 1896 to 1930, Curtis recorded more than 40,000 images of the disappearing American Indian culture, nearly all on glass plates. Curtis's work, The North American Indian, *is among the most ambitious projects ever undertaken by one person. Each one of its twenty volumes was accompanied by a portfolio of photographs that sensitively portrayed life among many of the vanishing Indian tribes.*

influenced New Yorkers and their governor, Theodore Roosevelt, that many reforms were legislated to relieve these conditions. Riis was one of the first to use flash powder to capture his devastating images in the dark back alleys, sweatshops, and tenement houses of New York City.

Lewis Wickes Hine, a sociologist, used his camera to dramatize the plight of poor European immigrants, iron workers, miners, and mill workers between 1905 and 1909. His photographs of immigrants arriving at Ellis Island and his magazine exposés of child exploitation and working conditions in mills and factories shocked the public. Hine was engaged as staff photographer to the National Child Labor Committee, and his photographs of children working under appalling conditions were instrumental in stimulating passage of child labor legislation.

Around the turn of the century, several photographers took note of the fact that the American Indian cultures were disappearing from the American scene and undertook to document these dying cultures while they still could be found. Edward S. Curtis was one among these; from 1892 to 1927 he attempted to chronicle all the surviving Indian tribes. Similarly, Adam Clarke Vroman sought to document what remained of the Indians of the Southwest.

One of the more influential documentary photojournalists, Henri Cartier-Bresson, began photographically documenting the workings of human nature in France in the 1930s. His 1952 book, *The Decisive Moment,* formalized an approach to documentary photography that remains a cornerstone of modern photojournalism. Cartier-Bresson's approach is characterized by the merging of strong documentary content with precise aesthetic composition. Photography, he said, requires the simultaneous recognition of the significance of an event and a proper organization of form to express it. To capture this coalescence of form and content, Cartier-Bresson would become intensely involved in the continuous action of an event. He would move about within the action, his camera held closely to his eye, until that "decisive moment" when all elements

FIGURE 1-33

Henri Cartier-Bresson. "Place de la Europe, Paris," 1932. Cartier-Bresson says that his intent in photography is to guess what the next moment will bring. In his best work, he believes he is working by intuition to anticipate the "decisive moment" when all elements come together.

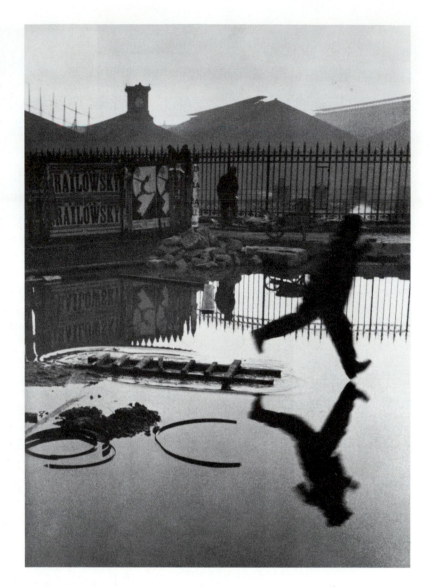

would visually converge. To recognize and capture that moment, he said, required that the photographer be intellectually, emotionally, and physically ready.

Probably one of the most ambitious projects of social documentation was sponsored by the Farm Security Administration (FSA) during the 1930s. Under the direction of Roy Stryker, a Columbia University professor, a unique staff of photographers was assembled that included Dorothea Lange, Walker Evans, Ben Shahn, Arthur Rothstein, John Vachon, Carl Mydans, and Russell Lee, some of America's leading documentary photographers of the time. The FSA project was commissioned to chronicle the economic, physical, and social disaster that was the Great Depression. For eight years, under Stryker's brilliant leadership, this group produced a body of straight, unmanipulated, unsentimental, yet insightful photographs that profoundly influenced the course of American photojournalism.

The picture magazine actually had its roots in pre-Nazi Germany, but when the new government shut these magazines down in the 1930s, many of their photographers migrated to America, where they joined in the creation of *Life* and *Look* magazines in 1936. Many of the FSA

FIGURE 1-34

W. Eugene Smith. One of the photographs from his photo essay "The Spanish Village," 1950. Smith explored and developed the photo essay form as a way of more completely reporting extended stories. One strategy he developed may be termed "A Day in the Life of . . . ," which has become a popular photo-journalistic approach.

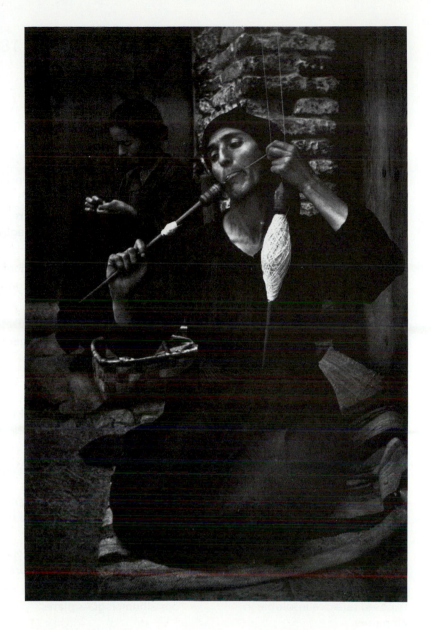

photographers also found their way to the staffs of these publications, and there began to emerge an American magazine idiom, the photo essay. Probably the leading exponent of this form was W. Eugene Smith, whose *Life* photo essay "The Spanish Village" (1950) explored life and death in a poor country village where Smith lived for a year while doing the essay. His later work, *Minimata*, published in book form after the demise of *Life*, exposed the effects of willful industrial contamination by the Chisso company in the Japanese town of Minimata. For years, the company had been dumping its mercury-laden wastes into the bay off the town, poisoning the fish and the townspeople who ate those fish. Smith's investigations apparently aroused company officials, for Smith was badly beaten by a large group of men hired by the company, and sustained injuries that cost him part of his eyesight and affected his health for the rest of his life. Notwithstanding his awful experience, Smith finally published his photo essay exposing the company's actions and their effects on the lives of the townspeople.

4th Century B.C. Aristotle manipulates passage of light through small hole in dark room to observe image of solar eclipse.

1521 Cesare Cesariano publishes brief account of *camera obscura.*

1544 Rainer Gemma-Frisius publishes illustration of *camera obscura.*

1550 Girolama Cardano recommends use of bi-convex lens in *camera obscura* to brighten image.

1558 Giovanni Battista della Porta describes *camera obscura* as drawing aid for artists.

17th Century *Camera obscura* develops from permanent, roomlike device into portable device and finally into tabletop model utilizing complex arrangements of convex and concave lenses, mirrors, and aperture controls to invert and sharpen the image.

1725 Johann Heinrich Schulze observes light sensitivity of silver salts.

1777 Carl Wilhelm Scheele demonstrates that sensitivity of silver salts varies with wavelength and that exposed salts are insoluble in ammonia.

1802 Thomas Wedgwood publishes results of his experiments with sun prints.

1826 Joseph Nicéphore Niépce invents heliography.

1832 Joseph Plateau patents phenakistiscope (moving image device).

1835 William Henry Fox Talbot makes first photographic negative.

1839 Louis Jacques Mandé Daguerre invents daguerreotype.

Talbot describes his "photogenic drawing."

Hippolyte Bayard makes direct positives on paper.

1840 Alexander Wolcott and John Johnson open first portrait studio in New York.

1841 Talbot patents his Calotype process.

1843 David Octavius Hill and Robert Adamson collaborate to make calotype portraits.

1844 Talbot describes calotype process in *The Pencil of Nature.*

1847 Niépce de Saint Victor develops albumen glass plates.

1850 Louis Désiré Blanquart-Evrard develops albumen paper for positive prints.

1851 Frederick Scott Archer introduces wet collodion process.

1854–1856 Ambrotypes, *cartes-de-visite*, and tintypes patented.

1861 Sir James Clerk Maxwell demonstrates principle of additive color mixing.

1869 Charles Cros and Louis Ducos du Hauron announce discovery of subtractive color mixing.

1871 Richard Leach Maddox introduces gelatin dry plate process.

1878 Eadweard Muybridge captures horse-in-motion sequence on film.

1880 *New York Daily Graphic* prints first halftone reproduction of a photograph on a printing press.

1882 Etienne-Jules Marey invents twelve-image multiple exposure camera.

1888 George Eastman introduces No.1 Kodak camera.

1889 Eastman introduces celluloid roll film.

Peter Henry Emerson publishes *Naturalistic Photography.*

Contemporary Directions

Since World War II, the uses of photography have multiplied, in both style and content. The small, hand-held camera has enabled photographers to examine their subjects ever more closely, entering into areas both physical and psychological that were denied them in earlier times. Examination of the works of Robert Frank, Diane Arbus, and Gary Winogrand suggests the complex psychological themes that are often the concern of contemporary photographers. Harry Callahan, Wynn Bullock,

1890 Jacob Riis publishes *How the Other Half Lives.*

Ferdinand Hurter and Vero C. Driffield lay foundations for sensitometry by describing characteristic density curve.

1892 Frederick E. Ives invents Kromstop color transparency camera.

Linked Ring Brotherhood formed.

1893 Charles Jasper (John) Joly introduces screen plate color process.

1895 Louis Lumière introduces roll film motion picture camera.

1902 Photo-Secession exhibition held.

1907 Auguste and Louis Lumière invent Autochrome color process.

1911 Lewis Hine begins photographing for National Child Labor Committee.

1912 Illustrated newspapers appear in Europe.

George Smith designs still camera to use 35-mm motion picture film.

1919 Exclusively photographic *Illustrated Daily News* appears in New York.

1924 Oskar Barnack introduces his 35-mm cine-film Leica camera.

1924 Leopold Mannes and Leopold Godowsky receive first patent on color process.

1930 Alfred Stieglitz opens *An American Place* gallery.

1935 Farm Security Administration Photography Unit formed under Roy Stryker.

Associated Press members send photographs by wire.

Kodachrome professional color film introduced.

1936 First issue of *Life* published.

1941 Edward Farber's stroboflash introduced.

1942 University of Missouri begins photojournalism program.

First Pulitzer Prize in photography awarded to Milton (Pete) Brooks of the *Detroit News.*

Ektachrome amateur color film introduced.

1945 National Press Photographers Association formed.

1947 Magnum Picture Agency formed.

1947 Edwin H. Land invents sixty-second Polaroid instant camera.

1951 W. Eugene Smith's seminal photo essay *Spanish Village* published.

1952 Henri Cartier-Bresson publishes *The Decisive Moment.*

1955 Edward Steichen's "The Family of Man" photography exhibit opens at Museum of Modern Art.

1961 Holography demonstrated.

1962 Edwin H. Land of Polaroid announces sixty-second Polacolor process.

1973 Susan Sontag publishes *On Photography.*

1981 *A Day in the Life of Australia* published.

1982 *USA Today* national newspaper introduced.

1984 Sony introduces digital camera.

1988 Video to computer transmissions demonstrated.

1989 150th anniversary of photography celebrated worldwide.

NPPA publishes an all-electronic newspaper.

1992 Kodak markets Photo CD system.

Lee Friedlander, and Aaron Siskind provide us with fresh visions of landscapes and cityscapes. Irving Penn, Bert Stern, and Richard Avedon suggest new directions taken in fashion and product photography. Yousuf Karsh, Philippe Halsman, Arnold Newman, Judy Dater, Nicholas Nixon, Chauncey Hare, and Annie Leibovitz provide insightful portraits.

Although the variety of directions and styles that has emerged in the last twenty years is overwhelming, some threads of continuity may be discerned. Many documentary photographers seem intent on making objective, nonjudgmental, formally organized, dispassionate images. Nevertheless, many continue to pursue social themes of passionate concern in an attempt to arouse response and effect change.

FIGURE 1-35

Yousuf Karsh. "Georgia O'Keefe," 1956. Karsh is known for his portraits of the famous and powerful. This image of painter Georgia O'Keefe shows Karsh's distinctive preference for photographing in his subject's own environment and his precise attention to light, shadow, tone, and detail.

Many photographers have turned to highly personal themes, involving themselves and their immediate friends and families, with little attempt to generalize. Few photographers seem intent upon making pretty pictures or on touching up the physical, social, or cultural blemishes that the camera reveals. In the arena of persuasive photography, however—the advertisements we see daily in print and on television—our skill in idealizing, romanticizing, and glorifying our subjects has never been greater.

Modern Photojournalists and the Extended Essay

Today's photojournalists often choose to document long-term projects, as exemplified by Eugene Richards's compelling study of the drama and tragedy of a late night hospital emergency room, *The Knife and Gun Club*, and his works on cancer and poverty. Mary Ellen Mark, one of the new breed of graduate-school-trained photojournalists, has made extended photo essays exposing the problems of teenage runaways, prostitutes, and the mentally ill. Both Richards and Mark are drawn to examine life on the fringes of society, and both make penetrating and insightful images of the most significant social events of our time.

Fabricating the Settings and Situations

Fabrication of photographic settings and situations provided another avenue of expression. In the 1980s some workers actually constructed stage sets and tableaux designed especially to be photographed, Sandy Skoglund fabricated complex room interiors filled with life-size and wildly colored cats, as well as goldfish and babies, that appear to overrun the room and its occupants in an urban nightmare. Laurie Simmons and Ellen Brooks both produce miniature stage sets populated with dolls that are then photographed as comments on a gender-oriented society.

Other photographers have elected to construct and control the content of their work by choreographing the actions of their subjects. Like movie directors, Joel-Peter Witkin, Nic Nicosa, Bruce Charlesworth, Cindy Sherman, and others spend weeks gathering costumes, props, and sets in which to position their models to create theatrical versions of contemporary domestic life. The photographs that result from these domestic dramas are often printed as extremely large-scale color prints that invite the viewer to enter into the human conflicts depicted. Through the literal fabrication of scenes and situations photographers have broken their dependence on a preexisting subject matter and extended the medium's creative range.

Manipulating Images

Contemporary photographers also continue to work in the realm of the manipulated image, a tradition defined as early as the 1850s by O. G. Rejlander and Henry Peach Robinson. The Starn twins, Douglas and Michael, tear up and reassemble the print itself, making a "new" photograph using the torn and crumpled pieces, tape, and other artifacts of the destruction-reconstruction process.

Rather than manipulating and collaging the print, John Pfahl chooses to make physical alterations to his landscapes by adding bits of colored yarn, aluminum foil, and wooden stakes that change the way the viewer perceives the scene. His altered landscapes are rich and beautiful but also contain witty spatial and scale distortions that question the photograph's illusion of three dimensions. In a similar manner, John Divola has applied stripes and patterns of paint to abandoned beach houses to alter their presence. Divola also transforms banal landscapes into suggestive narratives by placing intruding objects and figures lit by garish colored light in the frame. Barbara Kasten also manipulates colored filters of light in her formal studies of geometric mirror-covered forms juxtaposed against contemporary urban architecture.

Appropriating Images

The 1980s saw a renewed interest in "appropriation" of imagery. Pop artists of the 1960s commonly based their work on the omnipresent imagery of society, such as soup cans, cartoons, and maps; in the 1980s the work of some photographers reflects their fascination with this same kind of imagery. Vicky Alexander and Richard Prince clip images directly

Arthur Rothstein. "A Farmer and His Sons Walking in a Dust Storm, Cimarron, Oklahoma," 1936. One of many photographs made for the Farm Security Administration (FSA) to illustrate the plight of the dispossessed and the unemployed during the Great Depression. Many of the photographs made by the FSA photographers have become symbols of that era.

from published sources, glue them together and present the new imagery as their own. Robert Heinecken reprints unaltered images from fashion magazines but presents them along with fictional narratives he has written. In similar fashion, Barbara Kruger overprints her appropriated photographs with blocks of written text from books, newspapers, and advertising slogans to shift and skew the original meaning of the images.

These photographers and others choose to question the authorship, ownership, and manipulation of social information. Many who appropriate images attempt to investigate and demonstrate the pervasive cultural impact of everyday visuals. Their works are concerned more with the manipulation of signs and symbols than with the making of an art object, and the viewer is often regarded simply as the receptor of these media-produced messages.

The Impact of Color in Contemporary Photography

Color photography has clearly increased in importance in the last decade, perhaps catalyzed by the broad range of color images in the press and media that have become so much a part of contemporary culture. The expressive capabilities of color were fully recognized in the 1980s, and large-scale color prints appeared on the scene with a fury. Many workers took advantage of the higher film speeds, reduced processing times, and greater image stability of the new color film and print materials. Suddenly newspapers, books and galleries exploded with color images.

Viewers were tantalized by the sensuous colors and luminous shades of Joel Meyerowitz's quiet and compelling "Cape Light" photographs and were treated to hauntingly beautiful yet disturbing wasteland images by Richard Misrach. Color has become a staple of contemporary photojournalism, too, and the photo essays of Susan Meiselas and James Nachtwey led the way in demonstrating the role color could play in news coverage.

Summary

Many styles and visions stretched the medium of photography in the decade of the 1980s, and it has survived intact. Influenced by performance and conceptual art, some photographers turned away from work based on capturing actual life experiences. Instead they chose to use photography as a vehicle for ideas in a manner similar to conceptual art. Although these activities have contributed significantly to the range and scope of the medium, some critics doubt the staying power of the resulting images. Other photographers have continued to use the documentary power of the medium to challenge and shape our view of society and the world. The beauty of life, too, often has been rediscovered. This is particularly evident in the stunning formality and color quality of the large-scale prints that became so popular. Ultimately, the 1980s showed the medium of photography remained vibrantly alive, encompassing a greater variety of approaches than ever before.

HOW TO USE THIS BOOK

From this point on, the units in this book are organized to provide systematic, practical instruction in the craft of photography. You will learn what equipment and materials are currently available and how to use them. You will learn how to control the photographic process to obtain the effects that you want. And you will learn how to see and to communicate with photographs. Unit 2 contains specific instructions on how to use the special features of this book most effectively. Follow these instructions as you begin.

Unit **Two**

Michal Heron, fish-eye photo of a woman on a bus, New York City.

UNIT AT A GLANCE

Cameras and accessories come in a bewildering assortment of types, sizes, and features. Choosing the right camera to solve a photographic problem can be difficult. This unit examines cameras by viewing system type, film size, and exposure system. The advantages and disadvantages of the various camera designs are explained to help you determine what kind of camera best suits your requirements. Special function cameras, such as still video and electronic photography cameras, are described, as well as the kinds of photographic assignments for which they are likely to be used.

Characteristics of lenses, including speed, focal length, and angle of view are examined and the effects of telephoto and wide-angle lenses are explained in this unit. A discussion of common camera accessories and their use is included, followed by recommendations for proper camera care and tips for use.

The Human Camera

Objective 2-A Compare the human eye and the camera in terms of their basic parts and functions.

Key Concepts lens, light sensitive, retina, film, body, shutter, aperture, iris diaphragm

HOW TO USE THIS BOOK
Objectives and Key Concepts

Starting with Unit 2, each unit is divided into sections preceded by numbered objectives. For example, in Unit 2, the objectives are numbered 2-A, 2-B, 2-C, and so forth. The first objective, 2-A, is about the human camera. The objective describes what you will learn to do: "Compare the human eye and the camera in terms of their basic parts and functions."

Following each objective is a list of key concepts—the important terms and ideas that are included in this objective. The key concepts are **boldfaced** in the text when they are defined for the first time in each unit.

The human eye provides a good starting point for learning how a camera works. The lens of the eye is like the **lens** of the camera. In both instruments the lens focuses an image on a **light-sensitive** surface—the **retina** of the eye and the **film** in the camera. In both, the light-sensitive material is protected within a light-tight container—the eyeball of the eye and the **body** of the camera. Both eye and camera have a mechanism for shutting off light passing through the lens to the interior of the container—the lid of the eye and the **shutter** of the camera. In the eye, the size of the lens opening, or **pupil**, is regulated by the **iris**; in the

Eye

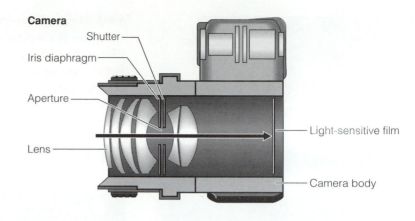

Eyelid

Iris

Pupil

Lens

Light-sensitive retina

Eyeball

A

Camera

Shutter

Iris diaphragm

Aperture

Lens

Light-sensitive film

Camera body

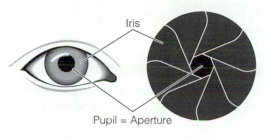

Iris

Pupil = Aperture

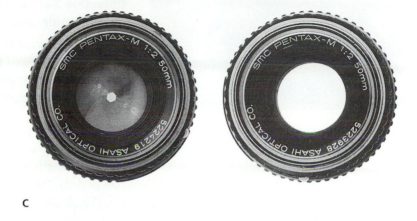

B

C

FIGURE 2-1

*Eye and camera. **A.** Notice the similarity of structures.*
***B.** The iris of the eye regulates the size of the pupil*
opening. The aperture setting on the camera deter-
mines how the iris diaphragm regulates the size of the
*lens opening (aperture). **C.** Actual appearance of small*
and large apertures.

camera, the size of the lens opening, or **aperture**, is regulated by an **iris diaphragm**. Study Figure 2-1 to compare the eye and the camera.

The eye adjusts automatically to high and low light conditions. In a darkened room the iris of the eye opens wide to allow as much light as possible to enter. In bright light the iris of the eye closes down to prevent too much light from entering. Observe the iris of your own eye in a mirror as you switch a bright light on and off. You will see that it adjusts the size of your pupil for each condition.

Many adjustable cameras do *not* adjust automatically for high and low light conditions. These cameras must be adjusted manually to regulate the amount of light that enters. To help with this manual adjustment, many cameras have built-in light meters that inform you of changing light conditions. Nevertheless, some cameras, even as the eye, do adjust themselves automatically for varying light conditions.

The eye also adjusts automatically to focus on the objects of interest to you. Small muscles attached to the lens of the eye alter its shape to focus on nearby or distant objects. Some cameras also adjust focus automatically; however, most adjustable cameras do not. In most cases you must adjust your camera manually to focus on the objects of interest to you. To help you with this adjustment, most cameras provide built-in features that indicate which objects are in and out of focus on the film. Thus in many ways the camera functions much as the human eye.

One important difference between eye and camera is that the eye sees selectively, whereas the camera sees indiscriminately. Human beings tend to observe only those elements that are important to them, because their

FIGURE 2-2

Eye's view and camera's view. What did the camera see that the photographer failed to see?

minds filter out the unimportant information. The camera, on the other hand, sees all the details in view and records them with equal emphasis on the film. It cannot judge which are important and which are not. That explains why sometimes a strange object may appear in the finished print that the photographer did not notice when taking the picture—the photographer saw selectively, whereas the camera saw indiscriminately. Photographers must train themselves to see what the camera sees. (See Figure 2-2.)

Basic Camera Types

Objective 2-B Identify several basic camera types and describe their similarities and differences.

Key Concepts pinhole camera, box camera, disposable camera, viewfinder (VF), fixed focus or focus-free, manual focus, auto focus, auto-focus lock, rangefinder focus, single-lens reflex (SLR), follow focusing, twin-lens reflex (TLR), view camera, bellows, swings and tilts, parallax, small format, 35-mm camera, half-frame camera, medium format, large format, sheet film, between-the-lens (BTL) shutter, focal plane (FP) shutter, self-timer, fixed exposure, manual exposure, match-needle, automatic exposure, shutter priority, aperture priority, fully automatic, programmed automatic, exposure override, instant cameras and films, wide-format camera, underwater camera, underwater housing, still video, electronic photography, analog, floppy disk, digital, picture file, integrated circuit memory cards (IC's), stereo camera, press camera

As camera technology has developed in many directions, cameras themselves have taken many forms. Modern cameras may be classified according to body type, film size and image formats, shutter system, viewing and focusing system, exposure-setting system, and special functions. Regardless of their complexity, all cameras operate on a common principle and share the basic elements found in even the most basic cameras.

Simple Cameras

To gain an understanding of the modern camera, consider first some of the earlier, simpler camera types.

Pinhole Camera

The **pinhole camera** (Figure 2-3) is the simplest of all cameras. It is basically a light-tight box with a pinhole in one end and the film at the opposite end. The camera has no lens; rather, a small pinhole forms the image

A

B

FIGURE 2-3

A. A pinhole camera can be made from any light-tight container. The photographer used a discarded film box and attached a 4-in. by 5-in. Polaroid film back for instant pinhole photographs. B. The resulting image is characteristic of the quality a pinhole camera can produce. Pinhole images are adequately sharp and possess nearly infinite depth of field.

What Is Pinhole Photography?

Pinhole photography is a quick, direct, and entertaining way to experiment with photographic principles while creating unique and exciting images. A pinhole camera is nothing more than a light-tight box with a piece of light-sensitive film (or photographic paper) at one end, and a pinhole for a lens at the other. Working pinhole cameras can be made from any container that can be made light-proof, such as oatmeal boxes or coffee cans. Even shoes have been used as successful cameras.

Why Make a Pinhole Camera?

Pinhole cameras are fun to make, easy to use, and produce images that have a unique and impressionistic look. You can make long wide-format cameras, curved wide-angle cameras, long focal length "telephoto" cameras—even cameras with multiple pinhole lenses that see like an insect's eye. Pinhole optics are also unique in having infinite depth of field. In a pinhole photograph, everything—regardless of distance—is equally sharp, or should we say, equally a bit unsharp.

How to Make a Pinhole Camera

First, find or make a light-tight box—one with a deep and snug-fitting lid is ideal. It can be any size, *(continued)*

but a container large enough to use 4-in. by 5-in. film or photographic paper is especially convenient. Devise some method for holding the film in the back of the camera. You can simply tape the film in place or create a pair of cardboard rails to slip it under. Paint the inside of the camera black to minimize reflections. Cut a small hole, about $1/2$ in. in diameter, opposite the film side of the box. This is where the pinhole will be mounted.

Making a Pinhole "Lens"

The best and sharpest pictures are made from perfectly round, small pinholes with clean edges. Smaller pinholes give sharper images up to the point of diffraction. You may use the chart below to select an appropriate sewing needle to make the pinhole for your camera, but you needn't be too accurate about this.

Using an appropriate size sewing needle, carefully drill through a small piece of aluminum foil or other thin sheet metal. Make the hole as smooth and round as possible. Now mount your "lens" on the camera and design some sort of shutter. The shutter could be simply a flap of black tape that you lift to make the exposure.

Taking Pinhole Pictures

Unless you devise a viewfinder, you will have to estimate what will be included in the picture. Exposures, too, will need to be estimated until you gain experience with your individual camera. As a starting guide, pinhole photography exposures

with ISO/ASA 400 film under bright daylight will need to be about 1–2 sec. long. If you are shooting with enlarging paper instead of film, its effective film speed of about E.I.= 3 will require longer exposures—about 30–90 sec. Develop and print the film or paper in the conventional manner.

Other Possibilities

If you have a 35-mm camera with interchangeable lenses, you could substitute a pinhole lens and save yourself the trouble of constructing a camera box. You would then be able to make multiple pictures without reloading, and it would be simple to use roll film.

The longer the camera you make, the larger the image you make can be. Make the longest camera you can for telescopelike effects or very large images. If you want to, you can even shoot on mural paper.

Pinhole photographers have created sensible cameras equipped with such features as Polaroid backs; they have also made highly fanciful and imaginative cameras in strange shapes. Have fun!

Best Focal Length	Needle	Size	Approximate f/stop
20"	#4	.036"	f/555
15"	#5	.031"	f/483
13"	#6	.029"	f/448
10"	#7	.026"	f/384
8"	#8	.023"	f/347
6.5"	#9	.020"	f/325
5"	#10	.018"	f/277
4"	#12	.016"	f/250
2.5"	#13	.013"	f/192

For More Information

Shull, Jim. *The Hole Thing: A Manual of Pinhole Fotography.* Dobbs Ferry, NY: Morgan and Morgan, 1974.

Smith, Lauren. *The Visionary Pinhole.* Salt Lake City: Peregrine Smith Books, 1985.

Kodak, *How to Make and Use a Pinhole Camera.* Publication AA-5.

FIGURE 2-4

Disposable cameras, a type of box camera, now come in many forms, including telephoto models and even simple underwater cameras. All are preloaded with film and are designed for one-time use.

A

FIGURE 2-5

A. An example of the popular point-and-shoot 35-mm cameras that feature automatic exposure, autoflash, and motorized film transport. B. Viewfinding and picture-taking systems.

on the film. A flap serves as a shutter to control the light entering the pinhole. All other cameras merely add refinements to this basic design.

Three important refinements are the **lens**, which substitutes for the pinhole and provides a much sharper and brighter image, the **iris diaphragm**, which allows the photographer to vary the intensity of the light entering the camera, and the spring-loaded **shutter**, a device that precisely controls exposure times and which substitutes for the flap on a pinhole camera.

Box Camera

The **box camera** (Figure 2-4) is an inexpensive refinement of the pinhole camera and is equipped with a simple lens and a shutter. The widely sold **disposable cameras** are modern examples of the box camera. Usually these cameras have a nonadjustable lens set to focus on objects about ten feet or more from the camera. The nonadjustable shutter, usually placed behind the lens, is preset for 1/60–1/125 sec., suitable only for shooting relatively stationary objects under average lighting conditions. The early box cameras and their modern counterparts can take excellent photographs under these conditions. Close-ups, action shots, and weak lighting conditions usually limit a box camera's capabilities.

Camera Types by Viewing System

The most common way of classifying cameras is by viewing system. At least four types of viewing and focusing systems are currently in common use: *viewfinder (VF)*, *single-lens reflex (SLR)*, *twin-lens reflex (TLR)*, and *view cameras.*

Viewfinder Cameras

The **viewfinder (VF)** camera (Figure 2-5) is distinguished by a separate eye-level window through which the photographer can plan and compose the picture within illuminated frame lines. The viewfinder system is easy and fast to use, especially in low light. The advantages of this type of camera include a small compact design, light weight, mechanical simplicity, quiet operation, and relative durability. Many photographers also feel that looking through a viewing window rather than looking at a ground-glass focusing screen allows a more direct and immediate interaction with the subject.

All viewfinder cameras do have one major disadvantage—parallax. Because the viewing window is separate from the picture-taking lens, the two views do not completely coincide; thus, what the photographer sees through the window may not exactly match what is recorded onto film. (For more on parallax, see Figure 2-11, p. 55.) Another disadvantage of most VF cameras is the lack of interchangeable lenses and the inability to shoot closeups.

VF cameras use a variety of systems to achieve sharp focus, ranging from simple fixed focus designs to wondrous electronic auto-focus systems. Note that the viewfinder camera typically uses a leaf-type shutter that is located either behind the lens or between the lens elements.

Fixed Focus or Focus-Free A **fixed focus** or **focus-free** viewfinder camera uses an eye-level window for composing the image; however, it possesses no focusing system at all. Fixed focus cameras are designed to provide acceptably sharp images of all objects that are beyond some specified minimum distance from the camera, usually 7–10 feet. Note that focus-free cameras are not the same as auto-focus cameras. Focus-free cameras have a single, fixed focus setting and provide no focus adjustments; they rely instead on depth-of-field to render most objects at medium distance and farther adequately sharp. Auto-focus cameras, discussed below, feature automatic, adjustable focusing.

Manual Focus A **manual focus** VF camera also uses an eye-level window for composing the image; however, it uses a separate focusing system. Typically, manual focus cameras are equipped with an adjustable lens on which is inscribed a distance scale. By turning the focusing ring according to the distance scale, the lens can be set for the estimated or measured distance between the camera and the subject. Some manual focus cameras provide only a few focusing positions—for distance, medium range, or closeup shots. Manual systems for viewing and focusing are typical of simple, inexpensive cameras that do not provide precise focusing controls. (See Figure 2-6.)

Auto Focus Many manufacturers have introduced cameras equipped with focusing systems that automatically focus the lens at the instant the shutter is released. These **auto-focus** cameras differ in design from fixed focus cameras. Some emit a signal pulse of either sound or infrared light in the direction the lens is pointed. In the manner of sonar or radar, the camera's receiver then translates the return reflection of the pulse into a distance reading and automatically sets the camera to focus on the subject. Others use a combination of optical and electronic sensors to focus the lens.

Using this technology, the camera makes focusing adjustments for the photographer. However, the camera does not have the benefit of the photographer's judgment as to which objects should be in focus and which not. These cameras typically focus automatically on the nearest object encountered at the center of the image field. To provide the photographer with some control, some auto-focus systems offer an **auto-focus lock** feature, which allows the photographer to prefocus on an object of choice and then lock the system to that focus distance.

Rangefinder Focus Classic VF cameras such as the Leica have a separate rangefinding optical system built into them. This rangefinder system is coupled to the picture-taking lens in such a way that adjustments in the rangefinder automatically produce like adjustments in the picture-taking lens. In this way the photographer can be certain that objects in focus in the rangefinder will be in focus in the final picture. (See Figure 2-7.)

FIGURE 2-6

Close-up of a manual focus camera showing the focusing ring and distance scale.

FIGURE 2-7

A modern viewfinder type camera. This precision-made Leica even offers interchangeable lenses.

Single-Lens Reflex Cameras (SLR)

Single-lens reflex (SLR) cameras have an optical system that allows both viewing and picture taking to be performed by the same camera lens. When using an SLR camera, the photographer views an image of the scene on a ground-glass screen. The image has been transmitted through the taking lens to the ground-glass screen by a mirror set at an angle just behind the lens. In this way the photographer sees exactly what the camera's lens sees and gains precise control over focus and composition. When the shutter trips, the mirror flips up out of the way, permitting light entering the lens to be transmitted directly to the film. When the shutter closes, the mirror returns to its viewing position. Figure 2-8 shows a typical SLR camera with its mirror in both viewing and taking positions. Note that the shutter of the SLR camera must be located behind the mirror if viewing is to take place while the shutter is closed. Therefore, SLR cameras are typically provided with focal plane shutters.

The SLR principle has been used in many types of cameras using film of many sizes and formats. Modern SLR cameras are manufactured primarily for use with 35-mm, 120, or 220 film. Some SLR's are available with automatic focusing and even advanced focusing features such as **follow focusing** for moving objects and the ability to trip the shutter when the subject enters a predetermined distance zone.

The ability to frame precisely what will be recorded on film is one advantage of the SLR camera type—an advantage that is shared only by the view camera. This viewing system eliminates parallax at all working distances and gives the photographer an exact view through any lens or accessory mounted on the camera body.

Another advantage of an SLR system is the wide range of easily interchanged optics that is available, such as telephoto and wide-angle lenses. SLR's equipped with a normal lens usually focus much closer than VF type cameras, even as close as one foot. Their ability to do close focus work may be extended even further with the addition of bellows, extension tubes, or a special macro lens. (See page 71.) The SLR type camera is not,

A

FIGURE 2-8

A. A single-lens reflex (SLR) camera. *B.* A cross section of an SLR camera showing focal plane shutter. Note that the mirror position adjusts up and down. *C.* Detailed cutaway of SLR body.

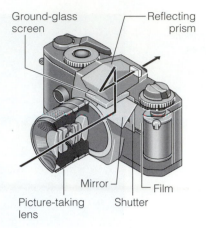
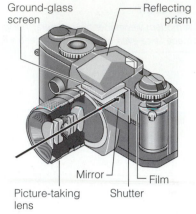

Ground-glass screen — Reflecting prism — Ground-glass screen — Reflecting prism

Mirror — Film — Mirror — Film

Picture-taking lens — Shutter — Picture-taking lens — Shutter

B

C

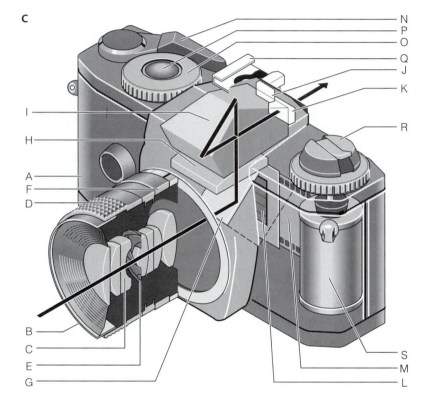

A. Body	K. Viewfinder eyepiece
B. Lens	L. Shutter
C. Lens elements	M. Film
D. Focusing ring	N. Film advance
E. Iris diaphragm	O. Shutter speed dial
F. Aperture ring	P. Shutter release
G. Mirror	Q. Hot shoe
H. Viewing screen	R. Rewind mechanism
I. Pentaprism	S. Film cassette
J. Metering cell	

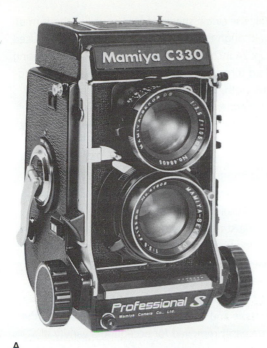

A

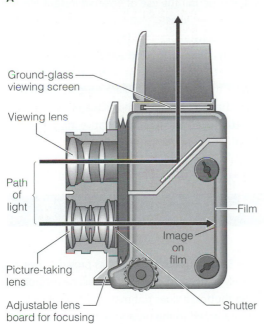

Ground-glass
viewing screen

Viewing lens

Path
of
light

Picture-taking
lens

Adjustable lens
board for focusing

Film

Image
on
film

Shutter

B

FIGURE 2-9

*A. A twin-lens reflex (TLR) camera. B. A side-view
cross section of a TLR camera. Note that the viewing
and picture-taking lenses are mounted to the same
adjustable lens board: they focus simultaneously.*

however, without its disadvantages. The SLR design is mechanically complex, and this intricacy translates into higher prices, larger bodies, greater weight, more noise during operation, and slightly more fragile workings than other camera forms.

Twin-Lens Reflex Cameras (TLR)

The **twin-lens reflex** (TLR) camera (Figure 2-9) is distinguished by two separate but quite similar lenses that are mounted on the lens board at the front of the camera—one to view the scene and the other to take the picture. By using two lenses of similar optical characteristics, the photographer can separate the viewing and picture-taking functions and at the same time couple them to act in unison. As with the SLR camera, viewing is accomplished by means of an image focused on a ground-glass screen, which is mounted on top of the TLR camera.

Typically the upper lens of the TLR camera is for viewing, whereas the lower lens is for picture taking. The focusing adjustment moves the entire frontal lens board, including both lenses, in such a way that the images produced by both lenses are in focus at the same time. In other words, when the image on the ground-glass screen is in focus, the image at the film plane is in focus also. Note that unlike SLR cameras, the TLR camera normally uses a leaf-type shutter located between or just behind the lens elements. This type of shutter and camera is very quiet in use and is often chosen when the typical "clank" of an SLR firing would be obtrusive.

Because the photographer views a subject through a lens mounted above the one used for picture taking, problems with parallax can occur, especially when focusing up close. Thus, most inexpensive TLR cameras usually focus no closer than three feet. Some TLR cameras do feature interchangeable lenses, but these are relatively expensive items, because the manufacturer must make a matched pair of lenses—one for viewing and one for taking. The latter must also include a shutter mechanism.

TLR's have long been favored for their durability and reasonable price, both qualities that result from the mechanical simplicity of the design. TLR cameras have been produced in many sizes and formats; the ones most commonly available today are designed for use with 120 and 220 film; photographers often select a TLR when they desire the greater image quality that such a medium-format film size provides.

View Cameras

View cameras are the oldest type of camera, descending directly from the historic *camera obscura* (see page 3). They represent the simplest camera design, consisting of little more than a flexible **bellows** with a lens and shutter mounted at one end and a ground-glass focusing screen and film plane affixed at the other. Despite their apparent simplicity, view cameras are powerful tools for work that requires precise control of perspective, depth of field, sharpness, and tone. For this reason, they are often chosen for use in portraiture, product photography, architecture, scenic photography, and technical and scientific photography. (See Figure 2-10.)

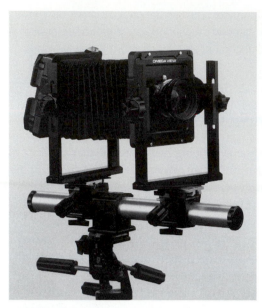

FIGURE 2-10

The view or studio camera. Offers many adjustments for controlling perspective.

View cameras commonly use single sheets of film, usually large format and typically 4 x 5 inches, although they have been commercially produced for film sizes as large as 20 x 24 inches and as small as 35 mm. Composing and focusing is accomplished through the picture-taking lens. The photographer, draped under a dark cloth, studies the image on a ground-glass screen at the back of the camera and makes the necessary adjustments before the film is put in place. The view seen by the photographer exactly matches that which will be recorded onto the film, and the large size of the ground-glass screen encourages an awareness of the design elements of the picture and a studious fine-tuning of its composition.

The main advantage of the view camera is its many physical adjustments, which allow precise control over the shape and sharpness of an image. In addition to focus adjustments, the relationship between the lens and the film can be widely modified by means of movements called **swings and tilts**. This makes the camera extremely useful for correcting and controlling perspective and optical distortions. The angular relationship between the lens board and the film can be adjusted by these camera movements to control the shape and sharpness of objects depicted in the photograph. Lens boards are easily removed for accepting a variety of lenses, and interchangeable backs permit the use of Polaroid instant films, roll film backs, and other sizes of sheet films.

Using a view camera is a time-consuming and deliberate process, not well suited for situations involving action or moving subjects. View cameras are also large, heavy, awkward to carry, require many adjustments, and generally must be used on a tripod or other camera support. Despite these disadvantages, however, the view camera remains the premier tool for the creation of exquisitely controlled and highly evocative images and has been the choice of many of the great photographers.

Parallax Error

The viewing system of the SLR and view type cameras provides a view of the subject that precisely matches the scene that will be recorded by the film upon release of the shutter. It does not matter if the subject is far or near, because the view presented to the photographer is formed by the picture-taking lens. Thus, what the photographer sees in the viewfinder is what will be recorded on the film.

Other types of cameras use different optical systems for viewing and focusing, as we have seen in the cases of VF and TLR cameras. When separate optical systems are used, the viewing system is displaced slightly from the optical axis of the picture-taking system. As a result, the image seen in the viewfinder may be slightly different from the image formed at the focal plane—the two systems see the subject from slightly different angles.

Separate viewfinding systems are designed so that the field of view *closely* matches that of the picture-taking lens at average snapshot distances. However, at closeup distances, the two images may be sufficiently different as to cause a problem. This discrepancy between the image seen through a camera's viewfinder and that recorded on the film is what photographers call **parallax error**. Some cameras compensate for this

Cameras, Lenses, and Accessories

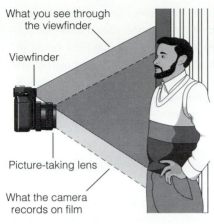

What you see through the viewfinder

Viewfinder

Picture-taking lens

What the camera records on film

A

B

C

FIGURE 2-11

Parallax effect. **A.** *Image seen in viewfinder may differ from image seen by picture-taking lens.* **B.** *Subject may appear perfectly centered in viewfinder while* **C.** *picture-taking lens is seeing off-center view. To remedy parallax effect, tip camera slightly in direction of viewfinder.*

FIGURE 2-12

Some viewfinder type cameras display additional parallax-correcting frame lines for closeup work.

discrepancy by providing a visual closeup frame within the viewfinder; others correct the view by optically displacing the viewfinder image as the picture-taking lens is focused at closeup distances. Some cameras do not correct for parallax error at all. If a camera provides no means to correct for parallax error, it can be corrected by tipping the camera slightly in the direction of the viewfinder when taking closeup pictures.

Film Size and Image Format

Many cameras are classified according to the size of the film they use or the format of the images they produce. The major types are small-, medium-, and large-format cameras.

Because a photographic image can be magnified only to a certain degree without visibly degrading its quality and sharpness, film size and image format should be considered in relation to how the images will be used. The larger the recorded image, the larger the acceptable degree of magnification. For enlargement to album-size prints ("snapshots") or small-room projection, small-image formats may be quite suitable; for exhibit-size enlargements, auditorium projection, or publication, larger-image formats may be required. When selecting an image format for projection, remember that most common slide projectors are designed for small-format images; projectors for medium- and large-format images are less readily available and more expensive. Keep in mind, too, that as image size increases, cost per image also increases. Choice of film size and image format should reflect, therefore, the expected uses of the recorded images.

Small Format

One type of **small-format** camera is the **35-mm** camera, so called because it uses 35-mm film—the same size as that used for making professional motion pictures. A camera of this type loads with a **magazine**, a light-tight metal container holding a strip of film sufficient for a number of images, each measuring 24 mm by 36 mm. These magazines are available

in many different sizes, some sufficient for twelve exposures, some for as many as seventy-two exposures. The most common sizes provide for twelve, twenty-four, or thirty-six exposures. Some 35-mm films are available in 50-ft. and 100-ft. rolls so you can load them into your own magazines to the exact length you prefer. Some 35-mm cameras are designed to produce a greater number of smaller images from the same film magazines. The **half-frame** camera, for example, uses the same 35-mm film but produces an image that measures 17 mm by 24 mm, half the size of the full-frame format of the standard 35-mm camera.

The 35-mm camera is the most popular type of camera today. It is available in many varieties, from simple, nonadjustable models suitable for use under a limited range of conditions to highly sophisticated models with interchangeable and adjustable components suited to a wide variety of photographic situations. Small-format cameras are easy to carry, versatile, compact, and easy to handle. For most types of photographic assignments, their small image format yields adequate quality.

Medium Format

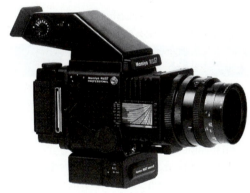

The most popular **medium-format** cameras are designed to use 120 or 220 film, which is supplied in rolls containing sufficient film for twelve or twenty-four images respectively, each measuring 2 1/4 in. square (6 cm by 6 cm). Some medium-format cameras using this size film are designed to produce rectangular images measuring 6 cm by 7 cm (2 1/4 in. by 2 3/4 in.), for example, or 4.5 cm by 6 cm (1 5/8 in. by 2 1/4 in.). The advantage of these formats is that they are close to the proportions of a standard 8-in. by 10-in. print. (See Figures 2-13 and 2-14.)

Medium-format cameras are often chosen for assignments that demand high-quality reproduction of nonstationary subjects; the film size offers greater detail and a richer tonal rendering than the smaller 35-mm format. Medium-format cameras are often the tools of choice for professionals in the fields of commercial, industrial, editorial, and portrait photography.

FIGURE 2-13

An example of a medium-format camera that uses 120 or 220 size film.

HELPFUL HINT
Metrication

In the field of photography, both U.S. customary measures (inches, quarts, pounds, degrees Fahrenheit) and metric measures (centimeters, liters, grams, degrees Celsius) are commonly used. Some standard product measures may be expressed in one system and some in the other, depending on where or for what market the product is manufactured. For example, some cameras are known as 4-in. by 5-in. cameras because of their image format; other cameras are known as 6-cm by 7-cm cameras because of theirs.

In this book we have provided metric equivalents in parentheses wherever U.S. customary measures are commonly used. Whenever metric measures are commonly used, the U.S. customary equivalent is provided in parentheses if appropriate. For example, a statement such as the following might be found: A 2 1/4-in. by 2 1/4-in. (6-cm

by 6-cm) camera uses the same size film as a 6-cm by 7-cm (2 1/4-in. by 2 3/4-in.) camera. A table of metric conversions is provided in Appendix C.

Large Format

Large-format cameras are designed to use **sheet film**, film supplied in individual sheets to fit standard film holders. Sheet films are commercially produced in many sizes and formats for both photographic and graphic arts purposes. The sizes most commonly used for photography are 2 1/4 in. by 3 1/4 in. (6 cm by 8 cm), 4 in. by 5 in. (10 cm by 13 cm), 5 in. by 7 in. (13 cm by 18 cm), and 8 in. by 10 in. (20 cm by 25 cm). Larger sizes up to 20 in. by 24 in. (52 cm by 62 cm) are produced for graphic arts and scientific purposes. These large-format films require little enlargement to produce relatively large prints; therefore, grain is virtually nonexistent in the final display. Large negatives and transparencies offer the ultimate in photographic reproduction, because they record even the most minute details and textures of a scene.

In selecting an image format, consider the tradeoff between image size and camera size. In general, obtaining larger images requires the use of larger, bulkier, and usually more expensive camera equipment. To obtain the convenience of smaller, lighter, portable, and usually less expensive camera equipment, smaller image formats must generally be accepted. Except to solve special problems and for studio uses, today's professional photographers rely heavily on small- and medium-format cameras for most purposes, particularly those using 35-mm, 120, and 220 film sizes. (See Figure 2-14.)

FIGURE 2-14

Comparison of small-, medium-, and large-format film.

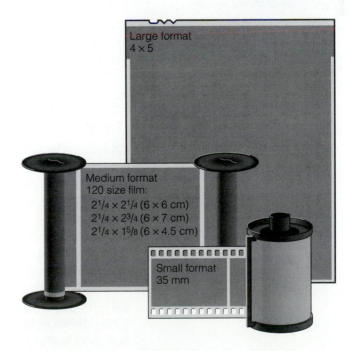

Large format
4 × 5

Medium format
120 size film:
$2^1/4 \times 2^1/4$ (6 × 6 cm)
$2^1/4 \times 2^3/4$ (6 × 7 cm)
$2^1/4 \times 1^5/8$ (6 × 4.5 cm)

Small format
35 mm

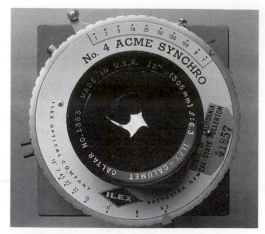

A

B

FIGURE 2-15

A. *A between-the-lens (BTL) shutter in action showing the opening* **B.** *and closing of the metal blades.*

Shutter Systems

There are two types of shutter systems in common use: between-the-lens (BTL) shutters and focal plane (FP) shutters.

Between-the-Lens Shutters

Between-the-lens shutters are made of thin, overlapping metal leaves designed to pivot outward from the center to admit light. Installed between the lens elements close to the optical center, the BTL shutter admits light to the entire film area throughout its exposure cycle. As the shutter begins its cycle, dim image-forming light is admitted to the entire picture area. As the shutter opens more widely, the illumination brightens until the shutter reaches its maximum opening. Then, as the shutter closes, the illumination dims again until the shutter is closed. The design of the BTL shutter imposes mechanical limitations on how quickly the blades can open and close. For this reason, BTL shutters rarely have top speeds of more than 1/500 of a second. (See Figure 2-15.)

Focal Plane Shutters

Focal plane shutters may be made of metal or cloth in the form of two overlapping curtains or sets of blades that open and close in rapid succession so that the opening between them admits light to the film. Installed in the rear of the camera close to the surface of the film at the focal plane, the FP shutter admits light successively to portions of the film as the opening between the curtains traverses the film gate. By varying the rate of travel and the width of the shutter opening, manufacturers can achieve a wide variety of shutter speeds. Some focal plane shutters offer exposure times as short as 1/8000 of a second, a duration almost fast enough to freeze a bullet in flight. (See Figure 2-16.)

Each type of shutter has its advantages and disadvantages. The BTL shutter is more flexible for flash synchronization, allowing electronic flash units to be used at all shutter speeds. This is a great boon for "fill-in" flash work. Its location between the lens elements, however, prevents its use in single-lens reflex camera designs. The FP shutter, on the other hand, is more suitable for single-lens reflex cameras and offers higher shutter speeds, but its method of exposure limits its usefulness with electronic flash. This subject will be treated more fully in Unit 11, "Flash Photography."

The range of shutter speeds varies with shutter design. Most modern adjustable cameras provide a range of speeds from several seconds or more to 1/8000 of a second or less. In addition, some provide a setting for manually timing longer exposures that allows the photographer to open and close the shutter at will. A further feature available with some cameras is a **self-timer**, which provides for delaying the exposure by ten seconds or so after the shutter is released. This feature is useful for stabilizing the camera on its support before releasing the shutter for a long exposure. It can also be used for self-portraits of the photographer.

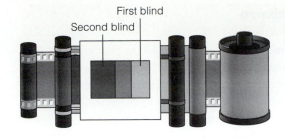

First blind
Second blind

1

2

3

FIGURE 2-16 ▲

The two curtains of a focal plane shutter form a narrow opening that moves across the film gate to expose successively the whole picture.

FIGURE 2-17 ▶

A match indicator is a type of automatic exposure-setting system. Adjust the aperture and/or shutter speed until the indicator light or needle seen in the viewfinder is properly aligned.

Exposure-Setting Systems

Two basic controls on an adjustable camera determine the amount of light that strikes the film—shutter speed and aperture. The length of time the shutter remains open affects the duration of the exposure; the size of the aperture affects its intensity. The simplest cameras use a **fixed exposure** system that possesses a single combination of shutter speed and aperture. Such nonadjustable cameras may be used effectively with a certain type of film under prescribed shooting conditions. Most cameras, however, are designed so that shutter speed and aperture can be adjusted to various settings, permitting use of the camera with films of various types and speeds and under many shooting conditions. Exposure-setting systems may be divided into three major classes: manual, automatic, and programmed.

Manual Exposure

A **manual exposure** system requires that each of the two settings, shutter speed and aperture, be adjusted by hand. These may be determined by using a published exposure guide and estimating lighting conditions. Exposure settings can also be determined by using an exposure meter to measure the lighting conditions. Most photographers prefer the latter method because it is more precise.

Before the 1960s, most photographers used a separate, hand-held exposure meter to determine correct exposure settings. At that time camera manufacturers were trying to design cameras with built-in exposure meters that would simplify exposure-setting operations. The earliest built-in exposure meters required the photographer to read the meter and then set the exposure in two separate operations. Today's manual exposure systems, using built-in microelectronics, combine the reading and setting functions into a smooth, efficient one-step operation.

As the scene is composed in the viewfinder, a meter needle or an indicator light at the edge of the viewing frame provides meter and exposure information. While viewing through the viewfinder, the photographer can adjust the shutter and/or aperture to match the exposure settings to the meter reading. Commonly called a **match-needle process**, this type of manual system ensures simple, accurate, and consistent exposure settings. (See Figure 2-17.)

Automatic Exposure

An **automatic exposure** system is designed to set the shutter speed, the aperture, or both, automatically. Since the late 1960s, camera manufacturers have designed cameras that use microelectronic and computer technologies not only to inform the photographer of lighting conditions but also to adjust the camera's exposure settings.

Three general types of automatic exposure systems are in common use. The **shutter priority** type requires that the shutter speed be set manually, with the camera setting the aperture automatically in response to lighting conditions. This is an excellent system to use when the photographer needs to control the ability to stop or freeze action, such as in sports photography. The **aperture priority** type requires that the aperture be set manually, with the camera setting the shutter speed automatically. This system gives the photographer precise control over the range of focus in the final image, something that is useful when dealing with near-far spatial relationships, such as those found in landscape or scenic photography. The **fully automatic** exposure system adjusts both settings automatically to obtain a proper exposure.

Programmed Exposure

The **programmed exposure** system utilizes a computer program designed to select the best combination of shutter speed and aperture for a given condition. In selecting the exposure setting, most programs consider how steady the average photographer can hold the camera; some of the more advanced programs even take into consideration the focal length of the lens used. Advanced featured cameras often have multiple program modes designed to give optimum results in a specific situation such as action or close-ups. Some cameras even allow the photographer to design a custom-tailored program mode. Programmed automation is handy both for the beginning photographer who might otherwise be overwhelmed with technical details, and for the expert photographer, who appreciates many of its special features.

Most intermediate and advanced cameras with automatic exposure systems have indicators in the viewfinder that provide a readout of the settings the camera has chosen. This important feature gives the photographer the information necessary for retaining creative control of the image-recording process. Contemporary cameras, with their computerized exposure systems, are quite accurate and will automatically produce properly exposed images at least 95 percent of the time. However, certain situations call for exposure settings different from those the camera may self-select, and in some situations the photographer may wish to alter the basic exposure setting to call attention to one particular aspect of the subject. The better automatic exposure cameras provide an **exposure override** control that permits the photographer to disengage the automatic functions and to adjust both settings manually. (See Figure 2-18.)

Some automatic exposure cameras allow the photographer to select one of several modes of operation—shutter priority, aperture priority, fully automatic, program—and some provide a selection of several program

A

B

C

FIGURE 2-18

Viewfinder information for three types of automatic exposure systems. **A.** *Aperture priority; the window displays the corresponding shutter speed automatically selected by the camera.* **B.** *Shutter priority; the window displays the corresponding lens opening.* **C.** *Programmed automatic; displays both the shutter speed and aperture selected by the camera.*

Cameras, Lenses, and Accessories

modes. All automatic exposure cameras are powered by batteries. Without battery power, the automatic features will not function; sometimes even the camera will not function. A desirable feature for an automatic camera is the ability to function in a manual mode even without battery power in case the batteries fail and cannot be quickly replaced.

Special Function Cameras

Many cameras have been developed to meet particular needs or to perform special functions. A few of these are mentioned here to provide an idea of the variety of **special function cameras** that exist today.

Instant Cameras and Film

One type of camera worth special mention is the **instant camera**. Using special instant film, this camera produces a finished print immediately after the picture is taken, without darkroom processing. The modern instant camera is designed to use a special film pack containing a complete system of chemically treated film and paper for either black-and-white or color prints. The processing chemicals are activated within the camera and, in seconds, a finished print is produced. (See Figure 2-19.)

The major advantage of instant photography, of course, is that a finished print is immediately available. A major disadvantage, however, is that duplicates and enlargements of the finished picture cannot be made easily. Although printable negatives can be obtained with a special type of instant film, duplicates and enlargements are usually available only by copying the original print. Some Polaroid materials produce instant positive transparencies in the same manner as the print films produce prints.

Many camera manufacturers provide interchangeable backs for their cameras suitable for the use of instant films. With such an accessory instant films can be used with most conventional medium- and large-format cameras. Working photographers commonly use such instant prints made with their normal cameras as proofs to check exposure, composition, lighting, and other critical factors before shooting their final exposure on conventional film. (See Figure 2-20.)

Special instant films are available for use in regular 35-mm cameras. After exposure, the roll of special 35-mm film is inserted along with a chemical pod into a small processing box. The user then turns a crank to combine the film and processing chemicals, waits a few seconds, and removes the developed film.

Various types of 35-mm black-and-white instant transparency films are also available, including a continuous tone material for pictorial use and a special high-contrast black-and-white positive film that is useful for producing slides of charts, graphs, and computer screens for public presentations. An instant 35-mm color slide film is also available.

FIGURE 2-19 ▲

A camera designed specifically for use with instant films.

A

B

FIGURE 2-20 ▲

A. *Some professional cameras offer instant film backs as accessories,* ***B.*** *which may be attached to the camera in place of the conventional film magazine.*

A

B

FIGURE 2-21

A. A montage of two or more frames may be used to create a panoramic effect. B. A wide-format camera designed to produce panoramic views that are twice as wide as a conventional postcard size print.

Panoramic or Wide-Format Cameras

There are essentially three ways to obtain photographic images that take in a wider angle of view than is normally seen by the human eye. One is to use what is called a wide-angle lens, which is discussed later in this unit. Another is to create a **montage** of several photographs, each of which has been taken from precisely the same camera position but with the camera pointed in a slightly different direction. (See Figure 2-21A.) These several photographs are then carefully trimmed, aligned, and mounted so as to created a single, panoramic image. The third way is to use a **wide-format camera**. These cameras have either an external revolving lens and shutter or a special wide-angle optical system and produce long narrow images. They are especially useful for architectural work, panoramic landscapes, and large group photographs. (See Figure 2-21B.)

Underwater Cameras

Circumstances that require protecting camera equipment from water arise more often than we think. Certainly we might like to take a camera underwater on occasion to photograph the flora, fauna, and terrain. However, we may also find ourselves in the rain, in snow, on a canoe trip, or exposed to ocean spray. In all of these cases an ordinary camera may not be up to the task. The **underwater camera** is a specialized piece of equipment that is designed for use when fully submersed in water down to some specified depth. In addition, some manufacturers offer **underwater housings** designed for deep-water use of their particular models. Also, some specialty manufacturers make Plexiglas housings for general camera use. These, however, are generally not designed for deep-water applications. Equipment designed for underwater use will also serve with other kinds of wet or severe shooting conditions.

Still Video and Electronic Photography Cameras

Still video and **electronic photography cameras** are designed to record images without the use of conventional film and wet processing. Sony

introduced a still video camera in 1981, but the first commercial model was made available by Canon in 1986. Still video cameras are similar in operation to home video cameras: both capture and store images as **analog video signals** on a magnetic medium. Still video cameras normally rely on **floppy disks** rather than video cassette tapes to store their images; a single floppy disk can usually hold twenty-five to fifty photographs.

A relatively new method of electronic photography is the **digital camera** system. Unlike still video, digital cameras create a **picture file** of digital information, using computer language to store the information on floppy disks or **integrated circuit (IC) memory cards**. With a digital camera, the information file is readable and available for manipulation or transmission by a computer as soon as it is captured. Some view this as a big advantage over analog still video signals, which require further electronic processing with some attendant loss of image quality in order to be computer usable.

All electronic photography cameras, analog or digital, have one great advantage over conventional photography—their speed. By eliminating film processing, a finished image is available in seconds. This advantage makes electronic photography cameras invaluable in the time-sensitive areas of news gathering and military applications. These cameras' magnetic media also provide rapid monitor display and compact storage and archiving of images, features that prove useful when multiple picture collections must be maintained, such as in personnel files or databases. Unlike film, the floppy disks are also reusable, a feature that offers considerable savings in film cost for heavy industrial users and the real estate field.

Electronic photography cameras do have several major limitations: they are usually rather expensive and, at present, have lower resolution than film. The technology is improving, however, and electronic cameras can be expected to follow the same cost/benefit evolution curve as the desktop computer. That is, the next generation of electronic cameras can realistically be expected to sell for half the price of the present models and offer four times the features and resolution.

Electronic photography cameras are available in a variety of forms, ranging from compact, self-contained, point-and-shoot models to sophisticated accessory backs for conventional film-based camera bodies. Photographers can expect to see an increasing offering of electronic cameras and applications for electronic still photography as the technology is further refined. It is, however, unlikely that conventional film-based photography will be totally supplanted. Rather, we can expect to see much overlap and fruitful interchange between the two image-producing technologies. (See Unit 13, Objective 13F, page 412.)

FIGURE 2-22

A still video camera.

Stereo Cameras

Stereo cameras are designed to take two pictures simultaneously through two separate but identical optical systems spaced a few inches apart—like human eyes. The resulting image pair may then be mounted for use in a stereo viewer to obtain a three-dimensional view of the original scene. Some camera manufacturers make stereo attachments for use with their own models.

FIGURE 2-23

4-in. by 5-in. (10-cm by 13-cm) sheet film camera.

Press Cameras

Press cameras are often identified as special-function cameras. For many years press photographers preferred large-format cameras that could be used in a wide variety of situations—2 1/4 in. by 3 1/4 in. or 4 in. by 5 in., for example—so that the images would not require great magnification. These old press cameras were simplified forms of view cameras fitted with optical, eye-level viewfinders and grips for hand-holding. For a long time the Speed Graphic camera was the standard of the industry. It was bulky, heavy, and hard to manage, but it was reliable and rugged. It used 4-in. by 5-in. sheet film, had an adjustable bellows, and certain versions had both focal plane and between-the-lens shutters. Figure 2-23 shows a modern 4-in. by 5-in. press camera.

Today's press photographer, however, often uses a variety of cameras, and any camera preferred by a press photographer may serve as a press camera. The availability of high-speed, fine-grain films, electronic flash units, and fast, high-resolution lenses makes possible the use of medium- and small-format cameras for press purposes. The press photographer often carries several lightweight cameras, supplementary lenses, and accessories for use under various conditions and for the many purposes encountered in press work.

Summary

Many types of cameras are available to suit a variety of needs, tastes, and special purposes. Cameras are tools designed to solve specific problems; no one type of camera is ideally suited to all image-making situations. The choice of what camera to use or purchase depends on the kind of photographic subjects most often encountered. Working photographers who are called upon daily to handle a variety of subjects will probably have different and specialized camera systems for each need; their camera "toolboxes" will likely grow as their photographic skills develop and their tastes expand.

Selecting a camera can prove a confusing and frustrating task for those with little prior experience in photography. In recent times, new camera technologies have developed so rapidly that today's newest model is likely to become obsolete within a few years. In fact, the economics of camera manufacture encourages rapid turnover of models so that owners will want to upgrade their equipment frequently and thereby create a constant market for new camera products.

No one camera or set of features will satisfy all needs and purposes. Each photographer develops unique working habits and becomes especially comfortable with some particular camera configuration. In the long run, only experience will reveal to you what features you are likely or unlikely to use. Only experience will show you what type of camera will best serve your own picture-taking style. Obviously, there is little economic advantage to paying a premium for features that you do not need and will not use. The novice photographer, therefore, is usually well advised to begin with a borrowed, hand-me-down, or inexpensive camera that provides adjustable focus, aperture, and shutter speed. A little experience will improve one's judgment about what additional features will be likely to

Cameras, Lenses, and Accessories

prove useful in the longer run. A good beginning camera for the serious photographer would be a moderately priced 35-mm SLR with a manual exposure override. Such cameras are relatively easy to use, and the exposure override allows the photographer to explore the fundamentals of photography as well as maintain creative control.

Although there are many quality camera brands on the market—almost all of them capable of producing fine images—certain makes and especially certain models within brands tend to stand out and are most often chosen by professional photographers for their combination of features, quality, durability, and adaptability. If you are seriously considering a career in photography, you would be well advised to investigate which major brands and models are most used by the working professionals in your area and select your camera system accordingly. If you own the brand most popular with local professionals, you will have access to a greater range of rental and company-supplied "pool" equipment and lenses than will those who own cameras with other styles and brands of lens mounts.

Lens Characteristics

Objective 2-C Describe two major characteristics of the camera lens and their effects on picture taking.

Key Concepts focal length (F), focal point, object at infinity, normal lens, image format, angle of view, telephoto lens, wide-angle, zoom lens, perspective, telephoto effect, wide-angle effect, speed, f/-number, maximum aperture, f/-number = F/d, bayonet mount, threaded mount, mounting adapter

Two major characteristics of the camera lens that affect the image are its focal length and its speed.

Focal length

The **focal length** (F) of a lens is the distance between the lens and the **focal point** at which a sharp image of an **object at infinity** is formed. Have you ever used a magnifying glass to focus an image of the sun on a piece of paper or a leaf? The focal length of the magnifying glass is the distance between the glass and the image of the sun on the paper when it is in sharp focus. The sun, of course, is very far away and we may consider it an object at infinity. Practically speaking, we may consider any object more than fifty feet away from the lens an object at infinity. Figure 2-24 shows how the focal length (F) of a lens is determined.

The manufacturer inscribes the focal length on the lens barrel. The focal length of most lenses never changes because it is a characteristic of the design to which the lens is ground.

Normally a camera is fitted with a lens that has a field of view approximately the same as that seen by a human when staring straight ahead with one eye closed. Such normal lenses have a focal length roughly equal to the diagonal of the image **format** used in that camera. Thus the

FIGURE 2-24

Focal length (F) is the distance between the optical center of the lens and the focal point for an object at infinity. Note that increasing the focal length also increases the size of the image on the focal plane.

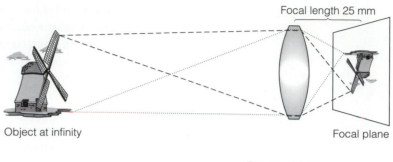

Focal length 25 mm

Object at infinity Focal plane

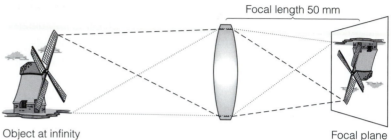

Focal length 50 mm

Object at infinity Focal plane

normal lens for a 35-mm camera using a 24-mm by 36-mm format would be approximately 50 mm. The normal lens for a medium-format camera producing 2 1/4-in. by 2 1/4-in. (6-cm by 6-cm) images would be approximately 3 in. (85 mm). Figure 2-25 shows how this was calculated using the formula for finding the diagonal of a square based on the length of the image format.

Lenses with longer or shorter focal lengths generally have differing **angles of view**. That is, they usually see less or more of the peripheral details in a scene than would a normal lens at the same distance. Figure 2-26 shows the different angles of view usually associated with lenses of differing focal lengths.

Lenses having a longer-than-normal focal length are commonly known as **telephoto lenses**; they increase the size of the image on the film. Objects are effectively brought closer to the camera; the effect is similar to

FIGURE 2-25

The focal length (F) of a normal lens is approximately equal to the diagonal of a square whose sides are equal to the length of the negative format. Given the length (L) of a negative, the normal focal length is $F = \sqrt{2L^2}$. Thus, for a standard 35-mm negative format (24 mm by 36 mm), a normal $F = \sqrt{2(36^2)} = \sqrt{2592} = 50$ mm. The normal F for a 2 1/4 in. by 2 1/4 in. (6 cm by 6 cm) film format is approximately 3 in. (80 mm).

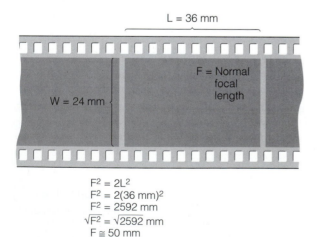

L = 36 mm

W = 24 mm

F = Normal focal length

$F^2 = 2L^2$
$F^2 = 2(36 \text{ mm})^2$
$F^2 = 2592 \text{ mm}$
$\sqrt{F^2} = \sqrt{2592} \text{ mm}$
$F \cong 50 \text{ mm}$

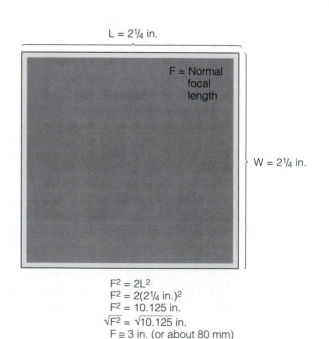

L = 2¼ in.

F = Normal focal length

W = 2¼ in.

$F^2 = 2L^2$
$F^2 = 2(2¼ \text{ in.})^2$
$F^2 = 10.125 \text{ in.}$
$\sqrt{F^2} = \sqrt{10.125} \text{ in.}$
$F \cong 3 \text{ in. (or about 80 mm)}$

A Wide-angle lens.
The field of view is expanded, but image size of specific details is reduced.

B Normal lens.
The field of view is smaller than with a wide-angle lens, but the image size is larger.

C Telephoto lens.
The size of the image is increased, but the field of view is reduced.

FIGURE 2-26

Angles of view with various lenses. As focal length decreases, the angle of view increases.

looking through a telescope. For 35-mm size cameras, any lens with a focal length much longer than the normal 50 mm is considered to be a telephoto; for example, a 105-mm lens is moderate telephoto.

The magnifying ability of a telephoto lens, or its ability to apparently bring objects closer to the camera, can be estimated by comparing the focal length of the telephoto lens to that of a normal lens for the same camera. Thus a 200-mm lens on a 35-mm film size camera has a focal length that is four times as long as the 50-mm normal lens; such a telephoto lens can be expected to produce an image on film that is four times as large. Similarly, a 300-mm lens might be thought of as a **six-power telephoto**.

Lenses with shorter-than-normal focal length are known as **wide-angle lenses**; their use will increase the camera's field of view. The effect is to reduce the image size of specific objects on the film; however, more peripheral detail is included in the picture at any given distance. As focal length decreases, the image magnification likewise decreases, but the angle of view increases. For example, switching from a 50-mm normal lens to a 25-mm wide-angle lens would result in an angle of view that is twice as wide, and individual objects in the resulting image would be only half as large.

A **zoom lens** has a variable focal length designed to be set at any point between the limits of its range. A 28-85 mm zoom lens, for example, may be set at any focal length between a 28 mm wide-angle and an 85 mm telephoto by adjusting a ring on its barrel. Zoom lenses permit the photographer to instantly change focal lengths and offer a compact and affordable alternative to carrying several conventional lenses. Zoom lenses rarely match the maximum apertures and speed of fixed-focal-length lenses, however, and many feel that zooms are not as sharp.

Perspective In addition to changing the angle of view, the focal length of the lens used is also related to linear **perspective** —different focal lengths affect the relative size and spacing of objects at different distances from the camera. A long lens not only photographs a smaller target area than a wide-angle; it also produces a different spatial rendering of the subject. Photographers often speak of a **telephoto effect** whereby objects in a scene seem abnormally compressed and the space appears flattened. The opposite perspective distortion occurs when wide-angle lenses are used. In a **wide-angle effect**, space appears to be stretched, and the distance between near and far objects looks exaggerated. These variations from normal perspective can be powerful tools with which the creative worker can interpret a scene, and photographers often consider these factors when selecting a lens to create a particular statement. (See Figure 2-27.)

For more information on lens use and selection, see Unit 3.

Speed

A second major characteristic of a lens is its **speed**. The speed of a lens indicates how much light the lens will transmit when it is open to its widest aperture. Just as a large window allows much light into a room, a large lens opening allows much light into the camera. Smaller windows, like smaller apertures, allow less light to pass. The speed of a lens is expressed

A

B

FIGURE 2-27

A. Telephoto compression. Notice how the ascending rows of stadium bleachers have been compressed into a single plane in this view made with a 400-mm telephoto lens. *B.* Wide-angle effect. Wide-angle lenses tend to open up and exaggerate near-far perspective as in this photograph made with a 24-mm wide-angle lens.

by the symbol **f/-**, such as f/1.4, f/1.8, or f/2.0. The more light the lens allows to pass, the "faster" the lens and the smaller the f/-number.

The f/-numbering system is a precise way of expressing the relationship between the diameter (d) of the lens at its **maximum aperture** and the focal length (F) of the lens. The f/-number of a lens is calculated as follows:

f/-number = focal length/lens diameter = F/d

For example, if the focal length were 50 mm and the diameter of the lens at its maximum aperture were 25 mm, then the speed of that lens would be

f/- = F/d = 50 mm/25 mm = f/2.0

The manufacturer inscribes the maximum f/-number on the barrel of the lens. An f/2.0 lens has a diameter that measures one-half of its focal length; an f/4.0 lens has a diameter one-fourth of its focal length, and so on. The greater the diameter of the lens, the more light can pass through it at its widest aperture. Thus for any given focal length, larger diameter lenses are faster lenses; f/2.0 is faster than f/4.0, f/4.0 is faster than f/5.6, and so on.

Any given f/-number defines an exact relationship between the lens aperture and the area of the image format no matter what camera or lens is in use. Thus f/8 on a normal lens of a 35-mm film-sized camera represents the same exposure setting as f/8 on a telephoto lens of a large-

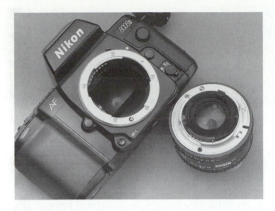

FIGURE 2-28

A bayonet-type lens mounting system. Notice how the flanges on the lens interconnect with the corresponding openings on the camera. Also visible are the electronic connections for auto focusing.

format view camera. The system of f/-numbers provides a common standard of light measurement for all cameras under all conditions.

Mounting Systems

Cameras that allow photographers to change lenses employ lens mounting systems for attaching lenses to the camera body. Most such cameras employ a **bayonet mount** system, in which the lens is aligned and seated in the mount and rotated a quarter turn to lock it in place. Some cameras use a **threaded mount** system, in which the lens is screwed into place in the camera body. Most manufacturers use their own mounting design, so that one manufacturer's lenses generally will not fit the camera body of another brand. However, some independent lens makers manufacture **mounting adapters** that make it possible to mount their lenses to many popular camera bodies.

Common Accessories

Objective 2-D Describe several common accessories used with adjustable cameras.

Key Concepts lens hood, UV (ultraviolet) and skylight filter, lens cap, cable or remote release, tripod, camera case, camera bag, exposure meter, flash meter, flash unit, filters, automatic winder, motor drive, teleconverter, supplementary lenses, extension tubes, extension bellows, dioptric correction lens

Hundreds of accessories are commonly available for simple as well as for complex cameras. Many are frequently, even constantly, useful, while others are useful only rarely for special purposes. Some of these accessories are described briefly here in the general order of their usefulness in beginning photography.

A **lens hood** is a detachable device fitted to the front of the lens to shade the lens surface from extraneous light. Use of a lens hood can improve image quality by reducing internal flare. Eliminating stray light can, at times, dramatically improve color saturation, increase contrast, and even boost apparent sharpness. A lens hood also helps protect the lens from accidental damage; many professionals use heavy-duty metal hoods to help protect their expensive lenses against damage from severe impact. For even more protection, and to prevent accidental scratches of the lens surface, almost all photographers semipermanently mount a basically clear glass **UV** or **skylight filter** on each lens in their bag.

A **lens cap** is a detachable, opaque cover fitted to the front of the lens to protect it and to block the passage of light. The lens cap is generally used when storing the camera, but it must be removed for picture taking. Some cameras with battery-operated light meters rely on use of the lens cap between shots to reduce battery drain. (See Figure 2-29.)

A

B

FIGURE 2-29

A. Lens hood. B. Lens cap.

FIGURE 2-30
Camera with a cable release on a tripod.

FIGURE 2-31
Soft-bodied camera bag.

A **tripod** is a portable, three-legged device used to support and stabilize the camera when a photographer needs precise framing control or during lengthy setups and long exposures. When slow shutter speeds are used (as they are in weak lighting situations), the slightest movement of the camera will blur the image on the film to some degree. A tripod is useful in such situations to eliminate the unavoidable movement of the hand-held camera. For slow shutter speeds, the use of a **cable release** —or its equivalent for electronic cameras, a **remote release** —is also recommended. Such a device enables the photographer to release the shutter without touching any part of the camera body, thereby avoiding camera movement. (See Figure 2-30.)

Most cameras may be provided with a snug-fitting **camera case** designed to enclose and protect the camera. These cases are designed so that the camera can be used quickly, without being removed from the case. Most photographers, however, prefer to remove the camera case altogether while shooting, to reduce weight and to simplify camera handling and film changing. Many manufacturers also make hard-bodied, fitted camera cases for their equipment, designed to hold the camera along with several accessories in neat compartments for storing and shipping.

Probably more useful in actual shooting is the soft-bodied **camera bag**, often called a gadget bag, designed to be carried from the shoulder. These are made in a great variety of sizes and shapes with various, often adjustable, interior compartments and pockets, suitable for any photographer's camera equipment and shooting style. (See Figure 2-31.)

An **exposure meter**, or light meter, is an essential accessory for an adjustable camera. It is used to measure the intensity of light in a given scene and to aid in determining exposure. Though many cameras have built-in exposure meters, photographers often carry an accessory hand-held meter as well to use when the built-in meter is inadequate. Many external meters also function as **flash meters** to determine exposure with professional strobe units. Use of exposure meters is explained in Unit 3, and flash meters are covered in Unit 11.

For controlling, supplementing, and improving lighting conditions, a **flash unit** is an essential camera accessory. The most common unit today is the electronic flash unit, commonly called a strobe, which provides a measured burst of light synchronized with the camera's shutter. The use of flash units is explained in Unit 11.

The way the human eye perceives color does not always agree with the way film responds to the same color. To be sure that a film will render the colors of a subject the way you wish them to appear, it is often necessary to use **filters**. A filter is a detachable device fitted to the front of the lens and designed to alter the color of the light transmitted to the film. By this means, the gray-scale rendering of various colors can be controlled in black-and-white photography and color rendering can be controlled in color photography, either to obtain correct color rendition or to create special effects. Use of filters is explained in Unit 9.

Many modern cameras are available with a device for advancing the film automatically after each exposure. An **automatic winder** is useful when photographing rapid action or fast-moving events, because the viewfinder need not be taken from the eye to advance the film. Some newer cameras have built-in automatic winders; however, automatic winders are more generally available as accessories. The simplest type is

Cameras, Lenses, and Accessories

A

B

FIGURE 2-32

Automatic power winder. ***A.*** *Detached from camera.*
B. *Mounted to camera.*

the power winder, which advances the film at a rate of about two frames per second. The professional type is the **motor drive**, which advances the film under force at a rate of about five frames per second. Automatic winders have battery-powered motors and add considerable weight when attached to the camera. (See Figure 2-32.)

Some accessories are designed to extend the uses of lenses. For example, the **teleconverter** may be used to increase the focal length of a lens. Commonly available as 2X, 3X, or 4X converters, they will double, triple, or quadruple, respectively, the focal length of any lens used with them. Thus, a 50-mm lens used with a 3X converter becomes a 150-mm lens. Though this procedure has optical disadvantages, it has the advantage of providing telephoto capability that is lighter and cheaper than an equivalent telephoto lens. Another function may be performed by a **supplementary lens**, which is used in front of the primary lens to shorten its effective focusing distance. The most common supplementary lenses are used for portraits, close-ups, and special effects. **Extension tubes** and **extension bellows** are used with interchangeable lenses to make extreme close-ups. (See Figure 2-33.)

FIGURE 2-33

Camera accessories designed to extend the uses of lenses. ***A.*** *Teleconverter (extender).* ***B.*** *Extension tubes.* ***C.*** *Extension bellows.* ***D.*** *Supplementary lenses.*

A

B

C

D

Wearers of eyeglasses may find that they interfere with eye-level viewing and focusing. To view and focus without glasses, a **dioptric correction lens** may be attached to the viewfinder. The manufacturers of most adjustable cameras make these lenses in various strengths; they can easily be attached to the viewfinders and will correct most common vision problems. For more severe vision problems, many manufacturers will grind special lenses to prescription.

The accessories discussed here are those that are most commonly used in general photography, although hundreds of others are made and sold to meet a great variety of special needs and purposes.

Care of the Camera

Objective 2-E Describe some important camera "housekeeping" practices.

Key Concepts lens tissue, lens-cleaning solvent, lens brush, spring tension, light fog

Good housekeeping in photography begins with the camera. Proper care of the camera and the film within it is the first essential for obtaining the best final result.

1. **Keep the lens clean and protect it from chips, scratches, dampness, and heat.**

 The most vulnerable part of your camera is the lens. It is a precision instrument. In most cases the lens is a combination of several soft glass elements. Some are cemented together with a resin that is affected by heat or dampness.

 The lens should be cleaned with photographic **lens tissue** or a bit of lintless, clean linen. Do not use lens tissue designed for eyeglasses. A soiled cloth may have dust on it, which could scratch the soft lens surface. Certain cloth fibers may be brittle and could also scratch the lens surface. Hand-held canisters of compressed air made to photographic standards are available commercially and also may be used for cleaning lenses. A rubber bulb syringe is also handy for blowing away dust particles.

 If the lens is coated too thickly with dirt or fingerprints, a drop or two of photographic **lens-cleaning solvent** may be needed. Do not use lens-cleaning solutions designed for eyeglasses. Lens-cleaning solvent should be applied to a lens tissue and then gently to the lens—never directly to the surface of the lens. Do not touch the glass surface with your fingers—they will deposit oils and acids harmful to your lens. Do not breathe on the lens or wipe it with a facial tissue or handkerchief. The moisture in your breath may be as harmful to your lens as the coarse fibers in ordinary cloth and paper tissue. Do not apply pressure when cleaning the surface of a photographic lens.

 When the camera is idle, keep it in a cool, dry, clean place. If the lens does not fold back into the camera body, where it is protected,

use a lens cap and store the camera in a case or drawer. Many photographers prefer to use a UV or skylight filter over the lens at all times to protect it from scratches.

2. **Keep your camera clean and protect it from heat, shock, and dampness.**

Dust sometimes seeps into the interior of a camera, where it is attracted to the smooth, soft surface of the film. Dust on the film shows up as black blemishes on the finished prints. Make it a habit to keep the inner face of the lens and inner surfaces of the camera dustfree. Use a soft **lens brush** for cleaning the interior of the camera when changing film, but avoid touching the fragile shutter mechanism. Occasionally clean the film pressure plate on the camera's back with a lightly moistened cloth to remove any accumulated film particles.

Use a camera case or bag to protect against dust and to shield the camera from casual bumps and shocks that occur in the everyday handling of the camera.

Avoid storing your camera where it will be exposed to extreme temperatures or dampness. Automobile glove compartments may seem like attractive storage places, but they become excessively hot during the summer months. Heat will affect both your film and your lens and should be carefully avoided. Boats, basements, and other damp places also should be avoided. Dampness will affect your film, your lens, and the metal parts of your camera.

3. **Relax all mechanical tensions and remove batteries during inactive periods.**

Do not leave the shutter of your camera cocked when the camera is to be stored for a period of time. Although it may not be necessary with modern cameras, it is good practice to release all **spring tension** adjustments built into the camera before storing it. Springs under tension tend to lose their strength over time, and shutter speeds or other fine adjustments may become unreliable. Remove batteries from battery-powered cameras and accessories to prevent damage from leakage if they are to be stored for any significant length of time.

4. **Load film in subdued light and store it in a cool, dry place.**

Never load film in direct sunlight. The backing paper and packing provide excellent protection for films, and with reasonable care all danger of **light fog** can be eliminated. Light fog is the unwanted exposure of the film to some ambient source of light. Handling film in direct, strong sunlight may expose the edges of the film and thus damage the film. A similar fog can result from multiple passes through the X-ray detectors used by many airport security departments. Some photographers protect their film with lead bags or request a visual baggage inspection to avoid all possibility of such a fog occurring.

Likewise, avoid storing film where it may be exposed to heat. During summer months, any place that has high temperatures from trapped heat should be avoided. A suitcase carried on top of a car and exposed to the sun may become excessively hot during a trip; it is a

poor place to store film. Buy fresh film as you need it. Many photographers refrigerate film in its unopened, original, air-tight packaging for maximum freshness. Refrigerated film must be brought to normal temperature before use.

5. **Have the camera inspected regularly.**

 Have an expert inspect the camera for light leaks and internal dirt in the lens approximately once a year. The shutter and diaphragm should be tested for accuracy, and the mechanism for holding the film flat during exposures should be checked. Small maladjustments in your camera can lead to major disappointments in the final photographs.

6. **Never attempt to repair or service the camera yourself.**

 Cameras are precision instruments. Repairs and service should be performed only by a skilled, reputable technician. Resist any temptation to do this work yourself; you will avoid needless expense and regret.

Good Habits of Camera Use

Objective 2-F Describe some good habits of camera use.

Key Concepts expiration date, outdated film, film advance, viewfinder, range, focus setting, infinity setting (∞), camera shake

1. **Label the camera with the kind of film in it and the expiration date.**

 If the film has been in the camera for some time, and if the empty carton has been misplaced, the kind of film in the camera and its **expiration date** may be forgotten. Different types of film have different photographic qualities. As film ages, its sensitivity to light and color may become impaired. Eventually the aging process may render the film totally useless. Never shoot with **outdated film**. If your camera's back is not equipped with a film-type identification window, note the type of film and its expiration date on a small tab of masking tape and mount it on the camera body when loading the camera.

2. **Make sure the film is loaded properly into the camera.**

 Improper film loading of 35-mm cameras has resulted in countless lost images for amateurs and professionals alike. It is very easy to mis-thread the film on the take-up spool; the result is that the film does not move through the camera even though the photographer is advancing the film wind lever. Some manufacturers have designed cameras with film movement indicators or automatic film-loading features, but not all 35-mm cameras are so equipped.

 There is one sure method of detecting film movement on conventional 35-mm cameras, thus ensuring that the camera has been loaded properly. After starting the film onto the take-up spool and closing the camera back, lightly turn the rewind crank in the direction of the

FIGURE 2-34

Occasionally watch the rewind crank while advancing the film. If the crank is turning in a direction opposite to the engraved arrow, then the film is advancing properly through the camera.

arrow until you feel a slight snugness and resistance. The purpose is to take up any slack within the cassette. Now, as you advance the camera the two or three frames necessary to move to the first picture, you should be able to see the rewind crank unwinding as the film is pulled across the camera. This revolving movement of the rewind crank is a certain guarantee that the film is advancing properly. Even in mid roll, many professionals occasionally check the crank for movement as the film is advanced to confirm that all is well with the shoot. (See Figure 2-34.)

3. **Advance the film after each exposure.**

Unless the **film advance** is operated after each exposure, film may be wasted and picture opportunities may be lost. If you make this a consistent habit, you'll never raise your camera to shoot only to find that the film has not been advanced and the camera is not ready. If your camera is the type that cocks the shutter spring as you advance the film, be sure to shoot off the last picture to release the shutter spring before putting the camera away.

4. **Carry extra film.**

Do not risk running out of film on a photographic expedition. Always carry a few extra rolls, including at least one roll of high-speed film for any extraordinary lighting conditions you may encounter.

5. **Use your viewfinder.**

A grand scenic view may dazzle the eye, but the camera won't take in anything outside the frame of the film. The camera's **viewfinder** is designed to show exactly what details will appear in the frame of the film. Use the viewfinder to carefully compose the photograph within that frame.

A camera that has automatic focusing may focus only on objects near the middle of the frame, even though you may prefer a less centered composition. Careful prefocusing and use of the focus-lock button will solve this problem.

6. **Correct for parallax error when shooting close-ups with a viewfinder camera.**

With cameras that have optical viewfinding systems that are separate from the picture-taking system, the viewfinder may not see exactly the same image as the picture-taking lens, especially when the subject is a close-up. If necessary, correct for this discrepancy by pointing the camera slightly in the direction of the viewfinder after composing your image. (See Figures 2-11 and 2-12.)

7. **Know the camera's capabilities.**

Don't try to take pictures beyond the camera's capabilities. If shutter speeds or lens apertures faster than those that are possible with the camera are necessary, the finished photographs will be disappointing. Know how your camera works and what it will do so that picture taking will become automatic.

8. **Get the *range*.**

 The **focus setting** should be accurate for subjects at any distance, but it is especially important at shorter camera-to-subject distances. For distances less than 6 feet, focus especially carefully. For distances of 30 feet or more, focusing has wider latitude—the distance need only be approximated. With a normal focal length lens, the **infinity setting (∞)** can be used if the camera-to-subject distance exceeds 50 feet.

9. **Avoid camera shake.**

 Camera shake, or any movement of the camera while the shutter is in motion, results in a blurred image. Learn to handle the camera so that the shutter release is operated by one finger using a gentle squeeze, while the rest of the hand holds the camera steady. Stand firmly with legs apart. Support the camera not only with your hands but also with your whole body. If you are using an eye-level viewfinder, snuggle the camera against your cheekbone. When using slow shutter speeds, hold your breath while releasing the shutter. When using very slow shutter speeds, rest the camera on a solid object or use a tripod while shooting.

10. **Wait before loading up with accessories.**

 Don't succumb to the temptation to buy too many accessories until you know what the camera can do without them. A good camera, used well, will probably produce results that are as good as or better than those produced by a mediocre camera that is used poorly and is cluttered with unnecessary accessories.

HOW TO USE THIS BOOK

At the end of each unit, starting with this one, you will find Questions to Consider. These questions are intended to help you check your own understanding and knowledge of the topics. Concluding each unit are Suggested Field and Laboratory Assignments. These assignments are designed to give you practical photographic experience by providing opportunities for you to assemble equipment as well as to shoot, process, print, and display pictures using the techniques and principles discussed in the unit.

You may also wish to refer to any of the many References at the back of the book for further study and clarification of the topics in each unit.

FIGURE 2-35

Stephen T. Horgan, "Shanty Town dwellings," March 4, 1880.

Although photography was widely used for personal and artistic purposes in its first sixty years, it was not used much for news reporting. There was no practical way to print a photograph with ink on paper and to preserve the gradations of tones. Pictures that did appear in magazines and newspapers were printed from wood and metal engravings that were cut by hand. Photography was used only to provide the original image from which the engravings were copied.

Almost from the beginning of photography, printers and craftsworkers sought a means for printing photographs in printer's ink on newsprint along with the type.

Many attempts were made dating from the early 1860s, but it was not until the *New York Daily Graphic* published this photograph in its March 4, 1880, issue that a practical means for doing so was demonstrated.

The *New York Daily Graphic* was established in 1873 expressly to promote the use of photography in news reporting. Stephen J. Horgan was hired as photographer and soon became manager of the newspaper's photomechanical printing operations. Horgan built upon the earlier work of F. W. von Egglofstein, Georg Meisenbach, and Frederic E. Ives to develop the halftone process by which this photograph was printed.

Describing this picture when it appeared, the *Daily Graphic* wrote:

We have dealt heretofore with pictures made from drawings or engravings. Here we have one direct from nature. . . . We are still experimenting with it . . . and feel confident . . . that pictures will eventually be regularly printed in our pages direct from photographs without the intervention of drawing.

Despite its early success, it took more than a generation before halftones significantly replaced hand engraving as a method of reproducing news pictures in the press.

Questions to Consider

1. How do the viewing systems used by the four camera types (VF, SLR, TLR, and view camera) differ, and how are they the same? Which viewing type or types is the most accurate? Which is the fastest to use?

2. Compare a typical viewfinder type camera to a single-lens reflex camera. What are the advantages and disadvantages of each? Consider size, cost, speed, versatility, and ease of use, among other factors.

3. How does a focus-free camera differ from one with auto focus?

4. What are the advantages of a medium-format film size? How would you calculate the focal length of a normal lens for a medium-format camera that produces negatives 6 cm by 7 cm (2 1/4 in. by 2 3/4 in.)?

5. Look at a current copy of *National Geographic.* Can you tell which photographs were made with telephoto lenses and which were made with wide-angle lenses? Were any special types of cameras or accessories used to produce the photographs in that issue?

Suggested Field and Laboratory Assignments

1. Make an appointment to meet with a local professional who works in the area of photography in which you're most interested. Ask what type of equipment is used most often and what brands and models are commonly used by colleagues in the field. You may also wish to ask about rental and repair facilities in your area for the brand of camera you are considering. Working photographers can provide a wealth of information as well as become valuable career contacts. You will find that most professional photographers are very willing to meet with students who courteously book an appointment with them in advance.

2. Assemble your camera kit and supplies. Make a list of optional equipment and accessories you might consider purchasing at a later date. Suggested starter lists are provided in Appendix A.

3. Arrange for the use of a photographic darkroom and equipment. Darkrooms and equipment are often available through schools, community centers, recreation centers, photographic retailers, and photography clubs. Try looking up "Darkroom Rentals" in the Yellow Pages.

Unit **Three**

Camera Controls

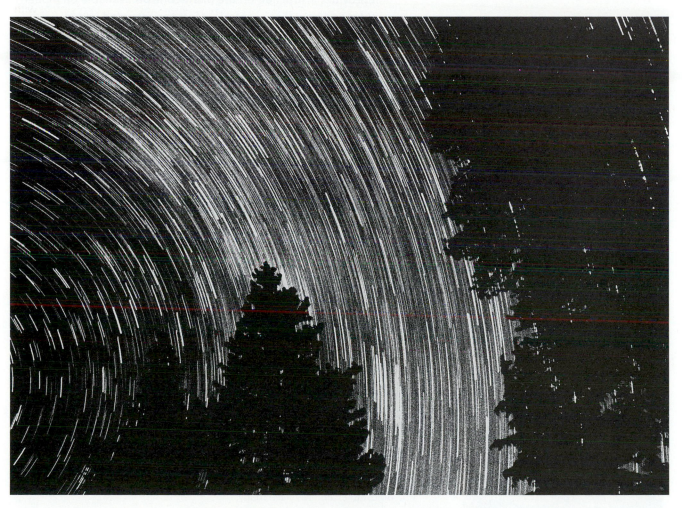

Karl W. Jacobs, "Star Trails at Mammoth Mountain," 1987.

Modern cameras are complex machines that incorporate advanced electronic, mechanical, and optical features. Although they are designed to be easy to use, their appearance often belies their sophisticated engineering. Within most modern cameras are features that control focus, aperture, shutter speed, flash synchronization, viewfinding—sometimes managed manually by the photographer and sometimes automatically by internal computerized devices.

The final appearance of a photograph is governed as much by the interaction of all of these variables at the time of exposure as it is by the processing and printing controls that occur afterwards. This unit provides instruction on the many controls available on modern cameras and how these controls affect the recorded image.

Basic Camera Settings

Objective 3-A Name three basic settings found on adjustable cameras and describe their functions.

Key Concepts amount of light, sharpness, shutter speed, B-setting, T-setting, X-setting, aperture, f/stop, stopping down, opening up, maximum aperture, lens speed, full stop, half-stop, focus, split-image focusing, superimposed-image focusing, ground-glass focusing, automatic focusing

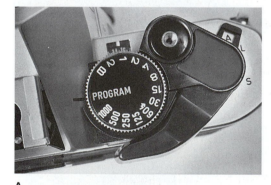

The three basic settings found on an adjustable camera are its shutter speed, lens opening, and focus. The shutter speed and lens opening determine the *amount of light* that strikes the film; the focus determines the *sharpness* of the image formed on the film.

Shutter Speed

When the shutter is closed, no light can enter the camera body. When the shutter opens, light enters, striking the film until the shutter closes. The interval between the shutter's opening and closing is known as the **shutter speed**. Simple cameras may have only a single, fixed shutter speed; adjustable cameras have many.

Shutter speed settings are marked on the camera with numbers such as 30, 60, 125, 250, and 500. These numbers represent fractions of a second—1/30, 1/60, 1/125, 1/250, and 1/500 sec., respectively.

Because these numbers represent fractions, the larger ones represent smaller fractions. Setting the camera at 60 means that the shutter will remain open 1/60 sec. If you reset the shutter to 30, the shutter will remain open 1/30 sec. A shutter speed of 30 will thus let in exactly twice as much light as a shutter speed of 60, because 1/30 sec. is twice as long as 1/60 sec. Figure 3-1 shows two types of shutter speed settings com-

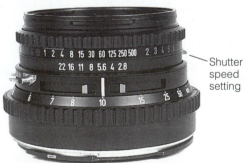

A

Shutter speed setting mounted on barrel of lens

B

FIGURE 3-1

Shutter speed settings. **A.** *Focal plane shutter.* **B.** *Leaf shutter.*

Shutter speed setting

monly found on adjustable cameras. This setting is sometimes found on the barrel of the lens and sometimes on the body of the camera.

On most adjustable cameras the standard sequence of shutter settings is as follows:

1, 2, 4, 8, 15, 30, 60, 125, 500, 1,000

Note that each shutter setting is approximately double the preceding one. Depending on the direction in which the shutter speed is adjusted, the exposure will be doubled or halved at each successive setting. Adjusting the shutter speed to double or halve the exposure is called adjusting the exposure by "one stop."

Note that 1/15 sec. is not *exactly* half of 1/8 sec.; similarly, 1/125 sec. is not exactly half of 1/60 sec. These slight discrepancies result from rounding off the numbers. The differences are negligible, and the result is a simpler arithmetic sequence. Some more expensive cameras also provide slower shutter speeds, often including settings of many full seconds.

Many cameras also are equipped with a **B-setting**. Set at B, the shutter will remain open as long as the release is held in. When the release is allowed to return to its normal position, the shutter will close. Some cameras also are equipped with a **T-setting**. Set at T, the shutter will open when the release is depressed and will remain open until the release is depressed a second time. Both B- and T-settings are used for time exposures longer than those provided by the shutter. Some cameras also provide an **X-setting** on the shutter speed dial, which is used to set the shutter for use with electronic flash.

Aperture

Light passes through the lens and into the body of the camera through an opening called the **aperture**. If the aperture is large, much light will pass through; if it is small, little light will pass through. Simple cameras may have only a single fixed aperture; adjustable cameras have many aperture settings.

The size of the aperture, or lens opening, is indicated by a number, called the **f/stop**. F/stop settings are marked on the camera with numbers such as 22, 16, 11, 8, and 5.6. These numbers also represent fractions—1/22, 1/16, 1/11, 1/8, 1/5.6, respectively. They represent the ratio of the diameter of the aperture to the focal length of the lens. F/stops need never be computed, because they are calibrated by the manufacturer and engraved on the lens barrel. Both the aperture and the shutter speed must be properly set for each photograph to obtain a correct exposure.

Because these f/stops are fractions, the larger numbers represent smaller lens openings and the smaller numbers represent larger lens openings. Changing the lens opening from one f/stop to the next is called adjusting the aperture "one stop." If the stops are changed to make the aperture smaller (for example, f/16 to f/22), this is called **stopping down** one stop. If the stops are changed to make the aperture larger (for example, f/16 to f/11), this is called **opening up** one stop.

The f/stops are arranged so that as the aperture is stopped down, each subsequent stop allows half the amount of light to pass through as the previous stop. Stopping down one stop—from f/16 to f/22, for example—

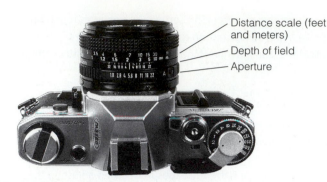

Distance scale (feet
and meters)
Depth of field
Aperture

Focal plane camera Shutter speed

A

FIGURE 3-2

*Aperture setting. Adjustments for aperture settings
are usually built into the lens barrel of both focal
plane and leaf shutter cameras.*

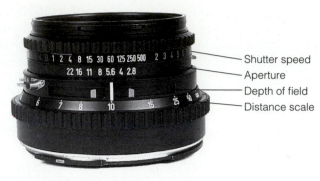

Shutter speed
Aperture
Depth of field
Distance scale

Leaf shutter camera lens barrel

B

reduces by half the amount of light passing through the lens. Opening up
one stop—from f/16 to f/11, for example—doubles the amount of light
passing through. The standard sequence of f/stops is as follows:

f/1.0, f/1.4, f/2, f/2.8, f/4, f/5.6, f/8, f/11, f/16, f/22, f/32, f/45

In the above sequence f/1.0 would let in the most light and f/45 would let
in the least light. Note that not all of these f/stops are found on every lens.
Figures 3-2A and 3-2B show the general appearance of the aperture set-
ting on a typical camera.

The **maximum aperture** to which a lens can be set is sometimes
referred to as the **lens speed**. This f/stop is generally inscribed on the
front of the lens barrel near the focal length. For example, on the front of
a lens barrel might appear the numbers 50 mm and 1:1.4. This means that
the focal length of the lens is 50 mm and its speed, or maximum aperture,
is f/1.4.

Some cameras provide a continuously adjustable range of apertures. In
other words, the aperture can be set not only at these **full stops,** but also
at points in between. Normally the in-between f/stops are not marked;
they must be approximated.

HELPFUL HINT
Remembering F/-Numbers

It may help you memorize the standard sequence to note that the
f/-numbers double in size at alternate stops going up in the series.
But the amount of light doubles at every stop going down in the
series. (See Figure 3-3.) Thus, going up in the series, the number
f/2.0 is double the number of f/1.0. However, the amount of light
doubles at each stop in the other direction. So, f/2.0 passes twice as
much light as f/2.8. Note that f/11 is not exactly double f/5.6 as you
would expect. This one discrepancy appears in the sequence to per-
mit whole numbers in the balance of the sequence.

To increase the amount of light passing through to the film without
doubling it, some cameras permit the aperture to be opened to a point
midway between two full f/stops. This is called opening up a **half-stop**.
Similarly, reducing the amount of light passing through by less than half is
accomplished by stopping down a half-stop.

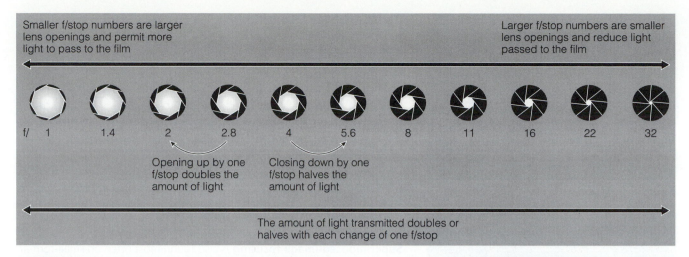

Smaller f/stop numbers are larger lens openings and permit more light to pass to the film

Larger f/stop numbers are smaller lens openings and reduce light passed to the film

f/ 1 1.4 2 2.8 4 5.6 8 11 16 22 32

Opening up by one f/stop doubles the amount of light

Closing down by one f/stop halves the amount of light

The amount of light transmitted doubles or halves with each change of one f/stop

FIGURE 3-3

Relationship between f/-numbers and amount of transmitted light. Note that f/-numbers double every other stop, but amount of light transmitted doubles every stop.

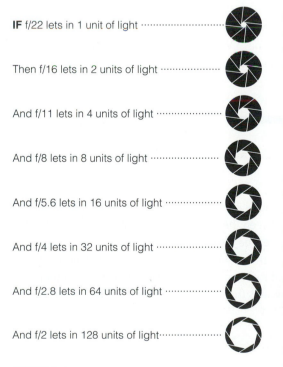

IF f/22 lets in 1 unit of light

Then f/16 lets in 2 units of light

And f/11 lets in 4 units of light

And f/8 lets in 8 units of light

And f/5.6 lets in 16 units of light

And f/4 lets in 32 units of light

And f/2.8 lets in 64 units of light

And f/2 lets in 128 units of light

FIGURE 3-4

Relationship of f/stops to exposure.

Figure 3-4 shows the relative size of the aperture at various f/stops and its relationship to the amount of light passing through it in any fixed interval of time.

Because opening up one stop doubles the amount of light passing through, opening up two stops will increase the amount of light fourfold. Remember, the amount of light doubles at each full stop as the aperture opens up. If the aperture opens up two stops, the amount of light is doubled twice to increase the amount of light four times. Similarly, if stopping down one stop decreases the amount of light passing through by half, stopping down two stops will decrease the amount of light passing through by one-fourth. Study Figure 3-4. Note that f/22 is used as a baseline for comparing relative amounts of light at various f/stops. If f/22 allows one unit of light to pass through, then opening up one stop to f/16 will allow two units of light to pass through. Opening up two stops to f/11 will allow four units of light to pass through, and so on.

Focus

The third setting on an adjustable camera is **focus**. As the camera is moved closer to or farther away from various objects in the camera's field of view, images become more or less sharp. Simple cameras may have only one fixed-focus setting, requiring the camera to be positioned some given minimum distance from the subject. As long as the camera is positioned at or beyond this distance, the subject will be in sharp focus. Should the camera be moved closer than the minimum distance, the subject will be out of focus in the picture. Adjustable cameras provide a range of focus settings, allowing the camera to be positioned at various distances from the subject while adjusting the image's sharpness on the film.

With simpler adjustable cameras the distance between the subject and the camera may need to be estimated or measured and then the lens set for that distance. Because this procedure is slow and imprecise, most popular adjustable cameras provide some type of focusing system to aid in setting the focus correctly. Some of the common types are described below.

A

B

C

D

FIGURE 3-5

*Different out-of-focus views. **A.** Out-of-focus view through split-image rangefinder. **B.** Out-of-focus view through superimposed-image rangefinder. **C.** Out-of-focus view through ground-glass viewer. **D.** In-focus view. Whatever type of focusing system is used, the in-focus view is a clear, sharp image.*

Split-Image Focusing

Split-image focusing is found most often on small-format cameras, such as those that use 35-mm film. As the subject is viewed through the view-finder, part of the image is split; one-half of the image is displaced some-what from the other half. By operating the focusing ring of the lens, the two halves of the image can be brought together. When the two halves of the image are aligned properly, the image is in focus on the film. (See Figure 3-5A.)

Superimposed-Image Focusing

Superimposed-image focusing is also found most often on small-format cameras. As the subject is viewed through the viewfinder, a part of the image is doubled. Two images appear, one offset slightly from the other. By operating the focusing ring of the camera, the two images can be lined up so that they appear as one. When this has been done, the image is in focus on the film. (See Figure 3-5B.)

Ground-Glass Focusing

Ground-glass focusing is typical of medium- and large-format cameras, but is also found on small-format cameras. This system allows the image to be viewed as it appears in the film plane. If the image is out of focus, it will appear unfocused on the ground-glass viewing screen. By operating the focusing adjustments on the camera, the image can be adjusted until it appears at maximum sharpness. Whatever appears in sharp focus on the ground-glass screen will be in focus on the film. (See Figure 3-5C.)

Automatic Focusing

Some popular cameras utilize **automatic focusing** systems similar to radar or sonar devices. As the shutter is released, the camera emits a short pulse of sound or radiant energy narrowly along the lens's axis. When it strikes an object in its path, the pulse is reflected back to a sensor on the camera. By timing the interval between the emission of the pulse and its return, the focusing system determines the distance between the object and the camera and sets the focus for that distance just as the shutter begins to open.

Whatever the type of focusing system, a clear, sharp image in the viewfinder generally indicates that a clear, sharp image is being formed on the film. (See Figure 3-5D.)

Depth of Field

Objective 3-B Define depth of field and describe the major factors that affect it.

Key Concepts depth of field, out of focus, in focus, zone of focus, control, maximum depth of field, shallow depth of field, infinity (∞), hyperfocal distance, hyperfocal focusing

A

B

C

FIGURE 3-6

*Estimating depth of field. **A**. With aperture set at f/4 at a distance of 12 feet, scale shows a depth of field from 10 to 14 feet. **B**. Depth of field scale for aperture set at f/22 at a distance of 12 feet shows depth of field from 6 feet to infinity. **C**. Many cameras feature a depth-of-field preview button that permits viewing through the stopped-down aperture. This helps estimate what depth of field will be recorded.*

Various objects will appear focused or unfocused on the film depending on their distance from the camera. The distance range within which objects appear in acceptably sharp focus is commonly called the **depth of field**. For example, suppose all objects between 10 feet and 20 feet from the camera appeared in sharp focus, whereas objects that were closer or farther away appeared **out of focus**. The depth of field would be said to be from 10 to 20 feet, meaning that objects within that distance range appeared **in focus**. This distance range is also sometimes called the **zone of focus**.

Depth of field is an imprecise concept. The degree of sharpness apparent in an image is due only partly to the physical characteristics of the image itself; it is partly due to the subjective judgment of the viewer—what the viewer considers acceptably sharp under the circumstances.

Several factors affect the apparent sharpness of objects within an image. Physical sharpness diminishes gradually from the point of maximum focus out to the boundaries of the depth of field. It is the viewer's judgment that determines just where objects within the image are no longer acceptably sharp. Also, apparent sharpness diminishes as the image is magnified—what appears acceptably sharp in an image of one size may become unacceptable as the image is enlarged. Further, apparent sharpness diminishes more rapidly when coarse-grain films are magnified than when fine-grain films are magnified.

Because of these many factors, depth of field should be regarded as a useful concept rather than as a precise measuring tool.

Depth of field can be used as a **control** in picture taking; that is, control can be exercised over the relative physical sharpness of objects at various distances from the camera. Suppose, for example, that the photographer wishes only the subject to appear in sharp focus and everything before and beyond to appear out of focus. On a portrait, for example, this approach would concentrate the viewer's attention on the subject. To obtain this effect, the camera would be set to achieve a very **shallow depth of field**. In Figure 3-6A the aperture has been set to f/4 and the focus has been set to about 12 feet. At those settings, the depth of field scale shows that objects between 10 feet and 14 feet will be in focus; objects outside the depth of field will fall progressively out of focus.

On another occasion, the photographer might wish everything in the picture, from the nearest objects to the farthest, to appear acceptably sharp, as in a landscape. In this case, the camera should be set to achieve **maximum depth of field**. In Figure 3-6B the aperture has been set to f/22 and the focus has been set to 12 feet. At those settings, the depth of field scale shows that objects between 6 feet and infinity will be in focus. (See the discussion of hyperfocal focusing later in this unit.)

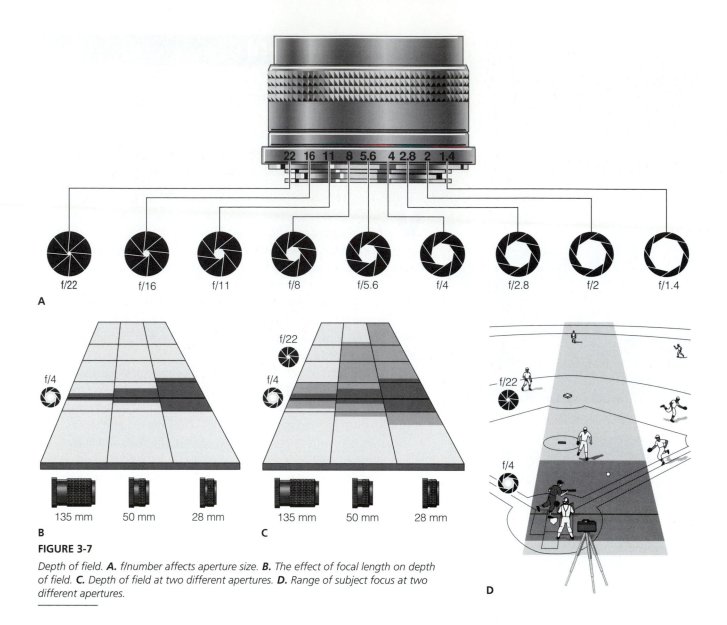

A

f/22 f/16 f/11 f/8 f/5.6 f/4 f/2.8 f/2 f/1.4

B

135 mm 50 mm 28 mm

C

135 mm 50 mm 28 mm

D

FIGURE 3-7

Depth of field. **A.** *f/number affects aperture size.* **B.** *The effect of focal length on depth of field.* **C.** *Depth of field at two different apertures.* **D.** *Range of subject focus at two different apertures.*

Many automatic SLR cameras provide a preview feature, which allows the photographer to view the scene through the lens at the selected aperture. This helps to estimate what objects lie within the depth of field. At very small apertures, however, the preview feature displays an image too dim to ascertain the relative sharpness of objects within the scene. (See Figure 3-6C.)

Aperture and Depth of Field

As the size of the aperture changes, the amount of light passing through the lens also changes. It is important to note, however, that the depth of field changes as well. At small lens apertures the depth of field is greater than at large lens apertures; objects will appear sharp over a greater range of distance at smaller apertures than at larger ones. When a large aperture is used, the depth of field is reduced; objects will appear sharp over a shorter range of distance at large apertures than at smaller ones. This principle is illustrated in Figure 3-7.

A View with a 35-mm wide-angle lens

B Enlarged segment of 35-mm lens view

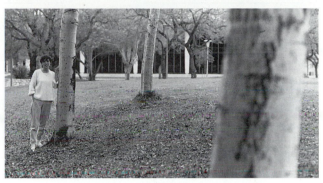

C View with 105-mm telephoto lens

FIGURE 3-8

A. Depth of field using 35-mm wide-angle lens. Note inset is equivalent to view produced by 105-mm telephoto lens from same position shown in Figure 3-8C. B. Enlarged view of inset shown in Figure 3-8A. Although the field of view is same as that produced by 105-mm lens from same position and at same aperture (shown in Figure 3-8C), note differences in depth of field. C. Same view from same position at same aperture using 105-mm lens. Even though the same perspective is produced by a cropped version of a wide-angle picture shot from the same position, the depth of field differs substantially.

Focal Length and Depth of Field

At any given aperture, the shorter the focal length of the lens, the greater the depth of field. Conversely, the longer the focal length of the lens, the shallower the depth of field. At given apertures, therefore, wide-angle lenses will produce greater-than-normal depth of field, whereas telephoto lenses will produce shallower-than-normal depth of field. Figure 3-8 illustrates this principle.

Distance Setting and Depth of Field

The focus setting of an adjustable camera is marked for various distances. Focusing on an object at any given distance from the camera ensures that the object will appear in maximum sharp focus. Objects nearer or farther from the camera but within the depth of field will also appear in relatively sharp focus.

The distance at which the lens is focused, however, also affects the depth of field. When focused on objects close to the camera, the depth of field is reduced; when focused on objects farther away, it is increased.

This principle is illustrated in Figure 3-9. Note that approximately one-third of the depth of field lies between the camera and the point of

FIGURE 3-9

Distance setting affects depth of field at any given aperture. A. Depth of field is shorter when distance setting is nearer. B. Depth of field is longer when distance setting is farther away.

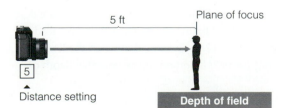

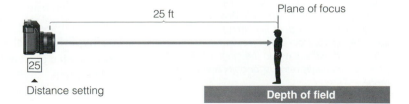

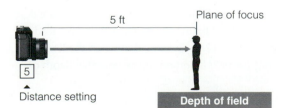 5 ft — Plane of focus — 5 — Distance setting — **Depth of field**

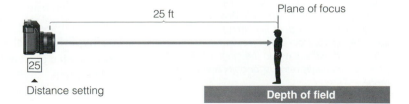 25 ft — Plane of focus — 25 — Distance setting — **Depth of field**

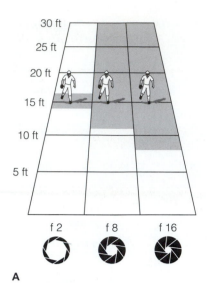

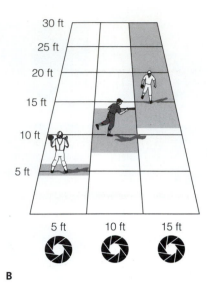

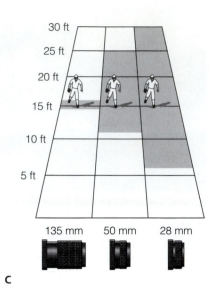

A B C

FIGURE 3-10 ▲

A. How aperture affects depth of field. B. How subject distance affects depth of field. C. How focal length affects depth of field.

A

B

FIGURE 3-11 ▲

Zone focusing. Set camera aperture to an f/stop that sets the depth of field in advance to the desired distance range. For example, A. Set depth-of-field index midway between 6 ft. and 25 ft. Read the aperture that will set that depth of field (f/16). B. Then set the aperture to f/16. Now any object within the range of 6 ft. to 25 ft. will fall within the range of focus. No need to continually refocus for objects within this range.

sharpest focus; approximately two-thirds lies beyond it. The maximum distance shown on the focus setting is **infinity (∞)**, a theoretical distance from the camera beyond which all image-forming light rays entering the camera are parallel and all objects appear to be in focus. For practical purposes, for normal focal length lens lenses, infinity starts at a point approximately 50 feet (15 meters) from the camera. If infinity is within the depth of field, then all objects 50 feet (15 meters) from the camera and beyond will be in acceptable focus. Figure 3-10 A,B,C illustrates the many factors that affect depth of field.

Zone Focusing

When subjects are moving or changing rapidly, many photographers avoid refocusing for every shot by setting the depth of field in advance for a wide range of distances. This is achieved by setting the focus to the *average* camera-to-subject distance that is expected, and then setting the aperture to provide a **zone of focus** that includes the expected range of distances.

For example, if action is expected between 6 feet and 25 feet from the camera, you would adjust the camera's focusing ring until 6 and 25 are equally spaced on either side of the focusing index mark. You would then set the aperture to the setting closest to these numbers. Figure 3-11 A, B shows that if the focusing index mark is set midway between 6 feet and 25 feet and the aperture is set at f/16, the zone of focus extends from 6 feet to 25 feet.

Hyperfocal Focusing

At any given f/stop, when the lens is focused at infinity (∞), the distance between the camera and the nearest point of acceptable focus is called the **hyperfocal distance**. Figure 3-12A illustrates that when the lens is focused on a point at infinity (∞) only a portion of the potential depth of field is used.

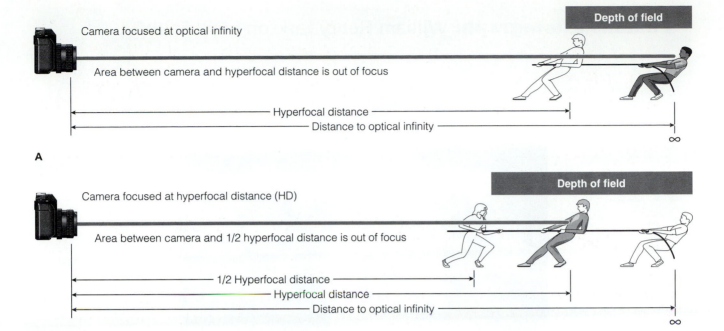

Camera focused at optical infinity

Area between camera and hyperfocal distance is out of focus

Depth of field

Hyperfocal distance

Distance to optical infinity

∞

A

Camera focused at hyperfocal distance (HD)

Area between camera and 1/2 hyperfocal distance is out of focus

Depth of field

1/2 Hyperfocal distance

Hyperfocal distance

Distance to optical infinity

∞

B

FIGURE 3-12

Hyperfocal focusing. **A.** *First focus camera at infinity. Note the near point of focus on the depth-of-field scale that aligns with your aperture setting; this is the hyperfocal distance.* **B.** *Now set the focus to the hyperfocal distance. Observe that the new depth of field now extends from half the hyperfocal distance to infinity.*

To obtain maximum depth of field to infinity, the technique of **hyperfocal focusing** is used. By focusing the camera on a point at the hyperfocal distance, as in Figure 3-12B, the depth of field is extended to a point closer to the camera and still reaches to infinity.

Another way to achieve hyperfocal focusing is to align the infinity marker (∞) with the current aperture setting on the depth-of-field scale. For example, with the aperture set at f/16, align the infinity marker with the f/16 mark on the depth-of-field scale. This technique yields the maximum depth of field possible for any given focal length and aperture setting by gaining additional foreground sharpness.

Summary

Depth of field is a concept that refers generally to the distance range within which objects will appear in acceptably sharp focus in the finished image. Five major factors operate to influence sharpness and depth of field in any given circumstance:

1. Aperture
2. Focal length of the lens
3. Focus setting (subject-to-camera distance)
4. Grain size
5. Degree of magnification of finished image

To obtain the maximum range within which objects will appear acceptably sharp, use the smallest possible aperture, a lens with the shortest possible focal length, hyperfocal focusing, film and processing to produce the finest possible grain, and the least possible image enlargement. Many adjustable cameras have a depth-of-field scale built into the lens that indicates the distance range of focus at various apertures and distance settings. Many cameras with ground-glass focusing allow direct observation of the depth of field before the shutter is released.

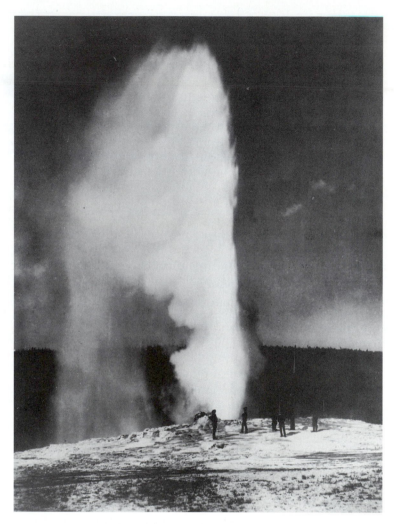

FIGURE 3-13

William Henry Jackson, "Old Faithful."

In 1871 William Henry Jackson was hired as a photographer by the U.S. Geological Survey's expedition to the Yellowstone area of Wyoming. From then until 1879, Jackson was official photographer of the United States Geological Survey Territories. Often traveling by mule with more than 200 pounds of photographic equipment, including a 20-in. by 24-in. glass plate view camera and a stereo camera, Jackson took some of the most breathtaking photographs ever recorded of the pristine western wilderness.

Jackson's employer, Dr. Ferdinand V. Hayden, was bent on a mission to preserve America's wilderness and to protect it from commercial exploitation. Hoping that the federal government would enact legislation to create a Yellowstone National Park, Hayden prepared a report on the region. Having a keen appreciation of the power of photography, he illustrated his report using Jackson's pictures and presented to every member of the House and Senate a bound volume containing nine of Jackson's most powerful and majestic images, including this dramatic photograph of Old Faithful. His actions resulted in the drafting of a bill that laid the foundation for the National Park System and was signed into law by President Ulysses S. Grant in 1872.

Jackson, called by many "the grand old man of the National Parks," died in 1942 at the age of ninety-nine. He was the last of the great frontier photographers.

Aperture and Shutter Speed Combinations

Objective 3-C Demonstrate how to select, using an exposure guide, appropriate combinations of apertures and shutter speeds under various conditions.

Key Concepts exposure, intensity, time, $E = I \times T$, reciprocity law, exposure guide, equivalent exposures, camera shake, stop action, blur action, control depth of field, basic exposure rule, reciprocity failure (RF) factor

Achieving the Correct Exposure

Exposure, the amount of light acting on the film, is the product of the **intensity** of the light and the **time** during which the light acts. This relationship may be expressed as $E = I \times T$ (Exposure = Intensity x Time). As long as the product of the light intensity and the time remains constant, the response of the film also remains constant. Thus if light intensity is doubled and time is halved, their product remains the same, as does their effect upon the film. The greater the intensity, the less the necessary time, and vice versa. This relationship is known as the **reciprocity law**.

The size of the aperture controls the intensity of the light reaching the film; the speed of the shutter controls the time. The combination of these two controls determines how much light acts on the film when the shutter is triggered. These settings determine exposure.

How does the photographer know how to set these two controls? Films of different speeds require different exposures. Most films used with adjustable cameras have instructions packaged with them. Table 3-1 is a daylight **exposure guide** for film rated ISO/ASA 125. This guide suggests a shutter speed of 1/250 sec. and a lens opening of f/11 to photograph an average subject on a bright, sunny day with film rated ISO/ASA 125.

Many combinations of lens opening and shutter speed will produce the same exposure. The various combinations that produce the same amount of light are called **equivalent exposures**.

For example, suppose that the exposure guide suggested a setting of f/11 at 1/250 sec. The lens could be opened one stop to f/8 (doubling the amount of light) and the next faster shutter speed, 1/500 sec. (halving the amount of light), used to obtain an equivalent exposure. Or, the lens could

TABLE 3-1 Outdoor exposure guide for average subjects for film rated ISO/ASA 125

Shutter Speed at 1/250 Sec.	Shutter Speed at 1/125 Sec.		
Bright or Hazy Sun	Cloudy Bright	Heavy Overcast	Open Shade (b)
Very light subjects f/16 Average subjects f/11(a)	f/8	f/5.6	f/5.6

(a) @ 1/125 sec. for backlighted, closeup subjects

(b) Subject shaded from the sun but lighted by a large area of sky

be stopped down one stop to f/16 and the next slower shutter speed, 1/125 sec., used. The exposure would be the same in all cases. There are four reasons to select an equivalent exposure rather than the one specified in the exposure table:

1. **To reduce the effect of camera movement**

 With a hand-held camera, **camera shake** during exposure is the most common cause of blurred pictures. By using a normal lens and taking reasonable care, camera shake can be avoided at speeds as slow as 1/60 sec. To avoid the effect of camera shake at this or slower speeds, a tripod or stabilizing support should be used to hold the camera steady.

 The recommended shutter speed for sunny-day picture taking is 1/250 sec. with most black-and-white films. This is a relatively fast shutter, which virtually eliminates the possibility that a hand-held camera will move during exposure and cause a blurred picture.

2. **To stop action**

 The image of a moving object moves across the film while the shutter remains open. Thus, a moving object will produce a blurred image if the shutter remains open too long. The recommended shutter speed of 1/250 sec. helps to stop the blurring of most moving objects. However, to photograph rapidly moving objects, such as those found at sporting or racing events, a faster shutter will be needed to "freeze" or **stop the action**. In such cases the photographer would select an equivalent exposure with a faster shutter speed.

3. **To blur action**

 Sometimes, to enhance the impression of speed and movement, the photographer may wish the moving object to appear blurred against its stationary background or to appear fixed against a blurred background. To accomplish this, a slower shutter speed will be needed than the one recommended. Photographing a rapidly moving object with a shutter speed of 1/8 sec. or slower will visibly **blur the action** of a rapidly moving object and/or its background. In this case the photographer would select an equivalent exposure with a slower shutter speed.

4. **To control depth of field**

 Shooting at small apertures provides maximum depth of field, allowing objects both close to and far from the camera to appear acceptably sharp. A larger aperture may be used to reduce depth of field. The photographer may wish, however, to have some of the nearer or farther objects in the scene appear out of focus. Setting the camera for an equivalent exposure with a larger aperture allows control of depth of field.

 In Table 3-2, the recommended exposure for ISO/ASA 125 film for an average subject on a bright day is boldfaced—1/250 sec. at f/11. To stop the action of a very fast-moving object, a shutter speed of 1/1000 sec. might be preferred. In this case the equivalent exposure of 1/1000 sec. at f/5.6 could be used to provide the same exposure with a very fast shutter—a direct application of the reciprocity law.

TABLE 3-2 Exposures equivalent to f/11 at 1/250 sec.

Sec.	1/30	1/60	1/125	1/250	1/500	1/1000
f/	32	22	16	11	8	5.6

Suppose that the photographer wants the image of a fast-moving object to appear slightly blurred in the final picture. A slower shutter of 1/30 sec. might be used to accomplish this. In this the equivalent exposure of 1/30 sec. at f/32 could be used. Applying the reciprocity law, this combination will produce the same exposure with a slow shutter.

The beginner should note that the photographer cannot always select an ideal equivalent exposure. Some cameras may not provide an ideal aperture or an ideal shutter speed for a given situation because the scale of settings is not long enough. In most situations the exposure that most nearly approaches the ideal setting must be selected.

Selecting a film of appropriate speed may often improve the range of acceptable exposures in a given situation. An ISO/ASA 400 film is four times faster than an ISO/ASA 100 film. Thus, if a proper exposure using the faster film is f/5.6 at 1/250 sec., a proper exposure with the slower film under the same conditions would be f/2.8 at 1/250 sec.—a two-stop (four times) exposure increase to compensate for the slower film speed.

One can see, therefore, that the range of equivalent exposures comes under the control of the photographer largely through the selection of film for use under any given set of conditions.

HELPFUL HINT
Basic Exposure Rule

If you do not have an exposure table or a light meter with you, you can use the following **basic exposure rule**—a rule of thumb for determining shutter speed and lens opening: f/16 at a shutter speed of 1/ASA sec. for average subjects in sunlight. For example, shooting with a film rated ISO/ASA 125, you could shoot at f/16 at 1/125 sec. for average subjects in sunlight. From these basic data you can estimate needed adjustments for different light conditions. For hazy sun, open up one stop; for very bright, stop down one stop.

Reciprocity Failure

For most practical purposes under normal conditions, the reciprocity law holds true. But it is not always so; there are times when films do not respond as the reciprocity law would lead one to expect. For example, when light intensities are reduced to a very low level, requiring extremely slow shutter speeds, increases in exposure time fail to produce proportionate responses in the film. Similarly, when light intensities require extremely short exposures, as when electronic flash is used, changes in exposure time also fail to produce proportionate responses. This departure from the normal film response is known as **reciprocity failure**.

TABLE 3-3 Typical RF corrections for black-and-white films

If indicated exposure time is (seconds)	either increase aperture	or increase exposure time to	and change developing time to
1/1000 sec. or less	none	none	20% more
1–10 sec.	1–1.5 stops	2–30 sec.	10–15% less
10–50 sec.	1.5–2.5 stops	30–300 sec.	15–20% less
50–100 sec.	2.5–3 stops	300–800 sec.	20–30% less

Exposure guides and meters do not take reciprocity failure into account. With black-and-white film, the exposure can be increased to compensate for reciprocity failure associated with long exposures. **Reciprocity failure (RF) factors** are published for each black-and-white film to help one calculate a corrected exposure. To compensate for electronic flash, increase the development time by 20 percent during processing. To compensate for long exposures of 1–10 sec., double the normal exposure; for longer exposures, quadruple it. Table 3-3 shows typical RF corrections for black-and-white film.

With color films, reciprocity failure is more complex because it affects the three color emulsions unevenly; thus, the effect is not only underexposure, but also a shift in color balance. One way to compensate for this effect is to use special filters (discussed further in Unit 9), or to use special films designed for extremely long or short exposures. Ordinarily, however, it is most convenient to avoid excessively long or short exposures.

Exposure and Action

Objective 3-D Given basic exposure data, describe techniques for photographing the action of a moving subject.

Key Concepts stop or freeze action, object speed, camera-to-subject distance, angle of movement, panning or panoramming

Freezing Action

Very fast shutter speeds are normally thought necessary to **stop or freeze the action** of a fast-moving subject. Yet, a shutter speed of 1/1000 sec. is not needed to take good action photographs. Good action shots can be obtained by using a few basic principles about speed, light, film, and camera technique.

Speed is relative. The actual speed of an object is less important than its apparent speed from the point of view of the camera. Sometimes fast-moving objects appear slow-moving, and vice versa. Three factors affect the apparent speed of the object: (1) the speed of the object itself, (2) the distance between the object and the camera, and (3) the angle of movement relative to the camera's axis.

1. Object speed Obviously a faster shutter is needed to freeze the action of a speeding car or a football player streaking for the goal line than is needed for a person walking slowly down the street. To freeze the action of a moving object, the shutter must open and close again before the image of the object on the film perceptibly changes position. Consequently, faster shutter speeds are normally required to stop the action of faster-moving objects.

2. Camera-to-object distance From close to the highway, speeding cars may seem to zoom rapidly past. Farther back from the edge of the highway, the apparent speed of the cars is considerably less. Speeding cars on the horizon may appear to be moving hardly at all. Translated into shutter settings, a general guideline for this effect might state: The closer the camera is to the moving object, the faster the shutter setting needed to stop or freeze its apparent movement.

3. Angle of movement A third factor that affects the choice of shutter speed is the angle of the object's movement relative to the axis of the camera. A car moving directly toward the photographer may appear to be moving hardly at all, whereas the same car at the same distance moving across the line of vision may appear to be moving quite rapidly. If the camera is positioned to photograph an object moving along the camera's axis rather than across it, the object's action can be stopped with a slower shutter speed.

Stopping fast-moving action most often requires fast shutter speeds, however. Fast shutter speeds, in turn, require larger aperture settings to maintain equivalent exposure. Because large apertures decrease depth of field, obtaining great depth of field tends to pose a problem in action photography, as in any situation requiring a fast shutter.

How can both a fast shutter and a small aperture be used? One way is to select a faster film. As film speed is increased, the amount of exposure required is reduced, permitting the use of smaller apertures with a fast shutter setting. Another way is to use some form of supplementary lighting, such as flash. Additional light intensity also will permit smaller apertures with a fast shutter setting. (This topic is discussed further in Units 10 and 11.)

Blurring Action

Good action shots do not always require freezing the action of an object. The sense of movement can be enhanced by using a slow shutter and deliberately allowing moving objects to blur on the film. By using a very slow shutter and stationary camera, for example, a fast-moving object may be made to appear blurred against a static background. Another slow shutter technique known as **panning** or **panoramming** may also be chosen. Panning is similar to the technique used by skeet shooters to aim at clay targets in flight. They aim and pivot their bodies, keeping the rifle barrel moving in the direction of the target's flight.

In panning, the camera is used in a similar manner. The photographer uses the eye-level viewfinder and spots the object as it moves into view,

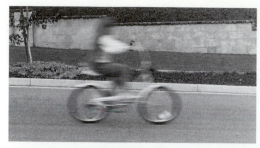

A

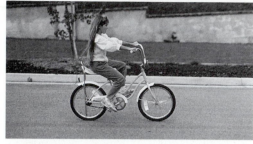

B

C

D

E

FIGURE 3-14

A. Blurred action. Moving object is blurred using slow shutter. *B.* Stopped action with fast shutter. Moving object is not blurred if fast shutter is used. *C.* Panning. Moving object is stopped against blurred background by panning with object using slow shutter. *D.* Stopped action with slow shutter. Object moving toward camera is stopped with slower shutter. *E.* Stopped action with fast shutter. Moving object is stopped using fast shutter.

then pivots head and shoulders, keeping the object in the viewfinder at all times. When the object is in correct view, the shutter is released without interrupting the pivot. It is important to follow through after snapping the shutter. The trick is to have the camera moving at the same relative speed and in the same direction as the object.

The resulting photograph will show the object—car, motorcycle, runner, surfer—frozen in relatively clear focus. The background and foreground, however, will be a mass of blurs and streaks caused by the camera's movement during exposure. Panning gives a visual sense of speed, and the object's movement will have stopped with a relatively slow shutter speed. Panning works best at shutter speeds under 1/30 sec. Figure 3-14 A, B, C, D, and E shows the effects of various techniques for shooting fast-moving objects.

Image Control with Automatic Cameras

Objective 3-E Describe some methods of working with automatic camera features to retain image control.

Key Concepts focus lock, automatic exposure disable, exposure lock, backlight compensation, exposure compensation, ISO/ASA reset, autoflash, autoflash disable, anti-red-eye, flash-fill, spot meter, spot-meter lock

Many modern cameras provide features designed to make photography simpler by automatically setting focus, exposure, and flash engagement. Unfortunately, automation tends to encourage mental laziness. The photographer may be lulled into a false sense of confidence, knowing that the camera will at least provide correct focus and exposure. Image possibilities that might exist through the use of override and disable controls may be lost.

Some automatic cameras provide override and disable features, which allow the photographer to maintain control over the image. Fully automatic cameras without override or disable features restrict image control and limit the range of image possibilities available to the photographer. By using the override and disable features, the photographer often can exercise far greater image control than would be possible by relying on automatic features.

Autofocus Override Features

Autofocus features are designed to focus automatically on a prominent detail in the image. An internal computer calculates the distance between the camera and an object near the center of the frame and focuses on it. This function works on the assumption that an object at the center of the frame is the object of principal interest; should your object of principal interest lie off the center of the frame, the autofocus feature may well focus the camera on something else, leaving your principal object out of focus.

To overcome this possibility, many autofocus cameras provide a **focus lock** feature, which allows you to point your camera at any object you choose, lock the focus in that position, and then point your camera elsewhere for best composition. Using a focus lock feature allows you to decide for yourself what object is of principal interest in your image, rather than having the autofocus feature decide for you. Some cameras also permit you to disable the autofocus feature altogether and retain manual focus control.

Automatic Exposure Override Features

Many advanced automatic cameras provide automatic exposure control using an aperture priority exposure setting system. Such cameras allow you to set the aperture as you wish. They then evaluate the light available in a scene and automatically set the shutter to obtain a proper exposure.

Other cameras provide automatic exposure control using a shutter priority exposure setting system. Such cameras allow you to set the shutter to any speed you wish. They then evaluate the light available in a scene and automatically set the aperture to obtain a proper exposure.

Using automatic systems such as these allows you to select an equivalent exposure using the shutter speed and aperture combination most appropriate for the image you wish to create. Keep in mind, however, that these options do not actually increase or decrease exposure; they simply provide the settings you prefer for any given exposure value. To increase or decrease exposure to compensate for unusual lighting situations, you will need to utilize autoexposure override or disable controls. In this way you can modify the exposure that would otherwise be set by the automatic system.

The built-in light meter that automatically sets the camera for a proper exposure by adjusting the aperture and/or shutter speed is designed to produce well-exposed negatives under average lighting conditions. However, when the subject and background are unequally illuminated, the exposure-setting system may not determine the best exposure for your purpose. A meter cannot tell the difference between the subject and its background; it reads the *average* intensity of light in the scene reflected from all sources. If this average is significantly more or less than the light reflected from the main subject, the system setting may under- or overexpose your principal subject. To overcome this effect manufacturers sometimes build exposure override or disable controls into their automatic cameras.

Automatic exposure disable Some cameras may possess an **automatic exposure disable** control that allows you to disable the automatic exposure feature. Such controls usually allow you to use the internal meter to obtain a reading of the subject and then set the aperture and shutter speed manually to the exposure of your choice. Such a control provides maximum flexibility for setting exposure but none of the convenience of automatic exposure setting.

Exposure lock Some automatic exposure cameras provide an exposure lock feature that allows you to point your camera momentarily at any object you choose for obtaining an exposure setting, lock the exposure in that position, and then point your camera elsewhere for best composition. Using an exposure lock feature allows you to decide for yourself what exposure will best represent the tonal values of a scene and avoid having the automatic exposure feature decide for you. In that way, any object you choose can be represented as a middle gray tone in your final image, regardless of its location within the frame, without sacrificing the convenience of automatic exposure setting.

Backlight compensation Some automatic cameras also provide a **backlight compensation** feature. Using this feature while shooting allows you to increase exposure for that image about 1.5 stops, providing about three times the normal exposure and thereby brightening the entire image. This procedure usually serves to brighten objects that might otherwise be underexposed because of strong light in the background. (See Figure 3-15.) This control also provides modified exposure anchored to the automatic exposure setting selected by the system.

A

B

C

FIGURE 3-15

A. Readjusting the ASA setting of an automatic camera. B. Backlight compensation. Many automatic cameras have a button that will increase exposure to compensate for backlighting situations. Pressing the backlight compensation button while shooting usually increases exposure about 1.5 stops. C. Exposure compensation. Many automatic cameras have an adjustment to manually increase or decrease exposure one or two stops. This allows the photographer to compensate for unusual lighting situations.

Exposure compensation Some automatic cameras provide even more control with an **exposure compensation** feature. Rather than providing simple backlight compensation, this feature allows exposure to be increased or decreased to compensate for any kind of out-of-the-ordinary lighting situation. Figure 3-15C shows a speed setting dial that permits automatic settings of one-fourth and one-half of normal exposure, two and four times normal exposure, as well as normal exposure, while retaining the underlying automatic exposure setting features.

ISO/ASA reset If your camera provides no override features and operates only in an automatic mode, you may still have an option, though a more limited one, for controlling exposure. Facing unusual lighting situations, such as strong backlight or overall darkness, you may use an **ISO/ASA reset** to alter the automatic exposure. By resetting the ISO/ASA film speed index programmed into your camera, you can fool the internal meter into increasing or decreasing its normal exposure setting. If you double the ISO/ASA setting, you will reduce normal exposure by one stop. If you halve the ISO/ASA setting, you will increase normal exposure by one stop. (See Figure 3-16A.)

Automatic Flash Features

Flash photography is the main topic of Unit 11 and is discussed in greater detail there. However, automatic cameras often possess unique automatic flash features. For example, fully automatic cameras often possess an **autoflash** mode that automatically engages the flash unit whenever there is insufficient light. Such cameras may also possess an **autoflash disable** feature that allows the photographer to turn off this automatic feature.

In addition to the autoflash feature, some cameras provide flash features designed to overcome unusual lighting situations. For example, some provide an **anti-red-eye** feature designed to offset the conditions likely to produce the red-eye phenomenon in color pictures. Some utilize the distance setting to determine if the principal subject is at a distance where red-eye might result. If flash is engaged, the system then fires off one or more bursts of flash before making the exposure. This has the effect of causing the subject's pupils to contract prior to the exposure, thus reducing a principal cause of red-eye. Other cameras mount the flash unit at a sufficient distance from the camera axis so that the cause of red-eye is eliminated.

Some automatic cameras may provide a **flash-fill** feature that automatically engages the flash unit when the principal subject reflects substantially less light to the meter than the background areas of the image. By detecting that a backlight situation exists in the image, the flash is automatically engaged to provide additional light to the principal subject.

The more sophisticated automatic cameras may also provide a **spot meter** feature that causes the flash meter to automatically set flash exposure for objects at the center of the image, rather than to set flash exposure for the overall average of illumination in the scene. Such cameras may also have a **spot-meter lock** feature, similar to the exposure lock feature discussed earlier, which allows the photographer to point the

camera momentarily at any chosen object to obtain a flash setting, lock the setting in that position, and then point the camera elsewhere for best composition. Using a spot-meter lock feature allows the photographer to decide which object in the scene should receive proper flash exposure. Without this feature, the autoflash unit might provide proper exposure to the object nearest the camera, at the expense of objects farther away. Table 3-4 provides a checklist of many features often found on automatic cameras. When evaluating an automatic camera, consider which of these features are most important to you.

Determining Exposure

Objective 3-F Describe the desirable characteristics of negatives and explain how to use an exposure meter to determine proper exposure.

Key Concepts density, characteristic curve, exposure, underexposed, range of density, overexposed, highlight areas, blocked up, shadow areas, latitude, exposure meter, incident-light meter, reflected-light meter, spot meter, built-in meter, averaging meter, center-weighted meter, film speed setting, exposure scale, average shade of gray, overall reading, closeup reading, highlight reading, shadow reading, range of brightness

Achieving Maximum Range of Density

Just as the amount of light reaching the film varies, the amount of silver deposited on the film also varies. Areas of the film receiving much light will possess greater silver **density** than areas receiving little light. These variations of silver density create the image in the negative and later in the final print.

Each film responds to light in a unique and characteristic way. This response can be graphed to show how much the silver density will increase for any given increase in the amount of light. (See Figure 3-16.) This **characteristic curve** (also known as an H & D curve after its inventors, Hurter and Driffield) shows how a particular film's silver density will respond to varying amounts of exposure.

Examining the characteristic curve of any film reveals that silver density does not increase in proportion to increases in exposure at all levels of brightness. At both low and high levels of exposure, the so-called toe and shoulder of the curve, great increases in brightness produce only slight increases in density. Only in the middle of the curve, the straight line section, does density increase in proportion to increases in exposure. That is why it is important to make exposures near the middle part of the curve— so that areas of different brightness within the scene will be recorded with maximum differences in silver density.

Underexposed negatives are those that receive too little light. The entire brightness range of a scene is recorded near the low end of the curve. As a result, the darkest and brightest objects in the scene differ little

TABLE 3-4 Automatic camera feature checklist

Manufacturer: _____
Model: _____

Focus Controls
☐ Autofocus
☐ Focus lock
☐ Autofocus disable
☐ Macro (closeup) focusing

Focal Length Control
☐ Normal lens
☐ Telephoto lens
☐ Wide-angle lens
☐ Manual zoom lens
☐ Power zoom lens
☐ Auto zoom lens

Exposure Controls
☐ Fully automatic
☐ Aperture priority
☐ Shutter priority
☐ Programmed exposure
☐ Continuously variable shutter speeds
☐ Continuously variable apertures
☐ Exposure lock
☐ Backlight compensation
☐ Exposure compensation
☐ Spot metering
☐ Fully manual mode

Flash Controls
☐ Automatic flash
☐ Spot-meter lock
☐ Spot metering
☐ Flash-fill
☐ Anti-red-eye feature
☐ Autoflash disable
☐ Multi-flash (strobe)
☐ Wide-angle flash
☐ Telephoto flash

Other Controls
☐ Autoload
☐ Autoread DX codes to set ISO/ASA index
☐ Automatic rewind at end of film
☐ Remote release
☐ Self-timer
☐ Auto advance
☐ Continuous exposure (auto advance/release)

FIGURE 3-16 ▶

The characteristic (H & D) curve.

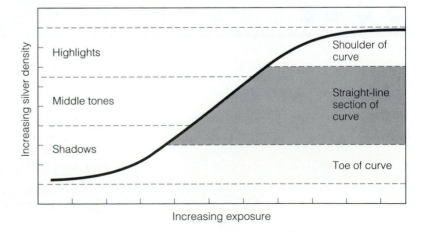

101

A

B

C

D

E

F

FIGURE 3-17

Improper exposure of negative. ***A.*** *Underexposure: detail is lost in shadows (light areas of negative).* ***B.*** *Print from underexposed negative. Print appears muddy; details in shadow lost.* ***C.*** *Normal negative. Well-exposed negative records details with optimal contrast over the full brightness range of the scene. Shadow and highlight details present.* ***D.*** *Print from normal negative. Prints full range of details throughout the brightness range.* ***E.*** *Overexposed negative. Detail is lost in highlights (dark areas of negative).* ***F.*** *Print from over exposed negative. Print appears washed out; details in highlights obscured.*

in silver density, and, overall, the negative appears thin and exhibits a narrow **range of density**. Tonal separation in the middle tones and shadows is weak, and the negative will produce a dark print. (See Figure 3-17 A, B.)

Overexposed negatives are those that receive too much light. The entire brightness range of a scene is recorded near the high end of the curve. Here, too, the darkest and brightest objects in the scene differ little in silver density; however, overall, this negative appears dense with silver and exhibits a narrow range of density. Tonal separation in the middle tones and highlights is excessively dense with silver, and the negative will produce a light, grainy print. (See Figure 3-17 E, F.)

Desirable Characteristics of Negatives

The preceding discussion emphasizes the importance of determining a proper exposure that will record the entire brightness range of the scene, with the middle tones being recorded near the middle part of the curve. In this way, brightness differences in the scene will produce maximum differences in density on the negative and thus produce optimum tonal separations throughout the brightness range. Under most circumstances it is advisable to strive to expose for the middle of the curve in order to record the widest range of tones and the maximum tonal separations. To accomplish this, proper exposure must be used. (See Figure 3-17 C, D.)

The well-exposed negative will be rich in detail. The **highlight areas** (the densest areas) of the negative will reveal many distinct details and variations in density. For example, the negative image of a white shirt in sunlight, dense on the negative, should reveal the texture of the cloth, its folds and wrinkles, and the separation of the collar against the front lapel. If these areas are too dense, such details will be **blocked up**—lost in the density of the silver deposits that record that highlight area. Blocked-up areas are difficult and often impossible to print well.

Similarly, the **shadow areas** (the thinnest areas) of the negative will reveal distinct details and variations in density. The negative image of a black flannel suit in the shade of a tree, thin on the negative, should also reveal its texture, folds, wrinkles, and lapels. If these areas are too thin, such details will not be recorded at all. No printing technique can replace details that are not recorded on the negative.

Important characteristics of a well-exposed negative, therefore, are its recording of detail in both highlight and shadow areas and its possession of density variations corresponding to brightness differences throughout the brightness range. Nevertheless, if the brightness range is very great, some of the darker tones will be recorded near the low end of the curve and some of the brighter tones near the high end. And even though tonal differences may be seen in these shadows and highlights, even the most responsive film may not record effectively all that the eye can see. Thus, the film's *latitude* is less than that of the eye; that is, the film is less sensitive to the range of brightness. In those cases in which the range of brightness in the scene exceeds a film's latitude, it is usually preferable to favor the shadow areas by exposing toward the shoulder of the curve. This tends to preserve the shadow detail while overexposing the extreme highlights, a type of exposure that can be partially corrected when the final print is made. Figure 3-17A-F illustrates these principles of proper exposure.

A

B

FIGURE 3-18

A. Incident light meter. Meter responds to light falling upon the scene, indicating a proper exposure for subjects of average contrast. B. Reading an incident light meter to measure light falling on the subject from all sources. Normal position for meter is at subject position on camera-subject axis.

The exposure guide packaged with the film may be generally helpful in determining exposure when the range of brightness is well within the film's latitude. A modern **exposure meter,** however, provides a higher degree of precision. By measuring precisely the intensity of light in various parts of the scene, the meter serves as a tool for determining an exposure that will record the scene in exactly the desired range of densities.

Using Exposure Meters

There are two basic kinds of exposure meters—**incident-light meters** and **reflected-light meters**. Incident-light meters read the intensity of light reaching the scene from all sources; reflected-light meters read the intensity of light being reflected from the various objects in the scene. Incident-light meters are designed to measure the relatively brighter intensity of light sources; reflected-light meters are designed to measure the much lower intensities of reflected light. Sometimes a single meter can be adjusted for use either way.

Usually a light meter admits light through a small aperture or diffusion screen to a photosensitive cell. When light strikes this cell, a small current of electricity is induced, proportional to the intensity of the light. This current deflects the meter's indicator needle. The brighter the light that strikes the cell, the more the needle is deflected. The needle is referenced to an exposure scale that helps the photographer determine a proper exposure.

Meters differ in design and handling. Some are designed to operate with batteries; some, without. Battery-operated meters are more sensitive to low light levels and are more effective in dim lighting. Some meters are designed to be held in the hand and used separately from the camera, some attach to the camera, and some are built into the camera itself. To use a light meter effectively, one must understand what it does and how to use the information it provides.

Incident-light meters Incident-light meters are designed to measure light falling on the subject. To measure incident light, the meter is placed in the subject area, and its light-sensitive cell is pointed in the direction of the camera. The diffuser bulb or panel must be used if the meter requires it. Light falling on the subject then will fall on the photosensitive cell, and the needle will indicate its intensity. From this reading a set of equivalent exposures is easily determined.

Use of the incident-light meter assumes that the objects in the scene have average reflectance. If the objects in the scene are predominantly light or dark, the indicated exposures must be decreased or increased accordingly if the middle tones in the scene are to appear as middle grays. If the light falling on the subject varies in intensity, as when a pattern of shadows falls upon the scene, readings taken from both the brighter and darker light sources must be averaged to measure the average light intensity. (See Figure 3-18 A, B.)

Reflected-light meters Reflected-light meters are designed to measure light reflected from the subject. Cameras with built-in light meters use this type of meter. To measure reflected light, the meter is placed between the camera and the subject, and its light-sensitive cell is pointed in the direction of the subject. A diffuser bulb or panel must not be used when

A

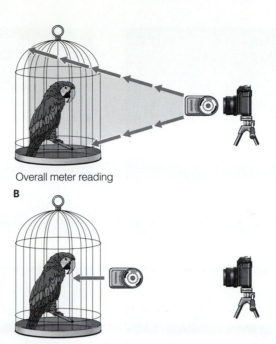

Overall meter reading

B

FIGURE 3-19

A. Hand-held reflected-light meter. After setting meter to ISO index of film in use, photographer can translate measurement of light intensity into a set of equivalent exposures. **B.** Obtain an average reading over entire scene viewed by camera by positioning meter near camera and directing it toward the scene. **C.** Obtain a closeup reading of an individual object by positioning meter near the object along the camera axis.

Closeup meter reading

C

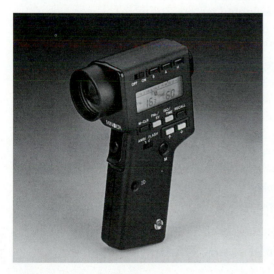

FIGURE 3-20

Digital auto-spot light meter.

measuring reflected light. Light reflected from the subject toward the camera then will fall on the photosensitive cell and the needle will indicate its intensity.

Various objects within a scene reflect different intensities of light; white objects, for example, reflect more light than black ones. The meter may be used to measure these various intensities separately by bringing it close to the various objects in the scene. A major advantage of the reflected-light meter is that it can be used to measure the light reflected from different areas of the scene and to evaluate the different effects these areas will have upon the negative image. Exposure may then be set to obtain optimal negative density for the more important elements in a scene. (See Figure 3-19 A, B, C.)

Spot meters The **spot meter** is a special type of reflected-light meter that is designed to obtain reflected-light measurements from very small areas within a scene with the meter positioned at some distance from the subject. From on the shore, for example, the spot meter can be used to obtain separate readings from the sailboats on the lake, the surface of the lake, the forest areas on the far side, the snowcapped mountains in the distance, and the sky. (See Figure 3-20.)

Built-In Meters

Light meters built into the camera itself are commonly used by both amateur and professional photographers. There are many types of **built-in meters**. Some simply report the intensity of light in the scene toward which the camera is directed and permit the camera to be set manually to an appropriate exposure. Some automatically set the camera to an appropriate exposure based upon the meter's reading. Some permit a choice between manual and automatic operation.

A

B

C

D

FIGURE 3-21

*Built-in meters. **A.** Averaging meters combine measurements from all areas of the frame. If important details are not dominant, they may not be properly exposed. Here, bright sky in one half of the frame caused important details in the other half to be underexposed, producing a muddy-looking print. **B.** Here, a correct exposure was determined by pointing the camera downward to emphasize details in the darker half of the frame. Then the indicated exposure was used to make this shot. **C.** Center-weighted meters are more sensitive to areas near the center of the frame. Here, the bright window at the center causes surrounding details to be underexposed. **D.** A correct exposure was determined by pointing the camera downward to include important details at the edges of the frame. Then the indicated exposure setting was used to make this shot.*

Among built-in light meters, the two most common types are **averaging meters** and **center-weighted meters**. The more common type is the averaging meter; it is designed to measure the average brightness reflected from all parts of the scene and to determine an appropriate setting based on this average. This works well for subjects of limited contrast and even lighting, but for scenes of high contrast, care must be taken to ensure that important objects in the scene are well exposed.

The center-weighted meter assumes that the important objects in a scene usually appear near the center of the frame. The meter is designed, therefore, to base its measurement mainly on light from this center area. This works well when the important objects are near the center of the scene, but care must be taken to ensure that important objects are well exposed when they occur elsewhere in the scene. (See Figure 3-21 A, B, C, D.)

Using a Hand-Held Light Meter

The most common type of light meter in use today is the reflected-light meter. To determine exposure using a hand-held reflected-light meter, both the speed of the film and the intensity of light available in the scene must be known. The meter uses both kinds of information to compute appropriate exposure data. Using these data, a proper exposure can be selected to obtain a desired image.

A

B

C

FIGURE 3-22

A. Exposure set at white card light reading. Note that the white card appears gray. B. Exposure set at gray card light reading. Note that the gray card appears gray. C. Exposure set at black card light reading. Here the black card appears gray.

The meter itself measures the amount of light available in the scene. The film speed must be programmed into the meter by adjusting the **film speed setting**. Then, by matching the **exposure scale** to the meter reading, the exposure data can be read directly off the scale. Figure 3-19A shows a meter that has been set for a film speed of ISO/ASA 100, which appears in a small window. Observe also that the indicator needle has been deflected to 17. Using this information, the photographer has adjusted the outer dial of the exposure scale to place the indicator arrow in the next lower window, also at 17. The set of equivalent exposures appropriate to the scene now may be read directly from the exposure scale at the top of the dial. In this case the set of equivalent exposures includes 1/250 sec. at f/4, 1/125 sec. at f/5.6, and so forth.

What do these indicated exposures mean? What is recorded on the film if one of these indicated exposures is used? To control the effects of exposure on the film and to select an exposure that will produce the desired results, the photographer should understand what the meter is reporting. Light reflected from various areas in the scene acts on the photoelectric cell, with light areas reflecting more light and dark areas reflecting less. The meter reports the *average* of all these various light intensities in the scene. The exposure scale has been calibrated in manufacture to give an exposure setting that, using standard procedures, will produce a negative that will print objects of average brightness as an average shade of gray. Thus, if an indicated exposure is used, objects of average brightness in the scene will be rendered an **average gray**, no matter how light or dark the scene is overall.

Imagine three blank cards, one black, one gray, and one white. Using a reflected-light meter, suppose you obtain a reading from the black card and use the indicated exposure to shoot its picture. You then do the same for each of the remaining cards, obtaining two more readings and using the indicated exposures to shoot two more pictures. What do you find when the three pictures are processed and printed using standard procedures? The three cards are no longer black, gray, and white; they all appear the same average shade of gray in their respective photographs. (See Figure 3-22 A, B, C.) The meter indicates the exposure to use to make the average brightness seen by the meter appear as an average shade of gray. To obtain tones darker or lighter than this in the final print, the indicated exposure must be modified. This is especially true for scenes with an average brightness that is darker or lighter than average gray. It is also true if the photographer wishes to make a final print that is darker or lighter than the average brightness in the original scene.

Average reading When photographing a large scene in which the light intensities are distributed fairly evenly—such as a landscape, seascape, or group photo under overcast skies—a reflected-light meter can be used from the camera position. Point the meter toward the scene to obtain an **overall** or **average reading**, and use one of the indicated exposures. Be careful not to point the meter toward the sky; tip it slightly downward. If the meter reads too much skylight, it will inflate the average reading, leading to underexposure of the shadow areas.

Closeup reading When photographing a scene in which there are extreme highlight and shadow areas, an average reading may not be

A B

FIGURE 3-23

A. Photo illustration refers to making photographs that visually interpret, present, or clarify a concept or an idea. *B.* The spot news photographer must be fast and resourceful to get to events, such as this plane crash, that occur in remote, often inaccessible locations, and to get the photograph back to the home office.

The field generally defined as publications photography includes photography for a wide range of visual media, including newspapers, magazines, motion pictures, and television. It may also include not only news and promotional photography, but also advertising photography and photo illustration. Many of the larger media organizations, such as daily newspapers, wire services, television networks, and major television stations, employ their own photographers who carry out specific news and promotional assignments. Assignment work, however, falls far short of satisfying the needs of

satisfactory. Suppose the subject is a sunlit girl in a white dress against a background of dark, shadowed trees. At some distance the overall reading will be influenced unduly by the darkness of the trees, leading to indicated exposures that will overexpose the subject. In such cases, take the meter closer to the subject, to a point at which subject and background are represented more equally. Such a **closeup reading** will assure you that the indicated exposure is not influenced excessively by irrelevant background details.

most major media, which must then compete with one another for the work of freelance photographers who service this market and who are willing to sell their work to all comers.

News photography is a form of photojournalism that focuses on events of current public interest— such fast-breaking events as war, crime, catastrophe, political or sporting events, or even ordinary human activities of timely general interest. One characteristic that distinguishes news photography is its timeliness—a news photograph must usually be published within hours of an event for it to have news value. The news photographer must find a way to get to the scene fast, even when an event occurs in an inaccessible area, to get the story, and to deliver the photographs rapidly for timely publication. To become a successful news photographer, one must possess uncommon single-mindedness about making photographs that tell the story— to a degree that obstacles, including the photographer's personal safety, are often ignored. Many find the frequent exposure to such dangers as fire, flood, crime, and conflict stimulating and develop a kind of insulation from the emotions that might impede their work. (See Careers in

Photography: News and Photojournalism, p. 174.)

Generally, advertising photography creates pictures that are published in the print, film, or television media for the primary purpose of selling products, services, or organizational images. It is typically carried out by freelance or commercial photographers under the direction of advertising designers, although some larger advertising agencies employ their own photographers. Unlike photography for personal expression or photojournalism, photography for advertising requires photographers to subordinate their personal attitudes and points of view to the selling task, upon which all imagination and creativity are focused. Although most advertising photographs are made in studios, a trend toward realism in advertising has led to an increased preference for photographs made in natural locations. Advertising photographers, therefore, must be able to work under any conditions that may be required by the client or the job. Today, a good deal of the work of an advertising photographer consists of finding suitable locations, interviewing and hiring models, working with clothing stylists and makeup artists, and producing numerous proofs and test prints for approval before actually shooting an assignment.

Photo illustration refers to making photographs that visually interpret, present, or clarify a concept or an idea. Photo illustrations may be made by freelance or commercial photographers, or by in-house industrial photographers that many larger companies employ. Photographic illustrations are published most frequently in brochures, annual reports, calendars, slide shows, and multi-media presentations. Typically, a photo illustration is made from a carefully planned setup, in the studio or on location, for the specific purpose of visually communicating an abstract idea so that it may be more easily understood by a lay audience.

Although publications and media photography is a field that is easily entered, it is a highly competitive and speculative business in which the freelancer can expend enormous time and resources without selling very much. The business tends to favor those who possess not only photographic skills but also reportorial, writing, and communication skills. Freelance media photographers who can put a story together, write effective copy and captions, and create images that effectively communicate abstract ideas are more likely to receive freelance assignments and to sell their work than their counterparts who possess only technical photographic skills.

Whether the average or the closeup method is used, the meter should be pointed along the axis of the camera, viewing the subject from the same angle as the camera. Figure 3-19 depicts both methods.

Range of brightness When a scene has a wide range of brightness, with extreme highlight and shadow areas, selecting a proper exposure is more difficult. If exposure is based on the brightest areas in the scene, the darkest areas may be underexposed and hence fail to record details in the

shadow areas. If exposure is based on the darkest areas of the scene, the brightest areas may be overexposed, so that details in the highlight areas may be too dense and blocked up to print well. To overcome these difficulties, the photographer must find an optimal exposure between the two extremes that will record the maximum detail within the full range of brightness.

One way to determine this exposure is to take the light meter to several points in the scene for closeup readings. Find the brightest important area in the scene and take a **highlight reading**. Then find the darkest important area in the scene and take a **shadow reading**. Average the two readings and select an exposure midway between the two extremes. This exposure will record light intensities midway in the brightness range as an average gray and maximize details recorded between the two extremes. This procedure is known as the **range-of-brightness** method for determining exposure. For best results with this method, obtain readings only from areas that are important. Ignore unimportant areas, even though they may be lighter or darker. If the shadow details are of special importance, using an exposure about two-thirds of the way toward the shadow exposure will improve the overall results.

Sometimes, of course, the photographer may not be interested in recording the entire range of detail and tone. Suppose, for example, that the subject is a sunlit portrait against a dark background of trees. In this case a full range of detail and tone in the face may be desired; the detail and tone in the trees is not important. One approach would be to take both highlight and shadow readings from the face of the subject, selecting an exposure between these extremes and ignoring the darker shadows of the background altogether.

Exposure for shadows or highlights The latitude of most black-and-white films approximates four stops—these films will record details within a range of brightness in which highlight areas are as much as sixteen times brighter than shadow areas. If the brightness range in a scene exceeds these limits, the range of brightness method may result in loss of detail in both the highlights and the shadows. One approach to solving this problem is to obey the dictum "expose for the shadows," or, more precisely, expose for at least a minimum of shadow density. One way to use this technique is to first obtain a meter reading for the darkest important shadow area in the scene. Then reduce exposure two stops from the indicated meter reading. This renders the darkest area as thin as possible on the negative while preserving details in the shadows. Of course, highlight areas may be overexposed because the exposure is not reduced enough to unblock them; however, overexposure can be compensated for somewhat during processing and printing. Details that have not been recorded on the film in the first place can never be recovered. For this reason, many photographers give priority to shadow areas when determining exposure, even when it means that highlight areas will be overexposed.

There are times, however, when highlight areas may be more important than shadows. In these cases, priority may be given to the highlights, even if it means sacrificing details in the shadows. To do so, first obtain a meter reading of the brightest important highlight area in that scene. Then increase exposure two stops from the indicated meter reading. In this way the brightest areas will be rendered as dense as possible on the negative

while preserving details in the highlights. The shadow areas may be under-exposed and detail lost, however, because the exposure has not been increased sufficiently to record them.

These procedures for exposing for shadows or for highlights may produce more satisfying results than the other methods discussed whenever the range of brightness exceeds the latitude of the film. They are simple adaptations of the zone system, which is discussed further in Unit 13.

The 18 percent gray card Reflected-light meters are designed to indicate exposures that will record an average light reflectance as a middle tone of gray. The industry standard for this average light level is 18 percent reflectance. This means that an object that reflects 18 percent of the light falling on it would be seen as average by a reflected-light meter. The exposures indicated by the meter would record that object as a middle tone of gray.

One way to take advantage of this feature is to obtain a meter reading from an object of average reflectance and then use an exposure indicated by the meter. Because it is difficult to judge which objects in a scene are of average reflectance, an 18 percent gray card may be substituted for this purpose. These gray cards are easily obtained at photographic supply stores and simplify many metering situations, especially those characterized by out-of-the-ordinary lighting conditions.

Use of an 18 percent gray card will not solve the problem of a scene with a range of brightness greater than the latitude of the film. It will only ensure recording the average portions of the scene as middle gray tones. If the scene has an excessively wide brightness range, both highlight and shadow details may be lost in the process. In such situations it may be better to modify the indicated exposures to expose for the shadows, as discussed earlier.

The 18 percent gray card is also useful for color printing. Because the card has standard reflectance and neutral color, it may be used to serve as a reference tone to guide the printing laboratory. Many photographers using color negative film will start each roll by shooting a frame showing an 18 percent gray card. This frame then serves as a color reference for the printer, who might otherwise have difficulty determining the precise color balance of the original scene.

Most commercially made gray cards have a white surface of 90 percent reflectance on the opposite side. The white side may be used in low light levels when the gray side does not reflect enough light to obtain an accurate reading. If the white side is used, the indicated exposure must be increased by two and one-half stops to obtain the reading equivalent to 18 percent reflectance.

Simulating closeup readings If the scene is such that closeup readings cannot be taken (and a spot meter is not available), the lighting situation can be simulated using objects close at hand. Consider the view across the lake, for example, with sailboats on the lake, trees on the far side, and snowcapped mountains in the distance. A closeup reading from a white sheet of paper can simulate the white sails and snow, and a reading from a nearby tree can simulate a distant tree. The palm of the hand can be used to simulate similar flesh tones at a distance. Remember,

however, that these substitutes will serve only if they are of similar reflectance and are viewed in the same type of illumination as the objects they simulate.

The use of the exposure meter to obtain previsualized tonal values is discussed in Unit 13.

To review, the steps in using a hand-held reflected-light meter are shown below.

STEP-BY-STEP PROCEDURE
Using a Hand-Held Reflected-Light Meter

1. Set the meter for the speed of the film you are using.

2. Point the meter toward the subject or area of interest. Always position the meter between the camera and the subject so that the meter sees the subject as the camera sees it.

3. Set the adjustable ring of the exposure scale to correspond to the needle reading.

4. Read the exposure scale.

5. Take as many readings as necessary for the method you are using.

6. Select an exposure that will record the details and tones in the scene as you want them to appear.

7. Set your camera for the exposure you have selected.

Questions to Consider

1. What types of focusing systems are most commonly used with 35-mm cameras? What are the advantages and disadvantages of each? What type does your own camera use? How is the focus setting adjusted on your camera?

2. What are the various types of exposure setting systems most commonly used with 35-mm cameras? How are the shutter and aperture adjusted on your own camera? What is the fastest shutter speed available? The fastest aperture?

3. Given exposure settings of 1/60 sec. at f/5.6 on your own camera, what might you do to double the exposure? To reduce it by half?

4. What steps would you take to obtain maximum depth of field using hyperfocal focusing with your own camera? How might you minimize the effect of a "busy background" by controlling depth of field?

5. You should be able to calculate equivalent exposures so that you can use an aperture and shutter speed appropriate for your subject. Suppose you determine that a correct exposure for your subject would be 1/125 sec. at f/5.6. If you wished to use an aperture of f/2 instead, what would be the correct shutter speed to obtain an equivalent exposure? If you wished to use a shutter speed of 1/30 sec., what would be the correct aperture to obtain an equivalent exposure?

6. What features of an automatic camera do you consider to be most important? Why?

7. How would you set your exposure settings to freeze the movement of a fast-moving subject? To blur the movement of a fast-moving subject? To freeze the movement of a fast-moving subject against a blurred background?

8. How would you use your reflected-light meter if you wanted the tones in your final image to correspond to the brightness tones in the entire scene? If you wanted a particular object to appear as a middle gray tone? If you wanted a particular object to appear as a near white tone? If you wanted a particular object to appear as a near black tone?

Suggested Field and Laboratory Assignments

1. Take your camera and light meter outside during daylight hours. Shoot a roll of color transparency film and a roll of black-and-white film. Shoot a variety of subjects under a variety of lighting conditions. Be sure to include close-ups and long shots, some in bright sunlight, some in shade, some moving subjects, some stationary subjects. Shoot toward the light source and away from the light source. Use your meter to determine proper exposures: Try each method of determining exposure. Keep a shooting log (see Table 3-5). Record a log entry for each shot showing lighting condition, meter method, and exposure.

2. Have your color film commercially processed. Keep your black-and-white film for processing according to the directions given in the next unit.

3. Review your color slides with your shooting log in hand. Note those slides that appeared as you expected them to appear. Then note the slides that appeared otherwise. What went wrong? What should you do to improve results the next time you approach a similar situation?

TABLE 3-5 Shooting log

Date: June 24, Roll: 1 Film: Plus-x (ISO/ASA 125)			
Shot	Lighting Condition	Method	Exposure
1	Bright sunlight	Average	f/11 @ 250
2	Backlight; face shaded	Close-up	f/5.6 @ 250
3	All in shade	Average	f/5.6 @ 250

Unit **Four**

Films

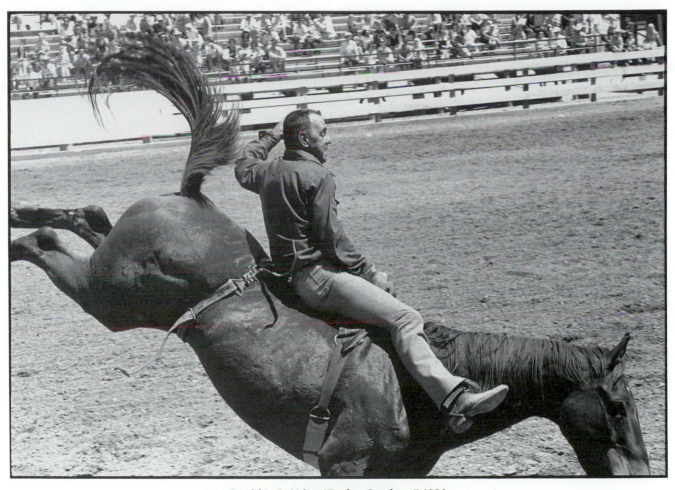

David L. DeVries, "Rodeo Cowboy," 1990.

Films for modern cameras are available in a great variety of types, sizes, and formats. Many films are designed to be used for general purposes, while others are designed for more specific purposes. No one film is perfect for all occasions. Sometimes the photographer might select a film that possesses qualities especially suited to a particular subject, such as fast action photography, portraits, night action, or landscapes. At other times, when the exact conditions may be difficult to predict, a photographer might select a general purpose film that is adequate for many subjects and occasions. This unit explores the way film works, the ways film is packaged, the various qualities that should be considered when selecting film, and how film should be handled and stored.

The characteristics of black-and-white films, including their speed, color sensitivity, graininess, contrast, resolving power, acutance, and latitude are discussed. The characteristics of color reversal and color negative films are also explained, including the factors that affect color balance and the various products that can be obtained from them. Descriptions of commonly available film products are provided in Appendix G.

The Photographic Process

Objective 4-A Describe the photographic process and the composition of black-and-white film.

Key Concepts electromagnetic energy spectrum, visible light spectrum, silver halides, gelatin, emulsion, latent image, silver process, top coating, subbing adhesive layer, support, antihalation backing, second adhesive layer

Light is a form of electromagnetic energy. Because our eyes are sensitive to this energy, we experience the phenomenon of sight. Actually, light energy is part of a much larger family of energy forms called the **electromagnetic energy spectrum**. The entire family includes many other forms of energy, such as radio, heat, X rays, infrared, and ultraviolet, which we cannot see, but which we experience in other ways. The **visible light spectrum**, that part that we can see, is only a small part of the entire electromagnetic energy spectrum.

Although they are not perfect in this respect, most photographic films are designed to be sensitive to the visible light spectrum and to record their encounters with light energy much as the human eye does. However, were you to look at a roll of exposed but undeveloped film in full light, you would see no hint of the pictures stored there. The pictures stored in the film are totally invisible to the naked eye until the film has been chemically processed.

To better understand how the photographic process works, we will look first at the structure and composition of a typical photographic film. At first glance, ordinary film appears to consist of a flexible base on which

FIGURE 4-1

Cross-section of black-and-white film.

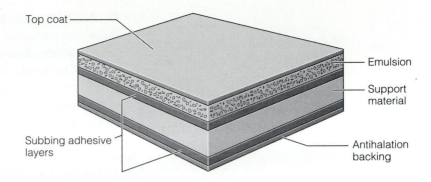

Top coat

Emulsion

Support material

Subbing adhesive layers

Antihalation backing

there is a soft, smooth, cream-yellow or gray coating. The coating can be scratched if handled roughly, and it can be washed off with hot water. The back of the film may appear blue, green, or red.

Underlying this simple appearance is a complex structure that has developed over a period of 100 years as photography pioneers pieced together the chemistry that makes photography possible. Figure 4-1 shows a cross-section of a typical black-and-white film. Within the creamy coating are millions of microscopic crystals of **silver halides**—mainly silver bromide and silver iodide—suspended evenly in a thin layer of **gelatin**. This coating, called the **emulsion**, is the principal active component of the film.

The silver halides are sensitive to light. An encounter with light changes their chemical structure—the greater the encounter, the greater the change. Yet the changes are so slight they cannot be seen even with a microscope. These minute alterations in the silver halide crystals form what is called a **latent image**—a hidden image waiting to be revealed.

The developing chemicals detect these changes and force the exposed silver halide crystals to release their metallic silver. As free silver is released, it clings to the latent image, slowly increasing in density until finally it creates a visible image. The fact that silver halides that have been exposed to light will release their metallic silver when developed is the basis of what is called **silver process** photography, the process that dominates today's photography industry.

A thin **top coat** protects the soft emulsion from casual abrasion as it moves through the camera. A **subbing adhesive layer** helps the emulsion bond to the support material. The **support** itself is a transparent, firm, flexible, chemically stable, plastic base, usually cellulose-acetate or Mylar.

Finally, a blue, green, or red **antihalation backing** is bonded to the back of the support by a **second adhesive layer**. The antihalation backing is a dyed gelatin that absorbs any intense light that penetrates both the emulsion and the support during exposure. If they are not absorbed, these light rays may reflect back from the far surface of the support into the emulsion and create halo effects around bright points of light in the image, such as around pictures of street lights at night.

In addition, manufacturers add hardeners, preservatives, and other ingredients according to their own formulas to improve the film's performance.

Although they are similar in structure and composition, films vary enormously in other respects. Some are designed for black-and-white, others for color photography; some are faster, some slower; some have finer grain than others; some are more sensitive to certain colors than others; some produce negatives, others positive images. You should experiment with a variety of films to explore these special characteristics. Most photographers, however, usually settle on a few films that they use consistently.

This unit emphasizes the silver-process films commonly used today. It should be noted, however, that new photographic processes and materials are constantly being developed that may compete successfully with silver in the future. Electrostatic photo-processes, for example, are based on the same principles as xerographic copying—the action of light electrically charges a photoconductive surface to form a latent image that is developed by carbon powders that adhere only to the charged areas.

Electromagnetic photo-processes represent other promising technologies. One of these is similar to video recording—an image resolved on a photo-sensitive cell is transformed into an analog video signal and is then stored in a magnetic medium, usually a floppy disk, which can hold twenty-five to fifty still images. The images may be viewed immediately on a television set.

Another electromagnetic photo process involves digitizing the resolved image—breaking it up into hundreds of thousands of discrete bits of information—and storing it in computer-readable form. Coupled with computer technology, images stored this way can be manipulated, modified, and transmitted electronically. This permits altering of the color, tone, and details of an image dramatically and instantaneously on the computer's monitor; it also makes it possible to transmit the image to distant places within seconds.

Holography represents yet another advanced photographic technology. Though still wedded to silver processes, holography employs laser light to record three-dimensional photographic information onto a two-dimensional transparency, called a **hologram**. While the recorded image is not normally readable under normal light, it appears in three-dimensional form under special lighting conditions. This technology has developed to the point that several magazines, including *The National Geographic,* have featured holograms in their publications.

Most of these newer technologies are still in an early state of development, producing images that lack the fine resolution and detail of silver process images. Nevertheless, the electronic media are reusable and require no chemical consumption, which promises considerable savings in materials costs for heavy users. Their image quality continues to improve rapidly. As a result, these new technologies are finding increasing acceptance in the marketplace among both professional and amateur photographers.

Characteristics of Black-and-White Film

Objective 4-B Define some basic characteristics of black-and-white film and explain how these characteristics affect photographs made under various conditions.

Key Concepts speed, fast-speed films, slow-speed films, medium-speed films, film speed ratings, ASA ratings, DIN ratings, ISO ratings, ultra fast-speed films, pushing the film, color sensitivity, panchromatic (pan) film, orthochromatic film, blue-sensitive film, infrared film, grain size, coarse-grain negative, fine-grain negative, coarse-grain film, fine-grain film, graininess, medium-grain film, contrast, inherent contrast, high-contrast film, resolving power, resolution, acutance or sharpness, latitude

Famous Photograph: Eadweard Muybridge's Galloping Horse

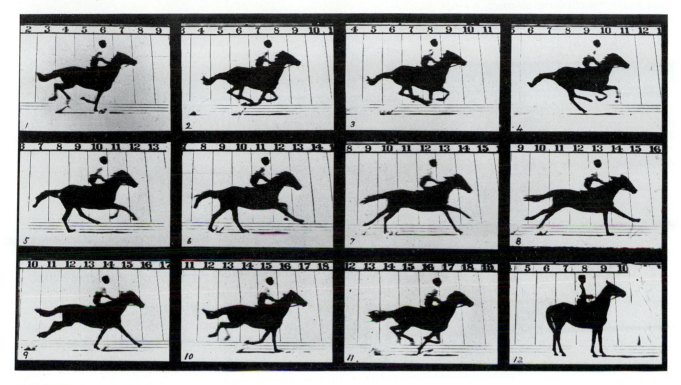

FIGURE 4-2

Eadweard Muybridge. "Horse in Motion," 1878.

Until Eadweard Muybridge's astonishing series of photographs of a galloping horse were published in *Scientific American* in 1878, people had little understanding of the actual movements of animals in motion. For example, it was commonly believed that a horse at gallop always had at least one foot on the ground at all times. Muybridge's photos proved this assumption to be false.

In 1872, Leland Stanford, former governor of California and then president of the Union Pacific Railroad, wagered $25,000 that a horse at gallop lifted all four feet off the ground at some point. He wanted a photographer to settle the bet. He brought the problem to Muybridge, who had earned a checkered reputation as a sometimes inventor, traveler, and gov-

ernment photographer, and who was then working in the Yosemite valley. With limited equipment and materials, Muybridge managed to produce some "photographic impressions" of the galloping horse, but the results were apparently inconclusive, and no record of these early images remains.

Muybridge, however, was intrigued by the problem, and Stanford was determined. Six years later, in June of 1878, after further experimentation and development, they tried again, staging the event in full view of the press in San Francisco. Muybridge set up twelve cameras, each attached by a fine black thread strung across the track so that each camera would be tripped successively by the galloping horse. The resulting "automatic electric photographs" showed conclusively

that all four of the horse's feet left the ground at one point.

Muybridge was so captivated by his experiments that he devoted the rest of his life to prolific studies of human and animal locomotion. He produced numerous books and lectured internationally on the subject. His studies influenced a generation of artists, physiologists, scientists, and engineers, who used his photographs as aids to their own work.

In 1879 Muybridge introduced the zoopraxiscope for animating and projecting his motion photographs, producing an effect so realistic that one reporter observed that "The only thing missing was the clatter of hoofs" (sic). What had started out as a simple wager emerged as a milestone in the development of motion picture photography.

TABLE 4-1 Equivalent film speed ratings

Films may be labeled with one or more film speed ratings: the American ASA, the German DIN, or the international ISO. The ASA and GOST ratings are based on an arithmetic scale and double as the film speed doubles; the DIN ratings are based on a logarithmic scale and increase by three degrees as the film speed doubles. The ISO ratings incorporate both ASA and DIN ratings.

ASA	GOST	DIN	ISO/ASA
12	11	12°	12/12°
20	18	14°	20/14°
25	22	15°	25/15°
32	28	16°	32/16°
40	36	17°	40/17°
50	45	18°	50/18°
64	56	19°	64/19°
80	72	20°	80/20°
100	90	21°	100/21°
125	110	22°	125/22°
160	140	23°	160/23°
200	180	24°	200/24°
400	360	27°	400/27°
800	720	30°	800/30°
1600	1440	33°	1600/33°

Films have many characteristics that affect their performance under different conditions. Some of the more important ones are speed, color sensitivity, grain, contrast, resolving power, acutance, and exposure latitude. All of these characteristics should be considered when choosing a film for a particular purpose.

Film Speed

Films vary in their sensitivity to light. This characteristic is termed the film's **speed**. Some films are extremely sensitive to light and do not require much exposure to record a usable image. These films are called **fast-speed films,** because their emulsions are highly active and respond to low levels of illumination. Other films require much more exposure to record a usable image. They are called **slow-speed films,** because their emulsions are less active and will respond only to higher levels of illumination. **Medium-speed films,** of course, fall in between.

The **film speed rating** is a numerical index that describes a film's speed. Historically, several different film speed rating systems developed, one in North America, one in Western Europe, and one in the Soviet Union. The American system of **ASA ratings** was developed by the American Standards Association (now ANSI, the American National Standards Institute). The European system is called **DIN ratings,** which stands for Deutsches Industrie Norm (German Industry Standard). A third standard, the **GOST** index, was developed by the former Soviet Union's standardizing authority and is commonly used there and in Eastern Europe to reflect film speed.

In an attempt to standardize film speed ratings, the International Standards Organization developed a system of **ISO ratings,** which most manufacturers now use for film distributed in Western Europe and America. Rather than create a new system, the ISO simply incorporated both ASA and DIN ratings into one. A film rated ASA 200 or 24° DIN would be labeled ISO 200/24°. Some manufacturers may continue to use a short ISO/ASA rating form that is identical to the ASA rating—ISO/ASA 200 for the same film.

In general, we may refer to the relative speed of films in the following way:

Slow-speed films: Ratings up to ISO 50/18°

Medium-speed films: Ratings between ISO 64/19°–160/23°

Fast-speed films: Ratings between ISO 200/24°–400/27°

Ultra fast-speed films: Ratings over ISO 400/27°

One convenient feature of the ASA system is that the ratings are directly proportional to the corresponding film speeds. The speed of an ASA 64 film, for example, is twice that of an ASA 32 film, and half the amount of light will be required to obtain an equivalent exposure. The GOST system ratings possesses the same feature. The DIN system, however, works differently. As film speed doubles, the DIN rating increases by 3°. Thus the speed of 24° DIN film is twice that of a 21° DIN film and will require half the amount of light to make an equivalent exposure. Table 4-1 reports some typical film speed ratings and their equivalents in the various systems.

Bear in mind that a film's rated speed is simply a numerical index assigned by the manufacturer that indicates the standard conditions of exposure and processing under which optimal results will be obtained. This index allows the user to compare the relative speeds of films and to obtain similar results when similar standard procedures are followed.

Experienced users may alter the standard conditions, however, to obtain results that are better suited to particular conditions. When a film is processed with a more energetic developer, for example, decreased exposure and increased development time are required to obtain optimal results, and this increases the film's effective speed. Similarly, when a film is processed in a fine-grain developer, increased exposure and decreased development time are required to obtain optimal results, and this decreases the film's effective speed. This technique is used mostly to increase the effective film speed and, for this purpose, is known as **pushing the film**.

Negatives that have been pushed may be of less than optimum quality, but the technique permits photography under extremely dim lighting conditions. For example, a photographer might choose to expose film rated ISO/ASA 400 as though its rated speed were ISO/ASA 3200 and then to alter standard processing to compensate for the reduced exposure.

Color Sensitivity

Black-and-white films are sensitive to different colors in varying degrees. Colors are recorded as different shades of gray. Thus black-and-white film sees color simply as varying degrees of brightness. There are several types of film, each of which sees the brightness of various colors differently— that is, each film has a different **color sensitivity.** Four of these films are panchromatic (pan) film, orthochromatic film, blue-sensitive film, and infrared film.

Panchromatic (pan) film **Panchromatic (pan) films** are sensitive to all colors. They see various colors in approximately the same brightness ratio as does the human eye. Pan film thus tends to produce black-and-white prints similar in appearance to the way our vision would translate scenes into black-and-white.

Orthochromatic film **Orthochromatic films** are sensitive to all colors except red. They can be developed by inspection under a red safelight. Because the film is insensitive to red, reddish objects tend to appear darker in the resulting prints than the eye would expect. This film is no longer in common use.

Blue-sensitive film **Blue-sensitive films** see only blue. They are blind to all other colors and oversensitive to blue. The film produces high-contrast negatives and prints. Thus it is well suited for black-and-white copy work on line drawings and manuscripts, and it is used extensively in lithography.

Infrared film **Infrared films** are sensitive primarily to the infrared and blue portions of the spectrum. They are used primarily for technical photography, such as aerial, medical, scientific, industrial, legal, documentary,

and photomicrographic photography. Used with a deep orange or red filter, they may give striking and unusual effects in landscapes and similar subjects. (See Figure 9-5, page 277.)

Grain Size

Grain size refers to the grouping or clumping together of the minute silver grains that form the film's negative image. The grain pattern of the negative affects the printed image. If a negative's silver grains are clustered in relatively large clumps, we refer to it as a **coarse-grain negative.** An enlarged print produced from it may appear grainy, mottled, or sandy and may suffer a corresponding reduction in sharpness. A **fine-grain negative,** on the other hand, has the silver grains clustered in relatively small clumps. It is more likely to produce prints that appear sharp and unmottled at the same magnification.

Grain size in negatives is related to several interacting factors:

1. *Film speed.* Faster films also tend to be **coarse-grain films,** as their emulsions necessarily are composed of larger, coarser grains of silver halides. **Fine-grain films** are necessarily slower. Should a film of greater film speed be required, a coarser grain pattern must generally be accepted. If a film of finer grain structure is needed, on the other hand, a slower-speed film must be accepted.

2. *Exposure and processing.* Overexposure and overdevelopment both increase the density of the silver deposits in the negative, thereby increasing negative **graininess**—the degree of coarseness in the image's grain pattern.

3. *Magnification.* Although magnification of the negative image does not alter the grain pattern of the negative, it does reveal it. Normally the graininess of a coarse-grain negative will not be apparent if the size of the final print is close to the size of the negative. But if the image is enlarged for printing, the grain pattern will also be enlarged, and thus the graininess inherent in the negative will become more apparent. Therefore, finer-grain negatives are usually used when greater magnification is required.

Graininess is not always undesirable in a print. The coarse, mottled appearance of a grainy image may serve certain aesthetic purposes. For general photographic purposes, however, many photographers prefer to work with a medium-speed, **medium-grain film** that strikes a compromise between their need for both fine grain and fast speed in a variety of circumstances.

Contrast

Contrast refers to the difference in density between light objects and dark objects in a scene. Factors that affect contrast are development time, temperature, and agitation. As these increase, the contrast for any particular scene brightness will be increased in the negative. Different films may achieve the same contrast for the same scene, but may reach it in different development times. A film that reaches a given contrast more quickly is said to have higher **inherent contrast.**

The manufacturer controls a film's inherent contrast when the emulsion is prepared. In general, slower films tend to have higher inherent contrast and achieve a given contrast in shorter development times. Faster films tend to have lower inherent contrast and need a longer development time to achieve a given contrast. This built-in characteristic can be increased or decreased by varying the exposure, processing procedures, and printing procedures. For most photographic purposes, photographers prefer to work with medium-speed films that have medium inherent contrast and that achieve normal contrast in moderate development time.

A **high-contrast film** is a special type of film that records only black-and-white tones—no middle gray tones. It is used in lithography and graphic arts to reproduce line copy, to make halftone negatives, and sometimes to impart a special effect to continuous tone images.

Resolving Power

A film's ability to record distinguishable fine detail is called its **resolving power.** A film's resolving power is tested by photographing sets of parallel lines that vary in size and in distance from one another. Then the negative image is examined under a microscope to determine the number of lines per millimeter that are recognizable as separate lines—the number beyond which the lines fuse together and become indistinguishable.

The resolving power of films ranges from low, where no more than fifty-five lines per millimeter may be distinguished, to ultra-high, where more than six hundred lines per millimeter may be distinguished.

The **resolution** evident in any given negative is very sensitive to exposure and falls off rapidly with under- or overexposure. Achieving optimal resolution with any given film depends on correct exposure, subject contrast, and other factors.

Acutance

The **acutance,** or **sharpness,** of a film is its ability to record finite edges between adjacent scenic elements. A film's acutance is tested by exposing the film to light while it is partially shaded by a sharp knife edge in contact with the emulsion. When the processed negative is viewed, the edge of the exposed portion, rather than ending abruptly at the unexposed area, can be seen to bleed into it somewhat. This bleeding is caused by the diffusion of light within the emulsion itself. Its extent is determined by the coarseness of the grain and the thickness of the emulsion, and it produces the apparent sharpness of the resulting image. To obtain the highest possible sharpness, select a film with a thin emulsion and fine grain, and avoid overexposure and overdevelopment.

Exposure Latitude

A film's **latitude** is its ability to produce a full range of tones despite variations from standard exposure and development. Films with wide latitude will produce a full range of tones even when exposure and development

vary widely from the standard. Films with narrow latitude must be exposed and developed to precise standards to obtain a full range of tones. In general, the faster the film speed, the wider the exposure latitude will be; the slower the film speed, the narrower the exposure latitude will be. Thus, slow films require more accurate exposure and development to give optimal results.

Types of Black-and-White Films

Objective 4-C Name some commonly available black-and-white slow-speed films, medium-speed films, and fast-speed films, and describe the speed, graininess, and special uses of each.

Key Concepts roll film, magazines, cartridges, disc film, film, sheets, chromagenic film

Packaging Forms

Films are packaged in forms suitable for the cameras in which they will be used. Some cameras are designed to use a long strip of film on which successive exposures are made. Films for these cameras are packaged in rolls as **roll film, magazines,** or **cartridges.** The entire strip of film is designed to be loaded into the camera at one time. Other cameras are designed to use rectangular **sheets** of film. Films for these cameras are packaged in boxes; the photographer preloads the sheets into special holders prior to use. Another system, called **disc film,** packages individual frames of film around a small wheel; however, black-and-white film is not currently available in this form. (See Figure 4-3.)

Magazines and cartridges The 35-mm camera was originally designed to use standard motion-picture film. For use in this type of camera, the film is wound onto a spool and contained within a light-tight metal magazine. A short leader of film is left protruding from the magazine for loading onto a take-up spool within the camera. Once inside the

FIGURE 4-3

*Film packaging. **A.** Film disk. **B.** Bulk 35-mm film. **C.** 120 roll film. **D.** 35-mm magazine. **E.** Sheet film holder. **F.** Box of sheet film.*

camera, the film is advanced from the magazine onto the camera's take-up spool as each exposure is made. When all exposures have been made, the film must be rewound into the magazine before it is removed from the camera.

Some cameras are designed to use special, light-tight plastic cartridges that contain both the film and the take-up spool. The film is advanced at each exposure entirely within the cartridge. After exposure the entire cartridge is removed without rewinding.

Some films display an electronic code that looks like a checkerboard pattern on the outside of the magazine or cassette. These DX codes can be read by many automatic, self-loading cameras, which will automatically set the camera's film speed setting when the film is loaded. There may be additional codings on both the film and the magazine or cartridge to identify the type and length of the film for automatic processing and printing machines.

Roll film For many cameras, a strip of film is rolled onto a spool together with an opaque paper backing. This roll of film is inserted into the camera and threaded onto the take-up spool. The camera is sealed, and the film is advanced one exposure at a time, onto the take-up spool. When exposures are completed, the take-up spool, now bearing both the film and the backing paper, is removed from the camera for processing.

Sheet film Sheet film is packaged in boxes of twenty-five sheets. The boxes may be opened only in total darkness. The film, notched near the corner to aid in identification and handling, is loaded into special light-tight film holders. Each film holder holds two sheets of film. The film holder is inserted into the camera to expose one sheet of film. It is removed, inverted, and reinserted into the camera to expose the second sheet of film. After both sheets of film have been exposed, another film holder containing fresh film must be used. In the darkroom, the exposed sheets of film are removed from the holder for processing.

Film Sizes

Films sizes are internationally standardized, assuring camera and film manufacturers a ready market for their products and assuring the user of the availability of materials throughout the world for almost all modern cameras. Some of the common film sizes are 35-mm magazines; 110 and 126 cartridges; 828, 120, 220, 620, 127, 616, and 116 rolls; 2 1/4-in. by 3 1/4-in., 3 1/4-in. by 4 1/4-in., 4-in. by 5-in., 5-in. by 7-in., 8-in. by 10-in., and 11-in. by 14-in. sheets.

Note that not all films are available in all formats. Some may be available in only one format, others in many. The characteristics of any given film may differ somewhat from format to format.

Common Black-and-White Films

Not all films will serve equally well for all purposes. Some films are especially suited for copying, providing high inherent contrast for this purpose.

Others are especially suited to infrared photography, providing high sensitivity to light of this color. Some films are suited for work under low light conditions, providing the high speed needed for this work.

New films and film technologies are constantly appearing on the market. For example, in the last few years the Ilford and Agfa companies introduced a line of **chromagenic films** that replace the metallic silver image with dyes to produce black-and-white images of extremely fine grain and exceptional detail. These films can be exposed at film speeds anywhere from ISO/ASA 100 to ISO/ASA 1600, even within the same roll, with excellent results. In 1986 Kodak introduced its line of T-Max Professional films that utilize T-grain technology—an emulsion technology that alters the shape of the silver halide crystals to produce much finer grain images at higher speeds. These films can be push-processed to speeds as high as ISO/ASA 6400 with very fine grain results.

Table G-1 in Appendix G describes some of the commonly available black-and-white films, their characteristics, and the purposes for which they may be especially useful.

Color Films

Objective 4-D Describe the process of color photography and the composition of color film.

Key Concepts primary colors, integral tripack, dye image, color reversal film, positive transparencies, duplicate transparency, color prints, internegative, color negative film, complementary colors, instant color print film, color balance, color temperature, Kelvin degrees (K), black body, daylight, tungsten light, Type A films, Type B films

One of the marvels of modern photography has been the development of inexpensive color materials that can be used with the same cameras and under much the same conditions as black-and-white materials. The ease with which even the beginning photographer can obtain full-color photographic images belies the long and tortuous history of color photography, which dates back well over a century. Today color films and processing can be obtained readily at general merchandise and grocery stores, and even at drive-through photographic outlets. Some of these films even are designed for user processing in home darkrooms by more advanced amateurs.

The products of various manufacturers differ in the details of their chemical design. Nevertheless, most modern color films are similar in construction to black-and-white films in many respects, except that they consist of three emulsion layers instead of one. Each emulsion layer is designed to record the image produced by only one of the **primary colors** of light in the scene—red, green, or blue—and to produce a corresponding colored image during processing. When it is exposed to white light in the image (a mixture of red, green, and blue), latent images are formed in all three layers. But when it is exposed to yellow light in the image (a mixture

FIGURE 4-4

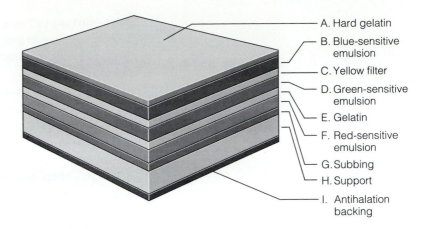

A. Hard gelatin
B. Blue-sensitive emulsion
C. Yellow filter
D. Green-sensitive emulsion
E. Gelatin
F. Red-sensitive emulsion
G. Subbing
H. Support
I. Antihalation backing

*Cross-section of modern tripack color film. **A.** Topcoat protects emulsion surface. **B.** Blue-sensitive emulsion records only the image produced by the blue light in the scene. **C.** Yellow filter absorbs blue light to prevent its transmission to the other emulsions. **D.** Green-sensitive emulsion records only the image produced by the green light in the scene. (This is an orthochromatic layer. It is insensitive to red light, which passes through it to the layers beneath, and it is not exposed to blue, which has been filtered out by the layer above.) **E.** Gelatin layer separates green-sensitive and red-sensitive emulsions to prevent dye contamination between layers. **F.** Red-sensitive emulsion records only the image produced by the red light in the scene. **G.** Subbing aids adhesion of the emulsion to the support. **H.** Support, a strong, flexible, plastic base, holds all layers firmly in place. **I.** Antihalation backing prevents back-reflection of highlights that may penetrate through all prior layers.*

of red and green), latent images are formed in only the red- and green-sensitive layers. Because of its three emulsions, this type of film is known as an **integral tripack.**

When color negative film is processed, the images on the three emulsions are developed first as negative silver images, as with black-and-white film. At a later stage of the processing, however, each of the images is converted to a **dye image** that is the complement of the primary color of light that produced it The red-produced image becomes cyan; the green-produced, magenta; and the blue-produced, yellow. The opaque silver and remaining silver salts are then dissolved away, leaving the three dyed image layers sandwiched close together in exact registration. When white light is transmitted through them, their images combine to produce a full range of colors that corresponds in negative form to those that were present in the original scene. When color slide film is processed, the negative images are converted to positive ones during processing.

Figure 4-4 shows a cross-section of a typical color film and explains the principles of its operation. Four basic types of color film are commonly available: color reversal film, color negative film, instant color print film, and instant color transparency film. Table G-2 in Appendix G describes some commonly available color films and their characteristics.

Color Reversal Film

Color reversal film is designed to produce color slides—**positive transparencies** that can be looked at through a viewer or projected onto a screen. The same film exposed in the camera is returned in the form of slides after processing. During processing the negative images are reversed to positive ones. Then each of the three positive images is converted to a dye that is the complement of the original primary color that produced it, and the silver image is bleached away. When viewed, the three images combine by a subtractive process to form a positive color image of the scene. This reversal of the negative to a positive image gives the film its technical name, **color reversal film.**

The transparency also can be used to reproduce the photograph in other forms. For example, a **duplicate transparency** can be made that is virtually equivalent to the original. Among other advantages, having a duplicate protects the original from the abuses of direct handling. Also, a

color print can be made from the original transparency. A color print is an opaque paper- or plastic-backed print that can be viewed without mechanical aids, mounted in an album or on a display board, and handled like any other print.

There are several methods of making color prints from transparencies; they differ in cost, complexity, and in quality of the end product. Some of these methods involve direct printing on special materials using a color reversal printing process. Many of these methods are no more complex than black-and-white printing and may be performed easily in a home darkroom. Others involve making an **internegative**—copying the transparency onto **color negative film** and then using the new negative to make positive color prints. Further, an internegative can be made using black-and-white film to produce black-and-white prints from the transparency.

Color Negative Film

Color negative film is designed primarily to produce color prints. It produces a transparent negative, which is then used for making the positive prints. As with a black-and-white negative, the brightness scale is reversed—bright objects appear dense in the negative, and dark objects appear thin. But the colors are reversed also—the original colors appear as their **complementary colors.** Thus blue objects will appear yellow in the negative, green will appear magenta, and red will appear cyan. The negative can be preserved, and reused as long as it is kept in good condition.

Color negative film is also of integral tripack construction. However, color negative film is not reversed in processing so that each of the three negative images is dyed the complement of its corresponding primary color. In printing, of course, both the brightness scale and the colors are reversed to correspond to the original brightness and hue in the scene.

Several end products can be made from the color negative. One of these is the color print. Positive transparencies can also be made from color negatives; in most respects these are equivalent to the transparencies obtained with color transparency film. Black-and-white prints also can be made from color negatives in a home darkroom. No internegatives, special equipment, papers, or chemicals are needed, although special printing papers are designed for this purpose to optimize results. The various products that can be made from both types of color film are summarized in Figure 4-5.

Instant Color Films

Instant color print film operates on the same general principles as conventional film and print materials. Silver halide emulsions are the basic image-forming media, and the chemical processes generally parallel those employed in color transparency films.

The primary difference between instant color print films and conventional ones is that the processing and printing materials are all sandwiched together into each sheet of film. The processing materials are held in an inactive state until they are activated following exposure. To develop the

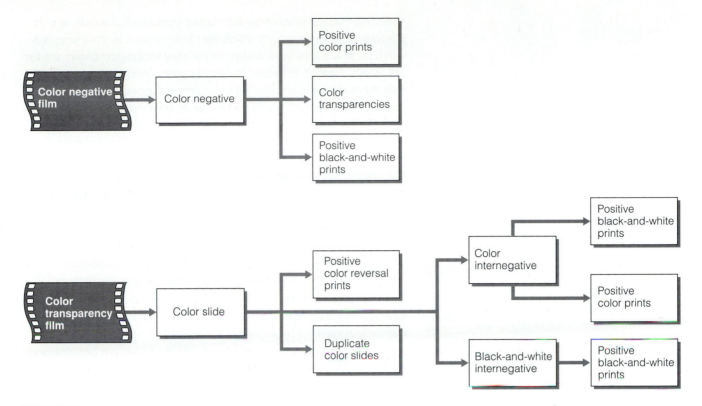

FIGURE 4-5

Color film products.

film and make the positive print, the film is squeezed between two rollers built into the camera, thus dispersing the activating chemicals throughout the emulsion.

The action of this process is self-limiting and terminates automatically, leaving at last only the completely developed and stabilized print. As with all photochemistry, development time is related to the temperature of the materials; depending upon outside temperatures, the process will take from twenty seconds to four minutes to complete.

Instant color print films are generally packaged in packs of eight or ten sheets. They may be used in cameras specially designed for their use or in special film holders designed to attach to conventional cameras. Though it is most commonly associated with the amateur market, instant photography has many applications in scientific, industrial, and commercial photography, and some photographs made from instant materials have found their way into art museums and galleries.

In addition, the Polaroid company markets an instant slide system that features a color transparency film that can be used in conventional 35-mm cameras.

Color Balance

A film's ability to reproduce colors as the eye perceives them is known as its **color balance.** Just as the human eye may selectively ignore details in a scene that the camera records, the eye also may ignore shifts in the color of the dominant light source, which the film will record.

We know, for example, that sunshine in the late afternoon is redder than at noon. The color of a white car does not appear significantly different to the eye at these times, but it does to color film. Because objects

reflect the characteristics of the light falling upon them, they will take on the colors of the source light. If that light is dominated by the warm, reddish hues of late afternoon sunlight or ordinary incandescent light, the film will record a reddish tinge over the entire scene. Ordinarily our minds will filter out this tinge in interpreting color, yet even a careful shopper knows this tinge exists and often views a new tie or dress in daylight to see its "true" color. Under ideal conditions color film records colors as they are reflected from objects, not as the viewer may believe them to be.

The color of light, from the red to the blue portions of the spectrum, is described in terms of **color temperature,** which is measured in **Kelvin degrees (K).** The Kelvin scale is based on the notion that an object such as a black iron rod, heated sufficiently, will eventually begin to glow. At first it will glow a deep red, but as the heat increases it will glow orange, then yellow, then white, and finally (if it does not evaporate) blue.

Were we to measure the temperature of the object at various points, we would find that we could consistently associate certain temperatures with certain colors. The Kelvin scale is based on the centigrade temperatures (corrected for absolute zero) of a theoretical **black body** associated with various colors of light found in the visible light spectrum. Thus the lower color temperatures are associated with the red-yellow portions of the spectrum, whereas the higher color temperatures are associated with the blue-violet portions of the spectrum. Figure 4-6 reports some common light sources and their approximate color temperatures in Kelvin degrees.

Color films are balanced in manufacture for the color temperatures of source lights commonly encountered in practice. One such source is **daylight** (5,500 K)—the color of daylight on a sunny day between 10 A.M. and 2 P.M. is the standard. Another such source is **tungsten light,** which refers to artificial light produced by tungsten-filament lamps. Most color films, known as tungsten or **Type B films,** are balanced for common indoor, incandescent lighting (3,200 K). Others, known as **Type A films,** are balanced for the slightly higher temperature of professional photo lamps (3,400 K). Color balance is more important for color transparency films, because no color balance adjustment can normally be made in processing; color balance can be restored when making prints from color negatives.

The most accurate color renditions are obtained when color films are used in the light for which they are balanced. If daylight film is used outdoors on a sunny day at noon, for example, a white car will appear white. Early in the morning, at sunset, or under floodlights on a showroom floor, the same film will make the car appear perceptibly reddish. If Type A tungsten film is used under professional photo floodlights on the showroom floor, the white car again will appear white. However, outdoors at noon, the tungsten film will make the car appear bluish, because the film is balanced for a lower color temperature than daylight.

It may sometimes be necessary to use a color film under conditions that vary from its rated color balance. Unit 9 discusses how to control the color shifts that might occur in such circumstances by using special filters fitted to the camera.

Control of color balance at the time of shooting is critical for color transparency films. The film in the camera ends up as the finished slide, and there is no opportunity to correct any imbalances once the picture is shot.

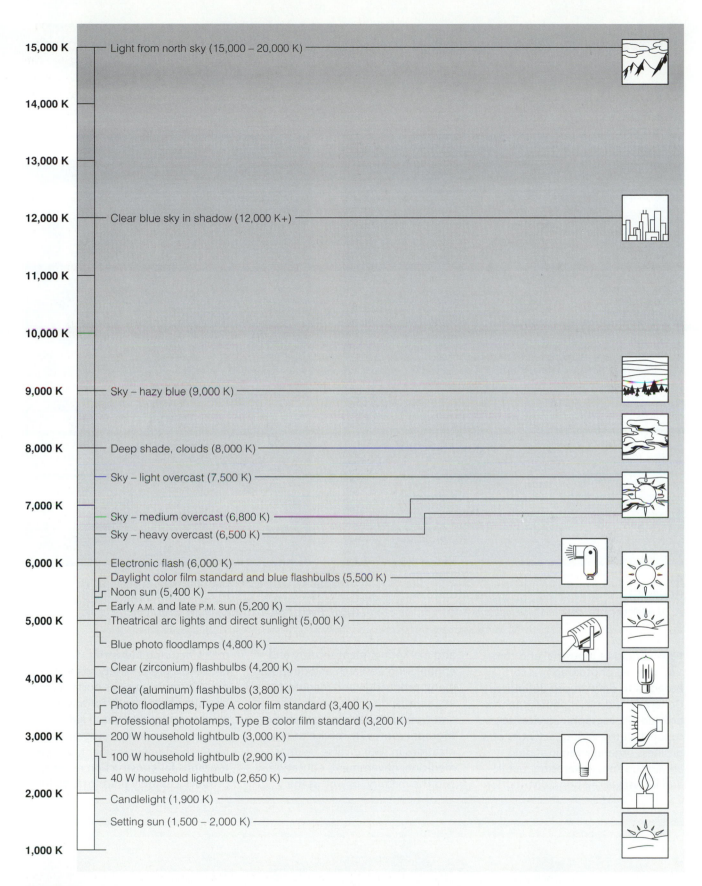

FIGURE 4-6

Color temperatures of various light sources.

A

B

FIGURE 4-7

*A. David D. Coleman, "Life in Maine Industries," 1987. **B.** "Rene Ego—Gagny, France," photo courtesy of Beckman Instruments, Inc.*

The field of industrial and commercial photography is so broad as to defy precise definition. Generally, industrial photographers provide photographic services to support all the various activities of a business organization including administration, advertising, public and industrial relations, distribution and marketing, plant security and engineering, research and development, production and manufacturing, sales and service, purchasing, and testing. Today's industrial photographers provide service to organizations in such diverse fields as medicine, government, education, and the military, as well as the manufacturing industries. They produce a great variety of photographic works, such as portraits and product photographs for advertisements and reports, visual aids for training, technical photographs for research and development, site photographs for construction reports, product assembly photographs for

time-and-motion studies, decor photographs, promotional films and videos, documentation photographs for accident and OSHA reports, and photographs for health and safety programs. According to the Occupational Outlook Handbook (1986–1987), industrial photography, particularly in science, engineering, medicine, and entertainment, is expected to grow faster than most other occupational fields through the 1990s.

As a specialist in visual communication, the industrial photographer may be called upon not only to perform routine photography, but also to produce highly creative solutions to visual communication problems. Engineers and scientists, for example, use photography constantly to reveal things that are otherwise invisible to the human eye—objects and events that may be too small, too fast, or too slow for normal observation. Further, the nature of many high-technology processes may be difficult to comunicate visually—such as high-speed data processing or laser surgery. Therefore, the industrial photographer may be called upon to use a variety of imaginative photographic approaches and advanced techniques to solve these problems.

Because modern industry has such diverse needs for visual communication, many industrial photographers find that during their careers their practice extends into such specialized areas as micropho-tography, macrophotography, photomicrography, electron microscopy, stroboscopic photography, time-lapse photography, high-speed still and motion picture photography, metallography, X-ray photography, holography, infrared and ultraviolet photography, aerial photography, autoradiography, bubble chamber photography, electron and X-ray diffraction photography, nuclear photography, seismography, spectrography, stereography, oscillography, microfilming, and computer imaging. Although few industrial photographers would need to be expert in all of these specialized techniques, they would certainly need to be aware of them and be prepared to learn them as the need arose. In the final analysis, industrial photographers will succeed or fail on their ability to produce effective photographs, no matter what special technique they may need to learn in the process.

Industrial photographers generally are employed by the companies they serve; however, many small businesses cannot justify employing a full-time photographer and must rely upon commercial photographers or freelancers to fulfill their industrial needs. Thus, independent photographers can find a lively market among smaller businesses that also need industrial and technical photographs. Photographers who wish to add clients who need industrial and technical photographs, should approach potential clients with a portfolio that includes a generous number of photographs showing not only the versatility, variety, and technical competence of their industrial work, but also their ability to illustrate and communicate visual concepts. Although the portfolio may consist of slides, prints, and tearsheets, there is some evidence of a trend toward video portfolios. A professional looking video that displays both still and motion work can go a long way toward communicating the skill of the photographer to potential clients.

Even in-house industrial photographers should not neglect the marketing of their services throughout the employer's organization. Often staff members and department heads may not fully comprehend how a skilled industrial photographer can contribute to their department's productivity and internal communications. Sometimes photographic assignments are handed to amateur photographers within a department because the staff within that department are unaware of the availability and special skills of the in-house professional. It is essential, therefore, that in-house industrial photographers approach their marketing task in a manner similar to that of the freelancer or commercial photographer—by maintaining a continuing effort to keep potential clients aware of the availability and capability of professional photographic services.

Color negative film, however, is another story. Color imbalances in the negative may be substantially corrected during printing, with compensatory filtration. In commercial processing laboratories it is standard practice to try to balance positive prints using flesh tones or other known values as a reference. Also, many photographers will use a standard 18% gray card at the start of a roll, within a scene, or in the frame preceding an important shot to provide the printer with a standard reference for balancing color in the print.

Color Film Speed

Black-and-white films usually have only one film speed rating regardless of the light source under which they are used. Color films, however, generally have different film speed ratings for use in daylight and under artificial lighting conditions. The film's instructions generally give you the standard ISO/ASA rating to use under daylight and another ISO/ASA rating to use under artificial light. The instructions also explain how to adjust for the use of filters.

Film Care and Storage

Objective 4-E Describe the conditions that may adversely affect film and describe how to store and care for films to avoid these effects.

Key Concepts humidity, heat, age, gases, X rays and radioactive material, static electricity, professional films

All photographic films may be affected by humidity, heat, age, gases, static electricity, X rays, or radioactive materials. Some films, such as professional films, require special handling. By taking the following precautions, however, film can be protected from adverse effects.

1. **Don't open a film package until you are ready to use the film.**

 Most films come in vapor-tight containers or packages for protection against **humidity**. No additional protection against moisture is normally required as long as this package is intact. If the package is opened prematurely, moisture in the environment hastens the aging of the film.

2. **Store unexposed film in a cool, dry place or refrigerate it in its original vapor-tight package.**

 Film packages do not protect against **heat**. Do not leave undeveloped film in direct sunlight or near any heat source, such as steam pipes, heat registers, or closed compartments of a car. Special care should be taken in hot seasons or regions. Films may be refrigerated or frozen as long as they are in their original vapor-tight packages. To prevent

condensation on the surface of the film, cold films should be allowed to warm to room temperature before they are removed from their vapor-tight containers.

3. **Expose and process film before it spoils.**

Films are chemically active and change with **age,** even if they are not exposed to light and are stored carefully. Films are given an expiration date at the time of their manufacture and with reasonable care can be guaranteed to give good results until that date. If they are kept in a refrigerator or freezer, they will give good results long after the expiration date.

4. **Expose and process film as soon as possible after opening its vapor-tight package.**

Opened, unprocessed film should be loaded into a camera and exposed in a reasonably short time. Once the vapor-tight package is opened, the film is affected by **external conditions** that cause aging to proceed rapidly. The loaded camera is neither vapor-tight nor heat-proof, so it should be stored in a cool, dry place. Store a loaded camera in an enclosed camera bag together with a small container of silica gel, available from most photo supply stores, to reduce relative humidity within the bag. Avoid prolonged storage of a loaded camera.

5. **Avoid storing film where it may be exposed to volatile gasses, X rays, or radioactive materials.**

Certain **gases** may adversely affect the chemical composition of film. Motor exhaust, mildew preventives, camphor or formaldehyde vapors, and vapors from cleaners and solvents may seep in and damage the film. Similarly, exposure to **X rays** and **radioactive materials** may damage the film. Special film containers should be used to ship film through customs or other X-ray security points. If no such container is available, request hand inspection.

6. **Advance and rewind film slowly and handle film carefully to avoid discharges of static electricity.**

Sparks of **static electricity** at the surface of the film also can cause marks in the developed negative. Static electricity may collect at the surface of the film during dry weather when the relative humidity is very low. Just as a charge of static electricity can be built up by walking across a carpet on a dry winter day, a static charge can be built up on the film by advancing it or rewinding it too rapidly.

7. **Store negatives in a clean, dry, cool place in protective envelopes or sleeves.**

The developed negatives of black-and-white film are normally very stable and require few special storage precautions. A cool, dry place will inhibit the growth of mold on the gelatin emulsion. Hydrogen sulfide and coal gas should be avoided because sulfur compounds may attack the silver in the negative image. Negatives should be kept as clean and dust-free as possible to avoid damage to the negative image.

8. **Professional films require special handling.**

Most major film manufacturers produce a line of **professional films.** These films are manufactured to particularly high standards with respect to film speed and color balance. They typically have less latitude and are more sensitive to aging and temperature. Professional films are intended to be stored at 55°F (13°C) or less and to be processed immediately after use. Purchase professional films only from reputable dealers accustomed to handling these films properly.

Questions to Consider

1. Describe the construction of a typical, modern black-and-white film. What are the functions of the various layers? Describe the construction of color film. What are the functions of the various layers?

2. What are the seven important characteristics of film described in this unit? What are the conditions that might lead you to select one film over another for a particular assignment?

3. Describe the several different ways that film is packaged.

4. Describe three basic types of color film and the end products obtainable from each. Describe how to obtain a positive color print from each type of color product.

5. What is meant by the color balance of a film? How is color temperature measured? For what three color balances are modern color films manufactured?

6. What steps should you take to protect your fresh film from adverse conditions?

Suggested Field and Laboratory Assignment

1. Obtain a roll of medium-speed black-and-white film and a roll of color transparency film to use with your camera. Study the procedures for properly loading your camera with film. Does your camera read film DX codes and automatically set itself for a correct ISO/ASA film speed index? Can you override any automatic settings and set the camera's film speed setting manually? (You will need to load your film into your camera and become familiar with your camera's features to complete the field assignments in the next unit.)

Unit **Five**

Developing Black-and-White Film

David L. DeVries, "After the First Snow, Winnipeg, Manitoba, Canada," 1991.

Doing your own black-and-white film processing is fairly easy and does not require a darkroom, nor much equipment. A careful worker can control the film processing procedures to yield results that are far superior to that of most commercial processing at only a fraction of the cost. Special processing procedures can even be employed to match the needs of unusual shooting situations.

This unit describes the theories, tools, chemicals, and step-by-step procedures used in film processing. It then describes how to evaluate and troubleshoot newly-developed film. Special developing procedures and the process referred to as push processing are explained, and safe handling procedures for photographic chemicals are also discussed.

Film Processing

Objective 5-A Explain and demonstrate the processing of black-and-white negative film.

Key Concepts latent image, processing, negatives, film-processing tank, developer, silver, stop bath, fixer, hypo, washing aid, clearing agent, wetting agent, time control, temperature control, reticulation, agitation, acetic acid, material safety data sheets (MSDS), ground fault interceptors (GFI's), changing bag, stock solutions, working solutions, time-and-temperature chart, one-shot developer, replenisher

Once the film has been exposed in the camera, the photographic image is recorded. Were one to look at the film at this time, however, it would appear no different from unexposed film. This recorded but invisible image on the film is called a **latent image**. To transform this latent image into a visible image, it is necessary to process the film. In **processing**, the film is passed through several chemical baths in total darkness, then washed free of all active chemicals, and finally dried. When this process is complete, the exposed film has been transformed into a set of **negatives**. In the negative image, everything on the black-and-white scale has been reversed: Objects that were white in the scene are black in the negative; objects that were black in the scene are transparent in the negative. To make a positive print from the negative, further steps must be taken; these will be discussed in the next unit. For now, let us study the processing of the film to produce negatives.

An Overview

An overview of the entire process might be helpful. First, keep in mind that most popular black-and-white films are panchromatic—that is, they are sensitive to all visible colors of light. Therefore, unprocessed panchromatic film cannot be viewed under any visible light without exposing it. All

handling of panchromatic film before and during processing, then, must be accomplished in total darkness. (Certain films, such as orthochromatic film, are not sensitive to all colors of light. These films can be examined before and during processing under special lights.)

Before processing, the film is normally loaded into a lightproof **film-processing tank.** The loading must be done in total darkness to protect the film from exposure to light. However, once the film is in the tank, with the tank lid properly sealed, it can be processed under normal lighting conditions. The chemical baths can be poured into and out of the tank through its light-tight openings without exposing the film to light.

How Developer Works

Once in its lightproof tank, the film is first bathed in a chemical **developer**. The crystals of silver bromide that have been exposed to light are attacked by the developer so that the bromine is freed, or dissociated, from the **silver**. The free bromine is carried off into the developer solution, while the silver remains in the emulsion. The greater the amount of exposure to light, the more silver remains. These silver deposits are actually tangled webs of tiny grains of silver. They appear black to the naked eye and make up the dark portions of the negative. To stop the action of a developer, the film is immersed briefly in a clear water rinse or an acid **stop bath.** The active ingredient of most stop baths is **acetic acid.**

CAUTION

Many **photochemicals** are poisonous or caustic and should be kept out of the reach of children. Particular care should be taken with developers, sepia and selenium toners, and acetic acid. In addition, some individuals may suffer allergic skin reactions to certain photochemicals. Plastic or rubber gloves usually provide adequate protection.

Handling Photographic Chemicals Safely

Dangers of Photographic Chemicals

Most photographic chemicals pose possible health hazards if handled improperly. Both black-and-white and color photographic materials contain numerous allergens, irritants, and other hazards. Negligence and improper handling of photochemicals have the potential to cause a host of respiratory problems as well as allergic reactions, mental confusion, eye irritation, and other health hazards. The length of exposure to a toxic substance directly affects the likelihood of developing a health problem.

Detecting problems resulting from exposure to photographic chemicals can be difficult. Many skin, eye, and respiratory conditions develop over a period of time and may not be noticeable for several years. Because exposure effects can be cumulative, lab technicians and others who spend long periods of time in the darkroom should be especially careful.

In an Emergency If photographic chemicals get in your eyes, immediately flush them with water for at least fifteen minutes; then seek medical advice. For all other emergency situations, seek immediate medical care. Specific health, safety, and environmental emergency information may be available from the following hotlines:

▶ **For Ilford photographic products, call the Ilford Photo 24-Hour Safety Hotline at (800) 842-9660.**

▶ **For emergency information on Kodak products call the Kodak 24-Hour Health, Safety and Environmental Emergency Phoneline at (716) 722-5151.**

Keep these numbers handy in your darkroom.

Toxins can enter the body in three ways: by ingestion, inhalation, or skin absorption. Many health problems can be avoided simply by using common sense when working in the darkroom: Keep chemicals out of the mouth and eyes, work in a well-ventilated area, and avoid prolonged skin contact with photo solutions and powders. Treat photochemicals with the respect you would give any other laboratory chemical.

Specific Guidelines for Safe Handling of Photographic Materials

Know What You Are Working With Know what chemicals you are using. Read the product label for specific precautionary and safety information. Manufacturers are required by law to make available **material safety data sheets (MSDS),** which describe the composition of their products. The MSDS will list any health hazards and exposure effects and note any special precautions to take if the compound is inhaled, ingested, or absorbed through skin contact. Any requirements for protective clothing will be noted, as well as specific first aid treatment and recommended methods for safe storage and disposal of the materials.

Respect the Materials Respect the hazardous nature of the materials you are using. Try to avoid splashes; pour powders slowly so that they don't become airborne. Use liquid concentrates whenever possible. Clean up spills promptly. Photographic chemicals that are allowed to dry on the floor will produce a fine dust that is likely to be inhaled. Avoid contamination; keep all equipment spotlessly clean. Rinse out graduates, funnels, and the like before and after each use.

Use Proper Ventilation Work only in well-ventilated areas. Kodak recommends ten to fifteen air changes per hour to prevent accumulation of chemical fumes. Don't stand for long periods of time directly over mixing containers and trays where the concentration of vapors is the greatest.

Avoid Chemical Ingestion Never store photographic chemicals in food containers or bottles; they could be mistaken for the real thing. Don't eat, drink, or smoke in the darkroom; these consumables could easily become contaminated with traces of chemicals remaining on the counter.

Minimize Skin Contact Protect your skin. Always use tongs to handle prints in trays. Minimize or avoid immersing your hands in tanks of chemicals. Photochemicals are known skin irritants and sensitizers. If you expect prolonged skin contact with photographic solutions, or if you have dermatitis or other allergic reactions, wear gloves. Use heavy-lined, form-fitting, rubber gloves, and be careful not to contaminate the cloth lining. (Thinner, surgical gloves, though more comfortable, can actually trap chemicals in the latex, causing constant absorption by the skin.)

Wash Your Hands After Handling Chemicals Practice good personal hygiene. The use of soap after contact with photographic chemicals can reduce the possibility of skin rash. A liquid soap with a pH of 5.0 to 5.5 is especially effective. Wash hands thoroughly with mild soap and dry them completely after handling photographic chemicals.

Eliminate Other Darkroom Hazards Take precautions to ensure that your darkroom is a safe room. Make sure the design and layout of your darkroom allow for the most efficient and safe traffic flow. All corners of counters and work tables should be rounded for safety. Some workers like to attach small luminescent dots to these projections to make navigating in the dark easier. Know the location of the nearest fire extinguisher and how to use it.

Work carefully to eliminate splashes that might result in wet and slippery floors. Keep in mind the danger of electrical shock when using water and liquids near powered equipment and outlets: Don't handle timers and other equipment with wet hands, and avoid the use of extension cords. The use of **ground fault interceptors (GFI's)** can prevent the possibility of serious electrical shock or electrocution. GFI's are devices that replace conventional wall outlets and act as circuit breakers that open if a short is detected. They are commonly installed in kitchens and bathrooms and are available at most hardware stores.

Dispose of Chemicals Properly Most working strength black-and-white processing chemicals can be safely discarded down the drain if flushed with plenty of water to assure high dilution. Reclaiming and removing the silver from photographic fixers and the like is both economically and environmentally sound. Some states have particular regulations on the nature and amount of photographic effluents allowed in the sewer system. Individual regulations may recommend the central collection and processing of photographic waste for ecologically safe disposal.

For More Information Consult the material safety data sheets (MSDS) for particular information on specific photochemicals. General information on recommended ventilation, safe handling procedures, and potential health hazards may be found in the following two publications:

Shaw, Susan, *Overexposure: Health Hazards in Photography.* Carmel, Ca.: Friends of Photography, 1983. This publication is out of print but is usually available through the library of most universities and colleges.

Tell, Judy (Ed.), *Making Darkrooms Saferooms: A National Report on Occupational Health and Safety.* National Press Photographers Association, 1988.

The Purpose of Fixer

The developer does not attack the silver bromide crystals that have not been exposed to light; if the film were viewed after development, the black silver image would be embedded in a creamy white background consisting of the unexposed and undeveloped portions of the emulsion. To eliminate these still-active silver bromide crystals, another chemical bath is needed. This one is called the fixing bath and uses a chemical **fixer**. The first chemical agent to be used as a fixer was hyposulfite of soda, and many photographers continue to follow tradition by referring to any fixer as **hypo**.

In the fixing bath, which is also carried out within the processing tank, all the remaining undeveloped silver bromide crystals are dissolved, along with the antihalation backing. In fact, all unnecessary chemicals and backings are dissolved in the fixing bath. All that remains after the bath is the metallic silver image produced by the action of the developer. This image, embedded in the gelatin emulsion coated on an acetate backing, is the negative that will be used to make the finished photograph.

At this point, with all the light-sensitive chemicals removed from the film, the tank can be opened and the negatives viewed in normal light. The processing, however, is not yet complete. All traces of the processing chemicals—the developer and the fixer—must be washed from the negatives. Any traces of these chemicals remaining embedded in the emulsion after processing will eventually dry and stain the negatives, damaging their usefulness. Many photographers use a washing aid, sometimes called a **clearing agent,** to reduce the amount of time and water necessary for completely washing the film.

Following a thorough washing, the negatives must be dried properly. Keep in mind that the wet gelatin emulsion is very soft. Particles of dust or grit that lodge on it may become firmly embedded and show up as white specks on the finished photographs. Also, droplets of water may dry firmly onto the surface of the gelatin emulsion and become visible in the finished photographs. To avoid these hazards, it is advisable to use a **wetting agent** together with correct drying procedures. These will usually assure that the processed film will dry free of dust, scratches, and water spots.

The Time/Temperature Processing Method

All chemical processes are sensitive to both time and temperature, so it is important to exercise careful **time control** and **temperature control** during processing—just the right amount of time at a proper temperature to get the best results. Clearly the development process does not take place in an instant—were you to remove the film from the developer too soon, the process would be incomplete and the film underdeveloped; were it left in too long, the film would be overdeveloped. Underdeveloping reduces contrast and produces images that are lacking in detail; overdeveloping increases contrast and produces dense, grainy negatives. Precise time control is essential to proper film processing.

Careful temperature control over all solutions used in processing is equally important. Heat speeds up chemical processes, whereas lower temperatures slows them down. If the chemical developer is too cold, it may

take hours to develop the film properly; if it is too warm, it may develop so fast that the film can't be removed from the developer quickly enough to avoid overdevelopment. Furthermore, if one of the solutions is very warm and another very cold, the sudden change in temperature may damage the film severely. Just as glass raised to a high temperature may crack if it is suddenly plunged into cold water, so the gelatin emulsion may react to an abrupt change of temperature. This cracking of the emulsion, which produces a "craze pattern," is called **reticulation**.

Throughout the chemical processing, proper **agitation** of the solutions is necessary. Were the film to remain quietly in the solution, the processing would affect the film surface unevenly. Small air bubbles clinging to the film's surface would not be dislodged and would show up as small, undeveloped spots where chemical processing failed to take place. Further, as the chemicals acted on the heavily exposed areas, the solution in direct contact with the film would become exhausted and inactive, and the process would slow down in those areas. In less-exposed areas of the film, the chemical activity would remain quite active. Thus, to assure even development over the entire film surface, the solution must be agitated to dislodge the air bubbles and bring fresh solution into contact with all areas of the film through the entire processing period.

Overly vigorous agitation, however, may create streaking effects and excessive contrast. Therefore, agitation too must be carried out under carefully controlled conditions. For each chemical step in film developing, the solution should be agitated continuously for the first thirty seconds; after that, the solution should be agitated every thirty seconds for five full seconds until the step is completed. Table J-3 in Appendix J describes some typical film developers.

With these general principles in mind, let us now examine the key piece of equipment used in film processing.

Film-Processing Tanks

Film-processing tanks come in several varieties. Most are made of plastic or stainless steel for use with either roll films or sheet film. All processing tanks provide some inner mechanism for holding the film so that it will not touch anything during processing. Should the emulsion touch anything—the sides of the tank, another sheet of film, or another part of the film roll—the processing chemicals will not act properly at the point of contact, and the negatives will be damaged.

Tanks for sheet films provide some type of cage with compartments for each separate sheet of film, or some type of hanger from which each sheet of film can be suspended separately in the solutions. Roll-film tanks generally provide a reel onto which the film can be wound so that the film at no point touches itself. Some of these reels are rigid. Some are designed to be loaded from the center outward, whereas others are designed to be loaded from the outside toward the center. One type uses a flexible plastic strip, called an apron, that is rolled up with the film. It holds the film so that the emulsion touches neither the apron nor other parts of the film. (See Figure 5-1.)

Whatever type of tank and loading mechanism is used, be sure that it is designed for the size and type of film that is being processed. The reels,

FIGURE 5-1

A variety of processing tanks and reels for roll film.

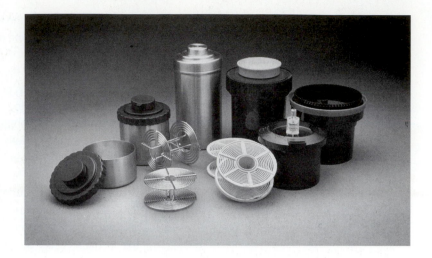

aprons, cages, and hangers are designed for use with particular sizes of films. Some are adjustable, some are not. Virtually all processing tanks are designed to be loaded in complete darkness and then sealed for processing. Once sealed, processing may continue under normal lighting conditions.

Using the manufacturer's instructions and a roll of surplus film, practice loading your tank and reel in total darkness as many times as necessary to ensure proficiency. *Do not load your first tank with a valued roll of exposed film.* Until the necessary skills are developed, expect to make a few mistakes.

HELPFUL HINT
Mixing Stop Bath

Most photochemicals are packaged with instructions for mixing and storage. Follow them carefully. Chemical stop bath, however, often is not explained. Stop bath is a 1 to 2 percent solution of acetic acid. Acetic acid can be purchased in two forms: glacial acetic acid (99 percent), which must be handled with great care, and commercial-strength acetic acid (28 percent), which is easier to store and handle. Purchase the commercial-strength if possible; if you must purchase glacial, dilute it to commercial strength for storage. Here are the dilution formulas:

> 3 parts glacial + 8 parts water = 11 parts commercial strength acetic acid (28 percent)

> 1 part commercial strength + 20 parts water = 21 parts working-strength stop bath

Safety Note

Proper chemical handling procedures call for mixing acid and water in a particular sequence. *Always start with the required amount of water; then add the acid.* Doing the reverse—that is, pouring even a small amount of water into a container of acid—could cause a dangerous reaction and/or acid splashes. *Remember: acid to water, never water to acid.*

Now study each step in the box entitled "Step-by-Step Procedure for Film Processing." Remember, those steps described for total darkness must be carried out in a totally dark room. If a photographic darkroom is not available, a **film changing bag** may be useful. Changing bags are light-tight, zippered fabric containers with tightly sealed sleeves through which you can insert your arms. With a changing bag, film can be loaded in normal lighting conditions. Another alternative is to seal a bathroom at night with blankets over the windows and around the doors to produce total darkness. Test the darkroom by turning off all lights and placing a white sheet of paper on the counter. If after two minutes the white paper cannot be discerned, the room is dark enough for handling light-sensitive film.

STEP-BY-STEP PROCEDURE FOR FILM PROCESSING
Lights On

1. *Prepare the processing solutions.* Following the manufacturer's instructions, prepare the three chemical solutions—developer, stop bath, and fixer. Some chemicals are prepared in concentrated form and diluted before use. The concentrated forms are called **stock solutions;** the diluted forms, **working solutions.** If possible, mix all powdered chemicals at least a day in advance to allow the mixture to thoroughly dissolve. Both light and air speed the oxidation of photochemicals. Storage bottles should be opaque or brown to inhibit the action of light; bottles should be kept full and tightly capped to inhibit damaging effects of air.

 Before use, bring all of the processing solutions to one of the recommended temperatures. One way to do this is to place the bottles in a tray containing water that is already at the recommended temperature. Use a darkroom thermometer to check the temperature of the solutions, taking care to rinse the thermometer between tests so that it does not contaminate the solutions. (See Figure 5-2A and B.)

 Most photo processing is recommended within a range of 65°- 75°F (18°–24°C). Temperatures outside that range should be avoided unless specifically recommended by the manufacturer. Refer to the manufacturer's **time-and-temperature chart** for exact developing time and temperature combinations. Normally a slight temperature variation of ±1°F (.5°C) will not require adjusting the specified development time. However, the temperatures of the developer, stop bath, fixer, and washing solutions should be within 5°F (3°C) of one another to avoid reticulation and excessive graininess. (See Figure 5-3A.)

 Professional darkrooms maintain a constant environmental temperature so that all stored solutions are maintained at the proper temperature for immediate use. In addition, temperature-controlling valves are used to mix hot and cold tap water so that water of the proper temperature is readily available. More involved procedures are needed to maintain proper temperatures in a nonprofessional darkroom. (See Figure 5-2C.)

A

FIGURE 5-2

*Temperature control. **A.** Solution temperatures may be adjusted before use by placing storage bottles in tanks of water at correct temperature. Shortstop is the stop bath preparation used here. **B.** Solution temperatures may be measured with a darkroom thermometer. **C.** Wash water temperatures may be controlled with a photographic mixing valve.*

B

C

2. *Set up the equipment and materials.* Divide the work area into separate dry and wet areas. Wet materials should never contaminate the dry areas. Until processing begins, film handling should be carried out in the dry area. All surfaces that the film may contact should be both dry and clean. To protect the film from casual moisture on their hands, some photographers use lintless cloth gloves for film handling.

Place all items on the counter before you in positions where they can be found easily in the dark. A small tray or box lid is useful to prevent small items from rolling off the counter. Processing chemicals should be near at hand in the wet area in a sink or on the counter. The following items should be arranged neatly:

Dry counter	*Wet sink or counter*
Film for processing	Working-strength processing solutions
Film-processing tank and reels or hangers	
Scissors	Photo thermometer
Film cassette opener or bottle opener	Graduates
Darkroom timer	Funnel
Negative storage pages	

Check the time-and-temperature chart provided by the developer's manufacturer. Set the darkroom timer for the developing time specified, but do not start the timer yet. Take a final look around at the items on the counter. (See Figures 5-3 and 5-4.)

A

B

FIGURE 5-3

*Getting ready to process film. **A.** Check time-and-temperature chart for film/developer combination for normal developing time. **B.** Place small items in a dry tray in front of you so you can locate them easily in the dark.*

FIGURE 5-4

Electromechanical darkroom timer. May be set for intervals up to 60 minutes. Signals audibly at end of interval. Luminous face and hands can be read in total darkness. Timer is set but not switched on until processing starts.

Lights Off

3. *Remove the film from its container.* For 35-mm film, use the film cassette opener or a bottle opener to pry the end off of the cassette (the end opposite the protruding film spool), and remove the film. Unroll about 6 inches of the leader. Holding the film *carefully by the edges,* cut the tongue of the leader off square. (For larger roll films, tear open the seal and unwind the backing paper until you uncover the film; then proceed as above.)

 Always handle film by the edges and do not touch the emulsion with your fingers. Moisture and oils from your skin, if deposited on the emulsion, will retard development and leave permanent marks on the negatives.

4. *Load the film.* Following the manufacturer's instructions, load the film onto the processing reel or into the film hangers. Be sure to remove the tape that affixes the film to the spool.

5. *Load and seal the processing tank.* Place the loaded reel or hangers into the tank. Place the lid on the tank and seal it from light according to the manufacturer's instructions. (On stainless steel developing tanks, the small cap on the top of the lid is removable and provides a light-tight opening through which the chemicals may be poured in and out.) Once the main cover is on the tank, all remaining steps can be done in normal light.

Lights On

6. *Prepare for developing.* Prepare the required amount of working-strength developer and pour it into a graduate; note the temperature of the solution. Consult a time-temperature chart to determine the correct developing time. Set the darkroom timer accordingly.

 Optional Step: Some photographers prefer to presoak the film in a plain water bath prior to actual developing. This can be done by filling the processing tank with water at the same temperature as the developer; agitating for thirty seconds to one minute; discarding the water; and continuing with the developing procedure described on page 148. A presoak is often recommended with short developing times to assure an even

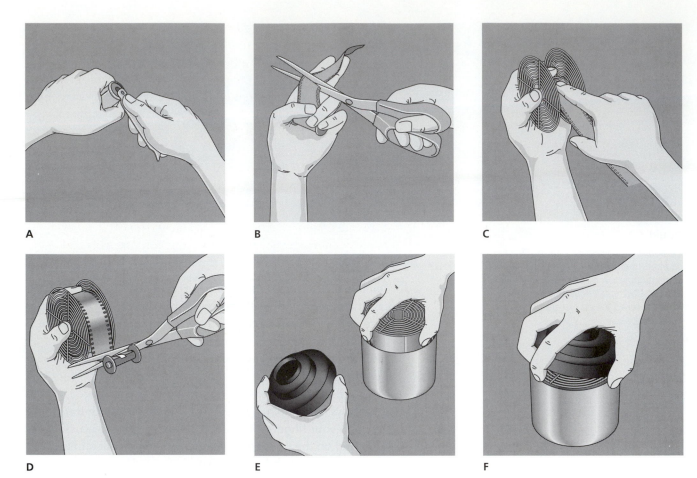

A

B

C

D

E

F

FIGURE 5-5

*Loading film. **A.** In total darkness, break open film cannister, magazine, or roll. Remove film, handling it only by edges. **B.** Square off leading edge of film if necessary. **C.** Start to load film onto reel according to manufacturer's directions. **D.** Remove tape at end of film. **E.** Place reel with film in processing tank. **F.** Seal with light-tight cover. Once sealed, work lights may be turned on for processing.*

penetration of the developing agents into the film emulsion, and also to reduce the possibility of air bubbles adhering to the film during processing.

7. *Start developing.* Pour in sufficient developer to fill the tank, place the small cap or vent cover over the opening, and then start the timer. The timer should be started immediately after each solution is poured into the tank.

 Optional Method: Some photographers prefer to fill the processing tank with developer and then, in total darkness, drop the loaded reels into the solution and place the cover on the tank. With either method the timer should be started as soon as the film is submerged in developer.

8. *Begin agitation.* Agitate the film according to the tank manufacturer's instructions. For roll films, tap the bottom of the tank gently on the counter or on the palm of the hand a few times before beginning each agitation cycle. This will dislodge any tiny air bubbles that may be clinging to the film surface. Then agitate the film gently for a full thirty seconds. After that, agitate the tank only intermittently—for five seconds every subsequent thirty-second period until the developing operation is completed.

 Different tank manufacturers may recommend different agitation procedures for their tanks. For most tanks, proper agitation consists of simply inverting the tank and returning it to

an upright position. Because this should be done gently, it will probably be possible to tip the tank upside down and back only two or three times in one five-second period. A gentle agitation moves fresh developer over all parts of the film and avoids patterned movements that may cause streaking. However, not all tanks are designed to be inverted during processing. Some tanks provide a device that rotates the reel within the tank, for example. Be sure to follow the instructions and establish a routine. Follow precisely the same agitation procedure every time.

9. *Pour out the developer.* When the darkroom timer indicates that the development has been completed, the developer should be removed from the tank immediately.

Some developers are meant for one-time use only and should be discarded after use or collected for ecological disposal. These **one-shot developers** can be poured down the drain or into a chemical refuse container. Other developers are reusable; they should be poured back into the bottles from which they came and retained for further use. Some reusable developers require that a special **replenisher** solution be added to the bottle after every use to maintain its strength; or, the developing time may need to be extended as successive rolls are processed. Keep track of the number of rolls of film developed with each bottle of reusable developer, because there is a limit to the number of rolls that can be processed before discarding it. (See Figures 5-6A through F.)

10. *Fill the tank with a clear water rinse or stop bath.* At this point, stop the action of the developer as quickly as possible by filling the tank with clear water or a chemical stop bath. Many photographers simply fill and empty the tank twice with plain water. Do not open the tank yet.

(Some acid stop baths tend to form small gas bubbles under the surface of the emulsion when they are used with certain developers, and the result may be small blemishes in the negatives. Nevertheless, the use of a stop bath is usually advisable with fast-acting developers; if only water is used, the action of the developer continues at a low level, and the result may be overdeveloped negatives.)

11. *Pour out the stop bath.* Water rinse is discarded; chemical stop bath may be saved after use. Again, do not open the tank. Follow immediately with the next step.

12. *Fill the tank with fixer.* After the stop bath, pour enough fixer into the tank to fill it. Set the timer for the fixer manufacturer's recommended fixing time. Agitate throughout the fixing cycle in the manner described in paragraph 8. Be sure that the film is fixed for the minimum recommended time; however, no harm will come to the film if it is overfixed for a brief time. Although the timing of fixing is not as critical as that of developing, extended immersion in fixer should be avoided, as it may tend to bleach the negative image.

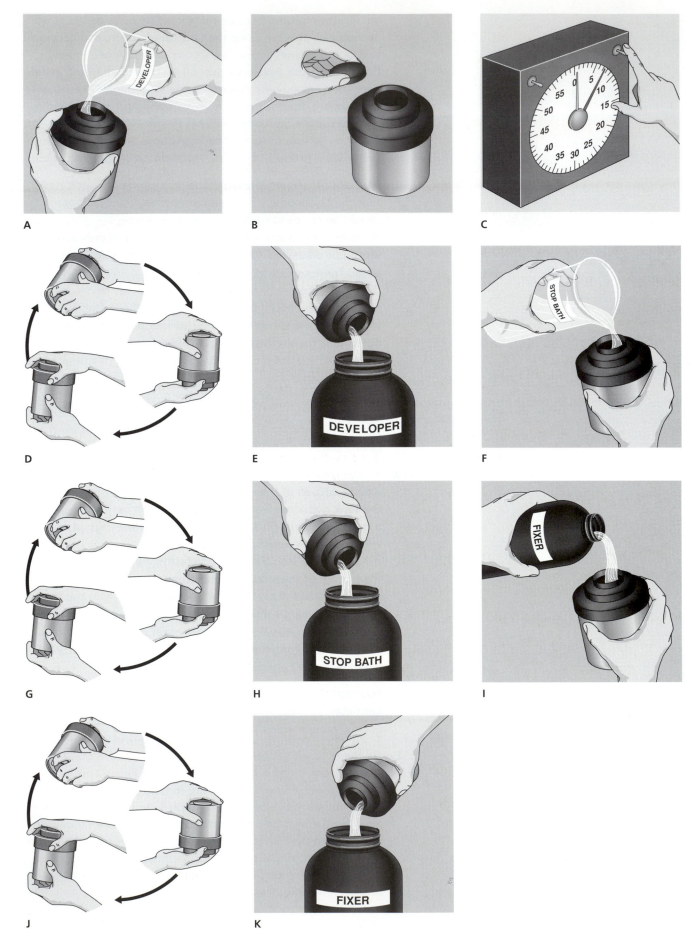

A

B

C

D

E

DEVELOPER

F

STOP BATH

G

H

STOP BATH

I

FIXER

J

K

FIXER

◄ **FIGURE 5-6**

*Processing film. **A.** Pour developer into tank through light-tight vent. (Handle later processing chemicals in same way.) **B.** Place vent cover over opening to prevent spillage of chemicals. **C.** Start timer. **D.** Agitate during development according to manufacturer's instructions. (Typically, tank is agitated continuously during first 30 seconds of development using a rotating and inverting movement; same movement is repeated for only five seconds in each subsequent 30-second interval throughout development.) **E.** Return developer to stock (or discard if one-shot developer is used). Pour all liquids from tank's light-tight vent. Never open tank during processing. **F.** Following development, pour water or stop bath into tank to stop developing action. **G.** Follow standard agitation cycle. **H.** Return stop bath to bottle, or discard water rinse. **I.** Pour fixer into tank, fix for the recommended time. **J.** Again, follow the standard agitation cycle. **K.** Return used fixer to bottle.*

13. *Pour out the fixer.* When the fixing cycle is completed, return the fixer to its storage bottle. The typical useful life of an acid fixer is quite long, and as many as twenty-five rolls of film can often be fixed in the same quart of reusable solution. The manufacturer's specifications will describe how long you can expect the fixer to last and how to tell when it is becoming exhausted.

14. *Check the condition of the negatives.* When the fixing cycle is completed, the processing tank may be opened for a look at the film. Take the cover off the tank and rinse the film briefly in water; then carefully unroll a few frames of the film for a quick inspection. Only the black negative image against a clear background should be visible; all traces of the milky white emulsion should have been cleared, along with the antihalation backing and the film should be ready for washing. If any traces of the opaque emulsion or purple antihalation backing remain, further fixing is required. Twice the clearing time is advisable for thorough fixation. (See Figures 5-7 A-B.)

15. *Begin the washing cycle.* Photographic processing leaves a residue of chemicals in the emulsion that can cause the image to deteriorate rapidly if it is not removed. To remove these residues, film should be washed twenty to thirty minutes under running water. Try to wash the film in running water at a temperature as close as possible to the processing temperature. The film can be washed in its processing tank under an open tap if care is taken to prevent the water from striking the emulsion directly. The water should flow gently across the surface of the film and carry chemical residues away. (See Figures 5-8 A-C.)

 Washing time may be considerably reduced by using either a high-speed washer or a chemical **clearing agent** or both. Many high-speed washers are available that significantly increase the flow of water across the surface of the film. A chemical clearing agent acts to neutralize most of the residue chemicals. With these two washing aids, the process can be shortened significantly, thereby conserving water as well. For best results, the film should be rinsed in water before using the clearing agent in order to remove the surface fixer.

FIGURE 5-7

A. Following fixing, open tank. Give film a quick water rinse and remove it from the tank. B. Inspect negatives under white light.

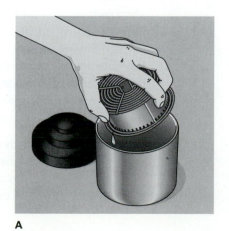

A

B

A

B

C

FIGURE 5-8

*Replace film on the reel for final wash. **A.** An efficient high speed film washer will shorten wash times. **B.** Or, a hose can be inserted in the tank to direct a gentle stream of water through the reel. **C.** After a thorough wash, place the film in a bath of wetting agent such as Kodak Photo-Flo.*

16. *Soak the film in a wetting agent.* Following the wash cycle the film can be dried. However, most water contains chemicals and minerals that leave visible spots when the water evaporates. To avoid the formation of water spots, a wetting agent may be used. Wetting agents reduce the surface tension of the water and encourage the water to drain from the film without forming droplets on the surface.

 Wetting agents are manufactured especially for photographic purposes. One popular agent is Kodak's Photo-Flo. Completely immerse the washed film, still wound on its processing reel or mounted on hangers, into the wetting bath for about one minute (or the manufacturer's suggested time). The wetting bath may be saved for further use.

17. *Hang the film to dry.* When the film is removed from the wetting bath, hold it stretched to its full length at a 45° angle for a few moments to allow the excess liquid to drain off. After this, roll film can be hung by a film clip in a dry, dustfree place, away from any walls or objects that might scratch or mar its surface. Roll film should have a film clip or clothespin attached to its bottom end as well to provide a weight, so that the film will hang straight and not curl as it dries. Film sheets are hung by a corner in a similar fashion.

 Some photographers advise removing excess water from the surface of the film at this point, using a clean photo chamois, a pair of squeegee tongs, a viscous sponge, or absorbent cotton that has been soaked and squeezed dry. Others recommend allowing the thoroughly wetted film to drip dry. If the film is wiped, floating particles of dust and grit may be rubbed firmly into the emulsion. On the other hand, drip drying risks the formation of water spots. Several methods should be tried under prevailing laboratory conditions to find the method that works best. (See Figures 5-9 A-B.)

18. *Tally and replenish the developer.* If a reusable developer is used, immediately add the exact amount of replenisher specified by the manufacturer. On the lid or label of the developer bottle, tally the number of rolls developed. If these procedures are

FIGURE 5-9

*Drying processed film. **A.** Remove excess water or wetting agent from film with photographic sponge or squeegee tongs, or allow to drip dry. **B.** Hang film in drying cabinet or other dustfree place.*

A

B

FIGURE 5-10

*Replenishing developer (optional). **A.** Following use of reusable developer, you may add replenisher to stock to revitalize developer's strength. **B.** Tally each roll developed on developer container so you will know when stock is exhausted.*

A

B

followed, the developer will be maintained at full strength and remain usable for the next batch of film. (See Figures 5-10 A, B.)

19. *File the negatives.* When the film is completely dry, cut and file the negatives. Roll-film negatives are cut into lengths of three to six negative frames each, depending on the film size. These strips are then stored in plastic negative file pages or sleeves for future use. Do not store negatives without protection, as they are easily scratched when stored loose. (See Figures 5-11 A, B.)

FIGURE 5-11

*Cutting and storing negatives. **A.** Cut finished negatives into strips. Do not separate individual frames. **B.** Insert negatives into plastic negative file pages.*

A

B

Evaluating Negatives

Objective 5-B Examine and evaluate negatives for proper exposure and developing.

Key Concepts density, thin, dense, expose for the highlights and develop for the shadows, underexposure, overexposure, tonal range, contrast, overdeveloped, underdeveloped, grain, flat

Careful visual examination of negatives can reveal much about the exposure and processing that the film received. It can also help to pinpoint problems that will need correction when the final print is made.

Evaluating Density

Begin by laying the negatives on a light table or holding them above a white sheet of paper illuminated by a desk lamp. Notice that the **density,** or degree of blackness, varies within the negative to correspond to the different subject brightnesses. Remember that negatives are tonally reversed: The bright objects in the original scene have become the darkest on the negative, and the original dark objects have become the lightest on the negative.

In general, we can describe a technically "good" negative as one that has a full range of tones. The film should be dense enough to record detail in all areas, but not excessively dark. Shadows, middle tones, and highlights should all show visible separation. No large, important shadows should be completely transparent, and no important highlights should be completely opaque.

Examine the strip of film. A few negatives may be very pale and predominately transparent. Such weak images, characterized by a lack of overall density, are often called **thin** negatives. Unless special printing controls are used, thin negatives will result in prints that are too dark. Conversely, a few frames may be very **dense**. Negatives that are overly dark with heavy deposits of silver are hard to see through and will produce prints that are too light. See Figure 3-17 for examples of thin, normal, and dense negatives.

Exposure and Its Relation to Shadow Density

Diagnosing negative defects can be difficult; problems of negative density can be caused by the amount of developing the film received, the amount of exposure the film received, or a combination of both. Both exposure and processing errors can create problems in the tonal rendition, granularity, and even sharpness of the resulting photographs. To help separate and identify exposure problems from development errors, remember this old photographic adage: *Expose for the shadows, develop for the highlights.*

The amount of detail recorded in the shadow areas of the negative is almost entirely determined by the amount of light originally admitted into

FIGURE 5-12

Negatives should be evaluated by an even and diffused light source. Here a desk lamp is bounced off a white card to provide proper viewing conditions.

the camera. Too little light or **underexposure** produces a negative that is thin or pale overall, but especially so in the shadows, where underexposure results in a failure to record some details at all. No amount of additional development can make those lost details appear.

Examine the light areas of the negatives for shadow detail. Even if the overall density of the negative seems adequate, look closely at the important light areas of the negative, which will produce the dark tones of the final print. An underexposed negative lacks the crucial shadow density necessary to record and render detail in these low values of the print. This underexposure will result in a weak print—one that is missing texture, fullness of detail, and a sense of volume in the darker subject areas.

Conversely, **overexposure** will result in negatives that are excessively dense overall, especially in the dark areas of the negative, which will produce the light areas of the final print. Excessive density anywhere in the negative causes an increase in grain and a loss of sharpness and detail.

A normal negative is neither excessively light nor excessively dark overall. It is rich in detail in all three important areas: shadows, midtones, and highlights. When negatives are viewed by reflected light, the viewer should just barely be able to see through the densest highlight areas of the negatives. This indicates that light is transmitted through these areas.

Development and Its Relation to Highlight Density

The lighter subject tones, or highlights, are strongly affected by film development. Film developers act by chemically multiplying the number of grains of metallic silver that are formed from the few atoms of silver that were originally affected by exposure to light. This process has a far greater effect on the highlight areas, which have had much greater exposure to light, than on the shadowed, darker areas, which have had much less exposure; the highlights tend to darken more and at a faster rate as development proceeds. Thus, changing the development time causes changes in the relationship between highlights and shadows, or the **tonal range**—what photographers call **contrast**.

Overdevelopment results in negatives that are excessively dense and too contrasty. Highlight areas in an overdeveloped negative will appear blocked or nearly solid black and will be devoid of textural information in the final print. The excess density also results in larger clumps of silver crystals on the negative, giving the print a **grainy** or textured appearance when it is enlarged.

Underdevelopment reduces highlight density, yielding a low contrast or **flat** print. Such negatives lack the tonal separation necessary for making prints rich and bright, with texture and detail. Flat prints are typically a muddy, overall gray, lacking crisp highlights, deep blacks, or both.

Factors Affecting the Action of the Developer

The type of developer used, the temperature of the developer, the time of the development, and the amount of agitation—all of these factors affect the action of the developer on the film. If the developer is too cool, if the development time is too short, or if agitation is insufficient, an

underdeveloped negative will result. Such a negative will be thin, lacking in contrast, and difficult to print well.

Conversely, if the developer is too hot, if development time is too long, or if agitation is excessive, an overdeveloped negative will result. Such a negative will be too dense, too grainy, with too much contrast, and it will also be difficult to print well.

Optimum results come only from a careful balance of development time, temperature, and agitation. Through experience, photographers eventually discover methods that produce results most satisfying to themselves. Until then, follow the manufacturers' recommendations. Film developing is a highly precise operation, and good results depend upon care and consistency.

Checking for Correct Film Development

Both incorrect exposure and incorrect development can cause abnormal negative density. One quick, rough way to check for correct film development is to look at the frame numbers and markings along the edge of the developed film. These letters and digits were imprinted with light at the time of manufacture and should appear crisp and dark on correctly developed film. If the numbers are excessively dark and the small spaces, or counters, within the letters appear partially filled in, the film was probably overdeveloped. Similarly, if the letters are weak and gray, the film was probably underdeveloped.

Importance of Optimum Exposure and Development

The ideal negative results from a combination of the correct film exposure and the right amount of development. Such a negative would have the minimum exposure necessary to assure good shadow detail and the shortest film development time necessary for adequate highlight density and contrast.

Although both exposure and development alter density, they are not interchangeable or mutually compensating. An underexposed negative cannot effectively be saved by overdeveloping. Such a procedure would boost density, but mainly in the highlights, and any gain in printing ease would come at the expense of added contrast and grain. Correspondingly, an overexposed negative that receives reduced development may be a bit easier to print, but will display a compacted tonal range and muddy values.

Common Film-Developing Problems

The first few rolls of film shot by a beginning photographer often suffer from a host of small, annoying mechanical errors. Until more experience with the procedures is gained, negatives are likely to show defects from improper loading of the reels, air bells, and other processing difficulties. For examples and descriptions of common film-developing problems, see Figure 5-14 and, in Unit 7, Figure 7-27.

A

B

C

D

E

F

G

H

FIGURE 5-13

*Troubleshooting film processing. **A.** No developer, bad developer, or fixer used first. Negative is clear with no edge markings. **B.** Print of A. **C.** No exposure. Negative is clear but edge markings are visible. Presence of edge marks assures that film was processed correctly.*

*D. Print of C. **E.** Film improperly loaded onto reel. No chemicals reach areas where film is touching itself, leaving gaps in image. **F.** Print of E. **G.** Film not fully advanced. One image exposed over another. **H.** Print of G.*

(continued)

I

J

K

L

M

N

O

P

FIGURE 5-13 CONTINUED

I. Light fog. Film struck by light when camera back opened with film in gate. J. Print of I. K. Insufficient developer in tank. If developer level does not cover film, parts of image may be underdeveloped. L. Print of K. M. Cinch marks. Film is sensitive to pressure; crimping

film during loading may cause marks such as these. N. Print of M. O. Air bells. Small bubbles formed on surface of film during processing prevent proper development if not dislodged by agitation. P. Print of O.

A

B

FIGURE 5-14

Contrast and processing. **A.** *A low contrast scene given normal film development will appear flat and lifeless when printed on normal contrast paper.* **B.** *Given extended film development time the negative will gain contrast and yield a print with greater tonal separation and vitality.*

Summary

The ultimate test of a negative's quality is its ability to print well and easily. A good negative yields a print that is rich in detail and expresses the photographer's intent. As photographic experience grows, so does ability to analyze, evaluate, and correct exposure and development problems. If prints are consistently lacking in shadow detail, it is likely that the film is being systematically underexposed. To correct for this and to increase detail in the darker areas of the scene, try slightly increasing camera exposure; lower the film speed setting on the camera or meter by 25 to 50 percent. For example, for a film rated ISO/ASA 400, try setting the camera's film-speed setting to ISO/ASA 300, or even ISO/ASA 200. Many photographers find the resulting additional exposure to be a more normal film-speed setting for their own photographic system.

Some photographers also make slight adjustments to the manufacturer's suggested film developing times for their personal working styles and subjects. Remember, expose for the shadows and develop for the highlights. In other words, if negatives systematically lack contrast and the darkest areas of the negative are too light, it may be necessary to increase negative contrast by increasing the development time. Increasing the development time will increase the highlight density, thereby raising the negative's contrast. Such negatives also will be easier to print normally. To experiment with increased development times, try increases of no more than 5 percent at a time.

Sometimes photographers modify development time in an effort to compensate for an abnormal contrast range in the original camera subject. For example, suppose a roll of film is shot under low-contrast lighting, such as that present on an overcast day. The resulting negatives from that roll can be expected to be too flat for normal printing; this can be compensated for by slightly increasing the film development time. Keep development time increases within 5 percent of the manufacturer's recommended time until some experience is gained.

Changing the film development time to adjust for subject and lighting values is practical only if a whole roll of film has been exposed to the same contrast conditions. Sheet film users have an advantage in this respect, because they can modify development time for each negative as they wish. (See Figure 5-14.)

FIGURE 5-15

Imogen Cunningham, "Two Callas," about 1929.

Greatly respected for her soft-form, rhythmic images, Imogen Cunningham, when ninety, said, "People often marvel at me. 'I don't know how you keep so busy,' they say. 'Keep busy!' I repeat. 'I don't keep busy. I am busy.'"

Indeed, Cunningham's career spanned more than seventy years, beginning with her study of chemistry at the University of Washington. After graduation, she took a job at the Curtis Studio, where she printed hundreds of Edward S. Curtis's photographs of North American Indians onto platinum paper. She spent a year in Dresden on a national scholarship for advanced study of photochemistry and then returned to Seattle to establish her first portrait studio.

Inspired by Gertrude Käsebier, Cunningham enjoyed her first major exhibition in 1912. She continued to exhibit throughout her life in major art museums, institutes, and universities throughout America, including the International Museum of Photography, the Art Institute of Chicago, the Library of Congress, and the Smithsonian Institution. Her work moved early toward new realism, with its emphasis on sharp focus and unmanipulated images. In 1932, she joined Willard Van Dyke, Edward Weston, Ansel Adams, and others in Group f/64. Later in her career, she taught at the San Francisco Art Institute and lectured widely at colleges and universities throughout the country.

Although portraiture occupied a good part of Cunningham's professional activity, she is best known for her nudes, plants, and nature studies. Her images, rich with tone, palpable textures, and clean, simple form, often convey great sensuality.

Adapting to Available Light

Objective 5-C Explain and demonstrate the rationale, materials, and procedures of push processing.

Key Concepts Available light, overrate, exposure index (EI), high-energy developer

News photographers, photojournalists, and others are often called upon to produce images by **available light** under conditions that are far from ideal. Working in low light frequently requires that the photographer use very wide aperture settings to achieve adequate exposure; however, using such large lens openings greatly reduces the range of focus and the chances for obtaining a sharply focused image. Alterna-tively, the photographer may select a smaller aperture to increase the range of focus and compensate for the reduced illumination by selecting a slower shutter speed; however, using a slow shutter speed increases the risk that the images will be blurred due to subject movement or camera shake.

Overrating the Film Speed

What can be done if the photographer's visual interpretation calls for higher shutter speeds or more depth-of-field than the lighting conditions permit? Some photographers continue to use their regular films for low light conditions, but deliberately underexpose them by overrating the film speed.

The ISO/ASA film speed index is an arbitrary rating set by the manufacturer. Its effect may vary from camera to camera, person to person, and process to process. Numerous variables may affect effective film speed, such as variations in actual shutter speeds, personal taste in negative qualities, and individual differences in processing methods. The term **exposure index (EI)** is a measure of effective film speed according to individual circumstances. Thus, a film with a manufacturer's rated speed of ISO/ASA 400 might intentionally be shot with the light meter set at an exposure index of EI 1600. In a sense, this is tantamount to pretending that the film's rated ISO/ASA is 1600 instead of ISO/ASA 400. Setting the camera's film-speed setting to ISO/ASA 1600 would allow use of smaller apertures and faster shutter speeds and would systematically underexpose the film by two stops.

Suppose a photographer is covering an indoor basketball game where the available light is too dim to use an appropriately fast shutter speed and small f/stop. For example, with ISO/ASA 400 film, the meter exposure might be 1/30 sec. at f/2.8. The photographer determines that this shutter speed is far too slow to stop sports action. To deal with this problem, the camera or light meter might be set to a film speed of EI 1600. Because each doubling of the exposure index reduces the required exposure by half, two stops less exposure is now required. The meter exposure now becomes 1/125 sec. at f/2.8. Here's how it works:

exposure at ISO/ASA 400 = 1/30 at f/2.8

EI 800 = 1/60 at f/2.8

EI 1600 = 1/125 at f/2.8

A faster lens would allow use of an equivalent exposure with a wider aperture, such as 1/250 sec. at f/2.0 for even more action-stopping power.

Push-Processing

Simply changing the exposure index has no effect on the real film speed, which is determined solely by the sensitivity of the silver halides used in making the emulsion. Overrating the film always results in underexposing the film. As discussed previously, underexposure causes a loss of shadow detail. Nevertheless, many photographers faced with less than ideal lighting conditions will elect to overrate the film speed and then **push-process** the film—increase development time to partly compensate for the underexposure. Push-processing helps make otherwise lost images printable by increasing the density of the midtones and highlights. In many available light situations, push-processing may be the only way to get the picture.

Conventional fast-speed black-and-white films can usually be exposed at an EI double their rated ISO/ASA film-speed index—from ASA/ISO 400 to EI 800—and still provide a print with acceptable detail and contrast. This is done by extending the development time 50 percent beyond normal. Note that only the developing time is changed; all other processing steps remain the same.

Doubling the film developing time provides approximately a two-stop push, say from ISO/ASA 400 to EI 1600. This is about as far as one can go with conventional films and film developers. For even higher exposure indexes it is advisable to use special **high-energy developers** with sodium sulfite. (See Table J-3, Appendix J, for a list of typical film developers.) These powerful special-purpose developers can give usable results with conventional fast-speed films to EI eight times the rated ISO/ASA film-speed index (a three-stop push).

Note that the above guidelines are for conventional black-and-white films only. For other films, see the manufacturer's product sheets for specific push-processing times.

An Alternative to Pushing

Recent advances in film manufacturing technology have introduced black-and-white films with nearly magical film speeds and image qualities. The new tabular-grain films, such as Kodak T-Max P3200, and a similar product from Ilford, offer exceptionally high film speeds combined with reasonably fine grain. These new films allow for photographing in situations that were previously impossible and have become the standard for working in low light levels.

T-Max P3200 film was designed to be shot at EI 1000 to EI 1600 without the need for push-processing. Working photojournalists routinely process it at normal processing times to EI 3200 or even 6400 with

excellent results; extended processing times can give usable results at speeds as high as a whopping EI 25,000! This is six stops faster than a conventional ISO\ASA 400 film.

These super high-speed films present new creative opportunities for many photographers. Sports photographers can now use longer (and slower) lenses for night football games, spot news pictures can be recorded by streetlight illumination alone, and evocative portraits can be made in the darkest environments. (See Figure 5-16.)

Summary

Push-processing is not a magic cure. Best results come from using the fastest film available and pushing as little as possible. The more the processing time is pushed, the more shadow detail decreases; further, extended development always results in extra contrast, bigger grain, and a loss of sharpness. However, if the picture must be captured, and light levels are too low, push-processing can help make a print that expresses just what the photographer had in mind.

FIGURE 5-16

Sports action shots often call for extended developing times or special film developers to "push" the speed rating of the film, thus permitting action photography under available light.

Questions to Consider

1. How does the developer affect the film? What is the purpose of fixer?

2. What are some of the factors that affect the action and rate of the film developer?

3. What factors can cause thin negatives? Dense negatives?

4. How does contrast relate to film developing time?

Suggested Field and Laboratory Assignments

1. Complete your acquisition of all film processing supplies, including developer, stop bath, fixer, clearing agent, and so forth. Complete arrangements for the use of a darkroom for film processing.

2. Prepare and mix all chemical solutions following the manufacturer's instructions. Determine the working dilutions, if any, processing times and temperatures, and other pertinent data. Record this information on the film-developing summary sheet in Appendix K on page 451 for convenient reference as you develop your initial rolls of film.

3. Using a processing tank, reel, and roll of dummy film, practice loading the film onto the reel under normal light. Practice until the loading becomes a reflex action. When you feel confident, practice loading the film in total darkness.

4. Develop one roll of exposed film (or more if necessary) so that you end up with a batch of usable negatives on a variety of subjects. If your first development efforts fail, shoot and process additional film until you have completed the assignment.

5. Conduct an experiment to observe the physical reaction of film to the processing chemicals. Take a strip of waste film, such as the leader tongue from an exposed roll, and process it in open containers under white light. Immerse the strip halfway into the developer tank or tray and note how the density gradually builds. Now transfer the strip through a brief rinse into a container of fixer. Immerse the entire strip in the fixing bath. Compare the action of the fixer on the developed areas to its effect on the undeveloped areas. Are frame numbers and other edge markings present? Why?

Unit Six

Basic Print Making

David L. DeVries, "Fall Evening," 1982.

The photographic printing process follows exposure and developing theories and steps similar to those that you used in camera work and film developing. The basic craft operations of print making are not difficult, but they do require a careful and orderly approach. Processing photographic paper, unlike film, is carried out in open trays under colored safelight conditions. Thus, you can watch the print develop as the paper is moved through the chemical baths. Seeing your first image materialize on what was a previously blank sheet of paper is an almost magical moment sure to delight you.

This unit describes the basic tools and materials used in photographic printing. An overview of contact printing, print processing, and enlarging is presented along with the theories involved in each procedure. Step-by-step operations provide guidance through the basic printing processes.

Tools and Materials

Objective 6-A Identify the basic printing materials and tools, including parts of a typical enlarger, and explain their functions.

Key Concepts lamp housing, condenser housing, negative carrier, condenser housing lever, bellows, lens and lensboard, elevator control crank, elevator lock knob, focusing knob, base, power plug, timer, easel, focusing magnifier, proofer, safelights, print siphon, archival washer, drying racks, heated drum dryer, fiber-base, resin-coated (RC)

The Enlarger

At the heart of a printing darkroom is the enlarger—the principal tool for making prints from negatives. Enlargers vary in complexity. Some offer adjustments for different negative sizes and formats, for modifying the optical system, for modifying perspective controls, and for automatic focusing, to name a few. Other enlargers are relatively simple mechanisms designed for a single negative format without additional features. The following discussion describes the features found on most modest enlargers, although the physical design may vary considerably among manufacturers.

The typical enlarger is designed to pass an evenly distributed beam of light through a negative and a lens so that an image of the negative is focused on a sheet of light-sensitive photographic paper. The design also provides that no ambient or stray light is emitted elsewhere from the enlarger and that the enlarger can be adjusted to change the size of the projected image. Figure 6-1 shows the functional parts of a typical enlarger.

The **lamp housing** is an enclosure for the light source—usually a photo-enlarger lamp. It is fully enclosed to prevent light from leaking out except through the lens. Typically it is designed with cooling vanes to dissipate excessive heat and to keep the lamp housing as cool as possible during use.

FIGURE 6-1

Anatomy of an enlarger.

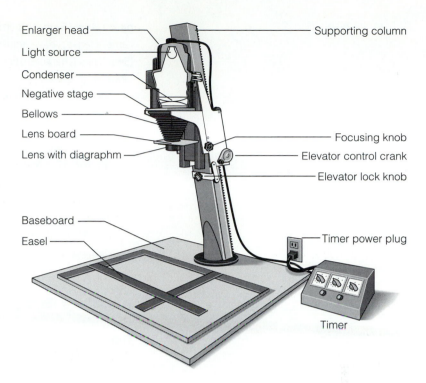

Enlarger head — Supporting column

Light source

Condenser

Negative stage

Bellows

Lens board — Focusing knob

Lens with diagraphm — Elevator control crank

— Elevator lock knob

Baseboard

Easel — Timer power plug

Timer

The **condenser housing** usually contains one or more lenses designed to gather and concentrate the light and to pass an even field of light onward through the negative. Usually these condenser lenses are adjustable for varying sizes of negatives. The housing may also contain a translucent sheet of glass to diffuse the field of light. Some enlargers, especially color enlargers, omit the condenser lenses and use only the translucent glass to create an evenly diffused field of light.

The **negative carrier** is a device for holding the negative in place during enlargement and masking off the edges. Negative carriers vary widely. Some hold the negative flat between two planes of glass. These require careful dusting of the glass surfaces as well as the negatives prior to exposure. Others omit the glass and sandwich the negative between two sheets of metal or plastic with cutouts to frame the negative image.

The **condenser housing lever** allows the entire lamp and condenser housing assembly to be raised so that the negative carrier can be inserted into position. The assembly is then lowered onto the surface of the negative carrier, forming a lightproof seal. During use, care must be taken not to raise the lamp housing while the source light is turned on—light will spill out of the enlarger in all directions and may fog sensitive materials.

The **bellows** is a collapsible housing on which the lensboard is mounted. It allows the lens to be moved closed to or farther from the negative for focusing.

The enlarger lens is mounted on a board and the board is mounted on the enlarger at the lower end of the focusing bellows. These **lenses** and **lensboards** are usually interchangeable so that lenses of different focal lengths may be used with different negative formats. For any negative format, the normal enlarger lens will have the same focal length as the normal camera lens. For example, a 50-mm enlarger lens is normal for 35-mm negatives; a 75-mm or 80-mm enlarger lens is normal for 2-1/4 in.

Tools and Materials **167**

by 2-1/4 in. (6 cm by 6 cm) negatives; and so forth. Enlarging lenses, like camera lenses, have adjustable apertures to vary the intensity of the light. (See "Lens Characteristics," page 65, for a discussion of normal focal length.)

The **elevator control crank** is used to raise and lower the entire enlarger head in order to change the size of the projected image.

The **elevator lock knob** is used to lock the enlarger head in position to avoid accidental slippage.

The **focusing knob** is used to focus the negative image on the printing paper.

The **base** is the board or surface on which the entire enlarger assembly is mounted and on which the paper-holding easel is usually placed.

The **power plug** provides power to the enlarger. Normally it is plugged into the timer, which in turn is plugged into the wall outlet.

Ancillary Equipment

Timer The **timer** is an important component of the enlarger system. It allows for precise timing of exposure to the nearest second, and it provides for manual lamp turn-on during focusing. Some timers make an audible click every second to help the operator time portions of the exposure. By controlling the duration of the exposure, the timer's function is analogous to that served by the shutter of a camera.

Easel The **easel** is simply a framing device that holds the photographic paper flat during exposure by an enlarger. The metal blades, or frame, of the easel overlap the edges of the photo paper and mask them from light, thereby creating white borders on the final print. Most easels can be set for a variety of different sizes and shapes of rectangles.

Focusing magnifier Focusing an enlarger can be done with the naked eye, but for greater precision many darkroom workers prefer to look through a device that magnifies the view. Some **focusing magnifiers** amplify the projected image by twenty-five times or more so that the individual silver grains that create the image are visible and can be used to focus on. (See Figure 6-2.)

Contact proof frame A **proofer** consists of a sheet of plate glass mounted in a frame and hinged on a base. It provides a convenient means for sandwiching negatives and photo paper under glass for contact printing. (See Figure 6-3).

Safelights Because most photographic paper is orthochromatic (insensitive to the red-amber portion of the spectrum), printing processes are usually handled under colored **safelights**. The most common printing safelights are light amber or yellow-green. Usually, the safelights are set at an intensity that will not affect the paper emulsion yet are bright enough for pleasant work.

Print washer After processing, the photographic paper is saturated with chemical residues that must be washed away. Most of these residues are heavier than water, so many washing devices feature some method of

FIGURE 6-2

Enlarger accessories. Electronic timer, adjustable easel, blower brush, and critical focusing device.

FIGURE 6-3

Proofer. Provides a convenient method for sandwiching negatives and photo paper under glass.

A

FIGURE 6-4

Print washers. ***A.*** *Drum-type print washer.* ***B.*** *Tray siphon washer is convenient at work station. Especially useful for RC papers.* ***C.*** *Archival washer designed to remove all traces of residual chemicals and to hold individual prints separate during washing. Prints processed in archival manner are suitable for long-term storage.*

B

C

FIGURE 6-5

Print dryers. ***A.*** *Commercial rotary dryer with heated ferrotype drum. Not for use with RC papers.* ***B.*** *Fiber-glass drying screens use no heat and only natural air flow, while also avoiding harsh treatment of prints and chemical contamination. Useful for drying archival prints. May be used with fiber-based or RC papers.* ***C.*** *RC print dryers are designed especially for drying resin-coated papers. They squeegee the prints and quickly dry them with blasts of heated air. Not suitable for fiber-based papers.*

removing the used wash water from the bottom of the tank or tray, while injecting fresh water on the top.

A simple **print siphon** clipped to a tray makes an economical and effective print washer, especially for RC prints. Aquarium-style **archival washers** are the ultimate tool for removing all traces of chemical contaminants from fine exhibition-quality fiber-based prints. (See Figure 6-4.)

Drying racks and lines The simplest method of drying photographic prints after processing is just to suspend them by clothespins from a line and allow them to air dry. Alternately, prints may be air dried by placing them flat on **drying racks** made of fiber-glass screens similar to the frames used for home window screening. Either method is recommended for use with resin-coated (RC) photo paper, which has short drying times. For even quicker drying, a heated air-impingement RC dryer may be used. In such machines the print, sandwiched between two net belts, is carried through a very heavy blast of heated air that rapidly removes all moisture. (See Figure 6-5.)

A

B

C

Fiber-based prints curl excessively if hung on a line to dry and need several hours to dry on screens. Nonetheless, racks and screens are often used to dry exhibition quality fiber-based prints when time is not of the essence.

Heated drum dryers Although all papers may be air dried, the process is quite slow for fiber-based papers that have absorbed a great deal of fluid and tend to curl if dried this way. To speed up the drying process, heated dryers have been developed for both amateur and commercial markets.

Heated drum dryers are for use *only* with fiber-based papers; their surfaces are hot enough to melt and damage the plasticlike coating of RC prints. These dryers often have highly polished, shiny metal drums that act as **ferrotype plates** to impart a high gloss finish when used with glossy fiber-based paper. Alternately, the prints can be dried face down for a nonshiny finish. The hot drums make quick work of drying fiber-based prints, but their cloth covering belts are easily contaminated with chemical residues that may stain prints.

Kinds of Photographic Paper

Photographic printing papers are of two general types: **fiber-based** and **resin-coated (RC)**. The emulsion of fiber-based paper is applied directly onto the surface of a sheet of porous paper. As photographic chemicals soak through the emulsion during processing they are absorbed into the paper base. Resin-coated (RC) papers differ in that the paper base is first coated with resin, a hard, plasticlike substance that produces a good gripping surface and is impervious to water. Photographic chemicals can enter the emulsion, but they do not penetrate the paper base. As a result, the paper base, sealed in its envelope of resin, remains free of photographic chemicals.

Relative advantages and disadvantages of photographic papers Resin-coated (RC) papers greatly speed up darkroom work by reducing the time required to process a print. Washing time is also drastically reduced, saving both time and water. Furthermore, RC prints dry very quickly and lay flatter than fiber-based prints. For these reasons resin-coated (RC) photographic paper has become the standard printing material for beginners, photojournalists, commercial photographers, and others who appreciate its convenience.

On the other hand, fiber-based papers come in a greater variety of surface textures, base tints, and image colors, and give the photographer a wider range of expressive choices. Also, some people think that RC prints have a slightly "veiled" look, perhaps caused by the plastic coating. A correctly processed fiber-based print is also more stable than a RC print and has a much longer life expectancy. Applications that require **archival images,** where the prints need to be suitable for long-term storage and use, are best handled on fiber-based materials. For all of these reasons, exhibition photographers and others seeking the maximum in print quality may choose to print on fiber-based papers.

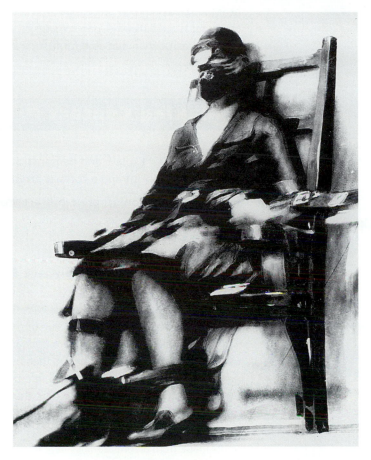

FIGURE 6-6

Tom Howard, "The execution of Ruth Snyder," January 12, 1928.

Convicted with her lover of murdering her wealthy husband, Ruth Snyder was sentenced to die in Sing Sing Prison's electric chair on January 12, 1928, following lurid and sensational coverage of the trial in the tabloid press. Although reporters were permitted to witness the execution, Sing Sing officials banned photographers.

In this era of "front page journalism," when every newspaper strove, by fair means or foul, to outdo and outwit the competition, the *New York Daily News* plotted a scheme to sneak a photographer into the death chamber to get the picture. City editor Harvey Duell and picture editor Ted Dalton enlisted the aid of *Chicago Tribune* photographer Tom Howard, who, they reasoned, because he was not known locally, could pass as a reporter. Duell and Dalton devised a way to strap a miniature camera to Howard's ankle and to run a cable release up his pant leg into his pocket.

With the aid of secretly obtained blueprints of the execution chamber, the men determined a shooting position and a range of focus. Howard proceeded to practice using his apparatus for a month before the execution date—they all knew that he would get only one chance at the shot.

On the night of the execution, Howard was admitted as a reporter without incident. He took up his position as planned. At the critical moment, he pointed his shoe in the direction of the condemned prisoner, hiked his trouser leg, and made one shot for each death-dealing jolt. A few hours later, in the early morning of Friday the thirteenth, Howard's picture ran full front page in an extra edition of the *Daily News* with a one word headline: "DEAD!"

Although many consider making the illegal picture to be a breach of journalistic principles and ethics, the memorable image captures the eery drama of the historic first execution of a woman by electrocution.

Print-Processing Chemicals

Processing black-and-white prints is done in open trays of chemical solutions. The exposed photographic paper is moved successively through baths of developer, stop bath, and fixer. Although these chemical steps bear the same names as those used in film developing, the specific chemical formulas are different—print-processing chemistry is generally stronger and more active than that used for film.

Making Contact Prints

Objective 6-B Explain and demonstrate the procedures used to make a contact print and a contact proof sheet.

Key Concepts contact print, contact proof sheet, enlarger method, contact proofer

Contact Prints and Contact Proof Sheets

A *contact print* is simply a print made with the negative in contact with the photographic paper. The emulsion side of the negative is placed in contact with the emulsion side of the paper under a darkroom safelight. A sheet of clear glass or a contact print frame is then used to press the paper and negative together, facing the light source. The paper is exposed briefly to white light and then processed. Because the negatives directly contact the paper, contact prints are the same size as the negatives.

A **contact proof sheet** is a single sheet of paper that contains contact prints made from an entire roll of film. Its main purpose is to provide a black-and-white, positive preview of the images contained in the strips of negatives. The individual images need not be fine prints; they need only provide a record of the negatives for later reference. Contact sheets are used to make editorial and selection decisions. Each frame can be inspected with a magnifier before enlarging so that composition and expression can be evaluated. Many photographers also use contact sheets as the heart of their filing system, and keep their negatives and proof sheets in three-ring binders designed for this purpose.

A contact proof sheet is made by contact printing a whole roll of negatives at one time. The roll is cut into strips of four to six frames, depending on the film size. These strips are then placed side by side on top of an 8-in. by 10-in. sheet of photographic enlarging paper, emulsion to emulsion. The negatives and paper are sandwiched into close contact under glass, and the exposure is made. The paper is then processed in the usual manner. Figure 6-7 depicts the steps for making a contact proof sheet.

A

B

C

D

◄ FIGURE 6-7

Making a contact proof sheet. **A.** *Cut negatives into strips about 7 in. to 8 in. long.* **B.** *Insert film strips into a negative file page.* **C.** *Place the page on top of an 8-in by 10-in sheet of enlarging paper, emulsion to emulsion. Cover with a clean sheet of glass and expose. (Tape the edges of the glass to prevent cuts.)* **D.** *A special film proofer may be used in place of a simple sheet of glass. Some proofers have clips to hold film strips for contact printing directly without the use of plastic negative pages.*

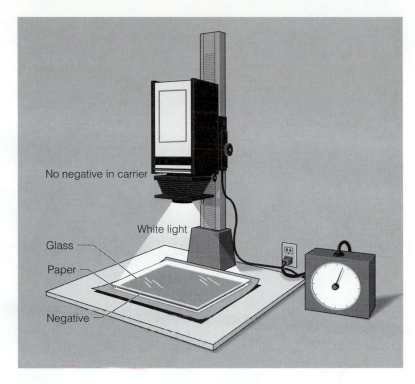

FIGURE 6-8

Enlarger method of contact printing. Enlarger used as source light for negatives in contact with enlarging paper on the enlarger base. Enlarging timer can be used to control exposure.

FIGURE 6-9

Open-bulb method of contact printing. Use enlarging paper for this method.

Light Sources, Test Prints, and General Procedures

Contact prints can be exposed by any accessible light source, such as a table light or even an open bulb. Photographic enlargers are commonly used for contact printing simply because they offer a convenient light source that is already present in most darkrooms.

The enlarger method is illustrated in Figure 6-8. The negative and enlarging paper are sandwiched together under glass, emulsion to emulsion, and placed on the base of the enlarger. Then the enlarger timer is switched on to make the exposure, with the enlarger providing a light source for the exposure. A **contact proofer** can be used to hold the negative and paper. It provides a glass lid hinged to a base for convenient handling. (See Figure 6-3.)

Test prints tell the correct exposure for any particular negative and lighting condition. As shown in Figure 6-9, an opaque card can be used to lessen exposure of portions of the negative that need less light for correct exposure. Or, a small hole can be torn in the card to give certain areas of the print more exposure than the rest.

Every roll of film contains negatives that vary in density and contrast. For this reason, it is rare that good prints will result from every negative on a single proof sheet; a single exposure may be too long for some frames and too short for others. Thus, some of the contact prints may appear too dark and some too light. The exposure time selected represents an average exposure for the whole roll.

FIGURE 6-10

Three members of the Dream Team at the awards ceremony of the Summer Olympic Games, 1992.

Many photographers seek to enter a career in news photography or photojournalism, which includes reporting timely news events as well as more general stories and features dealing with more complex ideas and social issues by means of photographs published in newspapers, magazines, television, and film.

The use of photography to chronicle important events began almost with the beginning of photography itself and continued a long tradition of visual journalism evident in the wood cuts and engravings made by artist-reporters found in newspapers and magazines throughout the seventeenth and eighteenth centuries. Within a decade of Daguerre's public announcement of a practical method of photography, early photographers were at work recording events such as floods, fires, earthquakes, war, as well as noteworthy advances in science and technology. For example, in 1842 a daguerreotype was made of the Great Fire of Hamburg and in 1846 a daguerreotype was made documenting a reenactment of the first surgery using ether. The earliest examples of war photography occurred during the Mexican War, 1846–1848.

Not only events but social issues also attracted these early photojournalists. In 1851, John Beard documented street life among London's poor, beginning a documentary tradition that was later pursued by John Thomson in England and Jacob Riis in America.

News photography and photojournalism are highly regarded segments of the profession and many young photographers aspire to a career in the field. Today, however, the field is crowded and few full-time positions for photographers exist on large daily newspapers, news magazines, news organizations, or magazines that feature photography. Some photographers are able to make a living by working freelance for many publications at the same time, usually with the help of an agent, photo agency, or news organization. Agencies, such as Black Star, Globe Photos, and Magnum Photos, have some staff photographers who work and bill exclusively through their agency, and numerous stringers from diversified geographical areas who accept occasional assignments to supplement their local incomes.

To enter the profession, a young photographer is probably best advised to start with assignments for small- or medium-size daily or weekly newspapers. Although the assignments are not likely to be of fast-breaking events or even of regional or national interest, the experience is invaluable for preparing the photographer for the major assignments that may follow.

It is important for the news photographer and photojournalist to realize that the photographer is usually required to write captions and is often expected to write blocks of copy and design and lay out photo pages. Sometimes, the photographer may be expected to write the entire accompanying story. Smaller publications can rarely afford to have a full staff of photographers and writers to perform these specialized tasks.

Until the middle of the twentieth century, photojournalism as well as most other photographic careers were usually entered by way of apprenticeship and job advancement. As might be expected, progressing from washing prints and mixing chemicals to darkroom printing and original photography provided a relatively narrow, technical background, usually lacking in the aesthetic, ethical, legal, philosophical, social, cultural, and economic concerns that are central to modern photojournalism.

Today most photojournalism jobs with major news organizations require at least an undergraduate college degree. Many colleges and universities offer major degree programs in communications, journalism, and photography, which often include an internship with a professional news organization either before or after graduation. A major in another discipline, however, may also provide an appropriate education. If the photojournalist's work is to transcend the mere recording of events and to explore complex ideas and social issues, it is important to have studied the workings of society, the human condition, visual and verbal expression, as well as the techniques of photography and journalism.

Another important source of continuing education and training is the short-term workshop, which brings students into contact with working professional photojournalists and news photographers. One very successful and highly regarded short-term workshop is the Flying Short Course sponsored by the National Press Photographers Association (NPPA), which annually gathers a team of accomplished press photographers from around the country and flies them to ten regional sites. At each site the team meets with a group of working press photographers and students to deliver a dawn-to-dusk workshop during which the team makes presentations, engages participants in active question-and-answer sessions, and evaluates portfolios. Other short-term workshops are available through many colleges and associations. In addition to providing opportunities for professional evaluation and guidance, these workshops also give participants a chance to meet others in their field and to establish helpful networking relationships.

Successful news photographers and photojournalists possess a knack for recognizing events and issues that will interest and engage the public, the technical and expressive skills to tell the story effectively in photographs, as well as the determination to get the story despite the potential dangers in situations involving such calamitous events as fire, flood, crime, riot, and war.

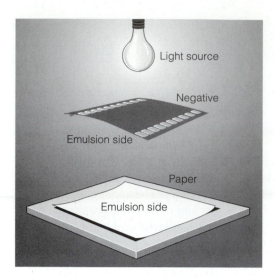

FIGURE 6-11

Emulsion side of negative normally faces emulsion side of paper for printing. Occasionally the negative may be reversed to reverse the direction of the image.

Here are some general rules to remember about contact printing:

1. Prepare all the materials and set everything up under a safelight. Do not expose the photographic paper to white light except during the controlled exposure. Do not open the photo paper box except under safelight.

2. Make sure the emulsion side of the negative faces the emulsion side of the paper. The emulsion side of the paper must face the source light. The emulsion side of the negative is the duller side; the emulsion side of the paper is usually the shinier side, but sometimes the emulsion side must be detected from the paper's curl. Photographic papers tend to curl inward toward the emulsion. (See Fig. 6-11.)

3. Determine the amount of exposure by testing. A procedure for determining exposure is discussed on page 112. Most normal negatives should print properly with exposures of ten to twenty seconds. If an enlarger is used as the light source, start with f/8 and adjust the f/stop until the exposure times are within this range. Base the exposure time on an average of the pictures on the sheet. If some of the frames appear too dark and others too light, that does not mean that these negatives cannot be made into good prints. Individual corrections can be made with exposures best suited to each negative at the time of enlarging. Consider the proof sheet as a record only.

4. Consider making the contact sheet with the negatives still in their clear plastic storage pages. Some workers prefer to do this; it minimizes the chances for scratching or damaging the negatives during handling. However, some loss of sharpness will result from printing through the plastic sheet.

STEP-BY-STEP PROCEDURE FOR MAKING A CONTACT PROOF SHEET USING THE ENLARGER METHOD

To make a contact proof sheet using a proofer and the enlarger method, follow these steps:

1. Place an empty negative carrier in the enlarger and put an empty proofer on the base of the enlarger.

2. Turn on the enlarger. Adjust the head so that the rectangle of white light produced by the enlarger is slightly larger than the proofer. Focus to make the edges of the projected rectangle sharp. Place the proofer in the center of the rectangle, and set the enlarger lens to f/8. Stop down one or more stops to print thin negatives; open up one or more stops to print dense negatives. Turn off the enlarger, leaving the proofer in place.

3. Place an 8-in. by 10-in. (20-cm by 25-cm) sheet of photographic paper in the proofer, emulsion side up. Arrange your negatives on the enlarging paper, emulsion side down. To protect the negatives, leave them in the plastic storage pages. Close the proofer. Be careful not to move the proofer during this step.

FIGURE 6-12

The contact print frame is positioned to receive the beam of illumination from the enlarger. The negatives are placed over the photo paper and the glass is then closed.

4. Determine the exposure time through testing. As a good starting point, set the timer for fifteen seconds. Trigger the timer to start the exposure. (For determining the exposure time accurately, a technique for making test strips and test prints is described in Objective 6-E on page 182.)

5. Process the exposed paper according to normal procedures.

6. Examine the proof sheet after processing. If it is too dark overall, make another proof sheet, reducing exposure. If it is too light overall, make another proof sheet, increasing exposure. Repeat until the average prints are rendered with normal density. Try to obtain a readable print from every negative containing an image. If necessary, make more than one proof, varying exposure, or use the masking technique described in Figure 6-9 to adjust the exposure of some negatives.

Black-and-White Print Processing

Objective 6-C Describe the procedures used to process black-and-white prints.

Key Concepts developing, stopping, fixing, clearing, washing, drying, positive print, dry area, contamination, wet area, ferrotype

Print processing follows the same general steps as film processing. It starts with a light sensitive material—in this case, photographic printing paper. Like film, this printing paper is coated on one side with a light-sensitive emulsion. For an image to be recorded on this printing paper, an *exposure* must be made in which the paper is exposed to image-bearing light focused on its surface. This emulsion must also be protected from accidental exposure to nonimage light.

Once the printing paper has been exposed to the negative image, it is ready for processing. The paper is passed successively through the following steps:

1. **Developing**. The latent image is transformed into visible patterns of metallic silver.

2. **Stopping**. The action of the developer is stopped.

3. **Fixing**. All remaining silver halide crystals, or other light-sensitive materials, are dissolved.

4. **Clearing and washing**. All traces of processing chemicals are removed.

5. **Drying**. The wet print is dried.

The resulting print is, of course, a reverse image of the negative. The thin, transparent areas of the negative transmit the most light to the paper and produce dark areas in the final print. Conversely, the dark or dense areas of the negative appear light in the final print. Thus a reverse print of the negative is actually a **positive print** that corresponds to the original scene.

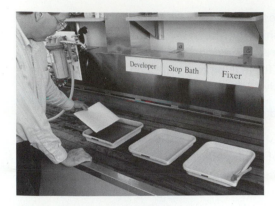

FIGURE 6-13

Three-tray setup for print processing. For film processing, first three solutions are developer, stop bath, and fixer.

Health Note Photographic developers can irritate the skin. Avoid immersing your hands in the solutions. Use tongs to handle prints. Wash hands with soap and dry thoroughly after contact with darkroom chemicals. See Handling Photographic Chemicals Safely" on page 139.

The printing darkroom should be organized into two areas—a **dry area** where printing paper is exposed to the negative images and where dry materials can be handled without **contamination** with processing chemicals, and a **wet area** where the processing chemicals, water taps, and sink are located. For processing prints, usually three trays are set up in the wet area. They contain the principal processing chemicals—the developer, the stop bath, and the fixer.

STEP-BY-STEP PROCEDURE
Basic Print Processing

1. *Developing.* Immerse the exposed printing paper—with its latent image recorded in the emulsion—in the developer. Insert it with the emulsion side down and slip it edge first into the solution as quickly as possible to immerse the entire emulsion surface under the developer in one motion. Holding the edge of the print with tongs, agitate the paper gently so that all surface areas of the emulsion are immersed thoroughly and no bubbles are formed on the surface.

 When the paper is thoroughly soaked with developer, it may be turned face up in the solution to observe the developing image. Time the period of development carefully according to the developer manufacturer's recommendations (normally one to two minutes). During development the photographic image gradually appears on the paper. Like film development, however, processing should be done primarily by the clock, not by visual inspection of the print.

 Throughout development, agitate the paper by gently rocking the tray or by using tongs to move the print in the developer. When the development time is up, remove the print from the developer with the print tongs, allow it to drain, and then slip it edge first into the stop bath. (See Figure 6-14 A, B, C.)

2. *Stopping.* The printing stop bath, like the one used with film, consists of a mild (1 to 2 percent) solution of acetic acid. (See the Helpful Hint on page 144.) This bath stops the action of the developer instantly. The acid stop-bath solution must not be carried back to the developer, because it can rapidly exhaust the developer solution. Therefore, take care that the tongs used in the developer are not contaminated by the stop bath. Once the print is immersed in the stop bath, handle it with a separate set of tongs used exclusively in the stop bath and agitate it in the same way as in the developer. The developer tongs can be returned to the developer tray after the print has been dropped into the stop bath. Follow the manufacturer's recommendations for time and procedure (usually fifteen to thirty seconds).

3. *Fixing.* After the print has been immersed in the stop bath for the recommended time, it can be removed, drained, and slipped into the fixer tray. Again, use the stop-bath tongs to carry the wet print to the fixer, but do not immerse the tongs in the fixer —return them to the stop bath. Use a third set of tongs to handle the prints in the fixer. If the tongs are used in the manner

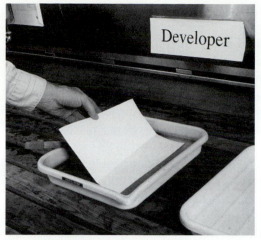

A

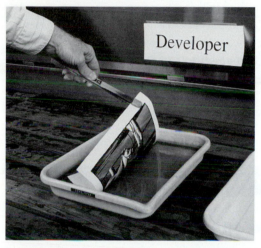

B

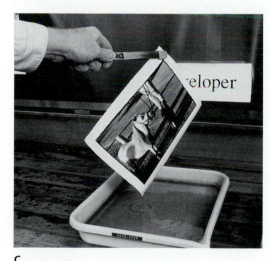

C

FIGURE 6-14

*Print processing. **A.** Immerse exposed paper evenly in developer. **B.** Handle wet prints with print tongs to avoid chemical contamination carried on hands. **C.** Drain print of excess solution between trays.*

described, the print-processing solutions will last longer and yield cleaner results than if the printing solutions are carelessly contaminated with one another. Prints should be kept immersed in the fixer with occasional agitation for the time recommended by the fixer manufacturer. RC prints are typically fixed for two to three minutes, while fiber-based prints usually need seven to ten minutes, but this is dependent upon the type of fixer used. Other prints can be exposed and processed while work accumulates in the fixer; slight overfixing will not harm the prints.

4. *Clearing and washing.* When the print has been in the fixer for a few minutes, it is no longer light-sensitive and can be examined under normal white light. However, be sure the unexposed printing paper has been put away before any white lights are turned on. A small white light mounted directly over the fixing tray may be useful for these brief visual inspections.

 After fixing, the print is ready for washing. As with film, all traces of processing chemicals must be removed from the print before drying. If any chemical residues remain, discoloration may occur later. RC prints can be taken directly from the fixer tray and placed into a running water wash, usually for three to four minutes. Excessively long wash times can cause the edges of RC prints to "frill."

 Most photographers using fiber-based paper employ a chemical clearing agent just prior to the final wash to ensure complete removal of the processing chemicals and a shorter washing time. Bathe fiber-based prints in the washing aid with continuous agitation for the recommended time—usually three to five minutes—followed by a running water wash. Washing aid manufacturers often recommend wash times of ten to twenty minutes; however, many photographers extend their wash times with fiber-based papers to one hour or more to assure that the print is free of all contaminates.

 If the "bathtub" technique is used—soaking the prints in a tub full of water—be sure that the wash water is continually replaced with fresh water to remove all traces of processing chemical. Never let a direct flow of tap water fall directly on the surface of the prints, because the force can damage the emulsion. Let the water flow into a tumbler and overflow onto the prints. Or, any one of a number of commercial devices that attach to the tray can be used to convert it into an effective washer. (See Figure 6-4.) Note that use of resin-coated (RC) papers substantially reduces washing time and saves water.

5. *Drying.* After the prints have been washed, the excess water needs to be removed from their surfaces. Place the prints on a smooth, clean surface and use a squeegee or a sponge to remove the excess moisture. This will help the print to dry quickly, evenly, and spotfree. Prints made on RC paper can be hung on a line by a clothespin to dry, or placed on a rack of fiber glass screens to air dry. With either procedure, they will be completely dry in only a few minutes. (See Figure 6-15.) Fiber-based prints, on the other hand, are saturated with water and require longer

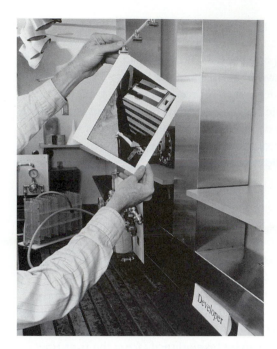

FIGURE 6-15

RC prints may be hung up to dry on a simple clothesline.

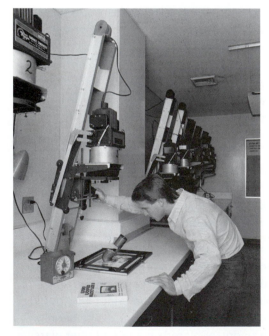

FIGURE 6-16

Enlarging setup. Using a critical focusing device to assure maximum sharpness.

drying times and procedures. They too may be air dried face down on clean fiber glass screens, but they usually need several hours or even overnight to dry. Fiber-based prints tend to curl when air dried and will later need to be flattened by being pressed under weight. Glossy photo paper that has been air dried gives a mellow, semi-gloss surface.

A hot drum dryer also may be used to speed the drying process for fiber-based prints. Such dryers have a mirrorlike, heated **ferrotype** plate or drum. Because the surface coating on fiber-based papers is relatively thick and malleable, these papers can be finished in two ways: high-gloss and nongloss. To obtain a very high-gloss finish, use only a glossy finish paper and dry the print with the face toward the ferrotype surface. As the print dries, the emulsion surface will take on the glossy appearance of the polished metal against which it was pressed. Facing the print away from the metal drum will create a nonglossy print. Keep in mind that driers designed for fiber-base papers should not be used with RC papers, because they operate at temperatures high enough to melt and damage the resin coating.

Please see the summary of print-processing steps on page 184.

Making Enlargements

Objective 6-D Describe and demonstrate how to make an enlargement.

Key Concepts image size, image focus, easel, aperture, timer

To make an enlargement, first place the negative in the carrier. Then place a **framing easel** on the base to hold the paper flat and to mask the borders. Place a dummy sheet of blank paper, like the back of an old print or contact sheet, in the easel, turn the enlarger on, and project the negative image onto the paper. By raising or lowering the enlarger head, the **image size** can be altered. Increasing the image size reduces the image brightness. By rotating the focusing knob, the **image focus** can be altered to achieve maximum sharpness. When the image is framed to the desired size and focus, lock the head, turn off the enlarger, replace the dummy paper with enlarging paper, set the timer, and make the exposure. Then process the exposed paper in the normal way. A typical setup for enlarging is shown in Figure 6-16.

The aperture of the enlarging lens can be adjusted to be larger or smaller. As the aperture is opened wider, more light passes through the lens and the image appears brighter. As the aperture is stopped down, less light passes through and the image appears dimmer.

The aperture size also may affect the sharpness of the projected image. Extremely large apertures, as well as the extremely small ones, may produce images that are less sharp overall than the middle apertures. Try to make exposures at the intermediate apertures—f/5.6, f/8, or f/11—

whenever possible. In the initial steps of framing and focusing, however, work with the lens wide open to maximize the brightness of the projected image for easier focusing. Then, just before making the exposure, stop down to the smaller aperture.

STEP-BY-STEP PROCEDURE FOR MAKING AN ENLARGEMENT

Follow these general steps in making a projection print or enlargement.

Enlarger is Off

1. Raise the lamp and condenser housing assembly. Remove the negative carrier and insert the negative strip into it. Adjust the strip to center the desired negative in the carrier, emulsion side toward the lens. Carefully clean all dust from the negative with a soft brush, bulb blower, or can of compressed air. Use a film cleaner to remove stains or fingerprints. Later retouching time may be saved by taking proper care at this point. Replace the carrier and negative in the enlarger. Lower the housing assembly into place.

2. Place a sheet of plain white paper in the easel. Use paper of the same weight as the paper to be used for printing, like the back of a old print. Adjust the easel to the desired enlargement size. Place the easel on the enlarger base.

3. Open the enlarger lens to its widest aperture.

Turn Enlarger On

4. Raise or lower the enlarger head to obtain the desired image size.

5. Adjust the focusing knob for the sharpest focus. Use a focus magnifier, if necessary, to achieve maximum focus. Focus on a sharp line such as the edge of a building, trees, eyeglasses, or other sharp detail. Remember, the projected image can be only as sharp as the image in the negative; unsharp or blurred negative images cannot be sharpened by an enlarger. Readjust the image size if necessary. When a sharp image of the desired size is obtained, lock the elevator knob in place.

6. Position the easel for the desired framing of the image.

7. Stop down the enlarger lens to the enlarging aperture—approximately f/8 for negatives of normal density.

Turn Enlarger Off

8. Do not move the easel. Make and process a test strip to determine proper exposure as described in Objective 6-E, page 182.

9. Select the proper exposure and set the timer. Without moving the easel, replace the blank paper with a sheet of enlarging paper, emulsion side up, toward the lens.

10. Trigger the timer to make the exposure.

11. Process the paper. If the overall effect is too light, make another print, increasing exposure. If it is too dark, make another print, decreasing exposure.

Important: Do not try to control the darkness of the image by under- or overdeveloping. Consistently develop prints for the amount of time recommended by the manufacturer.

Determining Exposure

Objective 6-E Describe and demonstrate how to determine exposure using the test strip method.

Key Concept test strip

Any photographer, regardless of experience, must estimate exposure for printing. With experience, most are able to make reasonable estimates based on visual inspection of negatives. To determine optimal exposure precisely, however, they rely on experimental tests. **Test strips** are widely used for this purpose. Using this test procedure saves time, energy, and money; it reduces waste; and takes much of the guesswork out of determining exposure.

Move mask 1" after every increment of time

Mask should almost touch surface of test strip

Test strip

Framing easel

FIGURE 6-17

Making a test strip. Procedure for exposing successive segments for additional increments of time.

Making a Test Strip

To make a test strip, follow this step-by- step procedure.

1. With the enlarger on, the aperture wide open, and dummy sheet of blank paper in the easel, size, focus, and frame the image as desired. Stop down to f/8.

2. With the enlarger off, cut a sheet of 8-in. by 10-in. (20-cm by 25-cm) enlarging paper into five strips, approximately 2-in. by 8-in. (5-cm by 20-cm.) Replace all but one of the strips into a paper safe or lightproof container. Visualizing the image, place the other strip in the easel across a representative segment of the picture.

3. Use an opaque sheet of stiff, dark paper as a mask to cover the test strip, holding it over the strip (see Figure 6-17). Turn on the enlarger and expose successive segments of the strip for a fixed number of seconds—for example, expose a 1-in. (2.5-cm.) segment for six seconds, the next 1-in. (2.5-cm.) segment for an additional six seconds, and so forth. When you have exposed five segments, each for an additional increment of six seconds, you will have a strip with successive segments exposed for thirty, twenty-four, eighteen, twelve, and six seconds respectively.

FIGURE 6-18

A. Each sement of this test strip has been exposed in fixed increments of 6 sec. *B.* In each segment of this test strip, exposure is doubled. To achieve this, the first segment was exposed for 24 sec., followed by segments of 12, 6, 3, and 3 sec. Result is test strip with segments differing by one stop each.

Total exposure

30

24

18

12

6

A

Total exposure

48

24

12

6

3

B

4. Process the test strip in the normal way. It will resemble Figure 6-18A.

5. Select the exposure that produced the best range of tones. A normal, full-scale print should have rich blacks and clean whites, as well as a full range of gray tones in between. Details in highlights and shadows should be clearly visible to the full extent that they are present in the negative. If none of the segments produced an acceptable range of tones, make another test strip, increasing or decreasing the lens opening or the exposure increments as needed.

Fixed Versus Proportional Increments

The procedure just outlined describes a sequence of fixed exposure increments: the first segment was exposed for six seconds, the next for six seconds more, and so on. Note in Figure 6-18A that the exposure in the twelve-second segment is 100 percent more than in the six-second segment, but exposure in the thirty-second segment is only 25 percent more than in the twenty-four-second segment—the exposure increments in each segment represent decreasing changes.

Another approach to incremental exposure is to increase or decrease exposure in each segment by a constant proportion, such as to halve the exposure time in each successive segment. For example, expose the first segment for twenty-four seconds, the next for twelve seconds, the next for six seconds, the next for three seconds, and the last segment also for three seconds. The result will be a test strip such as that shown in Figure 6-18B, with a much wider range of exposures: The successive exposures on the sheet are now 48, 24, 12, 6, and 3 seconds, with each successive increment representing one stop less exposure.

Using a Multistation Darkroom

Cooperation is essential in any multistation darkroom—one in which more than one operator can expose and process prints simultaneously.

Remember, use the dry counters for dry materials exclusively. Keep dry papers and negatives in the dry area. Only the sink should be used for chemical operations. Keep bottles and trays of chemicals in the wet area or under the sink. Wash hands thoroughly and frequently when printing and processing. If your hands become contaminated with processing chemicals, clean them promptly to avoid damaging prints. Hands contaminated with fixer, for example, may produce white smudges and fingerprints in the final print; hands contaminated with developer produce dark smudges and fingerprints. Use print tongs to handle prints, and drain them between solutions. Carry wet prints in trays to avoid dripping onto the floor and counters. Allow sufficient time following processing to wash and dry prints.

Be sure the enlarger source light is switched off before raising the condenser and lamp housing to insert or remove the negative carrier. Stray light from one enlarger may strike and ruin a neighbor's work and supplies.

Summary of Print-Processing Steps

In this unit we've discussed the detailed steps involved in print processing for both contact sheets and enlargements. Following is a brief summary of the steps involved, along with blank spaces to note your specific processing chemicals, times and temperatures.

Note your type of photographic paper here: _____

1. Immerse print in the developer tray. Agitate. At the end of the developing time, pick up the print with tongs, drain it, and transfer it to the stop bath. (Do not allow the developer tongs to be contaminated by the acid stop bath.)

 developer type and name: _____

 developer dilution: _____

 recommended time: _____

2. Drop print into the stop bath. Agitate. At the end of the time period, drain and transfer it to the fixing bath.

 stop bath type and name: _____

 stop bath dilution: _____

 time: _____

3. Drop print into the fixer tray and agitate. After one minute, the print may be examined under white light and then returned to the tray to

complete the fixing time. Fix for the recommended time for your type of paper.

fixer type and name: _____

fixer bath dilution: _____

time for RC prints: _____

time for fiber-based prints: _____

4. Follow suggested wash procedures. RC prints may be washed as soon as they are fixed; fiber-based prints are generally treated with a washing aid prior to the final wash.

For RC prints, wash for _____

For fiber-based prints use the following:

washing aid name: _____

dilution: _____

time and temperature: _____

followed by a wash of _____

5. Air dry RC prints. Use drying screen or heated dryer for fiber-based prints.

Questions to Consider

1. Compare the methods used for controlling exposure in the camera to those used in photographic printing. How are they similar?

2. What is the main physical difference between RC and fiber-based photo paper? How do the processing procedures differ?

3. Why are contact sheets made?

4. If raising the enlarger reduces the illumination received by the photographic paper, how would the exposure of a large enlargement differ from that of a small one? What controls could be changed to provide the proper exposure?

Suggested Field and Laboratory Assignments

1. Complete your acquisition and preparation of all print-processing supplies, including developer, stop bath, fixer, clearing agent, paper, and so forth. Complete arrangements for the use of a darkroom for printing, including processing tank, enlarger, safelights, and facilities for processing, washing, drying, and finishing.

2. Using the negatives you produced in Unit 5, make a contact proof sheet that shows the detail in every negative on the roll.

3. Carefully examine your contact sheet using a magnifying glass or loupe. Study the sheet for images that have good composition and expression. Mark possible frames on the proof sheet with a grease pencil. Marks or other notations may also be made on the sheet to indicate cropping or other printing manipulations.

4. Select a negative from your first roll for enlargement. Set up for enlarging. Determine exposure using the test strip method. Use both the fixed and proportional increment methods.

5. Using resin-coated paper, make an 8-in. by 10-in. (20-cm by 25-cm) enlargement of the negative selected. Make additional prints to achieve optimal density and contrast.

6. Make at least one print on glossy paper. Make at least one other print using matte or other nonglossy paper. Compare the tonal range, sharpness, rendering of fine detail, and handling characteristics of the two prints.

Unit **Seven**

Katherine A. Stollenwerk, "Break from Inspiration," 1991.

Many specialized darkroom controls and procedures exist that can be used as creative tools for interpreting photographs. The texture, color, contrast, tonality, and general appearance of a photograph can all be varied to meet different photographic needs. Mastering these controls allows photographers to create images that reflect their unique understanding and perception of their subjects.

This unit describes printing papers and print-processing chemistry, the control of contrast, printing controls such as burning in, dodging, split-filter printing, flashing, black-border printing, and the Sabattier effect. Print-finishing techniques, including spotting, bleaching, and mounting are discussed, and the unit also provides an overview of the materials, equipment, and space necessary to create your own darkroom.

Black-and-White Print Materials

Objective 7-A Describe the materials used in making black-and-white prints from negatives.

Key Concepts printing paper, print-processing chemicals, contact printing paper, chloride paper, enlarging paper, bromide paper, chlorobromide paper, image tone, surface texture, weight, tint, contrast grades, low-contrast paper, normal-contrast paper, variable-contrast paper, variable-contrast filters, resin-coated (RC) paper, paper developer, stop bath, indicator stop bath, fixer, hardening fixer, clearing agent, print conditioner, stabilization process, stabilization processor

Selecting the Proper Materials

Two types of materials are needed to make prints from negatives: **printing paper** and **print-processing chemicals.** Both materials are offered in a wide variety of types, depending on individual needs. When selecting a photographic paper, such factors as color, image tone, texture, thickness, tint, and contrast grade must be considered. In addition, a choice must be made between the quick-processing resin-coated (RC) papers or the more durable and exquisite fiber-based papers. Even the chemicals used to develop the print can be selected according to the desired image tone and amount of contrast. The creative photographer carefully selects the exact printing materials necessary to meet the expressive needs of each individual photograph.

Printing Papers

Emulsions Papers are manufactured for two types of printing: contact printing and projection printing, or enlarging. The active ingredients in

these papers, as in films, are primarily silver halide salts—silver chloride and silver bromide. **Contact printing papers** use a silver chloride emulsion and are slow—that is, they are relatively insensitive to light and require high exposure intensities to be effective. For this reason, these pure **chloride papers** are rarely used today.

Enlarging papers generally use an emulsion that contains a combination of both silver chloride and silver bromide. The mixture of the two silver salts can be varied in manufacture to obtain a desired emulsion speed, image tone, and contrast. These **chlorobromide papers** are much faster than chloride papers. Although they are intended primarily for making enlargements, they can also be used for making contact prints if the enlarger is used as a light source (see discussion on page 176). Some enlarging papers use an emulsion based almost exclusively on silver bromide. These **bromide papers** characteristically produce very blue-black or cold image tones.

Image tone Enlarging papers are manufactured in a wide range of tones, textures, weights, tints, and contrast grades. **Image tone** refers to the color of the actual silver image. The tone is determined by the type of emulsion and its development and may range from cold, blue-black tones through neutral-black to warm and brown-black tones. The neutral tones are most suitable for halftone reproduction processes. For exhibition, select the image tone that best suits the subject and idea of the photograph.

Surface texture The **surface texture** of the paper refers to the glossiness or roughness of the print surface. Many types of surface textures are available, ranging from the high-gloss surface that is used most commonly for halftone reproduction to highly textured surfaces that are used more commonly for display prints. Many specialty textures are also available, such as those designed to look like rough canvas, silk, linen, or tapestry. The most commonly used textures are the glossy papers, which produce a hard, mirrorlike surface, and the semimatte papers, which produce a dull, nonreflective surface more like ordinary paper.

Thickness or weight The paper stock is also available in several thicknesses, or **weights**, from lightweight or document stock—which is approximately the weight of ordinary typing paper—to double-weight stocks, which are about the thickness of light cardboard. The most commonly used fiber-based paper weights are single-weight (.18-mm) and double-weight (.38-mm). Resin-coated (RC) paper is available only in a medium or middle weight.

Tint The paper base **tint** refers to the color of the paper stock itself. Papers come in a variety of tints, from brilliant snow-white to natural white, cream, ivory, and buff. Specialty papers also may be obtained in pastel tints such as blue, red, and green. In general the warm-toned emulsions are matched with the warm-tinted stocks such as cream and ivory, while the cold-toned emulsions are more commonly teamed with the colder-tinted stocks.

Contrast grade Printing papers also are manufactured in several **contrast grades**, numbered from 0 to 6, corresponding to the inherent

contrast characteristics of the emulsion. The lower-grade papers, grades 0 and 1, refer to the **low-contrast papers,** which will produce prints with less contrast than the negatives from which they are made. Grade 2 paper is considered **normal-contrast paper** because it will reproduce approximately the same contrast range as the negative. The higher-grade papers, grades 3, 4 and above, refer to the **high-contrast papers,** which will produce prints with more contrast than the negatives from which they are made. Although most manufacturers market a grade 2 as a normal paper, many photographers find that they use a number 2 1/2 or number 3 grade more often to enhance the contrast characteristics of their prints.

By selecting the appropriate contrast grade, the tonal range of a negative that is too contrasty can be reduced by printing it on a low-contrast paper. This will have the effect of enhancing the gray, middle tones. Conversely, the contrast of a negative that is too flat can be increased by printing it on a high-contrast paper. This will have the effect of extending the range of tones to include deeper blacks and purer whites.

Variable-contrast paper Another method for achieving contrast control is by using a **variable-contrast paper,** such as Kodak Polycontrast or Ilford Multigrade, in conjunction with **contrast filters.** As their name implies, these papers offer varying grades of contrast by the use of filters. The papers combine two separate emulsion layers: One emulsion has very low inherent contrast and is usually made sensitive to yellow light; the other has very high inherent contrast and is made sensitive to magenta light. The contrast of the resulting print may therefore be controlled by using a blend of yellow and magenta colored filters to produce the desired contrast grade.

Variable-contrast papers combine all the contrast grades into a single paper product. The various contrast grades are then selected by using **variable-contrast filters** during the exposure process. A set of variable-contrast filters typically is numbered to correspond in a general way to graded paper. Thus a number 3 contrast filter used in combination with a variable-contrast paper will approximate the contrast range of a grade 3 paper. Variable-contrast papers offer the photographer extensive control over the range of contrast grades by allowing the selection of contrast filters in half-grade steps.

Color sensitivity and safelights Because the negative image from which black-and-white prints are made consists simply of patterns of light and shadow—no colors—the printing paper needs to be sensitive only to the relative presence or absence of light; it need not be sensitive to a full range of colors. Therefore, printing papers intended for normal use are basically orthochromatic—sensitive mainly to the blue portion of visible light and insensitive to the red-amber-green portions. This permits the printing darkroom to be well illuminated with amber or yellow-green safelights and allows the photographer to work conveniently in a well-lit space without exposing the light-sensitive printing papers. However, some printing papers are manufactured with panchromatic emulsions—they are sensitive to all colors of light. Such papers are often used for making black-and-white prints from color negatives. This special printing paper is designed to translate the different colors in the negative into a black-and-white scale having the same relative brightness. Because these papers are

FIGURE 7-1

Variable-contrast filters are available in two forms: as sheets for use within the lamp housing, and as mounted filters for use below the enlarger lens.

sensitive to all colors, they cannot be used with the same safelights as common orthochromatic papers. Any photographer using these papers must work in complete darkness or under a safelight recommended by the manufacturer.

Resin-Coated (RC) Papers

Resin-coated (RC) papers have been coated under the emulsion with a special plasticlike resin that resists the absorption of processing chemicals. This coating protects the paper base from saturation by photochemicals during processing. Because photochemicals are not absorbed into the paper base itself, RC papers fix very rapidly, require less washing, and air dry quickly without curling. Further, glossy RC paper, unlike fiber-based paper, air dries to a hard, glossy finish without ferrotyping.

Although these factors provide real advantages to both amateur and commercial photographers, RC papers are not without faults. First, they are sensitive to scratches while wet and require careful handling with print tongs. Additionally, the recommended wash time of four minutes should not be exceeded, or the emulsion may separate from the support. Dry mounting, which normally requires application of heat and pressure, must also be adapted to this material, employing lower levels of heat and special mounting materials to prevent separation of the emulsion from the support. Finally, because the resins and the emulsion expand and contract differently with changes in temperature, the emulsion may separate from the support over time under normal display conditions. For this reason, RC materials have not as yet been considered suitable for archival purposes. Nevertheless, where convenience and speed of processing are more important than permanence, these materials have become the contemporary standard. (See Figure 7-2.)

FIGURE 7-2

A. Cross-section of fiber-base printing paper. *B.* Cross-section of resin-coated printing paper.

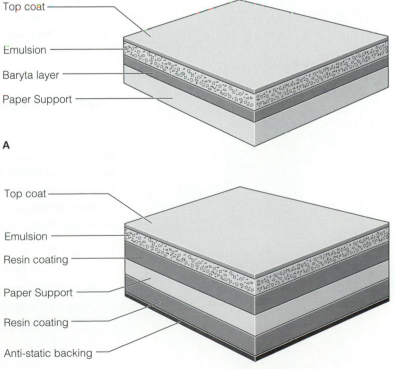

Top coat
Emulsion
Baryta layer
Paper Support

A

Top coat
Emulsion
Resin coating
Paper Support
Resin coating
Anti-static backing

B

Fiber-Based Papers

Fiber-based papers come in a greater variety of surface tints, image colors, surface textures, and thicknesses than RC papers. Many creative photographers use the range of options available in fiber-based paper to gain additional expressive control. Fiber-based paper is almost always chosen for exhibition work and other applications that demand the vibrant tonal rendering of a fine print. Although fiber-based paper takes longer to process, it is inherently much more stable than RC paper and has a much longer potential lifespan. Fiber-based paper should be strongly considered for any work that is likely to have historical interest.

Selecting the Best Paper

Various combinations of emulsions, surface textures, and developers can produce different tones, tints, and effects. Which of these possible effects is most appropriate for any particular print? The answer to that question is largely a matter of personal taste and judgment. No generalization can cover all situations. A combination of tone, tint, and surface texture should be selected that will enhance the characteristics of the image. For example, the crisp, bright look of cold-tone glossy papers tends to suggest an objective, mechanical representation of the subject. Conversely, warm-black image tones, a cream base tint, and matte texture combine to suggest a more subjective representation of the subject. For these reasons, cold-tone, glossy papers are often chosen to represent industrial subjects, such as architecture and machinery, while the warm-tone matte papers are often chosen to represent the flesh tones of portraits or other human interest subjects. Special surface textures such as canvas, silk, linen, or parchment may be used to call attention to the print as an object. Smooth-surface papers with a neutral black tone and white tint are preferred for copying or halftone reproduction. Smooth, glossy papers also preserve fine detail and should be considered when every last bit of detail needs to be captured in the image. Glossy papers also have the longest tonal range of any surface.

Paper Storage

Unless photographic printing papers are stored properly, both their physical and photographic properties may be affected adversely. Keep only the paper needed for immediate use in the darkroom. The balance of the stock should be stored in a cool, dry place. Refrigeration will help preserve freshness for long term storage. Observe the following recommendations for storing paper properly.

1. Avoid excessive heat. Do not store paper near a heating unit or in areas of heat buildup.
2. Avoid both very dry and very damp places. Relative humidity of 40 to 50 percent is recommended.

3. Avoid exposure to chemical fumes and gases such as formaldehyde, coal gas, sulfur, engine exhaust, paints, and solvents.

4. Avoid radiation. Do not store paper near X-ray or fluoroscopic devices.

5. Avoid excessive weight. Do not store paper under a weight that may press the sheets of stored paper together and cause the emulsion to fuse to the adjacent sheets.

6. Use the paper before its expiration date. Rotate the stock to use older papers first.

Table J-4 in Appendix J lists some of the commonly available contact and enlarging papers.

Print-Processing Chemicals

Paper developers The **paper developers** can affect the tone of the silver image in the print. Depending on its chemical composition, a developer may produce warm-, neutral-, or cold-toned images. Table J-5 in Appendix J describes several commonly used paper developers and the tones they tend to produce.

Stop bath The use of a **stop bath** following development is recommended. It stops the action of the developer, helps to preserve the life of the fixer, and removes calcium scum from the print surface. A 1 to 2 percent solution of acetic acid can be used for this purpose, as can any of several products that are available in photo stores. An **indicator stop bath** is particularly useful because it will turn dark when it is exhausted, signaling when replacement of the stop bath is needed. See the Helpful Hint on page 144.

Fixer To make the print permanent, all the silver salts in the emulsion must be dissolved and removed from the print. The **fixer** dissolves these silver salts. A **hardening fixer** also will toughen the soft surface of the gelatin emulsion and render it less susceptible to damage. The useful life of the fixer depends on the amount of silver salts that have been removed from the prints. Light prints deposit more silver salts into the fixer than do dark prints. On the average, one gallon of fixer is sufficient for approximately 100 8-in. by 10-in. prints, or the equivalent in surface area. The strength of the fixer can be tested at any time with a fixer-testing outfit, available in most photo stores. Take care to avoid using exhausted fixer, because the resulting prints will not be permanent.

Clearing agent **Clearing agents** aid washing, because they neutralize all residual chemicals. A clearing agent, or washing aid, is recommended for fiber-based paper before washing to assure freedom from residual chemicals and to reduce water consumption in the washing cycle. Cleared prints can be washed free of chemicals in approximately one-third the time required to wash them in water alone. RC papers do not require a clearing agent because they wash clean unaided in three to four minutes.

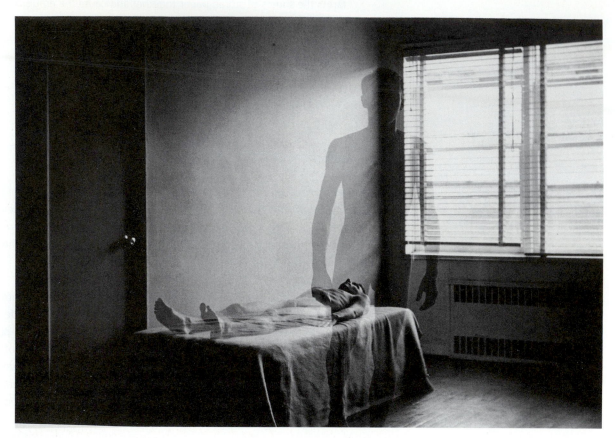

FIGURE 7-3

Duane Michals from "The Spirit Leaves the Body," 1969.

Duane Michals enjoys the interplay between the surrealistic and the ordinary, and the body of his work elaborates on this theme. His pictures demand involvement by the viewer to understand and experience their meaning. "Nice pictures are not enough," he says, and he studiously creates images that evoke wonder, apprehension, and sometimes fear about the mysteries of life and death.

Michals took up photography more or less by accident. While touring the Soviet Union, he borrowed a camera from a friend to record his journey. He became so captivated by the medium that he soon quit his job as a layout designer and traveled to Paris to study portraiture.

Influenced by the surrealist paintings of Balthus and Magritte, Michals is more concerned with symbolizing the personalities of his subjects and the "drama of the interior world," than with pictures of recognizable objects in recognizable surroundings. He often places his subjects in settings full of odd angles, symbolic objects, strange shafts of light, reflections, and shadows that darkly obscure details. The results are most often surrealistic expressions intended to arouse both awe and anxiety. Michals plans his photographs meticulously in advance and strives to realize a photograph that already exists in his mind. He considers the photographer's work to be 90 percent

thought and only 10 percent action and technique.

Always striving for something different, Michals once experimented with sequences of photographs in which each image varied only slightly from its predecessor in order to portray an event more fully. His "sequences" explore the realms of fantasy and the supernatural, often depicting the comings and goings of ghostly figures in ordinary and realistic settings. Death is one of the recurring themes in his work, represented sometimes as spectral shadows, and sometimes as a simple, ordinary ambience as seen by a phantom spirit.

Objective 7-B Describe and demonstrate how print contrast can be controlled and how to produce relatively normal prints with flat, contrasty, and normal negatives.

Key Concepts density, contrast, high contrast, low contrast, contrasty print, flat print, normal print, contrasty negative, flat negative, normal negative, contrast grades, normal paper, flat paper, contrasty paper, variable-contrast paper, contrast filters

Tonal Qualities of Finished Prints

We have already noted that the eye has greater sensitivity to minute tonal differences than film does and that film does not record all the tones that the eye can perceive. Therefore, one of the challenges of photography is to record on the film as much of the important visible tonal range as materials and procedures permit.

Printing paper is even less sensitive than film. Just as film loses many tones from the scene it is recording, printing paper loses many tones from the negative. To maximize tonal reproduction and preserve richness of detail, printing materials and techniques must be manipulated so as to gain greater control over density and contrast. (See Figure 7-4.)

Density refers to the overall lightness or darkness of the print—the amount of image-forming silver that it possesses. To control density, manipulate the exposure of the print. The greater the exposure, the darker the print; the less the exposure, the lighter the print.

Contrast refers to the range of tones and the distribution of those tones within the print. Think of the contrast control dial on a black-and-white television: When the contrast is increased, the picture contains more areas of pure black, more areas of pure white, but fewer areas of gray in between. Conversely, when the contrast is decreased, the television picture changes to include more middle grays and fewer areas of extreme blacks and whites.

In more technical terms, we can say that contrast refers to the range of densities present in the print between deep black (maximum density) and base white (minimum density). **High contrast** refers to the presence of maximum and minimum densities within the same print and relatively little presence of intermediate densities. A high-contrast print tends to possess deep blacks and base whites, with few intermediate shades of gray. **Low contrast** refers to the presence of only a narrow range of densities—the darkest and lightest shades tend to be close together. Deep blacks and base whites do not appear simultaneously in a low-contrast image.

Acceptable contrast and density can be achieved by selecting an appropriate contrast grade and exposing the image to yield a full tonal range print. Faithful reproduction of the original scene with clarity, definition, and sharpness is, however, only one criterion for evaluating prints. Also important is the photographer's use of these controls to express impressions of the scene, or to communicate feelings or ideas. Thus density and contrast may be also manipulated to set a mood for the scene, to

A

B

FIGURE 7-4

*Contrast and density. Tone and mood can be varied by altering print contrast and density. **A.** Low contrast and high density create a darker, more brooding atmosphere. **B.** Higher contrast and reduced density considerably brightens the mood.*

FIGURE 7-5

*Contrast. **A.** Low contrast. Picture is flat, with little contrast between darkest and lightest tones. **B.** Normal contrast. Picture shows full range of dark, middle, and light tones. **C.** High contrast. Picture shows only darkest and lightest tones; middle tones are lacking.*

emphasize important details, and to express certain relationships that the photographer perceives to be important. The use of these controls and others for effective composition will be discussed more fully in Units 8 and 12.

Negative and Print Contrast

Print contrast Print contrast refers generally to the range between the darkest and lightest tones present in the print, as well as the number of distinct gray tones in between. Black-and-white negatives vary in contrast because of several factors, including the brightness range of the original subject, the exposure, the type of film and developer used, the method of processing, and the lens quality. Prints also vary in contrast as a result of factors such as negative contrast, exposure, the type of enlarger used, the type of paper and developer, the processing method, and the type of enlarger lens.

A **contrasty print** has a wide density range but lacks the middle gray values. Because only dark and light values predominate, details in the highlight areas of the print, or in the shadow areas, or both, are often lost. A silhouette is an extreme example of a high-contrast print.

A **flat print** has a relatively narrow density range with only limited shades of gray. Because only a few values are present, the image appears soft or even drab. Details may be present, but they do not stand out markedly from their surroundings. A print showing a barely discernible scene through a mist or fog would be an extreme example of a low-contrast print.

A **normal print** has both a wide density range and a complete scale of middle gray values. Details that stand out distinctly from their surroundings can be seen in both the high density and low density areas of the image. Examples of contrasty, normal, and flat images are illustrated in Figure 7-5.

Negative contrast Not every negative has an ideal or normal contrast density range—some negatives, like prints, are flat or contrasty too. **Contrasty negatives** have a wide tonal range but weak and undefined middle tone areas. Pictures taken outside on a bright, sunny day at noon may tend to produce contrasty negatives because the light falling on the subject will consist of bright highlights and deep shadows. Some negatives are flat; that is, they have a relatively narrow tonal range; the difference between the lightest and darkest portions of the negative is slight. Pictures taken outside on an overcast or misty day tend to produce **flat negatives** because the light falling on the subject is even—there are no extreme

A

B

C

A

B

FIGURE 7-6

Using variable-contrast filters. **A.** *Optically correct mounted filters may be used below the enlarging lens.* **B.** *Large sheet filters should be placed in the lamp housing.*

highlights or deep shadows. **Normal negatives** have well-separated highlights, shadows, and middle tones. Details are clearly visible in the clearest and darkest portions of the negative.

Controlling Print Contrast

Regardless of the negative's contrast, the final print contrast can be controlled to a great degree by the photographer in the darkroom. By using contrast controls in printing, relatively normal prints can be obtained from a wide range of contrasty, flat, and normal negatives. Or, contrast can be manipulated to emphasize print details and tonal qualities. To control contrast, select printing papers that are appropriately graded for the contrast properties you desire. Or, use an appropriately graded filter with a variable-contrast paper. Choose a higher grade paper to increase the overall print contrast, a lower grade paper to reduce it. A photograph may need more contrast if the blacks are not as deep and pure as desired in an otherwise well-exposed print. Lower contrast may be indicated if details in the highlights and in the shadows are not visible in the print.

To produce a print of normal contrast from a negative of normal contrast, use a normal contrast grade paper, such as grade 2, 2 1/2, or 3. To produce a print of normal contrast from a contrasty negative, use a lower contrast grade paper (grade 0 or 1) to flatten out the negative's contrast. To produce a print of normal contrast from a flat negative, use a higher contrast grade paper (grade 4, 5, or higher) to increase the negative's contrast. If variable-contrast paper is used, select an appropriate grade filter to achieve the same result. Table 7-1 can help you select the appropriate grade of paper or filter. (See "Black-and-White Print Materials," page 188.)

TABLE 7-1 Selecting a contrast grade or filter

With a	Use a
very low-contrast negative	very high-contrast grade or filter (Grade 4 to 6)*
low-contrast negative	high-contrast grade or filter (Grade 3 to 4)
normal negative	normal contrast grade or filter (Grade 2 to 3)
high-contrast negative	low-contrast grade or filter (Grade 1 to 2)
very high-contrast negative	very low-contrast grade or filter (Grade 0 to 1)

*A graded paper of contrast grade 5 or 6 will generally produce a higher contrast result than the highest grade filter with variable-contrast paper.

STEP-BY-STEP PROCEDURE FOR CONTRAST GRADE SELECTION

A basic guideline to remember is that highlight density is controlled by exposure, and shadow density is controlled by the contrast grade. Appropriate contrast can be achieved by using a graded paper or by using a graded filter with variable-contrast paper.

Printing Instructions

1. Start by printing with a normal contrast grade 2, 2 1/2, or 3. Every negative has different contrast characteristics, but this will be a good starting point.

2. Adjust the exposure (enlarger time) to make the density of the highlights (the lighter tones) in the print look right. If the highlights are too light, increase the exposure; if they are too dark, decrease the exposure. Make several test prints until the highlight density is correct.

3. Process the test print and evaluate the contrast. If the shadow areas are too light, increase the contrast grade. The shadows will

then print darker without affecting the density of the highlights. If the shadows areas are too dark and lack detail, decrease the contrast grade. The shadows will then print lighter without affecting the density of the highlights.

4. In general, changing a contrast grade by two or more grades will greatly alter the appearance of a print. Changing by one grade will make a noticeable difference. Changing by half a grade will make a slight difference and may be used to fine-tune the contrast of a print.

5. With variable-contrast paper, filters of contrast grade 4 and higher need twice the exposure required by filters grade 3 1/2 and lower. If a grade 4 or higher filter is used, double the exposure by doubling enlarger time or opening the enlarger lens aperture one stop.

Printing Controls

Objective 7-C Describe and demonstrate several printing control techniques.

Key Concepts cropping, croppers, burning in, dodging, vignetting, texture screening, convergence control, diffusion, flashing, combination printing

In addition to normal printing techniques, there are several more specialized controls that can enhance the effectiveness of the final print. Described below are some of the commonly used controls: cropping, burning in, dodging, vignetting, texture screening, convergence control, diffusion, flashing, and combination printing.

Cropping

Often the negatives will contain more information than is desired in the final print. By **cropping** the print during enlargement, only that portion of the negative image that makes the best picture will be printed.

Some planning should be done before the enlargement process begins. Examine the image on the proof sheet to consider possible cropping formats. Using a felt-tipped pen or grease pencil, mark the desired cropping directly on the proof sheet. Then, during enlargement, the proof sheet will serve as a cropping guide for each print to be made. Darkroom time will be saved by not having to puzzle out each print in the darkroom. (See Figure 7-7.)

Prepare for enlarging by placing the negative in its carrier. Then place the printing easel on the base, and inserting a dummy sheet of blank paper into the print frame of the easel. Turn on the enlarger and examine the image projected into the easel's picture frame. Referring to the crop

FIGURE 7-7

Marking proof sheet with felt-tip pen or grease pencil for cropping. Planning cropping for enlargements saves much darkroom time and wasted prints.

FIGURE 7-8

Croppers.

marks on the proof sheet, raise or lower the enlarger head, adjust the focusing knob, and maneuver the placement of the easel and its blades until the desired image is in focus within the print frame of the easel. Then turn off the enlarger and proceed with printing.

Do not rely on cropping to create effective prints from poorly planned negatives. Remember, the more any portion of a negative is enlarged, the more the print quality is diminished by increased graininess and loss of definition. Cropping may be helpful for making minor corrections in composition, but it will not usually serve for performing major surgery. Composition must begin in the viewfinder of the camera, not at the printing easel.

HELPFUL HINT
Using Croppers

A set of **croppers** is often useful in composing the final print. Croppers are nothing more than two L-shaped pieces of paper or cardboard that allow various cropping positions to be tried on the proof before final printing. (See Figure 7-8.)

Burning In and Dodging

Often the range of brightness in a negative may exceed the range of tones that the printing paper can reproduce effectively. The result can be seen in the brightest and darkest areas of the print. In the bright areas (dark on the negative), details are lost and may appear simply as blank white areas on the print. In the dark areas (light on the negative), shadow details are similarly lost. These dark areas may appear as almost solid masses in which details cannot be easily distinguished. Two techniques can be used to partially overcome this difficulty: (1) **burning in,** which gives additional exposure only to those areas of the print that would otherwise appear too light, and (2) **dodging,** which reduces or holds back exposure in those areas that would otherwise print too dark. (See Figure 7-9.)

FIGURE 7-9

*Burning in and dodging. Keep tools moving during exposure to soften edges of burned-in or dodged areas. **A.** Technique for burning in. **B.** Technique for dodging.*

A B

The typical tool for burning in small areas of the print is an opaque sheet of light cardboard or plastic with a small hole in it that serves as a mask. To burn in, first give the print its normal exposure. Then insert the mask by hand under the enlarger lens about midway between the lens and the printing paper. Manipulate the mask so that only those portions of the image that need additional exposure pass through the hole; the rest of the image is masked from the printing paper. The size of the beam of light can be controlled by raising or lowering the mask. Holding the mask closer to the lens results in illumination falling on a larger area of the picture. During burning in it is important to keep the mask moving in a continuous cicular motion so that the edge of the burned-in area will not appear in the final print.

The typical tool for dodging is a sheet of opaque cardboard or plastic, or a small piece of opaque material attached to the end of a thin wire handle that looks something like a lollypop. Dodging is performed during the basic exposure so that the printing paper receives less than the normal exposure in the areas that might appear too dark in the normal print. During exposure, move the dodging tool over the area to be dodged, keeping it in motion so that its edges do not appear in the final print. Remember to allow sufficient exposure to reach the dodged area to produce an image.

It's a good idea to make test prints to determine the amount of time needed to burn in and dodge. For example, a series of test prints may indicate that the basic exposure necessary to produce a good print is fifteen seconds at f/8. However, examination of the test prints may also reveal that one or more shadow areas are too dark, and that perhaps the sky or another highlight appears too light when printed at this basic exposure. Small, additional test prints may be necessary to determine precisely the exposure required.

Suppose that a particular shadow area, like a doorway, printed best in a test print that received only nine seconds of exposure at f/8. Thus, if the basic exposure for the entire image will be fifteen seconds, but the door should be printed only for nine seconds, that area would need to be dodged for six seconds during the basic exposure. Suppose also that the sky printed best in a test print that received a twenty-five second exposure. Because that area will receive fifteen seconds of light during the basic exposure, it would need to be burned in for an additional ten seconds following the basic exposure. Thus the sky would receive fifteen seconds of basic exposure plus an additional ten seconds of burning in, for a total exposure of twenty-five seconds. To make the timing of these burning-in and dodging cycles easier, some enlarger timers have audible clicks, much like a metronome. Without an audible timer, it is helpful to count the seconds aloud during exposure.

Burning in and dodging can help to control the exposure at selected local areas within the print only if the detail already exists in the negative. No amount of dodging can restore details that were never recorded on the negative; no amount of burning in can restore details that have been lost in the dense highlights of the negative.

Many photographers also use burning in and dodging to creatively interpret the information in the image. These techniques can be used to control and direct the viewer's eye across the print; to emphasize or subordinate information in selected areas of the print, editorially directing attention to the main statement; or even to shift the apparent spatial depth of the image.

Advanced Print Making

Vignetting

Vignetting can be used as a control to eliminate unwanted backgrounds and to isolate a subject against a white space. Often vignetting is used in portraits; it works best when the portrait is composed mostly of light tones. (See Figure 7-10.)

The vignetting tool is an opaque piece of cardboard or plastic with a hole cut in it in the shape of the area to be printed. The edges of the hole are feathered so that the image will fade gradually into the white paper border without its edges being clearly visible. An effective vignetting tool can be made by using pinking shears to cut an oval hole in a sheet of black cardboard. This produces a jagged, feathered edge that helps to make a print with an image that gradually fades out to white.

Use the vignetter during the basic exposure. Insert it by hand below the lens about midway between the lens and the printing paper. Manipulate it so that only the portion of the image to be printed is projected onto the paper below, and the unwanted portions are masked off. As with dodging and burning in, keep the vignetter in continuous motion during use so that its edges do not appear in the final print.

FIGURE 7-10

Vignette. Technique works best with subjects set against light backgrounds.

Texture Screening

A textured appearance can be added to a print by printing through a **texture screen**. (See Figure 7-11.) The texture screen itself may be made of cloth, wire, glass, or plastic. Some texture screens are sandwiched together with the negative for printing. In this case, the texture pattern varies in size with the degree of enlargement. Other texture screens are placed in contact with the printing paper. In this case, the texture pattern remains the same no matter what the degree of enlargement. A texture screen of this type can be made by stretching a sheer cloth—or any other type of thin material that has an interesting structural pattern—over the printing paper.

Texture screens can also be made by photographing surfaces that have interesting surface characteristics, such as grain, nap, or weave. Light the textured surface with a strong side light to emphasize the texture of the material; then take a closeup photograph of it. The resulting negative can then be sandwiched together with another negative during printing. Printing both negatives at the same time will impart the texture to the printed image.

Convergence Control

When a camera is pointed upward or downward, the vertical lines in the resulting picture will appear to converge toward each other. This tendency is evident in pictures of tall buildings taken from ground level with the camera pointed upward to take in the top of the building. Although the converging verticals often may add to the feeling of height in the picture, they may sometimes be distracting. The preferred method of correcting convergence is to use a camera, such as a view camera, that possesses

A

B

FIGURE 7-11

*Texture screening. Screens are available in a wide variety of textures. Two examples are shown here. **A.** Canvas. **B.** Linen.*

FIGURE 7-12

*Convergence control. Parallel vertical lines that tend to converge in **A.** have been corrected in **B.** by the technique shown in the following figure.*

A

B

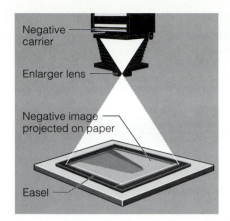

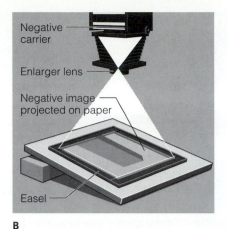

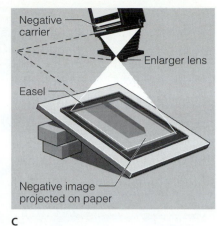

A B C

FIGURE 7-13

*Correcting converging parallel lines. **A.** Normal enlargement shows converging verticals in the negative. **B.** Slight correction can be made by tipping easel slightly and stopping down enlarger lens to increase depth of field. **C.** Extreme correction may require additional tilting of negative carrier.*

perspective control features. However, these converging verticals can be corrected to some extent during enlargement by exercising **convergence control**.

With the negative image projected on a dummy sheet of blank paper in the easel, tilt the easel by lifting up the edge closest to the point at which the converging verticals are at their widest. This tends to straighten out the convergence. Lift until the verticals appear to be parallel; then place an object under the easel to hold it in this position. Then, with the focusing knob, focus the image at a point about one-third of the way down from the high edge of the easel. If the needed correction is only slight, the image may be kept in focus over the entire picture area by stopping down the enlarging lens to f/11 or f/16 to increase the depth of field. However, if the needed correction is great and the easel must be tilted to a considerable incline, then also tilt the negative carrier in the enlarger and control for differences in exposure from one side of the easel to the other. Tilt the negative carrier until the complete image on the easel is in focus; use a cardboard mask to provide a sliding exposure that gives greater exposure to the side of the easel farthest from the light source. With many simpler enlargers, tilting the negative carrier in the enlarger is impossible, and thus it will not be possible to correct for severely converging lines. (See Figure 7-12 and Figure 7-13.)

Diffusion

By using the **diffusion** technique, a hazy or soft-focus effect can be obtained during printing. This effect may be used to subdue blemishes and wrinkles in portraiture, or to create a hazy, misty effect.

This effect is obtained by introducing a diffusing medium between the enlarger lens and the printing paper during exposure. This medium may be a diffusion screen, a transparent acetate sheet (such as a negative sleeve), or a thin piece of nylon or similar fabric (dark colors work best) stretched across the path of the light. Any transparent material that will pass the image projected from the enlarger and scatter the light rays only slightly can be used. The amount of diffusion increases as the diffusing medium is placed nearer the enlarger lens; thus the amount of diffusion that will appear in the final print can be controlled.

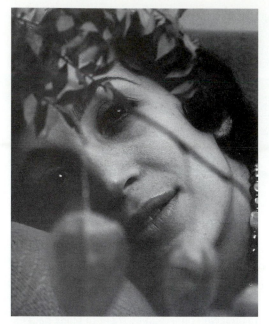

A

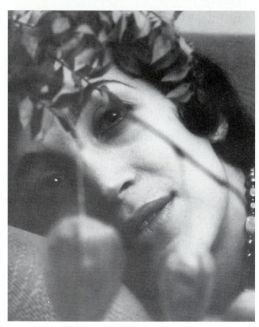

B

FIGURE 7-14

Diffusion. Harsh complexion details in
A. *are softened in* ***B.*** *by using diffusion techniques.*

Usually best results are obtained if paper with slightly higher than normal contrast is used and if the diffusion technique is applied for only part of the print exposure, with the balance of the exposure made without diffusion. Figure 7-14 shows the effect of diffusion.

Flashing

To subdue distracting highlights in a print, the **flashing** technique is often useful. Flashing is simply a method of locally fogging small areas within a print to add density to—or darken—unwanted highlights.

Typically a small penlight is used. Roll the penlight in heavy paper to form a long, thin tube, 6 inches or so long, through which a small circle of raw, white light can be projected onto the print. For best results, the intensity of this light should be quite dim, producing a medium gray from working distance after six to eight seconds of continuous exposure.

After exposing the print normally, place a red filter over the enlarging lens and turn on the enlarger. You will be able to see the image without exposing the print further. Then, using the modified penlight, expose the offensive highlights by "painting in" these areas with raw, white light, taking care to feather out the edges of the flashed areas. Keep the tool moving. Avoid flashing in any of the desired highlights to avoid degrading the contrast of these areas. Figure 7-15 shows the results of the flashing technique.

Combination Printing

Using more than one negative to make a single print is called **combination printing**. One common use of this technique is to add clouds to a clear sky. Basically the technique consists of exposing a portion of the image, such as the clouds, with one negative and the remaining portion, such as a building or landscape, with a second negative. Both the subjects and the relative densities of the two portions should appear logically consistent when the print is processed, and the joining of the two images should be artfully concealed.

In selecting two negatives for combination printing, be sure that the two subjects have been shot from the same point of view. When adding clouds, for example, be sure that the clouds and the subject are seen from the same camera angle. Similarly, the lighting of the two subjects should appear to derive from the same source; if the subject is lit from the right side, the clouds also should be lit from the right. The relative size of the two images should be consistent with experience. Clouds that are supposed to be a great distance away should appear relatively small in the scale of the photograph. Violations of these logical concerns are likely to produce photographs that appear strange, artificial, and unreal.

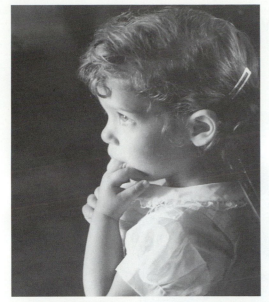

A

B

FIGURE 7-15

*Flashing. Distracting highlights on left ear and on back of head in **A.** are muted in **B.** by flashing during exposure.*

STEP-BY-STEP PROCEDURE FOR COMBINATION PRINTING

The steps involved in combination printing a background, such as clouds, are as follows:

1. Determine the correct exposure for each negative independently to ensure that the print densities of the two images are consistent.

2. Expose the foreground subject, masking off the original sky image to within an inch of the subject. If necessary, cut a mask to conform to the general contour of the subject. Move the mask slightly during exposure to build a slightly gray margin of density around the subject image. This margin will help you join the two images without revealing the joint between them.

3. Insert a red filter below the enlarger lens. Place tape markers on the easel to indicate the position of the margin adjoining the subject image. Then replace the subject negative in the enlarger with the cloud negative. With the red filter still in place, and without moving the easel, arrange the cloud image to a suitable location and size. (The markers must be used at this point be-cause the subject image is no longer visible.) Turn off the enlarger, remove the red filter, and proceed to expose the cloud image.

4. Mask off the previously exposed subject area, and expose the clouds. Cut the mask to conform to the subject's contour if necessary. Keep the mask moving within the marginal area to blend the second image into the first.

Figure 7-17 provides an example of combination printing using two negatives. Combination prints may be made using many negatives if desired. The basic principles are the same.

FIGURE 7-16

Wedding photo portrait.

One of the more traditional careers in photography is that of portrait photographer. Portrait photography as a profession is nearly as old as photography itself, for the early Daguerreotypists and tintype photographers of the nineteenth century often supported themselves by shooting portraits for a fee. From these early times, portrait photographers have been oriented toward serving local consumer markets; even the early itinerant photographers tended to serve a few, small, relatively stable communities. Today, portrait photography generally includes wedding and school group photography that caters to the needs and wants of a local community.

Photographers who specialize in portrait photography must have a knack of dealing with people in an understanding and friendly manner. Unlike commercial photographers who generally must please third-party clients through a

professional intermediary, such as an art director or an account executive, portrait photographers must learn to please the subjects themselves. These subjects, though less likely to be literate in photography, may be just as demanding and require that the photographer patiently explain photographic requirements in nontechnical terms.

The great majority of portrait establishments are individual proprietorships. Therefore, the field is inviting to individuals who wish to go into the photography business for themselves. Generally, a photographer may start a business in the portrait field with a minimum of equipment and capital investment. To keep overhead costs low, it is not unusual for beginning portrait photographers to work out of their own home offices and laboratories, without a studio of their own—photography may often take place outdoors or at the subject's location, such as at the subject's home, office, school, or wedding site. Because the portrait business is so easily entered, however, it is also fiercely competitive and often unprofitable for the newcomer.

If the business succeeds and develops, however, the need for a studio setting is likely to grow. The special requirements for portraits of children and groups will lead the photographer to seek greater control over backgrounds and lighting. A studio allows the photographer to control the amount of natural light, to add artificial light and flash as needed, and to provide both neutral and elaborate backgrounds as the subject may require.

Portrait photography is an art unto itself, demanding that the photographer capture the essence of the subject's personality, create an image that is itself sufficiently arresting to draw the viewer into a study of the subject, and simultaneously please the subject-client. Photographers have approached this challenge in a variety of ways, sometimes developing such a unique style and approach to their subjects that their work has achieved international and artistic recognition, such as the portraiture of Yousuf Karsh, Philippe Halsman, Arnold Newman, Richard Avedon, and Herb Ritts.

Most local portrait photographers also undertake wedding photography because it is akin to portraiture and can be a profitable, though hectic, activity. A wedding photographer needs to develop, through experience, knowledge of the significant events that make up a wedding. Because the bride and groom, and their families, usually have less wedding experience than the photographer, and are usually preoccupied with other matters during the event, the photographer must usually take the lead in planning and carrying out a plan for the photographs. The major events of a wedding include the bridal and wedding party preparations, the arrival of guests, the bridal procession, the wedding ceremony, the recession following the ceremony, the reception and party, the toasts, the cutting of the cake, the departure of the happy couple—and all significant guests must be photographed at some time or another during the event.

The self-employed portrait photographer must also possess, in addition to camera and darkroom skills, some business skills. It is important for the independent photographer to write and speak effectively, in order to prepare persuasive proposals and correspondence, and to present selling ideas to potential clients. It is important also for the independent photographer to possess some basic bookkeeping skills—to maintain records of income and expense, and payables and receivables. It is also important to maintain historical records of jobs, clients, fees, original images, rights, and permissions necessary for reproducing images on the demand of clients.

Operating a portrait business is much like operating any small service enterprise. Success or failure often rests not only on skillful performance of the service offered, but also on the communication and business skills of the proprietor.

FIGURE 7-17

Combination printing. Clouds added to self-portrait by double printing (using more than one negative to make a single print). This technique may be used to add realistic features or, as in this case, to heighten psychological effect.

Special Printing Techniques

Objective 7-D Describe and demonstrate the techniques of split-filter printing, chemical control of contrast, black line border, and Sabbatier effect

Key Concepts split-filter printing, color heads, color correction unit, CC, hydroquinone, water bath development, black line border, Sabattier effect, Mackie lines, solarization

Split-Filter Printing

Split-filter printing is a process that allows precise tonal control over different areas of the print. This technique can be used only with variable-contrast black-and-white photographic papers that use printing filters for contrast selection and control. The different contrast filters can be used to expose different areas in the print.

Variable-contrast paper is constructed of two separate emulsion layers. One layer has very low inherent contrast and is sensitive primarily to yellow-orange light; the other layer has very high inherent contrast and is sensitive to magenta or purple light. Variable-contrast printing filters are constructed to pass a mixture of both yellow and magenta light in controlled proportions ranging from nearly pure yellow for the low-contrast filters to nearly pure magenta for the high-contrast filters. (A filter that passes a nearly equal mixture of yellow and purple light produces normal contrast.)

Contrast is usually controlled by selecting a printing filter that will pass the desired color mixture of image-forming light to produce the overall desired contrast. However, the effective color of image-forming light also may be controlled by separate and additive exposures through two or more different contrast filters. For example, a print given half of its exposure through a number 5 high-contrast filter and half through a number 0 low-contrast filter would have an effective cumulative contrast near that of

a number 2 1/2 normal contrast paper. Some photographers expose to produce good shadows with a number 5 high-contrast filter. Then, without disturbing the enlarger head, they change to a low-contrast printing filter, such as a number 0, for an overall exposure that will add density to the highlights. By varying the proportions of the two exposures, many different contrast renderings can be achieved.

Achieving variable-contrast control With the use of separate filters, dodging and burning in can be used together to gain precise control over different tonal areas. For example, a print could be given an overall exposure with one contrast filter, followed by a separate burning-in exposure through a different contrast filter. (When using this technique, be careful not to move the enlarger while changing filters, or a double image will result.) In this way individual areas of even the most complex negatives can be printed with appropriate contrast. (See Figure 7-18.).

Bumping up the blacks Split-filter printing can also be used for "bumping up the blacks." Often when an image is printed for low contrast, no rich blacks are produced, even though the exposure and contrast grade may be ideal for that image. In such cases, some photographers give a brief secondary printing exposure through a high-contrast filter. The exposure time can be short enough so as to have little effect on the overall density of the print, yet still increase the depth and richness of the deep shadow areas. Bumping up the shadows with such a second exposure often adds visual vitality and spark to an otherwise lackluster image.

Variable-Contrast Printing with Color Heads

Some enlargers are equipped with **color heads** designed for printing color negatives and slides. These are variations of diffusion enlargers designed to use built-in, fade-resistant cyan, magenta, and yellow filters. Light passes

FIGURE 7-18

An example of split-filter printing. The main print exposure was made through a high contrast No. 5 filter to heighten the graphic shadow cast by the stairway. A low contrast No. 0 filter was then used to burn in the bright area around the light fixture to add tone and detail.

TABLE 7-2 Variable-contrast printing with a color head

Contrast Filter	Color Head Setting Y - yellow M - magenta
0	110Y
1/2	90Y
1	70Y
1 1/2	30Y
2	0 (white light)
2 1/2	30M
3	45M
3 1/2	55M
4	95M
4 1/2	130M
5	170M

through the filters into a mixing chamber, where it bounces around and emerges through a diffusion panel as an evenly colored beam of light. The color of the light is determined by adjusting how far each filter extends into the light path. The filters, and the resulting color strength, are usually adjustable from 0 to nearly 200 **color correction** units, called **CC's**. The intensity of the color is increased as the number of CC units is increased. Thus a color head might be set to produce light consisting of a rather pale 30 CC of magenta and a deep 80 CC of yellow.

A color head can also be used to make black-and-white prints and is especially versatile when used with variable-contrast enlarging papers. Two of the filters found in color enlarging heads are magenta and yellow—precisely the two colors to which variable-contrast papers are sensitive. Thus, by adjusting the amounts of these two colors, the color enlarging head can be used to produce any contrast grade of image-forming light. Table 7-2 shows approximate color head equivalents for common variable-contrast filter numbers. Exact equivalents will vary with the brand of photo paper and enlarger used.

Diffusion enlargers tend to produce prints with less apparent contrast than those produced by condenser enlargers. Often, a higher contrast filter equivalent must be used when printing black-and-white photographs with a color head. If a diffusion or color enlarger is usually used for black-and-white printing, the contrast of the negatives may need to be increased accordingly. A slight increase in film development time will cause a corresponding increase in the negative's contrast; experiment to find the amount of increased contrast that best matches the printing system.

Contrast Control During Development

The print contrast of some photographic papers can be fine-tuned by chemical means during paper development. This technique works best with photographic papers that have no developer incorporated into their emulsion. Fiber-based papers, especially the warm-toned chlorobromide papers, offer the most contrast control through chemical means.

Changing development time Minor changes in print contrast can be made simply by altering the print development time. Slightly longer developing times may be used to increase contrast a bit—but overextending the development time can have the opposite effect by fogging the whites and light grays. Experiment by developing three identically exposed prints for different times—two minutes, four minutes, and eight minutes, for example. Then carefully compare the density of the shadows and highlights to determine the effect of altering development time.

Changing developer chemistry Changes in print contrast can also be made by changing the developer chemistry. One method is to use more diluted developer to reduce contrast or to use more concentrated developer to increase contrast. Alternatively, selected chemicals can be added to the developer. Some photographers add a tablespoon or so of the high-contrast developing agent **hydroquinone** to a tray of conventional print developer to increase print contrast. Many manufacturers market special print developers for particular contrast effects. (See Appendix G-5.)

Water bath development One additional technique can be used to lower contrast when printing on fiber-based papers—the **water bath development** method. This technique works especially well with excessively harsh negatives. Expose the print normally and develop it in a conventional print developer until the image first starts to appear, usually about twenty to thirty seconds. Then transfer the print into a tray of slightly warm water and let it remain face down without agitation for one to two minutes.

Here's what happens in the water bath. The fibrous paper has absorbed enough developer to continue acting upon the image. However, this limited amount of developer is soon exhausted in the dark shadow areas, where there is much silver to act upon. It remains relatively fresh and strong, however, and continues to develop the less concentrated silver in the highlights. The effect is as though increased development time were given to just the highlights alone—and this reduces the overall contrast.

It is often necessary to repeat the cycle at least once more to build sufficient print density. Return the print to the developer tray and agitate for twenty seconds or so; this again saturates the paper base with developer. Then return it to the water bath for another one-to-two minute period.

Black Border Line Printing

You may have seen some prints where the image is surrounded and contained by a **black line border** and wondered how it was done. The line comes from printing both the image on the negative and the clear edges of the film that surround it. Because the film border is clear, it will print as pure black. Use of the black line became popular with photographers in the 1960s. Certain street photographers and others have used the black line almost as an aesthetic statement—as proof that the picture was made using the full frame of the negative, and that the integrity and reality of the original image was not tampered with by cropping. The black line also serves to help contain and frame the photographic image and has become a commonly used stylistic and graphic device for contemporary photographers. (See Figure 7-19.)

FIGURE 7-19

An example of a black-line border print.

The simplest way to print the black line is to use an oversize negative carrier, such as one designed for the next larger film size. The oversize opening will allow the film edge to print, and the width of the black line can be adjusted by careful positioning of the easel blades. You may find that this technique does not hold the negative flat enough, and that prints from the curled negative may have spatial distortions and/or problems with sharpness. A more effective technique is to cautiously file out the opening in a normal negative carrier until the aperture is approximately 1/16 in. larger than the dimensions of the negative. The metal or plastic must be removed carefully, however, and all edges must be free of file marks or burrs that could damage the film. If a negative carrier isn't available or can't be filed out, a copy of it can be made on heavy mat board. Black mat board works best. Just trace along the outlines of the metal carrier and carefully cut the film opening a bit larger with a sharp craft knife. If necessary, the edges can be smoothed with sandpaper. In any case, darken the edges with a black marker.

To use the oversize negative carrier, adjust the enlarger until the blades leave an opening about 1/8 in. larger than the enlarged image. The easel blade will provide the sharp outer edge of the black line and control its thickness. As printing takes place, white light will pass through the clear film edge, creating a black line around the image.

The Sabattier Effect

The **Sabattier effect,** named for Armand Sabattier who first described it in 1862, is achieved by reexposing a photographic print to white light during print development. The result is a partial tonal reversal—the print is not quite a negative and not quite a positive, and the borders between tones are defined by white lines called **Mackie lines,** named after Alexander Mackie. The process is sometimes incorrectly called **solarization**. (True solarization is a reversal of tones that is caused when film is grossly overexposed.) See Figure 7-20.

The strange tonal appearance of a Sabattier print is due to the decreased sensitivity of an exposed and partially developed print to light. When such a print is re-exposed, those areas that have already partially appeared on the print act as a mask, protecting the emulsion from further exposure. The print highlights, however, have no such protection and contain many sensitive silver crystals that can still be exposed and developed. This accounts for the tonal reversal. The Mackie lines are a by-product of the first development, which inhibits further action of the developer, thereby creating white outlines.

Sabattier printing is highly variable, and exact effects are hard to predict. In general, printing from a negative and giving only a slight second exposure will yield a print that is mainly positive but has some tonally reversed areas. Printing from a color slide or positive transparency produces the opposite effect.

The Sabattier effect works best with very high-contrast paper. Paper graded number 5 or 6 works well for this technique. With variable-contrast paper, it works best to use the highest contrast filter available for both the

A

B

FIGURE 7-20

A. A Sabattier print. Note the white lines that surround objects and the negative/positive effect. B. The same image printed in a conventional manner.

initial and secondary white light exposures. Experimenters have found that near-exhausted paper developer works much better than fresh. At least one manufacturer markets a developer made especially for making Sabattier prints (see Appendix G-5).

STEP-BY-STEP PROCEDURE FOR MAKING A SABATTIER PRINT

1. Set up and focus the enlarger in the conventional way. Use a negative of normal to high contrast, and print with the highest contrast grade of paper or contrast filter available.

2. Stop down the lens to f/8 and make a stepped test print to determine the first exposure. The example in Figure 7-21 was given exposures of 5, 10, 15, and 20 seconds (top to bottom) at f/8 using a cardboard mask.

3. Develop the print in normal or used paper developer for about half of the standard time. The example if Figure 7-21 was given a thirty-second first development.

FIGURE 7-21

A Sabattier test print. The first or main exposure runs from top to bottom while the second or re-exposure, is varied from side to side. In this manner, numerous combinations may be generated quickly and studied.

5 sec.

10 sec.

Main
Exposure

15 sec.

20 sec.

5 sec. 10 sec. 15 sec. 20 sec.

2nd Exposure

4. Move the print to a tray of running water for a thirty-to-forty-five-second rinse. Do not use acid stop bath. Remove the surface moisture from the print with a squeegee or towels. Place the damp print on a flat tray.

5. Place the tray with the damp print in place of the enlarging easel. Remove the negative from the enlarger but leave any contrast filters in place. Stop down the lens two stops. Make a stepped test print for the second exposure along the axis opposite that used for the first exposure. The example in Figure 7-21 was given a left-to-right stepped exposure of 5, 10, 15, and 20 seconds using a cardboard mask.

6. Return the print to the developer tray for the remainder of the normal developing time or until the desired effect is achieved.

7. Stop, fix, wash, and dry as usual.

8. Examine the checkerboard test print (Figure 7-21). Select one square that has the desired combination of first and second exposure times. Make a full print with these settings. For example, Figure 7-20 was given a 10-second first exposure and a 15-second second exposure.

The Sabattier technique encourages experimentation. Try varying the first and second development times as well as the first and second exposures. Try burning in and dodging during the second exposure. Exercise local control over the image by using a penlight or other small light source to re-expose and tonally reverse selected portions of the image. These and other variations of exposure and development can produce interesting variations in the resulting Sabattier effect.

Special Technique: Color Posterization

Joan Binkoff
Long Beach City College

The ability to recreate reality from a personal perspective is available through the creative use of darkroom techniques. Once an original photograph is captured on film, the photographer can add to and subtract from the basic image, introduce new forms and shapes, combine them with other images, and manipulate their colors and tones to achieve a personal version of the original.

The particular darkroom technique known as **color posterization** had its origins in printmaking, where photographs are transferred onto multiple screens for making silkscreen prints. Printmaking and photography are natural partners, and incorporating a photo-silkscreen procedure into creative darkroom photography was a logical transition. As is often the case, techniques used in one art medium are effectively applied to those of another.

Making Lithographic Separations

Begin the process by creating lithographic separations from an origi-nal tranparency, negative or positive, black-and-white, or color. High-contrast originals generally give the best results. In addition to the transparent original, the following materials will be needed:

▶ 8-in. by 10-in. high-contrast orthochromatic lithographic (ortho litho) film

▶ A & B litho developer

▶ Fixer

▶ Water or chemical stop bath

▶ Standard or borderless easel with three-registration pin setup

Here are step-by-step instructions for making the separations:

1. Work under ruby safelight.
2. Place the original transparency material in the negative carrier of the enlarger.
3. Focus and crop on a dummy sheet of paper in the easel.
4. Stop down to f/8 or f/11.
5. With the enlarger off, place a sheet of ortho litho film in the easel exactly in the registra-tion tabs.

 NOTE: It is critical that all separa-tions be in exact registration in order to reregister each separa-tion in sequence when making the final print.

6. Make a test exposure sheet of six increments. Try five to eight sec-onds for a black-and-white origi-nal, ten to fifteen seconds for a color original. (See Objective 6-E.)
7. Develop, wash, and fix according to manufacturer's instructions.
8. Inspect the test exposure sheet. Select three exposures as follows (Figure 7-22 A,B,C):

 A. An underexposure, showing a minimum of image densi-ties, mainly highlights and details

 B. A normal exposure, showing a normal range of image densities

 C. An overexposure, showing a maximum of image densities

 NOTE: Four litho separations may be used by simply extending this procedure to include an additional image.

9. Make three full-size litho film separation transparencies using the three selected exposure times.

(continued)

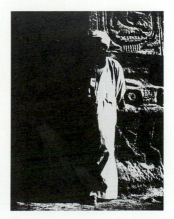

A B C D

FIGURE 7-22

A. Underexposed litho separation. B. Normally exposed litho separation. C. Overexposed litho separation. D. Reversal litho separation.

10. Examine the three transparencies. Bleach out opaque blemishes and rewash. Spot out transparent blemishes with opaque ink. Do not rewash.

11. Make contact reversal prints of each of the three transparencies onto fresh litho film. Maintain exact registration.

12. Examine the six transparencies. Select two negatives and a positive, or two positives and a negative. The three transparencies should include one of the underexposed images, one of the normal exposed images, and one of the overexposed images.

13. Use a punch or scissors to notch along the upper righthand edge of each transparency as follows (See Figure 7-23 A, B, C):

 A. One notch: underexposed image

 B. Two notches: normal exposed image

 C. Three notches: overexposed image

 NOTE: These notches are used to identify the transparencies in the dark so that they can be used in the correct sequence and position during final printing.

Making Color Separation Prints

At this point, experimentation and imagination can take over. The color filtrations and densities that are dialed into the color head can produce radically different results. Keep precise notes of the color filtrations, densities, and exposure times on the back of each print as work proceeds. If you wish, make test strips before making a full print.

Here are step-by-step instructions for making the prints:

1. Remove the original negative or transparency from the negative carrier. Use the enlarger as a

A B C

FIGURE 7-23

A. One notch: underexposed image. *B.* Two notches: normally exposed image. *C.* Three notches: overexposed image. Notches will enable you to identify and maintain correct sequence and position of lithos when doing final printing.

light source to make contact prints of the litho transparencies. (See Objective 6-B.)

2. Under safelight or total darkness: Place a sheet of color printing paper in the easel. Tape two corners in place with masking tape to prevent paper movement while changing litho transparencies.

3. Select a desired combination of yellow, magenta, and cyan. As a starting point, try 100% yellow, 0% magenta, and 0% cyan for litho transparency number 1.

4. Place litho transparency number 1 (one notch) on top of the printing paper. Be sure it is set exactly against the registration tabs. Select an exposure time and f/stop (try fifteen secs at f/8.) Expose.

5. Remove litho transparency number 1 without moving the easel or the printing paper.

6. Place litho transparency number 2 (two notches) on top of the printing paper. Maintain exact registration. Select a second combination of yellow, magenta, and cyan. (Try 0% yellow, 100% magenta, 0% cyan.) Expose. Remove litho transparency number 2.

7. Place litho transparency number 3 (three notches) on top of the printing paper. Maintain exact registration. Select a third combination of yellow, magenta, and cyan. (Try 0% yellow, 0% magenta, 100% cyan.) Expose. Remove litho transparency number 3.

8. Remove the exposed color printing paper from the easel and process according to manufacturer's instructions.

9. Examine the results in natural light. See Color Plate 9 A, B for an example of Color Posterization.

10. Continue to experiment with new combinations of filtration, density, and exposure, referring to past results to work toward the desired result.

Making Black-and-White Separation Prints

These same basic techniques are used to make black-and-white separation prints, except that the tonal qualities of the blacks and grays are controlled solely by the amount of exposure given to each litho transparency in sequence. Try starting with a thirty-second exposure for litho number 1, ten to fifteen seconds for litho number 2, and three to five seconds for litho number 3. After processing, continue to experiment with new combinations of exposure, referring to past results to work toward the desired result.

Objective 7-E Describe and demonstrate the processes of toning, mounting, spotting, and bleaching, and describe some guidelines for the care and storage of photographs.

Key Concepts toning, dry mounting, cold mounting, wet-mounting, spray-mounting, spotting, bleaching, archival processing

Even after an enlargement has been printed and processed, certain operations can still be done to enhance its appearance. If a few small dust specks escaped attention during print exposure, they will require touching up on the print. The color of the image can also be altered by bathing the print in one of many commercially available colored toning solutions. Further, every fine print looks even more striking if it is given proper presentation by careful matting or mounting. Because all of these operations are done after the print has been made, they are called **finishing controls**. Once the finishing process is complete, the photographs are in their final form. If the prints are to last for a long period of time, they must be properly stored and cared for.

Toning to Enhance an Image

Toning is one of several optional techniques that can be used to add a final touch to finished prints. The toning process alters the image tone to add a color dimension to the picture. The most popular toning shades are the sepia tones, which range from light reddish-brown to brown. These tones are especially effective for portraits because they convey the warmth and red-brown tones associated with the human skin. The same tones are also effective for wood subjects, trees, and landscapes, especially in the fall.

Blue is another popular toning shade. Blue tones are especially effective in communicating a sense of cold and are often used for wintry scenes of snow and ice. A blue toner may also enhance the cold, hard quality of steel.

Toner is most effectively used when it enhances the subject matter of a photograph without calling attention to itself. The use of a warm-tone toner with a cold subject or vice versa, or the use of odd or extreme colors, often will distract the viewer from the subject of the photograph. When this occurs, the viewer's concentration shifts from the subject to the technique, and the photograph may fail altogether to communicate the intended idea.

To use a typical toner, a previously processed print is first bathed in a special toning bleach and then put through the actual toning bath. When the desired color is reached, the print is washed and dried in the conventional manner.

The actual shade obtained when any toning product is used will vary with the type of developer used, the amount of development, and the type of paper emulsion. In addition, the intensity and shade produced by commercial toning products may be varied by altering dilution and immersion times. Color Plate 10 is an example of toning.

A

B

C

D

FIGURE 7-24

*Dry mounting. **A.** Tack mounting tissue to back of print, covering entire surface. **B.** Trim both print and tissue simultaneously so all edges are even. **C.** Tack tissue, with print affixed, to mounting board to hold it in place. **D.** Place print, tissue, and board in dry mounting press with protective covering sheet.*

Toning for Preservation

In addition to altering the image tone of black-and-white prints, toners are also used to preserve the life of photographic prints. Gold toner, for example, is designed to give any properly processed black-and-white print archival permanence. The gold in the toner combines with the silver in the image to create a print that is virtually impervious to chemical deterioration. The image tone changes very slightly toward a cooler, black-blue tone.

Selenium toner may be used for a similar purpose. In stronger concentrations, selenium toner changes the image tone toward the warmer, red-brown tones. However, in weak concentration, the selenium will combine with the silver in the image to create a chemically resistant print without noticeably changing the image tone.

Mounting

When display prints are properly mounted, they are set off from their potentially confusing surroundings by a neutral frame. This aids viewing by creating an aesthetic distance between the image and the background environment that enables the viewer to concentrate more fully on the subject. As with other finishing techniques, a mounting should enhance the subject of the picture without calling attention to itself.

Dry mounting **Dry mounting** is the preferred mounting process because it uses no liquid adhesives and provides a relatively stable and chemically neutral bond. To dry mount a print, the following materials and equipment are needed:

▶ Dry-mounting tissue.

▶ A mounting board. Ordinary mat board will suffice for most work, but special acidfree or rag board should be used for especially valuable prints.

▶ An electric tacking or household iron.

▶ An electric dry-mounting press or household iron.

The steps in dry mounting a photo to the mounting board are listed below and shown in Figure 7-24. If a dry-mounting press is not available, a household iron may be used.

1. Lay the print face down on a counter. Lay a sheet of dry-mounting tissue over the back of the print so that the print is completely covered by tissue. Use a tacking iron or a household iron to tack the tissue to the back of the print at the center. (Set the household iron between the silk and wool temperature settings for fiber-base prints. Be sure the steam setting is off.)

2. Trim the print and tissue simultaneously in a paper cutter so that the edges of the print and the tissue are exactly even at all points.

3. Position the print on the mounting board. Hold the print in place, lift one corner of it, and tack the mounting tissue to the mount. Repeat until three corners of the mounting tissue have been tacked to the mount.

4. With a dry-mounting press: Place the mounting board, with the print and mounting tissue tacked in position, into the press, with the print facing up toward the iron surface. Place a double thickness of craft paper or a special dry-mounting cover sheet over the entire mounting board surface to protect the face of the print from the heated surface. If fiber-base photo paper and standard mounting tissue are used, set the temperature of the press between 250°F and 275°F (120°C to 135°C). Close the press for approximately one minute, or until automatically signaled. Then remove the print from the heat, place a flat weight on its surface, and allow it to cool.

With a household iron: If a dry-mounting press is not available, a dry, electric, household iron can be used to tack and mount the print. Again, set the temperature gauge at "silk" or "wool." Cover the entire board and print with a double thickness of wrapping paper. Run the iron back and forth over the print area, keeping the iron moving at all times, and working from the center toward the edges of the print. Do not apply too much pressure. Continue the procedure until the mounting is firm. Place a flat weight on the print and allow it to cool. Properly mounted prints will not detach from the mounting board when the board is flexed slightly.

If RC paper is used, special low-temperature mounting tissue, designed for use at approximately 180°F to 190°F (82°C to 88°C), must also be used; temperatures above this level will melt the resin coating and destroy the print. Be sure to follow the paper manufacturer's recommendations for mounting.

Cold mounting Pressure-sensitive **cold-mounting** adhesive sheets are also available for mounting prints. Cold-mounting materials need no special presses and work well with RC prints. The material is essentially a sheet of adhesive with a removable protective backing on both sides. It is applied first to the back of the print and trimmed; then the second cover sheet is peeled off and the print is adhered to the mount. Some brands are positionable; that is, the print can be moved around on the mat until it is correctly positioned. The adhesive does not chemically affect photographic materials, and the bond strengthens as it ages. (See Figure 7-25.)

Prints can also be **wet mounted** or **spray mounted**. Mounting adhesives that are specially designed for photographic purposes should be used. Do not use rubber cement or other nonphotographic adhesives, because they may contain solvents that could ruin the prints. Follow the manufacturer's instructions for wet mounting or spray mounting photographs.

Spotting and Bleaching

Despite careful printing, some prints may end up with a few tiny white spots caused by dust or lint. These may be retouched by **spotting**, using spotting dyes and brushes. Spotting dyes are available in both dry and liquid forms; the common colors are black, white, and sepia. Spotting brushes are very fine art brushes, usually number 0 to 000. Both glossy and matte prints can be spotted when they are dry.

A

B

FIGURE 7-25

*Adhesive mounting. Two-sided self-sticking adhesive cards make picture mounting easy. **A.** Peel off backing and apply photo to adhesive surface. **B.** Peel backing off reverse side and apply photo to the mounting surface with even pressure.*

FIGURE 7-26

Spotting. Spotting the finished print to conceal blemishes. Spotting dyes may be diluted to match virtually any tone on the print. Modern spotting dyes may be used with RC papers, matte or glossy fiber-based papers, warm or cold tone papers.

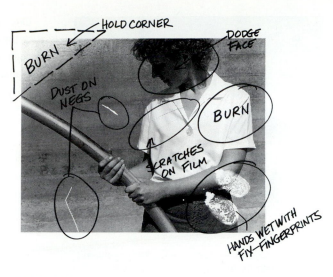

FIGURE 7-27

Common print problems. Note problems identified in the print. Some would be corrected by burning in and dodging, some by spotting, and others are beyond repair. Use proper procedure to avoid them.

To spot a print, dampen the brush slightly and pick up a little of the spotting dye that appears lighter than the area around the spot. Dab lightly at the spot to overlay the dye until it matches the surrounding area. Using a fine point, apply the dye to the spot using a dotting or stippling motion. Continue until the spot disappears into the surrounding area. (See Figure 7-26.)

Occasionally a print may acquire black spots as a result of pinholes or other negative blemishes that pass light. Eliminating these spots from the print is a somewhat more complex operation that, if not meticulously executed, can easily ruin the print. The process involves **bleaching** the black spot from the print with either a weak solution of potassium ferrocyanide or ordinary laundry bleach.

Use a small, tightly twisted cotton swab to apply the bleaching agent delicately and gently to the precise area of the black spot. Try to avoid bleaching any of the surrounding area—the larger the bleached area, the more visible it will be in the final print. When the black spot has been bleached away, the whitened area that remains can be spotted, as just described, to restore its tone to that of the surrounding area. Practice the technique on scrap materials before trying it with good prints.

Both spotting and bleaching are difficult, time-consuming tasks that should not be relied on to rescue carelessly made prints. Proper care in printing can save hours of laborious and often unsatisfactory retouching.

Care and Storage of Photographs

The first step in caring for a photograph is to be sure that it has been properly processed. Any image that needs to last longer than fifteen to twenty years should be printed on fiber-based paper and given careful **archival processing.** See Unit 13-C for methods to use when processing for permanence.

FIGURE 7-28

Archival storage boxes. Special boxes free of contaminants are used for the safe storage of valuable photographs.

Once the photos have been processed, avoid anything that could cause them physical damage. Never attach anything to a fine print. Paper clips can bend and crack the delicate emulsion, and adhesive tapes will leave a harmful chemical residue. Use only a soft lead pencil to write on a print—never a ball point pen, marker, or anything with ink that could bleed through or stain adjacent prints.

A fine photographic print is fragile. Proper mounting, especially window matting on chemically neutral and acidfree materials, will provide protection and act as a buffer to help preserve the print from staining. Any photograph that will be framed should also be window matted. The window or overmat will provide an air space to separate the surface of the emulsion from the glass of the frame. Without such a gap the emulsion of the print will gradually adhere to the glass and the image will be damaged as the paper base expands and contracts with changes of temperature and humidity.

When storing a fine photograph, place the mounted print in a polyethylene print storage bag. Store valuable prints only in special archival storage or portfolio boxes made of chemically neutral materials. Boxes or containers made of plastic or metal are generally safe (see Figure 7-28). Ordinary cardboard boxes and unpainted wood cabinets may contain chemical residues and vapors that can attack and stain prints over extended periods of time. When storing several mounted prints together, place a clean layer of acidfree tissue or interleaving paper between them. Archival storage materials and supplies are available at larger art supply stores and from mail order houses (See Appendix B).

Darkroom Design and Equipment

Objective 7-F Describe basic darkroom facilities and the equipment used in making black-and-white prints.

Key Concepts darkroom, fogged, safelight, enlarger, color printing (CP) filters, color head, enlarging lens, enlarger optical system, contact printer, enlarger timer, printing easel, print drying racks

The basic equipment and facilities used in printing black-and-white prints consist of the darkroom itself, safelights, white worklights, an enlarger, sometimes a contact printer, and print drying equipment.

The Physical Facility

Photographic printing procedures normally take place in a **darkroom** within which light is totally controlled. Ambient light that might affect light-sensitive materials is excluded; image-forming light is tightly controlled to prevent unwanted light leaks and reflections; and **safelights** provide overall illumination without affecting light-sensitive materials.

The size of the darkroom is determined by the type of work to be done and the number of persons to be working in it at the same time. Film processing and print making can be performed in the same space, but not

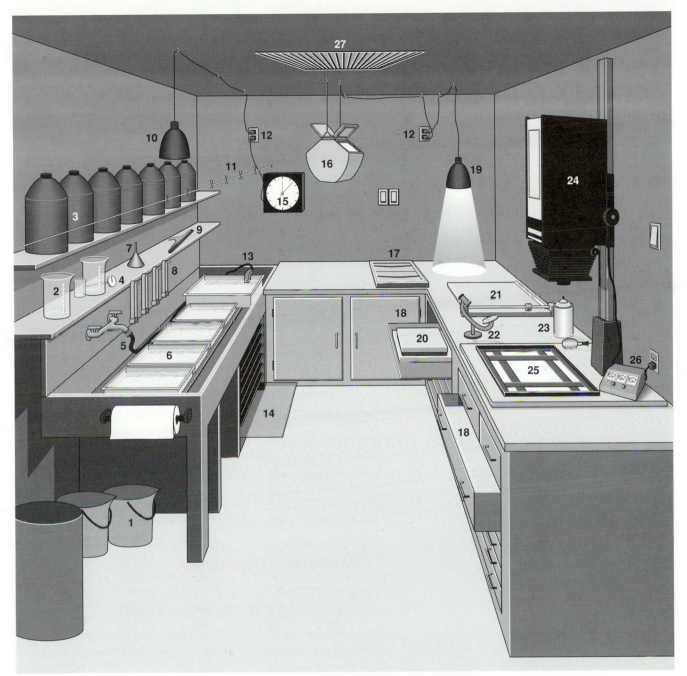

1 pails (2)	**8** tongs	**16** indirect light safelight	**23** negative cleaning brush
2 graduates	**9** squeegee	**17** contact printing frame	and canned air
3 chemicals for film and print	**10** safelight with filters	**18** drawers, cabinets, shelves	**24** enlarger
development	**11** clothesline and clothespins	**19** contact printing or flashing	**25** enlarger easel
4 thermometer	**12** electrical outlets	light	**26** enlarger timer
5 sink with faucet and drainage	**13** siphon print washer	**20** printing paper	**27** ventilator
6 trays (5)	**14** drying frames with screens	**21** paper cutter	
7 funnel	**15** timer	**22** focusing magnifier	

FIGURE 7-29

An ideal darkroom layout. Notice that the room has been divided into a wet-side for chemical processing and a dry-side for handling film and paper.

always conveniently at the same time. Film handling usually requires total darkness, at least while the film is being loaded into the processing tank. For a one-person darkroom this requirement poses no special problem. However, if more than one person will be using the darkroom, it is useful to provide a separate film-loading room where total darkness can be obtained without stopping printing operations.

An 8-ft. by 10-ft. darkroom is large enough to hold a normal amount of printing equipment and to allow a single operator to work in comfort. For large volume output, or for more than one operator, a larger space will be needed. The minimum requirements for a printing darkroom are: (1) at least 40 square feet of space, (2) a fully grounded electrical system equipped with ground fault interceptors, (3) adequate ventilation, (4) a seal against the penetration of outside light, and (5) access to water and drainage. Highly desirable features include a minimum of 80 square feet of space and an integrated water system. (See Figure 7-29.) In planning a printing darkroom, keep in mind the "Helpful Hint for Darkroom Planning" noted below.

HELPFUL HINT
Darkroom Planning

1. The enlarger and other printing equipment and materials should be no more than four feet from the developing position at the sink. This will make an efficient and convenient work space.

2. Electrical switches should be easy to reach.

3. The entire electrical system should be grounded and equipped with a ground fault interceptor to minimize electrical hazards.

4. Electrical receptacles should be plentiful and easy to reach. The circuit breaker should be of the GFI type; otherwise, every receptacle should be equipped with a ground fault intercepter.

5. The counter tops and the sink should be approximately thirty-six inches from the floor for comfortable work.

6. The floor should be dark, resilient underfoot, chemical- and water-resistant, and easily cleaned.

7. A light-trapped entry is desirable to provide free access and ventilation without opening doors or curtains.

8. Dust-collecting surfaces, such as pipes and open shelves, should be avoided. Provide plentiful shelf space in enclosed cabinets and under the sink.

9. The walls and ceiling should be light in color—ideally white or beige—and painted with a water- and chemical-resistant paint. (Don't paint the walls and ceiling black! The safelight should be able to reflect off these surfaces to provide an even, diffused safelight throughout the room.)

10. Provide dustfree, filtered ventilation sufficient to give at least ten to fifteen complete air exchanges per hour. Adequate ventilation is absolutely necessary for safe and healthful darkroom work.

11. Provide a counter for handling dry materials—papers, negatives, and so forth—that is separate from the wet sink area,

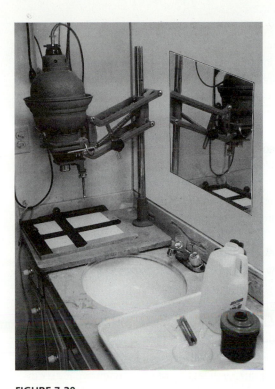

FIGURE 7-30

Portable darkroom setup. With ingenuity, a portable or semipermanent darkroom setup can be designed for use in small home bathroom or laundry room.

where liquid chemicals are used and processing occurs. This separation reduces the danger of contaminating dry materials.

12. Running water and drainage are highly desirable in the darkroom. Water taps should be within easy reach. Without running water and drainage, liquids must be prepared elsewhere and then carried into the darkroom; castoff liquids must be carried out again.

Figure 7-30 shows movable darkroom equipment adapted for use in a relatively small space. Many amateur darkrooms have been designed around a small portable cart, which can be wheeled into a bathroom and set up for operation within a few minutes. With a little imagination, any similar small space can be converted into a functioning darkroom on either a permanent or portable basis.

The Safelights

The darkroom should, of course, seal out all sources of ambient light that might fall upon the light-sensitive papers. Papers exposed unintentionally to such light may become **fogged**—that is, they may acquire an overall gray veil when developed.

Safelights should be positioned to produce the highest level of illumination possible that is consistent with the safety of the light-sensitive materials in use. Place safelights in several locations, reflecting their light off the walls and ceiling to provide an even field of safelight throughout the darkroom area. Additional safelights can be positioned directly over the work areas to provide a concentration of safelight for detailed work.

The level of safelight illumination should be tested for safety. To test safelights, expose a sheet of photo paper to a negative image. Before developing it, partially cover the exposed paper with another sheet of paper or cardboard. Then leave the partially covered photo paper exposed under the safelights for several minutes before processing it. If the safelights are affecting the paper, the covered and uncovered portions of the photo paper will have different appearances after processing. Exposed paper is used for this test because safelight fog may occur only in previously exposed portions of the print.

The White Worklights

Abundant white worklight should also be available in the darkroom to aid in toning and finishing procedures as well as for general use. The color qualities of the white light are important for proper print inspection. Most workers prefer to combine ordinary household light bulbs with one or two large fluorescent fixtures for overall illumination. Several individual tungsten lights can be positioned directly over the work areas to provide increased illumination for delicate work such as print spotting. The switch for the white worklights should be placed out of normal reach so that it will not be turned on accidentally while the darkroom is in use.

The Enlarger

Enlargers are designed in many varieties for many purposes. The major distinguishing features are their size, the type of light source used, and the method of distributing the light to obtain an even field of illumination during exposure. Some focus manually; others focus automatically as the head is raised and lowered.

Enlargers are designed for use with specific negative formats, from 8-mm to 8 in. by 10 in. Most are designed to use tungsten photo-enlarger lamps, which are manufactured in various wattages. Other enlargers use other light sources such as fluorescent, quartz-halogen, and xenon arc lights. Different light sources tend to produce slightly different print characteristics.

To obtain an evenly exposed print, the light that passes through the negative should be evenly distributed—it should be free of "hot spots" and "cold spots." There should be no difference in intensity between the center and the edges of the focal plane. Two methods are used to obtain even illumination: (1) diffusing the light emanating from the light source, and (2) optically condensing the source light. Diffusion is accomplished by inserting a ground glass between the light source and the negative; this method tends to produce prints with less contrast. Condensing is accomplished by inserting a set of condenser lenses between the light source and the negative; this method tends to produce prints with greater contrast and definition. Because of the weight of the condenser lens assembly, condenser enlargers tend to be heavier and sturdier.

Most black-and-white enlarger heads are fitted with a filter slot or drawer, a highly desirable feature. Such a device allows individual variable-contrast filter sheets to be placed in the light path. Locating the filters between the negative and the light source eliminates any optical problems that might result from dusty or slightly scratched filters. The filter drawer can also be used to hold stacks of individual **color printing (CP) filters,** to be used when printing color photographs. Color printing with individual cut filters is possible, but not nearly as convenient as using a color head.

Color heads Many modern enlargers are equipped with a **color head** in place of a condenser system. These heads contain three adjustable filters—cyan, yellow and magenta—and are designed especially for making prints from color negatives and slides. The filters are mounted on adjustable arms that can be extended or retracted in front of the light bulb to color the light. The user simply dials the desired filtration with calibrated knobs. After filtration, the light passes into a mixing chamber where it is further diffused and exits the head through a sheet of opal glass. Almost all color heads are of the diffusion design.

When purchasing a new enlarger, consider one equipped with a color head, or one that allows adding a color head later. Color heads can be used quite successfully for black-and-white work and even have some advantages when working with variable-contrast enlarging papers. (See Objective 7-D, page 208.) Color printing from slides and negatives is relatively easy when a color head enlarger is used, and many darkroom workers enjoy the added dimension that color photography offers. (See Figure 7-31.)

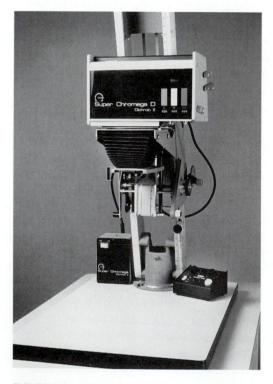

FIGURE 7-31

An enlarger equipped with a color head. Varying strengths of cyan, yellow, and magenta filters can be dialed in or out easily.

Enlarging lenses The **enlarging lens** is the heart of the enlarger system. Select a lens of the highest available quality; a low-quality lens will produce photographs that noticeably lack sharpness and contrast. Enlarging lenses cost about the same as camera lenses of comparable quality.

Enlarging lenses, unlike camera lenses, are designed for flat field work. Because both the negative and the printing paper are two-dimensional, it is important that the lens possess an extremely flat field—it should produce sharp detail all the way from the center to the edge of the print. Enlarging lenses come in a variety of focal lengths designed to match various negative formats. Generally an enlarging lens will have the same focal length as the camera's normal lens. For example, the normal lens of a 35-mm camera has a focal length of 50 mm; the enlarging lens that is normally used for negatives produced by 35-mm cameras also has a focal length of 50 mm. Most enlargers provide a means for changing the lenses for greater flexibility .

The entire system of condenser and optical lenses, including adjustment mechanisms, is known as the **enlarger optical system.** The enlarger is used commonly with adjunct equipment, including an enlarger timer and a printing easel. The timer precisely times exposures to the nearest second, automatically turning off the source light after the selected interval. The easel holds the printing paper flat and in proper position during exposure.

The Contact Printer and Contact Proofer

A **contact printer** is a simple piece of equipment, usually a light-tight box containing a light source, built with one or more glass walls. A clamp tightly sandwiches the negative between the contact paper and the glass wall. A built-in timer controls the contact exposures. Like enlargers, contact printers should provide even illumination, with no "hot spots" or "cold spots." Because today some enlargement is required even to produce album-size prints from small-format negatives, contact printers have fallen out of common use. Contact proof sheets and contact prints are now generally made using the enlarger as a source light. Contact proofers, or contact printing frames, allow the negatives from an entire roll of film and a sheet of photo paper to be pressed together against a sheet of glass. (See Objectives 6-B and 6-C, pages 172–180.)

Print Drying Equipment

A rubber squeegee or a clean photographic sponge will remove most of the surface moisture from a well-washed print. Resin-coated prints can then be dried on a simple clothesline hung along one darkroom wall. Fiber-based prints are best air dried on **print drying racks**. Such racks can be economically built by stretching fiberglass window screening over a wooden frame. Several frames of the same size should be built at one time; they will later be stacked for use. If greater drying speed is required, a heated dryer may be used. Hot air dryers are available that quickly and automatically dry RC prints. Heated drum-type models are available for fiber-based photo paper.

HELPFUL HINT
A Basic Darkroom Kit

The basic equipment for a functioning darkroom should include the following:

▶ enlarger equipped with one or more lenses of the proper focal length and negative carriers for each size of film

▶ variable-contrast printing filters

▶ enlarging timer

▶ brush for cleaning negatives

▶ blower or canned air

▶ enlarger focusing device

▶ safelights

▶ framing easel

▶ photographic paper

▶ paper safe

▶ paper cutter or scissors

▶ contact proofer

▶ various dodging and burning-in tools, usually homemade

▶ at least four trays: three for chemistry and one for wash

▶ darkroom tongs

▶ graduates, funnels, and so forth

▶ darkroom chemistry

▶ chemical storage bottles

▶ thermometer

▶ print washer or siphon

▶ print drying rack or clothesline

Questions to Consider

1. What factors should be considered when selecting an enlarging paper?

2. Describe several methods for controlling print contrast.

3. How are burning in and dodging accomplished? Which one is done during the main exposure?

4. How could split-filter printing be used with a typical landscape photograph?

5. If you were given the opportunity to design a darkroom, what size and layout would you select? How would it be equipped?

Suggested Field and Laboratory Assignments

1. Print the same image with at least three different contrast renditions. Change contrast grades or contrast filters to make one print with high contrast, one with low contrast, and one with moderate contrast. Experiment with various exposure times until you have a set of prints with matching highlight densities. Compare the prints. Is there a difference in the quality and interpretation of the information in the photograph? Does the viewer's emotional response to the image change?

2. Use at least one of the common printing controls—cropping, burning in, and dodging—to refine an enlargement.

3. Experiment with one of the special printing processes such as split-filter printing, black line border, or the Sabattier effect.

4. Make two prints of the same negative, one on resin-coated (RC) photo paper and the second on fiber-based paper. Work carefully and experiment until you have two prints that match in densities and contrast. Compare the two images for tonal beauty, richness, and feeling of spatial depth.

5. Try an experiment in toning prints. Purchase a small package of sepia toner and follow the directions on the package for mixing and use. Work only in a well-ventilated area. Compare several toned prints to untoned prints.

Unit **Eight**

Introduction to Composition

Scott Deardorff, "4th Street, Los Angeles," 1988.

Unless the visual elements in a photograph are organized and presented in a meaningful way, the photograph is likely to become only a shallow account of subjects and events that would have seemed far more intriguing had some planning taken place before the shutter was released. Organizing the visual elements and presenting them in such a way so as to convey meaning, mood, emotion, or insight is the function of composition.

This unit describes the elements of composition as well as the techniques photographers use to make photographs that better communicate their ideas and feelings. As photographers gain control of their medium, they increase their ability to emphasize important details and relationships, to subordinate others, to guide the attention of viewers, and to affect them intellectually and emotionally. The objectives of this unit are to provide some principles and guidelines that will help the beginning photographer to develop composition skills and judgment.

Composing Photographs

Objective 8-A Define composition and describe its elements and purposes.

Key Concepts composition, line, tone, mass, contrast, color, selection, emphasis, subordination, central or dominant idea, center of interest

Without the mind's organizing power, the visual world would be completely chaotic. There are so many details that we cannot take them all in; we cannot comprehend the visual world in its entirety. The mind helps us to pick and choose what we see—to view first this detail, then that, until a pattern of meaning emerges.

From a hillside, viewing a valley below, the naturalist may see an ecologically balanced pattern of life; the geologist, a pattern of earth formation that suggests a future earthquake; the industrialist, a pattern of valuable raw materials and energy sources; the developer, a site for a future community. Each may view the same scene, yet each sees a different pattern and derives different meaning from it.

The mind, not the camera, selects and organizes visual detail so that meaning emerges. If a photographer is to convey meaning to others, therefore, the photograph must be organized around an idea to be shared. Without an idea—without the mind of the photographer to organize the visual elements—a photograph is little more than an unorganized record of what stood before the camera when the shutter was released.

Composition, then, refers to the way in which visual details are selected and organized within a photograph to convey meaning. The organization will alter the content of the visual image and the relationships among the visual elements. The approach taken depends upon the photographer's interpretation of the details in the scene.

The Elements of Composition

Music is composed, as is a poem or a novel. We may even speak of "composing" ourselves or of retaining our "composure." The common thread in all these meanings suggests organizing diverse, confusing elements into a meaningful whole. That is what we do when we compose a photograph—we organize diverse visual elements into a meaningful pattern.

The musical elements are characteristics of sound, such as pitch, timbre, volume, harmony, and rhythm. The pictorial elements are characteristics of image, such as **line, tone, mass, contrast,** and **color**. Line refers to the arrangement, real or imagined, of outlines, contours, and other connecting elements within the image; mass, to areas of density within the image that cohere together; tone, to the color quality or brightness value in a portion of the image; contrast, to the magnitude or brightness differences between adjacent masses; and color, to the visual sensations produced by different wavelengths of light. Just as a musician composes sound elements to communicate ideas and feelings, so the photographer composes these image elements. In all cases composition refers to the art of organizing these diverse elements into effective communication—transmitting the composer's meaning with a minimum of distortion and ambiguity.

Compositions involving the visual elements of even a single scene may take many forms. Sometimes effective photographic compositions are simple, straightforward expositions of a single subject. Beginners often enjoy early success by concentrating on such simple compositions. However, other effective compositions may be probing explorations of complex visual patterns, communicating often subtle moods and feelings through richly varied patterns of detail and texture. A photographer's effectiveness in dealing with complex subjects tends to increase with command of the medium. (See Figure 8-1.)

Until they develop some command of the medium, beginning photographers are generally well advised to concentrate on images that tell one simple story with a single idea or dominant center of interest. Any attempt to crowd too much within a picture's borders tends to scatter the viewer's interest and confuse understanding. When this occurs, the image fails to communicate the photographer's intent, mood, or feeling. By keeping the central idea in mind while visualizing the final print before shooting, the photographer is more likely to achieve the intended effect.

The Functions of Composition

One function of composition is to achieve emphasis within the image. Many composition guidelines primarily suggest ways to accomplish this. In an effective composition, pictorial elements within the scene are **selected** and **emphasized** so as to communicate the photographer's ideas. Other elements within the scene are **subordinated** or excluded altogether. Thus, a major function of photographic composition is to focus the viewer's attention upon certain details in the scene to the exclusion of others.

To accomplish this, a photographer selects various details to include in the photograph and others to eliminate. Then, from among the included details, the photographer selects some to emphasize and others to subordinate—that is, some of the details are made to appear more prominent

A

FIGURE 8-1

Organization of pictorial elements. **A.** *Simple composition.* **B.** *More complex composition, probing subtle moods and feelings.*

B

A

FIGURE 8-2

Center of interest. **A.** *Single idea with careful selection of a few details.* **B.** *A single feature dominates picture, appearing especially important.*

B

A

B

FIGURE 8-3

Central idea without center of interest. **A.** *Repeated features establish rhythm that becomes central idea.* **B.** *The complex architectural pattern, rather than the structure itself, becomes the central idea of this image.*

and others less so. By selecting, emphasizing, and subordinating details, the photographer seeks to communicate a **central** or **dominant idea**.

To achieve effective composition, therefore, the photographer must have clearly in mind the message, idea, feeling, or mood that the photograph is to convey; otherwise, it will be difficult to select the details of special importance. This usually means that the photograph will be about something—that some single object or group of objects will stand out unmistakably as the reason for the picture. Within the picture, one feature will usually dominate and appear especially important, significant, or interesting. Such a feature or element in a photograph is called the dominant **center of interest**. (See Figure 8-2.)

A picture without a center of interest risks being like a sentence without a subject—the audience will not understand what it is about. Nevertheless, communication is still possible. Just as musical compositions sometimes succeed without a dominant theme on their tonal and rhythmic values alone, photographs too may succeed without a center of interest, on their tonal or rhythmic values alone. When a photograph succeeds through its use of textures, or through rhythmic repetition of pictorial elements, usually these become the central or dominant idea. The picture is then "about" these textures or rhythms. (See Figure 8-3.)

As photographers' experiences and purposes vary, so do their viewpoints. No two photographers will see the same subject in precisely the same way. Their compositions will differ as they try to communicate their own unique ideas. Their centers of interest may vary; certain details may be included by some, eliminated by others; certain details may be emphasized by some, subordinated by others. Through their compositions they direct viewers' attention to the details and relationships they think are important.

Several general principles of composition may help in composing pictures that communicate effectively. However, no rules or principles of photography will apply in all cases. Sometimes departing from these guidelines may lead to more effective communication. Ultimately photographers must rely on their own senses and instincts, learn to see in their own way, and express themselves photographically in their own style. (See Figure 8-4.)

Developing an instinctive judgment about composition becomes especially important when there is little time to plan a photograph carefully. Photographers often must take their shots as they find them—in the midst of rapidly moving events and under awkward physical conditions. Only

A

FIGURE 8-4

*Composition principles. **A.** Composition of richly varied tones and simple line creates mood of timelessness. **B.** Careful timing captures spontaneous moment.*

B

through experience and practice can the photographer learn to compose photographs quickly and effectively, even under difficult circumstances. The guidelines discussed below will help to make a beginning.

Control of Detail

Objective 8-B Explain and demonstrate how to achieve emphasis by controlling detail.

Key Concepts selecting details, busy background, sprout, relative sharpness, relative size, contrast, hue, primary hue, secondary hue, complement, saturation or chroma, value or brightness

Control of detail is one of the principal techniques of composition. By selecting the details to include and exclude, and by emphasizing or subordinating those that are included, the central idea of a photograph is expressed. The following discussion tells how to control details by selection, sharpness, size, and contrast.

Selection of Detail

The first major decision in composing a picture is selecting the details that are to be included and excluded from the photograph. One common error beginners make is to include too much detail. Decide which details are essential and which are nonessential. Then try to eliminate nonessential details that may distract the viewer from the picture's central idea.

A B C

FIGURE 8-5

Control of background. **A.** *Busy background. It is diffi-
cult to perceive subjects against a background of simi-
lar tonal values.* **B.** *Sprout. Metal bar appears to pro-
trude from child's head.* **C.** *Neutral background. By
selecting an appropriate angle, subject may be set
against neutral background, such as sky.*

FIGURE 8-6

*Vague center of interest. What is the central idea or
subject?*

Nonessential details may be eliminated from the picture by several
means. One common example of including too much detail is the **busy
background**. When we view a subject against a busy background, we
may have difficulty separating the subject from the other details in the
scene. Such a background may so overwhelm the viewer that the subject's
importance is diminished or even lost altogether. One way to avoid this
problem is to select a neutral background for your subject, such as the sky
or a hedgerow, thus eliminating these distracting elements and details.
(See Figure 8-5.)

Another example of including too much detail is the **sprout**—a promi-
nent background element directly behind the subject, such as a tree or
pole, which may appear in the final print to be "sprouting" from the sub-
ject. To avoid this problem, select a neutral background for your subject,
eliminating such distracting background elements whenever possible.

A final example of including too much detail is the picture with no
center of interest or no central idea. In this case the photograph displays
many details but fails to communicate the important relationships among
them. None is emphasized, none subordinated. All compete equally for the
viewer's attention. The viewer cannot tell what is supposed to be impor-
tant and what unimportant. By moving the camera closer to the essential
details, nonessentials will be pushed out of the frame. (See Figure 8-6.)

Control of Sharpness

Another way to emphasize or subordinate details in a photograph is to
control their **relative sharpness**. Once selected, details in the picture may
be shown with clarity and sharpness, or they may be shown as blurred,
fuzzy impressions. By using a lens's depth-of-field characteristics, back-
ground and foreground details can be shown out of focus while the sub-
ject is shown in sharp focus. This technique can be used, for example,

A

B

FIGURE 8-7

Control of sharpness. Sharpness of background detail is controlled in each picture to enhance subject.

C

when the subject cannot be framed against a neutral background. By presenting the subject in sharp focus against a background of out-of-focus details, the subject can be emphasized and the background subordinated. (See Figure 8-7.)

Control of Size

Controlling **relative size** is another way to emphasize and subordinate detail. The viewer will give greater attention to larger objects in a photograph than to smaller ones. A good guideline, then, is to move the camera as close as possible to the subject so that the subject will appear larger than other details in the picture. The presence of smaller details in a photograph tends to emphasize the larger ones. (See Figure 8-8.)

Control of Contrast

A fourth way to emphasize or subordinate detail is to use **contrast**. A bright object stands out against a dark background; a dark object against a light one. The subject can be emphasized by maximizing the contrast between it and its background.

A subject presented against a noncontrasting background may lack emphasis because it does not stand out readily. The subject and the background appear to be of equal value or importance. To emphasize the subject and subordinate its background, the "light against dark; dark against light" guideline is often a good one for the beginner. (See Figure 8-9.)

A

B

FIGURE 8-8

Control of size. Subjects emphasized by being largest details in the scene.

FIGURE 8-9

Control of contrast. Strong contrast—almost a silhouette—not only isolates subject against background but also creates atmosphere.

Control of Color

In color photography the additional element of color must also be controlled. By itself, color does not necessarily add impact or meaning to a photograph. In fact, improperly handled color may confuse and distract the viewer. Properly handled, however, color may help to emphasize and subordinate details and may enhance the mood, feeling, and central idea of a photograph.

Color has three major attributes:

1. **Hue**, which is the combination of wavelengths in the visible light spectrum that produces a specific color sensation. The **primary hues** are red, blue, and green; the **secondary hues**, cyan, yellow, and magenta. A primary and secondary hue are said to be **complements** when together they include all wavelengths present in light that is perceived as white.

2. **Saturation**, or **chroma**, which is the intensity or concentration of hue. When a color of a given hue is mixed with white, its saturation is reduced. The absence of saturation is no hue at all, or white.

3. **Value**, or **brightness**, which is lightness or darkness—the relative presence or absence of light rays. When a color of a given hue and saturation is mixed with black, its value is reduced. The absence of value is no light rays at all, or black.

Although hue, saturation, and value may be separately identified, they are not independent. When one is changed, the other two are often affected as well. Nevertheless, some independent control over each attribute can be exercised. The primary control over color detail is by selection. By placing the camera and the subject in carefully chosen positions, existing color details can be included or excluded from the photograph. In addition, some opportunity may be afforded to select details, such as clothing and backgrounds, that have desired color qualities.

As with black-and-white photography, the subject can be emphasized by presenting it against a neutral background of a simple, contrasting color. Greater emphasis can be achieved with a background of complementary color that is weaker in saturation and value.

Take care not to include too much color. A profusion of bright and varied background colors may emphasize the background at the expense of the subject. In an otherwise effective composition, even one bright-colored object in the background may draw the viewer's attention.

As with black-and-white compositions, earlier success may be enjoyed by keeping color compositions simple—by limiting the number of hues in the photographs, by keeping backgrounds uncluttered, and by subduing the saturation and value of background colors while strengthening those of the subjects.

See Color Plates 2-4 for illustrations of these principles of color composition.

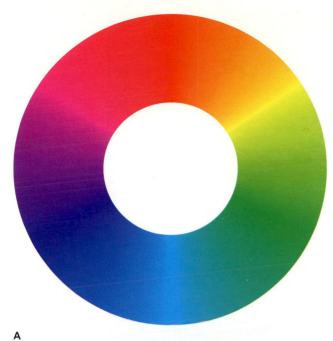

A

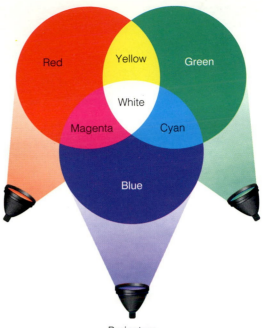

B Projectors

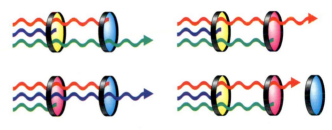

Filters

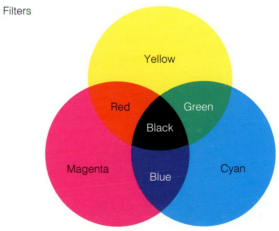

C

FIGURE 1

*Color theory. **A.** Color wheel. Twelve arbitrary hues from a visible light spectrum, including primary colors—red, blue, green—and their complements—cyan, yellow, magenta—respectively. Complements appear opposite the primaries. **B.** Additive color mixing. When pure monochramatic, primary light colors are projected onto a white screen from two or more projectors, the overlapping areas produce the secondary colors. Where all three overlap, white is produced. **C.** Subtractive color mixing. When white light is passed through successive filters of pure secondary colors, the light from the filter's complementary primary is blocked as the light passes through each filter. Any combination of two secondary filters will block two of the primary light colors and pass only one; all three secondary filters will pass no light at all.*

A

FIGURE 2

*Poor organization of color elements. **A.** Busy, disorganized color composition fails to direct attention to any central subject or to develop a coherent central idea. **B** The brightly colored object in the foreground competes with the central subject for the viewer's attention.*

B

A

FIGURE 3

*Simple compositions. **A.** A simple composition with a major and minor subject in a straightforward arrangement with minimal perspective.*

B

FIGURE 3 CONTINUED ▲

B. Good composition. Note how the chain of yellow raincoats and the yellow flower lead your eye through the composition.

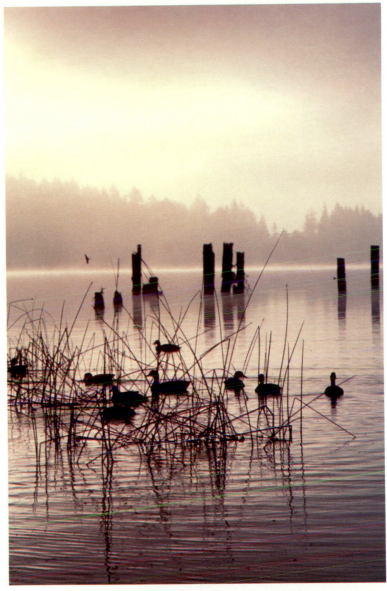

A

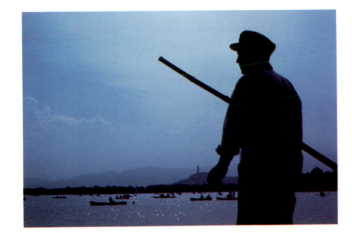

B

C

FIGURE 4

Color composition. **A.** Monochromatic composition. Overlapping elements and haze create an illusion of distance that, combined with monochromatic composition, generates a sense of tranquility. **B.** A silhouette of a boatsman is the center of interest in this monochromatic composition. A diagonal element adds a sense of movement to an otherwise static scene. **C.** Contrasting colors emphasize the intersecting lines and planes of this architectural composition.

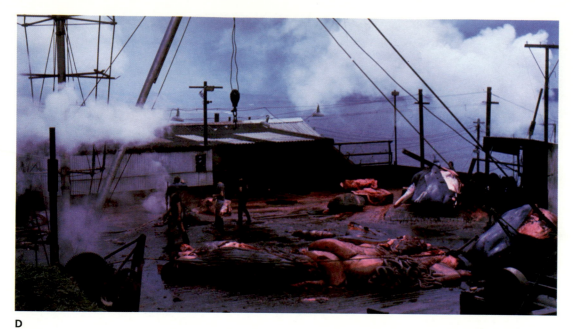

D

FIGURE 4 CONTINUED

D. Contrasting colors. The single contrasting color calls attention to itself and makes a powerful statement about this whaling station.

B

A

C

FIGURE 5

*Available light. **A.** The single bright light provides all the illumination needed for this image. The concentration of light upon the jade-worker's face, hands, and work focuses the viewer's attention on these elements. **B.** Available light photography often requires longer exposures. Strong side light from the doorway provided all the light needed for this image. Had flash been used from the camera position, the separation of the arches and the texture of the cobblestones would have been lost. **C.** Night photography. Colored lights create a mood of cheerfulness against the evening sky.*

D

FIGURE 5 CONTINUED

D. Backlighting. By deliberately facing into the sun, the photographer obtained a silhouette and lens flares to add a touch of drama to this view of Borobudur Temple.

A

FIGURE 6

*Using filters with color film. **A.** Three exposures on the same frame, each using a different color filter—red, blue, and green. **B.** An orange filter used with infrared film creates unusual, often unpredictable effects. **C.** A blue filter can be used to create a moonlight effect.*

B

C

FIGURE 6 CONTINUED

D. Without a filter, normal colors in a scene may lack brilliance and appear lifeless. E. Using a graduated, color-enhancing filter can increase saturation and brilliance.

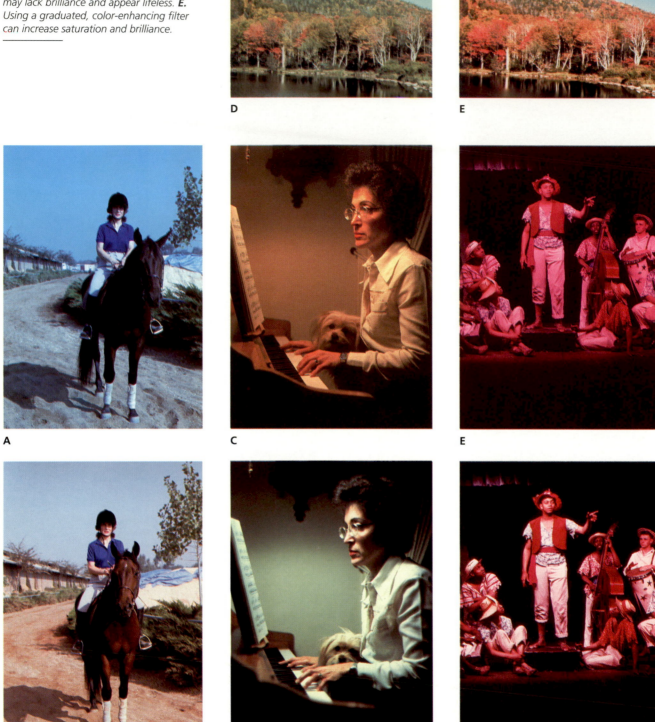

FIGURE 7

Color correction. **A.** Using tungsten-balanced film in daylight. Uncorrected, produces blue shift. **B.** Corrected by use of a conversion filter. **C.** Using daylight-balanced film in tungsten light. Uncorrected, produces an amber shift. **D.** Corrected by use of a conversion filter. **E.** Even using tungsten-balanced film, the colored gels used for lighting stage productions shift the color balance far into the red portion of the spectrum. **F.** Correction generally requires a considerable blue shift.

A

B

FIGURE 8

*New photographic technology. **A.** Digital analysis and computerized image enhancement make possible extremely high resolution and color separation from data received from far out in space. This enhanced image of Mars is made up of 102 separate Viking 1 images. Covering an area greater than the distance between New York and Los Angeles, the great canyon system Valles Marineris stretches across the lower third of this photograph. Three Tharsis volcanoes appear on the lower left. Without enhancement, these features would not be nearly as visible in the photo. **B.** Linda Ewing. "Family Plot I," 1990. Computer-generated color image in which the artist scanned in and combined various family photographs, manipulating their sizes, croppings, placements, colors, and densities to create a unique statement.*

A

FIGURE 9

Color posterization. **A.** A reproduction of the original color transparency. **B.** The posterized print. The technique used to make this posterized image is described on pages 215-217.

B

FIGURE 10

Toning. The use of a sepia tone on this black-and-white print enhances a feeling of warmth and supports the natural coloring of wood, earth, and skin tones.

Placement

Objective 8-C Explain and demonstrate how details can be emphasized or subordinated through placement.

Key Concepts rule of thirds, splitting the frame, movement into frame, camera angle, eye level, low angle, high angle

FIGURE 8-10

Any place marked X is a "natural" for the dominant subject. Dead center should be avoided.

The placement of details within the frame of a photograph is a principal technique of composition. By placing details in different areas of the frame, by facing them in different directions, and by placing them against different backgrounds, the photograph's mood, feeling, and central idea can be affected.

The Rule of Thirds

One useful placement guideline for emphasizing a center of interest is the so-called **rule of thirds**. Mentally divide the picture area into thirds, both vertically and horizontally. Any of the four points at which the imaginary lines intersect within the picture space has been suggested to be a "natural" for emphasizing the dominant subject (see Figure 8-10). It has been suggested also that secondary points of interest located at any of the other points of intersection also tend to be emphasized. According to this guideline, details elsewhere in the photograph tend to be subordinated.

The rule of thirds also cautions against certain placements within the picture frame. For example, it cautions against **splitting the frame** in equal halves with a strong horizontal element, such as the horizon. It suggests using one-third of the area for the foreground and two-thirds for the sky, or vice versa, to achieve emphasis.

Similarly, the rule cautions against splitting the frame exactly in half with a strong vertical element, such as a tree or telephone pole; it again suggests a one-third placement for emphasis.

Finally, it cautions against placing the center of interest in the exact, dead center of your picture. Such placement, being equidistant from all other points in the frame, tends to be static and uninteresting. Moving the center of interest even slightly toward the "thirds" lines may do much to add emphasis. (See Figure 8-11.)

Movement into Frame

The direction in which a subject faces or moves creates a space expectation on the part of the viewer, whose eye is drawn in that direction. Unless space to satisfy this expectation is provided in the frame, the viewer's eye tends to move outside the frame, creating a "dead" space in the picture behind the subject. To give the subject proper emphasis, therefore, it is suggested that a space within the frame be provided for the subject to look into, face into, or move into.

FIGURE 8-11

Placement by rule of thirds.

For example, a leaping horse whose landing place lies outside the picture will appear to be leaping out of the picture. This draws the viewer's attention out of the picture in the direction of the leap and generally creates an uninteresting, useless area behind the subject.

Similarly, in portraiture, a face too close to the frame toward which it faces will draw the viewer's attention into the small space between the face and the frame. This will appear to crowd the subject while creating a "dead" space behind the subject. Portraits are usually more satisfying if space is provided for the subject to look into.

In general, if there is action in a picture, it should lead into the picture, not out of it. Placement that allows **movement into frame** generally satisfies the space expectations of the viewers of the photograph. (See Figure 8-12.)

Camera Angle

The **camera angle** from which a picture is made affects the idea that is communicated. A picture shot from a normal eye position with the axis of the camera parallel to the ground is called an **eye-level shot**. Pictures made using eye-level positions tend to present the world as we normally view it. For this reason, eye-level shots appear most natural or normal to the viewer. In a more general sense, however, any shot made with the camera axis parallel to the ground may be considered an eye-level shot, since the camera views the subject from the same level as the subject. (See Figure 8-13C.)

The photographer can also look upward or downward toward the subject. A picture shot from a position lower than the subject is called a **low-angle shot**. Low-angle shots tend to emphasize the height, dominance, or impressiveness of objects. If the subject is a basketball player under the backboard, and the camera is pointed upward to view the subject, the player's height and elevated position will tend to be emphasized. (See Figure 8-13B.)

A picture shot from a position higher than the subject is called a **high-angle shot**. High-angle shots tend to emphasize the smallness, dependence, or insignificance of objects. If the subject is a child playing with blocks, and the camera is pointed downward to view the subject, the child's small size and lower position will tend to be emphasized. (See Figure 8-13A.)

A

B

C

D

FIGURE 8-12

Movement into frame. ***A.*** *Subject too close to right-hand edge of frame, appearing confined and about to collide with frame.* ***B.*** *Improved placement, shifting subject to left and providing space for moving into frame.* ***C.*** *Portrait too close to edge, appearing to look out of frame.* ***D.*** *Improved placement, allowing subject to look into frame.*

A

B

C

Famous Photographer: Roy Stryker and the FSA

FIGURE 8-14

Marion Post Wolcott. Coal miner's child taking home a can of kerosene; Pursglove, Scott's Run, West Virginia, 1938.

In the mid 1930s, America's farmers suffered the debilitating effects of the Great Depression, mechanization, and the worst drought in history. Farm prices plummeted, a series of dust storms laid waste to the Great Plains, and thousands of small farmers were dispossessed or driven into tenancy.

To divert this tragedy, President Franklin D. Roosevelt created an agency, later the Farm Security Administration (FSA), to help relocate dispossessed farmers and appointed Columbia University economist Rexford Tugwell to head it. Tugwell planned a massive, controversial, and expensive program of subsidies, which he knew a conservative Congress would oppose. To help persuade the public of the urgent need for his program, Tugwell sent for Columbia colleague Roy Stryker.

Stryker seemed an unlikely choice—he was an engineer and an economist, not a publicist. But Tugwell knew Stryker as a fervent teacher who had animated and humanized dry statistics in his undergraduate classes by using moving and informative photographs. Stryker took the same approach to his tasks at the FSA. Of a photograph, Stryker said " . . . that little rectangle, that's one of the damndest educational devices that was ever made."

Though not a photographer himself, Stryker managed to assemble a remarkable team of photographers that included Walker Evans, Dorothea Lange, Carl Mydens, Arthur Rothstein, Russell Lee, and painter Ben Shahn, many of whom became distinguished magazine and press photographers. Using his considerable gift for teaching and persuading, Stryker taught them to be photographic anthropologists, economists, and historians as they set out across America's highways, towns, and rural pockets of poverty to document the plight of the dispossessed, the poor sharecroppers, and the tenant farmers.

With unrelenting, uncompromising honesty and the fine, sharp detail that characterized new realism, this group produced what Edward Steichen later called "the most remarkable human documents ever rendered in pictures." They brought back on film not only the bitter truth about the farmers' plight, but also a sense of their indomitable spirit, their pride, and their strength. The pictures were widely published and succeeded in gaining both public and congressional support for the program. Just as important, however, their work inspired a generation of American photographers to seek and tell the truth.

A

B

FIGURE 8-15

*Linear perspective. **A.** Converging lines and diminishing size of objects convey illusion of depth. **B.** Vertical location and overlapping of more distant objects convey illusion of depth.*

Objective 8-D Describe and demonstrate how perspective controls can be used to modify apparent depth and distance in a photograph.

Key Concepts format, perspective, linear perspective, aerial perspective, selective focus, scale

The photograph's borders determine its spatial elements—its **format**. All details contained within the picture exist in relation to these borders. Each line is vertical, diagonal, or horizontal in relation to the borders; each mass is great or small in relation to the space contained by the borders.

Within this two-dimensional space, photographic elements are arranged to create an illusion of a third dimension. On the flat surface of the photograph, an illusion is created of a world that has depth. This illusion of depth is called **perspective**—the depiction of three-dimensional space on a flat surface by means of line, tonality, focus, and image size. Perspective can be controlled by several means.

Linear Perspective

Linear perspective is the illusion of distance created by the relative size and location of objects. We observe linear perspective when we see the edges of a highway apparently converge to a vanishing point on the horizon. We observe it when we see roadside telephone poles apparently diminish in size as they recede into the distance. We also observe it when we look downward to view things close to our feet and farther upward to view more distant objects.

If lines we know to be parallel appear to converge in a photograph, we interpret this as depth—the lines appear to be receding into the distance. If objects we know to be the same size appear to diminish in size within a photograph, we interpret this also as depth—the smaller objects appear to be at greater distances. Similarly, objects located high in the frame usually appear more distant, whereas those near the bottom of the frame usually appear closer. Finally, objects that overlap others appear closer than those overlapped. Figure 8-15 illustrates these principles.

Control over linear perspective can be gained in several ways. For example, the camera position can be moved, increasing or decreasing its distance from the subject and thereby altering the relative size of the subject and background details. The camera can be located in a position where nearby objects will overlap more distant ones, or a frame of large foreground details can be established.

Aerial Perspective

Aerial perspective is an illusion of distance created by relative tones and contrast in a scene. Haze, dust, or smoke in the atmosphere tend to make more distant objects appear lighter and less distinct than closer objects.

A

B

C

FIGURE 8-16

*Aerial perspective. **A.** Changes in tone enhance illusion of depth. **B.** Foreground detail and arch used as a frame enhance illusion of depth. **C.** Haze conveys impression of great distance.*

The effect of great distance can be created when light, hazy objects at a distance are viewed with darker, more distinct objects in the foreground.

These gradations of tone can be controlled to a degree. To darken nearby objects, a filter of a complementary color might be used. (See Unit 9 for discussion of filters.) For example, suppose the scene consists of a foreground of green shrubbery stretching out to a distant meadow of golden wheat under an azure blue sky. A red filter would darken the nearby green shrubbery, lighten the distant wheat, and darken the sky. Should the scene reach into the distance, the atmospheric haze might be exaggerated by using a blue filter.

In printing, too, aerial perspective can be controlled to a degree. For example, a foreground might be burned in to make it darker while more distant details might be dodged to make them lighter.

The effect of aerial perspective also can be enhanced by including a natural frame in the photograph. A foreground element, such as an overhanging branch, the trunk of a tree, or a bridge, can be used to establish a frame for a more distant subject. These frame details not only aid linear perspective but also enhance aerial perspective by tending to appear in darker tones. This combination of linear and aerial perspective increases the apparent depth of the image. Figure 8-16 illustrates aerial perspective.

A

B

FIGURE 8-17

Selective focus. In close-ups, shallow depth of field and selective focus create illusion of depth.

Selective Focus

Perspective can also be controlled by means of **selective focus**, with objects at one distance in sharp focus, and objects at other distances out of focus. Selective focus of nearby and distant details may also be observed in the physical world. Because the human eye can focus at only one distance at a time, objects at greater and lesser distances will appear to be increasingly out of focus. The depth-of-field characteristics of the lens can be used to enhance the illusion of three dimensions by controlling which objects are in focus and which are not. The greater the difference in sharpness between objects, the greater the distance between them will appear.

This type of perspective control often is used in portraiture. The difference in degree of sharpness between the features of the face and those of the background is exaggerated to create an illusion of depth. In many portraits sharpness begins to fall off at the subject's ears, closely approximating how a person is seen close up.

Focusing the lens and adjusting the aperture will modify depth of field. These adjustments can be used to hold certain details in sharp focus and record others out of focus. Long lenses, for example, offer greater control over selective focus, whereas short lenses afford greater depth of field. Precise control over depth of field is enhanced through the use of ground-glass focusing, one of the advantages afforded by reflex cameras. Figure 8-17 illustrates the effect of selective focus on perspective.

Focal Length as a Perspective Tool

Interchangeable lenses may also be used as valuable tools for controlling perspective. Lenses of various focal lengths can alter the apparent relative size of objects and thereby alter their apparent relative distances in the photograph. A lens of normal focal length approximates perspective as it is seen by the human eye—objects in the photograph appear to be of the same relative size and at the same relative distance as they appeared to the photographer.

Lenses of different focal lengths, however, tend to expand or compress normal perspective. For example, a shorter-than-normal focal length lens increases the size of nearby objects relative to those farther away. A short focal length lens tends to emphasize nearby objects and subordinate more distant ones by increasing the apparent distance between them. Extremely short focal length lenses distort objects close to the lens in relation to those farther away. Such distortion, while not normally desired, may some-times communicate an intended idea (see Figure 8-18). The longer-than-normal focal length lens, on the other hand, increases the size of distant objects relative to closer ones. Thus, a long focal length lens tends to emphasize more distant objects and subordinate closer ones by decreasing the apparent distance between them.

The degree to which perspective is altered varies with the focal length of the lens—the greater the departure from normal, the more exaggerated the effect on perspective. The creative use of these techniques to control perspective is one of the more powerful tools photographers use to express their unique perceptions of the world. Figure 8-19 illustrates the effects upon perspective of lenses of various focal lengths used at a fixed camera-to-subject distance. Figure 8-20 illustrates the effect achieved when lenses of various focal lengths are used to hold the field of view constant.

FIGURE 8-18

Wide-angle distortion. Subjects near the camera appear distorted and display foreshortened perspective, as in this portrait made with a 21-mm wide-angle lens.

A

B

C

D

E

F

FIGURE 8-19

*Controlling image size with various focal length lenses. **A.** 24-mm wide-angle lens. **B.** 35-mm wide-angle lens. **C.** 50-mm normal focal length lens. **D.** 105-mm telephoto lens. **E.** 200-mm telephoto lens. **F.** 400-mm telephoto lens. Pictures taken from the same camera position but with different focal length lenses vary the angle of view and image size. Focal length changes also alter depth of field and can be used to control selective focus.*

250

A

B

C

D

E

FIGURE 8-20

*Controlling perspective with various focal length lenses. In this series, the camera distance was varied to maintain similar image size of the main subject. Note how the illusion of depth diminishes as the near-far perspective compresses. **A.** 24-mm wide-angle lens. **B.** 35-mm wide-angle lens. **C.** 50-mm normal lens. **D.** 105-mm tele-photo lens. **E.** 200-mm telephoto lens.*

A

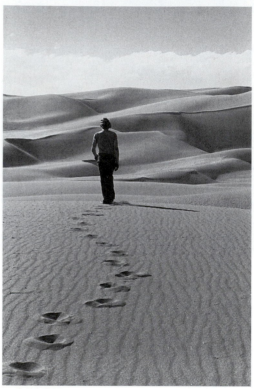

B

FIGURE 8-21

Scale. Objects of known size establish measure for judging depth, distance, and size of unknown objects.

Scale

The size of unfamiliar objects is often difficult to convey. A massive mountain may appear but a small hill in a photo, or a tiny insect may appear gigantic when the image is enlarged. When these objects are viewed in person, their sizes can be evaluated in relation to other familiar objects. The mountain is massive relative to the smaller size of the viewer; the insect is tiny relative to the leaf on which it sits.

Keep in mind that sizes and distances in photographs are relative. The apparent length, width, shape, volume, and distance of objects gain **scale** by their perceived relationship with other objects. If some perceived objects are of known scale, then the scale of unknown objects can become known also. Including objects of familiar size, such as trees, automobiles, houses, people, and animals, helps communicate the scale of a photograph and aids the viewer's perception of depth. Figure 8-21 illustrates this principle.

Lines of Composition

Objective 8-E Describe and demonstrate how lines of composition can be used to emphasize the center of interest and generate dynamism in a photograph.

Key Concepts lines of composition, real, implied, dynamism, horizontal, diagonal, zigzag, curved, vertical, opposing, converging

Within a photograph, various **lines of composition** tend to command attention. These lines may be **real** (visible) or merely **implied**. The edge of a building, the horizon, the edge of a road, or the top line of a fence—all are real lines in a photograph. The viewer's eye tends to travel along them.

Often these lines of composition are not visible, but they command attention just the same. A gesture, an extended arm, or the attention of many faces directed in a single direction can create implied lines of composition. The viewer's eye tends to follow the direction of the pointed finger, the focused gaze, or the moving object. (See Figure 8-22.)

When opposing lines of composition intersect at a sharp angle, attention is drawn to the point of intersection. The viewer is held in suspense at this point, expecting something to occur there. The intersection of composition lines acts as a powerful magnet, drawing the viewer's attention. By arranging lines of composition, the photographer can emphasize the center of interest by leading the viewer's attention directly to it.

The shapes and relationships of composition lines can also communicate **dynamism** within a photograph—a sense of force, energy, or movement. When composition lines are gently curved, they convey a sense of flowing, graceful movement; when they abruptly change direction or intersect, they convey a sense of vigorous, even violent movement; when they are parallel, they convey a sense of simultaneous, parallel movement.

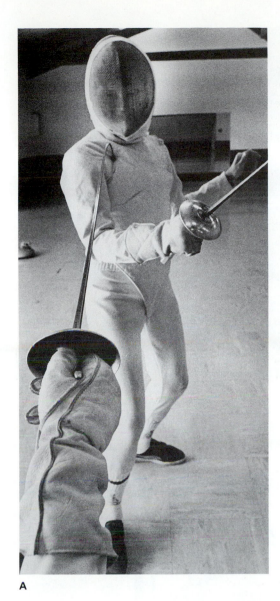

A

B

FIGURE 8-22

Lines of composition. **A.** *Real.* **B.** *Implied by pointing.*

FIGURE 8-23

Horizontal composition. Restful.

The function of composition is to organize pictorial elements to communicate the photographer's central ideas. Arranging composition lines to support a central idea is one of the photographer's essential tools. Gently curving lines of composition may communicate the graceful form and movement of a ballet dancer better than can opposing lines that are full of abrupt, angular changes of direction. On the other hand, the latter may more effectively communicate the violent movements of a boxing match.

The effects of different arrangements of composition lines may vary with subject matter and treatment, and so the following suggestions should be applied with discretion. As always, select a composition that best communicates a central idea.

Horizontal lines of composition tend to convey a sense of slow movement, inactivity, restfulness, tranquility, peacefulness, and inaction. (See Figure 8-23.)

Diagonal lines of composition tend to convey a sense of rapid movement—the more nearly they approach the diagonal, the more rapid the movement sensed. (See Figure 8-24.)

Zigzag lines of composition—lines that abruptly change direction—tend to convey a sense of vigorous, even violent action. We often symbolize lightning with a zigzag line. (See Figure 8-25.)

Curved lines of composition, such as the S-shaped curve, tend to convey a sense of graceful, flowing movement. (See Figure 8-26.)

FIGURE 8-24 ▲

Diagonal composition. Active.

FIGURE 8-25 ▶

Zigzag composition. Vigorous.

Vertical lines of composition tend to convey a sense of immobility, stability, and strength. (See Figure 8-27.)

Opposing lines of composition tend to convey a sense of conflict, resistance, and potential energy. (See Figure 8-28A.)

Converging lines of composition tend to convey a sense of converging, simultaneous movement and lead the eye to the point of anticipated intersection. (See Figure 8-28B.)

Because composition lines exert a powerful effect on the viewer's perception, their accidental occurrence in the middle of a picture should usually be avoided. A horizon or tree exactly splitting the image in two tends to create an image that lacks energy and resists advancing a center of interest. Usually such strong horizontal or vertical lines are best placed off-center, perhaps a third of the distance toward the picture's edge. Of course, if a sense of perfect symmetry and inactivity is to be conveyed, the exact center may be just the place for such a feature.

FIGURE 8-26
Curved-line composition. Flowing.

FIGURE 8-27
Vertical composition. Strong.

A

B

FIGURE 8-28
*Compositional arrangements. **A.** Opposing lines of composition convey a sense of resistance and conflict. **B.** Converging lines of composition lead the eye toward point of convergence.*

A

FIGURE 8-29

*Figure-ground contrast. **A.** Light objects stand out against contrasting darker background. **B.** Dark objects stand out against contrasting lighter background.*

B

FIGURE 8-30

Emphasizing objects. Eye tends to move from darker to lighter tones.

Use of Tone and Contrast

Objective 8-F Describe and demonstrate how tone and contrast can be used to reveal essential details, emphasize the central idea, and contribute to the mood of a photograph.

Key Concepts figure-ground contrast, silhouette, low-key photo, high-key photo, chiaroscuro

Emphasis

In addition to revealing details clearly, contrast can be used for emphasis. The arrangement of black, white, and gray tones in a print should create **figure-ground contrast**, with objects standing out clearly from their backgrounds. Light objects seen against light backgrounds afford little contrast, but against dark backgrounds they stand out. The eye follows light, moving from shadows to highlights and from highlights to shadows. The greater the contrast, the greater the attraction to the eye. (See Figure 8-29.)

One central object of interest against a plain background poses no problem of emphasis. But when there are two or more objects in the same photograph and one is to be emphasized, remember that the eye is guided by the arrangement of tones. If one object is placed against a contrasting background and the other against a noncontrasting background, the eye will be drawn to the object of greater contrast first. (See Figure 8-30.) An extreme example of figure-ground contrast may be found in the **silhouette**. Silhouette technique works well when details are easily recognized by their shapes. Unless objects can be recognized by their shapes, however, the silhouette may obscure the subject, essential details, and thus the entire idea of the photograph. (See Figure 8-31.)

A

FIGURE 8-31

Silhouette. Subjects are easily interpreted by their shapes.

B

Mood

Contrast can also contribute to the mood of a photograph. A **low-key** photo, for example, one in which the majority of tones fall in the darkest areas of the tonal range, tends to support a somber, serious mood, or one of mystery. A **high-key** photo, on the other hand, one in which the majority of tones fall in the lightest areas of the tonal range, tends to support a light, bright mood, or one of gaiety and happiness. Photos that have little contrast tend to convey a mood of stillness, peace, and quiet. Those with a wide range of contrasts, convey a mood of activity, vitality, and energy. (See Figures 8-32 and 8-33.)

Tonal Composition

Tonal composition refers to the arrangement of light and shade in a picture—the placement of the brightest highlights and deepest shadows to bring about a harmonious and logical tonal arrangement. Scattered highlights and disjointed shadow masses can destroy a harmonious effect,

despite an otherwise pleasing arrangement of details. This concept is generally referred to as **chiaroscuro** after a sixteenth-century woodcutting technique in which the forms of objects were represented by light and shadow masses, rather than by lines and cross-hatching. Applied to photography, the concept leads to a conscious arrangement of light and shadow masses to reveal the subject and to direct the viewer's attention.

A

B

FIGURE 8-32

*Tonality. **A.** High-key photograph. Majority of tones are light. **B.** Low-key photograph. Majority of tones are dark.*

A

B

FIGURE 8-33

*Tonal contrast. **A.** Flat contrast conveys feeling of repose. **B.** High contrast conveys feeling of activity, even with stationary subjects.*

Famous Photographer: Margaret Bourke-White

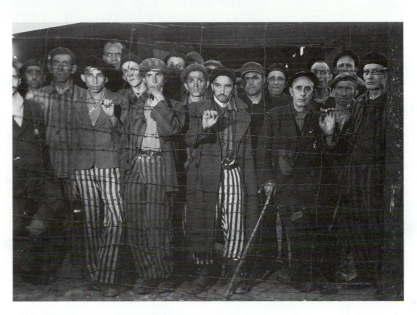

FIGURE 8-34

Margaret Bourke-White, "The Living Dead of Buchenwald," 1945.

A former student of photography at Columbia and a graduate in biology from Cornell, Margaret Bourke-White became a commercial photographer in Cleveland, Ohio, in 1927. Her architectural and industrial photographs gained her an associate editorship at *Fortune Magazine* in 1929. Her interests soon turned toward photojournalism, however. Traveling to Russia, she began to develop her own dynamic approach to photo reportage, weaving an assortment of related images into a cohesive, thematic whole. Her first book, *Eyes on Russia,* was published in 1931.

Picture magazine publishing was at that time in ferment. New, convenient, candid cameras had led European picture magazines to experiment with picture groups, sometimes organized around a single, psychological theme, that conveyed a new sense of action and immediacy. In the early 1930s, many European photographers and editors emigrated to America and brought these ideas with them.

Inspired by the success of the European magazines, Bourke-White's publisher, Henry Luce of *Time* and *Fortune,* was prompted to create a new American, large-format picture magazine—*Life.* He tapped Bourke-White, Alfred Eisenstaedt, Thomas McAvoy, and Peter Stackpole for the original photographic staff. Bourke-White was dispatched to Montana to photograph the construction of the Works Progress Administration (WPA) Fort Peck Dam for *Life*'s first issue, November 23, 1936.

Bourke-White shot the dam; however, before leaving Fort Peck, she also shot hundreds of pictures about life among the migrant workers in the shanty towns that had sprung up around the project. Her work captured the fake-front apartments, bars and stores, the night revelries—everything about the boom-town atmosphere, with its usual problems of prostitution, sewage, and gambling. When *Life* editor John Shaw Billings received the pictures, he quickly saw their

dramatic potential and assembled them into a carefully crafted, coherent picture story—a photo essay of the form that was to characterize *Life* throughout its history. *Life*'s first issue carried Bourke-White's bold, structural photograph of the dam on its cover, and inside, a nine-page photo essay about living in the shadow of the dam.

Bourke-White's photo essays are legendary. She later became an official Air Force photographer during World War II and a UN war correspondent for *Life* in Korea. Torpedoed once and awaiting rescue on a life raft, she documented the harrowing experience on film. She was on hand when the Army liberated the Nazi concentration camp at Buchenwald; she documented the surviving victims staring through barbed wire. Collections of her work are retained in the Library of Congress, Brooklyn Museum, Museum of Modern Art, Cleveland Museum of Art, and the Royal Photographic Society, London.

Color Composition

Objective 8-G Describe and demonstrate principles of color composition related to color harmony, psychological effects of color, effects of reflected light, and unnatural colors.

Key Concepts color harmony, contrasting colors, complementarity, monochromatic, cast

Color provides the photographer with additional controls in organizing pictorial elements to communicate an idea, mood, or feeling. In color photography, emphasis and subordination can be controlled not only by perspective, lines of composition, tone, and contrast, but also by the arrangement and manipulation of color details.

Color Harmony

Color harmony refers to the relationship among various color details within a photograph. Just as black-and-white details may be emphasized by setting them against a background of contrasting tone, color details may be emphasized by setting them against a background of **contrasting colors**. Similarly, certain hues and values tend to appear brighter than others and thereby attract attention to themselves, providing emphasis. A harmonious organization of color elements will support the central idea of a photograph and avoid distracting color elements.

Achieving a harmonious arrangement requires an understanding of the principle of **complementarity** of colors. Because white light is made up of all wavelengths in the visible light spectrum, any given hue is made up of only some of these wavelengths. The combination of wavelengths omitted from this hue makes up its complementary hue—the color of light that, when combined with the given hue, would produce white light. The color wheel shown in Color Plate 1A shows a sample of twelve colors from the visible light spectrum. The primary colors—red, blue, and green—are connected in the figure by the solid triangle. Their complements—cyan, yellow, and magenta—are connected in the figure by the dotted triangle. The complements appear opposite their primaries. Each complementary color is a combination of two primary colors.

When any color appears against a complementary background color of lower saturation and value, its own hue is enhanced. It appears more brilliant and therefore is emphasized. Against a background of equal saturation and value, however, complementary colors compete for attention, often appearing to clash and vibrate in disharmony.

Color contrasts can be developed in other ways besides using color complements. Even objects of the same hue may contrast if one is more highly saturated than the other. A scarlet rose may be set off nicely against a background of its pink cousins—a pink that may be identical in hue but of less saturation than the scarlet. Similarly, the dull blue of a predawn sky may provide a fitting contrast to a bright blue electric sign—a color of the

same hue, perhaps, but differing in value. Thus appropriate contrast can be developed even in **monochromatic** compositions—those based on one hue or several closely related ones—by controlling their relative saturations and values. The greatest contrasts can be developed, however, between complementary colors or between colors farther apart in the visible light spectrum. (See Color Plate 4.)

Psychological Effects of Color

It is difficult to generalize about the psychological effects of color. Under one set of circumstances, green and yellow hues may convey the general idea of new life, sunshine, and springtime; under another, the feeling of jealousy, sickness, or death. Red, the traditional color of hate and anger, may suggest the feeling of love and contentment in a cozy, firelight scene. Although blue is usually the color of cold, ice, and darkness, a photograph of an azure sky over a sandy shore may give a sense of warmth and summertime. In these matters there are far more exceptions than rules, and photographers should rely on their own taste and judgment in communicating their personal vision of a scene.

If we were to generalize about color, we would advance only the following few principles:

1. The red-orange-yellow hues tend to appear brighter to the eye than the blue-green-violet hues of similar value. These are popularly called warm tones, in contrast to cold tones. (These popular descriptions should not be confused with the Kelvin scale, in which reds represent the cooler and blues the warmer color temperatures.) The apparent brightness of the red-orange-yellow wavelengths may draw attention to objects of those hues in a color photograph. Similarly, these red-orange-yellow hues tend to convey a greater sense of activity than the blue-green-violet hues.

2. The greater the profusion of color and contrast within a photograph, the more the photograph will tend to convey a sense of activity, dynamism, and energy.

3. Monochromatic compositions—compositions developed around a few closely related hues—will tend to convey a sense of restfulness, tranquility, and stillness.

The Effects of Reflected Light

We noted earlier that the color temperature of the source light can affect the color rendering of objects in a color photograph. As long as the light reaching the film is matched to the color temperature for which the film is balanced, the image will be rendered in hues that appear as they were perceived in the original scene. When the light source and film are not matched, the image will be rendered with an overall **cast** reflecting this mismatch. These effects and the use of filters to correct the effects are shown in Color Plate 7. (See Unit 9 for a discussion of color correction filters.)

Not only the source light determines the light hues that illuminate objects in a scene, however. Within the scene, color is reflected from object to object. Light rays reflected from an object tend to assume the hues of the object and to lend those hues to other objects upon which they fall.

Light reflected from the green leaves of a tree, for example, would consist primarily of the green-blue wavelengths (the red wavelengths having been absorbed by the leaves). A nearby white object would reflect these predominantly green wavelengths as well as those of the source light. This phenomenon may not be apparent when the object is viewed; the mind interprets it as white. However, color film is more faithful; the influence of this green, reflected light is recorded as a greenish cast on the white object.

Any object of strong color value can be expected to influence the cast of other, nearby objects. This effect may be useful if the cast is desirable in the color composition, or it may be a distraction. To eliminate the effect, separate strongly colored objects from other objects in the scene.

Color Manipulation

In the hands of a creative photographer, color can become a powerful tool of visual communication. Color need not be thought of as an inherent characteristic of a scene needing only to be recorded accurately on film; color should be thought of as a controllable compositional element to be managed purposefully in an image so as to convey the photographer's unique idea. An object's color may be emphasized or subdued, of course, but it can also be exaggerated, altered, or even grossly distorted for special effect. Whether the photographer chooses to be faithful to a scene or to introduce creative color manipulations is largely a matter of choice driven by a personal vision.

Special lighting Some materials fluoresce blue-white, magenta, or other bright colors when lit by ultraviolet light. These materials include manmade fabrics and dyes, plastics, display boards, and chalk solutions. Experiment by illuminating materials in a darkened room with a UV lamp. The eye can detect those that fluoresce immediately. To make photographs of these effects, use a clear ultraviolet lens filter and a color film balanced for daylight.

Special films Objects that reflect infrared light, such as vegetation, living organisms, heat-generating and heat-reflecting objects, and the like, will record false colors on infrared film. Vegetation appears magenta, red paint appears yellow, flesh tones appear gray. Used with yellow, green, or red filters, these effects are further exaggerated and often produce unexpected and unpredictable results. (See Color Plate 6B.)

Misprocessing Normally exposed color slide film may be subjected to color negative processing. The resulting images show all colors reversed to their complements—blue and yellow are reversed, as are cyan and red, magenta and green. Further, the relative brightnesses are reversed—the

densities of the highlights and shadows. The result appears similar to a color negative, except that the image has greater density, colors are more saturated, and the overall orange-pink filter of color negatives is omitted. (Color prints made with these slides are generally unsatisfactory.)

Filters A variety of filters for both black-and-white and color photography may be used effectively with color film to manipulate the color image. These are discussed at length in Unit 9.

Printing and display manipulations Further color manipulation can be achieved during printing and display. Color printing (CP) filters can be used to alter or grossly distort color balances during printing and, combined with dodging and burning-in techniques, can be applied to selective portions of the image. Combinations of color negatives can be sandwiched together to create fantastic images; similarly, color transparencies can be sandwiched together to create combined images during projection.

A creative color dimension can be added to black-and-white prints by the use of toners. Toners, normally used to tint the overall black-and-white image, may be applied to selected portions of the image. More than one toner may be used to introduce a variety of colors to selected portions of the image.

Extreme distortion of color and density can be achieved through techniques such as color posterization and solarization. (See the color posterization feature on page 215; and see also Color Plates 9A, B.)

Photographic Guidelines

Objective 8-H Describe and demonstrate five photographic guidelines based upon principles of composition.

Key Concepts previsualize, move in close, select or create a neutral background, emphasize lighting contrast, apply rule of thirds, croppers

Beginning photographers may apply the general principles of composition by observing a few guidelines. These guidelines are intended only as aids, not as firm rules. In many cases, these guidelines may be helpful as a start to composing photographs. However, moving beyond these starting points may prove a better way to express some intended visual ideas. When that is the case, do not hesitate to do so—experiment with a variety of ways to express ideas in photographs.

1. *Previsualize the intended image.* Keep the central idea in mind and visualize the final print. Are the important details included? Are distracting details excluded? Are the more significant details emphasized; the less significant, subordinated? Are the important visual relationships revealed? To gain control over the final image, photographers must manipulate many variables, including camera angle, lens type and focal length, distance, aperture, exposure, contrast, and

processing. Even beginning photographers can improve their composi-
tions by training themselves to previsualize their final images.

2. *Move the camera in as close as possible to the subject without distor-
tion.* Doing so will increase the size of the subject in relation to other
objects in the picture, and will tend to force unnecessary details out of
the picture. If the camera cannot physically be moved in close, use a
telephoto or zoom lens to achieve a similar effect. Moving too close,
however, may produce distortion. Moving in as close as necessary to
exclude unwanted details, and to include only wanted details, and
positioning the camera to frame the subject in the desired way are the
most important ways to achieve emphasis, size, and location of the
subject within the frame.

3. *Whenever possible, select or create a neutral background for the sub-
ject.* Try to move the camera into a position from which the subject can
be viewed against a neutral background. If the background contains
too many unnecessary or confusing elements, try a low-angle shot
against the sky. If a neutral background cannot be selected, try creating
one by using a shallow depth of field to throw the background details
out of focus. With color photographs, select backgrounds of solid col-
ors or colors of relatively low saturation and value. Avoid bright-colored
background objects and profusions of colorful objects. Out-of-focus
backgrounds tend to be neutral; the colors tend to merge as focus is
diminished. To reduce confusion, avoid using too many colors in any
single photograph. Limit the colors to a few carefully chosen ones that
express the visual idea.

4. *Whenever possible, emphasize the contrast between the subject and
the background.* If the subject is brightly lit, try to shoot it against a
dark or shadowed background. If the subject is dark, try to shoot it
against a light background, such as a solid bright area or the sky. With
color, emphasize the color of the subject by shooting against a back-
ground of contrasting or complementary hue, weaker in saturation
and value. Select and organize colors within the photograph to lead
the viewer's attention to the important details and relationships in the
scene. Colors perceived as brighter tend to attract attention first.

5. *Use contrast to control visual energy.* Use a wide range of tones and
high contrast to heighten the sense of energy and activity in a scene.
Alternatively, use a narrow range of tones and low contrast to convey
a sense of tranquility and repose. With color, use contrasting or com-
plementary hues and a variety of saturations and values to heighten
the sense of energy and activity. Alternatively, use similar hues, satura-
tions, and values to reduce the visual energy conveyed in the scene.

6. *Apply the rule of thirds as a guideline or starting point for composing
your photographs.* Although the rule of thirds is a good starting point,
do not hesitate to move beyond it or any other arbitrary rules if an idea
is better expressed in other ways. The final test of a composition is
how well it communicates the photographer's idea, mood, and feel-
ing. As far as possible, rely upon the viewfinder to compose pictures,
not on subsequent darkroom printing controls.

Reading Photographs

Objective 8-I Describe and apply the process and criteria for evaluating and criticizing photographs.

Key Concepts active viewing, active questioning, photographer's intent, informed evaluation

A viewer cannot read, understand, and evaluate a photograph at a glance. Whether it is one of the viewer's own photographs, or one by a master photographer, a full understanding of the work often requires the viewer to engage in a process of **active viewing** and questioning.

The Importance of Active Viewing

Many people view photographs in the same passive way that they view a television movie. Passive viewing of this sort is unlikely to generate any enlightening information about a particular image. A more productive approach to understanding a photograph is to *actively* study the image, mentally describing it, and perhaps even asking questions about its origin, nature, intent, and value.

Describing the picture One way to start an active viewing process is to simply describe the picture, either mentally or in discussion with another person. To describe the picture, the viewer might engage in **active questioning** about the subject, the visual elements, the technical qualities, the context, and the intended viewing medium. For example:

▶ *Question the subject of the picture.* What is it? What details were selectively included and what supporting elements are provided? How are they shown?

▶ *Question the visual elements of the picture.* What choices were made regarding the relative size and location of various objects in the picture? What are the largest and most dominant picture elements? What choices were made regarding the placement and use of mass and line in the visual design? What visual elements did the photographer choose to represent and delineate space and time?

▶ *Question the technical qualities of the picture.* What techniques and processes were used in making the image? Does the craftsmanship fulfill the viewer's expectations regarding the techniques and processes used?

▶ *Question the context in which the photograph was made.* Was the photographer working in a particular social environment? Is the location or time period relevant to understanding the photograph?

▶ *Question the medium in which the photograph will be presented to an audience.* Is the picture intended to be seen in a newspaper? Magazine advertisement? Gallery wall? Where?

Although the answers may initially seem obvious, the questioning process may reveal some surprising insights. At the very least, the viewer will gain a richer understanding of the photograph.

Understanding the Photographer's Intent and Interpreting the Image

The process of describing the photograph provides a basis for understanding the **photographer's intent** and interpreting the picture. The viewer might ask additional questions regarding the photographer's approach, the relative importance of detail, the manner of presentation, the photograph's formal qualities, and the use of symbols. For example:

▶ Certain traditional approaches may dictate the subject matter and content of a picture. Is the photographer working in an established traditional genre or style that defines the meaning and content of the photograph? These might include landscape, portraiture, street photography, still life, fashion, advertising, or photojournalism. Alternatively, does the photographer seem to be intentionally breaking away from traditional approaches?

▶ The importance of the details in a picture may reveal what the photographer intended to communicate. Is "what" the photographer chose to photograph important? The photographer's intent generally determines what details are selected and the relative importance given to them. Is the subject of special importance due to its rare or exotic nature? Is the subject a glimpse of the past that might otherwise be lost?

▶ In some photographs, "how" the subject details are presented may transcend "what" information about the subject was presented. Are the details shown in a particularly unusual or striking way?

▶ Certain formal qualities of a picture can reveal its purpose. Is the picture a rich visual experience?

▶ Many photographs have as their subject simply the interplay of light and form, volume and space, and are intended mainly to delight the eye. How significant are these formal qualities of the picture?

▶ How the photographer uses symbols to convey meaning can reveal intent. Has the photographer used any symbols in the photograph? Do any picture elements suggest or resemble something else? Does the photograph use metaphor, for example, to suggest a comparison between elements in the picture, and elements found in another context?

▶ Given the answers to these questions, can the photographer's intent be stated?

Asking these questions can help to discern the photographer's intent. Before the effectiveness of a photograph can be evaluated, the photographer's intent must be understood.

Making an Informed Evaluation

When evaluating a photograph, viewers are often tempted to immediately express approval or disapproval. Such judgments should be restrained until the image has been actively questioned and understood. Hastily expressing like or dislike for a picture suggests a less than rigorous evaluation and rarely leads to a defensible critical position.

One way to make an **informed evaluation** of a photograph's effectiveness is to compare and contrast it with similar works. The viewer might ask additional questions regarding craftsmanship, visual qualities, effectiveness, imaginativeness, salience, insightfulness, technical prowess, sufficiency, and impact. For example:

▶ Is the craftsmanship and method of execution appropriate to the task?

▶ Have such visual qualities as design, use of light, color, and form been used well?

▶ Is the photograph appropriate to its intended use and audience?

▶ Does the photograph present information in a new and imaginative way?

▶ Does the image present its theme in a forceful manner and compel the viewer's attention?

▶ Does the work stimulate new insights?

▶ Does the image expand the expressive or technical boundaries of the discipline?

▶ What, if anything, could be changed to make the photograph more effective?

▶ Does the viewer experience an intellectual or emotional impact?

No single set of rules can be used to read and evaluate all photographs. What viewers see in a photograph is shaped by their individual experiences, interactions with the world, fluency in photography, knowledge of art, and feelings at the time the work is viewed. Perceiving the meaning of a photograph is an intensely personal process; each viewer will find unique meanings to share with others. However, each viewer should also be able to discern some threads of meaning common to others. Ultimately, the meaning and value of an image relative to the body of valued works will be determined by social consensus.

The effective evaluation of photographs is enhanced by an understanding and appreciation of all images. Photographers who actively involve themselves in the process of reading and evaluating their own works and the works of others will increase their fluency in visual communication—and enhance their efforts toward mature and sophisticated photographic expression.

Questions to Consider

1. What is meant by the term *composition*? What are its purposes?

2. What are the major elements of composition?

3. Explain what controls can be used to emphasize or subordinate details in a photograph.

4. Explain the rule of thirds.

5. What is meant by the phrase "movement into frame"?

6. Describe low-angle, eye-level, and high-angle shots and what each tends to emphasize.

7. How can the illusion of depth be controlled through linear and aerial perspective?

8. How can scale be established in a photograph?

9. Describe how the mood or feeling of a photograph can be conveyed through the use of composition lines.

10. Describe how tone and contrast can be used to emphasize a center of interest and convey a mood in a photograph.

11. Describe how color can be used to emphasize a center of interest and convey a mood in a photograph.

12. What is "active viewing" of a photograph? Describe the processes suggested for describing, understanding, and evaluating photographs.

Suggested Field and Laboratory Assignments

Roll #1 (black-and-white)

1. Shoot a roll of film under daylight conditions. For one series of shots, select a scene involving at least three interacting objects, such as adult, child, and football; photographer, camera, and subject; angler, worm, and fishhook; and so forth. Shoot several shots of the scene, each time emphasizing a different object in the scene using the controls described in this unit. Note how in each shot a different interpretation of the relationship among the objects in the scene can be communicated.

2. Keep a log of every shot, recording f/stop, shutter speed, and technique(s) used to select and emphasize various details in each shot.

3. Be sure to provide at least one example of each of the following:

 ▶ a shot using tone and contrast to emphasize the center of interest

 ▶ a low-key photograph, dominated by dark tones to create a somber mood

 ▶ a high-key photograph, dominated by light tones to create a bright mood

4. Develop and proof.

5. Make enlargements of the better negatives. Crop them for best composition.

6. Record on the back of the finished prints the details taken from the log.

Roll #2: (color slides)

Shoot several pictures using each of the following techniques. You may include more than one technique in each picture. Keep a shooting log identifying the techniques used.

1. A long shot, including the horizon, using one or more linear perspective controls to enhance the illusion of depth.

2. A long shot, including the horizon, using one or more aerial perspective controls to enhance the illusion of depth.

3. A shot using a natural frame to enhance the illusion of depth.

4. A shot using vertical composition lines to increase the feeling of strength or dignity.

5. A shot using horizontal composition lines to increase the feeling of rest, repose, or peacefulness.

6. A shot using diagonal composition lines to increase the feeling of violence or action.

7. A shot using curved composition lines to increase the feeling of graceful movement.

8. A shot using color to emphasize the center of interest.

9. A shot using converging lines of composition to emphasize the subject or opposing lines to create a sense of conflict.

10. A low-key photograph, dominated by dark colors, to create a somber mood.

11. A high-key photograph, dominated by light colors, to create a bright mood.

12. A photograph using a color manipulation.

Unit Nine

Filters

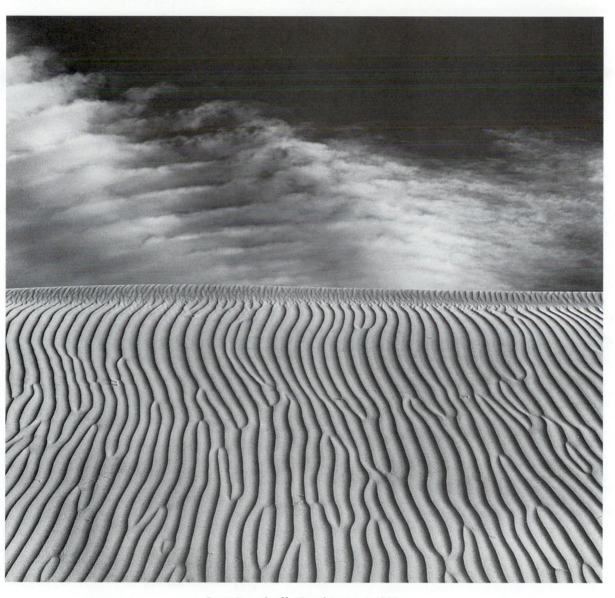

Scott Deardorff, "Sand Dunes," 1990.

ilters are transparent, tinted attachments made of plastic, gelatin, optical resin, or glass. They are designed to remove certain colors from the image-forming light or to manipulate the image in other ways. Filters provide a quick and simple way to dramatically alter the appearance of a picture. Their many uses include simply reducing the amount of image-forming light, altering tones and colors, and creating a variety of special effects.

Most filters are relatively inexpensive and very useful aids. This unit explains many of the principles on which filters are based, the types and purposes of filters commonly used for black-and-white and color photography, how filters are made and how they are attached to the camera, and how exposure is adjusted to compensate for the use of filters.

Principles of Filters

Objective 9-A State the principles on which filters are based and describe the general effect produced by using a filter when photographing a subject in black and white.

Key Concepts filter, primary colors, relative brightness, gray-tone rendering, tone separation, correction filter, contrast filter, law of transmission and absorption

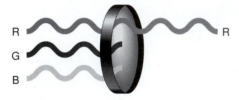

Red Filter
Nearly all blue and green light is absorbed by a red filter, so that blue is enhanced while red is rendered nearly white.

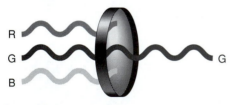

Green Filter
With a green filter, red light is blocked but green light admitted; reds then become darker than greens. It is useful for leaves and grass, which can often appear too dark.

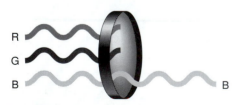

Blue Filter
A blue filter absorbs red and green, making them appear the same tone. Blue objects come out as white and thus disappear against a white background.

FIGURE 9-1

Law of transmission and absorption.

In general, any **filter** is a device for removing unwanted portions of anything passed through it. We filter our morning breakfast coffee to remove unwanted coffee grounds, or we may filter the gasoline in a camping lantern to remove particles that might clog the mechanism. A photographic filter removes unwanted portions of the light that reaches the camera before transmitting the desired portions through the lens to the film.

Why would a photographer wish to alter the light transmitted to the film? Remember that white light actually is made up of many colors—all colors of the rainbow, in fact—ranging from the deep violets at one end of the spectrum to the deep reds at the other. However, all these colors are made up of only the three **primary colors** of light—red, green, and blue. All the visible colors of light, including white, are composed of these three primary colors.

Black-and-white film, as the name implies, does not reproduce these colors. The film and the final black-and-white print record the **relative brightness** of objects, translating their colors into corresponding shades of gray. Thus yellow may appear in the final print as a lighter shade of gray than does red. This **gray tone rendering** is psychologically acceptable because we perceive yellow as a lighter color than red.

A photographic filter removes certain portions of the light reaching the film. One use of this effect is to alter the relative brightness of various objects in a scene so that they conform more closely to the way we see

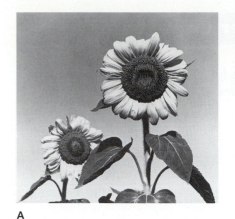
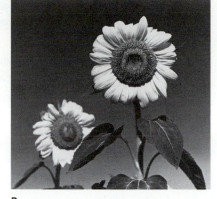
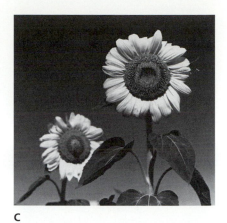

A B C

FIGURE 9-2

Effects of yellow and red filters. Yellow sunflowers were photographed against a blue sky. **A.** *No filter.* **B.** *Yellow filter.* **C.** *Red filter. Figure-ground contrast is increased using filters, red filter producing most extreme contrast in this case.*

TABLE 9-1 Effects of common filters with panchromatic film

Filter Color	Colors Lightened in Final Print	Colors Darkened in Final Print
Red	Red	Blue, green (cyan)
Green	Green	Red, blue (magenta)
Blue	Blue	Red, green (yellow)
Yellow (red, green)	Red, green (yellow)	Blue
Light pink (skylight)	None	Ultraviolet, some blue

them and achieve the proper gray-tone rendering with a **correction filter**. Another is to increase the contrast between objects and their backgrounds; a **contrast filter** to aid **tone separation**. Another is to reduce aerial haze at high altitudes or at long distances. And another is to reduce the overall intensity of light reaching the camera so that we can shoot at slower speeds and larger apertures.

Physically, a photographic filter is a thin sheet of colored plastic, optical resin, gelatin, or glass, usually attached to the camera immediately in front of the picture-taking lens. The rays of light of various colors, reflected from the subject, strike the filter and are either absorbed or transmitted, depending on the color of the light and the color of the filter. Thus a red filter will transmit red light to the film, but will absorb blue and green light, preventing it from reaching the film. A green filter will transmit green light, but absorb red and blue light.

Law of Transmission and Absorption

A general **law of transmission and absorption** that applies to any filter may be stated thus: *A filter transmits light of its own color and absorbs light of its complementary color.*

The colors of light that a filter transmits are reproduced lighter on the final print than are those that the filter absorbs. The colors of light that the filter absorbs are reproduced darker on the final print than are those that the filter transmits. Figure 9-1 illustrates the principle of transmission and absorption using a red filter.

A red filter transmits red light, making all red objects darker on the negative, and hence lighter on the final print; it absorbs blue and green light, making all blue and green objects lighter on the negative, and hence darker on the final print. Similarly, a blue filter makes blue objects lighter and red and green objects darker in the final print. A green filter makes green objects lighter and red and blue objects darker. Yellow light is a combination of red and green, so a yellow filter makes red and green objects lighter and blue objects darker. Figure 9-2 illustrates these principles. Table 9-1 shows the effects on the primary colors that result from the use of various common filters with panchromatic film.

Forms of Filter Construction

Objective 9-B Describe two forms of filter construction and state how each is attached to the camera.

Key Concepts glass disk filters, square filters, filter holder, adapter and retaining rings, flash head filter

Two common forms of filter construction are (1) glass disks bound with metal rims, and (2) squares of sheet gelatin, plastic, optical resin, or glass.

For general use the **glass disk filters** usually are easier to handle and less subject to damage. They are made of optical glass, however, and tend to be more expensive than the other forms. Most modern glass disk filters are designed with threaded metal rims so that the filter can be screwed directly to the front of the lens housing. They are manufactured in many millimeter sizes to fit exactly the diameters of standard lens housings. (See Figure 9-3A.)

The **square filters** are made of gelatin, plastic, optical resin, or glass. The gelatin square filters are the least expensive and are available in a wider variety of colors and special effects than glass. However, they are soft and easily damaged. They must be handled carefully by the edges, which are often taped or framed in metal, to preserve their usefulness. Plastic and optical resin filters are often made of the same high grade polymers that are used in eyeglasses and are both more expensive and more durable than their gelatin counterparts. Glass filters tend to be more expensive and are available in fewer colors and effects. However, they are the most durable and easily handled.

To use square filters, a **filter holder** is a necessary piece of supplementary equipment. The filter holder is mounted to the lens by means of threaded **adapter and retaining rings** that screw into the front of the lens housing and hold the filter holder securely in place. Then the square filters can easily be inserted or removed from the filter holder as needed. One set of square filters can be used with many different sizes of adapter rings to fit a variety of lenses. This is especially handy for the photographer with many lenses. Figure 9-3B shows a typical square filter mounting system.

Another type of filter holder is the **flash head filter**, designed to be used with an electronic flash unit. These square plastic filters are mounted in front of the flash light source and have the same effect as a lens filter if the source light comes solely from the flash. The effect of a flash head filter is reduced if other light sources are present.

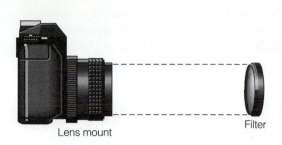

Lens mount Filter

A

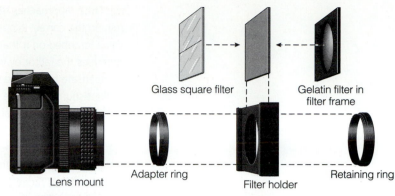

Glass square filter Gelatin filter in filter frame

Lens mount Adapter ring Filter holder Retaining ring

B

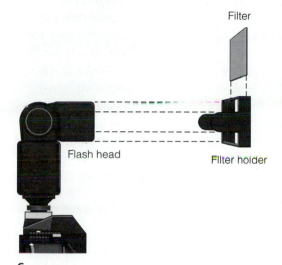

Filter

Flash head

Filter holder

C

FIGURE 9-3

Filter mounting systems. **A.** *Screw-in filter may be used only with lens mount of same diameter.* **B.** *Square filter mounting system. Adapter ring screws into or slips onto lens mount. Filter frame holder is inserted into adapter ring. Retaining ring screws into adapter ring to hold assembly in place. Filter squares are slipped into filter holder as needed.* **C.** *Flash head filter mounts to holder on front of flash unit to filter light emitted by the flash.*

Exposure with Filters

Objective 9-C Explain the exposure adjustments required by filters including the use of filter factors.

Key Concept filter factor

A filter absorbs part of the light passing through it, causing less light to reach the film. Therefore, to compensate for the reduction of light caused by the filter, exposure must be increased to avoid underexposure. External and through-the-lens metering systems require different procedures for increasing exposure by an appropriate amount.

Through-the-Lens Metering

Modern through-the-lens metering systems read the image-forming light through the lens and, hence, through any filter attached to the lens. With the filter mounted before the lens, the light meter reads the light intensity through the filter and thus takes into account the reduced light level. The meter will thus automatically indicate (or set) the correct exposure for the intensity of light passing through the filter. No special action by the photographer is required.

External Metering

If the camera does not have a through-the-lens metering system, the photographer must use special procedures to adjust exposure for the filter.

One approach is to read the external meter while holding the filter in place over the meter's light-sensitive cell. This procedure produces a reading based upon the filtered light and automatically takes into account the reduced light levels produced by the filter. The filter may then be attached to the lens and the exposure based on the reading thus obtained.

Other approaches require the use of **filter factors**. As an aid to determining the correct exposure required by a filter, the filter has a numerical value inscribed on it that corresponds to the needed increase. This number describes the factor by which the unfiltered exposure must be increased to compensate for the filter. The filter factor will vary, depending on the type of light source and type of film used. For example, a yellow filter used with panchromatic film usually has a factor of 2 in daylight and a factor of 1.5 in tungsten light. A filter factor of 2 implies that exposure must be doubled.

With an external meter, exposure must be increased manually. If an unfiltered exposure were to be f/16 at 1/125 sec., an exposure with a yellow filter (filter factor 2) would need to double to f/11 at 1/125 sec. or equivalent. A filter factor of 1.5 requires that exposure increase by 50 percent—to a point between f/11 and f/16 at 1/125 sec. or equivalent.

With an external meter, many photographers find it more convenient simply to divide their ISO/ASA film speed by the filter factor and then reset their meters. Using an ISO/ASA 64 film with a yellow filter (filter factor 2), for example, they would simply reset the meter to read ISO/ASA 32. Of course, the meter must then be reset when the filter is removed from the lens.

Two or more filters may also be used together, such as a yellow filter (factor of 2) and a polarizer (factor of 2.5). The resulting filter factor is the product of the two separate filter factors. In this case 2 x 2.5 = 5. Exposure in this case would need to be increased five times (approximately 2.3 stops).

In general, when the meter is read through the filter, the filter factor need not be used and the ISO/ASA setting need not be changed. If the meter is read without the filter, then action must be taken to increase exposure by the filter factor.

Filters for Black-and-White Photography

Objective 9-D Name and describe the purposes of six types of filters commonly used in black-and-white photography, and give examples.

Key Concepts correction filters, contrast filters, ultraviolet and haze filters, polarizing filters, neutral density filters, special effects filters, tungsten light, polarized light, soft-focus filter, fog filter, cross-screen or star filter, spot filter, multiple-image filter

The filters used in black-and-white photography can be divided into six main types according to their uses and characteristics:

1. **Correction filters**, used to render the colors in a scene as shades of gray that correspond to their perceived relative brightness

2. **Contrast filters**, used to increase the tone separation between two colors that otherwise might appear as nearly the same shade of gray

3. **Ultraviolet and haze filters**, used to reduce aerial haze, particularly in distance and aerial shots

Famous Photographer: Jacob Riis

FIGURE 9-4

Jacob A. Riis, "Room in a Tenement," 1910.

Sometimes credited with being America's first reporter-photographer, Jacob Riis left his native Denmark in 1870 and spent his first three years in New York often jobless, homeless, and destitute. He finally found employment with a news association and, with firsthand knowledge of the plight of the poor, devoted much of his attention toward photographing and criticizing social conditions.

Often photographing in the dark interiors of tenements, in back alleys, and in bars, Riis was one of the first to use flash, which then consisted of powdered magnesium and potassium chlorate packaged in a cartridge and detonated by a device that looked like a pistol. Many of his suspicious and sometimes terrified subjects responded by brandishing weapons of their own. Riis substituted an open frying pan to hold his powder, igniting it by hand while releasing the shutter. In the blinding explosion, Riis would make his shot and then, in the resulting dense smoke, grab his camera and tripod and run off. More than once he set fire to himself and to the places he visited, once nearly blinding himself.

As a police reporter for the *New York Tribune* and the Associated Press Bureau, Riis's daily stories criticizing the poverty and squalor of immigrant life in New York tenements aroused the public conscience and led to the appointment of a Tenement House Commission in 1884. He began working for the *Evening Sun* in 1888. He published his classic, *How the Other Half Lives,* in 1890. Heavy with moral indignation, weighted with irrefutable facts, and illustrated with thirty-eight engravings taken from his photographs, the book shocked the public. Theodore Roosevelt, then a young politician, sent Riis a note saying, "I have read your book and I have come to help." Later, as New York Police Commissioner, then Governor, and later President, Roosevelt remained true to that commitment, cracking down on the worst abuses, and joining in the reform movements that cleaned up many of the slums.

Riis continued his muckraking throughout his life, publishing nine photo-illustrated books that documented life among the poor immigrants of New York, and demonstrating the power of photojournalism to arouse public opinion and inspire reform.

4. **Polarizing filters**, used to darken blue skies, control reflections, and penetrate aerial haze

5. **Neutral density filters**, used to reduce the amount of light passing through the lens without altering relative brightness relationships within the scene

6. **Special effect filters**, used to produce special optical effects in the recorded image

Correction Filters

Film differs from the human eye in the way it sees the relative brightness of various colors. Thus film cannot translate all colors into fully satisfying gray tones. All films are especially sensitive to violet and blue, for example, and these colors tend to appear too light in the final black-and-white print. The eye, however, tends to perceive them as relatively dark. Because of this characteristic, the white clouds we see against the darker blue sky may not appear at all in an unfiltered photograph using panchromatic film. The film sees the blue sky as very light, as light as the clouds in fact, and does not record a tone separation between them.

Moreover, films are sensitive to ultraviolet light, which the eye cannot see at all, and which appears light in the final print. Conversely, panchromatic film is relatively insensitive to green. Thus green appears dark in the final print, whereas the eye perceives it as relatively bright.

When filters are used to correct these traits of a film—to reproduce colors with the relative brightness that most people see—they are called correction filters. For example, a yellow filter is often used with panchromatic film in daylight to reduce the amount of blue and violet light passing through the lens. The darkening of these colors in the final print serves to correct the gray tone rendering of sky and clouds and makes it appear more natural.

Similarly, **tungsten light**, such as that produced by ordinary household light bulbs, contains more red than does daylight. Because panchromatic film is sensitive to red, objects that reflect this additional red light may tend to appear too light in the final print. This is especially true of flesh tones. To filter out some of this red light as well as the blue and violet, a yellow-green filter is often used with panchromatic film to obtain the most natural-looking gray tones under tungsten light.

Contrast Filters

Sometimes the perceived relative brightness needs to be altered to improve contrasts. When an object of interest will photograph as about the same shade of gray as its background, for example, the tone separation, or contrast, between the two should be increased to add emphasis to the object. When filters are used for this purpose, they are called contrast filters.

FIGURE 9-5

This photograph was made with black-and-white infrared film and an orange filter. The trees and bushes appear white because they reflect large amounts of infrared light.

For example, red and green objects tend to appear as the same shade of gray when they are photographed with panchromatic film in daylight. A red apple, therefore, might not stand out very well against its background of green leaves in a black-and-white photograph. A red filter, however, will transmit the red light reflected from the apple to the film, causing the apple to appear light in the final print. The green light from the leaves, however, will be absorbed by the filter, causing them to appear darker in the final print. The tone separation between the two will be increased, and the apple will appear as a light object against a dark background. A green filter would produce the reverse effect. The green light from the leaves would be transmitted, whereas the red light from the apple would be absorbed. In this case the apple would appear as a dark object against a background of lighter leaves.

Sometimes ordinary contrast filters can be used with special films to produce unusual effects. For example, a deep orange filter used with infrared film often produces unusual tonal renderings of landscapes. Figure 9-5 is an example of such an effect.

Both correction and contrast filters work on the same principles. The only difference between them is the use to which they are put in any given case. By mastering the use of filters, control over the relative brightness of objects in prints can be controlled. In this way contrast can be manipulated to emphasize certain objects and to subordinate others. Remember the law of transmission and absorption: *A filter transmits its own color and absorbs its complementary color. A filter's own color appears lighter in the final print; its complement darker.* Figure 9-6 illustrates some of the effects that can be achieved by using contrast filters.

A

FIGURE 9-6

Effects of filters. **A.** *Unfiltered. Note minimal contrast between sky and clouds.* **B.** *Yellow filter. Greater contrast. Rendered approximately as eye sees scene.* **C.** *Orange filter. Greater contrast.* **D.** *Red filter. Contrast much greater than normal. Increases dramatic effects.* **E.** *Red filter plus polarizer. Greatest contrast for even greater drama. Note darkening at corners sometimes caused by use of wide-angle lens with stacked filters.*

B

C

D

E

Ultraviolet and Haze Filters

Atmospheric haze is often invisible to the naked eye but may appear in photographs as a light veil that masks some of the detail. In reality a bluish haze results from the scattering of light by tiny particles of dust and water vapor in the atmosphere. Because much of this haze is ultraviolet (to which the eye is insensitive), its presence may go unnoticed. Film, however, is very sensitive to ultraviolet, and hence records its presence.

To control haze, use a filter that will absorb the blue and ultraviolet light that produces it. The most common filter for this purpose is the ultraviolet (UV) or haze filter. Almost clear in appearance (or very pale yellow), this filter has almost no effect on light visible to the naked eye, but gives a more precise gray-scale rendering of colors in open shade or on overcast days and reduces the effect of aerial haze in distance shots.

Many photographers keep this filter constantly attached to their lens and use it to protect the soft surface of the lens from nicks and abrasions.

For greater haze control, other filters may be used. A yellow filter will reduce haze, a deep yellow filter will reduce it more, and a red filter will almost eliminate it altogether, while simultaneously exaggerating the darkness of the sky.

Sometimes haze may be exaggerated in a print to create a greater feeling of distance by masking distant details in a veil of haze. To accomplish this effect, use a filter that transmits the blue and ultraviolet light, and absorbs other colors. Thus a blue filter can be used to emphasize the effects of aerial haze. (See Figure 9-7.)

A

B

FIGURE 9-7

*Haze filters. **A.** Photo taken with red filter to eliminate haze. The darkness of the sky is exaggerated. **B.** Exaggerating haze can heighten sense of distance and provide contrasting background for foreground subjects.*

278

Polarizing Filters

A polarizing filter operates in an entirely different way. It appears grayish and does not filter out light of particular colors. All colors are transmitted equally, and no colors are absorbed. The relative brightness of various colors is unaffected by the polarizing filter. Instead, the filter acts upon light that has been polarized—caused to vibrate at only one angle—by reflection off nonmetallic surfaces. Such light is called **polarized light**.

Light is made up of rays that travel in straight lines and vibrate in all angles. When such a light ray strikes a nonmetallic surface and is reflected from it, most of the reflected light tends to vibrate in one plane only, as shown in Figure 9-8A. Depending on the angle of reflection, more or less of the reflected light is polarized. A polarizing filter can also polarize light, and if set at the correct angle, it will block light that has already been polarized, reducing or eliminating the reflections.

Most polarizing filters have an indicator mark or handle that designates the axis of the filter. Only light rays vibrating in a plane parallel to the filter axis will be transmitted; light rays vibrating in other planes will be absorbed.

Although direct sunlight is unpolarized, the light from a blue sky is polarized because it is made up of light reflected off particles of dust and water vapor in the atmosphere. If unpolarized light strikes the polarizing filter, only polarized light vibrating in a plane *parallel to the filter axis* will be transmitted, as shown in Figure 9-8B. If polarized light, such as light reflected off a window pane, strikes a polarizing filter, it will be

FIGURE 9-8

Polarization of light and relation of polarized light to polarizing filter axis. **A.** *Reflection from non-metallic surface polarizes light.* **B.** *When polarized light strikes polarizing filter, only polarized light is transmitted.* **C.** *Polarized light vibrating parallel to filter axis is transmitted.* **D.** *Polarized light vibrating perpendicular to filter axis is absorbed.*

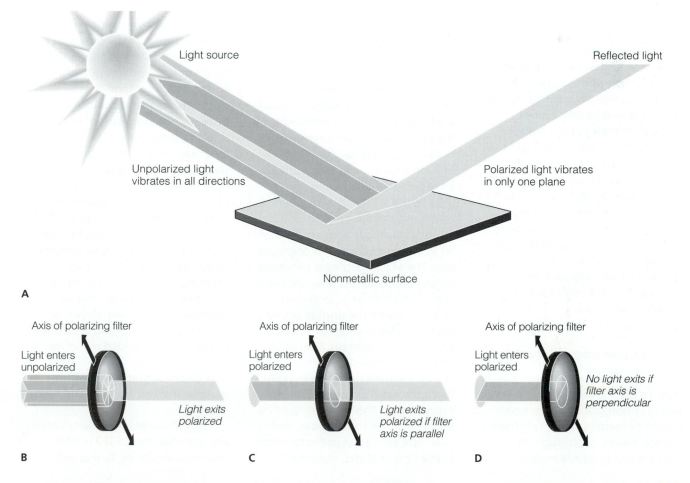

Light source

Reflected light

Unpolarized light vibrates in all directions

Polarized light vibrates in only one plane

Nonmetallic surface

A

Axis of polarizing filter

Light enters unpolarized

Light exits polarized

B

Axis of polarizing filter

Light enters polarized

Light exits polarized if filter axis is parallel

C

Axis of polarizing filter

Light enters polarized

No light exits if filter axis is perpendicular

D

What Is Creative Photography?

Unlike photojournalism and commercial photography, creative or fine art photography is not a client-based career; creative photographers are not employed by a publisher or business to execute and solve visual problems. Creative photographers are motivated to produce works solely to satisfy their own need for self-discovery and self-expression. As a result, creative photographers exercise complete control over their subject matter, techniques, and aesthetics. It is this freedom of expression that attracts many to the field.

Fine arts photography lacks a specific occupational niche. Most people who engage in creative photography do so out of a passionate desire to use the medium as a way to learn more about themselves and the world around them and, ultimately, to share and communicate these discoveries with others through their photographs. They are not primarily motivated by compensation and usually cannot depend on their photographs to support themselves financially; they usually need other sources of income. Some take on commercial photography assignments or work in another field while devoting their spare time to their personal photographic projects. Others prefer to pursue related careers, such as teaching photography or working as a staff photographer in a gallery or museum.

How to Become a Creative Photographer

Prior to the 1960s, most respected fine art photographers were self-taught or learned their craft from friends, books, or through an apprenticeship with a master photographer. Today, most photographers take formal studies in university art departments or at specialized schools of art. On the undergraduate level, many schools offer a B.F.A. (Bachelor of Fine Arts) degree in photography.

Art school training steeps the student in the ideas and challenges of the visual arts. Student photographers learn to "see photographically" and to develop a sensitivity to the interplay of light and form. They are immersed in the history and language of art and learn to critically examine and thoughtfully discuss their own work and the work of others. Guided critiques help students to advance their photographic techniques and to discover their own photographic personalities and styles.

Students interested in continuing their study of photography beyond the baccalaureate may enroll in an M.F.A. (Master of Fine Arts) program. Graduate school perfects the student's visual, conceptual and creative senses. Most programs are designed to develop skills in critical theory and analysis in addition to the production of photographic works of art. The faculty often will include established photographic artists who can provide important links to the art world and gallery community. Graduate school is essential for those who are interested in a teaching career in photography. The M.F.A. degree is generally required to teach art and photography on the college or university level. Choosing the right graduate school to match personal interests and goals is important. Two publications that provide information about graduate programs in photography are *A Survey of College Instruction in Photography,* publication T-17 by Eastman Kodak, and *Graduate Education in Photography in the United States,* published by

FIGURE 9-9

Many galleries now display fine art photographs which provide opportunities to see original prints by established masters as well as exciting experiments by new photographers.

the Society for Photographic Education. (See Appendix F.)

How to Build an Exhibition Record

Many students with a passion for creative photography dream of having a major gallery exhibition of their work or perhaps publishing a book of photographs. A record of successful smaller exhibitions must be built, however, before the attention of a large gallery or book publisher can be attracted. One way for the student photographer to begin is to participate in group exhibitions on a local and national level.

Many local organizations hold annual art and photography contests that are an excellent way for beginners to gain experience in entering group competitions. Area newspapers generally carry announcements of these shows, and the contests often feature substantial prizes as an added incentive. Local contests generally require that all photographs submitted must be matted, framed, and ready to hang.

On a national level, many university galleries host juried photographic exhibitions. Group exhibi-

tions often revolve around a theme, such as life in suburbia or the environment. The judge is usually a prominent photographer or photo critic, so receiving an award from this kind of competition is an honor that enhances a photographer's résumé.

One good source of information on upcoming exhibitions is the periodical *Artweek*. Each issue contains a full page of listings for competitions and group exhibitions, including any special requirements and entry fees.

Some national exhibitions prefer to jury and select works from 35-mm slides, so most creative photographers make slide copies of their best prints. Once an image is accepted, the gallery will expect to be supplied with a finished, mounted print. Frames are not normally shipped to distant shows because of their fragile nature; instead, the gallery usually takes responsibility for exhibiting works under protective sheets of glass.

One-Person Gallery Exhibitions

After compiling a record of several group shows, the aspiring fine arts photographer may wish to seek a solo exhibition in a commercial gallery. Because commercial galleries are swamped by requests from aspiring photographers, contacts and references in the art world can help to gain attention and consideration. A personal recommendation from a professor at graduate school or an established photographer can open the door.

To seriously seek a one-person show in a gallery, the photographer must put together a portfolio of his or her finest photographs to present to the gallery director. Most galleries prefer to see at least twenty to forty recent prints from a single project or body of work. Because galleries often receive between ten and fifty portfolios for review each week, the competition can be intense. Therefore, the photographer must make critical selections and edit the pieces carefully to ensure the best possible presentation.

A commercial gallery's financial existence depends on its ability to attract buyers and collectors; thus, gallery directors look for photographers whose works promise to contribute significantly to the field and appreciate in value. To attract the attention of a gallery director, the portfolio should demonstrate a consistency of vision and a unique perception. The director will also want to see a résumé and exhibition record to help gauge the photographer's progress and involvement with art. If the work interests the gallery and an opening is available in the exhibition schedule, the photographer will be invited to discuss details of having a one-person show. This will usually involve an agreement or contract of some kind that stipulates the date of the show, number of pieces, and the gallery's commission. Typically, the gallery will take a commission of 40% of the selling price; 50% commissions are becoming more common, however, and in some cases the gallery's commission can be as high as 60%. The photographer is responsible for delivering mounted prints to the gallery in advance of the show. The gallery will usually arrange for framing and hanging the works, printing the show announcements, and publicizing the show.

Having a one-person show brings social and artistic recognition to the photographer as well as a chance to realize some financial reward through the sale of prints. In practice, however, works by new photographers are rarely sold. Institutional buyers and collectors usually prefer the works of established, well-known artists.

Establishing an exhibition record is a long and continuing process. With each show the photographer gains the experience and exposure necessary to advance to more sophisticated and larger galleries. Well-developed exhibition records also help creative photographers receive grant money to support their work. Grants in fine art photography are available from such groups as the National Endowment for the Arts (NEA), the Guggenheim Foundation, and various state art councils.

Summary

Although producing self-expressive photographs may be personally satisfying, only a handful of creative photographers are ever able to support themselves solely from sales of their prints. Even Ansel Adams, perhaps the most financially successful creative photographer, found it necessary to accept commercial assignments and other odd jobs for most of his career in order to support his family.

Nevertheless, fine-art photographic education is excellent preparation for many professional careers in photography. The experience helps to develop good visual and creative senses, a diversity of approaches, the ability to communicate visually, and solid technical skills. These attributes are essential for professional careers in commercial and advertising photography, photographic illustration, photography education, documentary photography, and museum or gallery curatorial positions. In addition, tremendous personal satisfaction may be gained by developing one's creative talents to a high level and producing evocative works of self-expression.

A

B

FIGURE 9-10

Controlling reflections from non-metallic surfaces.
A. *Reflections on windows obscure interior of building.* ***B.*** *Polarizer reduces reflections revealing interior of building.*

transmitted only if the filter axis is parallel to the plane of the light's vibration, as shown in Figure 9-8C. If the axis of the polarizing filter is rotated until its axis is *perpendicular* to the plane of the light's vibration, the polarized light will be absorbed. (See Figure 9-8D.)

These features make the polarizing filter useful for several purposes in black-and-white photography. Its most common uses are for darkening blue skies, for controlling reflections and glare from nonmetallic reflective surfaces, and for reducing haze without altering the relative brightness of other colors in the scene. (See Figure 9-10.)

With a rangefinder camera, look through the polarizing filter and rotate it slightly in one direction and then the other, until exactly the desired effect is obtained. Then attach the filter to the camera in this same position. With a single-lens reflex camera, of course, the filter can be attached first and then adjusted. With a twin-lens reflex camera, place the filter first on the viewing lens, adjust it to the desired position, and then relocate it on the taking lens in the same position.

The polarizing filter reduces the total amount of light reaching the film. Its filter factor is 2.5 (about 1 1/3 stops) regardless of how much the filter is rotated. But in addition to the 1 1/3-stop increase needed to compensate for the filtering action, an additional one half-stop is usually needed because of the nature of the lighting conditions in which the filter is normally effective. The filter is most useful when the lighting is oblique—when the light strikes the subject from an extreme angle. So ordinarily slightly more exposure is needed to compensate for the deep shadows produced by such lighting. Thus, when using a polarizing filter, a two-stop increase in exposure over that indicated by the meter is typical. If the meter is read through the filter, however, exposures should be increased only one half-stop and the filter factor not used at all.

Neutral Density (ND) Filters

Neutral density filters are used to reduce the amount of light reaching the camera lens without changing the relative brightness of various colors in the scene. Although this kind of reduction can also be achieved by stopping down the aperture or by increasing the shutter speed, these adjustments are accompanied by alterations in depth of field and in the camera's ability to stop rapid movement.

ND filters are most useful when fast film is being used on a bright day, conditions that often call for both smaller apertures and faster shutter speeds. Sometimes it may not be possible to open the aperture to reduce depth of field, because the shutter speed is already at its fastest setting and cannot be increased. At other times it may not be possible to slow the shutter to pan with a moving object, or to synchronize the flash to fill in shadows because the aperture is already at its smallest opening. In such cases the ND filter may be useful, enabling the aperture to be opened or the shutter to be slowed without overexposing the film.

ND filters are gray in color and are manufactured in various densities, which typically range from 0.10 (ND-1), requiring a 1/3-stop exposure increase, to 1.00 (ND-10), requiring a 3 1/3-stop exposure increase. Two filters may be used together to add up to a desired density. Perhaps the most useful densities are 0.30 (ND-3), 0.60 (ND-6), and 0.90 (ND-9), because they reduce exposure by 1, 2, and 3 stops respectively.

Special Effect Filters

Many other filters are available that do not alter the color of light but produce different light patterns and effects instead. These filters may be used creatively to produce optical effects that enhance the photographic image.

One popular type of special effect filter simply diffuses the overall image. One of these is the **soft-focus filter**, which produces a soft-edged image that is often used to produce delicate, dreamlike impressions of portraits and landscapes. A more extreme version is the **fog filter**, which gives a natural misty look to scenic photographs.

Another popular type is the **cross-screen** or **star filter**, which produces star-shaped flares from any bright spots of light that appear in the image. This can be used to produce dramatic effects in night scenes or other scenes that feature bright spots of light.

A **spot filter** is designed to produce an image that is sharp at the center but whose sharpness gradually falls off toward the edges of the image.

Another type is the **multiple image filter**, which reproduces the subject in a pattern of identical images. Variations of this filter produce three, five, or six images in several different patterns, such as parallel, circular, or pyramid-shaped arrays.

Although not all special effect devices are technically considered filters, they have been included here because of their similarity of construction and handling. Figure 9-11 shows examples of some special effect filters used with black-and-white film.

FIGURE 9-11

*Special effect filters. **A.** Fog filter. **B.** Star filter. **C.** Multi-image filter.*

A

B

C

Summary

Table 9-2 suggests which filters are most useful for various purposes with black-and-white panchromatic film.

TABLE 9-2 Uses of filters with black-and-white film

Subject	Desired Effect	Suggested Filter
Portraits: outdoors	Natural skin tones; slightly darkened sky	Light green
Portraits: tungsten	Darker skin tones	Light green
	Lighter skin tones	Medium yellow
Blossoms and foliage	Natural	Yellow or yellow-green
	Lighter blossoms	Same color as blossom
Landscapes	Haze reduction	Medium yellow or polarizing filter
	Haze increase	Blue
Seascapes (when sky is blue)	Natural	Yellow
	Darker water	Deep yellow
Sky and clouds	Darker sky; lighter clouds	Medium yellow
	Dark sky; white clouds	Orange, red,* polarizer
	Black sky; chalky clouds	Dark red*
Architecture (sunlit)	Natural	Yellow
	Exaggerated texture	Deep yellow or red*
Sand or snow (sunlit and blue sky)	Natural	Medium yellow
	Exaggerated contrasts	Orange
Glass, polished surfaces	Reflections eliminated	Polarizer
Sunsets	Natural	Yellow
	Exaggerated brilliance	Deep yellow or red*
Natural wood furniture	Exaggerated grain pattern	Red*, orange, yellow
Aged documents and old photographs	Reduced stains	Match color of stain

** Note: Focus shifts slightly when using a red filter. This phenomenon is not usually a problem with subjects six feet or farther from the camera. For closeup work, reflex focusing and small apertures are recommended to ensure accurate focusing.*

Filters for Color Photography

Objective 9-E Name and describe the purposes of six types of filters commonly used in color photography, and give examples.

Key Concepts conversion filters, Mired system, color-compensating (CC) filters, skylight or ultraviolet filters, polarizing filters, neutral density filters, special effect filters

Color slide films are balanced in manufacture for particular kinds of light sources—daylight (5500 K), photolamp (3400 K), and tungsten (3200 K). However, the lighting conditions under which a film is used often do not match the rated color balance of the film. Sometimes we may find our cameras loaded with a daylight film when we want to go indoors to shoot by artificial light, or vice versa. In other situations, we may find that the available light source is of another type altogether, such as fluorescent lighting, arc lighting, or stage lighting, all of which produce light of a color temperature that does not match the rated color balance of any commercial film.

At other times the available light, although of the correct type for the film, simply may not match precisely the color temperature for which the film is balanced. For example, daylight on an overcast day or in the open shade is considerably bluer than the light for which daylight film is balanced; daylight before 10 A.M. or after 3 P.M. is considerably redder. Used under any of these conditions, color reversal film will produce slides that have an overall cast that reflects the difference between the rated color temperature and the color temperature of the available light. If an appropriate filter is used, the light that reaches the film can be altered to match the color temperature for which the film is balanced.

Filters can also be used with color film, as with black-and-white film, to give expression to the photographer's individual perception and interpretation of a scene. To achieve the desired emphasis and subordination of detail, filters can be used to lighten or darken the color rendition of various details and thus emphasize or subdue selected colors within the scene. Filters can be used to enhance the mood of a photograph by imbuing it with an overall cast of a desired color. Filters can be used not only to obtain a natural color balance within a scene, but also to distort deliberately the color balance to conform to a particular perception or to communicate a color idea.

The use of filters is particularly important with color reversal film, because control cannot be exercised over individual images during commercial processing. Filters may be less important with color negative film, because the color balance and special color effects of individual images can be manipulated significantly during the printing process. Nevertheless, it is generally good practice to provide planned filtration during shooting with color negative film as well as with reversal film. The resulting negatives will tend toward a standardized color balance, which should reduce the guesswork and labor during printing.

In general, the filters used in color photography can be divided into six main types according to their uses and characteristics:

1. **Conversion filters**, which convert the color temperature of available light to that for which a film is balanced; used to correct daylight to the color temperature of tungsten-balanced film; tungsten light to that of daylight-balanced film; etc.

2. **Color-compensating (CC) filters**, which filter primary and secondary colors of light by precise amounts to provide exact control of color reproduction during photographing and printing

3. **Skylight and ultraviolet (UV) filters**, used to reduce the overall bluish cast caused by ultraviolet light, particularly in open shade, under an overcast sky, and at high altitudes; often used constantly to protect lens

4. **Polarizing filters**, used to filter out polarized light to darken blue sky, saturate colors, control reflections and glare, and penetrate haze

5. **Neutral density (ND) filters**, used to reduce the amount of light admitted to the camera without altering color rendition

6. **Special effect filters**, used to produce special optical effects in the recorded image

Conversion Filters

Bluish and amberish in cast, **conversion filters** are designed to convert the color temperature of a given lighting source to that for which a given film is balanced. For example, a conversion filter can be used to obtain normal color rendering using a tungsten film (3200 K) in daylight (5500 K). Because conversion filters reduce the amount of light that reaches the film, it is necessary to increase exposure by an appropriate amount. Table 9-3 describes conversion filters that can be used with common film–light source combinations, and gives their associated filter factors. Note that film manufacturers usually provide a film-speed index to be used with a conversion filter in order to simplify exposure calculations.

TABLE 9-3 Conversion filters

	Available Light Source			
Film Balanced for	3200 K	3400 K	5500 K	Fluorescent
3200 K tungsten	none	no.81A (1.25)	no.85B (1.5)	FLB (2)
3400 K photolamp	no.82A (1.25)	none	no.85 (1.5)	FLB+82A (2.5)
5500 K daylight	no.80A (4)	no.80B (3)	none	FLD (2)

Note: Filters are identified by Kodak Wratten filter numbers. Filter factors for each filter appear in parentheses. In place of filter factor, film manufacturers provide a new film-speed index for use when their film is used with a conversion filter. No exposure adjustment is needed when using automatic, through-the-lens (TTL) exposure setting.

A special type of conversion filter is designed to eliminate the blue-green tint that results from photographing under fluorescent lights. Fluorescent lighting poses an unusual problem because, despite its white appearance, it is made up of only a few wave lengths of light, mostly from the blue-green portion of the visible light spectrum. Converting this discontinuous spectrum of light to a color temperature that matches a film's color balance is difficult at best.

Photography under fluorescent lighting is further complicated because tubes of different types and made by different manufacturers differ in this respect. Precise conversion, therefore, requires testing under the actual fluorescent lighting conditions encountered. For general photography, filters are manufactured that represent a compromise among the various commonly found fluorescent lighting conditions. Even though the correction is less than perfect, the results are more satisfying than they would be otherwise. The FLB filter is designed to convert fluorescent light to the approximate color temperature of tungsten-balanced film; the FLD filter is designed to convert fluorescent light to the approximate color temperature of daylight-balanced film.

Clearly, there is an infinitely greater number of lighting situations in the real world than the three for which film is balanced. There is no end to the variety of filters that could be produced to convert every possible lighting situation to match the color balances of available films. One attempt to simplify this problem was the development of the **Mired system** (pronounced my-red), which stands for *micro-reciprocal degrees*. A Mired, simply described, is a standard conversion of Kelvin temperature. By using combinations of filters based on Mired units, any amount of color temperature shift can be obtained.

Typically a Mired filter system consists of two sets of filters, one composed of several bluish filters, the other composed of several reddish ones. To use the system, the Mired value of the light source and the Mired value the film is balanced for must be determined. The difference between these values determines the amount and direction of color temperature shift needed to match the film's color balance. Then a combination of filters is selected that, used together, will closely approximate this value. Thus with six or eight filters a wide range of color shifts can be effected that are suitable for numerous film–light source combinations.

Color Plate 7 illustrates the use of conversion filters.

Color-Compensating (CC) Filters

Another approach to color control is the use of **color-compensating (CC) filters**. These are used most commonly in color printing to obtain control over color during the printing stages. However, they also can be used during shooting for color conversion or to achieve special color effects.

CC filters are manufactured in six colors—red, green, blue, cyan, magenta, and yellow—the primary and secondary colors in the visible light spectrum. Each color is manufactured in six or seven densities ranging from very light tints to very strong saturations. Each filter is numbered to identify both its color and its density (measured in relation to its complement). For example, a CC20M filter is a color-compensating magenta filter of 0.20 density to green light. Color-compensating filters give the color photographer extremely precise control over color production.

When used for color conversion, CC filters provide greater precision than the more common conversion filters. They can be used, for example, to obtain a relatively normal color balance under fluorescent lighting or similar conditions where available light represents a discontinuous spectrum. Their other uses, however, are many. Color can be added to a sunset by photographing it through a yellow or red filter. Moonlight can be simulated in sunlight by using a blue filter and underexposing two or three stops. Multiple exposures can be made on the same frame, changing filters between exposures, to obtain striking and unusual effects. Or, filters can be used in combination with special purpose films to produce images never seen in nature. Color Plate 6 illustrates some of these applications.

Skylight and Ultraviolet Filters

Daylight on overcast days, in open shade, at high altitudes or great distances, or in the snow has a higher proportion of ultraviolet and blue light than the daylight for which daylight film is balanced. Under these conditions, unfiltered daylight film will produce slides with an overall bluish cast. The **skylight filter** is a special kind of **ultraviolet filter** for color film. By filtering out ultraviolet light, the skylight filter tends to eliminate this excess bluishness and restore the reddish warmth that otherwise would be lost. Slightly pink in appearance, this filter requires no exposure increase and often is left on the camera all the time, both for its warming effect on the color balance and for the protection it provides to the camera lens. The ultraviolet (UV) filter also may be used with color film for the same purposes, but because of its slightly yellow appearance, its warming effect is somewhat less.

Polarizing Filters

The **polarizing filter** performs the same functions in color photography as it does in black-and-white photography—controlling reflections and glare, reducing haze, and darkening blue skies—without altering color balance, color rendering, or brightness ratios within the scene. In addition, when it is used with color film, the polarizing filter also tends to increase color saturation of objects within the scene. Hence it is often used to obtain a deeper, richer blue sky. By filtering out polarized light reflecting from objects in the scene, however, the polarizing filter also tends to render all the colors in the scene with greater color saturation.

Neutral Density Filters

The **neutral density** filters perform the same function in color photography as they do in black-and-white photography—reducing the amount of light passing through the lens without altering the relative brightness or color balance within the scene. Suppose that, under given circumstances, a normal exposure should be f/5.6 at 1/250 sec. However, suppose also that you wish to shoot at f/2 without increasing the shutter speed. A neutral density filter would make this possible. In this case using an ND-9 filter

would reduce exposure three stops, requiring a three-stop increase in the camera setting. The ND filter reduces light intensity without altering color balance, color renderings, or brightness ratios within the scene.

Special Effect Filters

The filters used for special effects in color photography are much the same as those used for black-and-white. Soft-focus, fog, cross-screen or star, spot, and multiple image filters are equally useful in color.

One special effect filter that is uniquely useful in color photography is the **transmission diffraction grating**. Ridges etched into the surface of this filter act as prisms and reveal the color spectrum of bright spots of white light in the image. This filter produces color-enhanced flares where the specular light strikes it and can be used to create unusual spectral color effects.

Another is the **multi-colored** filter, which combines several colors in different areas of the filter. For example, one multi-colored filter can be used to simultaneously increase the blue in the sky and the yellow in the foreground.

Many special effect filters can be used together to obtain their combined effects. Color Plates 6A and 6B show examples of special effect filters used with color film. The use of filters in color photography, as in black-and-white photography, is limited only by the photographer's imagination and willingness to experiment.

Questions to Consider

1. When using a filter with black-and-white film, what colors are lightened in the final print and which are darkened?

2. Explain why photographers and their panchromatic film do not see colors with the same relative brightness. How can using filters correct this?

3. Describe the methods by which photographic filters are attached to the camera.

4. What are filter factors, and how are they used to determine exposure? If a light meter reading is made through a filter, is it necessary to use the filter factor? Explain.

5. Given an unfiltered basic exposure of 1/125 sec. at f/16, what correction should be made for a filter factor of 2? 4? 8?

6. Describe the main types of filters used in black-and-white photography and their primary uses.

7. Describe the main types of filters used in color photography and their primary uses.

Suggested Field and Laboratory Assignments

Shoot a roll of panchromatic film using filters to solve the following problems. For each shot, make one filtered and one unfiltered exposure. Keep a shooting log showing the filter used, the reason for the use of that filter, and the exposure data for each shot.

1. Use a filter to increase sky-cloud contrast.

2. Use a filter to increase subject-ground contrast between an orange or red object against green foliage.

3. Use a filter to reduce aerial haze.

4. Use a filter to exaggerate natural wood grain in furniture.

5. Use a filter to eliminate reflected glare from water, glass, or other nonmetallic surfaces.

6. Use a filter to enhance flesh tones.

Unit **Ten**

Katherine A. Stollenwerk, untitled, 1991.

UNIT AT A GLANCE

The very term *photography*—which means "light writing"—tells us that light can do much more than merely illuminate a subject. Were exposure our sole concern, we would be satisfied with any light sufficient simply for recording an image. Yet many well-exposed images fail to move us or to excite our senses. Beyond illumination, light plays a central role in creating a dramatic image of a photographer's vision of a subject.

This unit introduces the principles and techniques of lighting subjects to reveal their unique visual properties—their colors, forms, textures, and fine gradings of tone. It describes approaches for using the light available at the scene to capture these qualities, as well as for arranging and manipulating supplementary lighting.

Basic Lighting Principles

Objective 10-A State and explain the basic principles of natural and arranged lighting.

Key concepts available light, arranged light, natural light, artificial light, angle of incidence, relative intensity, inverse square law, color of light, specularity, diffused light, specular light, single dominant light source, modeling, texturing, coloring, brightness ratio, reflectors, tonal composition, chiaroscuro

It is the play of light over the surfaces and edges of a subject that reveals the subject's form, its textures, and its shadings and colors, and that finally determines the sensory effect of the image upon the viewer. Photographers generally refer to the lighting that occurs naturally at a scene as **available light**. By this they mean lighting conditions that have not been arranged specifically for the photographer's purposes. Lighting that has been altered or modified is referred to as **arranged light**.

Available light may consist of natural light, artificial light, or a combination of these. **Natural light** may consist of the highly specular light of the sun, the diffused light of an overcast day, moonlight, or even the subdued light found in the shade of a tree, in the interior of a room, or in the gloomy depths of a cavern. **Artificial light** refers to manmade light sources such as electronic flash, household lamps, spotlights, and fluorescent lights.

Characteristics of Light

Several characteristics of light affect the way we see a subject: angle of incidence, relative intensity, color, and specularity.

Angle of incidence refers to the angle at which light strikes the subject. From the camera's viewpoint, light can strike a subject from above, from below, or from the subject's own level. Similarly, light can strike the subject from the side, from the rear, or from the front. Because natural

daylight falls on most subjects most of the time from an angle 40° to 60° above and to the side of the subject, this angle tends to produce a normal-appearing pattern of highlights and shadows.

We are most accustomed to viewing objects that are illuminated by natural light that comes from overhead. Except when a special effect of some kind is desired, therefore, subjects will tend to appear most natural when the angle of incidence emanates from a position above the camera's level. An angle of incidence from below the subject tends to produce unnatural highlights and shadows, because light from this angle is relatively rare in nature. Except in unusual settings, therefore, such as a fireplace scene, subjects tend to appear most natural when illuminated by skylight, sunlight, or artificial lights placed in overhead positions.

An angle of incidence from the front, close to the camera axis, tends to flatten out highlights and shadows, subduing the subject's contours and surface textures. An angle of incidence from the side tends to reveal textures and contours. The degree to which the subject's contours and textures are revealed can be controlled by positioning the camera and subject in such a way that the subject is illuminated from the side when viewed from the camera position.

The **relative intensity** of light reflected from the surface of an object reveals its form. It is the pattern of bright highlights, middle tones, and deep shadows that provides the information the viewer needs to interpret depth, shape, and texture. As the angle from which light falls upon the object changes, the pattern of highlights and shadows changes as well, revealing different aspects of form and texture. As we view the subject from different points of view, we see light falling upon the subject from different angles and producing different patterns of light and shadow—different representations of the object's physical form.

The distance between a light source and a subject affects the intensity of the light falling on the subject. As the distance between the source and the subject increases, the intensity of the light falling on the subject decreases. As the distance between the source and the subject decreases, the intensity of the light increases. This relationship can be expressed with mathematical precision because the intensity of light falling upon the subject is related inversely to the square of the distance between the source and the subject. Thus, if the distance between the two is doubled, the intensity of the light falling on the subject is reduced by a factor of 4—a two-stop decrease. If this distance is decreased by half, the intensity of the light is increased by a factor of four. This relationship is known as the **inverse square law**.

The **color of light** has greater impact in color than in black-and-white photography. However, color affects black-and-white photographs to some degree as well. Black-and-white films have different sensitivities to different colors of light. The colors to which the film is sensitive appear lighter in the final image; the colors to which it is insensitive appear darker. By altering the color of the light transmitted to the film, we also alter the light's effect upon the film and the appearance of the subject in the final image.

The **specularity** of light refers to its direction and hardness. On an overcast day, objects and persons can be seen clearly, but no hard and distinct highlights or shadows can be seen. However, there is plenty of strong light. Light such as this, emanating from a broad light source—in this case the entire sky—is called **diffused light**. Light rays of approximately equal

Daylight sky overcast

A

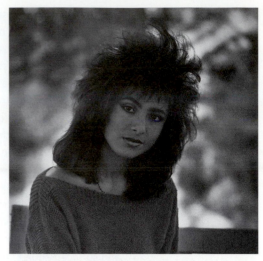

B

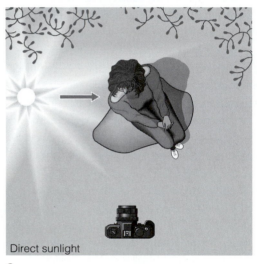

Direct sunlight

C

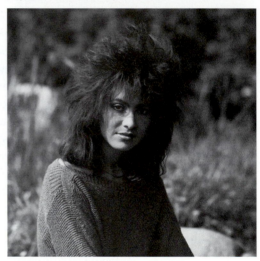

D

FIGURE 10-1

*Lighting. **A.** Diffuse light rays strike object from all directions, eliminating deep shadows. **B.** Effect of diffused light. **C.** Specular light rays strike object from single direction, producing deep shadows. **D.** Effect of specular lighting.*

strength strike the object from many directions, eliminating deep shadows. (See Figures 10-1A and B.) When the clouds clear to reveal the sun—a single, concentrated light source—immediately strong highlights and shadows appear. This concentrated type of light, produced by intense light rays emanating from a relatively small light source or reflecting from a mirror-like surface, is called **specular light**. Figures 10-1C and D show how specular light striking an object from one direction produces clear highlights and shadows.

Under natural lighting conditions, such as sunlight, both specular and diffused light are present. It is the presence of diffused light all around the subject that allows details in the shadows to be photographed. Were the diffused light not present, the details in the shadows would not be illuminated. The diffused light that is present in daylight is produced by sunlight reflecting off particles of dust and droplets of water vapor in the atmosphere as the light makes its way to the earth's surface. This diffusion of part of the sunlight lights up the entire sky, making it blue, and provides a broad source of diffused skylight in addition to the direct, specular rays of sunlight that also reach the earth. Additional diffusion occurs as the sunlight strikes the earth and other hard surfaces—the rays are reflected in

all directions, producing additional diffused light. Thus, under natural daylight conditions, both specular and diffused light are present. When the sky is overcast, blocking out the direct light of the sun, only diffused light is present, producing a soft, even, relatively shadowless field of illumination.

Functions of Light

In addition to capturing the physical characteristics of the subject, the photographer usually wants to portray the subject in the context of an overall composition, one in which an environment of light and shadow emphasizes the relationships and contrasts that are of the most interest.

Single dominant light source refers to perhaps the most important principle governing the lighting of subjects. In nature, subjects are usually seen illuminated by a single source of light that produces a single set of dominant highlights and shadows. This source may be sunlight or skylight if the subject is outdoors, or it may be ceiling light, window light, or a lamp if the subject is indoors. For the subject to appear most natural, there should be, or appear to be, a single dominant light source.

Modeling refers to revealing the three-dimensional quality of the subject. The highlights, the shadows, and the gradations of tones between them reveal the shape and contour of the subject.

Texturing refers to revealing the surface textures of the subject—the hard, crystal surface of a goblet; the soft skin texture of a young girl; the rough, weathered texture of an ancient tree.

Coloring refers to revealing the color details of the subject in color photographs or to the relative brightness of colors in black-and-white photographs.

Brightness ratio refers to the difference in the relative brightness of the highlights and the shadows at the subject position. If the difference in brightness between the highlight areas and that of the shadow areas is too great, the film may not have the latitude to record all the details at both extremes. If the difference is too great, an exposure that is suitable for the highlights may be too little to record fully all the details in the shadows. An exposure that is suitable for the shadow areas, on the other hand, may be too much for the highlights, resulting in overexposure in these areas.

Generally, for normal contrast, the brightness ratio between the highlights and shadows should be between 3 to 1 and 4 to 1. In other words, the highlights should be between three and four times brighter than the shadows. Translated to light meter readings, the difference between the highlight areas and shadow areas should be between 11/2 and 2 stops.

In available light situations, the brightness ratio can be controlled by the use of **reflectors**, light-colored or polished surfaces that reflect light. When reflectors alone are not sufficient, flash may be used to fill the shadows. To reproduce a natural lighting environment artificially, one or more specular light sources can be used to produce highlight illumination. Diffused light sources can be added to illuminate the shadows.

As we discussed earlier, **tonal composition**, or **chiaroscuro** (see pages 257–258), refers to the arrangement of light and shade in a picture—the placement of the brightest highlights and deepest shadows to bring about a harmonious and logical tonal arrangement. Whether using

available or arranged lighting, the photographer should seek to arrange highlights and shadow masses to reveal the subject and direct the viewer's attention in a harmonious, cohesive design.

Applying Lighting Principles

Whether the photographer is working indoors or outdoors, with natural or artificial light, available or arranged light, the most realistic lighting will usually resemble natural light, because that is what we see most often. These are some of the characteristics of natural lighting:

Main light. There will appear to be a single main source of light that creates the dominant set of highlights and shadows.

Fill light. There will be sufficient ambient lighting that the shadows are illuminated and shadow details can be discerned.

Accent light. Edges, surface, and prominent features are highlighted so as to reveal their shapes and surface textures and to set them apart from their backgrounds.

Background light. Details that lie beyond the subject are illuminated sufficiently to be discerned.

Even though the photographer may wish to alter or depart from the natural light standard, appropriate lighting should not be left to chance or accident. Photographers need to develop an eye for the lighting of their subjects and the craft to control it. They should develop an awareness of how the highlights and shadows, shapes and textures will be recorded on the film and then act to mold them to their purpose.

Although greater control over lighting may be gained with a studiolike arrangement, control may also be exercised in available light situations. By moving the camera or subject one way or another, or by shooting from a somewhat different angle, the way the subject is lit from the camera's point of view may be altered. Moreover, by using lighting accessories, a good deal of control over lighting may be gained, even in natural settings.

Purposes of Arranged Lighting

Even if it were possible to use natural outdoor illumination for every picture, it would not always be desirable. Outdoor lighting must be used largely as it occurs in nature. We cannot move the sun around in the sky to provide a perfect lighting angle. We can supplement daylight with reflectors, flash units, and the like, and we can move our subjects about on occasion, but we really cannot alter the quality or the source of the daylight very much.

One reason for moving indoors is to gain control over lighting and backgrounds that might be impossible to achieve outdoors. Another, of course, is to photograph subjects in their natural indoor habitats—the company executive in his or her office, a mother and child in the nursery, a man in his workshop, for example. When indoors, the photographer must either work under available light or create an arranged lighting setup around the subject. Except for the few photographs that may be taken using only light from a window or skylight, it will usually be necessary to arrange artificial lighting to obtain the desired image of the subject.

One principal purpose in the arranged lighting of a subject is to allow the subject's essential traits to reveal themselves. That is, the lighting is arranged partly so that the subject can be recognized for what it is—a person, a ball, a table, a bottle of wine, whatever. In most cases, however, the photographer will want to go a bit further—to emphasize certain traits and subordinate others in order to communicate a particular interpretation of the subject. The photographer may seek to *idealize the subject* by exaggerating or even distorting certain characteristics while subduing others.

Leonardo Da Vinci once said of portrait painting, "You do not paint features; you paint what is in the mind." The same may be said of photography, whatever the subject. A proper lighting arrangement is a powerful tool for expressing what the photographer thinks and feels about the subject—not just "here is a man," for example, but "here is a strong, rugged, weathered, determined farmer."

The following objectives address how these principles may be applied in available or arranged lighting, with natural or artificial sources, and by using lighting accessories.

Photographing in Available Light

Objective 10-B Describe and demonstrate techniques of available light photography.

Key Concepts bad weather, time of day, angle of incidence, relative position

The term *available light* refers to both natural and artificial lighting that occurs naturally at a scene. Sometimes the available light may be bright and pose no special problems; often, however, a photographer is faced with uneven light situations, indoors or out, that require some combination of fast films, slow shutter speeds, and/or large apertures to get a usable image.

Outdoors, **bad weather** and **time of day** may produce very dim natural light and unusual color shifts. Shooting in rain or mist, or shooting in very early morning, evening, or at night poses special challenges for photography. Indoors, window light may be very dim. Firelight from candles or a fireplace will flicker and produce multiple shadows from unusual directions. Indoors or outdoors, artificial light may come from several directions; its intensity may be very low and its color may be of limited range. The light may even be intermittent or flickering, such as from flashing signs or marquees.

Needless to say, such conditions often produce the barest minimum of light, often uneven, producing multiple, poorly lit shadows, high contrast, and unusual color shifts. Nevertheless, it may be necessary to shoot under available light when time or physical constraints prevent modifying, adjusting, or controlling the light at the scene. On other occasions it may even be desirable to shoot under available light to preserve the natural lighting quality or to capture a particular mood or feeling.

Dim Lighting Conditions

Just because the weather is bad, daylight has waned, or interior lighting is very dim is no reason to stop shooting. Although photography under dim available light may require special tools and techniques, the resulting photographs often convey a greater sense of atmosphere or mood than those shot in a studio or in the bright light of day. The major problem faced by the photographer is how to capture what little light exists in the scene.

Photography under dim light will generally require a fast film, a slow shutter speed, and/or a wide aperture. Photographs produced under these conditions often are relatively grainy and have shallow depth of field. Blurred images are also common—the camera as well as the subject can move during a long exposure. To make matters worse, light meters are least accurate when light is dim, and they generally underestimate the required exposure.

To answer these challenges, a fast film is essential, as are a slow shutter speed and a wide aperture. Exposure should be set fully for the shadow details and then increased by one additional f/stop to compensate for underestimation by the meter. Because full exposure for the shadows will probably require a slow shutter, the camera should be stabilized to avoid camera movement during exposure. Slight underdevelopment of the film is also advisable to prevent highlights and visible light sources from blocking up.

Selected Lighting

Without modifying the available light at the scene, the photographer may often position the camera and the subject so as to gain advantageous lighting angles and qualities. The subject might be placed near a window or a lamp; the camera might be placed to achieve a maximum of illumination, modeling, and texture. Light reflected from nearby surfaces can be used to illuminate the natural shadows in the scene. When working with window light, for example, light from the window may illuminate a nearby wall or a piece of furniture. By changing the **relative position** of the camera and subject appropriately, the light reflected from these surfaces can provide fill light on the shadowed side of the subject. Thus, without modifying existing light, the photographer can select a point of view and **angle of incidence** that optimizes the lighting of the subject.

Bad Weather

Bad weather lighting is usually flat and dull. Nevertheless, in color photographs, bad weather usually produces soft, pastel shades and an overall cold, blue cast. Black-and-white images are characterized by overall low contrast and a narrow range of tones. These characteristics are not inherently faulty—many photographers prefer them as a true reflection of natural conditions. Alternatively, the colors may be "corrected" by the use of an 81A filter or, for black and white, by the use of a yellow or orange filter.

Falling rain itself is usually difficult to capture on film. Unless the rain is backlit and shot against a dark background, it moves too fast to be stopped by the usually slow shutter speeds required in dark, rainy weather. The effects of rain, however, are easier to capture—the glistening surfaces, puddles, flowing water, droplets on eaves and window panes, umbrellas, sopping hair, drenched clothing—all of these can convey the sensations of rain effectively.

Storms often provide exciting and dramatic lighting conditions. In daylight, storm clouds can become luminous as light penetrates the clouds in a rich variety of intensities. The cloud effects can be exaggerated in color by slight underexposure or by the use of a polarizing screen; in black and white by the use of a yellow, orange, or red filter.

When photographing lightning, it is best to use a tripod, stop down, and use an open shutter until the burst of lightning occurs. Sometimes, more than one burst recorded on the same frame provides a more dramatic image; however, if the shutter remains open too long, the sky will eventually record on the film and reduce the dramatic impact. If possible, try to cover the lens between bursts, uncovering just before the next burst is expected. This same technique can be used for photographing fireworks against the night sky.

Morning and Evening Light

An exceptional sunset is irresistible as a subject for color photography. As important as the sky and cloud colors themselves are the foreground details that characterize the place from which the sunset is viewed. Against the sunset as a background, most foreground details appear in silhouette with bright edge highlights.

Sunsets are not constant; they continuously develop and change. A sunset's entire cycle lasts but a few minutes, during which the setting sun brilliantly illuminates the atmosphere and clouds and backlights foreground objects. The photographer needs to be ready as the sunset commences and must complete shooting within a few minutes. A meter reading should be taken of the sky itself, not directly from the sun. It is advisable to bracket exposures.

Light of the early morning and late afternoon is tinged with reddish hues, which many photographers prefer. For color photography, these colors may be "corrected" by the use of an 82A filter.

Night Photography

Aside from the moon, stars, and lightning, few natural light sources occur to illuminate the night. Therefore, most night photography captures artificial light sources or scenes that are lit by artificial light sources. These sources include street lights, illuminated buildings, automobile lights, fireworks, and fire light.

For many types of night photographs it is advisable to shoot in early evening, after the artificial lights have been turned on but before all sky light has disappeared. Photographs shot at this time give the impression of night photography while still preserving enough ambient light to record sky values and to fill the shadows.

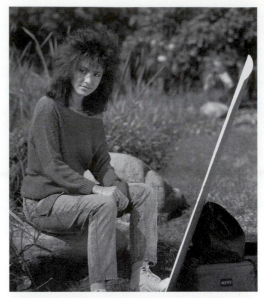

A

B

FIGURE 10-2

*Use of reflector to fill shadows. **A.** Sunlight or spot-light may produce strong highlights and shadows. Matte white reflector provides a diffused fill light. **B.** Effect of reflector.*

At night, the light that records on the film is often the light source itself. The light coming directly from lightbulbs, fluorescent and neon tubes, street lights, and car lights is the primary image-forming light, rather than illuminated objects lighted by these sources. To set proper exposure for night photography, the brightness of these light sources must be accounted for, and these bright points of light must be regarded as the image highlights.

For moonlit landscapes, it is advisable to shoot at late dusk at a time when the moon rises early. The image will benefit if the sky retains some level of illumination and illuminates the landscape features with dim residual daylight. Moonlight alone provides insufficient illumination for a short exposure, so if the moon appears in the picture, its movement during exposure will create a trace on the film. Often moonlit landscapes or cityscapes benefit by having some artificial light sources, such as interior building lights or signs visible in the picture.

Modifying Available Light

As noted, placing a subject near a reflecting surface may take advantage of the available light by reflecting fill light into the shadow areas. If reflecting surfaces do not exist naturally at the scene, light-colored reflectors may be placed in appropriate positions. Reflectors may be made of almost any available light-colored material—a white sheet, for example, or a large, light piece of plastic or paper. The reflector is positioned to bounce the available light into shadowed areas so that details in the shadows can be recorded. (See Figure 10-2.)

With a little imagination, the existing light can be directed and controlled to improve the image. By combining the direct main light source with reflected fill light, the photographer can control available light to produce a primary set of highlights and shadows while illuminating the shadow details.

A photographer can learn to appreciate the qualities and behavior of light and increase visual sensitivity by working with unmodified available light rather than trying to change it.

Available light photography under difficult conditions poses a challenge to many photographers who take special pleasure in capturing their images unaided by artificial devices. Of course, sometimes the only way to capture an image is by making do with available lighting conditions. It is advisable, therefore, to practice under a variety of available lighting conditions before adding and arranging such artificial light sources as flash and studio lighting.

A
B

FIGURE 10-3

*Harry Callahan. **A.** "Eleanor," 1947. **B.** "A Weed," 1951.*

Harry Callahan, a former engineering student, started work as a photoprocessor in the General Motors photo laboratories. Initially influenced by the work of Stieglitz and the approaches of Minor White and Ansel Adams, his early work was characterized by faithfully reproducing natural subjects and emphasizing the rich detail, tone, and texture that was the hallmark of new realism in the 1930s.

As his style developed, however, he experimented with complex multiple exposures and collages, sometimes incorporating snippets of hundreds of photographs to produce a single image. Often favoring building façades and architectural features, he repeated the patterns of various tones and overlayed lines and masses to reveal their abstract, graphic content. Ultimately he developed a style uniquely his own that isolated the abstract qualities of his subjects by emphasizing the stark contrasts of deep black and clear white line and mass with an absolute minimum of shading and texture.

Photography in the 1950s was often described in terms of unique regional styles, and it is worth noting that the photographic style associated with Chicago at that time was generally identified with the often abstract work of Harry Callahan and Aaron Siskind. Callahan started teaching at the Illinois Institute of Design in Chicago in 1946 and later, with Siskind, presided over the photography department there for twelve years. In 1961 he accepted appointment as head of the photography department at the Rhode Island School of Design. His work has been exhibited at the Kansas City Art Institute, the International Museum of Photography in Rochester, N.Y., the Museum of Modern Art in New York City, and the Worcester Art Museum, Massachusetts.

Artificial Lighting Tools and Their Functions

Objective 10-C Name and describe the functions of six basic lighting tools used in artificial lighting.

Key Concepts hot lights, electronic flash, strobe, tungsten-filament, tungsten-halogen, quartz lights, reflector lamp, pan-reflector light, umbrella, bounce light, softbox, spotlight, reflector cards, matte white reflectors, baffle, barn-door baffle, head screen, flag, snoot, diffusion screen, pattern screen, gels, standard, boom

When available light is insufficient or inadequate, the image can be enhanced by modifying and supplementing the existing lighting. Preserving the original mood and quality of lighting is the real challenge. A wide variety of artificial lighting tools and auxiliary equipment is available for photographic use, but all forms of artificial lighting can be divided into two basic categories: hot lights and electronic flash. **Hot lights**, also called incandescent lights, are similar in construction to common lightbulbs. They produce continuous illumination, whereas the light from an **electronic flash**, often called a **strobe** unit, produces instantaneous bursts of light.

Hot Lights

Hot lights are convenient and relatively inexpensive. Their name derives from the considerable heat that is produced by the lamps when they are in use. Hot lights may be of the tungsten-filament variety, which often resemble overgrown household lightbulbs, or the more compact tungsten-halogen type favored by location photographers. **Tungsten-filament** photo lamps are available in many wattages—250 W and 500 W are the most common. **Tungsten-halogen** photo lamps, sometimes called **quartz lights**, also are available in many wattages. Although quartz lights require careful handling and their replacement is more expensive, they are efficient, lightweight, and have a high, stable light output over a long, useful life.

Photo lamps are designed to more rigorous specifications than ordinary household lightbulbs. They produce a more even field of light and, more important, their color temperature is controlled carefully. Photo lamps are manufactured in both 3400 K and 3200 K ratings for Type A and Type B color film, respectively. Either may be used with black-and-white film.

Pear-shaped photo lamps (similar in shape to household lightbulbs) normally need to be inserted into a metal reflector for use, and these lamps usually are frosted to diffuse the light they produce.

The **reflector lamp** differs in shape because it has a built-in reflector coated on the inside surface of the glass bulb. Lamps with built-in reflectors are available for either flood or spot service. These self-contained units produce a broad field of relatively diffuse light for flood service or a narrow beam of specular light for spot service. Although typically a more expensive type of lamp, the reflector lamp eliminates the need for a separate metallic reflector.

Figure 10-4A shows various forms of inexpensive hot lights. The spring-clip mounted reflector is only one of several types commonly available; it is one of the more popular types because it is convenient and easy to use.

Electronic Flash Units

In addition to hot or incandescent lights, electronic flash units also can be used in an indoor lighting setup. In commercial studios, large electronic flash units, or strobes, powered by alternating current (AC) are commonly used. Two or more flash heads may be linked to the same power pack for synchronization. Many studio strobes have built-in tungsten modeling lights of a low wattage that are used to aid the photographer in positioning the lights. In this way the intended lighting pattern may be studied and adjusted before the brief flash exposure.

Most studio flash heads feature detachable and interchangeable reflectors. Thus, any head may be used with a variety of reflectors, umbrellas, and other devices to suit the lighting needs of the individual assignment. Like smaller camera-mounted flash units, the light-producing flash tube on a studio strobe head rarely wears out and is capable of thousands of flashes.

Electronic flash is generally replacing incandescent lighting in commercial studios, because it produces great quantities of light without much attendant heat. This feature permits the flash head to be enclosed and contained in light modifying devices such as soft-boxes that might pose a fire hazard with hot lights. Although the initial cost of a professional quality studio strobe system is fairly high, the units consume less power, are less costly to operate, and have a very long lifespan. Figure 10-4B shows some common studio electronic flash light heads and reflectors.

FIGURE 10-4

*Lighting instruments. **A.** Economy lighting. Tungsten reflector lamps and reflectors with bulbs are commonly available at low cost in hardware and lighting stores. **B.** Professional lighting. Professional lighting units including strobe (flash) and quartz lamps are available with a variety of heads and reflectors for more precise control of lighting.*

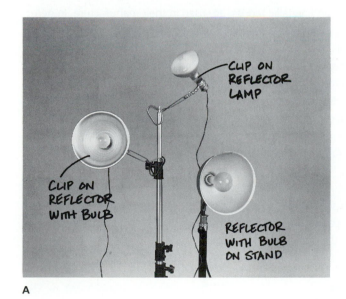

A

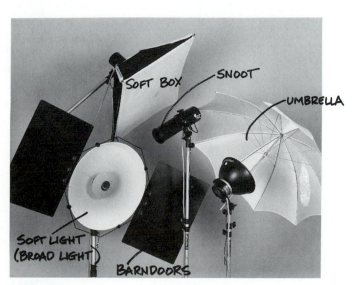

B

Reflector Types

Both hot lights and studio strobes can be outfitted with a variety of metal reflectors and other accessories designed to modify the quality of the light produced. In general, small reflectors tend to produce a highly directional and specular quality of illumination, while larger reflectors modify the light so that it is more diffused and less directional. The selection of an appropriate reflector is governed by the surface characteristics of the subject and the textural and tonal rendering desired in the final photograph. Some general reflector types and their lighting characteristics are described below.

Floodlights One type of floodlight reflector that may be found on both hot lights and strobe heads is the **pan-reflector light**. This instrument has a large, curved, panlike reflector bowl and generally uses only one light head for its source. Like other floodlights, the pan-reflector light produces a relatively broad, even field of light with some direction. Large pan-reflectors are often used as the key or main light in studio work and may be used to give the feel of direct sunlight illumination. One advantage of this type of floodlight is that auxiliary equipment can be clipped easily onto the reflector.

Small diameter pan-reflectors, and/or units having brightly polished inner surfaces will produce more specular light with greater directional traits. Positioned above or to the side of a subject, these small reflectors are often used to accent edges and textures. Using very large diameter pan-reflectors, or those with satin or painted finishes, results in softer, more diffused lighting. Thus, the size and type of pan-reflector will determine the sharpness and darkness of the shadows and the size of the highlights. Larger, less shiny pan-reflectors will produce open, soft shadows coupled with large, luminous highlights.

Umbrellas A special type of large reflector, called an **umbrella**, often is used to provide extremely even and diffused illumination. Many different materials, including metallic fabrics, are used in their manufacture. In general use, a light head with a small pan-reflector is directed into the hollow of the umbrella, which in turn reflects the light toward the subject. When the light is reflected in this fashion, it is commonly referred to as **bounce light**. Depending on the nature and shape of the material, the light is reflected and diffused in different ways. Normally, the light produced is sufficiently specular to produce clear highlights and shadows, yet it is sufficiently diffuse to give the shadows a soft edge that is especially pleasing for portraits. An umbrella is often used as a key light, as depicted in Figure 10-5.

A plain white fabric umbrella without any silver lining may also be used as a light diffuser. When this is done, the lighting standard is reversed so that the light passes through the umbrella toward the subject. The result approximates the quality of light from a softbox.

Softboxes

Classical painters were known to favor the soft, broad and even illumination produced by north-facing windows. **Softboxes** are the modern studio photographer's equivalent of this kind of lighting. A softbox is usually a

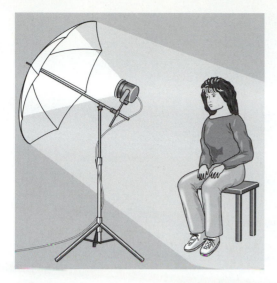

FIGURE 10-5

Light with umbrella reflector, mounted on lighting standard. This arrangement provides a broad, key-light effect — strong enough to provide highlights and shadows, but diffuse enough to soften the edges.

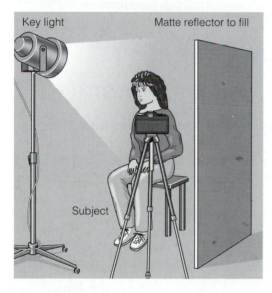

Key light Matte reflector to fill

Subject

FIGURE 10-6

Placement of reflector. Key light provides dominant source for highlights and shadows. Reflector provides fill for shadows.

large fabric-covered enclosure supported by metal rods. A flash head, placed inside the box, is directed through one or more layers of translucent diffusing material. The sides and back of the box are generally made of metallic-coated cloth to direct and reflect the maximum amount of light through the front opening. Softboxes are usually used only with strobe lights, because their use with hot lights could pose a fire hazard.

Softboxes come in a variety of sizes to light different-size objects. Automobile photographers, for example, use boxes as big as 10 ft. by 12 ft. for their large subjects. Most studios, however, are well served by 3- or 4-ft. square boxes that can be used as both main and fill lights for subjects ranging from portraits to still lifes.

Spotlights

Typically a **spotlight** is used to obtain a narrow, specular beam of light. The spotlight combines a light source, which may be either a flash tube or a hot light, with a small, highly polished reflector and one or more lenses to concentrate the light emanating from the unit. This design produces a small point source of light and focuses the light rays to minimize diffusion.

Spotlights are often used as an addition to a main or key light to add controlled illumination to small areas. This may be done to call visual attention to the area, to provide tonal separation and highlights, or to emphasize the texture and surface of a material. Alternatively, the spotlight itself may be used as the dominant key light to produce a more dramatic, theatrical effect.

Reflector Cards

Any light colored or white surface, as well as a mirror-bright polished surface, can serve as a **reflector card**. Light reflected by a matte surface, such as paper, cardboard, or cloth, will tend to be diffused, reflecting from the surface in many directions. Light reflected by a mirror or a highly polished, metallic surface will tend to be specular, reflecting from the surface in a single direction. A matte white reflector is often useful for reflecting diffused light into the shadowed areas of the subject. This procedure is sometimes more convenient than placing a fill light in that position, particularly when the key light is opposite. Figure 10-6 shows this arrangement.

Baffles, Screens, Flags, and Snoots

Sometimes a main light source produces unwanted highlights along with the desired highlights. In a portrait, for example, the key light may produce an unwanted highlight on a prominent ear. One method of removing this highlight is to shade the key light from this area with an opaque **baffle**. One kind of baffle is called a **barn door baffle**. It attaches to the light reflector and has hinged flaps that can be adjusted to shade any part of the light.

Another type of baffle is an opaque **head screen** that can be inserted into the light beam and held in place on a separate stand by a clamp. A

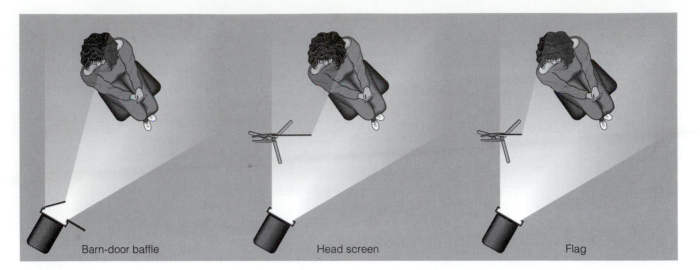

Barn-door baffle Head screen Flag

FIGURE 10-7

Baffles, screens, and flags. These devices aid in controlling light by introducing shadows in the main light path where needed.

small screen of this sort, often called a **flag**, can be used for very precise local control of shading. Figure 10-7 shows the use of baffles, screens, and flags.

Because artificial light travels away from its source in all directions, even the light from a spotlight spreads out over short distances. Baffles and flags will keep unwanted light from falling on the subject. Another approach is to use a **snoot** fitted to the front of the light—a long metallic tube that passes light only through its small, circular opening. Thus the light may be further controlled for exact placement on the subject.

Diffusion Screens, Pattern Screens, and Gels

Whereas baffles fully shade or block some portion of the light, diffusion screens, pattern screens, and gel filters alter the quality of the light in some way.

Diffusion screens are introduced into the path of the light to soften and diffuse it. The key light may be too specular, producing sharp edges between the highlights and shadows. To soften these sharp edges, a diffusion screen can be placed in the path of the light. Doing so will change the hard, specular light into a softer, more diffused light. Diffusion screens may be made of ordinary window screen material, light gauze, sheer nylon stocking material, or something similar. Usually a diffusion screen is mounted into a frame and clamped to a light standard in the desired position.

A **pattern screen** is used to create a pattern of shadows, usually on a background, often simulating shadows found in nature. For example, inserting a leafy tree branch into the background lighting will produce a leafy pattern of shadows. Similar effects can be obtained with patterns cut from opaque materials, such as cardboard. These cutout patterns may be abstract or representative of natural patterns. Pattern screens of this sort can lend interest to an otherwise uninteresting background.

Gels, or colored filter sheets, are sometimes positioned in front of the light head to produce special effects. A red gel, for example, might be mounted on a background light to color the backdrop in a portrait or product shot. By using a variety of colored gels, a single roll of grey or white background paper can be made to appear any desired color.

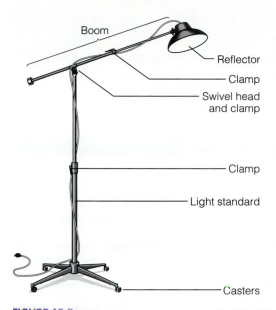

FIGURE 10-8

Lighting standard and boom.

Labels on figure: Boom, Reflector, Clamp, Swivel head and clamp, Clamp, Light standard, Casters

Although special photographic gels are sold, almost any sheet of suitably colored acetate can be used. Be sure to mount gels so that they will not touch any hot objects or modeling lights—they may be flammable. When used with hot lights, gel filters must be mounted in a filter frame and positioned some distance away from the lighting unit to avoid discoloration, melting, or combustion.

Light Standards and Booms

The lighting instruments, reflectors, baffles, flags, screens, and gels all need to be placed carefully and held in place while the setup is being made. A wide range of stands, clamps, extension arms, and mounting hardware is available for this purpose. The term **standard** commonly refers to a weighted or tripod stand, sometimes mounted on casters, designed to stand on the floor and to accept the mounting of lighting and auxiliary equipment. Standards come in many varieties, the most useful having telescoping extensions with manually operated clamps to hold the extensions in place. A **boom** usually refers to a cross member, sometimes counterbalanced, designed to attach to the standard and to hold an item of equipment suspended in the air at a short distance from the standard. Figure 10-8 depicts a light standard and boom with a spotlight affixed.

Having several standards and booms makes possible precise placement of lighting instruments. In the ideal studio, instruments are hung from the ceiling on adjustable mounts, eliminating a tangle of wires on the floor and concealing the equipment from the camera. An ideal portable lighting system includes several lightweight instruments, collapsible standards, cords, and connectors, all contained in a carton or case.

CAUTION: LIGHTING HAZARDS

The cords and connectors that provide power to the photo lamps must be of a suitable gauge. Ordinary household lamp cords (number 18 gauge) and connectors are usually not adequate for the wattages used by photo lamps and present a hazard if overloaded. Use heavier gauge cord and connectors to power photographic lighting instruments. (For typical U.S. 115 V AC power supply, use number 16 gauge for up to 500-W loads or number 14 gauge for up to 1500-W loads.)

Be sure not to overload the electric circuits when more than one photo lamp is used on a single circuit. To work out how many lamps can be operated on one circuit, use the formula: volts × amperes = watts. A typical U.S. household electric circuit has a 115-V power supply and a maximum capacity of 15 A. Thus, the total wattage of all loads that can safely be run from one such circuit is: 115 V × 15 A = 1725 W, or approximately three 500 W lamps. Consult an electrician or electrical supply store before setting up a home studio.

Do not place flammable screen, filter, or gel materials too close to, or in contact with, hot light instruments.

Summary

Table 10-1 shows the types of highlights and shadows obtained from various artificial lighting tools.

TABLE 10-1 Lighting effects

Tool	Type of Highlight	Type of Shadow
Floodlight	Fairly broad and diffused	Indistinct edges; good shadow detail
Umbrella bounce light	Broad; softened specular	Clear, soft edges; good shadow detail
Umbrella diffused light	Medium, softened specular	Soft edges, moderate shadow detail
Softbox	Very broad and diffused	Open shadows full of detail
Spotlight	Small and specular	Sharp edges; little shadow detail
Matte reflector card	Very diffused	Some shadow details; indistinct edge
Polished reflector card	Broad and specular	Sharp edges; little shadow detail
Diffusion screen with spotlight	Narrow; softened specular	Clear, soft edges; some shadow detail

A Basic Four-Light Setup

Objective 10-D Describe and demonstrate the functions of the key (or main) light, fill light, background light, and accent lights in a basic setup.

Key Concepts key (main) light, vertical placement, high angle lighting, top lighting, subject level or eye-level placement, low-level placement, horizontal placement, frontal lighting, 45-degree sidelighting, 90-degree sidelighting, backlighting, rim lighting, Rembrandt lighting, catchlights, fill light, highlight brilliance, background light, accent lights, hair light, backlight or kicker

Most lighting setups will benefit from a plan that applies the principle of the single dominant light source. To implement such a plan, imagine that the subject, whether a portrait or an object, is illuminated by some single natural source, such as a window, sunlight, an overhead lamp, a candle, or a fireplace. With this single source in mind, set up the lighting in a way that will simulate lighting from this source. The following basic four-light setup should be useful in developing such a plan.

The Key Light

The *key (main) light* is placed in the position of the assumed single dominant light source. The placement of the key light has a greater effect on the feel and form of the subject than any other light. In placing the key light, the photographer must consider both the vertical and horizontal placement.

Vertical placement **Vertical placement** involves deciding if the light is to come from above the subject, from the subject's level, or from below the subject. Because most natural sources originate from above, the key light usually is placed above the subject and directed downward. Light emanating from above the subject is called **high-angle lighting** and generally produces a pattern of highlights and shadows that is familiar in nature. Extreme high-angle lighting, or **top lighting**, is produced by placing the light source directly above the subject.

Light emanating from the level of the subject may be referred to as **subject-level** or **eye-level placement**. A key light at this level may simulate window light or lamplight because that is the level at which we are accustomed to seeing these natural sources.

Light originating from a source below the level of the subject is referred to as **low-level placement**. A key light in this position can be used to simulate a fireplace or campfire because that is the level at which we are accustomed to seeing these sources. Low-level light can also give a mysterious or "other world" feel and is often used for this effect in Hollywood horror movies.

Horizontal placement **Horizontal placement** involves deciding if the light is to come from in front of the subject, from the side of the subject, or from behind the subject. Light emanating from in front of the subject, approximately on the camera's axis, is referred to as **frontal lighting**. A key light in this position tends to eliminate most modeling and texture shadows and results in a relatively flat, textureless, representation characterized primarily by shape.

Light emanating from the side of the subject is referred to as sidelighting. If **45-degree sidelighting** is used, the key light is placed toward the side of the subject, about 45 degrees off the camera's axis. In this position, the key light produces good modeling and texture shadows and results in natural-appearing surface details and textures. If **90-degree sidelighting** is used, the key light is placed to the extreme side of the subject, 90 degrees off the camera's axis. In this position, the key light illuminates one side of the subject, casts the opposite side in deep shadow, and exaggerates surface textures.

Light emanating from behind the subject is called **backlighting**. If the key light is used in a backlighting position, the front of the subject that is facing the camera is cast in deep shadow, surface textures are not revealed, and the edges around the shape of the subject are brilliantly lighted. This effect is also called **rim lighting**.

Studio photographers select carefully from among these horizontal and vertical placements and various intermediate positions to control which features of the subject are to be emphasized and subordinated. The types of light sources selected and their positions will control how viewers

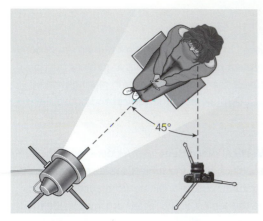

A

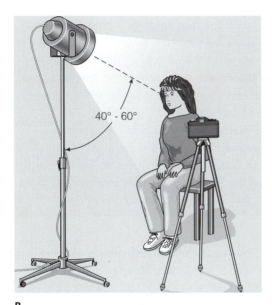

B
FIGURE 10-9

Normal placement of key light. ***A.*** *Top view.*
B. *Frontal view.*

perceive the shape, form, volume, mass, and surface characteristics of the subject. The creative photographer uses light to shape and refine his or her interpretation of the subject.

Typical Key Light Location

For portraits, a favored position for the key light is at approximately 45° to one side of the camera-subject axis and approximately 40° to 60° above the head (see Figure 10-9). When the light is correctly positioned a triangle of light should highlight the cheek on the shadow side of the face. This is often called **"Rembrandt lighting."** The reflections in the eyes produced by the key light, called **catchlights**, should be high in the eyes. For subjects with deep-set eyes, the key light may need to be lowered somewhat to keep the eye sockets from appearing excessively dark.

Recommended Types of Key Lights

For most portrait photography the key light is a flood lamp or broad light source, which produces a diffused light that tends to soften the shadows produced by skin blemishes and wrinkles. A medium-size softbox or a small pan-reflector light bounced from an umbrella is good for this purpose; each produces a soft, directional light. To produce a more dramatic look or to accentuate character lines, many photographers prefer a smaller light source of higher specularity.

In photographing objects, a harder, more specular key light usually helps to accentuate the shape, contour, and texture of the object. A common position for the key light in object photography is above and behind the object. This position, called "key backlighting," provides good definition of volume and form.

The Fill Light

The key light is intended to provide the basic pattern of highlights and shadows that will give the subject its three-dimensional appearance. In nature, however, considerable diffused light is also present to light up the shadows, revealing the detail in the shadow areas. In a basic light setup, therefore, some provision should be made to fill in these shadow areas with secondary, diffused light. That is the purpose of the **fill light**.

The fill light is generally a diffused light source such as a large floodlight, medium umbrella, small softbox, or a matte white reflector. Normally a fill light is placed on the side of the subject opposite the key light and at about the same height as the camera. The intensity and amount of fill illumination can be controlled easily by varying the light-to-subject distance. As the light is moved away from the subject, the amount of fill illumination declines.

The fill light should produce no visible shadow patterns of its own. This is very important to creating the impression of the single dominant light source. The viewer of the final print should be unaware that a light was

used in this position. It should appear that the shadow areas are illuminated solely by the diffused lighting normally produced by the dominant source.

In portraiture, the fill light may occasionally produce specular highlights on the cheeks, nose, or forehead of the subject. If these are too intense, this **highlight brilliance** may give the subject an oily or sweaty look. Once the fill light is in place, it can be adjusted slightly from side to side to minimize this effect. Also, the fill light at this position may sometimes produce an additional set of catchlights in the eyes. These secondary catchlights tend to give the subject a directionless gaze and generally are considered undesirable. If they cannot be eliminated in the lighting setup, they can be removed later by spotting them out of the final print.

The Background Light

Usually the **background light** is a small floodlight placed between the subject and the background. Its purpose is to light the background, not the subject, in a way that will help add tonal separation between the subject and background. This light will give the illusion of depth behind the subject and will separate the subject from the background. Care must be taken to place the lighting instrument in a position where it is not seen by the camera. Pattern screens may be used to add patterns of light and shadow to backgrounds that otherwise might appear uninteresting. Such pattern lighting of the background can be used to simulate a natural setting, such as the pattern sunlight might produce through a paned window or a leafy branch. Gel filters may also be used on the background light to introduce color effects.

Accent Lights

Additional **accent lights** can be placed at various positions to provide highlight accents that will help reveal the three-dimensional quality of the subject. An added highlight on the subject's hair, for example, or at the sides of the face to rim the features, often helps to separate the subject from its background and to add some sparkle to the final print.

One common accent light is called a **hair light**. It is usually a small lighting instrument, such as a snoot or spotlight, mounted on a boom and placed in a top lighting position slightly behind the subject. It may be placed directly overhead or slightly to one side. When it is used off center, it is usually most useful on the side of the head away from the key light. Its beam is directed from behind the subject slightly toward the camera to give the hair a brilliant, halolike highlight, which not only adds some detail but helps provide additional subject-background separation. Care must be taken, however, that light from the hair light does not fall on the subject's face and produce a secondary set of highlights.

Another common accent light is the **backlight**, or **kicker**, generally a snoot or spotlight placed behind and slightly above the subject's head, usually on the same side of the subject as the key light. If it is directed to the back of the subject's shoulders or to the back of the head, the backlight will rim these features with highlights, not only adding detail but also adding to the subject-background separation.

Care should be taken that accent lights are turned off while light meter readings are being taken; they may falsely inflate the reading, leading to underexposure of the key and fill areas. Care also should be taken that accent lights do not accidentally fall directly on the camera lens; this will create lens flare. Baffles can be used to shield the lens from these lights, or a lens shade can be attached to the camera lens.

Steps in Preparing the Lighting Setup

There is no one best approach to preparing the lighting setup. Most photographers advise that the lighting setup be constructed one light at a time, that each light be set up while all other lights are switched off. Not until all the basic lights are set up, then, are they all switched on at once to view the overall effect. Only at this time are the final adjustments made—instruments are moved slightly to modify their brightness or to alter their angle to the subject, or additional lights are added to fill shadows or to obtain special effects.

Most photographers begin this process with the main or key light, then add the fill light, background lights, and accents. (See Figure 10-10.) Experience and practice in the placement and adjustment of these components will lead to proficiency in setting up artificial indoor lighting. The step-by-step procedure outlined below is intended to provide a starting point.

STEP-BY-STEP PROCEDURE FOR MAKING A LIGHTING SETUP

1. *Decide on the general effect.* Think about the general effect to be produced. Is it soft? Hard? Dark? Bright? Settle on the single dominant source. Does it simulate a natural light source, such as sunlight, window light, or firelight? From what direction will it strike the subject? Plan the placement of the key, fill, background, and accent lights, and the instruments that will be used in each location. Place the lighting instruments approximately in these positions.

2. *Place the key light.* Locate the key light to create the dominant set of highlights and shadows. Place it far enough away that it produces an even light, without hot spots. Place the key light so that the highlights and shadows are modeling the subject in the desired way. Adjust its height and position until the desired highlight pattern is obtained.

3. *Add the fill light.* Use the fill light to flood the set with an even, shadowless, diffused field of illumination. Use the camera's viewing screen to be sure that no conflicting shadows are visible. Move the fill light closer to or farther away from the subject to control the brightness ratio. The brightness ratio can be set visually by changing the light position until the desired feeling is produced, or it can be calculated with a light meter.

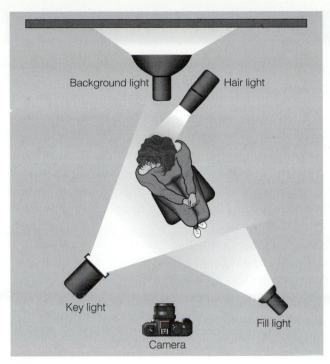

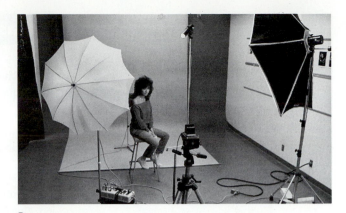

FIGURE 10-10

Typical four-light setup. **A.** *Top view.* **B.** *Frontal view.*

To calculate the lighting ratio, take a closeup meter reading of the subject with both the key and fill lights on. Note this reading. Now take a similar reading with only the fill light on. Adjust the position of the fill light to obtain a 3-to-1 or 4-to-1 brightness ratio between key-plus-fill and fill alone. (This is a 1 1/2- to 2-stop difference.)

4. *Separate the subject from its background.* Do not place the subject too close to its background. Add the background lights. Take care that direct light from these sources does not fall on the subject. Baffles, gels, and diffusion screens are useful for controlling and modifying the background lighting.

5. *Add the accent lights.* When a hair light and/or kickers are added, take care that their light falls only where it is wanted—that is, be careful not to add any secondary highlights or shadows on the subject's face. Flags and snoots are useful for controlling the placement of accent lights.

6. *Make final adjustments.* Examine the subject through the viewfinder with all the lights turned on. Are there unwanted highlights? Shade them off with baffles, flags, or snoots. Are there deep shadow areas that need additional fill? Add reflectors or additional floodlights. Is the subject not fully separated from the background? Add accents and/or background lights. Are the catchlights not properly located? Adjust the key and fill. Pose the subject. Shoot.

Basic Portrait Lighting

Objective 10-E Describe and demonstrate some basic lighting techniques for portrait photography.

Key Concepts broad lighting, short or narrow lighting, butterfly or glamour lighting

To achieve an ideal representation of the subject, the portrait photographer uses several tools—lighting, pose, camera angle, and retouching. One of the more useful and flexible tools is lighting.

Lighting for the portrait follows the same basic principles of lighting discussed previously—a single dominant light source, a dominant set of highlights and shadows, a natural angle of incidence, and the like. But in addition, by placing the key light properly, the photographer can emphasize the attractive features of the subject and subordinate the less attractive features, such as balding, high forehead, a sharp chin, or deep-set eyes. Features can be highlighted or obscured in shadow; round faces can be narrowed, narrow faces rounded, long noses shortened, broad noses narrowed, and so on.

There are three main types of lighting commonly used for portraits, each based on a different placement of the key light to produce a different effect.

Broad Lighting

Assuming that the subject is facing slightly off camera—that is, slightly to one side or the other of the subject-camera axis—the key light fully illuminates the side of the face turned toward the camera. It also illuminates the cheek on the shadowed side of the face. This type of lighting, termed **broad lighting**, tends to wash out skin textures but helps round out thin or narrow faces. To obtain a broad-lighting setup, place the key light to fully light the side of the face facing the camera. About three-fourths of the face will be in key light, whereas one-fourth will be in fill. Figure 10-11 depicts the basic key and fill positions for broad lighting.

Short or Narrow Lighting

When the subject is facing slightly off camera, the key light fully illuminates the side of the face turned away from the camera and produces a triangular highlight on the cheek on the shadowed side of the face. This type of lighting, termed **short** or **narrow lighting**, may be used effectively with average oval or round faces. It tends to narrow the face and emphasizes facial contours and textures more than broad lighting. With this setup, about one-fourth of the face is in key light, whereas the three-fourths facing the camera is in fill. Figure 10-12 depicts the basic key and fill positions for short lighting.

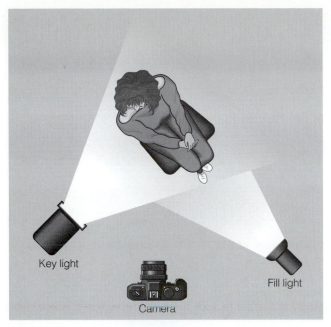

A

FIGURE 10-11

Broad lighting. **A.** *Normal key-light and fill-light placements for broad lighting.* **B.** *Effect of broad lighting.*

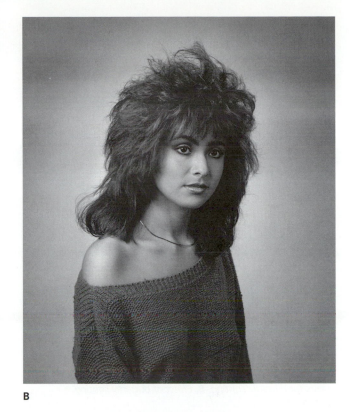

B

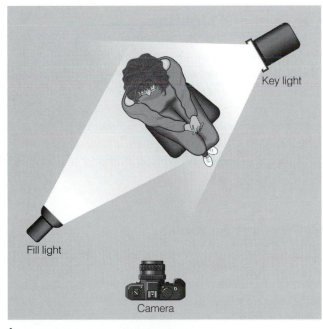

A

FIGURE 10-12

Short lighting. **A.** *Normal key-light and fill-light placements for short lighting.* **B.** *Effect of short lighting.*

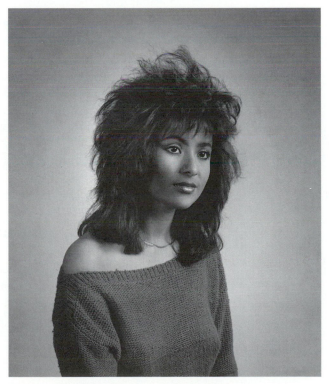

B

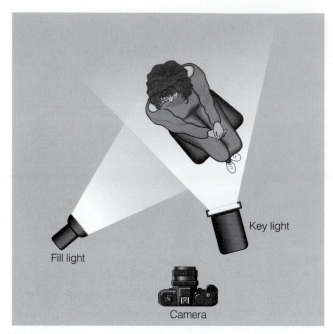

A

FIGURE 10-13

Butterfly (glamour) lighting. ***A.*** *Normal key-light and fill-light placements for butterfly lighting.* ***B.*** *Effect of butterfly lighting.*

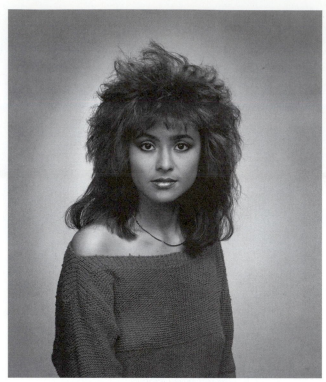

B

Butterfly or Glamour Lighting

In **butterfly** or **glamour lighting**, the key light is placed directly in front of the subject and slightly above the head so that the nose shadow appears directly under the nose and in line with it, forming a shape similar to a butterfly. It may be used successfully with the normal oval face. It is not usually recommended for photographing people with short hair because it tends to highlight the ears, making them undesirably prominent. Figure 10-13 depicts the basic key and fill positions for butterfly lighting.

Enhancing Physical Features

By appropriate arrangements of lighting and poses, certain physical features can be emphasized and others subordinated in portraits. Table 10-2 provides some suggestions for dealing with various physical features of the subject.

TABLE 10-2 Lighting physical features

Features	Lighting
Nose	Avoid profiles if nose uneven. For short noses, shoot from slightly high angle. Raise key light to lengthen nose shadow. For long noses, vice versa.
Eyes	Lower key light to reduce shadows in deep-set eye sockets. For large eyes, lower gaze; for small eyes, lift gaze.
Face	For round faces, use short lighting. Increase brightness ratio. Keep sides of face in shadow. For narrow faces, use broad lighting. Lower key light. Reduce lighting ratio. For bony faces, have subject face camera; use soft, diffuse lighting; avoid shadows and highlights.
Prominent features	Keep lights off prominent features, such as prominent ears, high foreheads, large noses.
Glasses	Use higher key light angle and adjust fill to minimize frame shadows. Rim shadows and hot spots from lenses will need retouching. Consider glassless rims. Tip glasses slightly forward to eliminate reflections.
Wrinkles	Use flat lighting angles and diffuse light to reduce wrinkles; use oblique lighting angles and specular light to emphasize them.
Secondary catchlights	Arrange lights so that one and only one catchlight appears in each eye in the one o'clock or eleven o'clock position. Remove secondary catchlights by spotting print or etching negative.
Body	View stout persons from the side; thin persons more from the front. Have plump persons lean forward to conceal paunchiness. Narrow lighting to slim plump persons; broad lighting to fill out thin ones.

Lighting Small Objects

Objective 10-F Describe and demonstrate some common problems and techniques for lighting small objects in product photography.

Key Concepts shape, surface texture, key backlighting, edge accents, texture accents, transillumination, tenting, spraying, dulling

As with other forms of lighting, small-object lighting usually challenges the photographer to create an arrangement of highlight and shadow that will reveal the characteristic shape, contours, and textures of the object. If a natural lighting effect is desired, the same natural lighting standard that was discussed in "Basic Lighting Principles" can be applied.

However, natural lighting will not always be desired; the photographer may choose to portray the object in some other lighting environment that better expresses his or her interpretation of the object. Whatever kind of lighting effect is desired, it is wise to adhere to these basic principles:

▶ There should be one dominant source light and one dominant set of highlights and shadows.

▶ Shadow detail will usually be illuminated by diffused fill light that is subordinate to the key light.

▶ The brightness ratio will usually not exceed 4 to 1.

▶ The object will usually be separated visually from its background.

▶ The major lighting components are the key, fill, background, and accent lights.

Even though the principles are the same, the approach to lighting objects is generally somewhat different. In object photography, the lighting setup is usually determined primarily by the object's **shape** and **surface texture**. Lighting setups for objects with curved surfaces will differ from those for objects with flat surfaces. Transparent objects, shiny metallic objects, and dull, matte-surfaced objects will each require somewhat different lighting treatments to reveal their surface textures.

Often the photographer will want to go beyond the mere recording of an object's physical characteristics to express its psychological meaning or to elicit an emotional response from the viewer. By selecting or arranging the lighting, the photographer can express unique visual ideas. One approach to lighting small objects is described in the following discussion.

The Key Light

In object photography it is generally useful to establish the key light first. Unlike the human face, an object's most important characteristics are often its shape and texture. One effective placement of the key light that reveals shape and texture is above and behind the subject. This **key backlighting** placement illuminates the top of the object with a brilliant highlight and projects the main shadow of the object toward the viewer. The backlight position tends to reveal surface textures, and the main shadow helps establish the shape of the object.

Although it is usually more flattering to a portrait subject if the key light is a diffused light, a hard, specular light is often used for small objects to emphasize their surface details and textures. This will vary, of course, depending on the surface texture of the object. Matte or coarse surfaces are revealed better by a hard, specular key light; however, a shiny surface may be revealed better by a diffused key light.

The Accent Lights

Two types of accents are often useful in lighting small objects: **edge accents** and **texture accents**.

The edge accents help to separate the various subject planes so that the viewer can perceive the subject's shape better. They also separate the

subject from its background by providing rim lighting around the outside edges of the object. Edge accents are established primarily by means of additional backlights that tend to produce brilliant edge highlights.

Texture accents are intended to reveal the surface irregularities of the object. Sidelighting is generally used for this purpose, either from above or from below the object, so that the light beam "skids" across the surface of the object and across the grain of the texture to be emphasized. Hard, specular light is most useful for this purpose, because it will tend to create a fine pattern of highlights and shadows that the viewer will perceive as texture. Lighting for texture also requires that the fill lighting be a bit weaker than normal so that the texture shadows are not washed out.

When establishing the accent highlights, take care to create no new major shadow patterns. The key light has established a single dominant shadow of the object. Additional accent lights placed at relatively low angles, shooting upward, will avoid producing new and competing shadows of the object.

The Fill Light

As with the accent lights, it is important that the fill light cast no identifiable shadows of its own. Fill light can be provided by a diffuse flood lamp or by a reflector, placed in a frontal position close to the camera-subject axis. The lighting ratio between key and fill areas usually should not exceed 4 to 1. (See "Basic Lighting Principles.")

The Background Light

Background light is directed toward the background rather than toward the object itself. One purpose of background light is to provide a light background against which a dark object can be emphasized. Another purpose is to lighten a background that otherwise might appear too dark in the final print. In setting up lighting for the background, take care that no ambient light from this source is cast onto the object—it might wash out the dominant shadows or create a new set of conflicting highlights. Figure 10-14 demonstrates the effects of one lighting arrangement of key, fill, accent, and background lights for lighting a small object.

Lighting Glass Objects and Shiny Objects

Certain types of objects pose special problems in object photography. Transparent objects, such as glassware, and highly polished, metallic objects require certain special treatments that are worthy of some consideration here.

Glass objects It is usually a good idea to avoid frontal illumination of glass objects. The reflective surface of the glass produces a profusion of distracting reflections from the light sources. One common method of photographing glass objects is to place them against an illuminated

A

B

C

FIGURE 10-14

*Lighting objects. **A.** Key backlighting. Light placed high and behind object to one side. **B.** Edge-light accent. Light placed low and to other side. **C.** Fill lighting. Light placed close to camera, lens high. **D.** Background lighting. Light directed to background only and masked from object itself. **E.** Effect of combined key, fill, accent, and background lights on object.*

D

E

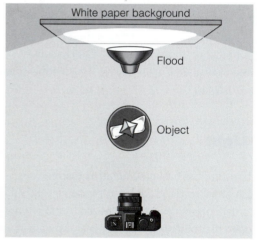

A

B

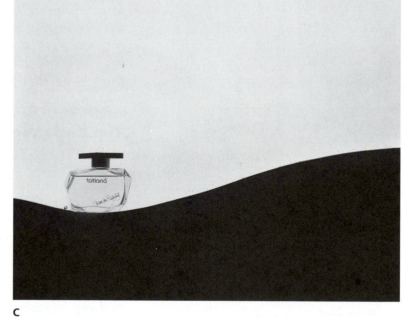

C

FIGURE 10-15

*Background lighting for glass objects. **A.** Frontally illuminated background. **B.** Transilluminated background using translucent screen. **C.** Bottle with liquid photographed against transilluminated background; no other light source used. Base line is simple black paper cutout.*

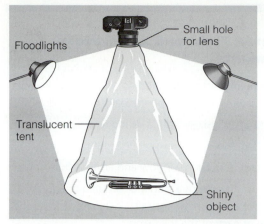

A

B

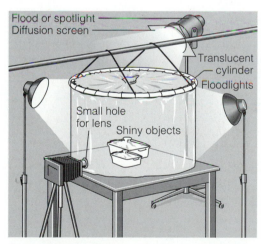

C

D

FIGURE 10-16

Tenting arrangements. **A.** *Photographing objects in tent from above.* **B.** *Result of tenting as shown in A.* **C.** *Photographing objects in tent from the side.* **D.** *Result of tenting shown in C.*

background, such as a white paper background illuminated frontally by a floodlight. Another method is **transillumination**, using a background of translucent material illuminated from behind by a floodlight. Figure 10-15 depicts these placements for photographing glass objects.

To add accents to a glass object, the careful addition of limited frontal lights may be helpful. Because the surface of the glass is highly polished, it produces highly specular reflections of any light sources that are visible from the object's position. By placing one or two light sources in front of the object and by using baffles to shape the light sources, very precise highlights can be produced.

Shiny objects The problem in photographing shiny objects, such as metalware or shiny plastic, is that they are highly reflective and will reflect images of their surroundings. Because most shiny objects have curved surfaces, the patterns of light reflected from them often are confusing and tend to mask the true surface textures of the objects themselves. The trick in photographing shiny objects is to eliminate from the surroundings all other objects that the shiny object might reflect. If the shiny surface of the object is surrounded with only blank surfaces, it can reflect only plain light without details. Under these conditions, the contours and texture of the shiny object will be revealed without confusion.

To accomplish this, a technique known as **tenting** is commonly used. White paper or other translucent material can be used to erect a tent, which then is transilluminated as evenly as possible with diffused light. Then the shiny object is photographed through a hole in the tent, placed above or to the side of the object. Figure 10-16 depicts tenting arrangements and their effects.

Occasionally a shiny object may appear in an arrangement that also includes other objects that may require stronger, more directional lighting treatments. After the lighting setup has been established, the shiny object may pick up many undesirable, specular highlights from the light sources and reflections of other objects in the scene. **Spraying** the shiny object with a matting spray is one way to diffuse the reflections from its surface. Spraying is often the best solution when both matte and shiny objects are in a scene. However, the spray should not be used indiscriminately on all types of objects—it may damage certain plastics. Both permanent and removable dulling sprays are available. The removable type is generally recommended so that it can be removed from the object once shooting is completed.

Other materials can be used to dull or matte shiny surfaces. **Dulling** can be accomplished also by brushing a white cosmetic eyeliner onto the offending surface with a broad, soft brush. This technique is especially useful for dulling small specular highlights from shiny surfaces where a matting spray is too difficult to control.

Questions to Consider

1. What characteristics of light affect the way we see a subject?

2. What characteristics of a subject are revealed by light?

3. What are the differences between specular and diffused light?

4. Describe the principle of the single dominant light source.

5. Explain the functions of main, fill, accent, and background light in photographing any subject.

6. What techniques can be used to obtain good images in dim light without adding artificial light sources?

7. What steps can be taken to control the lighting of a subject when shooting under unmodified, available light?

8. What is meant by the brightness ratio? Explain how to establish a recommended brightness ratio.

9. What is the purpose of each of these artificial lighting tools: floodlights, spotlights, reflectors, baffles and flags, diffusion and pattern screens, gels, light standards, and booms?

10. What is the purpose of each of these light sources in an artificial lighting setup: key light, fill light, background light, accent lights?

11. What steps are recommended for preparing a basic four-light artificial lighting setup?

12. Describe the characteristics of each of these types of portrait lighting: broad lighting, short lighting, butterfly lighting.

13. Name some techniques that might be used to subdue these facial features: round face, narrow face, bony face, deep-set eyes, multiple catchlights, wrinkles, prominent ears.

14. Describe how to plan the lighting arrangement for photographing a small object.

15. What are the problems often encountered in photographing transparent and shiny objects, and how may they be solved?

Suggested Field and Laboratory Assignments

1. Shoot a number of interior photographs under available light. Include several examples of each of the following:

 a. lighting exclusively from a window

 b. lighting exclusively from artificial light sources

 c. lighting from both window and artificial light sources

2. Arrange for the use of a studio or set up a temporary one. Shoot a number of portraits, including at least one example of each of the following:

 a. broad lighting

 b. short lighting

 c. butterfly lighting

 d. a portrait using key, fill, background, and accent lights

3. Set up lighting and shoot a number of objects. Include at least one example of each of the following:

 a. round object

 b. rectangular object

 c. glass object

 d. shiny object

 e. matte object

 f. a transparent, a shiny, and a matte object in a single arrangement

Unit **Eleven**

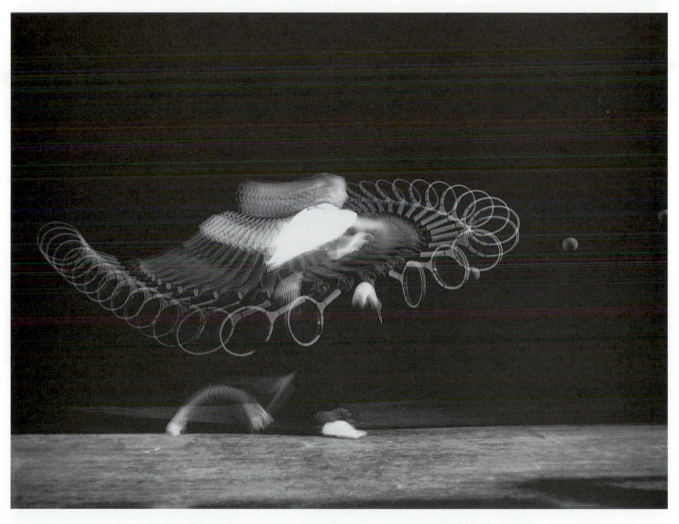

Dr. Harold E. Edgerton, "Jennie Turkey Forehand Drive Multiflash," 1949.

Great photographic subjects are not always accompanied by optimum—or even adequate—lighting conditions. Artificial light is sometimes necessary, and electronic flash is a convenient source. Flash photography allows light to be added for photographs at night or in darkened rooms. Flash also can be used to control the contrast and appearance of pictures taken in sunlight. Flash light is dependable and intense; it can be manipulated to produce the effect of natural lighting, or it can provide stroboscopic, multiple flash exposures.

This unit covers various types of flash, how electronic flash works, the differences among dedicated, automatic, and manual flash units, and special features found on flash units. In addition, synchronization, flash accessories, exposure setting with flash, common flash problems, and a variety of special flash lighting techniques are explained.

Principles of Flash Photography

Objective 11-A Describe the equipment used in flash photography and the principles and functions that apply to its use.

Key Concepts flash unit, combustible flash, electronic flash, recycling time, light output, BCPS, manual flash, automatic flash, dedicated flash, hot shoe, PC-socket, synch cord, thyristor circuit, angle of illumination, zoom head, swivel head, bounce flash, through-the-lens (TTL), handle mount, bare bulb, synchronization, X-synch, M-synch, FP-synch, bounce card, extension cord, wireless radio slaves, slave sensor, light stand, reflector, umbrella, snoot, filters, gels, external battery packs

Probably the most practical and widely used artificial light source available to photographers today is the portable **flash unit.** These units are simple to use, safe, and reliable, and attach easily to a camera. They are designed to provide a measured burst of intense light timed to the exact instant that the camera's shutter opens and closes.

Two methods for producing the flash are in use today. **Combustible flash,** now used primarily with simple, less expensive cameras, operates by igniting and burning a thin metallic filament within an oxygen-filled bulb. Although combustible flash units such as flashbulbs, flashcubes, and flash bars are still available, they are rapidly being replaced by electronic units and falling into general disuse. **Electronic flash,** now used extensively with all cameras, operates by passing a pulse of electricity through a gas-filled tube, causing a burst of intense illumination.

Electronic Flash

More than one hundred years ago, English photography pioneer William Henry Fox Talbot discovered that a high-speed electrical spark could be used as a photographic light source. The spark was so brief and so intense that it had the effect of stopping the action of rapidly moving objects. It was not until the 1930s, however, that this principle was developed into a practical system suitable for photography.

How electronic flash units work A modern electronic flash unit consists of (1) a power supply for the electric energy, usually a battery or a household AC circuit; (2) a set of capacitors that store the electric energy to a high potential; (3) a triggering circuit to release the stored electric energy; (4) a glass tube filled with inert gas, usually xenon, to convert the electric energy to light; and (5) a reflector. Because the light-producing gas in the tube is chemically inert, it is not burned or consumed during the flash. Therefore, the unit is reusable and can be fired thousands of times before it must be replaced. The batteries that power these units are designed for rapid recovery and long life and sometimes may be recharge-able, allowing them to be reused, often indefinitely. The light produced by these units is approximately 5500 K, the color temperature of sunny, noontime daylight, and is extremely bright. It is also of extremely short duration, making its flashes easier on the subject's eyes.

After each firing, the flash cannot be fired again until its capacitors rebuild their electric charge. The time that it takes a unit to recharge its capacitors is known as its **recycling time;** this varies considerably among units. The most popular units are designed to recycle from a completely discharged state in 2 to 6 seconds. Most units also are equipped with an indicator light to let the photographer know when the unit has completed its recycling and is ready to fire again. A useful feature of some units is an adjustment permitting the unit to operate at reduced power, providing an additional control over the amount of light generated at each firing and the recycling time required. The **light output** of electronic flash units is rated in terms of **BCPS** (beam candle-power seconds).

The three major types of electronic flash are manual, automatic, and dedicated units. With **manual flash** the photographer determines the exposure and sets the camera's aperture by hand. With **automatic flash** the photographer presets the film speed and an aperture, and the unit determines the exposure automatically by adjusting the flash output based on light detected by a built-in sensor. With **dedicated flash,** an automatic flash unit and camera designed into an integrated system, the film speed is preset and the system determines and sets a proper flash exposure auto-matically. This procedure is detailed in Objective 11-B, "Determining Flash Exposure Settings."

Contacts and Cords

Unless electronic flash is built into the camera, most cameras provide one or more devices for mounting and connecting a flash unit. One device in com-mon use is the **hot shoe,** a built-in mounting bracket that electronically

FIGURE 11-1

A PC-type flash unit connector.

FIGURE 11-2

Non-dedicated hot shoe contact.

FIGURE 11-3

Dedicated hot shoe and flash unit connections. Note that multiple pins allow camera and flash unit to exchange exposure data.

connects a properly designed unit to the shutter. The flash and shutter are directly connected through the hot shoe's electrical contacts, eliminating the need for any kind of connecting cord between the two.

The main drawback of the hot-shoe connector is that it attaches the flash unit to the camera and reduces the photographer's ability to vary lighting positions. To overcome this drawback, most cameras also possess a small **PC-socket** for connecting the camera to a flash unit by means of a flash **synch cord.** With a long cord, the flash unit can be positioned at a distance from the camera. The same effect can be achieved by using a hot-shoe extension that allows a flash extension cord to be attached directly to the camera's hot shoe. Figures 11-1 through 11-3 show these connectors.

Special Features

Some flash units incorporate additional useful features.

Thyristor circuit Some automatic strobe units completely discharge their capacitors even when the flash output is very low; others employ a **thyristor circuit,** to preserve the energy in the capacitors following the flash discharge and use it during the recharging cycle. The effect of the thyristor circuit design is to conserve energy and to shorten recycling time. At shorter distances, flash durations often will be as brief as 1/50,000 sec., less energy will be spent from the capacitors, and less time will be required to recycle the capacitors to full charge.

Angle adjustments Most flash units are designed with the light source and the reflector in fixed positions. This arrangement provides flash coverage within a fixed **angle of illumination.** The angle of illumination is usually designed to correspond to a normal lens's angle of view. With a wide-angle, telephoto, or zoom lens in use, however, the flash unit's normal angle of illumination often will not match the lens's angle of view and will result in uneven illumination. To overcome this discrepancy, some flash units are designed with wide-angle and telephoto adjustments. A few units feature a **zoom head,** which can be set to produce a wide, normal, or narrow angle of illumination to match the lens in use. Other flash units can be outfitted with wide-angle attachments to widen the spread of the light, or telephoto accessories to narrow it.

Swivel heads Many electronic flash units have a **swivel head** so that the flash unit may be attached to the camera but directed away from the subject. One common way to use the swivel head is to tilt it toward the ceiling or wall so that the flash is bounced off the ceiling toward the subject. This technique is called **bounce flash** and provides a soft key light effect as well as diffused fill light to produce a more natural appearance.

Camera-mounted sensors Some electronic flash units feature removable flash sensors. Mounting the sensor eye on the camera rather than on the flash assures that it always will be pointed at the subject regardless of the flash position. This system makes it possible, for example, to aim and bounce the flash light off a wall behind the photographer

FIGURE 11-4

Shoe-mount type of electronic flash mounts directly to camera body. Available in dedicated and non-dedicated models. Some have swivel heads for bounce flash work.

FIGURE 11-5

Example of handle-mount flash unit. Handle mounts generally feature greater capacity for more light and/or quicker recycling times than most shoe-mount flash units. Handle mounts are also available in dedicated versions.

while the exposure-determining sensor remains aimed at the subject. Some advanced cameras have built-in flash sensors that measure the flash output **through the lens**. TTL sensors of this type give proper flash exposure regardless of where the flash unit is held or aimed.

Handle mounts Some electronic flash units are designed with an integrated *handle mount* and camera bracket for quick detachment of the unit for off-camera use. The oversize handles of these units often hold additional batteries to increase power and decrease recycling time.

Detachable reflectors Some flash units have detachable reflectors. If the reflector is detached, light from the unit will travel in all directions. The direct rays from the unit will serve as a key light. The rest of the light from the unit will bounce around among the flat surfaces of the environment and provide a soft, even field of diffused light that serves to fill the shadowed areas. This technique is known as **bare-bulb flash** and is generally available only with advanced electronic flash units and those that employ flashbulbs.

Manual override of automatic flash units Most automatic flash units provide an option for setting flash exposures manually. Setting a unit to manual usually disables the flash sensing eye so that the full flash duration is always produced. Exposure settings are then determined by the photographer with the aid of a calculator dial mounted on the flash unit. Manual operation is often necessary when shooting at long flash-to-subject distances. This is an important feature if the photographer wants to retain full control over exposures under unusual lighting conditions or to obtain special lighting effects.

Synchronization

The method of timing the flash to coincide properly with the shutter is called **synchronization.** To assure correct synchronization, the flash unit and the camera must be set to properly coordinate the timing of the shutter and the flash unit's output. Older cameras, and some professional models, often have a variety of flash synchronization settings or offer a choice of more than one PC terminal for flash connection, such as **X-synch, M-synch,** and **FP-synch.** These options differ with respect to the timing of the flash ignition relative to the triggering of the shutter.

M- and FP-synchronization M-synch and FP-synch settings are used exclusively with flash bulbs—never with electronic flash. These settings fire the combustible mixture in the flash bulb a few milliseconds *before* the shutter opens so that the light output from the bulb will be at its peak when the picture is made. The type of shutter and the flash bulb used determine whether an M or FP setting should be selected. M and FP settings are rarely found on contemporary cameras, which are generally designed to work solely with electronic flash units.

X-synchronization An electronic flash unit emits a burst of intense light instantly at ignition. *X-synchronization,* therefore, dispenses with the

FIGURE 11-6

The highest recommended shutter speed for flash synchronization is usually indicated by "X" or other colored marking on the shutter speed dial of focal plane shutter-type cameras.

FIGURE 11-7

The result of incorrect flash synchronization. Only a portion of the photograph will receive the flash exposure if the shutter speed used is too fast.

lead time of M- and FP-synch settings and fires the flash a few milliseconds *after* the shutter is released so that the shutter will be fully open when the flash occurs. X-synchronization should *always* be used with electronic flash units; in fact, electronic flash has become so popular that most modern cameras offer only X-synch. If only one flash synchronization is provided and the camera is less than ten years old, it is intended to be used with electronic flash.

X-synchronization and focal plane shutters A proper setting for electronic flash requires both X-synch and correct shutter speed. Most 35-mm SLR cameras use a *focal plane shutter,* described in Unit 2, which will not synchronize correctly beyond a given shutter speed. The fastest shutter speed allowable for correct flash synchronization is usually indicated by a colored marking on the shutter speed dial. (See Figure 11-6.)

A maximum X-synch shutter speed of 1/60 sec. is common for most SLR cameras, but some advanced focal plane shutters will X-synch at 1/125 sec. or even 1/250 sec. The camera's manual will specify the fastest allowable X-synch shutter speed.

If the shutter is set at a faster shutter speed than is allowable with electronic flash, the focal plane shutter will not be open to the full width of the frame when the flash occurs, and only part of the frame will receive the flash exposure. (See Figure 11-7.)

Using a relatively slow 1/60 sec. shutter will have little effect on stopping action with electronic flash exposure. It is not the shutter speed that stops the action in this case; rather, it is the burst of flash light that usually lasts less than 1/1000 sec. In the relatively dim environments that require flash, the flash duration alone stops the action.

X-synchronization and between-the-lens shutters A *between-the-lens or leaf shutter,* described in Unit 2, permits any shutter speed to be used with X-synchronization. Large- and medium-format cameras often are equipped with between-the-lens shutters and can synchronize electronic flash pictures even at their fastest shutter speeds—usually 1/500 sec. This is because leaf shutters open fully at all shutter speeds. The availability of the full range of shutter speeds makes it easy to use fill-in flash; however, it has little effect on stopping action, which, as we have seen, is achieved by flash duration rather than by shutter speed.

Flash Accessories

A variety of accessories are available to fit electronic flash units. Some accessories, such as extension cords, slaves, and bounce cards, give the photographer more control over the lighting effect. Other items, such as radio control units and external power packs, offer greater convenience for the working photographer.

Bounce cards **Bounce flash** is often used instead of direct flash to create a softer, more natural light. For bounce flash, described fully on pages 339–341, the flash is pointed toward the ceiling, where it is diffused and reflected back toward the subject. Not all ceilings make suitable reflectors, however; some may be too high, painted the wrong color, or not

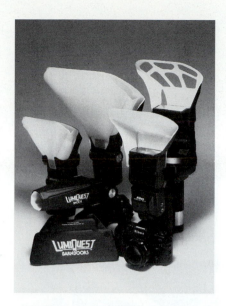

FIGURE 11-8

Various types of commercial bounce cards for shoe-mount and handle-mount flash units.

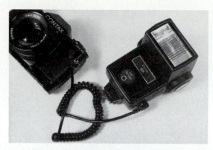

A B

FIGURE 11-9

A. PC extension cord. B. Dedicated hot-shoe extension cord.

sufficiently reflective for small, low-powered flash units. Instead of a ceiling, the photographer may prefer to use a **bounce card**—a reflector, placed over the upward-pointing flash unit—that acts as a substitute ceiling, reflecting and diffusing the light.

Although commercial bounce cards are available, some photographers prefer to make their own from small sheets of stiff white paper or board. Sizes may vary—larger cards capture more light but are harder to carry. Photographers usually select one that will fit conveniently into their gadget bag. To make a bounce card, cut the card into a tapered rectangle that can be attached to the flash head with tape or a rubber band. Then score the card where it meets the top of the flash so that it can be bent to form any angle. (See Figure 11-8.)

Extension cords A flash mounted to the camera is convenient, but the light it produces is not inspiring. Direct flash tends to eliminate distinguishing highlights and shadows and produces a very flat rendering of space and depth. Flash-on-camera also produces a shadow directly behind figures, making them appear like cardboard cut-outs. **Extension cords** allow the flash to be removed from the camera and placed elsewhere to improve modeling and texture or to produce other dimensional effects. Most extension cords are simply long PC synch cords that can be obtained at low cost. For cameras with dedicated flash, however, special dedicated hot-shoe extension cords are required. (See Figure 11-9.)

Wireless radio slaves **Wireless radio slaves** use radio waves to create the ultimate synch cord. The camera's synch cord is connected to a small transmitter, similar to a garage door opener, and a small radio receiver is attached to the flash unit. The flash unit, as well as additional flash heads, may be placed wherever they are needed—in the ceiling above a basketball gymnasium, for example. The photographer is then free to roam without the bother of cumbersome connecting synch cords. When the camera's shutter is released, the transmitter sends a radio signal to trigger the strobes. (See Figure 11-10.)

Flash slaves Like the radio transmitter, a **slave sensor** also can trigger a flash to fire without connecting wires. A slave sensor, however, responds to light rather than to radio waves. A slave sensor is simply a photoreceptive cell that connects to flash unit's synch cord. Light from another

FIGURE 11-10

A. Camera equipped with radio slave transmitter to signal remote flash unit. **B.** Electronic flash power pack equipped with a radio slave receiver to trigger flash upon receiving signal from radio flash transmitter located at camera position.

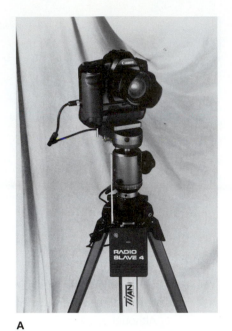

A

B

flash, perhaps one mounted on a detached camera, triggers the slave to fire the secondary flash. Through this arrangement, two lights can be set up to provide a main frontal light and a side-mounted fill light, which are easily triggered simultaneously without connecting wires. Any number of slaves can be fired from a single main strobe; multiple lights over very large areas are possible.

Slave sensors are relatively inexpensive and are no larger than a 35-mm film canister. Many provide an integrated bracket for mounting the supplemental flash units on tripods or light stands. Some small, inexpensive flash units are even designed with built-in slave cells. These may be battery-powered for use anywhere; others are AC-powered. Some are designed with a screw-in lamp base for use in any convenient lamp fixture to simulate existing room light.

Light stands and reflectors Taking the flash unit off the camera allows the photographer to control the light and shadow effects that give shape and form to subjects. Fine-tuning the lighting effect requires careful light placement. **Light stands** are designed to hold a flash unit in the right place at the right angle. An ideal light stand should be small enough to fit into a gadget bag, yet extendable to great heights; it should weigh little, but be strong enough to support a flash unit and umbrella. Although all of these features may not be found in one light stand, they should guide the photographer in considering which model to purchase.

The quality of illumination from a flash can be varied through the use of **reflectors**. For example, a broader and more flattering portrait light may be obtained by bouncing the flash off an **umbrella-style** reflector. Similarly, a tubular shaped **snoot** may be used with the flash to spotlight certain features or accent certain objects. A variety of reflectors and panels may be purchased, or they may be fabricated from common household materials such as aluminum foil and sheets of matte board.

Filters and gels Colored **filter** sheets, sometimes called **gels**, may be placed over a flash unit to produce special effects. A red gel, for example, might be used on a flash to obtain a special effect in a portrait. Coloring the subject red would produce an unreal effect and perhaps add a dramatic quality. Sometimes fill-in flash is filtered in this way for special effects or to enhance separation. When fill-in flash is filtered, the foreground subject receives colored light from the flash, whereas the background retains normal coloration from the sunlight. Thus, color may be used to create a dramatic separation between the subject and the background.

Flash gels in many photographic colors are available for purchase, but any colored, transparent acetate or plastic sheet, such as a transparent report cover, also can be used. When gels are used with nonautomatic flash units, exposure must be adjusted to compensate for the reduced light. In general, yellow gels require one stop greater aperture; red, green, or blue filters require two stops. Bracketing exposures is recommended.

One additional gel technique deserves special mention: filtering the flash light to match the color temperature of the available light. Photojournalists and industrial photographers who shoot in warehouses, schools, offices, stores and other areas under fluorescent lighting have developed a special technique for this purpose. They place a green gel (about a CC 30 Green) over the strobe so that the flash light will match the color of the fluorescent light. A complementary magenta filter (CC 30 M or FLD) is mounted on the camera lens to rectify the color balance. In this way, strobe can be used as fill or kicker illumination, and it will balance with the fluorescent lights. The technique is often adapted to match the color temperature of other light sources by varying the camera and flash filters used.

External power packs The batteries in portable flash units often are not large enough to power an extended shoot and still give acceptably short recycle times. For this reason, some professionals choose to connect their flash units to large **external battery packs** that permit extended use. These high-capacity battery packs are connected to the flash unit by an accessory power cord, but the pack itself is typically worn on the photographer's belt or hung from a carrying strap. The packs often contain rechargeable batteries that can provide as many as 2,000 flashes with 1 to 4 sec. recycle times before needing recharge. See Figure 11-11 for an example.

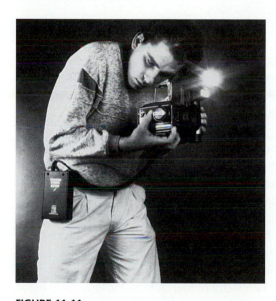

FIGURE 11-11

Most flash units can be fitted with an external battery pack. Such devices provide shorter recycling times and more flashes per charge than conventional batteries.

Determining Flash Exposure Settings

Objective 11-B Given shooting conditions, determine appropriate flash exposure settings for manual, automatic, and dedicated cameras.

Key Concepts flash-to-subject distance, inverse square law, reflectance, automatic electronic flash, sufficient light indicator, dedicated electronic flash, manual flash, flash meter, guide number

Variables Affecting Exposure with Flash

The intensity of light reflected from the subject and its duration determine exposure. Unless special flash metering equipment is used, the intensity of the flash cannot be measured, and the amount of light that will be reflected from the subject must be estimated. The variables that will affect the exposure settings are flash output, film speed, flash-to-subject distance, environmental reflectance, and type of reflector.

Flash unit output A major but relatively constant factor that affects exposure is the flash output. Various electronic flash units produce different intensities of light. The output of the flash unit will affect the amount of light reflected from the subject and, consequently, the amount of exposure needed. However, since the flash unit is seldom changed, that factor will remain relatively constant once it is determined.

The light output of the flash, as measured by the manufacturer, usually does not accurately reflect the actual output experienced in the field. Flash output under actual working conditions is often one-half to one stop less than the manufacturer's specifications.

Film speed Of course, the speed of the film will affect exposure. Faster film will require less exposure than slower film, and vice versa, for any given intensity of illumination. As with the flash unit itself, however, the film is not likely to change once the roll is in the camera, and so that factor will remain relatively constant during a shooting session.

Flash-to-subject distance The main variable factor in determining flash exposure is the **flash-to-subject distance**, which may change considerably from shot to shot and affect exposure profoundly.

The **inverse square law**, discussed in Unit 10, "Basic Lighting," states that the amount of light falling on a subject varies inversely as the square of the distance between the light source and the subject. This means that as the flash-to-subject distance is doubled—from eleven to twenty-two feet, for example—the intensity of light falling on the subject from the same flash unit is reduced by a factor of four. A two-stop increase in exposure would be needed to compensate. Moving the flash closer to the subject—from eleven to eight feet, for example—would double the intensity of light falling on the subject, and so require a corresponding one-stop reduction in exposure.

Environmental reflectance The **reflectance** of objects and surfaces in the surrounding environment also affects the amount of illumination reflected from the scene to the camera. A room with glossy, white walls and ceiling will reflect more of the light from the flash unit onto the subject and back to the camera than will a room with flat, dark-colored walls and ceiling. Shiny, light objects also will reflect more light back to the camera than will dull, dark objects. As the camera is moved from one location to another, the surface textures and coloration of the space will affect exposure profoundly.

Method 1: Automatic Calculation

Three basic methods may be used to determine flash exposure: automatic calculation, flash metering, and manual calculation; we will discuss automatic calculation first. Note that the camera's conventional light meter is *not* used to determine the camera settings for flash photographs.

In general, two types of units provide for automatic calculation of flash exposure: (1) automatic electronic flash designed for use with any adjustable camera, and (2) dedicated electronic flash designed for use with a particular adjustable camera.

Automatic electronic flash units have built-in automatic controls that determine the amount of light that is produced to make the flash exposure. To ready a camera for this type of flash unit, first set the camera's shutter speed to one of the speeds allowable for X-synchronization. Next, set the flash unit's calculator to the ISO/ASA speed in use. Finally, reading from the calculator, set the camera's aperture to that recommended for the desired automatic operating range. The flash unit will then control exposure by controlling light output.

A built-in sensor, similar to the photosensitive cell in a light meter, measures the light reflected from the subject. When the unit's integrated computer determines that the light is sufficient for proper exposure, it triggers a quenching circuit to terminate the flash. Once they are set, the exposure controls need not be reset as the camera is moved closer to the subject or farther away as long as the shot is made from within the limits of the selected operating range. The quenching circuit adjusts exposure automatically. On more powerful units the user has a choice of several different color-coded ranges that cover situations from close-ups to long distances.

Many automatic electronic flash units have a built-in **sufficient light indicator** that signals if the flash exposure was adequate. The flash exposure can be checked before a picture is taken by pressing the unit's open flash or test button and then reading the sufficient light indicator.

Dedicated flash units A **dedicated electronic flash** is linked electronically through its hot shoe to the camera for which it is designed. The flash is automatically coupled with the camera, and the system then responds by adjusting exposure for flash pictures. Dedicated flash units vary considerably with the type of camera and the design of the unit. Some automatically choose the proper shutter speed and lens opening for flash; others even adjust the angle of illumination to match the lens in use.

Highly automated cameras adjust most of the initial settings automatically when the dedicated flash unit is connected to the hot shoe. Less sophisticated cameras may require the photographer to manually set both the camera and flash unit for automatic operation and for the ISO/ASA film speed in use. Most units usually must be set for the desired operating range as well. Once these initial settings are established, these units will then set the shutter to the speed required for electronic flash and the aperture to the setting that is appropriate for the selected range. As with other automatic units, the flash usually controls its light output to provide proper exposure. Some units, however, may provide a constant light output and adjust the camera aperture instead as the camera is focused on nearer or farther objects.

FIGURE 11-12

An automatic flash calculator dial. Various maximum distance ranges can be selected by a color-coded dial. When the camera is set at the corresponding lens opening, the flash will automatically vary its light output for proper exposure.

FIGURE 11-13

Dedicated hot-shoe contact.

TTL dedicated flash Some dedicated flash units use sensors within the camera to measure the flash intensity *through-the-lens (TTL)*. With computerized control, these units analyze the amount of light that enters the camera and quench the flash when sufficient light has been received. With great accuracy, these units assure proper exposure no matter what lens is used or what direction the flash is pointed. A TTL dedicated flash also automates otherwise complex fill-in flash operations. When used for fill-in flash, the camera and flash simultaneously set the shutter speed, lens opening, and flash output to provide a balanced correct exposure for the subject and the background. Without the integrated performance of a dedicated flash system, fill-in flash tends to be an intimidating, complicated operation.

If the hot-shoe connector of a dedicated flash unit is examined, additional pins that correspond to contacts on the camera's hot shoe can be seen. These additional connections form the electronic linkage through which the unit manipulates the camera's exposure controls. Although a dedicated electronic flash unit can be used in a manual mode at full output with any adjustable camera, it will operate automatically only when used with its dedicated camera.

Automatic flash exposure problems Automatic flash is not without its drawbacks. Very light or very dark backgrounds can fool the unit into under- or overexposing the subject. To avoid these effects, analyze the scene beforehand to determine whether conditions warrant an adjustment. With automatic flash, the aperture can then be adjusted to provide more or less exposure than the calculator indicates. With any form of automatic flash, however, precise and correct exposure can be obtained by switching over to manual operation and calculating a proper exposure. (See Figure 11-14.)

Method 2: Flash Metering

The second method for determining flash exposure is flash metering. Because a normal light meter cannot usefully measure the brief, intense flash of light from a flash unit, a specially designed **flash meter** must be used instead. Flash meters are designed to integrate both the intensity of the light and its duration so as to record the total light energy that will be available to the film. The meter is normally held at the subject with its light-receptive dome facing the camera. The flash is then triggered and a measurement is made. Following the flash, the meter displays the correct exposure as a recommended aperture setting. The camera lens is then generally set to this recommended aperture.

Flash meters are available in several designs. Most can serve as conventional light meters in addition to providing their flash function. Some read incident light, some reflected light, and some the light at the film plane. The more advanced flash meters can be used several ways and may also feature spot attachments.

FIGURE 11-14

*Subject failure. **A.** When presented with a predominantly light-colored subject, most automatic flash units tend to underexpose the scene. **B.** To achieve a correct tonal rendering, open up the camera's lens by 1 to 2 stops and bracket exposures. **C.** The opposite exposure will occur with predominantly dark-colored subjects. Here the automatic flash overexposed the scene. **D.** To correct this error, close down the lens 1 to 2 stops and bracket exposures.*

A

B

C

D

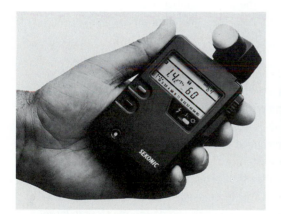

A

FIGURE 11-15

*Flash metering. **A.** Flash meter reads out proper f/stop in response to test flash. **B.** Incident flash meter directed toward camera from subject position and flash test-fired.*

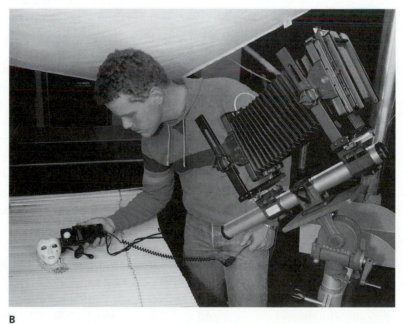

B

FIGURE 11-16

Calculator dial of a manual flash unit. Manual flash units require changes to the lens opening whenever the flash to subject distance changes. For example, with this flash unit set for ISO/ASA 160 film, a photograph taken at ten feet would require a lens aperture of f/8. If the photographer backed up to a distance of twenty feet, the aperture would need to be reset to f/4.

Method 3: Manual Calculation

The third means of determining flash exposure is through manual calculation. For either combustible flash or manual electronic flash, exposure must be determined by metering or by manual calculation, and the camera must be set by hand. The more advanced automatic and dedicated electronic flash units usually also can be set for manual operation by disabling their automatic features. This is desirable because in some situations the exposures determined automatically will not produce the effect the photographer wants. By selecting manual operation, the photographer gains greater control over the flash exposure and the resulting image.

One way to manually calculate flash exposure is to use a flash exposure calculator. Most **manual electronic flash** units have a built-in calculator dial into which is entered (1) the desired flash output, (2) the ISO/ASA film speed, and (3) the flash-to-subject distance. Similar calculators are also published in photographic data books. The calculator indicates an appropriate exposure in an environment of average reflectance. (See Figure 11-16.)

Another method for determining flash exposure involves the use of **guide numbers**. The guide numbers for a flash unit are usually given in the flash unit's manual; they take into account the film speed and the flash output. Guide number tables are also packaged with many films. Table 11-1 shows some typical guide numbers for electronic flash for a film rated ISO/ASA 125. Electronic flash output is rated in beam candle-power seconds (BCPS).

The guide number corresponding to the flash unit and film speed is used to calculate an appropriate aperture setting for a given shutter speed and flash-to-subject distance. After the guide number for the film and shutter speed is determined, the guide number is divided by the distance (in feet) to obtain a proper f/stop. The general formula is:

guide number / distance = f/stop

For example, if your guide number were 56 and the flash-to-subject distance were 10 feet, then a proper f/stop would be 56/10 = 5.6. If the quotient is not a full f/stop, then the aperture is set to the nearest f/stop.

Both flash calculator dials and guide numbers are intended as aids. The recommended settings may need to be adjusted to suit specific conditions. If the final pictures are consistently overexposed, a film speed higher than the film's rated ISO/ASA index should be consistently used; if underexposed, a lower film speed should be used. In small rooms with light-colored walls, the aperture should be stopped down one stop; in large, dark rooms, opened up one stop.

TABLE 11-1 Typical guide numbers for electronic flash for ISO/ASA 125

Output of Unit in BCPS:	350	500	700	1000	1400	2000	2800	4000	5600	8000
Guide Number:	45	55	65	80	95	110	130	160	190	220

Flash Techniques

Objective 11-C Explain and demonstrate several techniques for using flash for lighting a subject, and explain their purposes.

Key Concepts flash-on-camera, red-eye, bounce flash, bounce card, flash-off-camera, reflector card, kicker, open flash, painting with light, stroboscopic, fill-in flash, synchro-sunlight flash, lighting ratio, flash and slash, extension flash

The general principles of photographic lighting discussed in Unit 10 also apply to flash photography. The principle of the single dominant light source applies as well as the principle of filling in the shadows with some form of diffuse lighting to record shadow details. Accents to rim the edges of the subject, to help reveal its shape and contour, and to separate it from the background are also desirable, as is background lighting.

To achieve these with flash may be a bit more difficult only because the effects of lighting placement cannot always be observed in advance. For that reason, practice and experience with floodlights and spotlights provide invaluable knowledge when it comes to anticipating the effects that will result.

Most flash photography is carried out with a single flash unit. Let us first consider some of the techniques for using a single flash unit to provide the key, fill, background, and accent lighting that we consider desirable.

Flash-On-Camera

In most situations a single flash unit mounted on the camera close to the camera-subject axis will be the simplest, most straightforward approach. (See Figure 11-17.)

This **flash-on-camera** technique is convenient and adequate for many subjects. With flash-on-camera, the flash-to-subject distance is the same as the camera-to-subject distance and can usually be read directly off the camera's focusing scale. This is convenient if a manual flash unit is being used.

Flash-on-camera has several disadvantages, however. As a key-lighting position, it produces a flat, frontal illumination, devoid of the shadows needed for modeling and texture. It tends also to produce bounceback reflections from shiny walls and objects, and, if the subject is close to the background, it may also produce an unsightly shadow just behind the subject. With color film, flash-on-camera sometimes produces an undesirable effect called **red-eye**, in which luminous red spots appear in the center of a subject's eyes.

Bounce Flash

If flash unit has a swivel head or can be removed from the camera and aimed upward, some of the hazards of flash-on-camera can be avoided by tipping the flash head toward a wall or ceiling and bouncing the light

FIGURE 11-17
Electronic flash-on-camera.

toward the subject. This method is called **bounce flash**, and it provides a soft key-light effect. Some of the light also bounces among other room surfaces before it reaches the subject. This light travels farther and is diffused even more, thus providing fill light from many other directions from a single flash unit mounted on the camera. In very large rooms with high ceilings, in open areas, or in places where the color of the walls or ceiling may adversely affect the image, a similar effect may be obtained by bouncing the flash off **a bounce card**.

Bounce flash with automatic and dedicated flash Bouncing with an automatic or dedicated flash unit will provide proper exposure as long as the sensor is directed at the subject. If the flash has a swivel head, a detachable eye, or uses TTL metering, the flash is simply directed toward a suitable ceiling or wall, whereas the sensor is directed toward the subject. For units that offer a choice of distance ranges, a range greater than the total distance the bounced light will travel should be selected. Preliminary test flashes are recommended for units equipped with a sufficient light indicator.

If a flash unit is not provided with a swivel head or removable sensor, it must be used in a manual mode rather than automatic mode.

Bounce exposure with manual flash To calculate correct bounce flash exposure with a manual flash unit, figure the flash-to-subject distance as the total distance the key light travels from the flash to the reflecting surface and then to the subject. This distance may be used with the guide number or calculator dial in the usual way. The indicated aperture should then be opened one or two stops to compensate for the additional absorption and diffusion. Further increases should be made for dark or highly textured walls and ceilings, and larger rooms. Bracketing exposures is recommended because the reflectance of ceilings and walls cannot be accurately predicted. Bounce exposure may be determined more accurately with a flash meter.

Wall bounce Wall bounce is accomplished in exactly the same manner as ceiling bounce, except that the flash is directed at a wall rather than at a ceiling. The principles are the same, and the technique is used for similar purposes. Wall bounce is used to provide soft side lighting; it might be used, for example, to simulate window lighting in a portrait. Again, care should be taken to compensate for nonreflecting or colored walls and ceilings.

Wall bounce with automatic flash can be accomplished only if the flash sensor can be directed at the subject while the flash is directed at the wall. Flash units that lack this feature must be set for manual operation and used accordingly.

Wall bounce with manual flash is accomplished through the same procedures as ceiling bounce flash. The flash is directed toward the wall and the aperture is calculated by guide number or calculator dial, using the total light path distance as the flash-to-subject distance. Again, because walls are not perfect reflectors, the aperture should be opened one or two stops to compensate for lost light. Bracketing exposures is recommended for success.

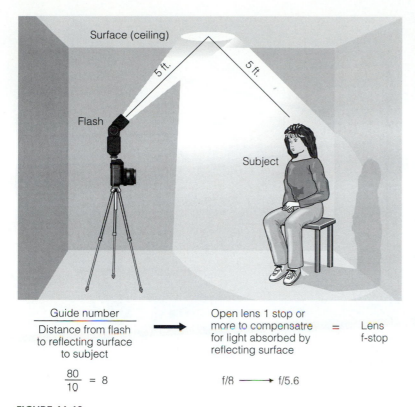

$$\frac{\text{Guide number}}{\substack{\text{Distance from flash} \\ \text{to reflecting surface} \\ \text{to subject}}} \longrightarrow \substack{\text{Open lens 1 stop or} \\ \text{more to compensatre} \\ \text{for light absorbed by} \\ \text{reflecting surface}} = \substack{\text{Lens} \\ \text{f-stop}}$$

$$\frac{80}{10} = 8 \qquad\qquad f/8 \longrightarrow f/5.6$$

FIGURE 11-18

Bounce flash produces a pleasant soft lighting but manual exposures can be tricky to calculate. Measure the total distance the light travels from the flash to the reflecting surface and back to the subject. Then calculate an exposure 1-2 stops larger than normal to compensate for the light absorbed by the reflecting surface. Some automatic flash units have tilting heads that will automatically calculate the correct bounce flash exposure.

FIGURE 11-19

Bare-bulb flash or bounce flash creates soft highlights and eliminates distracting shadows.

Flash-Off-Camera

Flash-on-camera, although it is often more convenient, is not usually the most effective flash position. To place the flash unit in a more desirable key-light position, use a flash extension to remove the flash from the camera and use it in an off-camera position.

As we discussed in Unit 10, key lighting from above and to the side of the subject tends to produce the most natural set of highlights and shadows. Using a **flash-off-camera** technique, the flash unit can be held in one hand, high and to one side of the camera, while holding the camera in the other hand. If the camera is placed on a tripod the flash unit can be moved even farther to the side. By using the flash in this position, the modeling of the subject can be improved and textures revealed that add to the three-dimensional effect of the photograph. With a special clamp, the flash unit can be attached to any handy edge, such as a door or chair. Figure 11-20 shows two ways to place the flash unit in a flash-off-camera position.

Flash-off-camera, although it produces a dominant set of highlights and shadows that help to model the subject, does not by itself produce the additional fill light needed to illuminate detail in the shadows. The flash-off-camera technique tends to produce high-contrast prints with deep shadows, but several procedures can be used to enable a single flash unit to produce both key and fill lighting.

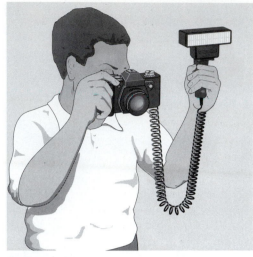

A

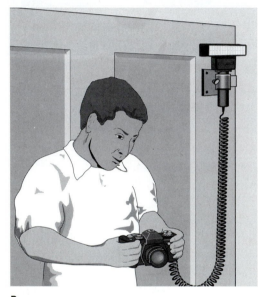

B

FIGURE 11-20

A. Electronic off-camera flash. Held high and to one side. B. Flash clamped high on edge of door.

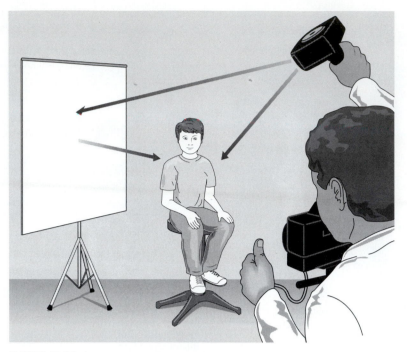

FIGURE 11-21

Using subject reflector to fill with electronic flash.

Fill light with reflectors One way to obtain both key and fill light from an off-camera flash is by using subject reflectors. In this case, the flash unit is held in a good key-light position. Then a **reflector card**, such as a piece of light cardboard, is placed on the fill side of the subject to reflect light from the flash into the shadow areas. The same effect can be obtained by placing the subject close to a wall on the fill side. Figure 11-21 depicts the use of the subject reflector.

Bounce flash off camera with kicker card Another way to obtain both key and fill light is to use the bounce flash technique discussed earlier; except with a *small* bounce card attached to the flash. In this way, most of the light is directed toward the ceiling or wall to produce bounce light that serves as the key or main light. A small portion of the light, however, is reflected by the bounce card directly to the subject as a **kicker**. The effect of the kicker is to open up the shadows a bit and to place a visible catchlight in the eyes. If a small bounce card is not handy, three or four fingers may be cupped in front of the flash head for a similar effect.

With flash-off-camera, the bounce flash technique can be used even if the unit does not have a swivel head. Simply point the manual flash unit toward the ceiling or a wall to reflect its light toward the subject. When figuring flash-to-subject distance, be sure to include the entire distance the light travels from the flash unit to reach the subject. If the unit is automatic, be sure the sensor is pointed toward the subject from close to the camera position. If the flash head and the sensor cannot be directed independently, set the flash unit to manual and calculate the exposure settings.

Flash diffusion To obtain a soft, diffused key light with flash, throw a clean, white handkerchief over the unit as a hood. Be sure the sensor is not blocked by the handkerchief. Place the unit in a good key-light position off-camera. On automatic units, compensate for the light loss by selecting a longer range setting; on manual units, calculate normal exposure and then increase the obtained aperture one or two stops.

Open flash technique One way of making a single flash unit perform as many units is to use the **open flash** method. This technique is useful when ambient light is very dim or absent and the subject is absolutely stationary. At night, or in a darkened room, open the shutter and allow it to stand open. Then, carry the off-camera flash unit to several positions in succession, firing it in each location. With this technique, often called **"painting with light,"** flash may be fired once from the key-light position, then again from a fill-light position, and a third time from behind to create rim accents. After firing the flash several times, go back and close the shutter.

 The open flash technique can be used for night scenes if the distance between the flash unit and the camera is too great for a flash extension cord. Set up the camera and have a helper stand with the flash unit where the flash source is needed. Open shutter and let it stand open as the helper fires the flash. When the flash has been fired, close the shutter.

Stroboscopic results A variation of the open flash technique can be used to produce photographs of movement that have a **stroboscopic** or multiple-image effect. Using a black background or a dark, empty space at night, mount the camera on a tripod and open the shutter. Fire the flash repeatedly as quickly as it recycles while the subject slowly moves through an action. Each step of the action will be crisply recorded. If the separate recorded images do not overlap, normal flash exposure should be used; if they overlap significantly, normal flash exposure should be reduced.

 A few dedicated systems feature a true stroboscopic mode that can be used with natural motion. Such systems automatically produce as many as ten flashes per second during exposure. The camera may be hand-held or mounted on a tripod. The result is a multiple-image study of the flow of action, such as the stroke of a tennis racket contacting the ball, or the mid-air leap of a dancer.

Experimenting with off-camera flash As with studio spotlights and floodlights, one or more flash units can be used to enhance the subject and to simulate natural lighting sources. Photographers who experiment with off-camera flash in various positions generally are rewarded with more dynamic and dimensional images. High and low lighting angles as well as partial and full sidelighting can alter the modeling and texturing of the subject as well as place shadows to create more interesting and dramatic visual effects. A small flashlight taped onto the strobe head is a helpful tool for visualizing the effects that the flash will produce.

 When placing off-camera flash units, consider unorthodox as well as conventional positions. Placing a flash unit outside a window directed toward the interior of a room can simulate sunlight or moonlight; in a fireplace, it can simulate the light from a fire; inside a lampshade, it can simulate an existing light source. Using slave units allows even more control over the placement, quality, and ambience of the light.

Fill-In Flash

Aside from its uses for providing a main source of illumination, the flash unit has another important use strictly as a fill light. As we have seen, pictures taken in bright sunlight tend to have high contrast. The highlights are brilliant, and the shadows are often deep. The range of brightness from highlights to deep shadows often exceeds the latitude of the film; the shadow detail may be lost if the film is exposed for the highlights. Nature does not automatically provide an ideal brightness ratio. In bright sunlight, unless appropriate steps are taken, the brightness ratio may far exceed the latitude of the film.

One way to fill in the shadow areas in a sunlit scene is to use subject reflector cards—matte white or shiny pieces of cardboard—to reflect and diffuse the sunlight into the shadow side of the subject. By properly placing these reflectors, a more favorable brightness ratio between highlights and shadows can be achieved.

Another way to fill in these shadows is to use **fill-in flash**, sometimes called **synchro-sunlight flash**, to provide fill light outdoors in the bright sunlight. The trick is to provide flash illumination just strong enough to fill in the shadows without overpowering the main illumination provided by direct sunlight. This may be done by placing the flash unit at a proper distance from the subject or by reducing the brightness of the flash.

Although these fill-in flash techniques are most commonly used to fill in the shadows when shooting in bright sunlight, they also may be used in other available light situations to provide a more desirable balance between highlights and shadows.

Dedicated fill-flash Using fill-in flash with most dedicated systems is automated—an internal computer chooses the ideal flash power, lens opening, and shutter speed to provide a balanced fill light. Some dedicated systems even allow the user to select the desired **lighting ratio** between the highlights and shadows. Normally a 2 to 1 ratio between highlights and shadows is desirable for fill-in flash; the direct sun highlights should be twice as bright as the fill-in flash illumination. For a more dramatic effect, the ratio may be increased to accentuate the shadows; for a softer effect, the ratio may be decreased. Ratios from 4 to 1 to 1 1/2 to 1 are commonly used.

Fill-flash with manual and nondedicated flash Without a dedicated system, calculation is required. The objective is to provide fill-in flash to brighten otherwise dark shadows without overpowering the correct sunlight exposure. To do this, normal flash exposure must be reduced by one or two stops.

STEP-BY-STEP PROCEDURE FOR CALCULATING FILL-IN FLASH

1. Start by setting the shutter to synchronize properly with the flash unit. Then set the aperture properly for the sunlight scene as though flash were not to be used. Suppose that with the shutter set at 1/60 sec. the aperture is set at a meter-recommended f/16.

2. Using the calculator dial, such as the one built into the flash unit, find the normal distance opposite the f/stop to which the camera is set—in this case, f/16. If a flash calculator is not available, divide the guide number by the f/stop to calculate the normal distance. If the guide number were 80, the calculation would be:

guide number / f/stop = 80/16 = 5 feet

If the flash is placed at the normal distance, its exposure will exactly balance the brightness of the sunlit highlights—the brightness ratio will be 1 to 1. Although balanced, flat lighting of this kind may sometimes be desirable, the flash exposure should usually be reduced by one or two stops to obtain a greater brightness ratio.

3. One way to reduce the flash exposure is to reduce the flash output to one-half or one-fourth. With manual flash, a thickness or two of white handkerchief can be placed over the flash head or, if the unit provides for it, the flash unit can be set to one-half or one-fourth power. With automatic units, the settings can be adjusted to obtain one or two stops less than normal exposure. Check the unit's manual for the recommended method for doing this.

4. Another way to reduce the flash exposure with manual flash is to place the unit at a greater-than-normal distance from the subject. For example, if the flash calculator scale indicates that a flash-to-subject distance of 5 feet will exactly balance the sunlit highlights, doubling that distance to 10 feet would reduce the flash intensity to one-fourth the brightness of the sunlit highlights, producing a 4 to 1 brightness ratio. Intermediate distances may be selected to obtain intermediate brightness ratios. (If the camera is also moved to this distance, a proper focal length lens must then be used to obtain the desired framing of the subject.)

Fill-flash problems Manual fill-in flash with a focal plane shutter is especially difficult because the range of available X-synch shutter speeds is limited. Often the sun exposure will be too strong for the relatively slow synch speeds available. It may be necessary to use slower speed films and higher powered flash units to obtain correct fill-in flash exposures under these conditions.

Manual fill-in flash is comparatively easy with between-the-lens shutters because electronic flash can be synched with any shutter speed. On such cameras both shutter speed and aperture can be set for proper sunlight exposure; thus, an equivalent exposure can be selected that will provide the correct aperture for fill-in flash.

Flash and Slash

A variation of fill-in flash combined with a slow shutter speed can produce a combination of blurred motion and sharp images. Dubbed **"flash and slash"** by photojournalists, the technique is often used in indoor available

A

B

FIGURE 11-22

Achieving desired brightness ratio. **A.** *Bright sunlight from side or behind produces excessive brightness ratio, obscuring details in shadow areas.* **B.** *Fill-in flash opens up shadow areas and keeps brightness ratio within film's latitude.*

FIGURE 11-23

The flash-and-slash technique can be used to provide a sense of motion.

light situations. The technique is similar to fill-in flash, except that the flash is set to overpower normal exposure by one or more stops, giving proper exposure to the flash light while simultaneously underexposing the ambient light. Slow shutter speeds of 1/8 sec. or slower are usual. When the shutter is released, the instantaneous flash forms a sharp subject image; the slower shutter continues to record a secondary ambient light image. Any subject or camera movement during the slow ambient exposure blurs the secondary image. This technique is often effective for depicting motion and for visually separating a subject from its background. (See Figure 11-23.)

STEP-BY-STEP PROCEDURE FOR FLASH-AND-SLASH TECHNIQUE

1. Choose an ambient lighting situation that will allow shooting at 1/8 sec. or slower—outside at dusk or in a dimly lit room, for example.

2. Set the aperture for a correct flash exposure.

3. Use the camera's light meter to determine a shutter speed that will give a one-stop underexposure for the ambient light. For example, adjust the shutter speed until the light meter needle points to the underexposure region. Set the shutter for this speed.

4. For more blur, select a slower shutter speed. The slower the shutter speed, the more blur will result from any subject or camera movement.

Multiple-Unit Flash Technique

As we have seen, more than one source of light may be needed to create a desired lighting effect. A single flash used off-camera to improve modeling can create harsh shadows, for example, and although these shadows can be filled by using a reflector, sometimes added control can be obtained by using additional lighting units instead. Similarly, additional lighting units may be useful to illuminate a background, to provide edge accents, or to accomplish any of the other purposes discussed earlier in Unit 10, "Basic Lighting."

Advanced dedicated cameras now allow two or more battery-powered portable electronic flash units to be used simultaneously. Often the secondary units are called **extension flash** units and are connected to the main unit and camera by multiple dedicated cords. In use, these units are placed to provide the necessary main, fill, accent, and background lighting. One or more units may be used for bounce light to provide soft overall illumination. The dedicated and computerized systems automatically calculate the required exposure.

Multiple flash with nondedicated systems requires more calculation. As above, several conventional battery-powered flash units are used; however, they need not be physically connected either to the camera or to

each other. The units may be fired instead by using a light-sensitive slave cell that is triggered by the flash of the main unit.

The photo-eye slave cell triggers the slaved flash unit instantaneously when light from the main unit strikes it. The slave units, together with their photo eyes, are generally mounted on light stands or clamped in the positions of fill, background, or accent lights. A portable, multiple-flash lighting system is no more complicated nor costly to assemble and operate than a comparable incandescent lighting system.

STEP-BY-STEP PROCEDURE FOR NONDEDICATED MULTIPLE FLASH

This example will describe a typical three light setup for an interior environmental portrait. It will require three small strobe units; two of them should be equipped with slave cells and mounted on light stands or clamps.

1. Set all flashes to the manual mode. If used in an automatic setting, the sensors in each unit will respond erroneously to the light from all the units.

2. Select one stand-mounted flash to serve as the main or key light. Set it to one side of the camera at about a 45° angle to the subject. Raise it until its angle of incidence is also 45°. Use the strobe's calculator dial to figure an exposure based on the flash-to-subject distance. For this example, assume the main flash requires an exposure of f/16.

3. Mount a second flash on the camera as the fill light. To obtain a 2 to 1 lighting ratio, the fill light should be half as bright as the main light. (In this example, the output of the fill unit should give correct exposure at f/11.) There are several ways to achieve this:

 a. Dial in a lower power setting.

 b. Cover the flash head with a neutral density filter or thicknesses of white handkerchief.

 c. Change the flash-to-subject distance.

 d. Use bounce flash or bounce-card technique. This might be preferred when providing general room illumination for an environmental portrait.

4. Use a third stand-mounted flash and slave as a rim or separation light. Position it almost behind the subject on the side opposite the main light—on a very high or very low stand to prevent its direct light from striking the lens. Use a lens shade. As described above, adjust this unit to give a 2 to 1 brightness ratio—one stop less than the main light—in this example, f/11.

5. Check that the camera's shutter speed and synch setting are correct. Then set the aperture to correspond to the main flash unit—in this example, f/16. Test fire to verify that all three units are functioning before making any exposures.

FIGURE 11-24

Three small flash units were used to create this environmental portrait of an artist in her studio. **A.** One flash, equipped with a slave unit, was placed on a stand to the left of the camera as a main light and aimed directly at the subject. A camera-mounted flash fitted with a bounce card served as a fill light. **B.** A third flash unit and slave was positioned on a stand high behind the subject to act as a rim light and to provide separation from the background. **C.** An overhead view of the lighting setup. (For clarity, the bounce card was removed from the camera's flash for this shot.) **D.** When the photographer trips the shutter, the camera-mounted flash fires the two slave units.

This setup may be modified to suit any expressive purpose. Various reflectors, bounce cards, snoots, and gels may be used to modify the results. For example, colored gels might be placed over separation lights to create colored rim accents with color film. A flash meter, if available, can be used to eliminate exposure calculations and to make multiple flash setups easier to arrange.

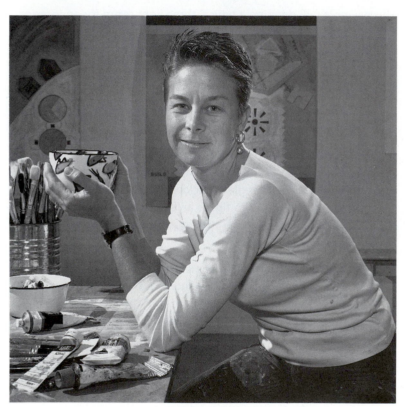

A

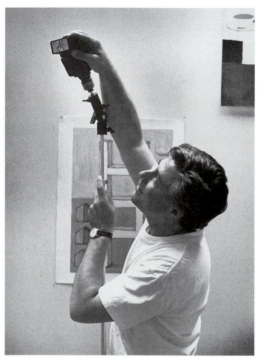

B

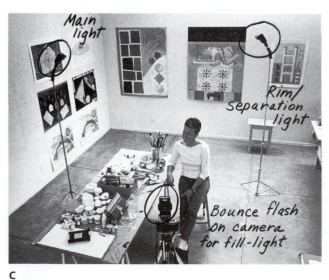

C

D

Famous Photograph: Splash of a Milk Drop

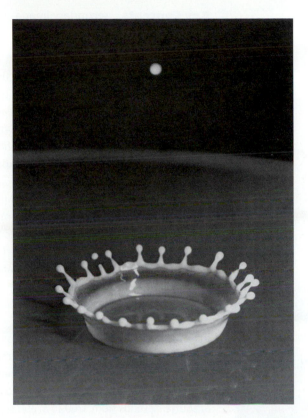

FIGURE 11-25

Dr. Harold E. Edgerton, "Drop of Milk," 1931.

The freezing of extremely fast movement by the abrupt discharge of an electric spark had been demonstrated by Sir Charles Wheatstone many years before the invention of photography. Even Fox Talbot had experimented with this phenomenon in 1851 to obtain a clear photograph of The Times attached to a rapidly spinning wheel exposed by an electric spark discharge of 1/100,000 sec. duration. It was not until Dr. Harold E. Edgerton's development of the stroboscope and related electronic flash equipment in the 1930s, however, that a truly practical method of high-speed, electronic photography became possible.

In his original experiments with the electronic discharge lamp, precursor of the modern electronic flash, Edgerton and his associates at the Massachusetts Institute of Technology demonstrated that previously "unstoppable" action could be stopped by an extremely short burst of intense light. Using bursts of light as short as 1/1,000,000 sec., Edgerton was able to freeze successfully the piercing of an apple by a bullet in flight, the collapse of a bursting balloon, the wings of a flying hummingbird, and the shattering glass of a milk bottle struck with a hammer.

In this photograph of a drop of milk falling on to a plate that was covered with a thin layer of milk, he produced a photograph of unusual beauty showing the crown-like coronet, rimmed with pearl-like droplets created by the instantaneous impact. When this photograph was published in 1931 it made an enchanted public aware of the invisible worlds that lay just beyond the realm of natural sight.

During World War II, Edgerton developed this technology into an effective system of night aerial reconnaissance, a system that was used the night before the D-Day Allied invasion of Normandy. Further applying this technology to high-speed, multiple-exposure photography, Edgerton and other scientists explored the movement patterns of such rapidly moving objects and processes as ballet dancers, sports and games, nature studies, explosions, and disturbed air currents—carrying forward the work started by Eadweard Muybridge nearly a half-century earlier. (See Famous Photographer, Unit 4, page 119.)

Objective 11-D Explain and demonstrate how flash can be used to stop fast action.

Key Concepts secondary image

As discussed in Unit 3, stopping fast action requires a very short exposure—usually a very fast shutter that will open and close before the image of the subject can move perceptibly across the film. The requirement for fast shutter speeds normally leads to large aperture settings to maintain proper equivalent exposure. Often, however, even with a large aperture the existing light may be insufficient to obtain the required shutter speed. Additional light and faster exposure may be achieved by using high-speed electronic flash.

Early on, photographers discovered that the bright, brief burst of an electric discharge could provide sufficient light for a short enough interval to stop fast action. Today, the electronic flash unit conveniently produces just such a short burst of intense light—from about 2 milliseconds to as short as 1/50,000 sec. for some automatic units. As long as the shutter is fully open at the moment of the flash, it is the burst of light, not the shutter, that generally determines the duration of exposure.

With a leaf shutter, electronic flash will produce its brief exposure as the shutter reaches its fully open position, regardless of the shutter setting. With a focal plane shutter, however, remember that the shutter stands fully open only up to the indicated maximum shutter speed. Thus, cameras with this feature can be synchronized to operate with electronic flash only at shutter settings from 1/60 to 1/250 sec., depending on the shutter design. (See Figure 11-26.)

Under bright lighting conditions, take care that the shutter setting is not too slow. Were an electronic flash with a 1/2-sec. shutter speed to be used to shoot a basketball player leaping into the air, the flash would record his image frozen in flight. But the ambient light would also record a blurry **secondary image** while the shutter was opening and closing at 1/2 sec. To avoid these secondary images, set a leaf shutter for a high speed, fast enough to stop the action by itself. Electronic flash works effectively with leaf shutters at all shutter speeds. (See Figure 11-27.)

There is a greater risk of producing secondary images when a focal plane shutter is used with electronic flash under bright illumination. The fastest shutter that can be synched with the electronic flash may not be short enough to prevent producing secondary images. One way to overcome secondary images when using a focal plane shutter is to reduce general illumination on the scene by turning out some of the room lights. Another way is to use slower film and higher intensity flash. Alternatively, a controlled secondary image may be deliberately introduced by using the flash and slash technique to obtain an almost cinematic motion effect.

The use of flash to stop action has a fringe benefit, too. Because of the rapid falloff of light intensity over distance, a foreground subject is lighted more intensely than its background. The farther away the background is, the darker it will appear. Thus, when a flash is used as the main light

FIGURE 11-26

Stopping fast action with flash.

source for an indoor action shot or outdoors at night, the subject-ground contrast in the print will be increased and the subject will be shown against a dark background.

Flash Problems

Objective 11-E Name the common problems encountered with flash photography, and give methods for correcting them.

Key Concepts red-eye, secondary images, uneven coverage, near objects brighter than far objects, flash reflection, distracting shadows, empty shadows, partial exposure

With experience, the photographer can develop an ability to predict the effects of flash. Until enough experience is gained, however, the effects are often difficult to predict. Highlights and shadows are not evident in the available light. Improper exposure and unwanted effects may not be discovered until long after the picture opportunity has passed. Some of the flash problems that occur most often are discussed in this section, along with their solutions.

Red-Eye

In color photography, light from the flash may sometimes enter the subject's pupils and be reflected from the retinas, causing luminous red spots to appear in the subject's eyes. This effect, called **red-eye,** is caused by placing the flash unit too close to the camera's lens axis, as when the flash unit is mounted to the top of the camera or when a built-in flash unit is used.

To avoid red-eye, move the flash unit farther from the lens by using the flash-off-camera technique or by mounting the unit on an extender that removes it at least 5 inches from the lens. Another solution is to photograph subjects when they are looking slightly away from the camera. Some modern cameras with built-in flash feature a preflash system that releases a flash burst an instant before the exposure. This has the effect of contracting the subject's pupils just prior to the flash exposure, thus reducing the effect of red-eye.

Secondary Images

When an electronic flash with a slow shutter is used under bright available light, the available light may record a blurry **secondary image** in addition to the image recorded by the electronic flash. Secondary images can occur whenever a slow shutter is used with electronic flash, but they tend to occur more often with cameras equipped with focal plane shutters because a slower shutter is usually required.

To avoid secondary images, reduce the brightness of the available light if possible. If not, try timing the action shots to record peak action, when

FIGURE 11-27

Secondary images with moving subject shot with flash under bright available light and slow shutter.

the subject is nearly motionless. If a leaf shutter is in use, shoot at a shutter speed fast enough to stop the action even without flash. If a focal plane shutter is in use, switch to combustible flash so that faster shutter speeds can be used. Otherwise, switch to slower film and higher output flash.

Uneven Coverage

If a wide-angle lens is used with a flash unit, the center of the resulting image may be properly exposed, whereas the edges may be underexposed. **Uneven coverage** such as this occurs when the lens's angle of view is greater than the unit's angle of illumination.

Most flash units are designed to match a normal lens's angle of view when used in the normal way. Switching to a shorter focal length lens without making a corresponding adjustment to the flash will produce uneven coverage. To avoid this effect, use the wide-angle adjustment recommended for the flash unit. If the unit lacks such an attachment, place a thickness or two of white handkerchief over the flash unit to diffuse the light over a greater area. Note that this technique reduces the range of automatic units and requires an exposure increase with manual units.

If the lens's angle of view is greater than the flash can handle, bounce flash technique may be used to spread and diffuse the flash or open flash may be used to "paint" the scene with more than one flash.

Near Objects Brighter than Far Objects

With direct flash, sometimes nearby objects are overexposed, middle-distance objects are correctly exposed, and more distant objects are underexposed. According to the *inverse square law,* discussed in Unit 10, "Basic Lighting," light intensity diminishes over distance. This means that the brightness of objects is determined by their distance from the light source—nearer objects are brighter than those farther away.

The inverse square law is a basic law of physics and cannot be changed. Some techniques can be used, however, to avoid foregrounds that are too bright and backgrounds that are too dark. One direct solution is to select a camera angle that places subjects equally distant from the flash. If this is not feasible, another solution is to use bounce flash to diffuse the light to provide more even coverage. A further solution is to place multiple flash units at various subject depths to balance the illumination.

Flash Reflection

Sometimes a finished print or slide shows a pronounced bright spot in its center, bright enough to obscure the details within it. This is often caused by shooting perpendicular to a shiny or light surface, so that light from the flash is reflected from the surface directly back into the lens.

Flash reflections of this kind can be avoided by facing blank walls or flat surfaces at an angle, rather than head-on. Mirrors especially should be avoided—if the flash unit can be seen in the mirror, its picture will be

FIGURE 11-28

Flash units may produce uneven light coverage when used with a wide-angle camera lens. The light fall-off and darkening of the corners can be avoided by placing a sheet of diffusing material or special wide-angle attachment over the flash head.

A

B

FIGURE 11-29

Flash fall-off. **A.** *Subjects close to the camera are overexposed by direct flash while objects at a distance receive insufficient light and appear too dark.* **B.** *Bounce flash provides a more uniform and natural field of light over a wide range of subject distances.*

A

B

FIGURE 11-30

*Single unit flash techniques. **A.** Use of on-camera flash. Shooting directly at reflective surfaces produces hot spots and reflections. Slight angle would have directed reflected light away from camera. **B.** Use of off-camera flash. Subject too close to background will produce distracting shadows. Separate subject from background.*

taken as it fires. The correction is simple. Change position so that the flash will strike such surfaces at an angle—45° if possible. Then the flash reflection will be thrown off in another direction and will not bounce back into the taking lens.

Another source of unsightly flash reflection is eyeglasses worn by subjects. Many a portrait of a bespectacled subject has been ruined by flash reflections from the surface of the glasses. If a subject is wearing glasses, shoot at an angle to the glasses, have the subject turn slightly off-camera, or have the subject tip the glasses slightly downward to direct reflections away from the camera. (See Figure 11-30.)

Distracting Shadows

When a subject is placed too close to a background and the flash is positioned at an angle, a **distracting shadow** of the subject may appear on the background in the final print.

Shadows of this sort can be predicted easily—flash always casts a shadow. The trick is to anticipate where the shadow will fall. By sighting along a line between the flash and the subject, where the shadow will fall can be predicted and steps taken to avoid its appearance in the final print.

Shadows can be positioned harmlessly out of the frame by either moving the subject away from the background or moving the flash unit to another position. Place a subject at least several feet from the background. The subject's shadow will fall out of the camera's view, and the background will be close enough so that it will not be underexposed. Otherwise, try moving the flash unit to a higher or wider angle so that the shadow falls out of the picture's frame. (See Figure 11-30B.)

Empty Shadows

If the highlights of a print are well defined, but the shadow areas are deep black and devoid of detail, it is likely that the brightness ratio exceeded the latitude of the film.

Empty shadows are likely to occur when the flash unit is placed at too extreme an angle to the subject without fill light provided for the shadows. The shadow areas can be filled by using subject reflectors placed opposite the flash unit, by using multiple flash technique to provide illumination to the shadows, or by using bounce flash.

Partial Exposure

Occasionally, only part of an image is properly exposed, whereas the rest is not exposed at all, as if a mask had been placed over part of the picture. **Partial exposure** of this kind occurs when electronic flash is used with a focal plane shutter set at an excessive shutter speed. The flash fires when the shutter is only partially open, causing a portion of the film to remain unexposed. (See Figure 11-7, page 328.)

To avoid this effect, be sure to set the shutter speed correctly to synchronize with the flash. Leaf shutters can be used at all speeds with electronic flash, but focal plane shutters generally are limited to slower speeds. The maximum shutter speed for electronic flash is generally marked on the camera.

Flash Maintenance and Safety Recommendations

Objective 11-F List several maintenance and safety recommendations for handling flash equipment.

Key Concepts alkaline batteries, nickel-cadmium batteries, zinc-carbon batteries

The following list describes the most sensible procedures to follow when using flash equipment.

1. Keep the electrical contacts on the flash batteries and in the camera and flash unit clean. Use rough cloth or a pencil eraser to clean them before each new roll of film.

2. Be sure the photoflash batteries are fresh. **Alkaline batteries** are generally recommended for long life and short recovery time. However, if the manufacturer's recommendations are different, they should be followed.

3. If a flash unit is to be stored for long periods of time, remove the batteries to avoid corrosion and damage.

4. Rechargeable **nickel-cadmium** *batteries* are an economical alternative to conventional batteries. They may be used with most flash units, and their use is ecologically sound. Ni-cads, as they are called, give quicker recycle times but fewer flashes per charge than alkaline batteries. Consult the owner's manual for details.

5. Never attempt to recharge conventional alkaline or **zinc-carbon batteries**. Use only special nickel-cadmium rechargeable batteries and a correctly matched charger.

6. Always turn the unit off and aim it away from yourself while connecting or disconnecting it. Several conditions may cause the unit to fire during connection and disconnection.

7. Never use flash in an explosive atmosphere. Never use flash equipment where there are volatile fumes, such as natural gas or gasoline. Exercise caution when using electronic flash around swimming pools and bathtubs.

8. When multiple flash units are used, position any connecting cords carefully out the way. Tape long connecting cords securely to the floor to prevent anyone from tripping over them during the shoot.

Questions to Consider

1. Describe the ways that flash can be used to stop motion in a frozen moment or to capture the expressive gesture of an action.

2. Find two flash photographs by Annie Leibovitz, two by W. Eugene Smith, and two by Weegee. Describe the flash techniques of these three photographers, and discuss how their use of flash affected the content and visual qualities of their photographs.

3. Examine a current issue of a large metropolitan newspaper. Which photographs were made with flash? How can you tell? What specific flash techniques were used?

4. Describe several ways of using bounce flash with your camera and flash. How do you determine exposure?

Suggested Field and Laboratory Assignments

1. Arrange for the use of an electronic flash unit for your camera. Mount the unit to the camera. Practice setting the unit, shutter, and aperture for subjects at various distances from the flash.

2. Make bounce cards for your flash out of pieces of white cardboard or the equivalent. Make a series of test photographs with a small card, about 5 in. by 7 in., and with a very large card, about 11 in. by 14 in. What are the visible differences in the final photographs?

3. Shoot a roll of film using your flash unit. Include at least one example of each of the following. Keep a shooting log describing the technique used, why it was used, what type of flash was used, and exposure data.

 a. flash-on-camera

 b. flash-off-camera: flash held in good key light position

 c. flash-off-camera: bounce flash

 d. stop rapid action indoors

 e. flash and slash

 f. fill-in flash with strong backlight

 g. fill-in flash with strong sidelight

Unit Twelve

Subjects and Approaches

Rusty Hood, "J. R.," 1991.

UNIT AT A GLANCE

Certain subjects have always captured the interest of artists and photographers. When we look at the subjects that continue to fascinate us, we discover that certain themes recur repeatedly, not only in photography, but in painting, graphic arts, sculpture, and other forms of artistic expression. This unit briefly introduces a few of these subjects and discusses how to approach them through photography. We'll examine the principles that can help you make interesting and expressive photographs of scenery, architecture, still life, people, action, human interest, and contemporary events.

Scenery

Objective 12-A Describe some of the principles and techniques of scenic photography.

Key Concepts grand view, intimate view, haze, contrast, actinic light, foreground detail, flat lighting, cross-lighting, backlighting

A visit to a national park, beach, resort, desert, or mountains offers spectacular scenery that virtually begs to be captured on film. Photographs of such vast scenic grandeur often fail to measure up to the glorious scenes that inspired them. The endless, breathtaking space has been shrunk into the small borders of a print. A magnifying glass is needed even to see the once great distant mountain ranges. The fields of brilliant flowers have merged with the surrounding foliage into a pallid gray mass. It is easy to see why scenic photography poses such a challenge to photographers and provides a lifetime of study for many.

Many factors affect the making of a scenic photograph. As the sun moves across the sky or passes behind a cloud, the lighting continually changes. In spring, summer, winter, or fall, in rain, snow, or sun, each change of season or weather alters the landscape. Add to these factors the myriad of possible viewpoints, moods, land formations, vegetation, and living creatures, and it is apparent that the picture possibilities in even a single landscape are virtually limitless.

As with other types of photography, scenic photography requires first that one learn to see—to study the subject and to visualize the final result. Next, one must learn to execute—to perform the operations necessary to achieve what has been visualized.

As breathtaking as it may seem, the natural landscape is not organized into a two-dimensional frame. Unlike the actual scenery, which has no borders and extends off into space in all directions, the scenic photograph looks in one direction through precisely defined borders at the top, bottom, and sides. Visualizing the landscape within the two-dimensional format of the final print is one of the photographer's major tasks. Because of these limiting boundaries, successful scenic photography involves deciding carefully what features will appear within them, what features will not appear, and what features will be emphasized.

To make these decisions, it helps to understand what it is about the scene that motivates the photograph. Why is the picture being made in the first place? Is it the way the sunlight filters through the trees that inspires the photograph? Or the awesome height of the cliff face nearby? Or the primitive wariness of the feeding buck? Sound compositional decisions follow naturally when the purpose is clear. Visualize the final result before shooting the picture, and be wary of trying to include too much within the limiting borders of the frame.

Scenic photographs tend to be interesting if a principal feature in the scene is emphasized—one or more animals, a landform, an arrangement of flora. Using the viewfinder as a basic tool allows the photographer to explore the scenic relationships within the top, bottom, and side boundaries of the frame. If the intended center of interest is obscured or dominated by other elements in the frame, the camera can be moved to a different position, or the focal length or depth of field can be changed. By these means, the composition can be altered in the viewfinder until the principal feature of interest is properly related to the rest of the scene.

A vast landscape encompassing miles of space is sometimes termed a **grand view;** a narrow scene measured in yards, an **intimate view.** Whatever the view, the photographer's usual purpose is to convey the character, the mood, and the feeling of the place in a unique visual form rather than to make a simple record. Generally, the photographer hopes to stir the viewer to experience the ideas and feelings that motivated the photograph in the first place. Scenic photographs tend to be more successful if they attempt to reach beyond the mere record to tell the story of a place.

The camera favored by professional landscape photographers has traditionally been the large-format view camera. Bulky and cumbersome though it may be, especially when trudging through the forests or clambering up rocky cliffs, it provides control over the image unmatched by more convenient cameras. Mounted to a tripod, the view camera affords the photographer a studied view of the image on its large, clear ground-glass screen. Its adjustable swings and tilts provide perspective and focus controls for shaping and locating the image to the photographer's vision. And the large-format negative plate provides a medium for representing details in the final image with utmost clarity and precision.

The ubiquitous 35-mm camera also serves as a popular tool for landscape photography. The SLR camera is particularly well suited to the physical trials of landscape work. In addition, the SLR camera equipped with a *perspective control (P-C) lens* provides many of the viewing advantages as well as the perspective and focus controls offered by view cameras. Certainly, the 35-mm approach to landscape photography provides an advantage when it comes to spontaneity.

The Grand View

To capture the expanse of a grand view, the photographer will often want to emphasize the elements of distance, such as atmospheric haze, tone and contrast, foreground detail, lighting, and depth of field.

Often a grand view contains natural **haze** because of the distance involved. To eliminate haze in black-and-white photographs so that distant

details appear clearer, a haze-penetrating filter, such as a yellow, red, or a polarizing filter, may be used. To include natural haze so that enhance aerial perspective is enhanced, a filter may be omitted or a blue filter may be used to exaggerate haze.

Scenic photographs may also benefit from control of **contrast**. Even though white clouds may be set dramatically against a deep blue sky, the panchromatic film may rob the final print of these values. Similarly, the stark contrasts between green foliage, blue water and sky, and red-brown earth tones may turn into a dull, pasty gray mass in the final black-and-white print. At high altitudes, at the seashore, or in the snow, the intense ultraviolet light, called **actinic light,** may further drain scenic images of brilliance. Filters often help not only to retain the contrast in a scene but also to improve upon it by emphasizing the features of particular interest. (See Unit 9, "Filters.")

Foreground detail may also add to the sense of distance. A rock, tree, shrub, or person in the scenic foreground can provide a visual reference by which the viewer of the photograph may judge the scale of distance.

Lighting is also important to the grand view. The adage "keep the sun at your back" rarely provides the best lighting for grand scenic views. In that position, the sun produces relatively shadowless **flat lighting** that reveals little texture. Similarly, noon sunlight from directly overhead seldom produces the shadow patterns that best reveal landscape features.

Cross-lighting, on the other hand, skimming across the landscape from a relatively low angle, increases image contrast and reveals the contours, textures, and shapes of scenic features. **Backlighting**, striking the scenic features from behind, reveals their shapes and outlines and often produces spectacular rim highlights. Natural cross-lighting and backlighting are most often available when the sun is relatively low on the horizon, during the early morning and late afternoon, times favored by many landscape photographers.

For the grand view, the photographer may want features in the near foreground as well as those in the distant background to appear in sharp focus. To obtain maximum depth of field, it is often useful to use extremely small apertures and hyperfocal focusing.

Figure 12-1 shows examples of the grand view.

The Intimate View

Great scenic photographs do not need miles of space; many focus on only a few square yards of natural scenery and closeups of such features as a bough of leaves, a few rocks in a stream, or the gnarled roots of an old tree. Many potentially exciting photographs may lie close by as well as in the distance. By paying attention to closeup details, the photographer can learn to convey a sense of the region that produced them.

The intimate view may picture sailboats at a lakeside dock, a rural church, or mailboxes along a country road. Whereas the grand view seeks to picture great scale and distance, the intimate view focuses on particular features closer at hand. Once again, significant foreground detail may provide a useful frame of reference, a feeling of depth, and a means to direct the viewer's attention to the details of particular interest.

B

FIGURE 12-1

Grand scenic view. Pictures convey sense of great distance and magnitude.

A

B

FIGURE 12-2

Intimate scenic view. Pictures draw attention to close details.

As with grand views, intimate views may also benefit from control of contrast. Without controls, contrasts between color elements that show clearly in nature—foliage, earth tones, sky, water, structures—may fade to insignificance in the gray scale of the final print. However, the important contrasts can be retained, even enhanced in black-and-white images, by the judicious use of filters—red, orange, or yellow, for example, to lighten earth and wood tones and to darken foliage and sky. These filters also tend to reduce haze which, in an intimate view, may give an unwanted feeling of distance.

Figure 12-2 shows examples of the intimate view.

Scenes with Water

Water may be a part of either a grand or an intimate scenic view, and it sometimes poses problems for the photographer. For example, if a picture of a quiet pond includes a reflection of the shore, the viewer may have to rotate the picture to figure out which side is up. For such scenes, breaking the smooth reflecting surface of the water with a stone or including a strong, unreflected foreground feature often helps the viewer to distinguish up from down and adds interest to the water detail.

Marine scenes, too, may be grand or intimate views, usually dominated by sea and sky. Large foreground waves or rocks may appear as a center of interest; boats, birds, or interesting cloud formations may establish the mood or idea of the scene. Sometimes a marine scene would benefit from the presence of living creatures, creatures that are often camera-shy. When shooting at the shore, try carrying some food along to attract the wildlife (providing such action is legal, of course.)

Backlighting and silhouettes can often be used to excellent effect in marine scenes. Light reflecting over the water and toward the camera reflects a myriad of glints, dapples, and sparkles from the surface of the water that enliven the picture and provide a brilliant background against which foreground objects may be silhouetted.

To darken the surface of water under blue skies, proceed as to darken the blue sky itself. As the surface of the water only reflects the light of the sky, a red, orange, yellow, or polarizing filter will serve to darken the surface of the water. A red filter combined with a polarizing screen will produce spectacular night effects with back- or side-lighted surf.

Figure 12-3 shows an example of a scene with water.

FIGURE 12-3

Scene with water. Yellow filter used to darken water reflecting expanse of blue sky.

HELPFUL HINT
Shielding the Lens from Sunlight

One caution should be exercised whenever shooting directly toward the sun. Should the sun's rays strike the lens directly, they may produce flares and reflections within the internal structure of the lens. Even the shadowy image of the iris diaphragm may be recorded on the negative. To avoid these effects, shield the surface of the lens from direct sunlight with a lens shade. If no lens shade is available, hold a hand, a hat, or any similar object above the lens to shade it from the sun.

Architecture

Objective 12-B Describe some of the principles and techniques of architectural photography.

Key Concepts record shot, interpretive shot, keystone effect, perspective-control (P-C) lens

Famous Photographer: Alfred Stieglitz

FIGURE 12-4

Alfred Stieglitz, "Winter-Fifth Avenue," 1893.

More than any other person, Alfred Stieglitz, influenced the course of photography as an art form in America. As photographer, critic, editor, publisher, curator, and forceful gadfly for the arts, he promoted influential and *avante-garde* work, not only of photographers, but also for other artists for more than 60 years.

Stieglitz's perceptions as an art connoisseur and critic were far ahead of his time. His galleries, often kept afloat financially by the force of his will and personality—291, the Intimate Gallery, and An American Place—exhibited the works of many contemporary artists and photographers. With Edward Steichen, he introduced to America the works of such modern artists as Cézanne, Matisse, and Picasso. From 1903 to 1917 he edited *Camera Work,* the most influential of all photographic magazines, in which he published a wide range of photographic criticism and works that he considered to be artistically worthy, often exhibiting a surprising tolerance toward those styles he opposed. Through his influence, major museum curators and art critics eventually accepted photography as a legitimate art form.

Stieglitz twice influenced the style of photography in America: first toward the pictorial impressionistic ideal and later toward sharply realistic, "straight" photography. An early advocate of "pure," unmanipulated photography, he made his early reputation, starting in 1892, with a series of "pictorial" photographs of New York street scenes. These photographs showed convincingly that it was not necessary to manipulate images to reveal the pictorial qualities in everyday scenes. At first he photographed "in small," producing prints that were smaller than a playing card, mounted on a large sheet of wrinkled buff or brown paper, and would not allow his pictures to be enlarged, even in magazine reproduction.

By photographing the natural elements—clouds, rain, snowstorms—Stieglitz found a way of expressing what was in himself. "When I see something that serves as an 'equivalent' for me, of what I am experiencing myself," he said, "then I feel compelled to set down a picture of it as an honest statement . . . to represent my feelings about life." It was his opinion—quite revolutionary for his time—that any work, whether the work of a painter, pastrycook, or photographer, should be judged on its own merit and only in terms of itself.

FIGURE 12-5

Architectural record shot. Seeks to represent entire structure without interpretive comment.

FIGURE 12-6

Interpretive architectural shot. Seeks to capture character of structure by focusing on particular details and to convey photographer's feeling about it.

Photographs of buildings or other architectural subjects may be classified as either record or interpretive photographs. A **record shot** is one that attempts to represent all of a structure's essential details from a relatively neutral point of view with a minimum of distortion. An **interpretive shot** attempts to convey an impression of the structure's character and meaning by adopting a unique point of view and emphasizing certain of the structure's features.

Interpretive architectural photography is closely related to outdoor portraiture. The photographer must study the subject and come to know it quite well—its character, its personality, its moods at different times, in different seasons, and in different weather—and ultimately develop a statement about it through a photograph. Only then may the photographer select an appropriate point of view, lighting angles, and time of day for picturing the subject. Only then may the photographer decide which features of the structure should be emphasized and which tonal qualities to seek. (See Figures 12-5, 12-6, and 12-7.)

Architectural photography may call for special equipment. For example, the photographer may wish to picture a tall building from across a narrow street or a long bridge from a position near one end of it. Under these conditions a wide-angle lens may be useful to encompass the entire structure from such short range. At other times it may be necessary to capture a feature far up the facade of a building or far out along the span of a bridge. Under these conditions, a telephoto lens may be useful to obtain a closeup image of some distant detail.

Because architectural subjects are typically large and deep, small apertures are commonly used to assure maximum depth of field. As a consequence, exposure times are typically long and the use of a tripod or other camera support is usually necessary.

Architectural subjects often benefit from the use of contrast filters that increase figure-ground contrast. So that the structure may be separated from its background, for example, it may help to create a dark sky against which the structure will stand out in bold relief.

Ordinarily the pictured structure may gain impact if it does not appear isolated in space. To convey a sense of scale, other objects of known size, such as trees or people, may be included within the frame. So that the viewer may gain a sense of the locale, other nearby features, such as other buildings, lakes, or mountains may also be included. These additional features provide the viewer with a frame of reference that contributes to a more complete understanding of the subject.

To photograph an architectural subject, the photographer often must shoot from ground level upward toward the top of the structure. Because its top is more distant than its base, its parallel vertical sides tend to converge as they recede toward the top. This is called a **keystone effect.** (More on this topic, see Unit 13-D.) To deal with this and other problems of perspective, the serious architectural photographer often prefers to use a view camera with a full complement of swings and tilts. Ground-glass focusing and composing also are considered essential for this kind of work.

To achieve similar results with a 35-mm SLR camera, a **perspective-control (P-C) lens** may be used. This wide-angle lens is designed so that its optical elements may be shifted off center and the entire lens rotated on its axis. With these adjustments, it is possible to obtain some control

A

B

C

FIGURE 12-7

Techniques for interpretive architectural photography. **A.** *Low angle and repetitive forms reveal distinctive character of building.* **B.** *Diagonal composition combined with reflections accent dominating structural and surface qualities.* **C.** *Bold forms and strong contrast reveal mass of building.*

over perspective similar to that provided by a view camera, although not to the same degree.

Perspective should be controlled at the time the exposure is made in order to obtain optimal image quality, but that is not always possible with a standard camera and lens. If perspective cannot be controlled at the time the exposure is made, remember that perspective can be corrected partially, and sometimes even completely, during enlargement. If proper adjustments of this sort are made during enlargement, the combination of the negative's distortion and the enlarger's distortion in the reverse direction will make the perspective of the subject appear normal. See "Convergence Control," in Unit 7, on page 201.

Still Life

Objective 12-C Describe some of the principles and techniques that can be used in photographing still-life subjects.

Key Concepts closeup lens, extension tubes

Still-life photography, because it attempts to convey ideas and feelings from an arrangement of inanimate details and objects, often poses a special challenge for the photographer. The arrangement of the objects and the approach to them should create an image that transcends the objects themselves. If the final image turns out to be little more than a record shot of several lifeless objects, the photograph is likely to convey little meaning. The viewer may be left wondering, "I see these objects, but so what?" To succeed, the photograph must invest the image with a life of its own—it

A

B
FIGURE 12-8

*Still life. **A.** Effective use of perspective, strong graphics, and clean design. **B.** Strong graphic design achieved by tight cropping to simplify shape. Technique of bleeding objects to edge of frame serves to emphasize composition rather than objects.*

must affect the viewer's senses and feelings. It must convey meanings beyond the mere record of the objects themselves. Without an idea as a basis, a still life tends to lack vitality and interest. (See Figure 12-8.)

The equipment necessary for still-life photography need not be elaborate. A camera, a camera support, and a few lights are all that are necessary. However, a camera that permits accurate viewing and focusing on a ground-glass screen will help to gain greater control over framing and depth of field. SLR and view cameras work well for this purpose. For close-up work, an accessory **closeup lens,** a bellows unit, or a set of **extension tubes** will be useful for focusing at closer-than-normal distances. (See Objective 13-E, "Closeup and Copy Photography.")

Effective pictures can be made with just one light source, preferably a spotlight, and a piece of white cardboard to provide fill. More elaborate setups may be used, of course, to enhance the subject. The basic principles of object photography apply to the lighting of inanimate objects for still-life photographs. (See Objective 10-F, "Lighting Small Objects.")

Ordinary household tungsten lamps can be used in still-life photography when the subject is small. Especially bright lighting is not needed because the subjects are inanimate and long exposures are possible. Larger subjects, however, may require more than one light source. A camera support, such as a tripod, is a useful aid in composing a still-life image because it helps to hold the camera steady during painstaking framing and focusing, as well as during slow exposures.

People

Objective 12-D Describe and demonstrate some common sense guidelines for photographing people.

Key Concepts characteristic activity

People like to look at pictures of people. Those who study photography for their own pleasure usually find that people—family, friends, and children—are among their most important subjects. Those who study photography for professional reasons soon learn that the ability to capture the feelings and personalities of people in both natural and planned settings is an invaluable asset. Some of the compositional guidelines that were studied earlier apply especially well to photographing people.

1. **Avoid distracting backgrounds.**

 A photograph of people will benefit from simplicity. The photograph should draw the viewer's attention to the people who are the center of interest. Any kind of background that might confuse or distract the viewer's attention is usually best avoided.

 To simplify shots of people, consider using a neutral background. The sky, with or without clouds, usually provides a flattering neutral background for people, especially if steps are taken to darken the sky tones—by using a yellow or yellow-green filter, for example. Outdoors, posing the subject in a position for shooting a low-angle shot against the sky is one useful approach.

FIGURE 12-9

Edward Weston, "Artichoke Halved," 1930.

At the turn of the century two approaches to photography prevailed in America—the east coast approach that was preoccupied with defining the atmosphere of its cities, streets, and interiors, and the west coast approach that was preoccupied with defining the natural landscapes and subjects. Edward Weston, later acclaimed as one of America's great photographic artists, was the quintessential western photographer.

Early in his career Weston utilized all the crafts of processing and printing to produce romantic, impressionistic, soft-focus images that transformed his photographs into works closely akin to painting. By 1911 he had his own studio in Tropico, California, and had achieved an international reputation as a salon photographer. However, the San Francisco Fair of 1915 introduced him to modern art, music, and literature and his work began to break from the salon traditions. By 1922 he had come under the influence of Alfred Stieglitz, Charles Sheeler, and Paul Strand and was clearly striving for an aesthetic based upon objectivity.

In 1923 he moved to Mexico, where he lived and worked for three years with a circle of artists that included Diego Rivera, Orozco, and Siqueiros. By 1925 his photographs demonstrated the pinsharp, objective, unretouched qualities that characterized new realism in America. Late in 1926 he returned to California, but not to his studio work. With his son, Brett, he took up residence in the mountains near Monterey and with his 8-x-10 inch view camera he began making the photographs of the sea and the shore around Point Lobos and of the dunes at Oceano that many consider to be his finest work. In 1932, with Ansel Adams and Willard Van Dyke, he formed Group f/64, and in 1937 he was the first photographer to be awarded a Guggenheim Fellowship.

He always managed to photograph his subjects with such meticulous precision that he rendered the most mundane subjects into objects of artistic interest. Whether the subject was a blistered and peeling abandoned car, the caked and cracking walls of an adobe house, a farmhouse doorway, a piece of vegetable, or a sweeping vista of orchards or sand dunes, his exacting technique and vision would enable him to surpass documentary realism and to reveal the transcendent beauty of his subject, to communicate the personal feelings, and to affect both the senses and the emotions of his viewers.

"The camera should be for the recording of life, for rendering the very sustenance and quintessence of the thing itself, whether it be polished steel or palpitating flesh," he wrote. The subject should be "rendered with the utmost exactness: stone is hard, bark is rough, flesh is alive."

His exhibitions include: Mexico City, 1923 and 1924; Museum of Modern Art, New York City, 1946, and Paris, 1950. Major collections of his work are held by Guadalajara State Museum, Los Angeles Public Library, Museum of Modern Art, and the International Museum of Photography in Rochester, New York.

A

B

FIGURE 12-10

*Background. **A.** Background reveals context of subject's activity. **B.** Background provides strong visual form for composition and sets stage for subject.*

The ground, too, may provide a neutral background. By standing on a chair or posing your subject seated on the ground, a high angle shot may be taken.

The side of a plain building may provide a suitable neutral background for a subject, but such busy patterns as brick or stone are usually best avoided. Indoors, a plain wall or drape may provide an uncluttered background. If background objects must appear in the picture, they may be arranged in such a way that they contribute to the overall composition, rather than distract from it.

Neutral backgrounds are not necessarily always best, however. If it is relevant, a carefully selected background can help the viewer gain a more complete impression of the subject. Photographing a steel worker against the background of the steel plant, or a farmer against his wheat fields, for example, places such a person in context and gives the viewer a more complete picture. (See Figure 12-10.)

2. **Use closeups.**

The camera should be moved in as close as possible to the subject. A simple guideline is to shoot at a conversational distance. It is desirable to obtain the largest image possible on the negative. A negative with a small image outline must be enlarged considerably, and this may result in an undesirably grainy print. The larger the image outline, the less the needed enlargement and the less its accompanying graininess.

This distance may be achieved not only by moving physically closer to the subject, but also by using a long focal length lens. Many photographers prefer this latter approach because it allows them a closeup view without intruding into their subject's personal space.

3. **Photograph the subject doing something.**

If nothing else, the subject may be engaged in conversation. An animated conversational expression is vastly preferable to a self-conscious smile into the camera. Better yet, the subject may be photographed doing something meaningful—reading a book, arranging some flowers, brushing a horse, examining a stamp collection—something characteristic of that person. Often the most revealing pictures of people, like portraits, depict the central figures engaged in **characteristic activity**, something that interests them and that they do regularly. (See Figure 12-11.)

4. **Eliminate distracting objects.**

If possible, distracting objects should be removed from the background—the picture on the wall, the lamp, the monkey in a cage. Light sources, mirrors, or other reflective objects that might form distracting highlights should also be removed. Only those objects that support the central visual idea should be allowed to remain in the background. For example, if the subject is shown painting a picture, brushes, paints, and similar objects may support the central idea. Moving in closer to the subject, either physically or by means of a long lens, is a good way to eliminate extraneous background objects that distract from the subject or that might have to be cropped out of the final print.

FIGURE 12-11

Activity. Subject engaged in characteristic activity reveals more of self than one who simply smiles into camera.

5. Use lighting to help portray the subject.

Diffused, flat lighting tends to support such impressions as quiet, inactivity, passivity, and softness. It also tends to minimize surface textures. Specular, contrasty lighting tends to support such impressions as activity, vitality, aggressiveness, and hardness. When it is used to cross-light the subject, it also tends to reveal surface textures.

The midday sun produces deep, harsh shadows. If subjects face directly into the sun, its glare may cause them to squint unnaturally. The principles of basic lighting discussed in Unit 10 apply to photographing people. (See Figure 12-12.)

FIGURE 12-12

Lighting. **A.** *Soft lighting conveys feeling of gentle character.* **B.** *Contrasty lighting appropriate to dynamic subject.*

A

B

FIGURE 12-13

W. Eugene Smith, "Tomoko Uemura in her Bath, Minimata, Japan," 1972.

W. Eugene Smith, whose name is nearly synonymous with the modern photo essay, was a moody, seemingly tortured personality, who brought to his work not only technical perfection but an intense, passionate sense of beauty and conscience that shone through his often brutally frank photographs. While still a high school teenager during the depression, he worked as a news photographer for the *Wichita Eagle* and the *Wichita Beacon*. Then and thereafter, a sensitive, compassionate vision and a sense of social purpose permeated his work, whether the subject concerned Pittsburgh steel workers, Welsh coal miners, Haitian fishermen, life in a Spanish Village, the work of a country midwife, or life in combat during World War II.

Every photograph he made carried an emotional impact. For Smith, feeling was the essence of a photograph. He once destroyed a batch of his work because he believed it lacked sufficient feeling. "Great depth of field; very little depth of feeling," he explained. His emotional investment in his work is obvious to anyone who views it. "I've never made any picture, good or bad, without paying for it in emotional turmoil," he wrote.

The photo essay, brought to its zenith by Smith and the editors of *Life*, emerged from a simple sequence of pictures into a complex documentary art form with often profound emotional impact. Smith's essays were driven by a strong sense of "story," which dictated image selection, sequence, sizing, placement, and caption text to achieve a final, integrated layout with a singular unity of theme.

His coverage of mercury pollution in the small fishing village of Minimata in 1971 was vintage Smith. The Japanese government had officially charged the Chisso corporation with having caused

widespread environmental pollution and birth defects by carelessly dumping methyl mercury into the bay off the town for years. His brutal, compassionate photographs documenting the horrible physical effects of the poison on the townspeople so angered company officials that they had Smith beaten up and his cameras destroyed. Despite injuries that cost him part of his eyesight, Smith persisted—the poignant photograph of a Japanese mother bathing her deformed 17-year-old daughter was published by *Life* and other magazines and newspapers worldwide, arousing international indignation and a new awareness of the terrible costs of industrial pollution. Smith went on to publish his own book, *Minimata,* an extended photo essay that exposed the effects of the company's actions on the town.

After high school Smith received a photography scholarship to Notre Dame University, but left after a year to become a *Newsweek* photographer. He began a long on-again, off-again relationship with *Life* magazine in 1939, leaving in 1941 to become a war correspondent for Ziff-Davls, and returning again to *Life* in 1944. During World War II, he covered 13 invasions, made 23 combat air missions, and was seriously wounded at Okinawa in 1945. After two years of painful convalescence, he resumed his work for *Life,* remaining until 1955. He was awarded Guggenheim Fellowships in 1956, 1957, and 1968. His exhibitions include the University of Oregon; the Rochester Institute of Technology, New York University; the Museum of Modern Art in New York; and the International Museum of Photography in Rochester, New York. Major collections of his work are maintained at the International Museum of Photography, the Museum of Modern Art, and the Art Institute of Chicago.

Action

Objective 12-E Describe real action, simulated action, and peak action and demonstrate a technique used for photographing each.

Key Concepts real action, peak action, simulated action, blurred movement, time exposures, photo sequence

Action may be classified into three types: real, peak, and simulated. Each requires a different approach to setting the shutter speed.

Real Action

Real action is what the name implies: movement that occurs as the picture is taken. Real action is a halfback's run in a football game, a speeding car, a baseball player in the middle of a swing, a runner during a 100-yard dash. Because the subject is in motion at the moment the shutter snaps, faster shutter speeds are required to stop the action.

Peak Action

Peak action is the split second when real action slows or even stops. In most action situations, a moment occurs when the action reaches a peak. This moment provides an opportunity for a picture in which action can be stopped with a slower shutter than that required for real action.

Sports are generally thought of as full of real action. Yet most sports have many moments of peak action as well. At the very top of a pole vault, for example, as the vaulter's body reaches the top of its upward flight, movement momentarily slows. The baseball pitcher, for another example, winds up and then unwinds to throw the ball. At that peak moment between winding and unwinding, the action is suspended. Peak action can also be seen in the moment when a diver reaches a high point of ascent before starting the descent, when the football kicker reaches the top of a punt, when a tennis player reaches the end of a stroke before setting up for the next one.

At the moment of peak action, the action can be stopped with a slower shutter speed and therefore a smaller f/stop, which permits greater depth of field. In low light, the ability to record action with a slower shutter speed may mean the difference between success and failure.

FIGURE 12-14

A. Real action. B. Peak action. C. Simulated action.

A

B

C

FIGURE 12-15

Blurred vs. stop action. **A.** *Intentional blurs enhance feeling of action.* **B.** *Idea of motion expressed by stopping or freezing action at an instant in time.* **C.** *Implied action. Diagonal composition adds to feeling of dynamic movement.* **D.** *Time exposure. Movement expressed by allowing moving subject to create trace across film.*

A

B

C

D

Simulated Action

Simulated action refers more to mental than to physical action. For example, a person talking on a telephone is seen to be in action, yet the action involves little physical movement. The president may appear to be signing new legislation. New officers of an organization appear to be examining a record book. A person is pictured drinking something, writing, or typing. All of these are examples of simulated action—he subjects are doing something, but physical movement is hardly present.

As these examples indicate, simulated action, by conveying a sense of activity, reveals more of the subject's personality than does a picture that merely shows the subject grinning benignly into the camera. (See Figure 12-14.)

Depicting Action

For a good action picture, it is not always necessary that movement be frozen. Sometimes an effective photo results when the photographer purposely uses a slower shutter speed to obtain the effect of **blurred movement**. The resulting slightly blurred picture may emphasize the impression of movement by tracing the rapid passage of the image through space. At other times, however, when the action is obvious, freezing the action may promote more interest than blurring it. In the case of a high hurdler, for example, a stop action shot might reveal the runner's straining muscles and concentration, whereas a blurred shot would obscure these details. The stop-action shot allows the viewer to study many aspects of an intense moment during continuous action. (See Figure 12-15.)

Whatever the type of action, the sense of movement can be enhanced by appropriate timing and composition. For example, action may be implied if the subject of the picture is off-balance or suspended in midair. Use of compositional lines—especially zigzag and diagonal lines—also enhances the illusion of movement and action. At night, **time exposures** can be used to capture the action patterns of moving lights or the tracings of exploding fireworks.

Finally, action can be depicted by means of the **photo sequence.** As the viewer's eyes move from picture to picture in a well-designed sequence, a sense of action and movement is conveyed.

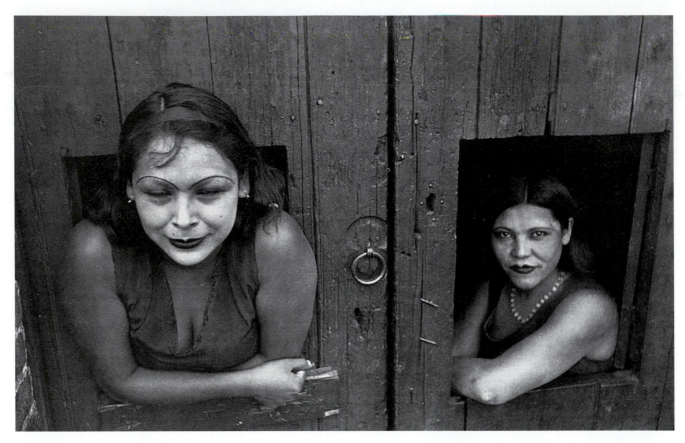

FIGURE 12-16

Henri Cartier-Bresson, "Two Prostitutes' Cribs," Mexico City, 1934.

Henri Cartier-Bresson worked hard to remain unobtrusive, even invisible to the principal actors in the ordinary human dramas from which he squeezed significance with his camera. Perhaps the most influential proponent of candid photography of his generation, Cartier-Bresson dressed plainly and clung to the fringes and shadows of events, better to view the world without disturbing it, and even covered the shiny parts of his equipment with black tape to prevent any sudden reflection from distracting his subjects.

For Cartier-Bresson, timing was the essential ingredient of photography. As events unfold before the eyes of the photographer, he insisted, "there is one moment at which the elements in motion are in balance." It was this "decisive moment," he said, that photography must capture to reveal the essence of an event. For Cartier-Bresson the decisive moment was more than simply freezing movement; it was that single instant in time when all the diverse elements that make up an event align in the photographer's mind in a meaningful pattern that tells all there is to tell about that event.

He always sought to capture an event as a complete composition, often viewing the image upside down in the viewer the better to see its formal organization, and rarely cropping during printing. He once wrote: "To me photography is the simultaneous recognition in a fraction of a second of the significance of an event, as well as the precise organization of forms that give that event its proper expression."

Seemingly always on the prowl for a "moment of realism," he brought to his search a sharp intelligence, a profound wit, and a sensitive compassion that enabled him to reveal the sad, the grotesque, the bizarre, the embarrassingly comic, all without cruelty or bitterness. His work is rich with a sense of humanity and an unerring sensitivity to the customs and foibles of

distinct cultures, forcing his viewers to see in ordinary events, wherever they might occur, that which is common to all.

Born in France, Cartier-Bresson first studied painting and literature, but later became entranced by the cinema and the work of Man Ray and Eugene Atget. He started to photograph seriously in 1930, traveling and exhibiting widely. In 1936 he returned to France, worked on Jean Renoir's film, *Partie de*

Campagne, then made his own documentary film about medical aid during the Spanish Civil War. Drafted into the French army in 1939, he served in a photographic unit and was captured in 1940. After three years as a prisoner of war he escaped on his third attempt and joined the Paris underground in 1943. After the war, in 1945, he made a film for the US Office of War Information about French prisoners of war returning home in

1945. His major exhibitions include Madrid, 1934; Mexico City, 1935; Julien Levy Gallery, New York, 1935; Museum of Modern Art, New York, 1946 and 1968; Pavillon de Marsan, at the Louvre, Paris, 1957. Major collections of his work are maintained at the Bibliothèque Nationale in Paris and the Museum of Modern Art in New York. With Robert Capa, David Seymour, William Vandervert, and others, he founded Magnum Photos in 1947.

Human Interest

Objective 12-F Describe how interesting pictures of people appeal to basic human emotions.

Key Concepts emotion, conflict appeal, sex appeal, ambition appeal, escape appeal

Photographs that appeal to basic human emotions have a special kind of impact. The viewer does not simply observe the image, but reacts emotionally to it. The viewer may laugh, feel sad, or simply empathize with the subject. The range of human **emotion** is extremely wide and complex—far beyond the scope of this discussion. Nevertheless, mention might be made of a few of the emotional appeals that have provided a basis for successful human interest photographs. Some of these subjects are related to conflict, sex, ambition, and escape.

Conflict appeal refers to human interest in witnessing people struggling against others or against the forces of nature or society to achieve their goals. Conflict has been at the center of literature, art, and drama since the beginning of history. In photography, it may be seen in photographs of firefighters battling a blaze, residents sandbagging to fight a flood, ordinary people struggling against disasters. Conflict appeal may also characterize human interest in competitive activities, such as sports, elections, business, and, in a grimmer way, war. Accidents are another context in which we can observe basic human conflict against the forces of nature and society. (See Figure 12-17.)

FIGURE 12-17

Conflict appeal. Emotion is evident in competitive sports.

Sex appeal is so widely recognized as a human interest that it has become a standard phrase in our language. Photographs of attractive men and women, singly, in couples, and in groups, usually appeal to human beings of both sexes. They attract the eye and trigger an emotional response. Sex appeal may be observed in action in newspaper and magazine advertisements, in literature, drama, music, and in news stories and articles.

Ambition appeal refers to a human interest in people who have achieved success in some area of human endeavor, such as business, science, athletics, cultural activities, or industry. Human beings are interested in others who have achieved success, who have overcome odds, or who by the workings of chance have attained a measure of fame or a notable position.

Escape appeal refers to a human interest in escaping from everyday reality by fantasizing, daydreaming, or otherwise projecting one's self to another world, real or imagined. A photograph may provide the viewer with an opportunity to escape when it portrays subjects pursuing pleasure and adventure or when it depicts life in faraway places—subjects such as these appeal to the viewer's desire for escape. For a moment the viewer can empathize with the subject and be transported psychologically from the routines of life. (See Figure 12-18.)

Seeing picture possibilities that appeal to basic human interests such as these is a skill that can be developed. Study photographic subjects and analyze the feelings that a scene generates. Then consider how best to convey those feelings to a viewer. Emotional sensitivity can be developed, and with it the skill to create photographs with strong human interest.

FIGURE 12-18

Escape appeal. Desire to escape is conveyed in pictures of adventure, sport, and faraway places.

A

B

Photojournalism

Objective 12-G Describe some of the principles and techniques of news and documentary photography.

Key Concepts photojournalism, news photography, documentary photography, spot news, long shot, medium shot, closeup, general news, sports news, feature photographs, picture stories, shooting script, lead photograph

Photojournalism is a global concept that refers to the photographic reporting of a wide range of subjects and events of public interest, usually for publication. It includes both **news photography**, which reports events and other subjects of current interest, and **documentary photography**, which photographs subjects that possess some practical or historical significance.

The boundaries are not neat—news photographs often become historically significant and documentary photographs often make the news. What all types of modern photojournalism share is a dedication to objectivity and a commitment to communicate truth. Truthfully reporting an event often leads a photojournalist, as it does other journalists, to seek out a unique point of view that dramatizes the event, that calls attention to its salient details, and that involves viewers both intellectually and emotionally, not only in the event itself, but also in its meaning.

Photojournalists are journalists with cameras and, as such, share many of the obligations of other reporters. Although they may not be primarily writers, photojournalists still have an obligation to obtain sufficient information to write a small story or caption to accompany any photograph, explaining the who, what, why, where, when, and how of the captured moment and identifying featured people with correctly spelled names. Some photographers make use of a portable taperecorder to keep notes as they move rapidly from one shot to another, thereby avoiding having to stop shooting to write notes.

News Photography

The traditional categories of news photography are news (both spot and general), sports, features, and picture stories. The distinctions among these categories, however, are often blurred. Some sports stories may be of news interest and appear in the news sections of the newspaper; some news stories that affect sporting events may appear on the sports pages. Then again, any story may be approached as a feature—capturing an image that has a broad and timeless appeal, unbound by the urgency of a news deadline— or as a picture story—an in-depth exploration of the subject. What is most important in news photography, whether news, sports, features, or picture stories, is reader appeal—learning to recognize what interests the news reading public and to tell the story in a visually effective way.

FIGURE 12-19

*Spot news photographers often must place them-
selves close to the center of action that may threaten
their own personal safety. Demonstrations such as this
may suddenly turn violent as participants escalate
their actions and reactions.*

Spot News

Spot news generally refers to a breaking news event—an unexpected,
rapidly changing, newsworthy event of limited duration. As spot news
photographers, photojournalists may find themselves covering stories
such as crimes, accidents, fires, or natural disasters to a news publication
deadline. Spot news photographers must possess an uncommon single-
mindedness to get to the scene rapidly, to get into the middle of the
action, and to get the story, often under adverse and dangerous conditions.

Getting to the scene in a timely way is often the major challenge faced
by the spot news photographer. Arriving at the scene of a major fire just
as the last glowing embers are being extinguished provides little opportu-
nity to capture a dramatic news shot of the blaze in progress. Most spot
news photographers, therefore, equip themselves with a radio scanner to
learn about breaking stories early, and good area maps to help them get
to the stories fast.

The photographer should arrive at the scene prepared to start shooting
immediately—cameras loaded with film, flash units fully charged, and a
cool head prepared with a plan. Breaking events are unpredictable and it
rarely pays to wait patiently for a better shot—the shot at that moment
may very well be the best that will occur. Saturation shooting—continuous
shooting from every conceivable angle—is the general rule for spot news
photography. Nevertheless, it pays to have a strategy for approaching fast-
moving events.

One way to be sure that the events are fully covered is to look for
three basic types of shots—the long shot, the medium shot, and the close-
up. The **long shot** establishes the overall scene of the event and the rela-
tionships among all the important elements. It is useful for establishing the
scale of the event and describing its location. In a fire scene, for example, a
long shot might include the fire itself, the firefighters and their equipment,
and perhaps even the nearby structures that may be threatened by the
fire. If it is a major fire, one photographer might even be dispatched in a
helicopter to obtain long aerial shots of the scene that include the sur-
rounding neighborhood.

For **medium shots**, the photographer will move in closer to the events so that the important participants and their actions can be seen clearly as well as the background of their activities. In the fire scene, for example, a medium shot might include several firefighters struggling to direct a high-pressure stream of water onto a hot spot of the fire, or using a crane to attempt a rescue from an upper story window.

For **closeups**, the photographer moves in even closer to obtain details that provide additional impact. Often so tight that nothing more than a face fills the frame, a closeup of the fire scene might include only the sweaty face of an exhausted firefighter, or a paramedic comforting an injured child.

Of course, varying camera-to-subject distance alone does not guarantee adequate coverage of a spot news event. The photographer must continually look for a point of view that will best dramatize the subject and call attention to the most important details. Furthermore, the photographer cannot stop shooting until the event is concluded, and even then must be alert to subsequent events of possible interest. From beginning to end, the photographer must continually evaluate the news value of all elements of the event and try to capture them on film from various points of view.

General News

General news refers to newsworthy events and subjects that are planned, expected, or predictable. As general news photographers, photojournalists may cover such events as meetings, news conferences, stage performances, courtroom proceedings, political and government events, award ceremonies, or funerals.

While the major challenge of spot news photographers is getting to the event in time, the challenge for general news photographers is to find something interesting and meaningful at the event. Although they have the advantage of knowing when and where an event will take place and can plan well ahead to be there, general news photographers face endless repetitions of cliché events that all look astonishingly alike. After all, what visually distinguishes one meeting from another, one award ceremony from another, one news conference from another, other than the fact that different persons perform the rituals? It is a challenge to the creativity of the general news photographer to seek out and dramatize that which characterizes an event and makes it unique. As with spot news photography, it pays to have a strategy for covering general news events.

The key to shooting interesting general news photographs is to focus attention on the participants—the principals as well as the audiences, observers, and onlookers to the event. Good people pictures make good general news pictures. Seek out medium and closeup shots showing animated, emotional facial expressions, characteristic hand and arm gestures, and actions that reveal relationships, such as the natural embracing, shoving, or comforting actions or the handling of objects that occur naturally between people as the event unfolds. Try to capture the principals in action and avoid the cliché smiles and handshakes, handing off of awards, posed lineups, and document signings that are sure to bore editors and viewers alike.

FIGURE 12-20

Free movement for photography is often restricted during congressional hearings, courtroom proceedings, or other formal meetings. The general news photographer often must shoot closeups such as this from a distance under available light without disturbing the decorum of the event.

Because many general news events involve political and government figures, entertainers, or legal proceedings, photographers often face substantial restraints on their movements. It is always a good idea to arrive early to establish an advantageous shooting position; however, photographers often find themselves locked in closely to that position throughout the event. Usually they are not permitted to roam freely about courtrooms or during other government proceedings, and security staff may restrict their movements when government officials or leading entertainers are nearby. Further, most stage events and legal proceedings prohibit the use of flash photography. Therefore, many general news photographers arrive at an event equipped with fast lenses and films for shooting in available light, and several cameras, each with a different lens, so that long shots, medium shots, and closeups can be shot from nearly the same position.

Knowing that picture opportunities may be limited during a general news event, general news photographers should remain alert to opportunities both before and after the event. Sometimes the best shots are obtained before the event, during preparations or rehearsals, or after the event when the party is breaking up and the principals move from center stage. At both times the principals tend to be more relaxed and informal, and the photographer has more mobility to gain an advantageous position.

The task of the general news photographer is to recognize the essence of an event and to tell its story in a truthful and interesting way. It is important that the photographs reveal the meaning of the event, and not merely accidental, irrelevant details that contribute nothing toward the viewer's understanding.

Sports News

Sports news covers a wide range of subjects, including team sports such as football and basketball, individual competitive sports such as tennis and boxing, and personal sports activities such as surfing and skiing. A sports news photographer needs a complete knowledge of the sport, including its fine points, the athletes, the teams, and their equipment to be in the right place at the right time to capture its decisive and dramatic moments.

The challenge for the sports photographer is to capture the dramatic shots that best summarize the most significant moments in the action. For the viewer, the sport picture of greatest interest is the knockout punch, the game-winning play, the record-breaking jump, the turning point in the game. Even though other plays and actions may be wonderful to behold, it is that decisive, significant moment that most captures reader interest. As with other types of news photography, it pays to have a strategy and to be prepared to seize that moment when it happens.

Know the sport. Without an intimate knowledge of the sport, the photographer cannot have the sense of when and where the decisive action will take place and what equipment will be needed to capture it. In many sports, such as in boxing or during the running of a football play, a motor drive may be useful to capture the decisive moment if it occurs in the midst of very fast and continuous action. Many sports photographers who use a motor drive still prefer to click off their shots one at a time,

FIGURE 12-21

Good sports photgraphy requires the photographer to know the sport well enough to anticipate where and when critical action or plays will occur and to be ready to capture these moments on film.

using the motor drive only to advance the film rapidly between shots. They prefer to use their own instinct to capture the decisive moment rather than hope that the moment will be captured in a mindless, motor-driven sequence of shots.

Know the venue. At local games, photographers are likely to have greater mobility to move around the edges of the action and to position themselves advantageously. At major games of national import, their movements may be more limited and arriving early with long lenses and fast film will provide a better opportunity to obtain a better shooting location. Indoor sports may provide opportunity to move in close to the action with flash while outdoor events may force the photographer farther from the action and require available light photography. For outdoor events held at night, an early arrival will permit the photographer to obtain light-meter readings at various points on the field.

Know the stats. If any records are about to be broken, the photographer will want to be in position to capture that record-breaking moment.

Know the players and the teams. If photographers understand a team's strategies and the techniques of individual athletes, they will be more likely to anticipate what action will take place, when, and where. In this sense, sports photographers function nearly as the athletes themselves, thrusting and parrying with their cameras in the very heart of the action.

The task of the sports news photographer is to recognize the significant moments during sport action and to capture those moments in a dramatic way. The photographer's task also includes telling the complete story of the event, including spectator reactions, preparations for the event, and followup photographs of key players, both winners and losers, and their coaches and staffs.

Features

Feature photographs differ from news photographs in several different ways. News photographs are timely and interest in them wanes rapidly. A photograph of tonight's winning touchdown pass by the local high school quarterback has great news value in tomorrow's local morning paper. But its news value is close to zero a couple of weeks later. It is no longer news!

A feature photograph, on the other hand, has an enduring quality, unbound by the ephemeral quality of news, maintaining interest value weeks, months, often years later. Sometimes called "evergreens," good feature photographs do not fade with the season, but remain ever fresh.

A feature photograph usually records some commonplace moment in the flow of everyday events, but presents it in a way that arouses immediate empathy in the reader. In a sense, a feature photograph is a moment in the life of Everyperson, dramatizing the trivial adventures that are common to folks like ourselves, and sometimes even to human beings everywhere. A good feature can make you laugh, cry, or just pause for a moment of amazement or recognition.

FIGURE 12-22

Feature photographs possess a timeless quality that transcends the immediacy of news. Not necessarily tied to particular events or personalities, a good feature can be published at any time.

Usually we do not recognize the persons in feature photographs—their identity is not important to our understanding of the picture. In fact, it is our lack of recognition that helps us empathize—the subjects could be anyone, even ourselves, and the meaning would be the same.

Making good feature photographs is the business of all news photographers. Rarely are news photographers sent out on an assignment to do a feature. Rather, they must be alert to feature opportunities that arise in the normal course of their other news assignments. In the midst of a flood, for example, the photographer might spot a burly rescue worker ministering to a small puppy tucked in his shirt. Years from now it won't matter who that worker was or what disaster it was. Its lasting interest value arises from our recognition that in an extreme situation a tough person reached out to protect a helpless creature.

There is no simple strategy or checklist for making good feature photographs. What is required is an abiding sense of humanity—an ability to

empathize with other human beings and to recognize that which makes us human. The photographer must have the capacity to be moved by an event to recognize that others would also be moved. Beyond this recognition that the event has a human interest appeal, the photographer must have the technical and personal skills to capture the essence of the moment without disturbing it.

Picture stories

A **picture story** is a set of images that work together to tell a story or explore a subject. Sometimes the set of images represents a sequence of events; other times it represents various aspects of a subject, unrelated in time, but connected by the underlying theme or subject. A picture story includes not only photographs, but also the headlines, captions, and accompanying text, all in a carefully coordinated layout of pages.

This form of photojournalism developed during the 1930s when picture magazines were beginning to appear in Europe and America and was brought to perhaps its highest form by *Life* and *Look* magazines in the middle of that decade. The approach to picture stories that these great magazines developed so successfully involved careful research and planning of the story in advance, usually by the editors. Following this approach, the editors would develop an outline of the story, called a *shooting script*, and then assign it to the photographer, who would then set out to photograph a set of related and cohesive images defined by the script.

In the decade that followed, many photographers began to experiment with freer approaches to picture stories, unbound by the preconceived structures of shooting scripts prepared by editors who were often less visually literate than themselves. Led by the work of W. Eugene Smith, these photojournalists would take up a story idea with few preconceptions of what direction it might take. Working without a script, they would immerse themselves in the story, sometimes for extended periods of time, to gain intimate understanding of all its angles and nuances, allowing the story to take shape out of their experiences. Smith's own seminal photo essay on the life of a country doctor, published by *Life* in 1948, grew out of a six-week stay during which he accompanied the doctor night and day, making photographs of the ordinary as well as the extraordinary activities of this dedicated man. His story was a revealing and sensitive portrait that moved readers to a new level of understanding about the work of rural doctors.

Few publications today, however, will fund extended photographic projects of this sort. To photograph long-term projects, photojournalists generally must underwrite them themselves or seek grants from foundations or agencies outside the publishing industry.

As with good features, there are no simple formulas for developing good picture stories. A good story starts with a good idea, and ideas for picture stories arise from the photographer's knowledge and understanding of what interests people and what is interesting about them. Armed with a good idea, however, the photographer may then develop an approach to the story.

Before shooting, it is a good idea to gather as much background information about the subject as possible. This will help the photographer establish rapport with the principals of the story, and also will prepare the photographer to recognize and capture the salient moments when they occur. Try to imagine the headline for the story and the **lead photograph** that best summarizes it. Although these may not actually be used and both may change as the story develops, at any given moment they provide a central point of view to guide shooting and to keep the photographer close to the subject.

Some photographers prefer to develop a shooting outline at this point, one that is flexible and responsive to constantly changing events. Even though the outline may change moment-for-moment, having an outline will assure that the photographer stays on track and does not overlook shots that are important to the story's continuity. At best, the outline should serve as a guide rather than a rigid plan; the photographer should remain focused on the story, changing the outline as needed to tell the better story.

Once the photographs have been made they must be edited—a few photographs must be selected to tell the story from the hundreds that were taken—and accompanying text must be written. The photographs and text must then be laid out on the pages in an effective manner. Usually one photograph is selected as a lead photograph that best summarizes and captures the story as a whole, made larger than the others and placed in a dominant position. Then text, captions and other smaller pictures are arranged to support and explain the lead.

Many photojournalists consider the picture story as the highest form of their profession because it allows them to explore their subjects deeply, digging below the surface to reveal complex issues and subtle nuances of meaning from many points of view. The picture story releases them from the constraints of time—where the single photograph captures a single fleeting moment, the picture story permits photographers to extend their vision through time to document and comment upon complex processes and human activities.

Documentary Photography

Writing shortly after the invention of photography, Oliver Wendell Holmes, the noted doctor and philosopher, recognizing the camera's enormous potential for shaping the world to come, made a remarkable proposal. Wondering what was to become of the millions of photographs that were already gathering on tabletops and in bureau drawers throughout the world, he suggested that these fabulous pictures "will have to be classified and arranged in vast libraries, as books are now." Prophetically, he wrote,

We do now distinctly propose the creation of a comprehensive and systematic [photographic] library, where all men can find the special forms they particularly desire to see as artists, or as scholars, or as mechanics, or in any other capacity.

Clearly Holmes saw the value of photographs as documents—vivid, concrete, and dramatic records for the study of history, science, technology, or any other matter of human interest. From the click of the first camera's shutter, photographers have been recording the sights and events of history—trivial events of family life, the cataclysmic events of war and catastrophe, or the sights of faraway places and people. While some of these photographers were subsidized in their efforts by employers or sponsors, and others were motivated by an expectation of profit, millions made photographs simply because opportunity and interest were there. Most were likely unaware that their photographs might possess some social or historical significance. With a few notable exceptions, these graphic, silent records gathered in private attics and albums for nearly a century before Holmes' "distinct proposal" was formally realized in the founding of the National Archives, which maintains one of the world's great collections of American historical and documentary photographs.

In documentary photography we see a form of photojournalism that is often motivated more by a personal need to record significant sights than to report the news. When John Lloyd Stephens and Frederick Catherwood recorded daguerreotype images of their archeological expedition to the Yucatan in 1841, they were motivated by a scholarly need to record what they did and what they found. Similarly, William Henry Jackson and Timothy O'Sullivan, as official photographers on geological surveys, were motivated to record the sights and features of newly explored territories, not for news reportage, but for the historical record. Others, like John Thomson in London and Eugene Atget in Paris, documented ordinary street life in their respective cities, not for profit and not for news, but to satisfy a need within themselves to show what life was like in their own time. Atget pursued this work for over thirty years, died in poverty, and left a legacy of over ten thousand photographs to future scholars and historians.

Some enormous documentary enterprises cannot be fully explained. For example, all that we know about Mathew Brady's legendary documentation of the American Civil War suggests that Brady himself could never explain why he did it—certainly there was no profit in it and only a small number of his images, copied onto woodcuts, ever appeared in the news media. Yet Brady had a sense of the historical significance of his work and was driven to persist. Similarly, Edward S. Curtis undertook to document the life and culture of the vanishing indians of North America. Starting in 1896, Curtis endured incredible physical hardships for over thirty years, gathering over forty thousand negatives, mostly large glass plates, before completing his work. Curtis suffered enormous financial hardship for the first decade of his work until he found a patron. Curtis, like Brady, was driven to his work for reasons he found difficult to explain. He felt it needed to be done before the indian culture vanished altogether.

Many other major documentary projects have been undertaken for reasons other than news value. The work of Jacob Riis, Lewis Hine, and the Farm Security Administration under Roy Stryker are a few notable examples. What distinguishes documentary photography from news is that history provides its primary motivation—a need to record events and sights so that their graphic, visual details can be remembered, and perhaps studied by future generations.

Famous Photographer: Lewis Wickes Hine

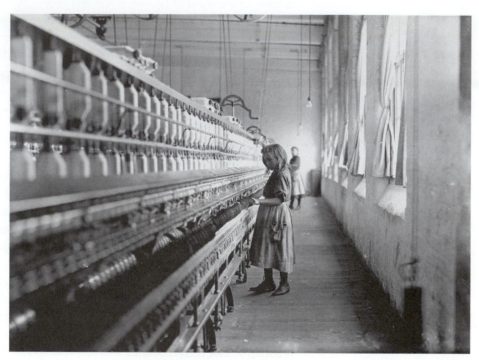

FIGURE 12-23

Lewis W. Hine, "Little Spinner in a Carolina Cotton Mill," 1909.

Lewis Wickes Hine first established his reputation as a "conscience with a camera" with his photographic investigations of immigrants at Ellis Island in 1905 while he was still teaching science at the Ethical Culture School in New York. In 1908 he published a strong, illustrated criticism on social conditions that led *Charities and the Commons,* a magazine of social commentary, to hire him away from teaching to make photographic "documents of injustices." His early photographic investigations concerned the plight of the underprivileged brought on by industrialization—the atrocious living conditions of immigrant laborers on the New York State Barge Canal, the growing tenement slums of Chicago and Washington, living and work-

ing conditions among Pittsburgh miners and steel workers (later published as *The Pittsburgh Survey*), and the exploitation of children who were forced to perform menial mining and factory labor.

Three years after his first set of child labor photos appeared in *The Pittsburgh Survey,* the National Child Labor Committee appointed him, as a staff photographer, to investigate child labor conditions in the United States. Between 1908 and 1921 he made over 5000 photographs for the Committee. His brief, but carefully documented sociological records accompanied by his shocking pictures of young children tending dangerous factory machines, working in hazardous coal mines, and hawking newspapers in freezing weather late at

night, made the truth vividly clear. He found that over 40,000 children under 16 years of age worked in the cotton industry alone—a massive labor force that not only exploited these children and doomed their futures, but also undercut the wages of an entire adult labor force. Ultimately, an aroused nation demanded and the federal government enacted a protective child-labor law that put an end to such practices.

During World War I, Hine covered the work of the Red Cross and the effects of the war in Europe. Returning home afterwards, he turned to documenting industrial working conditions, emergency relief, rural nursing, and health programs. He wrote, "I wanted to show the things that had to be

corrected: I wanted to show the things that had to be appreciated."

Wisconsin born, Hine worked at a succession of labor and factory jobs after high school, learning first hand what he would return to document years later. He took extension courses in art, but decided to pursue a teaching career, for which he enrolled at the University of Chicago in about 1898. In 1901 he took a position teaching science at New York's Ethical Culture School, where he remained for seven years. He studied sociology at Columbia and New York Universities and was awarded a masters degree in teaching from New York University in 1905. Hine was a self-taught photographer who began photographing seriously at the age of thirty-seven. His exhibitions include: Civic Art Club, New York, 1920; Riverside Museum, New York, 1939; Des Moines Fine Art Association Gallery, Iowa, 1939; Lewis W. Hine traveling exhibition organized by International Museum of Photography, Rochester, New York. Collections of his work are maintained by the International Museum of Photography; Library of Congress; Exchange National Bank of Chicago; Hine Collection, New York Public Library; Tennessee Valley Authority Graphics Division; Prints and Photographs Division, National Archives.

Questions to Consider

1. Describe the basic differences in approach that are appropriate for grand and intimate scenic photographs.

2. How may filters be useful in scenic photography?

3. Name several ways to approach a scenic shot.

4. In what situations might backlighting be desirable in scenic photography? In what situations might cross-lighting be desirable?

5. Distinguish between architectural record shots and architectural interpretive shots.

6. How can the converging parallel lines in architectural photography be dealt with?

7. Suggest several ways to provide a frame of reference against which to view an architectural shot.

8. How might filters be used to enhance architectural shots?

9. What is the difference between a record shot of objects and a good still-life photograph?

10. Describe the lighting principles that apply to still-life photography.

11. List the accessory equipment that may be of particular use in still-life photography.

12. Describe one approach to photographing people. What principles might be applied?

13. Name and explain several types of action.

14. What techniques might be used to enhance movement and action in action photographs?

15. What are human interest photographs? Give some examples.

16. How do the photographer's feelings about a subject affect his or her approach to photographing it?

17. Describe how you might approach covering a freeway accident with fatalities, a press conference by a political candidate, and a circus performance. What are the major differences in your approach to these subjects?

Suggested Field and Laboratory Assignments

1. Shoot, process, and print a roll of film that includes at least the following shots:

 a. a grand view scenic photograph

 b. an intimate view scenic photograph

 c. a record architectural photograph

 d. an interpretive architectural photograph

 e. a still life

 f. people engaged in characteristic activity

 g. people in action (real, peak, simulated)

 h. emotional appeal subjects

 i. a general news subject

 j. a spot news subject

 k. an action sports subject

 l. a feature subject

Unit **Thirteen**

Carl Jensen, "Doppelgänger #9," 1992.

UNIT AT A GLANCE

The field of photography is constantly evolving as new techniques and technologies emerge. Those who wish to delve a little more deeply into some of the more advanced or specialized areas within the field or who wish a glimpse of some of the more advanced technologies will be interested in the special topics addressed in this unit. The following objectives elaborate upon the fine print, the zone system, processing for permanence, large format photography, closeup and copy photography, electronic photography and imaging, and law and ethics in photography.

The Fine Print

Objective 13-A Describe the appearance and production of a fine photographic print

Key Concept Full-scale print

The Difference in Quality

Many beginning photographers have difficulty making fine prints because they have never seen one. We are usually exposed to great photographs only in books and magazines, and without thinking, we form expectations of what a good photograph should look like based on these rather poor reproductions. There is a great difference between looking at a printed reproduction of a photograph and viewing an actual photographic print. An image in a book is made up of small dots of black ink absorbed into a sheet of paper. A photographic print on the other hand, consists of sparkling bits of silver suspended over the paper in a gelatin emulsion. A fine photographic print has a sense of internal illumination and a sensuality of tones that no reproduction process can match.

The technical quality of a fine print can be defined, and understanding the components of fine printing will help to guide the photographer's own efforts. The expressive potential of a fine photograph depends to a great extent on the range of tones represented in it and the clarity with which different tones are separated from one another. A **full-scale print** is one in which all tonal values are present and well defined. In a high-quality full-scale print, only the small areas of specular highlights are reproduced as pure paper white, and only small areas of the darkest shadow values are printed as maximum black. The remainder of the bright highlights and dark shadows are clearly delineated and contain textural information, value, and depth. The many middle gray tones are clearly differentiated with vibrancy and clarity. Figure 13-1 shows a full-scale print and identifies the major tone values present in it.

A photographer's mastery of the craft of fine printing, as well as his or her expressive growth, will be much assisted by seeking out and studying original photographic prints. Many metropolitan galleries and museums have fine collections of outstanding photographic work on display. It may even be possible to view the work of a photographer that one has grown

0 I II III IV V VI VII VIII IX

A

FIGURE 13-1

Example of a full-scale print. **A.** *Zone system scale.*
B. *Full-scale print showing all tonal values.*

B

to know and admire through books and other reproductions. The richness and depth of expression that the original silver prints offer make a lasting impression, one that can only serve to enhance a photographer's own darkroom work.

Control of Tone and Contrast

Many factors affect the tonal qualities of the final print. In fact, every step in the photographic process contributes to the final result. Film selection, image format, lighting, exposure, film processing, paper selection, exposure, print processing, and finishing all work together to determine the technical quality of the resulting print.

The tonal richness of a print depends primarily on the negative, so achieving good print quality requires that good negative quality be obtained at the outset. Although tone and contrast can be enhanced during printing, the characteristics of the negative limit the range of enhancement that is possible. Some major factors affecting tonal rendering, densities and contrast of negatives are described below.

Film selection Some films possess more inherent contrast than others. Generally, slower speed films have higher inherent contrast than faster speed films. Slower speed films also tend to have a smaller grain structure.

Image format Medium- and large-format negatives have a larger storage capacity for recording information than does the comparatively small 35-mm format. Larger negatives permit more details, textural information, and tones to be initially recorded on the film for later translation to the print.

Lighting Exposures made in bright sunlight produce higher contrast negatives than exposures made in diffused light. Choose a lighting condition appropriate to the subject and rendering desired. Low-contrast photographic subjects may benefit from the added tonal separation provided by specular lighting, while other subjects may need the harmonious treatment of diffused illumination.

Exposure Density in the thinnest areas of the negative (the shadows) is controlled primarily by exposure. Underexposure results in some shadow details not being recorded on the film. Unrecorded details can never be made to appear in the final print. Details in the densest areas of the negative (the highlights) are controlled by exposure plus development. Overexposure and/or overdevelopment may result in highlights so dense that they are difficult to print. Bracket your exposures on important subjects to assure a correct negative.

Film processing Increasing development time tends to increase negative contrast, while decreasing it tends to reduce negative contrast. Altering development time affects the highlights more than the shadows. Also, some developers tend to increase contrast; others tend to decrease it.

Control of Print Quality

Just as many factors affect negative quality, many factors also affect print quality. The materials and chemicals used for printing can be carefully selected to interpret the negative for the desired expressive statement. Within the limits imposed by the negative, final print quality will be affected by such factors as the paper selected, exposure time, enlarger system, and print processing.

Paper selection Print contrast is controlled primarily by choice of paper grade (or contrast filter, in the case of multigrade papers). Some papers have more inherent contrast than others and tend to increase print contrast. Surface texture also affects contrast and the overall tonal range. Glossy surfaces tend to produce a wider range of tones and greater separation than less glossy or matte surfaces. The type of paper selected also plays a role in producing fine prints. It is generally easier to achieve a rich, full tonal range when printing on fiber-based paper rather than on resin coated paper.

Exposure Print density is controlled primarily by exposure. Ideally, prints should be exposed so that they will reach their optimal density in the full, normal developing time. Overexposed prints suffer loss of tonal separations in the darkest areas. Underexposed prints fail to achieve needed tonal separations in the lightest areas.

Enlarger system The quality, cleanliness, and condition of the enlarger lens affects both sharpness and contrast. A fine enlarging lens capable of producing images that are sharp from corner to corner is a must.

The enlarger head should be aligned to ensure sharpness, and it must produce an even illumination across the picture field. Condenser lighting systems also tend to increase contrast and sharpness; diffusion lighting systems tend to decrease contrast and to soften apparent sharpness.

Print processing Many processing factors can affect print quality. Papers and chemicals should be stored and used under conditions that will maintain proper temperatures, freshness, and purity. Failures to use materials that are in the best possible condition can result in loss of contrast, poor image tone, and stains. Optimal contrast and density are best achieved using full, normal development time. Underdevelopment of prints causes muddy-looking, often uneven, brownish image tones. Overdevelopment of prints and improper fixing can cause loss of tonal separations in the highlight areas, fog, and chemical stains. Decisions about which developer to use will also affect contrast. Some developers increase contrast, while others decrease it.

Characteristics of a Fine Print

When all the factors affecting technical quality in the negative and in the print are under control and working together, optimal technical quality can be expected in the final print. The desirable characteristics of a high quality, full-scale print are:

1. Specular highlights print as white (base white). The presence of any image density in these small highlights reduces image brilliance.

2. Darkest subject tones print as deepest black (maximum density). The lack of deepest black also reduces image brilliance and restricts the overall tonal range.

3. Light objects in the shadows are visible as dark gray tones. Shadow details can be seen.

4. Light objects in the highlights are visible as light gray tones. Highlight details also can be seen.

5. Different tonal values are separate and distinguishable throughout the mid-tone range. The print has a rich variety of middle-grays.

6. Grain is not obtrusive unless used for special effect.

7. Image is clear and sharp except where selective focusing or blurring is used for special effect.

8. Print is totally free of imperfections such as dust specks, stains, scratches, fingerprints, uneven borders, retouching marks, or other, unintended, nonimage blemishes.

Figure 13-1 shows a high quality, full-scale print. Of course, the ink reproduction in this book can only approximate the tones and contrast of the original photograph; a fact that is true of all photo reproductions. However, the qualities of a good print should become clear. A review of Figure 7-27, page 221, will remind you of the characteristics of poor prints.

The Zone System

Objective 13-B Describe the basic principles of the zone system.

Key Concepts previsualization, zone scale, expansions, contractions

A more comprehensive approach to precise control of tone and contrast is the **zone system,** developed originally by Ansel Adams and Fred Archer.

The zone system is based on the concept of **previsualization,** a process by which the photographer analyzes the tonal values present in the subject and plans, before exposing the film, how to represent these values in the final print. In other words, one tries to visualize just how the final print will appear. Then, a light meter is used to measure the relative brightness of various parts of the scene, and an exposure is determined that will, with proper development, render the various tonal values in the scene to the desired levels of density in the negative.

The system is based on a printed gray **zone scale,** such as that shown in Figure 13-2. Ten distinct shades, or zones, of gray are represented. The deepest black (maximum print density) of Zone 0 results from no exposure on the negative; the maximum white (minimum print density) of Zone IX results from maximum exposure on the negative. Each successive zone represents double the exposure of the preceding zone—a one f/stop increase. The average shade in a full-scale print is the medium gray of Zone V, which is the same tonality as an 18% grey card. Reflected light meters are designed to read Zone V values. For all practical purposes, clear, visible details may be expected only in Zones III through VII.

Table 13-1 explains the zone scale and the exposure adjustments that must be made to a light meter reading to place a subject on a zone other than Zone V.

The density of the low zones (I through IV) is determined mainly by exposure; small changes in exposure will greatly affect the amount of detail rendered. The low zones can be placed at any point on the tonal scale by making the exposure adjustments noted to the left of the zone number. Changes in development have little effect on the low zones. The density of the high zones (VI through IX) is controlled primarily by the film development. Changing the development will greatly shift the tonal values of the high zones, even though changes in exposure have comparatively little effect.

Through careful testing of each film/developer combination, photographers can learn to place various subject light values in the zones they desire. By manipulating exposure, they can shift the entire tonal range of the image upward or downward in the scale, altering the tonal rendering of various details. The development time can be manipulated to alter the range of tonal values and contrast. Longer than normal development times, or **expansions,** give further contrast and separation to a flat tonal scene. Alternately, the development time may be reduced to give a **contraction** of an overly high subject brightness range in order to better represent the relative light values present in the scene. See Figure 13-2 for examples of zone system applications. The books by Ansel Adams and Minor White that are listed in the References on page 479 provide extensive explanations of the zone system.

TABLE 13-1 The zone system scale

Exposure Adjustment	Zone	Description/ Normal Subject Values
+4	IX	Pure photo paper white without tonality or details. The highest zone modern photo materials can handle.
+3	VIII	Very light gray—the least perceptible change of tone from pure white. Zone VIII carries only a suggestion of very light details: sunlight on white walls, white t-shirts, and so on.
+2	VII	Light gray. *The lightest usable detail.* Bright textured detail such as snow or sand, highlights on skin, clouds.
+1	VI	Richly textured light gray. A blue north sky, Caucasian skin, light hair, sand or snow in shadow.
O	V	*Middle gray* value. 18% gray. Green grass, foliage, stone, dark skin, or skin in shadow.
−1	IV	A medium dark value. Important dark shadows, blue jeans, dark hair, shadows under trees. Full detail held.
−2	III	Dark values. *Darkest usable detail.* The darkest area of the print where full detail and texture are rendered. Deep textured shadows.
−3	II	Very dark values. Shadows within shadows. The first slight suggestion of detail and texture.
−4	I	Almost black. The first barely perceptible change from pure black. No detail or texture.
−5	0	Pure black, the blackest tone of photo paper.

FIGURE 13-2

Zone system applications. *A.* For soft light the range of densities was limited to only a few middle tones. *B.* Zone system scale. *C.* For stark contrast the middle densities were omitted and only the extremes were included.

A

C

B

Processing for Permanence

Objective 13-C Describe the methods and materials used in processing for permanence.

Key Concept Archival processing

Fiber-based prints that have received normal processing may still contain some residual chemicals that can cause staining and fading over several years. **Archival processing** involves taking special precautions to assure that the print will be as chemically free, stable and long-lasting as possible. Any image that may have historical or collectible value should be produced with archival processing procedures. A correctly developed and stored fiber-based photograph may be expected to last several thousand years. A poorly processed photograph may begin to deteriorate in only a few months.

Selecting Materials

Producing long-lived archival images begins with the selection of the most stable materials. Although resin-coated papers are convenient, there is some concern about their long-term stability. High-quality double-weight fiber-based enlarging papers are generally recommended for maximum stability. Many fine art photographers adjust their easels to allow for large, one-inch white borders. Such borders act as a barrier and a "telltale" area for potential stains and degradation. Quality chemistry is also important; use only freshly mixed chemicals and change the baths frequently. The manufacturer's recommended capacities are usually reduced by 50% for archival processing to assure fresh solutions.

Special Processing and Fixing

Careful processing technique is important, especially in the fixing, washing and drying steps. The fixing step must be thorough enough to remove all residual silver salts, but it cannot be prolonged or the fine highlights may be degraded and washing efficiency will be hampered. A single fixing bath is not desirable; it is far better to use two separate fixing baths, both composed of powdered sodium thiosulfate-based fixer.

The first fixing bath is used for three minutes. Because it does most of the work, it will contain most of the harmful fixing byproducts. After the first bath, the prints are transferred to a second bath, again for three minutes. This bath, which does comparatively little work, remains fairly fresh and free of byproducts, thus assuring complete fixation. After roughly one hundred 8-in. by 10-in. prints (or equivalent square inches) are processed per gallon of fixer, the first bath is discarded and is replaced by the second bath. A new batch of fixer is then prepared for the second bath. This two-bath procedure has been favored by most critical workers, including Ansel Adams. Many photographers place the prints in a holding tank of running

water after the first fixer and do the second fixing step only when a group of prints has been accumulated.

A different fixing method has been advocated by Ilford; many creative photographers have adopted it as a workable and convenient way to assure archival-quality fixing. This method uses a single bath of ammonium–thiosulfate-type film-strength fixer, without the hardener. The hardener is left out to reduce the washing time and make spotting easier. In this method, the fix lasts only sixty seconds, with continuous agitation. The short fixing time reduces the saturation of the fixer deep into the paper fibers, where chemical byproducts become trapped and are difficult to wash free. No more than fifty 8-in. by 10-in. prints should be processed per gallon of fixer with this method. Ilford recommends a five-minute first wash, followed by a ten-minute treatment in a sodium–sulfite-based washing aid such as Ilford's Universal Wash Aid, and a final wash for five minutes.

Toning for Preservation

A very dilute selenium toning solution will cause a subtle change in the image color, intensify the maximum black, and protect the print from atmospheric pollution. A partially washed print placed in selenium toner immediately forms blotchy yellow stains. Such stains can be avoided only by a complete wash before toning, or by placing a print straight out of the fixer tray into the toner. Most photographers prefer to do the latter; the toner can be combined with hypo clearing agent so that both steps can be carried out in a single bath. Use one part Kodak Rapid Selenium Toner diluted with twenty parts Kodak Hypo-Clearing Agent. The time in the toning bath varies with the intensification desired, but five to six minutes is usually adequate. The print should be thoroughly washed after toning. Wash temperatures higher than 68°F should be avoided.

Washing

Prints should be thoroughly washed in a washer designed to bring fresh water to the surface of each print. Tray washing is not effective unless the prints are frequently interleaved so that fresh wash water can reach all prints. If a tray must be used, only a few prints should be washed at a time; they should be well separated; and the tray should be dumped often to remove the heavier fixer residues that accumulate on the tray bottom. The washer design, water flow, and print processing procedures used all affect the final wash time. It is not unusual to wash for one-half to one hour or longer.

Drying

A safe and archival way to dry prints is to air dry them on fiberglass screens. A simple dryer can be built easily with a frame of canvas stretchers or 1-in. by 2-in. lumber covered with fiberglass window screening. Drying time depends on the ambient temperature and humidity but usually takes overnight. After drying, the prints can be placed in a stack under a heavy weight to flatten them.

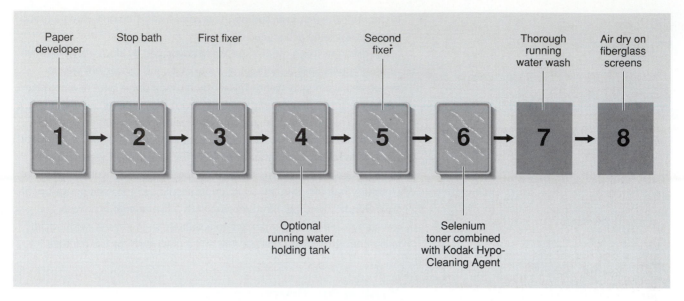

FIGURE 13-3

The steps in archival processing.

Mounting and Storage

To protect prints, only rag or other acidfree mounting board and window mat should be used. Even archival quality mat board will absorb pollutants from the air and will need to be replaced in time. For this reason, fine prints should not be dry mounted. Instead, archival photo corners or special tissue hinges should be used to attach the print to the board.

Prints should be stored with care in archival boxes. High temperatures, high humidity, and high lighting conditions (if prints are displayed) should be avoided.

Large-Format Photography

Objective 13-D Describe a large-format view camera and its basic controls.

Key Concepts camera movements, field camera, monorail camera, standards, covering power, neutral position, rise and fall, lateral shift, swing, tilt, Scheimpflug Rule, sheet film holders, corner notches, dark slide, film hangers

Reasons for Using a View Camera

Compared to working with the electronic, automated, and computerized 35-mm cameras we know today, using a view camera is almost like stepping back in time. The view camera requires the photographer to do everything, and often in a cumbersome way. A view camera is large and heavy and anything but spontaneous. It must nearly always be used on a tripod, it must be loaded with one piece of film at a time, and it makes the photographer hide his head under a dark cloth in order to barely see a dim

image that is upside down and backwards. Large format photographers go to all this trouble because they know that the view camera can make images that are impossible to duplicate with a roll-film camera.

Most view cameras use large format sheets of film that are 4 in. by 5 in. and larger. These large film sizes permit the recording of a wealth of details, textures and tonalities that cannot be equalled by smaller formats, and the development of individual sheets of film can be tailored to meet the requirements of each subject. In addition, most view cameras permit a range of **camera movements** that give control over the shape and sharpness of objects in the final image. By altering the position of the camera's front lens board and the rear film plane, the image can be manipulated to control perspective.

Types of View Cameras

View cameras are the simplest and oldest type of camera. They basically consist of little more than a lens at one end of a flexible bellows, with a ground-glass focusing screen at the other. Two basic designs are used for modern view cameras: field and monorail. **Field cameras** are usually lighter, more compact, much easier to carry around, and quicker to set up than their monorail competitors. On the other hand, **monorail cameras** are much more flexible tools that offer a greater range of camera movements for image control.

Field cameras Field cameras, sometimes called flat-bed cameras, are usually made out of wooden frames that interconnect to form a U-shaped base. This base sometimes has more than one section to allow the camera to telescope out for close focusing or long lenses. Field cameras fold up into very small packages and are convenient to travel with. Unfortunately, they cannot offer the full range of camera movements found on a monorail type camera and may not be quite as strong or stable. Composing and focusing is done directly on the camera's ground glass, as in any view camera.

Serious studio work, architectural photographs, and other demanding subjects are difficult to impossible to handle with field cameras. They are designed for landscape and other location work and are a delight to use under these conditions. Edward Weston and Paul Strand are among those who have worked with these beautiful polished wooden cameras.

Monorail cameras The front and rear uprights, or **standards**, on a monorail camera are mounted on a single metal tube that attaches to the tripod. This design sacrifices portability for a wider range of camera movements. Almost all rail cameras have a larger range of movements than any subject would ever need. Monorail cameras are the standard choice for studio, product, and architectural photographers who need precise image control.

The versatile design of a monorail cameras can accept accessories such as a interchangeable bellows and special recessed lens boards for wide-angle lenses. Some may even be outfitted with reflex viewing attachments and behind-the-lens light meters.

FIGURE 13-4

An example of a folding wooden field-type view camera.

FIGURE 13-5

An example of a monorail type of view camera.

Lenses

The lens is really the heart of a view camera. It is usually permanently mounted on a lens board that may be removed and exchanged with other lenses similarly mounted. A normal lens for a 4-in. by 5-in. film-size view camera would have a focal length of about 150 mm. A typical telephoto lens would be 210 mm; an often used wide-angle lens would be 90 mm. These two lenses would have approximately the same angle of view as 70-mm telephoto and 28-mm wide-angle lenses on a 35-mm camera.

Covering power is another important consideration in lens selection. **Covering power** refers to the size of the circle of illumination produced by a lens. To make full use of the view camera's ability to control perspective, the lens must project a usable image that is larger than the film size used.

Camera Movements

Conventional cameras are permanently aligned in the **neutral position** so that their lens and film planes are exactly parallel. View cameras can be deliberately unaligned through *camera movements.* The lens board and ground-glass film plane—the front and back standards—should be capable of a variety of physical movements on a quality view camera. These movements, described below, enable the photographer to precisely control the placement, shape, and sharpness of the image.

Rise and fall On view cameras, both standards are capable of moving up and down. This movement is called the **rise and fall**. Rise and fall controls the vertical position of the image on the film and can be adjusted to include more of the top or bottom of the subject without tilting the camera.

Lateral shift On many view cameras the standards can be moved sideways in a **lateral shift** and adjusted to include more of the right or left side of the subject. These movements are often used for refining the composition and framing of an image without disturbing the tripod.

Swings Swings are movements that twist the front or rear boards around a vertical axis. The front swing swivels the lens into a new relationship with the film plane and is used mainly to control depth of field of subjects arrayed along a horizontal line. The back swing angles the film plane and is used mainly to control the shape and perspective of objects.

Tilts Tilts are similar to swings except that they move around a horizontal axis. In this manner the standards may be tilted up and down. Tilts are also used to control depth of field and make perspective corrections.

Using camera movements effectively Camera movements are made to control the shape of objects—that is, perspective—and the sharpness or depth of field in the image. As a simplified rule, perspective is generally controlled by adjustments to the rear standard, and sharpness is usually controlled by adjusting the lens board.

To achieve correct perspective, the film plane must be positioned parallel to the main subject plane. This can be done by using the swings and

tilts on the rear standard to change the angular relationship of the camera's back to the subject. The effect of these changes is readily visible as a change in the shape of the image on the ground-glass focusing screen.

For maximum depth of field the **Scheimpflug Rule** should be observed. This rule states that the greatest sharpness will be achieved when imaginary lines drawn through the film plane, the plane of the lens board, and the subject plane all meet at some common point in space. The Scheimpflug Rule also is satisfied when the film plane, lens board, and subject plane are all parallel, for parallel lines can be considered to intersect at infinity. In practice, sharpness is controlled by changing the movements of the front standard, usually the front swings and tilts, until the Scheimpflug Rule is satisfied. Or, the correct position of the lens board may be found by observing the ground-glass focusing screen and noting where the increase in sharpness is apparent.

In photographing a tall building, for example, the back standard would be tilted until it was parallel with the building. This would produce the correct perspective on the film and give an image of a building whose top is the same width as its bottom. In this case the lens board also would be inclined toward the subject plane to increase sharpness. This movement would satisfy the Scheimpflug principle, as all three planes would be parallel. Remember, the effect of the camera movements can be seen on the ground-glass focusing screen, and the settings may be adjusted and refined until the desired visual relationship is achieved.

Using Sheet Film

Most view cameras are designed to use film in sheets, not rolls. Sheet film must be loaded into carefully cleaned **sheet film holders** that accept one piece of film on each of their two sides. Each sheet of film has a series of **corner notches**, which allow the photographer to determine the type of film and the emulsion position in complete darkness. Once safely in the holders, the film is protected from accidental exposure by a removable **dark slide**. After exposure the film is given conventional black-and-white processing. Sheet film can be developed in open trays, by using sheet **film hangers**, or in special daylight developing tanks. (See Figure 5-1 and the discussion on page 144.)

Common View Camera Accessories

Plenty of sheet film holders, a sturdy tripod, an accurate light meter, a cable release, and a dark cloth are all essential for successful use of a view camera. A Polaroid back is a highly valued accessory, because it allows the photographer to check composition and technique with an instant print. Roll film adapters are used by some photographers who like the control of the view camera but appreciate the convenience and inexpensive nature of roll film shooting. For location work the added protection of a lens hood and a UV filter may be desirable.

A

B

FIGURE 13-6

*A. Convergence results when tall buildings are photographed from a low angle with the camera movements in a neutral position as shown in B. **B.** The neutral camera position used for A. **C.** Correct perspective can be achieved by tilting both the camera's lens board and the film back until they are parallel to the building as shown in D. **D.** The position of the camera movements used in C.*

C

D

STEP-BY-STEP PROCEDURE FOR USING THE VIEW CAMERA

1. *Set up the camera.* Mount the camera on a sturdy tripod, screw in the cable release, and position all camera movements to their middle or *neutral position.*

2. *Roughly focus and compose.* Set the camera's lens to the largest aperture and open the shutter. Achieve an approximate focus by adjusting the length of the bellows. Use the focusing cloth and a small magnifying glass or jeweler's loupe for a better view. Move the tripod, or use the lateral shift and rise and fall to compose and frame the desired image.

3. *Make any perspective adjustments.* Use the swings and tilts to adjust the position of the rear standard to control the shape of the subject. Generally, the film plane should be aligned so that it is parallel to the subject.

4. *Adjust for sharpness.* Check the focus and, if necessary, adjust the plane of focus with the front swings and tilts according to the Scheimpflug Rule. Check final focus carefully.

5. *Make the exposure.* Close the shutter. Take a light meter reading and set the appropriate lens opening and shutter speed. Cock the shutter. Insert a loaded film holder, and remove the front dark slide. Make the exposure by tripping the shutter with the cable release. Replace the dark slide so that the black side faces the lens. Another exposure can now be made by reversing the film holder if desired.

Closeup and Copy Photography

Objective 13-E Describe some of the principles and techniques of closeup and copy photography.

Key Concepts closeup photography, image-to-object ratio, photomacrography, photomicrography, microphotography, macrophotography, focal distance, closeup lens, focal frame, bellows unit, extension tubes, macrolens, reverse adapter, exposure factor, ringflash, copying, the copy, copy negative, reproduction, copy stand, copy board, printing frame, line art, continuous-tone image, duplicate

Closeup Photography

Most cameras equipped with a normal lens can take pictures from as close as 2 to 3 feet (.6 to 1 meter). However, this is not usually close enough to get extreme closeups of small objects such as flowers, small animals, or insects. To obtain really dramatic closeups of small objects, the camera must be moved much closer to the subject. In order to focus this close to the subject, special lenses or accessories are needed.

Not all cameras are well suited for closeup work. At close distances, focusing and framing are critical. The slightest misdirection of the camera axis may shift the field of view far off the subject. Depth of field is extremely shallow at close distances, often no more than a small fraction of an inch. Consequently, extremely precise framing and focusing are necessary to assure that essential details are recorded in sharp focus.

The cameras best suited for closeup work are those that permit framing and focusing directly through the camera's picture-taking lens—the single-lens reflex and view cameras. Only these cameras permit one to frame and focus the image precisely as it appears at the focal plane before making the exposure. Closeups can be made, of course, with viewfinder

and twin-lens reflex cameras, but the process requires precise measurement to correct parallax and to obtain correct frame and focus.

Techniques The techniques of photographing objects at close range have been classified in several categories. The term **closeup photography** is used to describe photography between a camera's minimum focusing distance (with a normal lens) and a distance of about two focal lengths from the subject. At the normal minimum focusing distance, the image of an object is recorded at about 1/10 life-size, or at a 1:10 **image-to-object ratio.** When the camera is brought to a distance of two focal lengths from the object, the object is recorded at about life-size, or at a 1:1 image-to-object ratio.

The term **photomacrography** is used to describe the photographing of objects to produce an image larger than life-size. The image-to-object ratio produced by these techniques ranges from 1:1 to as much as 50:1, or fifty times larger than life. The term **photomicrography** is used to describe the photographing of objects through a microscope to produce an even larger image-to-object ratio. Using an electron microscope, for example, it is possible to record an image-to-object ratio as great as 200,000:1, and to make visible images of details that are far beyond the range of the unaided eye. Figure 13-7 distinguishes among the several classes of closeup photography. All of these procedures for photographing objects closer than the minimum focusing distance of a normal lens require the use of special techniques and equipment.

Two other techniques are often confused with these. The term **microphotography** is used to describe techniques for producing extremely small images, such as those used in microelectronic circuits. The term **macrophotography** is used to describe techniques for producing extremely large images, such as photomurals and posters.

Equipment In normal operation, a camera's lens is positioned so that, at infinity, the distance between the lens and the focal plane, known as the **focal distance,** is approximately equal to one focal length. Minor extension of the focal distance is needed to focus at closer distances within the normal focusing range; to focus on objects closer than the minimum focusing distance, the focal distance must be extended significantly beyond one focal length. The types of equipment used to extend the focal distance are closeup lenses, extension tubes, bellows units, macrolenses, and reverse adapters.

Closeup lenses. A **closeup lens** is a simple magnifying lens fitted in front of the normal lens to shorten its effective focal length. Most modern closeup lenses attach by means of a threaded mount or an adapter ring, just as filters attach. Closeup lenses are available in various strengths commonly designated as +1, +2, +3, and so on, which relate to their focal length—the stronger the lens, the greater the degree of magnification. Closeup lenses also may be used in tandem. Combining a +2 and a +3 lens, for example, will produce the effect of a +5 closeup lens. By shortening the effective focal length, a closeup lens increases the ratio between the focal distance and the focal length.

One advantage of using closeup lenses over other alternatives is that no exposure compensation is required. Another advantage is that they can be used with fixed lenses as well as with interchangeable lenses.

FIGURE 13-7

Closeup photography.
A. Reduced, lifesize, and magnified focusing distances.
B. Normal focusing distance. A community of bees. C. Closeup photography. A family of bees.
D. Photomacrography. One handsome bee.
E. Photomicrography. A bee portrait.

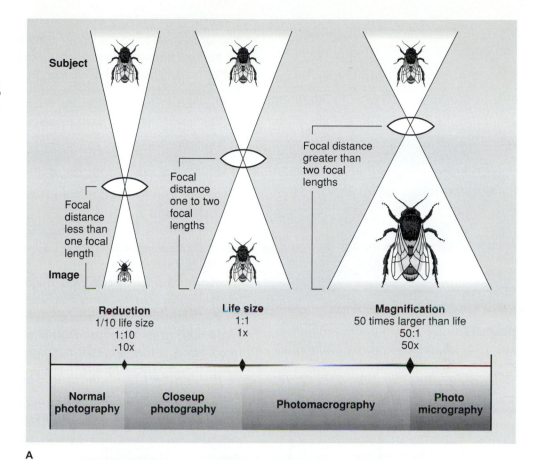

A

B

C

D

E

FIGURE 13-8

Macro zoom lens. Some zoom lenses feature a macro setting for closeup photography.

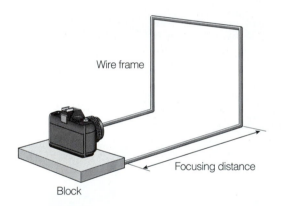

Wire frame

Focusing distance

Block

FIGURE 13-9

Focal frame.

TABLE 13-2 **Closeup lens data for 35-mm camera with 50-mm lens focused at infinity**

Closeup Lens	Focusing Distance (cm)	Approximate Field Size (cm)
+1	100	46 x 68
+2	50	23 x 34
+3	33	15 x 23
+3 plus +1	25	11 x 17
+3 plus +2	20	9 x 14
+3 plus +2 plus + 1	17	8 X 11

A disadvantage, however, is that image quality is somewhat degraded by introducing these additional lens elements into the optical system.

Bellows units and extension tubes. The **bellows unit** is an accordion-pleated housing that attaches between the lens and the camera body. The focal distance can be continuously extended by adjusting the bellows between its minimum and maximum limits. A bellows unit is useful for extreme closeups that require exact framing and focusing.

Extension tubes are a less costly alternative to the bellows unit; they also attach between the lens and the camera body. Manufactured in sets consisting of several interconnecting hollow tubes, they can be used singly or in combination to extend the focal distance by fixed increments up to two focal lengths.

Both the bellows unit and extension tubes can be used only on cameras with interchangeable lens systems, because they attach between the camera body and the lens.

Macrolenses. The **macrolens** is designed especially for closeup photography and is used in place of a camera's normal lens. It is designed to give optimal performance in the closeup focusing range and beyond; however, it may not operate as well as a normal lens in the normal focusing range, especially toward infinity. A macrolens can only be used, of course, if your camera provides for interchanging lenses. (See Figure 13-8)

For closeup photography, using a macrolens is generally a better alternative than using a camera's normal lens with a closeup attachment. The normal lens is designed to give optimal performance between the normal minimum focusing distance and infinity. Using attachments to focus closer than that introduces optical aberrations that degrade image quality as the focusing distance is reduced, although the image is generally acceptable up to a 1:1 or life-size image-to-object ratio. The macrolens, on the other hand, is designed to give optimum performance within the closeup range.

HELPFUL HINT
The Focal Frame

A device for precisely framing and focusing subjects using closeup lenses with a viewfinder camera is the **focal frame.** A focal frame may be made from a block of wood and some heavy metal wire, such as that from a wire clothes hanger. Figure 13-9 shows how the wire, formed into a frame, is attached with the camera to the block to measure an exact focusing distance and to frame the area included in the field of view. A different focal frame is needed for each closeup lens and focusing distance, because each focal frame is good for only one situation.

To determine the dimensions of a focal frame, use a published table to determine focusing distance and field size for various closeup lenses and focus settings. Table 13-2 is an example for a 35-mm camera with a normal 50-mm lens focused at infinity.

Reverse adapters. **Reverse adapters** are manufactured for various lens-mounting systems and permit interchangeable lenses to be mounted front-to-back for photomacrography. A normal lens may focus satisfactorily up to a 1:1 ratio—with the focal distance extended to about two focal

Special Topics

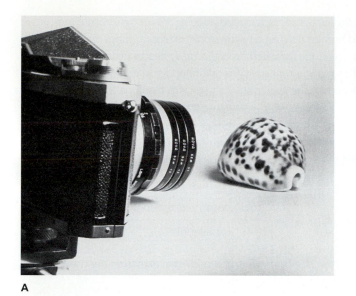

A

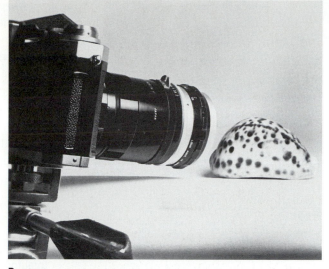

B

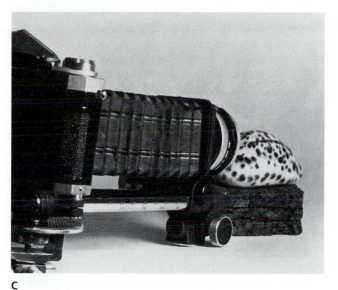

C

D

FIGURE 13-10

Closeup accessories in use. **A.** *Closeup lens attachment.* **B.** *Extension tubes.* **C.** *Bellows unit.* **D.** *Reverse adapter. Note arrow points to adapter which allows normal lens to be mounted to the camera in reverse position.*

lengths. However, when it is used at greater focal distance for greater magnification, image quality may be degraded. Image quality may be improved by using a reverse adapter to reverse the normal lens in its mount. Figure 13-10 shows several types of closeup equipment.

Determining exposure Determining exposure for closeup photography involves many considerations that are simplified by using appropriate equipment. Obtaining a reading with a conventional light meter at the object position is difficult because of shadows created by working so close to the camera and the subject. Furthermore, a conventional meter is ill-equipped to distinguish important highlight and shadow differences within the extremely narrow fields of view characteristic of closeup photography. For these reasons, a built-in, through-the-lens (TTL) light-metering system is generally more accurate and convenient than a hand-held light meter. If it is necessary to use a conventional light meter, exposure may be determined more easily by using an 18 percent gray card in the object position (see page 111).

When closeup lenses or a reverse adapter are used, exposure may be determined normally. When a bellows unit, extension tubes, or a macrolens is used, however, the indicated exposure may need to be increased. The f/numbers on the aperture scale are calibrated for a focal distance of about one focal length. If the focal distance is greater than one focal length, the f/numbers on the scale will overestimate the actual image brightness. Under these conditions, the photographer must increase the exposure.

To increase exposure for any given focal distance, an **exposure factor** must first be determined. The following formula can be used to determine the exposure factor:

$$\text{Exposure factor (EF)} = \frac{(\text{focal length} + \text{extension})^2}{\text{focal length}^2}$$

For example, if a 50-mm lens plus a 20-mm extension are used, the total focal distance would be 70 mm. Thus:

$$EF = \frac{(50 + 20)^2}{50^2} = \frac{70^2}{50^2} = \frac{4900}{2500} = 1.96, \text{ or about 2}$$

In this case, the exposure indicated on a conventional meter would have to be multiplied by 2 to obtain a proper exposure.

When using a TTL light-metering system, the problem is overcome automatically because the system reads the actual image brightness, not the f/numbers on the aperture scale. If a macrolens is used, an exposure-compensating scale inscribed onto the lens barrel indicates the exposure adjustments needed at various focal distances.

Because closeup focusing distances produce shallow depth of field, it may be desirable to maximize the field of focus by selecting a small aperture. Furthermore, if a closeup lens is used, its performance will be improved through the use of a small aperture. With a small aperture it's likely a slow shutter speed will be used—often longer then one sec. As mentioned earlier, for exposures longer than 1 sec., further adjustments may be needed to compensate for reciprocity failure. (See page 94.)

Lighting The principles of lighting objects for closeup photography are the same as those for lighting in other situations, although working at such close distances requires special techniques.

To obtain a balanced light effect, sunlight or a single spotlight may be used as the key light, with a reflector of white paper or aluminum foil to bounce fill light into the shadows. For soft, even, shadowless light, the diffused light of an overcast day is suitable for the main light source. Flash may also serve as a suitable main source, but with the flash so close to the subject, care must be taken to mute its intensity to avoid overexposure. A layer of white handkerchief placed over the flash will diffuse the light and reduce its intensity at close distances. Flash-off-camera can be used in the usual way to improve the modeling of closeup subjects. Table 13-3 suggests flash exposures for various units at distances under 30 in.

A **ringflash** unit is especially useful for closeup work. The unit is a circular electronic flash tube that fits around the front element of the lens to illuminate closeup subjects. These units provide an even field of relatively shadowless flash illumination at closeup focal distances.

TABLE 13-3 Closeup flash exposure table

Electronic Flash Output*	Subject Distance	
	10 to 20 in. (25 to 50 cm)	20 to 30 in. (50 to 75 cm)
700-1000 BCPS	f/16	f/8
1000-2000 BCPS	f/16 **	f/11
2000-4000 BCPS	f/22	f/16
4000-8000 BCPS	f/22 **	f/22

* All settings assume one layer of handkerchief used over the flash except those marked **.

** Assume two layers of handkerchief used over the flash.

Copy Photography

In most cases, **copying** is a form of closeup photography in which the subjects are two-dimensional, such as drawings, paintings, photographs, or other documents, and the products are exact recordings of the originals in each and every detail of line, tone, and/or color. Because the original subject, termed **the copy**, is two-dimensional, copy photography is not concerned with depth of field; rather, it is concerned with obtaining a sharp, undistorted image over the entire flat surface of the original.

Sometimes it is necessary to produce a **copy negative**—a negative obtained by photographing the original copy—from which a positive print is then made. Sometimes a positive transparency is made rather than a copy negative. Whatever procedure is used, the final product—an exact positive print or transparency of the original—is termed a **reproduction.**

As with other closeup photography, an SLR or view camera affords the most accurate method for framing and focusing. A camera support, such as a **copy stand** or tripod, is also useful for achieving the necessary stability during exposures. Unlike other forms of photography, however, flat, even, shadowless illumination produces the most faithful reproductions of flat materials.

Basically, all copy setups consist of (1) a camera; (2) a camera support to hold the camera in a fixed, stable position during focusing, framing and exposing; (3) a **copy board** for holding the copy in place; (4) an arrangement of lights to illuminate the copy; and (5) a cable release to operate the shutter without shaking the camera. The more complex forms of copying, such as those used in the graphic arts industry, employ commercial process cameras to copy large volumes of various sizes and types of originals onto a variety of negative and print formats. (See Figure 13-11.) Except to meet these commercial copying needs, however, relatively simple copying setups will satisfy the needs of most photographers.

A simple horizontal copying setup To copy most simply, the original may be affixed to a wall, illuminated with a pair of floodlights, and photographed with a camera mounted on a tripod, as shown in Figure 13-12. This setup adapts easily to the available space and to the size of the originals to be copied.

In this arrangement, the camera axis will remain aligned with the center of the copy board as the camera-to-subject distance is adjusted. The floodlights are on movable standards so that they can be adjusted easily to illuminate different sizes of copy. The original can be kept flat during copying by pinning it to the copy board, by using double-sided tape or magnets, or by placing it in a glass **printing frame,** which is then hung on the copy board.

Copying with an enlarger Some enlargers are designed to be converted to copy cameras by attaching a camera-back adapter in place of the negative carrier. By placing the original on the easel and illuminating it, the enlarger then works as a copy camera. Enlarging lenses are well suited to copy work because they have an exceptionally flat field; however, this method is satisfactory only for small and medium-size originals, when space is at a premium, when the frequency of copying is very low, and when the enlarger will not be needed for other purposes during the copying operations.

FIGURE 13-11

Commercial process camera for copying.

FIGURE 13-12

A simple horizontal copying setup.

FIGURE 13-13

A simple vertical copy stand.

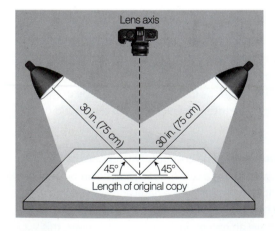

FIGURE 13-14

A lighting setup for copy photography. Ideal arrangement to provide even field of light without reflections.

A vertical copying setup for 35-mm cameras Vertical copy stands designed for 35-mm cameras are generally available from photo stores. A vertical, tubular post is mounted to a copy board. The camera is mounted to a collar assembly that slides up and down the post and can be locked in any desired position. Flood lamps are mounted to the post or to the copy board for illuminating the original. (See Figure 13-13.)

A 35-mm SLR camera fitted with a waist-level ground-glass focusing screen or angle viewfinder is most suitable for use in a vertical copying setup. The photographer can frame and focus the image while standing in a relatively normal position.

As we have seen, a 35-mm camera with normal lens has a minimum focusing distance of about 2 or 3 feet (.6 to 1 meter), a distance that does not allow for obtaining a frame-filling image of small- to medium-size copy. Under these conditions, the principles of closeup photography must be applied in order to obtain an image of satisfactory size. For critical copying work, the use of a closeup lens is not recommended because of its curvilinear aberrations. The use of extension tubes, a bellows unit, or a macrolens is preferred, or even better, a flat-field copy lens could be used.

Lighting for copy photography For copying, it is essential to illuminate the original uniformly over its whole surface. Uneven lighting will produce a reproduction of uneven density.

Small originals, 8 in. by 10 in. (20 cm by 25 cm) or smaller, can be illuminated with two flood lamps placed about 30 in. (75 cm) from the center of the copy board and at an angle of 45° to it. (See Figure 13-14.)

Even when the copy is evenly illuminated, the image at the focal plane may not be uniformly exposed. The lens itself, especially one with shorter than normal focal length, may distribute the illumination unevenly, so that the film gets less exposure at the corners of the frame than it does at the center. An improved arrangement, especially for larger originals, is to use four lamps, one at each corner of the copy board. This will provide a broad, even field of light over the entire surface of the copy, with a bit of extra intensity at the corners to offset the effect of lens fall-off.

If the copy is a continuous-tone original, slightly uneven image brightness is not usually serious. When copying originals consisting of fine lines and small printing with high contrast film, however, even slightly uneven image brightness can seriously impair the quality of the reproduction. In such cases, great care must be taken to obtain an even field of illumination over the copy.

To copy with black-and-white film, ordinary frosted tungsten (3200 K) lamps or photolamps (3400 K) can be used, although the latter have too short a life to be economical for copying. Reflector flood lamps can be used if care is taken to assure that there are no hot spots in the light they produce. Opalized enlarging lamps, used with or without satin-finished reflectors, also provide a good, even illumination for copying. Fluorescent tubes are particularly useful in black-and-white photography for providing a broad, diffused light source that will eliminate any surface texture from the original.

For copying with color film, a film should be selected that is balanced for the light source. Tungsten light sources should be used with a film balanced for tungsten light; daylight or electronic flash sources should be used with a film balanced for daylight. Color compensating or conversion filters may be used to match the light source to the color balance of the film. Fluorescent lighting is less useful for copying with color film, because its discontinuous spectrum is difficult to match to a film's color balance.

For best results in copying, all the lamps in the setup should be of the same type, brightness, and age. The use of a lens hood when copying to shield the lens from the direct rays of the lamps is also recommended; light from the lamps striking the lens directly can cause lens flare and loss of contrast.

As the lamps in the copy setup begin to age and burn out, they should all be replaced at one time. If one lamp burns out and is replaced, that new lamp will burn brighter and at a higher color temperature than the older lamps around it. This will produce uneven density and color quality over the picture area.

Eliminating reflections Sometimes the surface of the copy itself can give off unwanted reflections. The varnished surface of an oil painting, for example, or the glossy surface of a photograph can create troublesome highlights reflected from the source lamps. The glass covering of a picture frame or a copy frame can do the same. Sometimes glass may even reflect the image of the copy camera, the photographer, or other objects so that these become ghostly parts of the recorded image. Eliminating these reflections is an important task in copying.

Several procedures are used to eliminate unwanted reflections:

1. Both glare and reflections can be corrected by using anti-glare photographic glass on top of the copy. This method also serves to hold the copy flat on the base. In addition, the source lights can be placed at right angles to each other and at 45° to the copy plane. Also, polarizing filters can be used over the lamps and over the lens. By these means, surface glare and reflections can be reduced to a minimum.

2. In addition, by using a large aperture and thus reducing depth of field, the copy image can be held in sharp focus while the reflections from a covering glass are thrown out of focus to diminish their distracting effect.

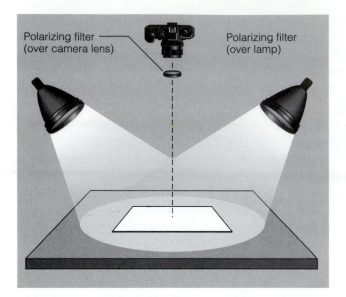

Polarizing filter
(over camera lens)

Polarizing filter
(over lamp)

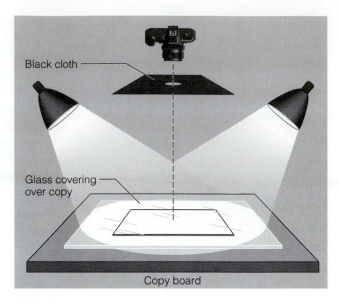

Black cloth

Glass covering
over copy

Copy board

A

B

FIGURE 13-15

*Eliminating unwanted reflections. **A.** By using polarizing filters over light sources and camera lens, reflections from glass or glossy surfaces can be eliminated. **B.** By shooting through a small hole in a black cloth stretched in front of the camera, reflections of camera and photographer in glass covering of copy frame are eliminated.*

3. By shooting through a lens-size hole in a sheet of black cloth inserted between the camera and the copy, the reflections from a covering glass surface can be eliminated.

Figure 13-15 shows the use of these techniques.

Although in most copying situations it is desirable to eliminate surface reflections, occasionally it is useful to retain or even emphasize some of them. For example, the surface texture of an oil painting or a tapestry might be retained so that the reproduction includes these textures of the original. When the details of surface texture are to be retained, the highlights and reflections that reveal them should not be eliminated. A faithful reproduction of such an original will retain enough of the surface highlights and reflections to reveal the surface texture without distracting from the underlying image.

Determining exposure for copying The main criterion for lighting copy is that the illumination be even over the entire surface of the area to be copied. TTL metering is not very useful for this purpose, because it is designed merely to obtain an average light reading for the entire image frame, not to reveal variations within the frame. A hand-held light meter is more useful for this purpose.

An incident-light meter should be held in the plane of the original being copied and the light collector passed slowly over the copy area while observing the indicator needle. A reflected-light meter should be used with an 18 percent gray card in place of the original to be copied to obtain readings from all points within the copy area. A spot meter is especially useful for this purpose, as it permits readings to be taken from various points within the copy area while avoiding the creation of shadows by the meter itself. Whatever meter is used, any variations of light intensity observed within the copy area should be eliminated by repositioning the lamps until an even field of light is obtained.

The exposure indicated by the light meter must be adjusted to compensate for lens extension, as described above, and also for the overall tonal value of the copy. If the overall tone of the copy is dark, exposure

should be reduced; if the tone is light, it should be increased. (See the section entitled "Exposure for Shadows or Highlights," page 110).

Copying different types of originals The original may consist solely of **line art**, such as a drawing, woodcut, or printed document. In this case, the objective of copying is to obtain maximum contrast so that the lines or lettering appear strong and black against a white background. Best for this purpose are high-contrast films and developers that will drop out any hint of intermediate gray tones. High-contrast copy work demands precise exposure and processing to obtain perfect results. Filters are useful in high-contrast copying to exaggerate the contrast between the lines and the background if either or both are colored. A general approach is to use a filter that transmits the paper color but that absorbs the ink color.

The original may consist of a **continuous-tone image**, such as a black-and-white photograph. In this case the objective is to reproduce the full range of tones present in the original. Best for this purpose are normal-contrast, fine-grain films and soft-working developers that will record a full range of tones between the extremes of black and white. The color sensitivity of the film is of no concern when the original is in black-and-white.

The original may consist of a colored image, such as a painting, color drawing, or color photograph. Best for producing a black-and-white reproduction are fine-grain, high resolution, panchromatic films. Best for producing a color reproduction are any of several color films. For the highest quality color reproduction prints, a color negative film may be used. A color transparency film may also be used—the positive transparency can be used with direct positive materials to produce the color reproduction prints. Although ordinary color transparency film is acceptable, best for this purpose are the specially formulated copying films, because they have the low inherent contrast necessary for optimal reproduction of flat copy originals.

Instant color print films also have proved to be excellent media for making positive color prints from color transparencies. Several devices that adapt 35-mm cameras and enlargers for this purpose are available.

Appendix J-6 describes some of the films commonly used for copying.

Slide duplicating Making **duplicates** of 35-mm slides is basically a closeup copy photography procedure. Its objective is to produce an exact recording of an original slide at life size or larger on positive transparency film. To accomplish this objective, one of several approaches may be used.

If the camera is equipped for interchangeable lenses, a slide-copier with its own lens may be attached in place of the normal lens (see Figure 13-16A). Many slide copiers of this type are designed to zoom between 1X and 2X magnification, permitting the original image to be cropped during duplication. Similarly, a bellows unit with a slide copier can be used with the normal lens and operated in a similar way (see Figure 13-16B).

If the camera is not equipped for interchangeable lenses, a special rear-projection screen may be used to enlarge the slide image. The enlarged, projected image can then be photographed using a closeup lens if necessary. This approach is not ideal but will yield useful results when other methods are not convenient. Another approach is to use one of the many special slide-copying cameras designed solely for this purpose.

A

B

FIGURE 13-16

*Slide duplicating accessories. **A.** 35-mm camera with zoom slide copier attachment. **B.** Bellows unit copier attachment.*

FIGURE 13-17
Commercial slide duplicator.

Although duplicate slides can be made using any color transparency film that is correctly balanced for the light source, using film that is specially formulated for slide duplicating is preferable. (See Table 13-3.) Using ordinary color slide film to copy color slides results in reproductions that have higher contrast than the original. Furthermore, if electronic flash is used as a light source in slide duplicating, the extremely short exposure results in a blue shift caused by reciprocity failure. Slide-duplicating films have been formulated to overcome these effects. Proper film and conversion filtration are essential to obtain color reproductions that closely match the originals.

For large-volume slide copying, a number of special-purpose devices are manufactured that use electronic flash and precise exposure and filtration controls (see Figure 13-17). For less frequent slide copying, however, any of the above procedures will meet the needs of most photographers at moderate cost.

Electronic Photography and Electronic Imaging

Objective 13-F Define and explain the terms, basic processes, and steps used in electronic photography and imaging.

Key Concepts electronic imaging, video, still video (SV), digital imaging, image-processing software, pixels, analog information, digitized, digital information, scanner, frame grabber, photo CD, hard copy, modem, film camera, slide writer, electronic image processing, download, thermal printers, multimedia

A Break from Tradition

The basic processes of photography have remained virtually unchanged for more than 150 years: Light reflected from the subject is focused by a lens onto a light-sensitive silver-halide emulsion. Chemical solutions are then applied to enhance and develop the image and produce a negative or slide. Silver-based emulsions have become the staple of image production. However, photography is currently undergoing an exciting transition from silver-based technologies to digital electronic technologies. One recent method, electronic imaging, is rapidly gaining acceptance and promises to revolutionize visual communication technology.

Experts predict that by the year 2000, most newspapers and commercial studios will use still video capture devices and computer-based manipulation and storage programs for image processing. The wet negative and print processes traditionally performed in dimly lit darkrooms will coexist with or be replaced by still video and computer processes performed in the bright light of newsrooms and other common work areas. The basic theories and concepts of visual communication will still apply, but this dramatic shift in technology will redefine the equipment and procedures that photographers use.

Equipped with a still video camera that resembles a 35-mm camera of the early 1990s, a photojournalist is covering the aftermath of an earthquake seventy-five miles away from her paper's San Francisco newsroom. Rescue workers search carefully for survivors amid the crumpled ruins while nearby firefighters attempt to control a burning home. The photographer captures these and other dramatic scenes on a 2-in. floppy disk coated with magnetic material.

After filling several disks, each of which holds twenty-five images, the photographer pauses to review the pictures on a small display monitor and finds several newsworthy shots. One shows the daring rescue of a small boy by an exhausted fireman. The deadline for the next edition is only minutes away, but the picture can make the deadline easily—the photographer need not drive back to her office nor develop and print the film. Instead, she returns to the car where the pictures are transmitted in electronic form over a cellular telephone directly to the newsroom.

When the pictures are received, the photo editor displays the transmitted pictures on a desktop computer screen. With only a few clicks of the mouse button, he makes a few corrections in the densities and colors. After a quick phone conversation with the photographer in the field, the editor selects the final images and transmits digital copies to the Associated Press by telephone. The news agency then distributes the pictures via their digital PhotoStream transmission service to newspapers around the world.

Once the computer file containing the earthquake coverage is selected for publication, it is transferred electronically to the editor who lays out the front page on a pagination terminal. Here, the color pictures are cropped, sized, and positioned on the page along with the story, which has also been transmitted electronically from a reporter at the scene. Within moments of the original event, the images and the story are on presses around the world.

What Are Electronic Photography and Electronic Imaging?

Electronic imaging is the general term used to describe any aspect of the capture, storage, manipulation, and output of a picture by electronic means. **Video** generally describes the visual portion of a television image and is commonly used to designate moving images. **Still Video** describes the use of video signals for recording and displaying nonmoving pictures. **Digital Imaging** is a form of electronic photography by which information is captured, stored, or manipulated in discrete numerical bits. In all cases the resulting images are instantly accessible and can be randomly accessed, erased, or recorded over.

Will Electronic Imaging Replace Conventional Film Technology?

Even the most sophisticated and expensive electronic cameras cannot match the picture quality of simple, inexpensive 35-mm cameras. Nevertheless, electronic image quality is more than sufficient for many applications, especially for halftone magazine and newspaper reproduction and for home snapshots.

Electronic imaging offers an excellent alternative to conventional photography when speed is important or when images must be transmitted

Around the corner from the newspaper, a photo artist is at work refining images for two upcoming gallery exhibitions. The photographer, together with a colleague on the opposite coast, are working on a collaborative project that will combine parts of both of their photographs into several new creations. As the work continues, files containing the images in various stages of progress are quickly exchanged electronically from one photographer's electronic darkroom to the other.

One of the photographers has been working seriously with a new electronic still camera for a few months and has found that it functions in a surprisingly comfortable and familiar way. The other photographer, working with conventional materials, later scans his original images into digital form. Personal computers in both studios are equipped with communications and image-processing software capable of working with any form of digitized information.

Both photographers' transmitted images are displayed on a color monitor screen that appears much like a conventional proof sheet. Individual images or parts of images are easily selected with the click of a mouse, manipulated, and placed in a new image format. The photographers deftly assemble portions of four original images into a new composition. Notes and preview versions of the work are exchanged instantly over standard telephone lines.

Even though some of the individual images may have been originally shot in black-and-white, they now can be colored manually in the digital darkroom to blend in with the other picture elements. The photo-artist simply selects from a palette of colors that appears at the edge of the computer screen and "paints" the images with a brush-like cursor. Other picture elements are then adjusted for size and rotated as needed before they are used in the new composition. Once all the picture parts have been cloned, copied, color corrected, and moved into place, the photographer uses a computer graphics tool to blend and smooth them into a harmonious whole.

After a few more keystrokes, a full-color paper print emerges from a desktop printer. This print, along with prints of other images, will hang in a gallery on the West Coast. And what about exhibiting the prints on the East Coast? No problem here—a professional photo lab in New York accepts the image files electronically. With but an additional phone call, the file is transmitted to the lab, where the images are made into large color prints ready for pickup the next morning.

quickly to distant sites, as in photojournalism. Electronic imaging is also unsurpassed for storing and quickly accessing large numbers of images, as is required when working with real estate or personnel databases.

Conventional film will most likely be used for a long time as the initial medium for recording an image. Film remains the highest quality, most flexible, and most widely used method for producing high-quality images. Within a few years, however, we can expect that images destined for newspaper or magazine reproduction will be digitized and processed electronically at some stages. Virtually all touch-up, color correction, image enhancement, page design and prepress work will be carried out on personal computers and computer work stations.

Advantages of Electronic Imaging

Why will some photographic needs best be served by electronic imaging? Among the many reasons are speed, simplicity, cost, ease and power of image manipulation, image permanence, and environmental factors.

A

B

FIGURE 13-18

A. An example of a conventional camera fitted with an accessory back for electronic still photography.
B. Linda Ewing, "Unknown Soldier," 1990 (original in color. See also Color Plate 8B). Computer-generated image in which the artist scanned in and combined various family photographs and historical images, manipulating their sizes, croppings, placements, colors, and densities to create a unique statement.

Speed and simplicity The great advantage of electronic still cameras is the instant capture availability of the images. With electronic image systems, the photographs are ready immediately for display, printing, transmitting to other terminals, and publishing.

It is already faster and easier to make a print electronically than to make one chemically. How convenient it is to simply drop a disk into a camera and display the image on a monitor moments after the shot. Loading film into a camera, waiting to finish an entire roll of film before viewing the work, and processing negatives and prints may soon seem to be a burdensome chore.

Cost Using still video (SV) cameras reduces film and processing costs; the storage media can be reused when previous images are discarded. The need for many prints is also reduced, because the images can be viewed and edited on a monitor screen before prints are made. One aviation firm estimated that their cost per print dropped from $12 to $1.50 when they switched to electronic imaging.

Image manipulation Anything that can be done in a conventional darkroom can be accomplished easily with computer-based **image processing software**—and often in a fraction of the time. Image processing can perform cropping, burning and dodging, contrast control, density adjustments, and can even sharpen or soften focus. Powerful computer programs make it possible to rearrange and combine elements from several different shots into new creations, giving entirely new meaning to the concept of combination printing.

Image permanence All silver-based and dye-formed images change and fade over time. Although the images may be preserved to some degree by making copies onto fresh material, each copy is slightly degraded from its original, as sharpness, tonal separation, and contrast are lost in each successive generation.

Truly archival electronic media does not yet exist either, and long-term preservation of digital images also requires copies to be made onto fresh material. However, copies of digital images are identical, bit for bit, to the originals and, to the extent that bits of data may be lost in use, computer programs can restore the lost data with virtually unerring accuracy.

FIGURE 13-19

The technologies and processes of television, computers, conventional photography, and printing and publishing all converge to form the new field of electronic imaging.

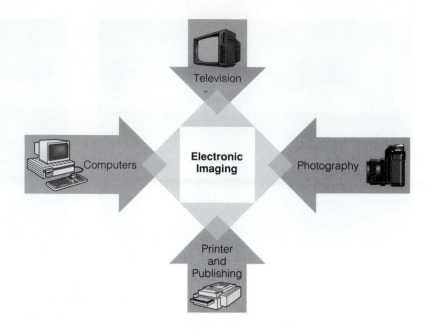

Effect on the environment

Effect on the environment Current film technologies employ costly processing chemicals that are potentially toxic when introduced into the environment. Also, they use and often waste valuable silver resources. Electronic imaging requires no chemical processing; thus, no waste chemistry or other pollutants are generated.

Equipment and Materials

Today there are many ways to create electronic images. An original image may be produced directly from reality using an analog or digital still camera, a digital camera back fitted to a traditional camera, or a video camera. Alternatively, an existing transparency, negative, print, or other flat art may be scanned and digitized to create an electronic copy.

A basic setup for electronic photography would consist of a camera or scanner for image input, a playback device and/or a monitor, and a computer for image manipulation and processing. A transceiver can be added for transmitting images over phone lines, and a variety of output devices can be added to produce **hard copy** from the stored images. Hard copy output can take the form of paper prints made with special thermal, laser, or color printers, or slides produced with the aid of a **film camera** or **slide writer.** Newspaper, magazine, and desktop publishers also may choose to make color separations directly from the electronic files.

How Electronic Imaging Cameras Work

A still video camera is much like a scaled down version of a video camcorder; however, instead of a tape cassette, the camera uses a small floppy disk or memory card to store the images. Like VCRs, still video cameras record the information contained in each picture as electronic information. Like a conventional camera, there are shutter, aperture, and focusing

controls. Unlike a conventional camera, however, the lens does not focus on a sheet of film, but rather it focuses on an array of electronic image sensors.

Two Ways to Build an Electronic Camera

Two approaches to building cameras for use in electronic imaging are available. One approach uses existing film-based cameras equipped with a special electronic imaging receptor back; the second, uses special self-contained cameras designed to record images only in electronic form.

Electronic-imaging backs for conventional film cameras

Some manufacturers have designed systems that use both traditional camera equipment and the new electronic technologies. With these systems, the film-holding back of a conventional camera, usually 35 mm, is replaced with a special electronic-imaging back. Metering, aperture, shutter speed, and focus functions, are set in the usual way. The image-forming light, however, is received by an array of optical sensors contained in the special accessory back. The main advantage of these systems is that they use the same cameras and lenses that many professional photographers already own and use.

Many camera manufacturers, including Hasselblad, Kodak, and Minolta, offer accessory systems that feature an electronic "film" back. Such an approach provides a bridge between older film-based technology and new electronic-imaging methods. These systems also give the photographer the option of shooting film or electronic images as the situation demands. Such hybrid devices appeal to photographers who have built complete systems of bodies and lenses. One disadvantage of this approach is that usually the hybrid unit is larger and heavier than its self-contained counterpart. Furthermore, the camera is often tethered to a boxy storage unit by awkward connecting cables.

Self-contained electronic cameras
Other manufacturers, notably Canon, Panasonic, Toshiba, and Sony, have elected to design entirely new cameras that record images only by electronic means. These still video cameras don't look or feel much different than professional-quality 35-mm cameras, and generally offer features similar to advanced film-based cameras, including shutter speeds to 1/2000 sec., automatic or manual exposure, zoom lenses, and even built-in flash units. The difference is that they record twenty-five to fifty visual images on 2-inch floppy disks or memory cards rather than on film.

Some still video cameras also record the date, time, exposure value, and shutter speed for each shot on a hidden track, and even permit brief audio recordings, like captions, to accompany each picture. Most still video cameras can input and output signals in various forms, such as NTSC composite, analog RBG, and S-Video. These various file languages allow the still video images to be read, combined, and manipulated in a variety of television and computer formats, and still-video transceivers can send pictures thousands of miles over standard telephone lines.

The Kodak Professional Digital Camera System is typical of the hybrid approach to building an electronic camera system. It is designed to replace the back of a standard Nikon F3 camera. It uses all of the camera's conventional controls and can capture up to 2.5 images per second. The system uses a high resolution Kodak Digital Camera Back as the imager connected by cable to a separate box that houses the Kodak Digital Storage Unit, a disk drivelike device. Unlike analog still video cameras, the DCS stores information digitally, which gives sharper and more detailed electronic images.

The original model had effective film speeds of ISO 100–1600 for color images and ISO 200–3200 for black-and-white. The storage pack holds several hundred images in a compressed digital form. Accessories to the DCS include a video monitor for the immediate viewing of captured images and a keyboard for notetaking or captioning of the pictures. As in other electronic systems, the images can be **downloaded** to a computer for storage, image enhancement, color correction, image manipulation, and transmission via phone lines.

The Kodak DCS debuted at the National Press Photographers Electronic Workshop in Tempe, Arizona, in the fall of 1990, where it was used to produce an all-electronic newspaper. It has since

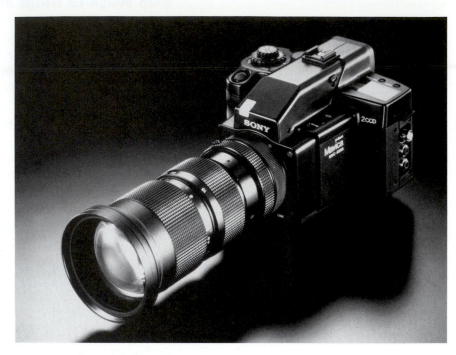

FIGURE 13-20

An example of a camera designed exclusively for electronic still photography.

been used by many newspapers, including *USA Today,* to meet short deadline news assignments.

Sony introduced the first commercial self-contained still video camera, the Mavica, in 1981. In 1983, Sony and others established the Electronic Still Image Video Camera Committee, which adopted an industry-wide standard of a 2-inch floppy disk with a horizontal resolution of 360 lines. One disk could hold twenty-five images in a "frame" format, or fifty images in a lower-quality "field" format.

Maximum resolution for analog still video images depends upon the bandwidth of the system, but 500 lines is about the best the system can achieve.

Canon was the first to market an easily available and affordable still video camera, the Xapshot. Designed as a do-everything point-and-shoot camera for amateur and home snapshot use, Canon's Xapshot could be found in camera stores as early as 1990, priced to compete with mid-range SLR's.

Self-contained cameras have the advantage of being much smaller and lighter in weight than most hybrid systems, and many can use lenses from conventional 35-mm cameras. Cost is another advantage, and moderately-priced still video cameras can be readily found for home use. One disadvantage is that most self-contained units can only record and must be connected to a player and/or monitor to display the images. However, many of these systems can display images on standard television sets for proofing, editing, entertainment, and other uses that don't require high resolution.

What Is Digital Imaging?

The basis for electronic image processing and enhancement is the capture of an image stored as analog information and its conversion and storage as digital information.

Analog information is a stream of continuously variable data, variations, and differences represented by varying quantities, or amplitudes. A continuous-tone photographic negative or print is an example of analog information. The details, tones, and contrasts are represented by continuously varying densities of silver on the surface of the medium. For a continuous tone image to be readable by a computer, these analog values must be **digitized,** or converted to **digital information**—information encoded into discrete, discontinuous, minute particles, called bits, that can be read, stored, and later decoded by a computer program into a pictorial image.

In many ways the halftone printing process works by using digital information. The analog photographic print is first encoded through a halftone screen into a pattern of discrete dots. Each dot may be thought of as one digital bit; it either prints ink or does not. The pattern of dots is then decoded on the printed page as a pictorial image.

To save this digital information electronically, a system is needed to record which dots are "on" and which are "off" in the entire array. This is a crude approximation of what an electronic imaging system does. The analog information captured by the lens is encoded into electronic, digital bits that record which elements in the array are "on" and which are "off."

Actually, the digital information needed to record and transmit photographs is more complex, since each "dot" must also possess color and intensity. To encode this additional information, an electronic imaging system must first encode the image into millions of tiny picture elements called **pixels.** Each pixel is represented by several digital bits that together record the intensity of red, green, and blue light at each "dot" location. As with a film's grain structure, more pixels per frame yields finer image resolution. Each pixel, like a small tile in a large mosaic, represents one small part of a much larger picture. With image processing software, photographers can manipulate and adjust images electronically at almost any level of magnification or reduction—even pixel by pixel.

Once digitized, the encoded pixel information can be stored within a computer system, recalled for processing or transmission, and transferred instantly from one application to another. Decoded, the pixel mosaic is reconstructed and can be seen again as an image and converted back into prints or other hard copies.

Sources of Electronic Images

Electronic images can be made without electronic or still video cameras. Conventional photographic transparencies, negatives, and prints, as well as television images, can be used as image sources for creating electronic images.

Film and print scanners One way to digitize photographic images is to use a **scanner**. Any 35-mm film image or flat artwork can be digitized. Film scanners generally accept single frames or strips of film; print scanners accept sketch-pad-size artwork and prints. The original is placed in the scanner, which then reads the image and converts it into digital form for storage or transmission. Photojournalists commonly use the Leafax 35 film scanner to transmit images back to their offices over regular phone lines. In this way negatives, either color or black-and-white, can be sent directly to a newspaper's electronic picture desk.

Scanning takes only a few moments, and the original image remains unharmed and unchanged. Scanned photographs are often sharper and cleaner than images transferred from still video sources, partly because film images are of higher quality than images produced by still video cameras.

Frame grabbers A **frame grabber** allows the capture of one frame from a continuous video source. Such sources include video cameras, video tapes, and broadcast television. Like scanners, frame grabbers digitize images for electronic processing, storage and computer use.

Kodak's photo CD system Kodak offers another option for electronic image processing with conventional photographs. Kodak's **Photo CD** System stores conventional film-based images on compact disks. The original 35-mm film or prints must be digitally scanned and recorded onto the compact disk by a special lab. As many as 100 images may be cropped, enlarged, corrected for density and color, and stored in any sequence on a single CD. Prints can then be made from the stored images using a special thermal printer and paper made by Kodak. The CD also can be used with a photo compatible CD player to play back the equivalent of an electronic slide show on a home television set.

The images on the CD also can be accessed by a computer equipped with a CD-ROM player, manipulated, and outputed to hard copy with image-processing software just as any other digitized images.

Uses for Electronically-Stored Images

Electronically-stored images may be used in a variety of ways. With a **modem** the electronic image may be sent by telephone to any other similarly equipped computer in the world. News photographers often send pictures from remote locations to their home offices this way. Fine art and advertising photographers often manipulate electronically-stored images in an interactive and instantly responsive way to accomplish special creative effects. Desktop publishers employ digitized images in newsletters and other publications. Audiovisual photographers assemble and edit

FIGURE 13-21

Film scanners digitize black-and-white or color film images for further electronic processing and use.

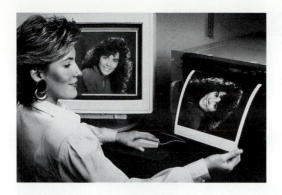

FIGURE 13-22

An electronic photography work station and printer in use.

sequences of selected electronically stored images into complex presentations. The rapid access, instant manipulation and editing, and variety of hard copy output possible with electronically stored images increases not only the efficiency of visual communication, but its quality as well.

What is Image Processing?

Advances in computers and electronics in the early 1980's led to the widespread use of word processing and desktop publishing that provided fundamentally new ways to work with blocks of text and graphics. A similar revolution also occurred that provided new ways to store and manipulate pictures—**electronic image processing.**

Image processing software introduced in the late 1980's, such as Adobe's Photoshop, allowed the input of digitized images into personal computers and created new ways to enhance, modify and combine them with other visual elements into final composite designs. Access to powerful computers and versatile software have literally brought photographers out of the darkroom and into the light.

What Can Image Processing Do?

Software is available to perform electronically all of the image processes available in a traditional darkroom. Once the digitized image has been stored in the computer, the fun can begin. With a few clicks of a mouse, the image can be adjusted for size, cropping, brightness, contrast or color, and the density of selected areas may be controlled with electronic burning and dodging. Color separation negatives for printing reproduction can also be made.

This is just the beginning, however. Sophisticated image processing programs such as Adobe's Photoshop or Letraset's ColorStudio offer capabilities that extend beyond what is possible in a conventional darkroom. Selected areas of the image can be blurred to hide distracting details or, conversely, sharpened where the original image is out of focus. Negatives can be switched instantly to positives. The image can be instantly inverted, rotated, stretched, and skewed to modify perspective. Black-and-white images can be colored manually. Color images can be instantly posterized without creating the usual separation negatives.

Today's image processing software also allows selected parts of an image to be altered in color and size. Selected parts may even be cloned, copied, and moved to another location within the image frame. Details can be masked, painted, blended, adjusted for contrast, distorted, and even recombined to create one or more new images. Whatever special effect may be needed, it usually can be achieved with just a few key strokes.

Each manipulation can be seen instantly on the computer's monitor, and hard copy can be printed at any time. Each transformation can be saved as a permanent file for later use or discarded, without altering the image being manipulated. Seeing the image change and evolve with each manipulation is an exciting process.

FIGURE 13-23

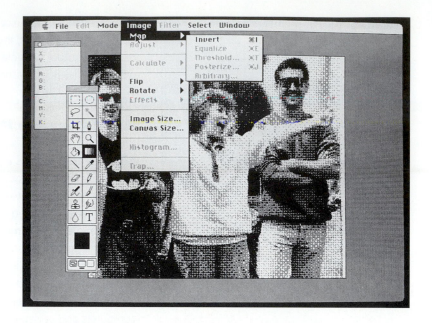

Is Image Processing Hard to Learn?

Basic image processing can be learned easily, even by those new to computers. Using Photoshop on a Macintosh computer, for example, a beginner can master the basics of image enhancement in a few hours.

All image processing programs perform the same basic functions, but each product has unique characteristics that give it a special "feel." The most commonly used programs include Photoshop and ColorStudio for Macintosh computers, and PhotoStyler and Image-In for PC platforms. Some photographers use more than one program to process different parts of complex images.

Common Capabilities of Electronic Image Processing

Most commonly used image-processing software provide features that allow the photographer to:

▶ enhance contrast and color to insure accuracy of tones or to increase saturation

▶ retouch and eliminate flaws, including eliminating dust spots and scratches, correcting minor facial blemishes, eliminating or altering unwanted highlights, even removing and replacing entire backgrounds or other areas

▶ manipulating the total image, including hand coloring, posterizing, softening or sharpening selected areas, "flopping" the image, reversing tones, and embossing

▶ combining parts of many images into a single image

▶ correcting poor exposure or poor focus of the original image, including restoring the images of faded or physically damaged photographs to better than new condition

- ▶ combining photographic images with text, graphics, or other elements
- ▶ outputting instantly in any of many forms, including hard copy in paper, print, or slide form, modem transmission, and pre-press color separations

Producing Hard Copy

Displaying an image on a monitor is adequate for many purposes, such as proofing and editing. However, hard copy is usually required for publication and exhibition purposes. The quality and cost of hard copy reproduction have improved rapidly. Basic printers that can produce proof prints suitable for newspaper reproduction are available for less than one thousand dollars.

Advanced **thermal printers** now produce hard copy that approaches photographic quality. Kodak's XL 7700 digital continuous tone printer, for example, makes 8 1/2-in. by 11-in. thermal prints in full color. These prints have a feel and weight similar to conventional photographs, and their resolution is comparable to high quality magazine reproduction. The device can also produce color transparencies up to 11 in. by 11 in.

Some color copiers also can be used to produce large quantities of digitized photographs with acceptable quality. In addition, the computer can output digitized images to imagesetters, such as those made by Linotronic and Compugraphic, to produce hard copy suitable for reproduction by offset printing.

For more demanding work, second-generation film originals can be produced by outputting the file to a film recorder or a slide camera. In this way, conventional 35-mm slides or negatives can be made. If a larger film image is desired, professional imagesetters can be used. These devices are similar to rotary scanners and produce large sheets of film in the form of color transparencies, color negatives, or color separations ready for printing.

FIGURE 13-24

Special compact disks and players can store and retrieve digitized photographs for monitor display, electronic transmission, or image processing.

Computers for Photographers

The image-processing capability of modern computers is remarkable and is improving rapidly. Many add-in boards are available that convert analog information captured from video sources into digital form. In practice, however, many personal computer systems are unsuitable for image processing because of their limited memory and disk storage areas. Digitized image files require large memory and storage spaces that increase as demands for image resolution increase.

Ethical and Social Restraints on Electronic Image Processing

The new electronic technologies have not only changed the working techniques of photographers; they have also given rise to a number of ethical and social issues. Photojournalists increasingly must face the sensitive question: To what extent is it ethical for images used for editorial purposes

Technical Feature: Overview of Electronic Imaging Tools

Input
- Analog or digital still video cameras
- Video tape
- Camcorders
- Film scanners
- Flatbed scanners

Processing Platforms
- Macintosh or PC computers

Manipulation Software
- Image processing and enhancement
- Page makeup and production

Soft Image Displays
- Television screens
- Computer monitors

Storage Media
- Magnetic devices such as
 - 3 1/2-inch floppy disks
 - 2-inch still video floppy
 - Video tape
 - Computer hard drives
- Optical storage via CD's
- Solid state
 - IC cards and other forms of solid memory
 - RAM

Hard Copy Output
- Film recorders
- Thermal prints
- Laser color printers
- Ink jet
- Image setters or modem transmission

to be altered or manipulated? The National Press Photographers Association (NPPA) has adopted an electronic manipulation policy statement that says in part:

As journalists we believe the guiding principle of our profession is accuracy; therefore, we believe it is wrong to alter the content of a photograph in any way that deceives the public.

Most newspaper editors and photojournalists seem to be following the lead of the Associated Press. The AP has traditionally accepted the use of burning, dodging, cropping, and color correction to improve the readability of photographic images used for editorial purposes. The current policy simply extends this principle to electronic image processing. However, they caution that actual retouching should be limited to the removal of scratches and dust spots only. No changes should be made to the content of the image itself if the credibility of the journalism profession is to be maintained.

Advertising photographers face a similar dilemma. To what extent is it ethical for images used for advertising purposes to be altered or manipulated? Although no comparable policy statement has been forthcoming from the advertising profession, it seems ethical to say that no alteration of an image should be made that would deceive the public with regard to a product's features or capabilities.

Commercial and creative photographers will encounter additional quandaries respecting reproduction rights and copyright. Who owns the right to publish an image assembled piece-by-piece by an art director from a file of stock photographs purchased last year? Indeed, who is the artist

or creator of such a work? How will copyright violations be handled when small desktop publishing users can easily scan, alter, and reuse previously published photographic material?

These questions and others still need to be resolved, but two guiding principles seem clear:

▶ If the factual content of a photograph is significantly altered, the alterations should be identified.

▶ No copyrighted material should be used as a source by a photo-artist without obtaining prior permission from the copyright holder. Appropriating another's image, or even part of an image, into a new work without permission is wrong and may be a crime.

Future Implications

Improvements continue to be made in the capabilities of computers used for image processing. Computers are also now being used to integrate many different visual art technologies. Until recently, conventional photography, television, printing and publishing, and telecommunications technologies were completely separate entities, each with its own standards and vocabulary. Few ways existed for communicating and exchanging information data.

Today's electronic imaging offers a common technology and language that promises to bring these separate methodologies together. Technologies as dissimilar as desktop publishing and video tape editing can now employ a common electronic file format, allowing images to be exchanged between one medium and another. In an exciting new technology called **multimedia,** electronic images combined with music and other audio sources, text, typography and graphics can be viewed on a monitor, transmitted to distant locations, or produced in hard copy form to meet the needs of any audience.

In the future, those involved in visual communications will need to understand the entire process, from picture taking to final presentation, as a continuous flow of information to be processed and managed electronically. Computers, photography, film, and the various mass communication media will all interact with a common core of electronic imaging to open many new creative paths for the visual professional.

Law and Ethics for Photographers

Objective 13-G Describe some of the major principles of law and ethics important to photographers

Key Concepts privacy, intrusion, trespass, implied consent, publication, public disclosure of embarrassing private facts, false light, libel, appropriation, model release, Copyright Act of 1976, works for hire, declaration of intent to retain copyright, fair use, implied contract, licensing agreement

Photographers are not entirely free to shoot pictures of anything they wish, anytime, anywhere, in any manner, or to use the pictures however they wish without considering the rights of others. Sometimes the law limits what photographers can and cannot do; sometimes good taste, courtesy, and ethical judgment limit what photographers should and should not do. Except in the area of copyright, however, few laws pertaining to photography are national in scope—most vary from state to state, and practices may vary from community to community.

Two areas of law that are of special interest to photographers are those pertaining to privacy and those pertaining to copyright. The laws pertaining to privacy tend to govern photographic activity; the copyright law governs who owns what rights in the photographic works.

Privacy

The law tends to recognize that individuals have certain rights to **privacy** and that the public has certain rights to news and information. Balancing these rights has been the subject of considerable case law.

Invasions of privacy can occur while pictures are being taken or when the photographs are subsequently published. In general, the law defends the rights of photographers to take pictures in public places and, in many cases, in private places open to the public. Similarly, the law tends to protect the privacy rights of property owners and of photographic subjects when they are on private property that is not open to the public.

Even when photography is permitted, such as in a public place, a private place open to the public, or on private property where entry and photography have been permitted, photographers are not necessarily free to use the photographs they take in any way they choose. For example, a photographer may shoot a picture of an acrobat performing in a public parade or, with permission, at a private party, without violating any right of privacy. If the event is newsworthy, the photograph may be published in the news media without violating any right of privacy. However, in neither case could the photographs be sold or used for advertising purposes without violating a right of privacy unless the performer grants permission to use it in that way.

Invasions of privacy may be grouped into four major types, commonly called the four torts of privacy. These include:

1. intrusion upon a person's seclusion, solitude, or private affairs,

2. public disclosure of embarrassing private facts about a person,

3. publicity that places a person in a false light in the public eye, and

4. appropriation of a person's name or likeness for advertising or trade.

Each tort is described briefly with its application to photography.

Intrusion The tort of **intrusion** generally refers to the acts of photography themselves—the presence and actions of the photographer, which may intrude upon the plaintiff's seclusion, solitude, or private affairs.

While closely related to **trespass,** intrusion goes beyond the simple entry upon private property without permission. Even if entry to private property is permitted, any subsequent photographic activity may be

regarded as an intrusion upon the expected seclusion to the subjects or into their private affairs. Further, shooting into private property from a public vantage point does not mitigate the intrusion—shooting pictures of people in places where they have a reasonable expectation of privacy is likely to be an invasion of their privacy. Although intrusion is more difficult to prove than trespass, it is usually unethical for a photographer to intrude upon the private lives of people in private places. Since intrusion may occur without trespass, therefore, it is generally a good idea for the photographer to obtain permission not only to enter upon private property but also to photograph subjects who are in private places.

Entering private property, however, that is open to the public is no trespass. Nevertheless, photography on private property that is open to the public, such as most places of business, theaters, and concert halls, may be restricted at the whim of the owner. Generally, unless notices are posted or communicated to the contrary, or the owner verbally refuses permission to photograph on the property, photography may proceed. However, any disruption of the normal flow of business caused by the photographer may be judged an intrusion.

Public places, such as libraries, museums, schools, hospitals, courthouses, and the like, may limit photography to protect the facilities and their users, and to avoid disruption of normal activity. As with private property, unless notice is posted or otherwise communicated, photography may generally proceed.

Military commanders have generally been judged to have extraordinary rights to search, seize film and cameras, and eject photographers in areas under their control.

Photographers are generally safe to photograph what they see on public streets an thoroughfares without fear of committing an intrusion. Anything that any person might see from the same location with the naked eye may be photographed. This does not mean, however, that the photographer may startle, frighten or intimidate subjects, disrupt their right to go about their normal activities, or that the photographs they take in these places may necessarily be published.

Because celebrities may be considered newsworthy and public persons, they often do not enjoy many of the legal rights of privacy that ordinary persons might enjoy. Although photographers may have an ethical responsibility to be considerate of all their subjects in all places and to respect their privacy in private places, some will often go to extreme lengths to photograph celebrities wherever they may be, sometimes pursuing them relentlessly, harassing them, and interfering with their activities. In some extreme cases the courts have been moved to restrain individual photographers from approaching particular subjects too closely, from unreasonably harassing them or interfering with their activities during photography. Publication of the photographs for purposes other than news would, of course, require the subject's permission.

Gaining access to news events that occur on private property may pose special problems for photographers. Generally, if it is common usage, custom and practice in a given locality for a news photographer to accompany or follow police or fire officials onto the site of a newsworthy event, the photographer is not likely to be judged guilty of either trespass or intrusion. However, not all police and fire officials may be equally aware of local practices and policies, and individuals may seek to order a news

photographer away from the site of a breaking news event or to otherwise restrain photography. Failure to comply may result in the photographer's arrest for disorderly conduct or for obstructing an officer's performance of duty.

In some states, the National Press Photographers Association (NPPA) or regional press photographers associations, have established guidelines with state police for news photographers to access news sites. Although not all local police cooperate with these state guidelines, these attempts have gone far to create a more cooperative working relationship between public officials and the news media. Objective 12-G, Photojournalism, elaborates on some of the special challenges of news photography and photojournalism.

Many potential problems of intrusion may be avoided by using common sense and a few precautions. When photographing people who are aware of the presence of the camera, photographers should verbally identify themselves as photographers and the reasons why they are shooting. It is also good practice to obtain full identification of persons who appear prominently in photographs. Precautions such as these may help to establish **"implied consent"** to being photographed—by not protesting, the subjects implicitly consent to the photographer's actions. However, the concept of implied consent is very subjective and often is difficult to establish in court.

Disclosing embarrassing private facts This tort of privacy and the others that follow generally refer to the publication of photographs rather than to the acts of photography themselves. Although the term "publication" is often thought of as some form of reproduction in print or other media, such a definition is insufficient as it is applied under the laws of privacy. For these purposes, **publication** may include displaying, offering for sale, or even simply showing a photograph to another person.

This tort of privacy refers to **public disclosure of embarrassing private facts** that holds persons up to public ridicule, offends public standards of taste, or that publishes private and embarrassing information about them. Although federal case law is uneven in this area, no universal right exists to disclose publicly all private true facts about individuals that the public has no real right to know. Newsworthiness may serve as one defense against legal action under this tort and disclosing information that is a public record, no matter how old, may serve as another. However, circumstances may cloud the issue and notable exceptions remain. For example, reprinting photographs of rehabilitated ex-convicts or reformed prostitutes with descriptions of their names and earlier deeds have been judged invasions of privacy under this tort.

Generally, public persons, such as politicians, relinquish their rights of privacy under this tort. Further, when persons become newsworthy, many of their rights of privacy are lost, including this one. Publication of photographs in news media which disclose embarrassing private facts about newsworthy persons has not generally been held a violation of their rights of privacy—newsworthiness is generally a defense under this tort. But the same photograph may not necessarily be published again, whether in news or other media, after the person has ceased to be newsworthy.

False light This tort of privacy refers to placing a person in a **"false light"** by incorrectly representing the subject in the public eye. Rather than from the photograph itself, the offense usually results from misrepresentation or misidentification in text accompanying the published photograph, such as in the headline, caption, or story. For example, the photographer might take a picture of a group of students outside the student center with their consent. However, if the photograph were then published to illustrate a story about drug abuse on college campuses, the photograph would place the identifiable students in a false light by implying that they were drug abusers.

Although "false light" rarely results from the photograph itself, it is nonetheless possible. Needless to say, deliberate image alterations by photographic or electronic means that create a false image of the subject and related details are examples. Although such deliberate alterations were a popular form of early news photography, such practices invite lawsuits under this tort today. Nonetheless, distortions and compressions that result accidentally and inadvertently from the use of wide-angle and telephoto lenses can result in image alterations that may cast the subject in a "false light"—for example, by making them appear nearer to persons or objects than they actually were, in conversation with persons to whom they never actually spoke, or in groups of persons they were never in. Careful attention to the headline, caption, and story accompanying the photograph can usually counteract any such inadvertent distortions.

Libel is the printed form of defamation—the wrongful damaging of a person's reputation by communicating a false statement or making a false accusation. As with with false light, libel arising from a published photograph usually arises from the accompanying caption or text, even though a photograph alone may be libelous if it conveys a false and defamatory image. Libel actions undertaken under this tort suggest five points that must be proved for the action to succeed:

1. the representation must have been published,

2. the subject must be identified or clearly identifiable,

3. the representation must be false,

4. the representation must be defamatory, and

5. private persons must show that the representation was published through some fault or negligence on the part of the publisher, and not through an honest mistake. Public persons and celebrities must show that the representation was published with actual malice, with knowledge that it was false, or with reckless disregard for the truth.

Appropriation The tort of **appropriation** for advantage of a person's name or likeness has been more a problem for advertisers and commercial photographers than it has for news photographers and photojournalists. The news photographer enjoys many safeguards to the process of reporting the news in the public interest, and public persons and celebrities are often an integral part of the newsworthy landscape. Usually, the issue arises with photographs taken of celebrities in public places, which are later used to sell products without their consent. The subjects may not wish to be associated with the product, or they may wish to be paid for their implied endorsement.

Appropriation is considered to possess a proprietary rather than a personal value under the privacy laws; therefore appropriation has monetary value. The image or likeness of a celebrity is what that person trades upon and its trade value may be diminished by uncontrolled exposure. Thus, the appropriation of a celebrity's likeness for gain may be regarded as an appropriation of valuable property.

The subject need not be a celebrity, however, for their image to possess proprietary value. Ordinary persons, even professional models, who consent to photography may not wish to have the photographs published for advertising or trade without their permission. Thus, the tort of appropriation gives rise to the need for model releases. A **model release** is simply a written consent to the photography and its subsequent uses. News photographers rarely need model releases to make or publish "hard news" photographs in news publications. For magazine and feature photographs, as distinguished from "hard news" photographs, model releases are generally recommended from featured or identifiable persons in the photographs.

Although not necessary in some states, a valuable consideration for the use of the image, generally a token payment of $1.00 or a copy of the photograph, is usually sufficient to establish a business contract under which the photographer has received consent to shoot and publish the photographs. See Appendix I for an example of a model release.

Copyright

The Copyright Act The federal Copyright Act of 1976 overhauled the copyright system in the United States. The Act created for the first time a separate field of "visual art," including photographs, and extended federal protection to both published and unpublished works. An unpublished, original photograph is automatically protected under the Act from the moment of its creation. To protect it when it is published, the print must bear a simple declaration that includes the copyright symbol ©, the name of the owner, and the year of creation, or the phrase "Copyright (year of creation) by (name of owner)," where it can be seen easily. A more complete declaration that is recognized by many international copyright treaties includes: Copyright © (name of owner), (year of creation), all rights reserved.

Under the Act, the creator of a visual art work retains ownership of the original work for life plus fifty years unless that ownership is sold or given away.

In general, a photographer working as a salaried employee relinquishes copyright to the employer. The Act defines works created by salaried employees as **"works for hire,"** and stipulates that such works are the employer's property unless the employment agreement stipulates otherwise. Works made for hire are protected by copyright for 75 years from the date of publication or 100 years from the date of creation, whichever is shorter.

The Act confers upon the copyright owner four exclusive rights that are of special interest to photographers. These include:

1. the right to reproduce the visual work,
2. the right to prepare derivative works (such as combination prints, croppings, enlargements, manipulated images, and so on),

3. the right to distribute the work to the public, and

4. the right to exhibit the work in public.

Under the Act, copyright is automatic upon the creation of the work until the work is published—ownership of the work is vested in the creator of the work or the employer together with the right to register the copyright and to control publication. In the field of copyright, the term publication has been defined in many ways. In this context, publication may be said to occur when the work is offered to another for display, sale, or further distribution, with or without showing the work, when it is printed or distributed, with or without payment , or when it is shown with a reasonable assumption on the part of the viewer that the work may be for sale, such as in a gallery showing. Upon publication, ownership of the work passes into the public domain unless the owner makes a **declaration of intent to retain copyright** by marking the photograph or the transparency mount with a simple copyright declaration where it can be easily seen.

For the photographer to retain copyright of a photograph that appears in a publication, the copyright declaration must appear with the photograph. A credit line is not sufficient. Even though the publication itself may be copyrighted, the copyright protects its contents for the publisher; the photographer needs further protection by having a separate copyright declaration appear with the work, as described above.

It is not necessary to register a copyright immediately. The owner has ninety days after an infringement of copyright to register the work with the Copyright Office and to begin an action against the infringer. To proceed, the copyright declaration must have been attached to the work. If the copyright was registered before the infringement, the owner may seek punitive damages, a sum of money intended to punish the infringer, as well as actual damages, a sum of money intended to compensate the owner for losses suffered as a result of the infringement. If the copyright is registered after the infringement, then the owner may seek only actual damages.

The Copyright Act contains a **"fair use"** provision that allows some uses of copyrighted works without permission and without infringing the copyright. Among these are uses that will have a negligible effect upon the work's market potential and uses for nonprofit educational purposes. Thus, copying a copyrighted photograph from a book or exhibit and displaying a transparency of it for classroom discussion would likely fall within the Act's fair use provisions. Making 500 copies for distribution in a course syllabus would not likely be considered fair use because 500 copies might impact upon the work's market potential.

Ownership of photographs Freelance photographers encounter many situations affecting ownership. Under the general provisions of the Act, freelance photographers shooting on speculation at their own expense generally retain copyright to their own works. If they are contracted to perform photographic work for hire, their works become the property of the employer, unless the photographer and the contractor agree otherwise. The work-for-hire rule was established in 1913 when a New York court ruled that an ordinary contract between a photographer and a customer constituted a contract of employment. This decision still holds and is incorporated into the Copyright Act of 1976.

Established freelance photographers often derive a substantial part of their income from the resale of publication rights long after an original photograph was taken. Ownership of the works is, therefore, an important economic consideration that photographers should carefully consider when establishing working agreements with their clients. Unless contracted otherwise, a photograph made to order for a paying client belongs to the client, including the negatives and all rights. Even though the negatives may be retained by the photographer, they may not be used in any way without the client's permission. Photographs made on speculation at the photographer's own expense belong to the photographer.

Photographers who take photographs on their own that are intended for someone else must exercise care that they do not enter into an **implied contract.** For example, suppose that a photographer verbally agrees to provide photographs of a client's widget, shoots a dozen or so product shots trying to get one that will please the client, and then sends them all to the client to make a selection. Who owns the photographs? Ownership is clouded because no written agreement exists. Perhaps the client believes that the verbal request and agreement constitute a work-for-hire agreement under which the client owns all the photographs. Perhaps the photographer believes that the work was undertaken on a freelance basis, that the photographer owns all the photographs, and that the client is entitled to purchase only those photographs the photographer is willing to sell. Situations such as this need not arise if the terms of engagement are stipulated in a written agreement beforehand.

Freelance photographers should understand that work-for-hire provisions are often included in the fine print of standard commercial contracts. A photographer who wishes to retain the rights to photographs shot for a paying client and to sell them again in the future, must make an agreement with the client stipulating this before shooting begins. A **licensing agreement** is one such type of agreement that, for a fee, gives the client the right to use the photograph under stipulated conditions while leaving the photographer's ownership intact. The licensing agreement can stipulate the fee, restrict use of the photograph to a particular edition of a particular publication, define where the photograph may be distributed, such as only in the United States, specify how the credit line is to read, and state a date for the return of the photographs along with penalties for late or absent returns. An example of a licensing agreement appears in Appendix L.

Many periodical publications, understanding licensing agreements, engage freelance photographers under "shoot-and-ship" agreements that commonly grant the assigning publication the first North American publication rights but otherwise leave the photographer's ownership intact. Other clients may be less willing to give up their ownership of works made for hire.

Questions to Consider

1. Describe the characteristics of a fine print and how to produce one.

2. Describe the basic principles of the zone system and the relationship between this system and a full-scale image.

3. What is the purpose of archival processing and how does it differ from normal processing?

4. Describe several situations that might lead a photographer to prefer to use a view camera rather than a 35-mm viewfinder or reflex camera? What features of the view camera make it more suitable for these situations?

5. Describe the tools and techniques needed to photograph life-size closeups of three-dimensional objects.

6. What are the main problems the photographer faces when making a copy of a two-dimensional object, such as an oil painting?

7. How do you expect you might use electronic photography and electronic imaging in the next three to five years? How will these uses improve upon the techniques you use today?

8. Briefly describe the four torts of privacy and the steps a photographer can take to avoid invasions of privacy.

9. Under what conditions do photographers relinquish ownership of their photographic works? How may photographers retain their ownership of works produced for hire?

Suggested Field and Laboratory Assignments

1. Select a subject with a wide range of tonal values. Try to previsualize these tonal values and then photograph it to produce a full-scale print of the subject.

2. Process one print for permanence using techniques of archival processing.

3. Obtain access to a view camera and experiment with the perspective controls.

4. Shoot, process, and print a roll of black-and-white panchromatic film that includes at least one example of each of the following:

 a. close-ups of small objects such as flowers, insects, or coins, to produce a 1:1 or life-size negative image

 b. photomacrographs of similar objects to produce a 2:1 (double life-size) or larger negative image

 c. copy photographs to produce a reproduction of a photograph or other continuous-tone black-and-white original.

5. Visit the photography department of a large daily newspaper and observe how electronic photography is currently being used in photojournalism. Visit a graphic production or publishing house and observe how electronic imaging is currently being used in publishing.

6. Go on a shoot in a public place and obtain model releases from the subjects of your photographs.

Appendix A: Recommended Equipment Packages

The wide variety of camera equipment available to the contemporary photographer complicates the selection of a single camera system. Almost all the cameras on the market will deliver excellent results, yet some brands and items are consistently favored by working professional photographers.

Over the years, certain photographic materials have demonstrated their ability to ease, or simply withstand, the rigors of the creative photographic process. Certain camera tools and lenses seem to "fit" certain tasks. The following lists suggest materials that are likely to be useful for three general types of work: entry-level photojournalism, medium-format photography, and large-format photography. The lists describe many of the tools commonly used by photographers performing such work.

A Camera and Lens System for the Entry-Level Photojournalist

35mm Camera Bodies

A rugged camera body made by Nikon or Canon is the standard tool for most photojournalists. Specialized optics can easily be rented or borrowed from a newspaper's "pool" if one of these two brands is used. A model priced in the middle of the high end of the manufacturer's line usually represents the best buy. Two camera bodies—one with a wide-angle lens, the other with a short telephoto—are often required to cover breaking news.

Lenses

Good lenses are a lifetime investment. Poor lenses suffer from a host of optical and mechanical ills and often need to be replaced. Nikon or Canon lenses are usually a good choice for cameras of the same brand. Lenses with fixed focal lengths are generally faster than zoom lenses, so it is usually a good idea to build a basic system of prime lenses before supplementing it with a zoom lens.

The following list describes lenses that are useful for a variety of photojournalism assignments. (Note: * indicates basic system.)

20–24mm wide-angle	Useful for very wide angle shots.
*35mm wide-angle	Used as a "speed" lens; should be the fastest affordable—f/1.4 or f/2. Photojournalists use a wide-angle more than any other lens.
50mm	This "normal" focal length is not essential. Many professionals who include a 50mm lens select either a very high speed normal lens for available light work or a macro lens that also allows for closeup work from one-half life size to infinity.
*100 or 105mm	A "short telephoto" lens great for pictures of people and offering enough speed for available light and sports use.
180, 300, or 400mm	A long telephoto lens for sports and other distance situations. The fastest affordable one could be a 180mm f/2.8, 300mm f/2.8, or 400mm f/3.5.
Fast zoom	Some photographers supplement their lens kit with a fast zoom such as the Nikon 35–70mm AF f/2.8.

Flash Equipment

If affordable, a new high-tech flash unit such as Nikon's SB-24 can make flash work, especially fill-in flash, very quick and easy. One or two basic flash units, such as the durable Vivitar 283 or 285, can be used instead or as a supplement. If two flash units are on hand, one can be connected to a small slave sensor. The addition of a couple of compact light stands and a small softbox would make a complete location lighting kit.

Filters

Because shooting conditions are unpredictable and often rough, photojournalists usually keep an ultraviolet (UV) filter on every lens for physical protection. A fluorescent-to-daylight (FLD) filter is commonly used when shooting color film, and a polarizing filter is handy for increasing color saturation. A neutral density (ND) filter is also useful; it enables wider apertures to be used for simplifying backgrounds.

Other Supplies

Professionals always carry along spare batteries, plenty of film, a cable release, and basic lens-cleaning supplies. A small notebook and pencil for recording caption information and a permanent marking pen for labeling film cassettes are also useful.

Special Tools

For location lighting, a flash meter is very helpful. Both the Minolta Auto Meter IIIF and the Sekonic Digi-Lite F, L-328, have proven to be dependable and accurate.

A monopod can make working with long telephotos easier. The super-compact model made by Gitzo is a good solution. Bogen offers less expensive as well as larger models.

A Camera and Lens System for Medium-Format Commercial Work

Many commercial clients require medium-format or larger images because the larger film size permits more detailed reproduction than does the 35mm format. Most advertising location work, for example, or assignments that involve movement and people are typically handled on 120-size film. Although many excellent cameras are available in this film size, Hasselblad has become the standard tool for the commercial and advertising photographer. Its Zeiss lenses are unmatched for sharpness and contrast, and lenses with a variety of focal lengths can be rented from most professional supply houses to meet the demands of special assignments.

Hasselblad Body

Hasselblad offers a choice of several bodies; however, the basic 500 Classic and the 503CX are the workhorses of the trade. (The 500 camera series has been around for many years, and used models are readily available. Especially good buys can be found on a used 500CM or the slightly older 500C camera bodies.)

The body should be purchased equipped with the standard A12 film magazine, folding focusing hood, and the 80mm normal lens. The 150mm telephoto lens and Polaroid back should be added to round out the system.

Lenses

The 80mm f/2.8 Zeiss Planar normal lens is a versatile and widely used tool that should be included in every Hasselblad camera system.

The 150mm f/4 Zeiss Sonnar is probably the second most popular lens for commercial photography. This short telephoto is perfect for portraits and for assignments that involve both products and people.

Polaroid Back

Hasselblad and other manufacturers make Polaroid backs that attach to the camera as easily as the roll film magazines. These devices are very practical and popular. The resulting instant print gives a fast check of focus, lighting, and composition.

Tripod

Every medium-format system should include a very sturdy tripod suitable for supporting both medium- and large-format cameras. The Bogen tripod model #3021 with a #3047 head is a good choice.

Other Common Accessories

Additional useful accessories include a cable release, a lens shade, and a hand-held light meter that can also be used for flash work, such as the Minolta Auto Meter IIIF or the Sekonic Digi-Lite F, L-328.

A Large-Format Camera and Lens System

The type of large-format camera selected will depend on its intended use. Architecture, advertising, and studio photographers require the extended movements of a monorail-type camera. Landscape photographers and others who expect to travel frequently with the camera will be better served by the more compact field cameras. Although view cameras are available in many sizes, the 4-in. by 5-in. format is most widely used.

Some popular monorail camera brands are Calumet, Cambo, Horseman, Linhoff, Omega, Sinar, and Toyo. Popular field cameras include Deardorff, Calumet, Ikeda, Linhoff, Toyo, Wista, and Wisner.

Lenses for 4-in. by 5-in. View Cameras

For general-purpose work, short telephoto lenses are far more versatile than the "normal" focal lengths. A lens in the range of 180mm to 210mm is strongly recommended. Because the lens is the heart of a large-format system, the highest-quality affordable lens should be selected. The 210mm Schneider Symmar-S lens is a very good choice. The lens should be purchased mounted to a lens board designed to fit the selected camera.

Accessory Equipment

Additional equipment useful in large-format photography includes the following:

carrying case
sturdy tripod
cable release
hand-held light meter
at least 6 sheet film holders
focusing cloth
focusing magnifier or loupe
Polaroid 545 film back
lens shade

Appendix B: Equipment and Supply Sources

Calumet, The Photographer's Catalog
890 Supreme Drive
Bensenville, IL 60106
(800) 225-8638
A well-stocked, professional supply house, including large-format cameras, darkroom gear, and lighting equipment. Comprehensive catalog available.

Freestyle Sales
5124 Sunset Boulevard
Los Angeles, CA 90027
(800) 292-6137
(800) 545-1011
In California: (213) 660-3460
One of the oldest and least expensive suppliers of film, paper, and darkroom supplies.

Light Impressions
439 Monroe Avenue
Rochester, NY 14607
(800) 828-6216
(800) 828-9629
An excellent source of photographic books and archival supplies. Outstanding, must-read catalogs.

The Photographer's Formulary
Box 5105
Missoula, MT 59806
(800) 922-5255
Offers bulk photo chemicals and supplies for those who want to mix their own photographic brews. Also offers chemicals, kits, and products for nonsilver photo processes.

Porter's Camera Store
Box 628
Cedar Falls, IA 50613
(800) 553-2001
(800) 772-7079
In Iowa: (800) 553-2450
Imagine a catalog that looks like a tabloid newspaper filled with hard-to-get, useful, and sometimes weird and wacky photo items.

ReSource: A Catalog of the Maine Photographic Workshops
2 Central Street
Rockport, ME 04856
(800) 227-1541
A limited selection of the highest-quality items for the serious photographer.

Spiratone
135-06 Northern Boulevard
Flushing, NY 11354
(800) 221-9695
Their ad appears regularly in the back of the popular photography magazines. A mail-order house that offers many house-brand items at low prices.

Zone VI Studios
Newfane, VT 05345
(802) 257-5161
Fred Picker designs, modifies, tests, and sells a carefully selected number of products mainly for the large-format photographer.

Appendix C: Metric and U.S. Customary Measures

In this edition, wherever practical, both U.S. customary and metric measures are provided. Where one system is more commonly used in a particular case, that measure appears first; its equivalent in the alternative system then follows in parentheses. Occasionally, you may need to convert measures from one system to the other. The following table provides conversion information.

Units of Length

meter	= 39.370 inches
centimeter	= .3937 inch
foot	= .3048 meter (30.48 centimeters)
inch	= .0254 meter (2.54 centimeters)
centimeters	= inches × 2.54
inches	= centimeters × .3937

Units of Volume

liter	= 1.056 U.S. quarts
	= .2640 U.S. gallon
U.S. quart	= .9463 liter
U.S. gallon	= 3.785 liters
milliliters	= U.S. ounces × 29.6
	= U.S. quarts × 946.3
U.S. ounces	= milliliters × .034
U.S. quarts	= milliliters × .001

Temperatures

°Fahrenheit = 32 + (°Celsius × 1.8)
°Celsius = (°Fahrenheit − 32) × .5556

°C	100	90	80	70	60	50	40	30	20	10	0	-10	−18
°F	212	200	180	160	140	120	100	80	68 60		40 32	20	0

Appendix D: Professional Organizations and Hot Lines

Advertising Photographers of America
27 West 20th Street
New York, NY 10011
(212) 807-0399
APA also has branches in Atlanta, Chicago, Los Angeles, Miami, and San Francisco.

American Society of Magazine Photographers
205 Lexington Avenue
New York, NY 10016
(212) 889-9144

Eastman Kodak Company
343 State Street
Rochester, NY 14650
(800) 242-2424

Friends of Photography
101 The Embarcadero
San Francisco, CA 94105
(415) 391-7500

Ilford Photo
West 70 Century Road
Paramus, NJ 07653
(800) 262-2650

National Press Photographers Association
3200 Croasdaile Drive
Durham, NC 27705
(800) 289-6772

Polaroid Corporation
575 Technology Square
Cambridge, MA 02139
(800) 343-5000

Professional Photographers of America
1090 Executive Way
Des Plaines, IL 60018
(708) 299-8161

Society for Photographic Education
Box BBB
Albuquerque, NM 87196
(505) 268-4073

Appendix E: Workshops and Programs

Anderson Ranch Arts Center
Box 5598
Snowmass Village, CO 81615
(303) 923-3181

Center for Creative Imaging
Eastman Kodak Company
51 Mechanic Street
Camden, ME 04843-1348
(800) 428-7400

Daytona Beach Community College
Photographic Society Photo Center
Box 2811
Daytona Beach, FL 32115
(904) 255-8131

Film in the Cities
2388 University Avenue
St. Paul, MN 55114
(612) 646-6104

Friends of Photography
101 The Embarcadero
San Francisco, CA 94105
(415) 391-7500

International Center of Photography
1130 Fifth Avenue
New York, NY 10128
(212) 860-1777

Maine Photographic Workshops
2 Central Street
Rockport, ME 04856
(207) 236-8581

Zone VI Workshops
Putney, VT 05346
(802) 257-5161

Appendix F: Publications

Annuals

Adweek Portfolio
49 East 21st Street
New York, NY 10010
(212) 529-5500

American Showcase
724 Fifth Avenue
New York, NY 10019
(212) 245-0981

The Creative Black Book
115 Fifth Avenue
New York, NY 10003
(212) 254-1330

The Workbook
940 N. Highland
Los Angeles, CA 90038
(213) 856-0008

Periodicals

American Photographer
1515 Broadway
New York, NY 10036
(212) 719-6000

Aperture
20 East 23rd Street
New York, NY 10010
(212) 505-5555

Artweek
12 South First Street
Suite 520
San Jose, CA 95113
(800) 540-7330
(408) 279-2293

Darkroom and Creative Camera Techniques
7800 Merrimac Avenue
Niles, IL 60648
(312) 965-0566

Darkroom Photography
Box 16928
North Hollywood, CA 91615
(818) 760-8983

E.S.P.R.I.T.
Electronic Still Photography at Rochester Institute of Technology
1 Lomb Memorial Drive
Rochester, NY 14623
(212) 630-8000

News Photographer
National Press Photographers Association
3200 Croasdaile Drive
Durham, NC 27705
(800) 289-6772

Peterson's Photographic
6725 Sunset Boulevard
Los Angeles, CA 90028
(213) 854-2200

Photo/Design
1515 Broadway
New York, NY 10036
(212) 764-7300

Photo District News
49 East 21st Street
New York, NY 10010
(212) 677-8418

Photo>Electronic Imaging
1090 Executive Way
Des Plaines, IL 60018
(708) 299-8161

Popular Photography
1515 Broadway
New York, NY 10036
(212) 719-6000

Shutterbug
Box 1209
Titusville, FL 32781
(800) 327-9926

Appendix G: Tables of Current Films and Materials

TABLE G-1 Commonly available black-and-white films

Speed and Purpose	Manufacturer and Name	ISO
Slow speed films (up to ISO 50/18°): Excellent in high illumination, such as at the beach or in the snow, when fine detail and delicate tones are needed. Full range of gray tones across wide range of brightness values. Little apparent graininess. Generally require quite accurate exposure settings. Most suitable for extreme enlargement.	Agfa Dia Direct* Agfa Agfapan Pro 25 Ilford Pan F Kodak Panatomic-X Kodak Panatomic-X Pro Kodak Technical Pan 2415 Kodak High Speed IR‡ Kodak Kodalith HCS§	32/16° 25/15° 50/18° 32/16° 32/16° 25/25° 50/18° 12/12°
Medium-speed films (ISO 64/19°–160/23°): Excellent under a wide range of conditions. Wide exposure latitude, allowing exposure variations of up to two stops while still producing usable images. For general photography. Slight apparent graininess.	Agfa Agfapan Pro 100 Agfa Agfa Vario XL Pro* Ilford FP4 Ilford XP1 400* Kodak Verichrome Pan Kodak Plus-X Kodak Plus-X Pan Pro Kodak Plus-X Pan Pro 2147 Kodak T-MAX 100	100/21° 125/22° 125/22° 125/22° 125/22° 125/22° 125/22° 125/22° 100/21°
Fast-speed films (ISO 200/24°–400/27°): Wider exposure latitude. Best when light is weak or when fast shutter speeds are needed. For general photography that includes weak light and/or action. Medium apparent graininess.	Agfa Agfapan Pro 400 Agfa Agfapan VarioXL Pro* Ilford HP5 Ilford XP1 400* Ilford XP2 400* Kodak Tri-X Pan Pro Kodak Tri-X Pan Kodak T-MAX 400	400/27° 400/22° 400/27° 400/27° 400/27° 320/26° 400/27° 400/27°
Ultra fast-speed films (ISO over 400/27°): Special-purpose films usually used when other films are too slow. Especially suited to extremely low light levels and combinations of low light and fast shutter. Generally have high apparent graininess that shows up under slight enlargement.	Agfa Agfapan VarioXL Pro* Ilford XP1 400* Kodak Recording Film 2475** Kodak Royal-X Pan Kodak T-MAX P 3200	1600/33° 1600/33° 1250/37° 1250/32° 3200/36°

* *Positive transparency film*

‡ *Infrared film*

§ *Lithographic (line image) film*

* *Chromagenic film with variable speeds (C-41 compatible)*

** *Variable-speed film (ISO 1000–4000/31–37°)*

TABLE G-2 Commonly available color and instant films

Manufacturer	Name	ISO/ASA Available	Notes
Color Reversal Films			
Agfa	Agfachrome CT	50, 100, 200	Processing included
	Agfachrome RS	50, 100, 100, 1000	E-6 compatible
Fuji	Fujichrome	50, 100, 400	E-6 compatible
	Fujichrome Pro	50, 100, 400	E-6 compatible
	Fujichrome T	64	Pro tungsten, E-6
Kodak	Kodachrome	25, 64	
	Kodachrome Pro	25, 64, 200	
	Kodachrome Type A	40	Tungsten
	Ektachrome	64, 100, 200, 400	Push for all but 64, E-6
	Ektachrome Type B	64, 160	Tungsten, E-6
	Ektachrome P	800/1600	Push processing, E-6
3M	Color Slide	100, 400, 1000	E-6 compatible
	Color Slide 640T	640	Tungsten, E-6
Color Negative Films			
Agfa	Agfacolor XRS	100, 200, 400, 1000	C-41 process
Fuji	Fujicolor	100, 200, 400, 1600	C-41 process
Kodak	Kodacolor VR	100, 200, 400, 1000	C-41 process
	Ektar	25, 100	C-41 process
	Ektapress Pro	100, 400, 1600	Photojournalism, C-41 process
	Vericolor III	160, 400	C-41 process
	Vericolor II (T)	125	Tungsten, C-41
	Vericolor HC	100	Extra contrast, C-41 process
Konica	Color Print	100, 200, 400	C-41 compatible
3M	Color Print HR	100, 200, 400	C-41 compatible
Instant Films			
Polaroid	SX-70	Polaroid makes a complete line of black-and-white and color films in a great variety of speeds.	Color prints
	600		Color prints
	Polacolor		Color prints
	Polapan		Black-and-white prints
	P/N		Positive/negative

TABLE G-3 Some typical film developers

Type	Manufacturer and Name	Grain	Effect on Film Speed	R or O*	Comments
General-purpose film developers. These are compromise formulas that strike a balance to give moderate grain, contrast, film speed, and resolution with general-purpose films	Kodak D-76	Medium–fine	Normal	O/R	World standard film developer
	Ilford ID-11	Medium–fine	Normal	O/R	Same as Kodak D-76
	Ilford Universal Film Developer	Medium–fine	Normal	O	Convenient liquid concentrate
	Kodak HC-110	Medium–fine	Normal	O/R	Versatile range of dilutions for various effects
	Edwal FG-7	Medium–fine	Normal	O	Liquid concentrate, versatile
	Agfa Rodinal	Medium–fine	Normal	O	Compensating with high dilutions
	Kodak T-Max	Fine–very fine	Normal	O	Designed especially for use with T-Max films
Fine-grain developers. Produce less apparent grain, may be coupled with some loss of acutance. Tend to be slower working. Afford contrast control for films with inherently high contrast.	Kodak Microdol-X	Extremely fine	Slight decrease	O/R	Extremely fine grain with slow films
	Ilford Perceptol	Fine to extremely fine	Depends on dilution	O/R	Fine grain and retains sharpness
	Ethol UFG	Extremely fine	Slight increase	R	Can be used with roll or sheets
Compensating developers. Designed to handle high contrast ranges and preserve highlight detail. Many liquid-concentrate general-purpose film developers such as Rodinal, FG-7, and HC-110 become compensating when used at very high dilutions.	Edwal FG-7 plan B	Medium–very fine	Slight increase	O	Contrast control possible through dilution
	Ethol TEC	Very fine	Normal	O	Very fine and sharp grain with slow films
High-energy developers. Good for push processing. Provides printable negatives with high exposure indexes.	Photo Systems PressMaxx	Medium–fine	Increased	O	Can triple printable film speed
	Kodak T-Max developer	Medium–very fine	Increased	O/R	Designed especially for T-Max films, useful with others
	Acufine	Medium–fine	Increased	O/R	Can double the printable film speed
	Diafine	Medium–fine	Increased	R	Two-bath formula helps preserve shadow detail with boosted exposure indexes
	Ilford Microphen	Fine–very fine	Increased	O	Very fine grain coupled with increased film speed

*R = reusable; O = one-shot; O/R = may be used either way

TABLE G-4 Some typical enlarging papers

Type	Manufacturer and Brand	Image Tone	Contrast	Comments
Resin-coated	Agfa Brovira-Speed	Neutral	Graded	
	Agfa Portriga-Speed	Warm	Graded	A warm-tone chlorobromide emulsion.
	Ilford Multigrade	Neutral	Variable	Good image tone. Three surfaces available. The pearl finish comes close to matching the surface of an air-dried fiber-based glossy print.
	Ilford Ilfospeed RC	Neutral	Graded	Also available in pearl finish.
	Kodak Kodabrome RC	Warm	Graded	A pleasant, slightly warm-tone image.
	Kodak Panalure RC	Neutral	Graded	A panchromatic paper used to make black-and-white prints of color negatives.
	Kodak Polycontrast Rapid II RC	Neutral	Variable	
	Kodak Polyprint	Neutral	Variable	Similar to Polycontrast II, but has more developing latitude.
	Oriental Seagull Select VC	Cold black	Variable	
Fiber-based	Agfa Brovira	Cold black	Graded	A rich cold-tone paper available up to grade #6.
	Agfa Portriga Rapid	Warm	Graded	A premium warm-tone paper on a creamy base. Very good developing latitude.
	Agfa Insignia	Warm	Graded	Similar to Portriga Rapid but on a pure white base.
	Ilford Ilfobrom	Neutral	Graded	
	Ilford Galerie	Neutral	Graded	A premium paper with strong blacks.
	Ilford Multigrade FB	Neutral	Variable	A high-quality variable-contrast paper.
	Kodak Ektalure	Warm	Graded	Available in highly textured surfaces.
	Kodak Elite	Neutral	Graded	A premium "gallery weight" paper.
	Kodak Kodabromide	Neutral	Graded	
	Kodak Panalure	Neutral	Graded	A panchromatic paper used to make black-and-white prints of color negative.
	Kodak Polyfiber	Neutral	Variable	
	Oriental New Seagull	Cold	Graded	Exhibition quality.
	Oriental New Seagull Portrait	Warm	Graded	
	Oriental New Seagull Select	Cold	Variable	

TABLE G-5 Some available paper developers

Manufacturer and Brand	Tone	Comments
Agfa Neutol	Neutral	Similar to Dektol
Ethol LPD	Warm to cold	Variable tone with dilution
Ilford Bromophen	Neutral	A good standard developer
Ilford Ilfospeed	Neutral	Especially designed for RC papers
Ilford Multigrade	Neutral	Matched for use with multigrade papers
Kodak Dektol	Neutral	The world standard; hard to beat
Kodak Selectol	Warm	A standard developer for "portrait" and other warm-tone papers
Kodak Selectol Soft	Warm	Similar to Selectol, but gives approximately one grade lower contrast
Kodak Ektaflo 1	Cold	A convenient liquid concentrate
Kodak Ektaflo 2	Warm	A convenient liquid concentrate
Solarol	Neutral	Especially formulated for Sabattier printing, can also be used for normal printing

Appendix H: Time and Temperature Charts

TABLE H-1 Kodak Tri-X (ISO 400)

	65°	68°	70°	72°	75°
HC-110 A	4¼	3¾	3¼	3	2½
HC-110 B	8½	7½	6½	6	5
D-76	9	8	7½	6½	5½
D-76 1:1	11	10	9½	9	8
Microdol-X	11	10	9½	9	8
Microdol-X 1:3	NR	NR	15	14	13
Hobby-Pac	8½	7½	6½	6	5
T-Max	7	6	6	5¾	5½

TABLE H-3 Kodak T-Max 400 film

	65°	68°	70°	72°	75°
T-Max	NR	7	6½	6½	6
D-76	9	8	7	6½	5½
D-76 1:1	14½	12½	11	10	9
HC-110 dil. B.	6½	6	5½	5	4½
Microdol-X	12	10½	9	8½	7½
Microdol-X 1:3	NR	NR	20	18½	16

TABLE H-2 Kodak T-Max 100 film

	65°	68°	70°	72°	75°
T-Max	NR	8	7½	7	6½
D-76	10½	9	8	7	6
D-76 1:1	14½	12	11	10	8½
HC-110 dil. B.	8	7	6½	6	5
Microdol-X	16	13½	12	10½	8½
Microdol-X 1:3	NR	NR	20	18½	16

TABLE H-4 Kodak T-Max 3200 film

	Exposed at E.I.	70°	75°	80°	85°
T-Max Developer	400	7	6	5	4
	800	7½	6½	5½	4½
	1600	8	7	6	5
	3200	11	9½	8	6½
	6400	13	11	9½	8
	12,500	15½	12½	10½	9
	25,000	17½	14	12	10
D-76	400	9½	7½	6	4½
	800	10	8	6½	5
	1600	10½	8½	7	5½
	3200	13½	11	8½	7½
	6400	16	12½	10½	9
HC-110 Dil. B	400	6½	5	4½	3½
	800	7	5½	4¾	4
	1600	7½	6	5	4½
	3200	10	7½	7	5¾
	6400	12	9½	8	6¾

TABLE H-5 Kodak verichrome pan

	65°	68°	70°	72°	75°
HC-110 B	6	5	4½	4	NR
D-76	8	7	5½	5	4½
D-76 1:1	11	9	8	7	6
Microdol-X	10	9	8	7	6
Microdol-X 1:3	15	14	13	12	11
Hobby-Pac	6	5	4½	4	NR

TABLE H-6 Kodak high speed infra red film #4143

	65°	68°	70°	72°	75°
HC-110 B	7	6	6	5½	5
D-76	13	11	10	9½	8

Appendix I: Model Release

A model release is a document that provides the photographer with the written consent of persons appearing in a photograph both for the photograph to be taken in the first place and for it to be used subsequently. Without consent, publication of a person's name or image may expose the photographer to an invasion of privacy action, especially if the photograph is used for promotion, advertising, or trade. Consent is all that is necessary in order to avoid such action—compensation is not required, nor need the consent be written. Although oral consent is binding, it may be difficult to prove in the event of an action; therefore, most professional photographers routinely obtain written releases from persons appearing in their photographs if they expect the photographs to be published, displayed, or exhibited.

Many forms of model release have been developed, some long and very detailed and others short. Standard model release forms can be obtained at most photography stores. Following is a typical general-purpose model release that can be modified as needed.

Model Release

Date: _____

Photographer: _____

Address: _____

City, State, Zip: _____

For valuable consideration received, I hereby irrevocably consent to and authorize the use and reproduction by the above named photographer, or anyone authorized by same, of any and all photographs made of me, or in which I may appear, on this date by the named photographer, whether in negative or positive form, in whole or in part, alone or with other photographs, in any medium and for any purpose whatsoever, and including my name in conjunction therewith if desired, without further compensation to me.

All negatives and positives, together with all derivative images, shall constitute the property of the photographer, solely and completely, without reservation.

I hereby release and discharge the above named photographer from any and all claims, actions, and demands arising out of or in connection with the use of said photographs.

I am 21 years of age or older: Yes _____ No _____

Model: _____
 (signature)

Address: _____

City, State, Zip: _____

Witness: _____
 (signature of witness)

(If model is under 21 years of age, consent must be given by parent or guardian.)

I hereby certify that I am the parent or guardian of _____,
the model named above, and for valuable consideration received, I give my consent without reservation to the foregoing.

Date: _____

Parent or guardian: _____
 (signature of parent or guardian)

Witness: _____
 (signature of witness)

Appendix J: Approximate Equivalent Focal Lengths for Various Film Formats

	Film Size				Angle of View
	35mm	2¼ × 2¼	2¼ × 2¾	4 × 5	
Wide-angle lenses	15mm	22mm	28mm	54mm	100°
	21mm	32mm	40mm	75mm	81°
	28mm	45mm	50mm	90mm	65–68°
	35mm	50mm	65mm	125mm	53–55°
Normal lenses	**50mm**	**80mm**	**90mm**	**180mm**	**39–44°**
Telephoto lenses	70mm	100mm	125mm	210mm	30–35°
	85mm	125mm	150mm	300mm	24°
	100mm	150mm	180mm	350mm	20°
	135mm	180mm	250mm	450mm	15–17°
	200mm	300mm	375mm	700mm	10°
	400mm	600mm			5°

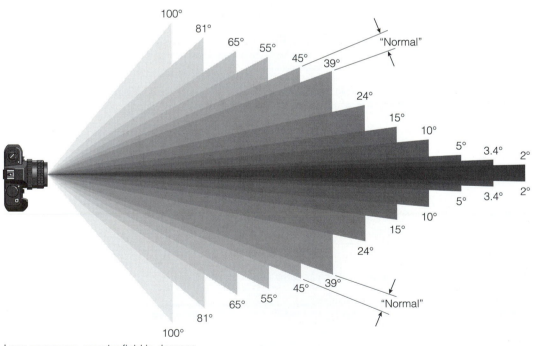

Lens coverage: angular field in degrees

FIGURE J-1

Lens angular coverage chart.

Appendix K: A Personal Film Developing Sheet for Recording Specific Film Developing Data

Summary of Film Processing Steps

Here is a brief summary of the steps involved in processing your exposed film to transform the latent images into usable negatives. Blank spaces are provided for noting your specific processing chemicals, times, and temperatures.

Note:

Developing tank type and capacity: _____

In the light, prepare working strength processing solutions and bring them to the proper temperature. Place them in the wet area.

In the dry area, set up your equipment and materials neatly before you. Turn out the light.

In total darkness, remove the film from its container and trim it. Load it onto a dry processing reel or hangers. Load into the processing tank and seal. Turn on the lights.

Pour a suitable developer into the tank. Agitate. Develop for precisely the recommended time. Discard one-shot developer; return reusable developer to storage.

Note:

developer type and name: _____

developer dilution: _____

time and temperature: _____

Pour stop bath into the tank. Fill and empty the tank with water twice, or use an acid stop bath. Discard water; save stop bath.

Note:

stop bath type and name: _____

stop bath dilution: _____

time and temperature: _____

Pour fixer into the tank. Agitate. Fix for recommended time. Return fixer to storage. Check negatives.

Note:

fixer type and name: _____

fixer bath dilution: _____

time and temperature: _____

Rinse the film briefly to remove excess fixer and then pour in a clearing agent or washing aid. Clear for the recommended time. Save the clearing agent for re-use.

Note:

washing aid name: _____

dilution: _____

time and temperature: _____

Wash the negatives to remove all traces of processing chemicals. Follow the wash times provided by the maker of your clearing agent. Use of high-speed film washer will help to assure a complete wash.

Bathe the negatives in a wetting agent.

Note:

 agent type and name: _____

 agent dilution: _____

 time and temperature: _____

 wash time: _____

Dry the film.

Tally and replenish reusable developer.

Carefully cut the dry film and file the negatives.

Appendix L: Licensing Agreement

A licensing agreement is a document that stipulates to a photographer and a client the terms and conditions under which the client has the right to use photographs that are owned by the photographer. In a sense, the photographer agrees to "rent" to the client certain rights to reproduce the photographs for a fee. The licensing agreement can stipulate whatever terms and conditions are agreeable to both parties, but it is usually a good idea to include a description of the photographs being licensed, dates when the prints are to be delivered and returned, what rights are being granted, what fees shall apply, what penalties for non-performance shall apply, how any credit lines are to read, and signatures of authorized persons.

A standard licensing agreement form follows. It may be modified as needed to suit the needs of any particular licensing situation.

Licensing Agreement

Client: _____

Material for use: _____

Rights granted: _____ Delivery Date: _____

Model release uses: _____

Reproduction fee: _____ Service fee: _____

Credit line to read: _____

Color transparencies, color negatives, and black-and-white negatives remain the property of the photographer and are to be returned by the client within 10 days of delivery. Client agrees to pay a holding fee of $_____ per week per transparency or negative held beyond 10 days.

Client agrees to assume all responsibility for the safe and undamaged return of transparencies and negatives to the photographer. In the event that the client's use of the materials results in loss or damage, the client agrees to pay monetary damages to the photographer. The client further agrees that the minimum reasonable value of a lost or damaged color transparency is no less than $_____, and the minimum reasonable value of a lost or damaged black-and-white negative is no less than $_____.

The photographer will not be liable for any legal action or claim arising from publication of the material by the client in uses other than those specified by model release.

Any objection to these provisions must be made in writing prior to any use of delivered materials.

Accepted by: _____ Date: _____
(signature of user)

_____ Date: _____
(signature of photographer)

Glossary

aberration an inherent lens fault that causes the lens to form an unsharp or distorted image.

absorption the assimilation of light by a medium. Absorbed light is neither transmitted nor reflected; it is transformed to another energy form, for example, heat. See *law of transmission and absorption*.

accent lights lighting instruments used to produce secondary highlights that reveal the three-dimensional qualities of the subject. See *backlight*.

acetic acid a colorless, pungent liquid used in photography to halt developing action in film and print processing. It is the primary acid in vinegar.

acid fixer See *fix*.

actinic light light rays that have powerful effects on photosensitive materials and possess larger-than-normal proportions of ultraviolet and blue wavelengths.

acutance edge sharpness between adjacent tonal areas in a photographic image.

adapter ring a device used to mount filters on the lens barrel of a camera.

additive color theory theory of mixing primary colors of light by adding red, green, and blue to produce white light.

adhesive layer a stratum in photosensitive film or paper that bonds adjacent layers together.

advance See *film advance*.

aerial perspective the representation of three dimensions and distance on a two-dimensional surface by means of tonal variations.

agitation the systematic movement of processing chemicals to ensure even immersion of all surfaces in active solutions throughout processing.

air-bells minute bubbles of air or gas that cling to the film surface during processing, preventing processing and causing tiny clear spots or "pinholes" in the negative.

albumen egg white; used for photographic paper emulsions from about 1850 until replaced by gelatin in the 1880s.

alkaline battery a type of battery recommended for most flash units. It is not recommended if the unit's electrical contacts are unplated brass or copper. See *zinc-carbon battery*.

ambient illumination the light existing at the subject location.

ambrotype silver photographic image on glass and backed with a black fabric to produce a weak positive image, popular in the 1860s and 1870s.

analog information a stream of continuously variable data, variations, and differences being represented by varying quantities, or amplitudes, for example, a continuous-tone photographic print.

angle of incidence the angle at which incident light strikes an object.

angle of movement the subject's direction of movement in relation to the camera's axis.

angle of view field of view covered by a lens, expressed in degrees.

ANSI American National Standards Institute, formerly ASA. See *ASA*.

antihalation backing a dye coating on film designed to prevent halation around intense points of light. See *halation*.

aperture the opening, usually regulated by a diaphragm, through which light passes into a camera. Aperture size is expressed as an *f/number,* which signifies the ratio of the focal length of the lens to the effective diameter of the lens. See also *maximum aperture*.

aperture priority a type of automatic exposure-setting system that requires the photographer to set the aperture manually while the system sets the shutter speed automatically for proper exposure.

archival processing photographic processing procedure to produce a chemical-free, stable image for long-term storage.

ASA American Standards Association (now ANSI) system for rating film speed. See *film speed rating*.

ASA rating See *film speed rating*.

at-the-back shutter See *focal plane shutter*.

at-the-lens shutter See *behind-the-lens shutter and between-the-lens shutter*.

auto-focus a focusing system that automatically adjusts distance setting by means of emitted sound or infrared light pulses reflected from the subject.

automatic diaphragm a device that closes the aperture to a pre-selected setting as the shutter is released. Not automatic exposure.

automatic electronic flash a variable-output flash unit that uses measurements of light reflected from the subject during the flash ignition cycle to govern proper exposure. See *thyristor circuit*.

automatic exposure an exposure-setting system coupled to a built-in light meter that sets shutter speed, aperture, or both electromechanically.

automatic winder a power-driven device that advances film automatically after each exposure.

available light the light conditions that prevail at the scene being photographed; existing light.

average gray a point between pure white and pure black representing the typical tone found in nature. The standard tone of average gray is 18 percent gray when 100 percent = pure white and 0 percent = pure black. See *gray card*.

averaging meter a type of exposure meter designed to measure the average brightness reflected from all parts of a scene.

B See *bulb*.

background light a lighting instrument used especially to illuminate the background.

backlight a light source behind the subject that creates edge highlights or accents. It is also called a *kicker*.

baffle a device used to shield a portion of the light from striking objects in a scene; a mechanism for introducing a shadow into a field of light.

bare-bulb flash the use of a flash unit without a reflector, causing both direct and reflected light rays to illuminate the subject.

barn door baffle a baffle with four folding leaves that is designed to attach to a lighting instrument to shape the light beam.

base (1) sheet material that serves as a foundation for coating photographic emulsions. Film bases are transparent and made of acetate or polyester. Print bases are opaque white or tinted, and made usually of paper, but sometimes of glass, metal, or cloth; (2) rigid foundation on which an enlarger is mounted.

base plus fog density the density of unexposed film that has been developed; film base + fog; fb + f.

base tint the color of the base material on which a print emulsion is coated. It is also called *tint* or *paper tint*.

basic exposure rule a rule of thumb for determining basic exposure without the aid of a guide or meter: f/16 @ 1/ISO for average subjects in sunlight. Variations may be extrapolated for varying conditions.

bayonet mount a lens-mounting system using flanges by which lens is aligned and seated in the mount and turned slightly to lock it in place.

BCPS See *beam candlepower seconds*.

beam candlepower seconds a measure of the light output of a flash unit; BCPS.

behind-the-lens shutter shutter located immediately behind the picture-taking lens elements. See *leaf shutter*.

bellows a light-tight, accordion-pleated, collapsible unit for adjusting focus, usually made of leather, cloth, or plastic and used between a lens and a camera body or a lens and an enlarger body.

bellows extension See *extension bellows*.

bellows unit See *extension bellows*.

between-the-lens (BTL) shutter a shutter located between elements of the picture-taking lens. See *leaf shutter*.

binary numbers a numerical system that uses only the digits 1 and 0 to express all numerical values.

bit one binary digit. The smallest unit of computer data storage.

black body a theoretical unit of matter, conceived to be unreflecting, that, when heated, is conceived to radiate pure energy; theoretical basis for the Kelvin color temperature scale. See *Kelvin*.

bleach a chemical agent capable of dissolving metallic silver and reducing the density of silver images; often potassium ferricyanide is used, or laundry bleach.

blocked up negative density of such magnitude as to prevent the passage of light; overexposed and/or overdeveloped negatives may develop such areas, especially in the highlights. Also called *burned out*.

blue-sensitive a type of photographic emulsion sensitive to blue and ultraviolet wavelengths and insensitive to red and green.

blur indistinctness of image caused by movement of camera and/or subject during exposure interval. See also *out-of-focus*.

blur action a means of depicting action by intentionally permitting images of moving objects to move across the film surface during exposure to cause blur.

boom an adjustable arm, used with a standard, for mounting lighting equipment.

bounce flash use of flash unit directed away from the subject so that light is reflected off nearby surfaces toward the subject; usually intended to produce a soft, diffused light. See *bounce light*.

bounce light any light source directed away from the subject toward some nearby surface, usually matte, so that light is reflected onto the subject indirectly. See *bounce flash.*

box camera one of the earliest forms of hand-held, roll-film cameras; characterized by fixed-focus lens, simple viewfinder, and limited, if any, adjustments of shutter-speed and aperture.

bracketing the practice of shooting, as a margin for error, several frames of greater and lesser exposure in addition to frames of a "normal" exposure.

brightness See *value.*

brightness ratio the relative brightness of highlight and shadow areas. A four-to-one brightness ratio indicates that the highlights are four times brighter than the shadows. Also called *lighting ratio.*

broad lighting a portrait lighting setup characterized by placement of the main light to illuminate the side of the subject's face nearer the camera.

bromide See *halide.*

bromide paper a printing paper, typically used for projection printing, in which silver bromide is the principal active ingredient.

B-setting See *bulb.*

BSI British Standards Institution system for rating film speed. It is used primarily in Great Britain. See *film speed rating.*

built-in meter an exposure meter integrated into the physical structure of a camera, often electronically coupled to it to form an exposure-setting system.

bulb a shutter setting (B) at which the shutter remains open as long as the shutter release is depressed. (The shutter closes as the release returns to a normal position.)

burned out See *blocked up.*

burning in increasing exposure to a particular area of a photograph during printing. It is a means of increasing print density in selected areas during exposure. It is also called *printing in.* See also *dodging, flashing, vignetting.*

busy background a background characterized by peripheral details and contrasts that serve to distract the viewer's attention from the subject and/or to obscure figure-ground relationships in a photographic composition.

butterfly lighting a portrait light setup characterized by placement of the main light in front of and above the subject's head to produce a small shadow directly below the nose.

byte a group of binary digits, or bits, treated as a unit. Commonly, eight bits make up a byte.

cable release a camera attachment of flexible cable that permits the release of the shutter without touching the camera.

calotype photographic process invented by Fox Talbot about 1840 that was the forerunner of modern negative-positive process; also *Talbotype.*

camera a light-tight receptacle designed to gather light rays and resolve them as an image. *Camera* is from the Latin word for "room." Modern cameras can record the resolved image permanently by means of light-sensitive film.

camera angle the orientation of the camera to the subject. See *high-angle shot, eye-level shot,* and *low-angle shot.*

camera body the housing into which the lens, shutter, viewer, film-loading feature, and film-advancing feature are fitted.

camera obscura an ancient device for resolving images through a small opening in a darkened room. Used as an artist's aid from the sixteenth century, it was the forerunner of the modern camera.

camera shake movement of the camera during exposure, causing the photographic image to blur.

camera-to-subject distance See *distance.*

carrier See *negative carrier.*

carte-de-visite a popular form of photography in the 1860s and 1870s by which multiple images of individuals and groups were printed on a single card. The small individual images were often used as visiting cards and exchanged as keepsakes.

cartridge a light-tight container, usually disposable, in which lengths of film are dispensed and loaded into cameras designed for their use. It is also called a *cassette* or *magazine.*

cassette See *cartridge.*

cast a slight shift in the apparent color of objects that is produced by variations in the light rays acting upon them.

catchlights highlights in the eyes of the subject produced by reflection of the light souces.

cathode ray tube a visual display device. Often refers to the monitor of a computer terminal.

CC filters See *color-compensating filters.*

CCD See *charge coupled device.*

CD-ROM compact disk-read only memory. An information storage system that uses compact disks to store digital information.

celsius (C) a temperature scale in which 0° and 100° respectively represent the freezing and boiling points of water at seal level; also Centigrade (C) scale.

center of interest See *central idea*.

center-weighted meter a type of exposure meter that bases its measurements mainly on light reflected from the central area of a scene.

Centigrade (C) scale See *Celsius (C) scale*.

central idea the subject of a composition; the key meaning or impression of a composition; the major cognitive or affective representation intended to be communicated by a composition; often associated with a center of interest—a dominant feature or detail within the composition that serves as its main integrating element.

central processing unit (CPU) the main component of a computer system that performs input, output, logical, and arithmetic functions.

CGA See *color graphics adapter*.

characteristic curve See *H & D curve*.

charge coupled device (CCD) a type of light-sensitive, electronic matrix that serves as an image receptor in electronic and still video cameras.

charge-injected device (CID) a type of light-sensitive, electronic matrix that serves as an image receptor in electronic and still video cameras.

chloride See *halide*.

chloride paper a printing paper, used primarily for contact printing, whose principal active ingredient is silver chloride.

chloro-bromide paper a printing paper sensitized with a combination of silver bromide and silver chloride.

chroma See *saturation*.

chromagenic film type of film in which the final image is composed of dyes rather than metallic silver.

chromatic aberration an inherent lens fault that causes light rays of different wavelengths to focus in different planes causing loss of resolution in black-and-white images and color-fringing in color images.

CID See *charge-injected device*.

cinch marks parallel exposure marks or scratches in the emulsion caused by physical overwinding or tightening of the film prior to processing.

clearing agent a chemical agent designed to transform fixing compounds into more readily soluble salts to aid in cleansing them from film and prints during washing. Also called *hypo neutralizer, hypo eliminator,* or *hypo clearing bath*.

clearing time the fixing time required to clear a film or print of all undeveloped silver salts.

close-up a photograph characterized by focus on an object at an apparent distance of no more than a few feet from the camera. It may be achieved by placing the camera within a few feet of the object or optically by the use of appropriate lenses.

closeup lens a type of magnifying lens designed to be fitted in front of the normal lens to foreshorten focal length and increase focal distance, thereby resulting in closeup focusing distances and image magnification.

closeup photography photography between a camera's minimum focusing distance and a distance of about two focal lengths from the camera. Generally refers to image magnification of one-tenth life size to life size.

closeup reading light-meter measurement taken at a close apparent distance from an object. See *closeup*.

coarse grain a grain pattern characterized by the grouping of silver grains in the image into relatively large clumps.

coating a transparent film applied to lens elements and designed to absorb extraneous, nonimage-forming light and to increase contrast.

cocking the shutter loading tension onto the shutter spring mechanism to store the energy needed for its operation.

cold tones bluish hues associated with the metallic silver image of a print, often emphasized by the use of certain emulsion-developer combinations.

collodion a viscous solution of guncotton, ether, and alcohol that was used first for bandaging wounds and later as an emulsion medium in wet plate photography, a process invented by F. Scott Archer in 1851.

color a visual sensation that permits differential perception of various wavelengths of light generated by the interaction of light and the qualities of the objects perceived; one of the elements of visual composition.

color balance the capability of a film to reproduce colors as they are perceived, notwithstanding differences in light sources; a property of color film that specifies under what lighting conditions the film will reproduce colors as perceived.

color-compensating (CC) filters optically corrected filters, available in various saturations of the six primary and secondary hues, used principally in color photography to modify the overall color balance of the transmitted image.

color composition the relationships among color details within a photograph; the organization of color elements to support a central idea in a color photograph.

color contrast the relationship among color values by which colors of complementary hue and varying brightness are composed to achieve emphasis.

color fringes in color images, color outlines apparent at the edges of color masses caused by chromatic aberration of the lens.

color graphics adapter (CGA) a relatively low resolution color adapter board used in early IBM PC's and similar computers.

color harmony the pleasing arrangement of color details in a photograph. See *color composition*.

color negative a color image, reversed as to brightness and color, supported on a transparent base for the purpose of making positive prints and transparencies. See *negative*.

color negative film a film designed to produce, after processing, a color negative. Compare with *color reversal film* and *color slide film*.

color print a positive color image supported on an opaque base of paper or other sheet material; a positive color image designed for unassisted viewing. See *print*.

color reversal film a film designed to produce, after processing, a positive color transparency; color slide film; film that, after processing, reproduces the colors originally present in the scene. Also called *color slide film*.

color sensitivity the responsiveness of a photographic emulsion to various wavelengths of light energy.

color slide a positive color image supported on a transparent base, designed primarily for viewing by projection or transillumination; a product of color reversal film; a *color transparency*.

color slide film See *color reversal film*.

color temperature a characteristic of visible light, usually measured in Kelvin degrees, measured in terms of the relative dominance of red (lower temperatures) or blue (higher temperatures). See *Kelvin*.

color transparency a positive color image supported on a transparent base. See *color slide, transparency*.

color transparency film See *color reversal film*.

coma a lens aberration common in high-speed lenses produced by failure of light rays to converge to a common image point

combination printing a printing technique by means of which portions of more than one negative are used to produce a single print.

compensating developer a developer that works more vigorously in areas of underexposure than in areas of overexposure.

complementarity See *complementary colors*.

complements any two hues of light that will, in combination, produce all wavelengths in the visible light spectrum in relative proportions so as to yield white light. The complementaries of the primary colors—red, blue, and green—are the secondary colors—cyan, yellow, and magenta, respectively. Also includes any two hues which, when subtracted from white light, will absorb all wavelengths to yield black.

complements See *complementary colors*.

composition the arrangement of visual elements in a photograph.

compositional lines See *line*.

compression ratio the relationship between the original size of a data block and its size after compression. A 50:1 ratio indicates that data is compressed to one-fiftieth of its original size. See *data compression*.

condenser housing the component of an enlarger that holds the condenser lens system in place and provides for its adjustments.

condenser lens a lens used within an enlarger to concentrate light and to direct it through the negative to the lens.

condenser system an adjustable set of condenser lenses designed for use in an enlarger to concentrate light from the source and to distribute it evenly through the negative to the enlarger lens.

conditioning solution, also called *conditioner*. See *print conditioning solution*.

contact paper a slow-speed printing paper designed for use in contact printing.

contact print a print made by placing the negative in direct contact with photographic paper and exposing the paper to light through the negative.

contact printer a device used to control exposure in making contact prints.

contact printing a method for making contact prints. See *contact print*.

contact printing paper See *contact paper*.

contact proofer See *proofer*.

contact proof sheet See *contact sheet*.

contact sheet a set of negatives, contact printed simultaneously on a single sheet of photographic paper.

contamination the introduction, at any stage of processing, of alien or neutralizing agents that produce an unintentional deleterious effect upon the finished product.

continuous spectrum light consisting of all wavelengths in the visible light spectrum. Compare with *discontinuous spectrum*.

continuous-tone image an image characterized by gradations of tones between the extremes of light and dark.

contrast the differences in density or apparent brightness between adjacent tonal areas of a negative or print image; one of the elements of visual composition. See *gray tone separation, image contrast*.

contrast filters (1) filters used with variable-contrast printing papers to control print contrast; (2) filters used in black-and-white photography to increase contrast between gray tone renderings of two colors that might otherwise record at the same density.

contrast grade a contrast characteristic of a printing paper emulsion, identified by a grade number, generally in the range of 0-6. Lower grades signify lower contrast papers; higher grades, higher contrast papers.

contrast index an expression of the relationship between the range of negative densities and the brightness range of the subject. See *gamma*.

contrast range See *contrast*.

contrasty See *high contrast*.

convergence control a technique for manipulating linear perspective by modifying the relationship between parallel lines in a photographic image.

conversion filters filters used primarily with color films to alter the color of available light to conform to the color balance of the film.

converter See *teleconverter*.

copy to photograph two-dimensional material; the original or material to be copied.

copy board illuminated easel or flat surface to which original is attached for copying.

copy negative negative obtained by photographing two-dimensional material.

copy stand a support that holds camera and copy in position during copying.

correction filters filters used in black-and-white photography to render colors in shades of gray that correspond to their perceived relative brightness.

CPU See *central processing unit*.

crimp marks crescent-shaped marks in the negative image caused by pinching or crimping the film prior to processing. Usually caused by improperly loading a film developing reel.

crop to place the boundaries of a photograph, and thus control the locus of edges and borders in relation to the image.

cropper an adjustable frame used as an aid in planning photographic compositions.

cross-light lighting from the side of the subject characterized by modeling and textural shadows.

CRT See *cathode ray tube*.

curtain shutter a type of shutter that effects exposure by opening and closing two or more strips of metal or cloth to create an opening between them that traverses the film surface. See *focal plane shutter*.

cut film See *sheet film*.

darkroom a facility designed for the handling, processing, and printing of photosensitive materials; it must be capable of maintaining levels of ambient illumination compatible with these activities.

dark slide See *slide*.

data compression data processing technique that increases the capacity of a data storage system by using mathematical algorithms to reduce redundant data. See *compression ratio*.

daylight in photography, any light source similar in color temperature to standard daylight, 5500–6000 K. At any given time, natural daylight may or may not conform to this standard.

decamired ten mireds. See *mired*.

dedicated flash electronic flash unit designed to operate with a specific camera model to automate the setting of many camera functions in response to sensed light intensity.

definition the clarity of details in a photographic image; the ability of a lens or photo emulsion to produce images of high clarity.

delay the interval of time between flash ignition and shutter release. See *flash synchronization*.

dense characterized by high density. See *density*.

densitometer a device used to measure the amount of light transmitted by small negative areas.

density the mass of metallic silver or dye per unit area in a photographic image, which determines the amount of darkening, light absorption, light reflectance, or light transmission associated with that unit of area.

density range the range of densities present in a photographic image (DR). See also *contrast, tonality*.

depth of field the region within which objects in a resolved image appear in acceptably sharp focus—a zone of sharpness which, for any given lens, varies with the aperture setting and plane of maximum focus; the distance between the nearest and farthest limits of acceptable focus; also *zone of sharpness*.

depth-of-field scale a calibrated scale that indicates the depth of field for any given lens at various apertures and distance settings.

desktop publishing a personal computer methodology for producing printed works using wordprocessing, typesetting, and graphics software.

develop to process exposed photographic materials to transform the recorded image into visible patterns of metallic silver grains. See *developer*.

developer a chemical solution that acts upon exposed silver halide crystals, releasing the halogens and leaving a residue of metallic silver.

developing tank See *film-processing tank*.

diaphragm a device for controlling the size of the lens aperture by means of a circular iris of overlapping leaves.

diffraction grating a type of special effect filter used with color film that breaks bright points of light into their spectral components creating a rainbow-like color effect.

diffused light light scattered in all directions relative to its source, usually as a result of reflection or filtration, and characterized by soft-edged shadows.

diffusion See *diffused light*.

diffusion screen a translucent medium that causes a given degree of diffusion when introduced into the path of light.

digital imaging a type of electronic photography by which graphic information is digitized, stored, and manipulated in computer readable form.

digital information information encoded into discrete, discontinuous, minute data units, called bits, each consisting of a single binary digit, that can be read, stored, and later decoded by a computer program into its original form.

digitize the process of converting analog information into digital information.

dimmer a device for controlling the brightness of artificial lighting units by electrical or electronic means.

DIN Deutsche Industrie Normen; a system for designating the speed of light-sensitive materials commonly used in Europe. See *film speed rating*.

DIN rating See *film speed rating*.

diopter a measure of the magnifying power of a lens.

disc camera small automatic camera that uses a film cartridge containing a rotating wheel of fifteen film frames.

disc film film cartridge containing fifteen exposures on a rotating wheel designed for use in a disc camera.

discontinuous spectrum light that does not contain all wavelengths in the visible light spectrum; light from which bands of electromagnetic energy of certain wavelengths are absent.

distance in photography, generally camera-to-subject distance—a critical factor in controlling depth of field and focus in photographic composition.

distance scale the focusing scale of a camera, usually calibrated in feet and meters.

distortion in photography, the alteration of an image, intentional or not, from its true form, usually by the curvature of apparently straight lines or by disproportionate magnification.

D log E curve See *H & D curve*.

dodging a technique for partially shielding certain portions of a photographic image from exposure during printing in order to reduce print density in those areas. Also called *holding back*. See also *burning in*.

dominant idea See *central idea*.

double exposure the exposure of a single film frame to more than one image, which has the effect of superimposing images.

double printing See *combination printing*.

DR See *density range*.

dry to subject wet film or paper to procedures by which retained moisture will evaporate without visible residue.

dry area a portion of a darkroom, separated from the chemical processing and sink areas, intended solely for the handling of dry materials.

dry mounting a thermoplastic technique for affixing finished prints to a mounting surface by means of a dry, heat-sensitive adhesive. Compare with *wet mounting*.

dry mounting press a thermal press used for dry mounting.

dry mounting tissue a thin, shellac-impregnated sheeting that becomes adhesive when subjected to heat and pressure in the dry mounting process.

dry plate term used to distinguish the newer gelatin-coated plates of the 1880s from the highly popular wet-collodion photographic plates.

dulling a technique used to eliminate reflected specular highlights by spraying, powdering, or waxing the reflecting surface.

duplicate a reproduction that corresponds to its original in every possible respect. A duplicate negative is a photographic reproduction of a negative; a duplicate slide is a photographic reproduction of a positive transparency.

dye the coloring matter used to color photographic images, usually by means of adhesion to the metallic silver of which the image is formed.

dynamism an impression of movement, force, and/or energy conveyed by a photographic composition.

easel a device placed at the base of an enlarger and designed to frame the image, hold the enlarging paper in proper position, and create borders during exposure.

edge accents highlights, produced by light sources behind or to the side of the subject, that define the edges of the subject and are often of intensity equal to or greater than the major highlight area. See *rim light*.

electromagnetic energy spectrum See *spectrum*.

electronic flash a photoflash light source produced by electrical discharge through a gas-filled tube and typified by high intensity, short duration, and the approximate color temperature of daylight. Also see *strobe*.

electronic imaging a general term used to describe any aspect of the capture, storage, manipulation, and output of pictures by means of electronic devices.

elevator control crank a device for raising or lowering the head of an enlarger to adjust image size.

emphasis the relative stress or importance given to a particular detail or feature in a photograph; special prominence, distinctiveness, or vividness given to such a feature.

emulsion the coating of light-sensitive chemical suspended in a gelatin medium that gives film and photographic paper their photosensitive properties.

enlargement a photographic reproduction larger than the original from which it was produced. See *projection print*.

enlarger a device used to project negative images in varying scale onto photosensitive materials for the purpose of making prints larger or smaller than the original negative.

enlarging See *projection printing*.

enlarging lens a lens designed with a flat field of focus that is especially suitable for enlarging and copying.

enlarging paper See *projection printing paper*.

equivalent exposure a member of a set of differing shutter speed/aperture combinations possessing the same exposure value; given a basic shutter/aperture combination, any alternative shutter/aperture combination that yields the same exposure.

existing light See *available light*.

expiration date a date assigned to photosensitive materials at the time of manufacture to indicate the limits of their shelf life when stored under normal conditions, a date beyond which photosensitive materials may not be expected or guaranteed to perform to standard. Actual shelf life may be extended beyond the expiration date under special conditions of storage.

exposure the product of the intensity of light acting upon a photosensitive material and the time interval during which it does so; the subjection of a photosensitive material to the action of radiant energy.

exposure compensator a mechanism on automatic cameras that permits intentional under- or overexposure.

exposure factor the factor by which exposure must be increased to compensate for greater-than-normal focal distances or the use of filters.

exposure guide a table, usually published for use with a particular photosensitive material indicating proper exposure under various conditions of illumination.

exposure index (EI) See *film speed index*.

exposure latitude a property of photosensitive material involving the degree of exposure variance possible without significantly degrading image quality.

exposure meter a device used to determine proper exposure by measuring the intensity of light present in the scene in relation to the speed of the film in use.

exposure override a control that allows the photographer to disengage automatic exposure features of a camera for manual exposure setting.

exposure scale an adjustable, graduated, and ordered set of shutter-speed and aperture settings, such as is inscribed on an exposure meter or camera, that indicates equivalent exposures for a given exposure value or photographic situation.

extender See *teleconverter*.

extension bellows a unit inserted between lens and camera body enabling continuous extension of focal distance for closeup focusing.

extension tubes a set of interlocking hollow tubes designed to be inserted between lens and camera body to increase focal distance for closeup focusing.

eye-level shot a camera-to-subject angle such that the axis of the camera lens is parallel to the ground. Compare *high-angle shot* and *low-angle shot*.

F See *focal length*; also see *fast peak*.

f/- See *f/number*.

Fahrenheit (F) scale a scale of temperatures in which 32° and 212° respectively represent the freezing and boiling points of water at sea level.

fall-off progressive loss of density in a negative or progressive loss of light intensity over a distance or area.

fast highly sensitive to light; responsive to low levels of light (said of photosensitive paper or film); capable of transmitting relatively large amounts of light per unit of time (said of photographic lenses of relatively large diameter in relation to focal length).

fast peak (F) a type of flashbulb that reaches peak output five milliseconds after ignition; flash synchronization designed for use with such flashbulbs. Rarely used with modern cameras.

fast-speed film See *fast*.

FB fiber-base

ferrotype a procedure for giving fiber-base photographic prints a high-gloss finish by drying them while the emulsion is in close contact with a highly polished metal surface.

ferrotype plate the metal plate used in ferrotyping.

fiber-base a type of photographic printing paper made with a high quality paper base. Distinguished from resin-coated (RC) papers.

field an analog video image format that uses one half of the scan lines needed to reproduce a high resolution image. Still video cameras can store fifty images in low resolution field format. See *frame*.

figure-ground contrast the tonal relationship between foreground and background details.

fill-in flash the use of flash as secondary, fill light to illuminate shadows produced by main light or sunlight.

fill light light used to illuminate shadows produced by main light or sunlight; light used to reduce the brightness ratio by increasing illumination in shadow areas.

film photosensitive material consisting of a light-sensitive emulsion coating on a transparent base capable of recording a photographic image.

film advance a mechanism for advancing roll film a prescribed distance within a camera to obtain a succession of evenly spaced exposures; the knob or lever used to advance such film.

film base + fog See *base plus fog density*.

film camera a camera designed to record images and graphics from a computer onto conventional photographic film.

film clip a spring-loaded device designed to clip onto the end of a strip of film to hold it while it dries.

film holder a frame designed for handling sheet film. It holds two sheets of film in a light-tight compartment, is inserted into the camera to hold the film in a precise relationship to the lens, and is withdrawn from the camera following exposure.

film pack a frame designed to hold sheet film. It is loaded with several film sheets that can be used sequentially by manipulating a series of paper tabs without removing the pack from the camera.

film plane the locus of the film within the camera, usually placed to intersect the focal point of the camera's normal lens.

film-processing tank a light-tight container, used for developing and fixing film, that provides for the entry and egress of fluids through a light trap; also the container used for processing sheet film.

film speed the relative sensitivity of film to light, as indicated by its film speed index. See *speed, film speed rating*.

film speed rating a number indicating the sensitivity to light of a given film. The most common film speed rating systems are ISO, ASA, DIN, BSI, and ANSI.

film speed setting the mechanism on a photographic device, such as a light meter or camera, by which the film speed index is programmed into the device.

film transport indicator signaling device that informs the photographer when film is being properly advanced within the camera.

filter a transparent medium, usually plastic or glass, that absorbs and transmits precisely selected wavelengths or other components of incident light.

filter drawer an opening built into an enlarger head designed to accept printing filters.

filter factor the number by which exposure must be multiplied to compensate for the absorption of light by a filter used during exposure.

filter holder a device that attached to the front of a lens designed to hold filters in place.

fine grain a grain pattern characterized by the grouping together of silver grains in the photographic image into relatively small clumps.

finishing controls See *print finishing*.

fix to dissolve light-sensitive materials from a photographic emulsion in order to render it chemically stable; the chemical agents employed in the process.

fixed exposure an exposure-setting system using a single, nonadjustable aperture and shutter-speed combination.

fixed focus a focusing system without adjustments that is preset to focus within a given distance range.

fixer the chemicals used to fix film.

fixing bath See *fixer*.

flag a small baffle used to create shadow in a photographic lighting setup.

flare nonimage-forming light produced by interreflections between lens surfaces; a fogged or dense area produced on the negative as a result of such light on the film in the camera.

flash in photography, any artificial light source that produces a brief, intense pulse of light, usually synchronized with the opening and closing of a camera's shutter.

flash bar a type of flash unit consisting of ten individual flashbulbs, each with its own reflector and shield, designed to fire one at a time as successive shots are taken.

flashbulb a consumable lamp containing combustible materials and designed to produce a measured quantity of intense illumination for photographic purposes upon electrical ignition synchronized with a camera's shutter.

flash contacts the electrical connections that complete the ignition circuit and allow flash equipment to be synchronized to a shutter's action; the metallic connectors by means of which flash units are linked to a camera's circuitry.

flash cube a cube-shaped unit consisting of four small flashbulbs and their reflectors, designed for shooting four flash pictures in succession without replacing spent flashbulbs.

flashguard a transparent plastic cover fitted to a flash reflector in order to contain spent flashbulbs, which occasionally shatter.

flashing a technique for increasing density in certain portions of a print by means of controlled exposure of the printing paper to raw, white light.

flash meter a type of exposure meter designed to measure the intensity of electronic flash illumination and to output exposure information.

flash-off-camera a flash technique in which the flash unit is placed or held at a distance from the lens axis.

flash-on-camera a flash technique in which the flash unit is mounted on the camera, close to the lens axis.

flash peak the moment in the flash cycle when the flash reaches its maximum intensity; see F, M, FP, X.

flash synchronization the mechanical coordination of flash ignition and shutter release so that flash peak is timed to occur at a precise moment during the shutter's action; see *F-synchronization*, *M-synchronization*, and *X-synchronization*.

flash-to-subject distance the distance light travels from the flash unit to the subject; the distance between the unit and the subject if aimed directly; the total distance traveled if bounced off reflecting surfaces.

flash unit generic term referring to any one of many devices used as flash lighting sources.

flat See *low contrast*.

flatbed scanner a type of scanner similar in appearance to a photocopier designed to hold flat art work and photographic prints and to convert the images into digital format.

flat peak (FP) a flashbulb burn pattern in which maximum output is reached approximately twenty milliseconds after ignition and is maintained at a relatively constant level for the next twenty to twenty-five milliseconds before extinction. Designed for flash bulb use with focal plane shutters. Becoming obsolete in modern cameras.

floodlight an artificial light source designed to illuminate a wide area with relatively uniform intensity.

f/number a standardized numerical expression describing the light-admitting characteristics of a lens at a given aperture setting; the ratio of a given aperture diameter to the focal length of a lens. Also f/stop.

focal distance the distance between the optical center of a lens and the plane of the focused image it produces.

focal frame the device used for precise focusing and framing of close-ups with a viewfinder camera.

focal length the distance between the optical center of a lens and the plane in which the image of an object at infinity is resolved into sharpest focus; the symbol for focal length is F.

focal plane the plane in which a lens forms a sharp image of an object at infinity. Within a camera, the film is located in the focal plane.

focal plane shutter a mechanism for controlling exposure that is located slightly forward of and parallel to the camera's focal plane; a camera component designed to initiate, time, and terminate exposure by means of the opening and closing of two overlapping panels.

focal point the point, characteristic of a given lens, at which the lens resolves parallel light rays to a point of sharp focus.

focus the adjustment of a lens system to resolve the transmitted light rays in a given plane; to adjust a camera to achieve a clear, sharply defined image of the subject.

focus-free See *fixed focus*.

focusing magnifier magnifying device designed to assist in focusing the projected image during enlarging.

focus setting the mechanism by which a lens is adjusted so that a clear, sharply defined image of the subject is formed on the photosensitive material.

fog negative or print density produced by nonimage-forming light or chemical action.

fog filter a filter used to diffuse image-forming light to create a soft-edge effect in the image; creates foglike effects in scenic images.

folding camera a type of camera characterized by a bellows that collapses the lens and shutter assembly into the camera body for ease in carrying and storing.

forced development a technique for developing photographic materials for a longer-than-normal time span, usually to compensate for underexposure.

foreground that portion of a visual composition perceived to be nearest the viewer.

format print or negative dimensions; aspect ratio; the length and width of a photographic product.

FP See *flat peak*.

FP-synchronization See *M-synchronization*.

frame (1) to adjust the image within the image boundaries; (2) the boundaries within which the image is presented; (3) an analog video image format that uses twice the number of scan lines needed to reproduce a low-resolution image. Still video cameras can store twenty-five images in high-resolution frame format. A complete analog video frame is made up of two fields. See *field*.

frame grabber a computer expansion board designed to capture and digitize a video image for computer use.

frame numbers numbers printed at the edges of a film during manufacture to aid in identifying specific frames.

framing easel See *easel*.

freeze action See *stop action*.

f/stop See *f/number*.

F-synchronization the mechanical synchronization of shutter and flash used with fast peak (F) flashbulbs; a flash synchronization that delays flash ignition five milliseconds after shutter release. No longer in common use.

full frame a negative format using the normal 35-mm format (24 mm by 36 mm).

full-scale print a continuous tone black-and-white photograph characterized by presence of all density values from deepest black to pure (paperbase) white through many clearly differentiated gray tones.

full stop a full f/stop; a full-stop exposure increase implies a doubling of exposure; a full-stop opening of the lens aperture implies a doubling of the light-transmitting characteristic of the lens.

gamma a numerical expression of the degree of contrast in a negative relative to the degree of contrast present in the original scene. Also see *contrast index*.

gelatin a chemically neutral medium used as a binder for the photosensitive chemical agents in photographic emulsions.

gelatin square filter a thin, transparent, flexible medium designed to absorb and transmit specified portions of the visible light spectrum. It is usually used in a special holder during the exposure of film or papers.

ghost image See *secondary image*.

gigabyte (Gb) approximately one billion bytes of data.

glacial acetic acid a concentrated, 99 percent form of acetic acid.

glamour lighting See *butterfly lighting*.

glare a harsh, bright light or reflection of light. See *polarized light*.

glass filter a thin, transparent, rigid medium designed to absorb and transmit specific portions of the visible light spectrum used in the exposure of photosensitive materials.

glossing solution See *print conditioning solution*.

glossy characterized by a smooth, glasslike lustre—a surface texture of a photographic print commonly produced by ferrotyping; a print possessing such a finish.

grain the pattern of the metallic silver particles that form a photographic image. Characteristic grain patterns are produced by the interaction of given combinations of film and developer.

graininess the degree to which the grain pattern of a photograph is visible or has a tendency to become visible in enlargement; adjective describing coarse grain.

grand view a photograph that encompasses great distances and relatively large scenic features.

gray card a neutral test sheet of 18 percent reflectance that can be used as a standard to control tone or color rendering in photographic printing. See *average gray*.

gray tone rendering the pattern of relative densities recorded on black-and-white film in response to light of various colors or wavelengths.

gray tone separation the ability of photosensitive material to record at different densities the differences between adjacent tonal areas. See *contrast*.

ground glass a plate of frosted glass that functions as a screen for viewing the transilluminated image focused in the focal plane of certain cameras.

guide number a numerical index reflecting the light output of a flash unit, used for determining exposure when that unit is in use.

guide number table a table listing guide numbers for given combinations of film speed, flash unit, reflector type, and shutter speed; an aid to determining exposure with any of these combinations.

hair light spotlight placed to produce highlight accents on the subject's hair.

halation in photographic images, halo-like blurring around intense points of light caused by reflection of light from the film base back into the emulsion. See *antihalation backing*.

half-frame a negative format, using half the normal 35-mm format (24 mm by 18 mm).

half-stop half an f/stop; an intermediate point between full f/stops, popularly used to increase or decrease exposure approximately 50 percent.

halftone a continuous tone image that has been broken up into a pattern of dots by copying it through a screen. The result is an image that can be made into a printing plate for printing the image in ink that gives the impression of continuous tone.

halide a light-sensitive compound of silver and one of the halogens, commonly bromine or chlorine, fundamental to most modern photographic emulsions.

H-D See *hyperfocal distance.*

H & D curve a graph, characteristic of a given photosensitive material, expressing the curvilinear relationship between exposure and density. After the inventors, Hurter and Driffield. Also called *characteristic curve and D log E curve.*

hard See *high contrast.*

hard copy computer information output into a tangible form such as a printout on paper.

hardener a chemical agent introduced in processing to toughen the gelatin medium of a photographic emulsion and thus increase its resistance to abrasion.

haze a degree of opacity in the air, caused by smoke, dust, or similar particles, which renders distant details less distinct than those nearby; also called aerial or atmospheric haze. Haze is produced in photographic images by the presence of ultraviolet light reflected from such particles.

haze filter a medium used to reduce aerial haze in a photograph by filtering out ultraviolet light present in the scene.

head screen a form of baffle.

heliography early photographic process by which a polished sheet of pewter coated with bitumen of Judea creates an image when exposed to light. Invented by Niépce in early 1820s.

high-angle shot a camera-to-subject angle in which the camera is directed downward. Compare *eye-level shot* and *low-angle shot.*

high contrast characterized by extreme differences in density between adjacent tonal areas; characterized by extreme highlights and shadows and limited middle tones; also said of lighting situations or photographic materials that tend to produce such tonal differences. Also *contrasty, hard.*

high-key dominated by light or white tones to the exclusion of dark or black tones. Compare with *low-key.*

highlight brilliance the degree of specularity of highlights, particularly in portraits, as seen from the camera position.

highlight reading a light meter reading of the brightest areas in a scene.

highlights photographic image densities corresponding to the brightest accents and areas in the original scene; the densest areas of a negative; the least dense areas of a positive print.

holding back See *dodging.*

hot-shoe contact a flash synchronization socket providing for simultaneous physical and electrical connection of the flash unit to the camera system.

hot spot a concentration of light in one area of an otherwise even field of light. Usually an undesirable characteristic.

hue the property of light determined by the wavelengths of electromagnetic energy of which it is composed; the color characteristic.

hyperfocal distance the shortest distance setting on the focusing scale that will give a depth of field extending to infinity for a given aperture. When a lens is set at the hyperfocal distance, depth of field will extend from half the hyperfocal distance to infinity (∞).

hyperfocal focusing a technique used to obtain maximum depth of field. When set at the hyperfocal distance, maximum depth of field is achieved; objects will appear in sharp focus from half the hyperfocal distance to infinity. See *hyperfocal distance.*

hypo See *fixer.*

hypo clearing bath See *clearing agent.*

hypo eliminator See *clearing agent.*

hypo neutralizer See *clearing agent.*

image an optical counterpart of a scene; in photography, a two-dimensional counterpart of a scene that may be three-dimensional, usually produced by an optical system and formed at the surface of a photosensitive material to create a permanent record of the image.

image contrast See *contrast.*

image format See *format.*

image texture See *texture.*

image tone See *tone.*

image-to-object ratio the ratio of the size of an object's image as it appears at the focal plane to the object's actual size.

incandescent light artificial light produced by the glow of a heated substance. It typically refers to electric light illumination.

incident light light rays falling upon or striking a subject.

incident-light meter a device designed to measure the intensity of light falling upon or striking a subject. Compare *reflected light meter*.

indicator stop bath a type of stop bath containing agents that change color, signalling when its effectiveness is exhausted.

infinity (∞) a theoretical distant point at which emanating light rays may be regarded as parallel; in photography, for most practical purposes, any point fifty feet or farther from the camera.

infinity setting the distance setting on an adjustable camera at which all objects fifty feet (fifteen meters) or farther from the camera will be recorded in sharp focus.

in focus an optical situation in which the light rays emanating from a scene are resolved within a focal plane; the optical resolution of light rays into a sharp, clearly defined image.

infrared relating to a band of electromagnetic wavelengths just longer than those perceived as red in the visible light spectrum; describes an invisible band of electromagnetic waves detectable with special equipment and photosensitive materials.

inherent contrast a characteristic of film referring to its capacity to reach a given image contrast in a given development time. Films that reach a given image contrast more quickly have higher inherent contrast.

instant camera a camera that uses instant print film.

instant color print film a film designed to produce a final positive print moments after exposure by means of processing action that is integral to the film and activated by the camera's mechanical operation.

integral tripack the structural design of modern color film by which the color components of light from a scene are separated and the images formed by each color component are recorded on separate emulsions built into a single film.

intensity the brightness of light. Also *brightness*. See *value*.

interchangeable lens a lens designed to be mounted on and removed intact from a camera body.

internegative a transparent negative produced from a photographic positive as an intermediate step in reproducing or duplicating the positive.

intimate view term used to describe a photograph encompassing relatively short distances and small scenic features.

inverse square law a basic principle of physics which, applied to light, states that as light spreads from a source the intensity of its illumination diminishes as the square of the distance from the source.

iris diaphragm See *diaphragm, iris.*

ISO International Standards Organization. Film speed rating system that combines both ASA and DIN ratings, for example, ISO 125/22°.

ISO ratings See *film speed ratings.*

Kelvin a unit of measurement, numerically equivalent to degrees Celsius plus 273°, used to measure the color temperature of light. After the inventor W. T. Kelvin.

Kelvin degrees See *Kelvin.*

Kelvin temperature See *color temperature, Kelvin.*

key backlighting a lighting setup, characterized by placement of the main light above and behind the subject, often used in small-object photography.

key light See *main light.*

keystone effect an optical effect by which parallel lines appear to converge because of their varying distance from the camera.

kicker See *backlight.*

kilobyte approximately one thousand bytes of data.

lamp light bulb; an artificial light source, usually consisting of a wire filament within a transparent globe and heated or ignited by electricity.

lamp ejector a device built into flash bulb units for removing spend flashbulbs without directly handling them.

lamp housing the component assembly of an enlarger or projector that contains the light source.

large format See *format.*

latent image the invisible image recorded on a photographic emulsion following exposure and preceding development; a pattern of chemical changes in a photographic emulsion produced by the action of light, and not normally visible until chemically processed.

latitude See *exposure latitude.*

law of transmission and absorption a principle of the behavior of light that states that a transparent medium, such as a filter, passes light rays of its own apparent color and assimilates light rays of its complementary color.

LCD See *liquid crystal display.*

leader a length of film or paper preceding usable roll film provided to protect the film and aid in loading the film into a camera.

leaf shutter a camera component designed to initiate, time, and terminate exposure by means of the opening and closing of an assembly of overlapping, concentric metal leaves.

LED See *light-emitting diode*.

lens a device consisting of one or more elements, usually transparent, designed to direct and focus light; in photography, the device used to focus an image onto a focal plane.

lens barrel the metal or plastic tube in which the lens elements are mounted.

lensboard a removable panel used as a support for one or more lenses and designed to be mounted onto the body of a camera or enlarger.

lens brush a nonabrasive, soft brush used to clean the surface of a lens.

lens cap an opaque device used to fit the barrel of a lens to provide protection to the lens surface and to block the passage of light.

lens-cleaning solvent a liquid used to clean grease and dirt from lens surfaces without affecting the surfaces or their coatings.

lens hood a detachable device fitted to the lens barrel and designed to shade the lens surface from extraneous, nonimage-forming light so as to maximize contrast and reduce flare. Also see *sunshade, lens shade*.

lens mount a mechanism by means of which the lens is attached and held firmly to the camera body.

lens shade See *lens hood*.

lens speed See *speed*.

lens tissue a soft, nonabrasive paper used for cleaning lenses.

light electromagnetic radiation, including infrared, visible, ultraviolet, and X rays, that act upon the optical faculties and photographic emulsions.

light balancing filters See *correction filters*.

light-emitting diode a small, light-generating device commonly used for indicator and warning lights within camera viewing systems and flash units.

light fog See *fog*.

lighting ratio See *brightness ratio*.

lighting standard See *standard*.

light meter See *exposure meter*.

light output the amount of light produced by a flash unit, usually measured in beam candlepower seconds (BCPS).

light primaries See *primary colors*.

light-tight capable of preventing the admission of light.

line an element of visual composition; the arrangement, real or imagined, of outlines, contours, and other connecting elements in an image.

linear perspective the representation of three dimensions and distance in a two-dimensional plane by means of converging lines and diminishing size.

line art graphic representation made up entirely of lines and marks on a contrasting background, devoid of intermediate tones.

lines of composition elements in an image that lead the viewer's attention from detail to detail and often affect the apparent organization of details within the visual structure.

liquid crystal display a thin-film, low-power display device popularly used in photography for digital readouts in cameras, meters, and flash units.

lithography a method of printing using ink and a flat plate. Originally, handmade stone plates were used with ink or crayon; modern lithography uses metal plates prepared by photographic process.

long lens any lens possessing a focal length longer than is normal for the camera on which it is used. The use of a long lens reduces the angular coverage across the film's diagonal, renders images of distant objects larger than normal, and tends to foreshorten perspective. See *telephoto lens*.

low-angle shot a camera-to-subject angle in which the camera is directed upward. See *eye-level shot* and *high-angle shot*.

low contrast characterized by minimal differences in density between adjacent tonal areas; without contrast; dominated by middle tones to the exclusion of clearly defined highlights and shadows; also said of lighting situations and photographic materials that tend to produce such images. Also *flat, soft*.

low-key dominated by dark or black tones to the exclusion of white or light tones. Compare *high-key*.

M See *medium peak*.

macro lens a type of lens used in place of a camera's normal lens for closeup photography.

macrophotography techniques used to produce extremely large images such as for photomurals.

macro-zoom lens a zoom lens with a closeup focusing feature.

magazine See *cartridge*.

magnification an image dimension divided by its corresponding subject dimension; a factor describing the relative sizes of object and image.

main light the principal light source in a studio setup, which establishes the dominant pattern of highlights and shadows. Also *key light, modeling light.*

manual exposure an exposure-setting system requiring the photographer to determine proper exposure and to set both aperture and shutter speed by hand.

manual focus a focusing system by which the lens is hand set to an inscribed scale based on the photographer's estimate of camera-to-subject distance.

manual mode a setting on an automatic camera that enables the photographer to override the automatic functions to select all settings.

mass an element of visual composition; an aggregate of relatively homogeneous tonal densities cohering together such that they appear as one body within a composition.

match indicator a type of automatic exposure-setting system that requires the photographer to adjust the aperture and/or shutter speed so that an indicator light or needle seen in the viewfinder is properly aligned.

matte a dull, nonreflective surface texture.

matte white reflector a reflector with a dull, white surface of relatively high reflectance and diffusing qualities.

maximum aperture the rated aperture of a lens; its largest useful opening; its aperture when wide open.

maximum depth of field See *depth of field.*

medium format See *format.*

medium grain a grain pattern characterized by the grouping together of silver grains in the photographic image into clumps of moderate size.

medium peak (M) a type of flashbulb that reaches peak output fifteen to twenty milliseconds after ignition. Camera synchronization for common combustible flash bulbs.

medium speed moderate sensitivity to light of a photographic film or paper; moderate light-transmitting capability of a lens.

medium-speed film See *medium speed.*

megabyte (Mb) approximately one million bytes of data.

metallic silver See *silver.*

metal oxide sensor (MOS) a type of image receptor used in place of film in electronic and still video cameras.

microphotography techniques used to produce extremely small images, such as for microelectronics.

microprism a substructure of a ground-glass focusing screen consisting of a pattern of refracting prisms to enable more accurate focusing.

Mired a unit of measurement, derived from Kelvin, used to measure the color temperature of light; contraction of *micro-reciprocal degrees.* The Mired system simplifies the selection of filters to achieve a desired color balance in color photography.

modeling revealing by means of lighting the three-dimensional qualities of an object.

modeling light See *main light.*

modem a device that converts digital data into electronic signals that can be transmitted over standard phone lines. An abbreviation of *Modulator-Demodulator.*

monitor a visual output device similar in appearance to a television screen designed to display computer information.

monobath a single solution for rapidly developing and fixing photographic materials.

monochromatic based entirely upon a single or several closely related hues.

monochrome a single hue. See *monochromatic.*

MOS See *metal oxide sensor.*

motor drive a device that automatically advances film under force at a rate of about five frames per second.

mounting adapter a device that enables a given lens to mount to a given camera body.

mouse a hand-held input device commonly used to interact with a computer.

M-synchronization the mechanical synchronization used with medium-peak (M) flashbulbs; provides a twenty-millisecond delay between flash ignition and subsequent shutter release. Similar to FP-synchronization designed for use with flat peak (FP) flashbulbs and a focal plane shutter.

multicontrast filter See *variable contrast filter.*

multicontrast paper See *variable-contrast paper.*

multigrade paper See *variable-contrast paper.*

narrow lighting See *short lighting.*

ND filter See *neutral density filter.*

negative a photographic image in which subject tonalities (and colors) have been reversed from light to dark (and from primaries to complements) and vice versa *vis à vis* the original scene. Usually the negative is used to make finished positives that possess tonalities (and colors) corresponding to the original scene.

negative carrier a framelike device used to hold a negative in position in an enlarger during printing.

negative format See *format.*

neutral background the absence of distracting peripheral details and contrasts in a photographic composition.

neutral density (ND) filter a filter toned to a specific density of gray and used over a camera's lens to reduce the intensity of image-forming light without altering its color balance.

normal contrast a photographic image characterized by the presence of a wide range of tonal densities, including whites, blacks, and a variety of middle gray tones; lighting situations and photographic materials that tend to produce such images.

normal lens any lens possessing a focal length approximately equivalent to the diagonal measurement of the film format of the camera on which it is used. See *long lens, short lens*.

notching code pattern of small cutouts in the edges of sheet film which identify the type of film and the emulsion side of the film sheet so it can be identified in the dark.

NTSC National Television Standards Committee. The broadcast and reception standard for television in the United States, Japan and Canada approved by the committee.

object a visible entity, originally possessing three dimensions; a photographic detail. See *subject*.

object at infinity an object that is at least fifty feet (fifteen meters) from the camera.

one-shot developer a developing solution intended to be used once and discarded.

110 camera a camera designed to use 110 film cartridges.

126 camera a camera designed to use 126 film cartridges.

opacity a medium's ability to block the passage of light; the reciprocal of transmittance.

opaque resistant to the passage of light.

open bulb a method of contact print making in which exposure is made with a bare electric light bulb.

open flash flash technique in which the flash unit is fired manually, often more than once, while the shutter stands open. Sometimes called *painting with light*.

opening up increasing the size of the lens aperture to control exposing and focusing.

optical drive a removable mass storage device for computers that uses a laser beam to access the data.

optimal exposure the exposure that yields the maximum shadow detail with minimum density under given developing conditions.

orthochromatic a type of emulsion characterized by sensitivity to all wavelengths in the visible light spectrum except red.

outdated film film unexposed and/or unprocessed after its published expiration date.

outdoor lighting standard an arrangement of highlights and shadows that reproduces the appearance of natural outdoor light sources, which typically originate from above and to the side of the subject.

out-of-focus indistinctness of image caused by lack of image resolution and sharpness. Compare *blur*.

overall reading a reflected-light meter reading obtained by placing the meter at the camera position and pointing it in the general direction of the scene to be photographed. It records the average light intensity of the entire scene.

overexposure the action of too much light upon a photographic emulsion. Overexposed negatives, developed normally, are characterized by overall excessive density, loss of detail in highlight areas, overall loss of contrast, and graininess in the final print.

override to set an automatic camera to disable its automatic functions for manual operation.

painting with light See *open flash*.

pan (1) contraction of *panchromatic;* (2) to swing the camera during exposure to follow a moving subject. Also *panning, panoramming*.

panchromatic a type of emulsion characterized by sensitivity to all wavelengths in the visible light spectrum.

panning See *pan*.

panoramming See *pan*.

paper negative negative image on a paper base. Characteristic of the calotype process during the 1840s before transparent negative media were available.

paper tint See *base tint, tint*.

parallax the discrepancy between the image seen through a camera's viewfinder and that recorded on the film.

pattern screen a type of baffle that, introduced into a light beam, produces a shadow pattern. Used for background interest.

PC contact a flash synchronization socket by means of which the camera and flash unit are connected using a short cable.

P-C lens See *perspective control lens*.

peak action a moment when a moving object is relatively motionless due to a change in its direction; for example, a high jumper at the top of his jump when upward movement has ceased and downward movement has not yet begun. Compare *real action, simulated action*.

pentaprism a five-sided prism used to provide correct vertical and horizontal orientation in SLR viewfinders.

perspective the representation of three dimensional space on a flat surface by means of variations of line, tonality, focus, and image size. See *linear perspective, aerial perspective, selective focus.*

perspective control (P-C) lens type of wide-angle lens providing for rotation and shifting of its optical elements to control convergence and depth of field.

Photo CD a Kodak technology that stores up to 100 digitized photographic images on a compact disk.

photo eye a photoelectric triggering device used to operate slave flash units.

photoflood an artificial lighting instrument that produces an even, relatively diffused field of light over a broad area.

photographic paper paper coated with a photosensitive emulsion and used for making photographic prints.

photomacrography techniques used to produce negative images that are life-size or larger.

photomicrography techniques used to photograph objects through a microscope.

photosensitive subject to chemical change in response to exposure to light.

pinhole camera a camera characterized by a tiny hole rather than a lens to resolve admitted light into an image in the film plane.

pinholes small transparent spots in a negative caused by airbells where the image failed to develop.

pixel the single, smallest element in a matrix of elements used to make up an entire electronic image. Abbreviation of *Pic*ture *El*ement.

pixel editing pixel-by-pixel manipulation of an image.

pocket camera a camera of small size and shape suitable for carrying in a pocket.

point of view the position from which a scene is viewed; the position from which a photograph is taken; the relationship between the subject and its viewer.

poised action See *peak action.*

pola filter See *polarizing filter.*

polarized light light composed of electromagnetic waves vibrating predominantly in, or parallel to, a single plane. It is commonly produced by source light reflecting off non-metallic surfaces, or passing through a polarizing screen.

polarizing filter a filter designed to block or pass polarized light by positioning its axis to oppose or conform to the axis of polarization; a filter designed to block the passage of any light except that which is vibrating in the plane of its axis. Thus, only polarized light is transmitted by such a screen.

positive a photographic image in black-and-white (or color) in which subject tonalities (and colors) correspond to those in the original scene; the reverse of a negative.

positive print See *print.*

positive transparency See *transparency.*

press camera historically, a large-format camera, such as a Graflex or Speed Graphic, commonly used by press photographers; currently, any camera used by a press photographer.

previsualization the process of visualizing the final photographic print prior to exposure. In the zone system, a method of analyzing brightness values before exposure to plan a desired range of densities in the final print.

primary colors a set of hues from which all other hues may be derived. The additive light primary colors—red, green, and blue—can, when added together in varying proportions, produce a maximum number of hues, including white (all colors). The subtractive light primary colors—magenta, yellow, and cyan—can, when added together in varying proportions, absorb all hues from white light to pass any specific hue, including black (no color).

print a photographic image, usually understood to be positive, reproduced in final form on an opaque photographic paper, to make a print.

print conditioning solution a photoprocessing agent that functions to soften the gelatin emulsion, thereby reducing curling and generally improving the effect of ferrotyping.

print finishing those procedures subsequent to washing—including drying, ferrotyping, spotting, bleaching, mounting, and similar techniques—intended to produce photographic prints suitable for their intended purposes.

printing the procedures for making prints; making prints.

printing frame a flat, rectangular holder equipped with removable or hinged front glass or back, designed to sandwich copy, negative, and/or printing paper tightly in place for exposure or copying.

printing in See *burning in.*

printing paper See *photographic paper.*

processing the sequence of steps, usually including developing, stopping, fixing, and washing, necessary to transform a latent photographic image into a permanent image; to subject photographic materials to such a sequence of steps.

programmed exposure a type of automatic exposure-setting system that sets both aperture and shutter speed automatically to obtain proper exposure.

projection the act of causing an image of an original to fall upon a surface by directing and controlling the passage of light onto and/or through the original; the act of reproducing on a surface the image of a transparency, negative or positive, by directing and controlling the passage of light through the transparency.

projection print a print produced by projecting the master image onto the surface of photosensitive material; usually understood to be and often called an enlargement.

projection printing paper relatively fast photosensitive paper used primarily for projection printing. Also see *printing paper.*

proof sheet See *contact sheet.*

push-process to expose film at a higher-than-normal film speed ratings and then to prolong development to compensate for resulting underexposure. See *forced development.*

quartz light an extremely intense incandescent lamp designed with a filament bathed in bromine or iodine vapor, having longer life and more constant color temperature than ordinary tungsten-filament lamps.

quench to terminate flash duration when a predetermined exposure value has been reached. See *automatic electronic flash.*

RAM See *random access memory.*

random access memory (RAM) a computer's working memory where data is temporarily stored and processed.

range (1) the distance between the camera and the objects intended to be in focus in a photograph; (2) the spectrum of tones, from lightest to darkest, in a photographic image is referred to as its tone, contrast, or density range.

rangefinder a mechanical-optical mechanism, usually integrated with a camera's viewfinding system, used to focus an image onto the camera's film plane.

rangefinder camera a camera with a built-in rangefinder.

range-of-brightness a method of using a light meter to measure the intensity of light in the important highlight and shadow areas of a scene.

range of density the difference between the thickest and thinnest silver deposits on a negative produced by the total range of brightness in the scene.

RC paper See *resin-coated paper.*

ready light an indicator light that activates when an electronic flash unit is fully charged and ready to fire.

real action movement of the subject at the moment it is photographed. Compare *peak action* and *simulated action.*

reciprocity failure the nonoccurrence of normally expected density changes, resulting from exposures of extremely short or long duration. See *reciprocity law.*

reciprocity failure (RF) factor the number by which exposure time must be multiplied to compensate for reciprocity failure.

reciprocity law a principle of photography stating that a constant density is obtained on a photo-sensitive material if the product of light intensity and exposure duration remains constant. Thus density is postulated to remain constant if, for example, light intensity is halved while exposure duration is doubled, and vice versa. Also see *reciprocity failure.*

record shot a photograph that represents a subject objectively and accurately and is devoid of interpretation by the photographer; a theoretical ideal, since any photograph requires the photographer to select, emphasize, and subordinate details in the process of composition.

recycling time the time interval necessary to recharge an electronic flash unit following discharge.

red-eye the appearance of red pupils in color photographs when flash illumination is reflected off the retina of the subject's eyes back toward the camera. It is avoided by placing the flash unit off the camera axis and/or by directing the subject's gaze off the camera axis.

reducer a chemical agent capable of dissolving metallic silver, and thereby reducing the density of photographic images. See *bleach.*

reflectance the light-reflecting characteristic of an object or surface. Surfaces of high reflectance reflect much of the light incident upon them; subjects of low reflectance absorb much of such light.

reflected-light light rays that are deflected or bounced from a surface or subject after striking it.

reflected-light meter a light-measuring device designed to respond to the intensity of light reflected from a surface or subject and to compute proper exposure. Compare *incident light meter.*

reflection the partial or complete deflection of light rays from an encountered surface; the production of an image composed of reflected light, as if by a mirror.

reflector a polished and/or light-colored surface for reflecting light.

reflector floodlight a lightbulb with a built-in reflector designed to function as a floodlight.

reflector spotlight a lightbulb with a built-in reflector designed to function as a spotlight.

reflex camera a camera whose viewfinding mechanism utilizes an inclined mirror to reflect an image onto a ground-glass screen. See *single lens reflex* and *twin lens reflex*.

refraction the deflection of a light ray in passing obliquely from one transparent medium to another in which its velocity is altered.

relative brightness comparative light reflectance among various elements of a scene to be photographed.

replenisher a chemical agent added to a developer to restore its strength following use.

reproduction a print made from a copy negative; an exact positive print or transparency of the original; the end product of copying.

resin-coated (RC) paper a photosensitive printing paper characterized by a tough, smooth resin coating on the paper base below the emulsion layer.

resolution (1) the number of pixels in a given matrix area. Usually expressed in columns by rows, such as 1,000 by 1,200 pixels; (2) See *definition*.

resolving power the capability of a lens to form an image in fine detail; the capability of a photographic emulsion to reproduce fine detail in a recorded image.

retaining ring a device used with an adaptor ring to hold a filter in place in front of a camera's picture-taking lens.

reticulation a network of wrinkles and cracks in a photographic emulsion, brought about by exposure of the emulsion to extreme temperature changes during processing.

retina a light-sensitive membrane that lines the interior chamber of the eye upon which the image is formed by the lens.

reversal film a film designed to produce a positive image after exposure to a positive image; a film that reproduces tonal densities corresponding to those of the image to which it is exposed. Also see *color reversal film*.

reverse adapter a device used to invert the position of a normal lens back to front to improve its performance in closeup photography.

rewind button a mechanism on 35-mm cameras used to unlock the takeup spool to permit the film to be wound back into its cartridge.

rewind crank a mechanism on 35-mm cameras used to wind the film from the takeup spool back into its cartridge.

RF factor See *reciprocity failure factor*.

RGB video a type of color video technology used in computer monitors that employs separate red, green, and blue signals to build full-color images.

rim light backlight placed to produce edge accents from the camera's viewpoint. See *edge accent*.

ringflash a circular flash unit used at the front of the lens in closeup photography.

roll film film manufactured in a strip and wound onto a spool, designed for use in a camera that advances the film in measured increments to produce separate negative frames.

rule of thirds an approach to placement of a photographic subject based upon division of the picture space into thirds, both horizontally and vertically.

safelight darkroom illumination of such limited wavelength and brightness that it does not affect the photosensitive materials being handled. Materials of different sensitivities require different safelight.

saturation concentration of hue; also *chroma*. The absence of saturation is no hue at all, or white.

scale the relative sizes of an object in a photographic image and in actuality.

scanner a device that reads analog images and converts them into digital format for computer use.

second adhesive layer See *adhesive layer*.

secondary color a complement of a primary color; a hue consisting of equal proportions of any two primary colors. In light, the complements of the primary colors red, blue, and green are the secondary colors cyan, yellow, and magenta respectively.

secondary image the recording of two images, when using flash under bright existing light conditions and a slow shutter speed, one from the flash and a secondary one from the existing light; also *ghost image*.

selection the choice of details to appear in a photograph.

selective focus the representation of three dimensions and distance on a two-dimensional surface by means of variations in the sharpness of foreground and background details.

self-timer a device used to delay release of the shutter a preset interval of time after the shutter release has been pressed. May be built into automatic cameras or used as an accessory with manual cameras.

semigloss finish a surface texture of a print characterized by a soft, slightly reflective sheen.

sensitivity the potential of a photographic material to be chemically altered by the action of light energy.

separation the differentiation of tonal areas within a photographic image; the process of differentiating and recording the primary color components of a photographic image as three distinct black-and-white images.

series number an adapter-ring designation that specifies the size of the filters the ring is designed to accept.

shadow area any mass within a photographic image corresponding to the least illuminated areas in the original scene or subject; the least dense areas of a negative, the densest areas of a print. Also see *highlights*.

shadow reading a light-meter reading of the least illuminated areas of a scene, or those that will produce the areas of least density on the film.

Shallow depth of field See *depth of field*.

sharpness the apparent clarity and definition of details in a photographic image; a function of such factors as graininess, image resolution, density, and contrast of the negative, which interact to create an impression of sharpness.

sheet film film manufactured and packaged in individual pieces; cut film.

shifts and swings See *swings and tilts*.

short lens any lens possessing a focal length shorter than is normal for the camera on which it is used. See *wide-angle lenses*.

short lighting a portrait lighting setup characterized by placement of the main light to illuminate the side of the subject's face farthest from the camera.

short stop See *stop bath*.

shutter the mechanical component of a camera system by means of which the time interval of exposure is controlled.

shutter priority a type of automatic exposure-setting system that requires the photographer to set the shutter manually while the system sets the aperture automatically for proper exposure.

shutter release a mechanical component of a shutter system by means of which the action of the shutter is activated.

shutter speed (1) the interval of time during which the activated shutter is admitting light into the camera; (2) the calibrated markings on an exposure scale indicating a shutter-speed setting.

silhouette a visual representation of an object's mass and shape, but lacking details within the mass.

silver the metallic element Ag, commonly compounded with halides to form the main active ingredient in most modern photosensitive materials.

silver bromide one of the silver halides.

silver chloride one of the silver halides.

silver density See *density*.

silver halide See *halide*.

silver iodide one of the silver halides.

simulated action an impression of activity in the absence of real action. Compare *real action* and *peak action*.

single-lens reflex (SLR) a type of camera that has a hinged mirror device through which the viewing and picture-taking functions may be performed by the same lens; SLR.

skylight filter a filter that performs with color film a function similar to that of a haze filter with black-and-white film. It filters ultraviolet light, reduces bluishness, and restores warmth to scenes characterized by excessive ultraviolet light sources.

slave unit a secondary flash unit designed to supplement a primary flash unit through a remote, photo-triggering operation.

slide (1) a positive transparency designed for use in a projector; (2) a component of a film holder that seals the film within against light; a darkslide.

slow minimally sensitive to light; responsive only to relatively high levels of illumination (said of photosensitive paper or film); capable of transmitting relatively small amounts of light per unit of time (said of photographic lenses of relatively small diameter relative to their focal length).

slow-speed film See *slow*.

SLR See *single-lens reflex*.

small format See *format*.

soft See *low contrast*.

soft focus focus that is slightly diffused, often used to reduce the clarity and definition of details in a photograph.

software coded sequences of instructions, or programs, that tell a computer what operations to perform.

spectrum an ordered series of electromagnetic wavelengths to which photographic emulsions are sensitive, made up largely of those perceived as light by the human eye.

specularity See *specular light*.

specular light highly directional, nondiffused light such as that emanating from a relatively small point source or reflected off a highly polished, mirrorlike surface.

speed the relative sensitivity to light of photographic materials; the light-transmitting characteristic of lenses, as expressed by the ratio of their focal length to their maximum aperture diameter; the apparent movement of an object being photographed.

split-image focusing See *split-image rangefinder*.

split-image rangefinder a type of rangefinder in which opposing halves of the image are displaced except when the device is properly focused. Such a rangefinder is commonly built into a camera and integrated with the camera's lens-focusing mechanism.

splitting the frame a colloquial term for a compositional arrangement in which a strong vertical or horizontal feature splits the picture format into approximately equal halves.

spotlight a lighting instrument, usually possessing an integrated lens and/or reflector, used to produce a focused, narrow, relatively specular beam of light.

spot meter a type of exposure meter, often built into modern cameras, characterized by its capability of measuring light intensity reflected from a very small area within the viewing format.

spotting a technique for bleaching and/or tinting out undesirable spots on a print, such as those caused by pinholes or dust particles on the negative during printing.

spotting colors tinting materials, used in spotting, that can be mixed and applied to match print tones.

spraying a technique for dulling a shiny surface to eliminate specular reflections.

spring tension the stored energy produced by the compression or expansion of an elastic device.

sprout a colloquial term for the alignment in a photographic composition of a background detail with a foreground object such that the former appears to be appended to the latter.

square filter a type of filter, square in shape, requiring a special filter holder to mount it to the camera.

stabilization process a process for developing and fixing prints rapidly. It requires specially treated materials and a mechanical processing unit that automatically conveys the exposed paper through the processing chemicals to produce a processed print in about ten seconds. Such a print will oxidize over time unless subsequently fixed for permanence.

stabilization processor a mechanical processing unit used in stabilization processing.

stain a nonimage-related color or tone on a print, usually produced by chemical oxidation and rarely expected or desired.

standard a stand, often weighted and castered, for mounting lighting equipment; also the front and rear parts of a view camera. See *swings and tilts*.

standard average gray 18 percent gray. See *average gray*.

star filter an etched glass filter that produces starlike patterns around specular highlights.

stereo camera a camera designed to take a pair of photographs simultaneously, as though seen separately by each eye. When mounted side-by-side as a stereograph and viewed through a stereoscope, the photographs are perceived as a three-dimensional image.

stereograph a pair of photographs mounted side-by-side designed for viewing through a stereoscope.

stereoscope a device used for viewing stereographs to produce a three-dimensional effect.

still video a type of video technology that employs video signals to record and display nonmoving pictures.

stock solution any photographic solution used for storage, usually in a concentrated form.

stop (1) a change in an exposure setting, either aperture or shutter speed, that either doubles or halves exposure; (2) to terminate development by means of a stop bath.

stop action an approach to photographing real action that seeks to capture an unblurred image of a rapidly moving object by means of extremely short exposure intervals. Also *freeze actions*.

stop bath a processing solution of dilute acetic acid, introduced following development to neutralize the action of residual developer promptly prior to fixing.

stopping down reducing the aperture size of a lens to control exposing and focusing.

strobe a device that produces rapidly flashing bursts of light; derived from "stroboscope," now commonly used to refer to an electronic flash unit. See *electronic flash*.

strobe peak (X) a flash burn pattern that reaches maximum output within one millisecond after ignition and sustains this level up to two milliseconds prior to extinction. See *electronic flash, X-synchronization*.

studio camera See *view camera*.

subbing adhesive layer adhesive coating used to bind a photographic emulsion to its support. See *adhesive layer*.

subject the center of interest or central idea; the person, place, thing, or view photographed. A photograph may include many objects, but usually only one subject. Compare *object*.

subject speed See *speed*.

subordination the reduction to a subordinate status of a particular detail or feature in a photograph; minimization of the attention-attracting position, size, or clarity given to such a feature. Compare *emphasis*.

subtractive color theory theory of mixing primary colors of light by subtracting red, green, and blue from white light to produce black by absorbing all wavelengths.

sufficient light indicator a signal light built into automatic cameras and flash units that indicates if the flash illumination has been adequate to obtain proper exposure.

sunshade See *lens hood, lens shade.*

superimposed-image focusing See *superimposed-image rangefinder.*

superimposed-image rangefinder a type of rangefinder in which two images of the subject appear to overlap except when the device is properly focused on the subject. Such a rangefinder is commonly built into a camera and integrated with the camera's lens-focusing mechanism.

supplementary lens a lens used in front of a primary lens to alter its performance. Often used in closeup photography or for special effects.

support a transparent, firm, chemically stable base upon which is coated the emulsion of a photographic film or plate.

surface texture See *texture.*

swings and tilts the adjustments of the front and rear standards of a studio or view camera. Also *shifts and swings.*

synchronization the mechanical-optical method of timing the ignition of a flash unit in coordination with the release of the shutter to obtain optimal exposure. See *X-synchronization, M-synchronization, FP- synchronization.*

T-setting See *time (T).*

tacking iron a hand-held electrical tool used in mounting prints to attach dry-mounting tissue to the mounting surfaces prior to pressing in a dry-mount press.

taking lens the camera lens that resolves the photographic image on the film; the picture-taking lens (as distinct from other lenses used in viewfinding). Compare *viewing lens.*

talbotype See *calotype.*

tank See *film-processing tank.*

teleconverter a device inserted between lens and camera body to increase the effective focal length of the lens. 2X and 3X teleconverters effectively double and triple the effective focal length respectively. Also *extender, converter.*

telephoto lens a type of long lens characterized by its resolution of an image on the film larger than that resolved by a given camera's normal lens.

tenting a method of lighting through a translucent medium in order to produce an even, diffused field of light devoid of reflected details. It is especially useful for photographing shiny objects.

test exposure See *test print, test strip.*

test print a full-size print exposed in segments for varying exposure intervals in order to determine optimal exposure for printing.

test strip a narrow strip of printing paper exposed in segments for varying exposure intervals in order to determine optimal exposure.

texture (1) image texture—an apparent surface characteristic produced by the photographic image; (2) surface texture—a physical surface characteristic of the photographic paper, such as glossy or matte textures; (3) a physical surface characteristic of an object that may be exaggerated or subdued by means of lighting.

texture accents highlights that reveal the surface irregularities of an object.

texture screen a device used to produce image texture in a print. See *texture.*

texturing emphasizing or revealing surface texture, such as by the use of lighting.

thermal printer a type of printer that uses heat to transfer image-forming pigment to paper.

thin characterized by low overall print or negative density.

thin emulsion film a type of film characterized by an exceptionally thin photosensitive layer of high resolution and contrast, fine grain, slow to moderate speed, and narrow latitude.

35-mm camera a type of camera designed to use 35-mm sprocketed motion picture film, popularly packaged for use in such cameras.

threaded mount a lens-mounting system using screw-threads by which a lens may be aligned with the mount and screwed into place.

thyristor circuit a type pf automatic electronic flash that conserves unused energy in its capacitors following each flash to reduce recycling time and extend capacitor life.

tilt head an adjustable head on an electronic flash unit that can be used to redirect the unit to obtain bounce light.

time (T) a shutter setting (T) at which the shutter remains open following depression of the shutter release until the release is depressed a second time. Rarely seen on modern cameras. Compare *bulb.*

time and temperature the main variables requiring precise control during chemical processing of photographic materials.

timer a device used in the darkroom to measure time intervals during processing and printing, often integrated into the design of photographic equipment.

time exposure an exposure interval, usually longer than a few seconds, timed by the photographer while the shutter stands open rather than by the camera's automatic settings.

tint a hue of very low saturation. Paper tint or base tint is the color of the paper stock itself.

tintype wet collodion process on dark-varnished metal plate to produce positive image. Inexpensive process extremely popular in the 1860s and 1870s.

TLR See *twin-lens reflex.*

tonality the range in values, in gray or color, present in a photographic image; the range of distinct values that can be discriminated between black and white. See *contrast, gray tone separation.*

tonal range See *tonality.*

tone white, black, or an intermediate shade of gray; the tint present in the silver image. See *tonality, tint.*

toner a chemical agent used to alter the color or tint of the silver image in a black-and-white print. Toners affect only the silver image, not the base tint.

tone separation the rendering of varying brightness values in a scene as distinctly different shades of gray in a black-and-white print.

toning See *toner.*

topcoat an abrasion-resistant material coated onto the surface of a photographic emulsion as a protection.

transillumination illumination produced by lighting through a translucent medium.

translucent capable of transmitting light, but not image; characteristic of a medium that transmits light only at a high level of diffusion.

transmission the passage of light through a medium. See *law of transmission and absorption.*

transmittance a medium's ability to pass light; the reciprocal of opacity.

transparency a photographic image, positive or negative, recorded on a transparent medium and capable of projection.

transparent capable of transmitting light and image; characteristic of a medium that transmits light at a minimum level of diffusion.

tripod a three-legged, usually foldable, support commonly used for positioning and stabilizing a camera.

T setting See *time.*

TTL through-the-lens. Type of built-in exposure meter that measures light transmitted by the taking lens.

tungsten-filament See *tungsten light.*

tungsten-halogen improved smaller version of tungsten-filament lamp that emits whiter, brighter light.

tungsten light conventional artificial light produced by passing an electric current through a tungsten filament in a vacuum or in inert gas. In photography, it usually refers to lamps designed to burn at specific color temperatures (3,200 or 3,400 K).

twin-lens reflex (TLR) a reflex camera characterized by its use of separate but optically similar built-in lens systems to perform the separate functions of viewfinding and picture taking; TLR.

2 1/4-square camera a camera that produces a 2 1/4-inch by 2 1/4-inch negative format.

type A a designation identifying color film balanced for tungsten light of 3,400 K.

type B a designation identifying color film balanced for tungsten light of 3,200 K.

ultra-fast film film designed for use under low lighting levels; arbitrarily, film with film-speed rating over ISO/ASA 400.

ultraviolet relating to a band of electromagnetic wavelengths just shorter than those perceived as violet in the visible light spectrum; describes an invisible band of electromagnetic waves detectable by most photosensitive silver halide emulsions.

ultraviolet (UV) filter a filter medium that inhibits the passage of ultraviolet light. See *skylight filter, haze filter.*

umbrella reflector a highly reflectant metallic cloth, stretched over a foldable frame resembling an umbrella, that reflects a soft, directional field of light.

underexposure an amount of exposure inadequate to produce normal density and tonal range on a photosensitive emulsion by means of standard developing procedures.

underwater camera a camera designed for use under water.

underwater housing a container designed to provide a waterproof enclosure for underwater operation of the camera.

unipod a camera support with a single leg.

UV filter See *ultraviolet filter.*

value brightness; the relative presence or absence of black; lightness or darkness. The absence of value is equivalent to zero electromagnetic energy, or no light at all.

variable-contrast filter a type of filter designed for use with variable-contrast printing paper to control, contrast in photographic printing. Also *multicontrast and polycontrast filters.*

variable-contrast paper a type of printing paper coated with both high contrast and low contrast emulsions, each sensitive to a given band of electromagnetic wavelengths. It is used with variable-contrast filters to control contrast in printing. Also *multicontrast, polycontrast, and multi-grade paper.*

vari-focus lens a variable focal length lens, similar to a zoom lens, that requires re-focusing whenever the focal length is changed; see also *zoom lens.*

video the electronic system by which the visual portion of a television image is generated.

view camera a type of camera characterized by large-format ground-glass viewing of the image in the film plane, and considerable adjustability of the lensboard and film plane to control linear perspective and depth of field.

viewfinder (VF) a mechanism on a camera that indicates to the photographer the details the camera will record and, commonly, the details that will be in focus.

viewing lens the lens of the viewfinding system, rather than the picture-taking system. The term commonly refers to the lens that forms the viewfinder image in a twin-lens reflex camera. Compare *taking lens.*

vignetting (1) a dodging technique for achieving progressive reduction of exposure toward the edges of a picture format, isolating the subject within borders that gradually fade to the value of the base; (2) the progressive reduction of exposure toward the edges of a negative, produced by using a lens or attachment optically inadequate for the camera design.

visible light spectrum See *spectrum.*

warm tones brownish hues associated with the metallic silver image of a print, often emphasized by the use of certain emulsion-developer combinations.

wash to clear active chemicals from photographic materials by rinsing in water.

washed out a colloquial term describing a print of inadequate density in which a full range of highlight detail has failed to develop, typically as a result of underexposure in printing.

washing aid See *clearing agent.*

wavelength a characteristic of electromagnetic energy which, within the visible light spectrum, activates differential neural sensations that are perceived as color.

weight the thickness of printing paper stock, for example, document weight, single weight, double weight.

wet area a portion of a darkroom, designed especially for handling processing chemicals, solutions, and water so as to minimize the possibility of contaminating chemically sensitive, dry materials such as films and papers.

wet mounting a technique for affixing finished prints to a surface by means of a liquid or spray adhesive. Compare *dry mounting.*

wet-plate process photographic process invented by F. Scott Archer in 1851 and popular for more than thirty years by which glass plates were coated with an emulsion of collodion and silver nitrate and loaded into the camera and exposed while still wet.

wetting agent a water additive that acts to break down surface tension and is used in photography to aid in spot-free drying of film.

white light light consisting of virtually all wavelengths in the visible light spectrum; standard daylight; light capable of making normal exposure of photographic emulsions.

wide-angle camera a camera with a revolving lens and shutter system or a wide-angle optical system, designed for making panoramic photographs.

wide-angle lens a lens with a shorter focal length and wider angle of coverage than is normal for the camera on which it is used.

winder See *automatic winder.*

working solution any photographic processing solution, usually diluted from its more concentrated stock form. Compare *stock solution.*

X-synchronization mechanical synchronization of shutter and flash for use with electronic flash units; X, zero-delay, is designed to make flash contact when the shutter stands fully open.

zero-delay to peak a flash burn pattern in which peak flash output is reached almost instantaneously upon ignition. Electronic flash units peak with almost zero-delay (actually less than one millisecond) and are used with cameras set for X-synchronization.

zinc-carbon battery a type of battery recommended for flash units with unplated brass or copper contacts. Compare *alkaline battery.*

zone focusing technique for presetting an aperture to obtain a desired depth of field to facilitate shooting subjects at various distances without adjusting the focus.

zone of sharpness See *depth of field.*

zone system a precise method for controlling density and contrast using analysis of brightness values in a scene to plan the exposure and processing necessary to obtain a previsualized result in the final print.

zoom lens a lens with a continuously adjustable focal length within its design limits.

References

Adams, Ansel. *The Negative.* Dobbs Ferry, N.Y.: Morgan and Morgan, 1968.

Ahlers, Arvel W. *Where & How to Sell Your Photographs.* New York City: AMPHOTO, 1979.

Barrett, Terry. *Criticizing Photographs; An Introduction to Understanding Images.* Mountain View, Calif.: Mayfield, 1990.

Beaton, Cecil, and Gail Buckland. *The Magic Image.* Boston: Little, Brown, 1975.

Blaker, Alfred A. *Photography: Art and Technique.* London: Focal Press, 2nd ed., 1988.

Brooks, David. *Photographic Materials and Processes.* Tucson, Ariz.: H–P Books, 1979.

——— *How to Control and Use Photographic Lighting.* Los Angeles: H–P Books, revised, 1989.

Brown, Joseph Epes. *The North American Indians: Photographs by Edward S. Curtis.* New York: Aperture, Inc., Vol. 16, No. 4, 1972. Catalogue for the exhibition presented at the Philadelphia Museum of Art, 1972.

Busselle, Michael. *Master Photography.* New York: Rand McNally, 1978.

Cavallo, Robert M., and Stuart Kahan. *Photography: What's the Law?* New York: Crown Publishers, 1976.

Craven, George M. *Object and Image: An Introduction to Photography.* Englewood Cliffs, N.J.: Prentice-Hall, 3rd ed., 1990.

Crawford, William. *The Keepers of Light.* Dobbs Ferry, N.Y.: Morgan and Morgan, 1979.

Cutler, Joel Leslie. *What the Camera Never Saw: Photo-Exploration of the Sabattier Effect.* Long Beach: California State University, 1981. Unpublished Master's Thesis.

Davenport, Alma. *The History of Photography: An Overview.* London: Focal Press, 1991.

Davis, Phil. *Photography.* Dubuque, Iowa: W. C. Brown, 6th ed., 1990.

Doherty, R. J. *Social-Documentary Photography in the USA.* Garden City: American Photographic Book Publishing Co., 1976.

Doty, Robert, ed. *Photography in America.* New York: Random House, 1975.

Drei, Pat. "The Filmless Camera: State of the Art Is Here." *Photomethods,* September, 1991.

Eastman Kodak Co. *Basic Developing, Printing, Enlarging in Black-and-White.* Rochester, N.Y.: Eastman Kodak Co., Kodak Photo Information Book AJ-2.

——— *Bigger and Better Enlarging.* Rochester, N.Y.: Eastman Kodak Co., Kodak Photo Information Book AG-19.

——— *Black-and-White Darkroom Techniques.* Rochester, N.Y.: Eastman Kodak Co., Kodak Photo Information Book KW-15.

——— *Building a Home Darkroom.* Rochester, N.Y.: Eastman Kodak Co., Kodak Photo Information Book KW-14.

——— *Close-Up Photography.* Rochester, N.Y.: Eastman Kodak Co., Kodak Publication KW-22.

——— *Copying.* Rochester, N.Y.: Eastman Kodak Co., Kodak Publication M-1H.

——— *Copying and Duplicating in Black-and-White and Color.* Rochester, N.Y.: Eastman Kodak Co., Kodak Publication M-1.

——— *Electronic Flash.* Rochester, N.Y.: Eastman Kodak Co., Kodak Photo Information Book KW-12.

——— *Filters and Lens Attachments for Black-and-White and Color Pictures.* Rochester, N.Y.: Eastman Kodak Co., Kodak Photo Information Book AB-1.

——— *Kodak Films: Color and Black-and-White.* Rochester, N.Y.: Eastman Kodak Company, Kodak occasional publication.

——— *Professional Portrait Techniques.* Rochester, N.Y.: Eastman Kodak Co., Kodak Publication No. 0-4.

——— *Professional Photographic Illustration Techniques.* Rochester, N.Y.: Eastman Kodak Co., Kodak Professional Data Book 0-16.

Eauclaire, Sally. *The New Color Photography.* New York: Abbeville Press, 1981.

——— *New Color/New Work.* New York: Abbeville Press, 1984.

——— *American Independents: Eighteen Color Photographers.* New York: Abbeville Press, 1987.

Edom, Clifton. *Photojournalism: Principles and Practices.* Dubuque, Iowa: W. C. Brown Co., 1976.

Eggers, Ron. "Expanding a Photographer's Toolbox." *Photomethods,* October, 1991.

Foss, Kurt, "The Big Squeeze: Compression Makes Time and Photos Fly." *Photo-Electronic Imaging,* Vol. 34, No. 12, December, 1991.

Foss, Kurt, and Adams, Jeff. "The Digital Toolbox: Reality and New Realities." *News Photographer,* October, 1991.

Gassan, Arnold. *Exploring Black and White Photography.* Dubuque, Iowa: W. C. Brown, 1989.

Gernsheim, Helmut and Alison. *The History of Photography.* New York: Grosset and Dunlap, Revised and enlarged edition, 1969.

Gidal, Tim N. *Modern Photojournalism: Origin and Evolution.* New York: Collier: Macmillan, 1973.

Grill, Tom, and Mark Scanlon. *25 Projects to Improve your Photography.* New York: AMPHOTO, 1981.

——— *Photographic Composition.* New York: AMPHOTO, 1990.

Grimm, Tom. *The Basic Book of Photography.* New York: New American Library, 2nd ed. revised, 1985.

Hastings, Lou. "Digital Dictionary." *Photo-Electronic Imaging,* Vol. 34, No. 11, November, 1991.

Hedgecoe, John. *The Complete Photography Course.* New York: Simon & Schuster, 1979.

——— *The Art of Color Photography.* New York: Simon & Schuster, 1989.

Hodgson, Pat. *Early War Photographs.* Boston: New York Graphic Society, 1974.

Horenstein, Henry. *Beyond Basic Photography: A Technical Manual.* Boston: Little, Brown, 1977.

——— *Black & White Photography: A Basic Manual.* Boston: Little, Brown, 2nd ed. revised, 1983.

Horton, Brian. *The Associated Press Photojournalism Stylebook.* New York: Addison-Wesley, 1990.

The Instant It Happened. New York: The Associated Press, 1975.

Jacobs, Lou Jr. *Photography Today.* Santa Monica, Calif.: Goodyear, 1976.

——— *Selling Photographs: Rates and Rights.* New York: AMPHOTO, 1979.

Jones, Bernard Edward. *Encyclopedia of Photography.* New York: Arno Press, 1974. Reprint of *Cassell's Cyclopaedia of Photography.* London: Cassell, 1911.

Jussim, Estelle. *Visual Communication and the Graphic Arts: Photographic Technologies in the Nineteenth Century.* New York: R. R. Bowker Co., 1974.

Katzman, Louise. *Photography in California, 1945–1980.* New York: Hudson Hills Press, 1984.

Kerns, R. L. *Photojournalism: Photography with a Purpose.* Englewood Cliffs, N.J.: Prentice-Hall, 1980.

Kobre, Kenneth. *Photojournalism: The Professionals' Approach.* Boston: Focal Press, 2nd ed., 1991.

Langford, Michael. *35mm Handbook.* New York: Alfred A. Knopf, 1989.

Langford, Michael, contributing ed. *Creative Photography.* New York: RD Home Handbook, 1991.

Larish, John. *Understanding Electronic Photography.* Blue Ridge Summit, PA: Tab Books, n.d.

——— "Digital Photography." *Photo-Electronic Imaging*, Vol. 34, No. 11, November, 1991.

Lasker, Tim. "Glossary of Computer Terminology." *The Electronic Times,* Vol. III, N. 1, September, 1991. Published by the National Press Photographer's Association.

Leekley, Sheryle and John. *Moments: The Pulitzer Prize Photographs.* New York: Crown Publishers, 1978.

Lemmon, Byron. "Still Imaging: A Peek at Tomorrow Today." *The Rangefinder*, September, 1991.

Lewis, Greg. *Photojournalism: Content and Technique.* Dubuque, Iowa: W. C. Brown, 1991.

London, Barbara. *A Short Course in Photography.* Boston: Little, Brown, 1987.

Lovell, Ronald P., F. C. Zwahlen, Jr., and J. A. Folts. *Handbook of Photography.* Belmont, Calif.: Wadsworth, 1984.

Lucie-Smith, Edward. *The Invented Eye.* New York: Paddington Press, Ltd., 1975.

MacLennan, Donald W. "Still Video May Be Better Than Still Film." *Audio Visual Communications*, January, 1991.

Marzio, Peter C. *The Men and Machines of American Journalism.* Washington, DC: The Smithsonian Institution, 1973.

Mast, Gerald. *A Short History of the Movies.* New York: Pegasus, 1971.

Mathews, Oliver. *Early Photographs and Early Photographers.* New York: Pittman Publishing Co., 1973.

McGarry, Jerome T. "Slide Duplicating Techniques." *The Fourth Here's How: Techniques for Outstanding Pictures.* Rochester, N.Y.: Eastman Kodak Co., Kodak Publication AE-85.

Monk, Lorraine. *Photographs That Changed the World.* New York: Doubleday, 1989.

Morse, Mike. "Fitting More Pieces to the Technology Puzzle." *The Electronic Times,* Vol. III, Number 1, September 3, 1991. Published by the National Press Photographer's Association.

National Archives and Records Service. *The American Image: Photographs from the National Archives, 1860–1960.* New York: Pantheon Books, 1979.

National Press Photographer's Association. *The Electronic Revolution in News Photography.* Durham, N.C.: NPPA, 1987.

——— *The Ethics of Photojournalism.* Durham, N.C.: NPPA, 1990.

——— "NPPA's Electronic Manipulation Policy Statement." *NPPA's f/10 Forum*, February, 1991.

Newhall, Beaumont. *The History of Photography from 1839 to the Present Day.* New York: Museum of Modern Art, 4th ed., 1964.

Petzold, Paul. *The Focal Book of Practical Photography.* London: Focal Press/Pitman House, 1980.

Pollack, Peter. *The Picture History of Photography.* London: Thames and Hudson, 1977.

Q, Mike and Pat. *The Manual of Slide Duplicating.* New York: AMPHOTO, 1980.

Rainwater, Clarence. *Light and Color.* New York: Golden Press, 1971.

Rand, Glenn. "Transition into the Hybrid Environment." *Photo Educator International*, March, 1991.

Rea, Douglas Ford. "Let's Talk Software for Photographers!" *Photo Educator International*, March 1991.

Rhode, Robert B., and F. H. McCall. *Introduction to Photography.* New York: Macmillan, 4th ed., 1981.

Riis, Jacob A. *How the Other Half Lives.* New York: Dover Publications, 1971. Unabridged republication of the text of the 1901 edition of the original work published by Charles Scribner's Sons, New York, 1890.

Rosenthal, Marshall M. "Moving Toward 2000: The Digital Image, Part 1." *The Rangefinder,* November, 1991.

Schaub, George. *Using Your Camera: A Basic Guide to 35MM Photography.* New York: AMPHOTO, 1990.

Shaw, Susan. *Overexposure: Health Hazards in Photography.* Carmel, Calif.: Friends of Photography, 1983.

Smith, Joshua P. *The Photography of Invention: American Pictures of the 1980's.* Cambridge: MIT Press, 1989. A catalog to accompany the Smithsonian Institution exhibition at the National Museum of American Art, Wash., D.C., 1989.

Stryker, Roy, and Nancy Wood. *In This Proud Land.* Greenwich, Conn.: New York Graphic Society, 1973.

Swedlund, Charles. *Photography.* New York: Holt, Rinehart & Winston, 2nd ed., 1981.

Taft, Robert. *Photography and the American Scene*. New York: Dover Publications, 1964. Republication of original work published by Macmillan, 1938.

Teeman, Lawrence, ed. *Photographic Equipment Test Reports Quarterly*. Skokie, Ill.: Periodical Consumer Guide.

Tell, Judy. *Making Darkrooms Saferooms: A National Report on Occupational Health and Safety*. Durham, N.C.: National Press Photographer's Association, 1988.

Time–Life Books. *Life Library of Photography: The Camera*. New York: Time, Inc., 1970.

———— *Life Library of Photography: Color*. New York: Time, Inc., 1970.

———— *Life Library of Photography: The Great Themes*. New York: Time, Inc., 1970.

———— *Life Library of Photography: Light and Film*. New York: Time, Inc., 1970.

———— *Life Library of Photography: Photographing Nature*. New York: Time, Inc., 1970.

———— *Life Library of Photography: The Print*. New York: Time, Inc., 1970.

———— *Life Library of Photography: Special Problems*. New York: Time, Inc., 1970.

———— *Life Library of Photography: The Studio*. New York: Time, Inc., 1970.

———— *Life Library of Photography: The Art of Photography*. New York: Time, Inc., 1971.

———— *Life Library of Photography: Great Photographers*. New York: Time, Inc., 1971.

———— *Life Library of Photography: Photojournalism*. New York: Time, Inc., 1971.

———— *Life Library of Photography: Caring for Photographs*. New York: Time, Inc., 1972.

———— *Life Library of Photography: Documentary Photography*. New York: Time, Inc., 1972.

———— *Life Library of Photography: Photography as a Tool*. New York: Time, Inc., 1973.

Truitt, Rosalind. "Electronic Photography." *Presstime*, October, 1988.

Tucker, Charles Lee. *Industrial and Technical Photography*. Englewood Cliffs, N.J.: Prentice-Hall, 1989.

Upton, Barbara London, with John Upton. *Photography*. Boston: Little, Brown, 3rd ed., 1985.

Welling, William. *Photography in America: The Formative Years*. New York: Thomas Y. Crowell, 1978.

White, Larry. "The Wonderful World of Electronic Imaging: Is It the Photographic Future?" *Popular Photography,* May, 1991.

White, Minor. *The Zone System Manual*. Hastings-on-Hudson: Morgan and Morgan, 1968.

Index

Credits